Mrs. Delany & her Circle

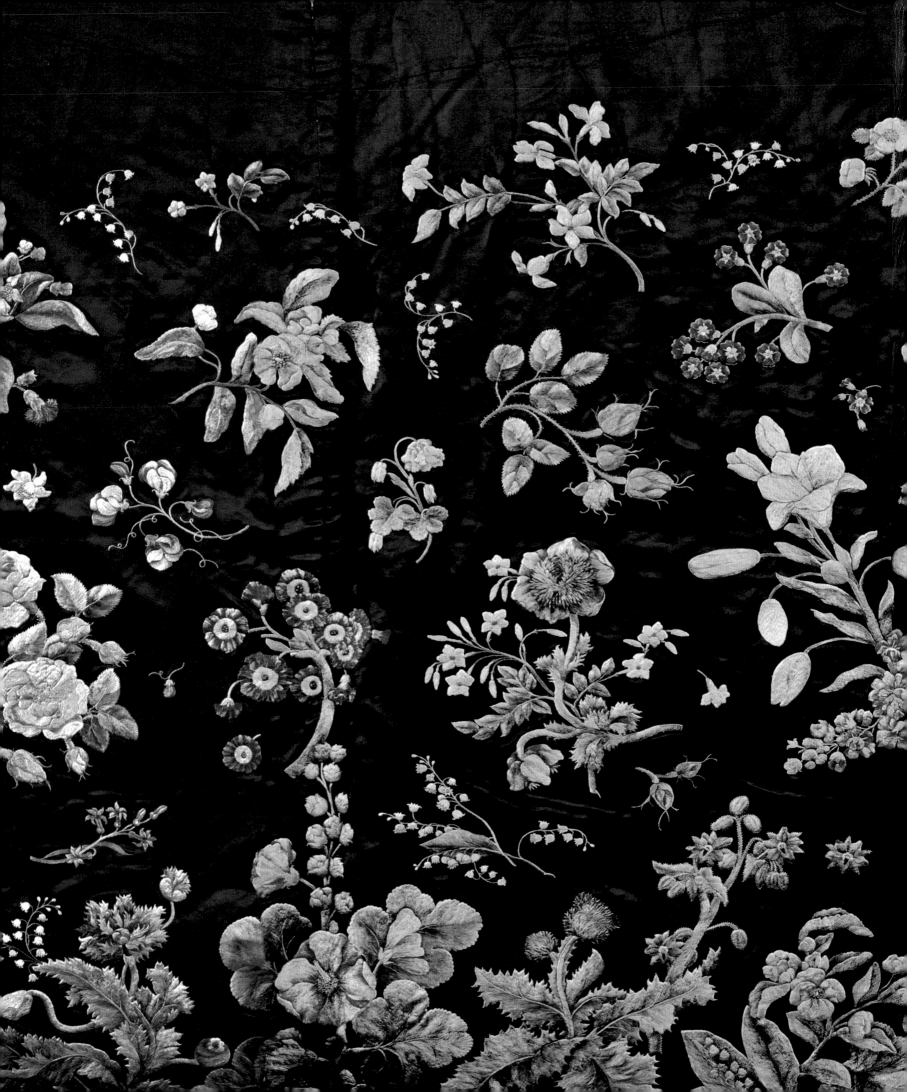

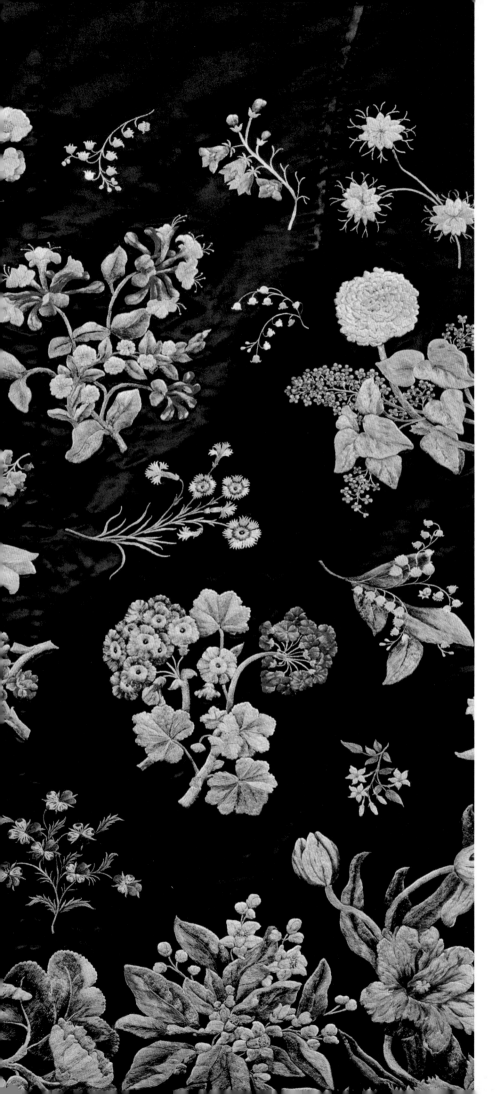

Mrs. DELANY

& HER CIRCLE

Edited by Mark Laird & Alicia Weisberg-Roberts

Yale Center for British Art
Sir John Soane's Museum
In association with
Yale University Press, New Haven and London

This publication accompanies the exhibition
Mrs. Delany and her Circle

Co-organized by the Yale Center for British Art
and Sir John Soane's Museum, London,
on view at the Yale Center for British Art
from 24 September 2009 to 3 January 2010
and at Sir John Soane's Museum
from 18 February to 1 May 2010.

Designed by Derek Birdsall R.D.I.
Typeset by Shirley & Elsa Birdsall / Omnific
Printed in Italy by Conti Tipocolor S.p.A., Florence

Library of Congress Cataloging-in-Publication Data

Mrs. Delany and her circle / edited by Mark Laird and
Alicia Weisberg-Roberts.
 p. cm.
 Includes bibliographical references and index.
 Publication to accompany an exhibition co-organized by
the Yale Center for British Art and Sir John Soane's Museum,
London, which will be on view at the Yale Center for British
Art, Sept. 24, 2009-Jan 3, 2010 and at Sir John Soane's Museum,
Feb. 18-May 1, 2010.
 ISBN 978-0-300-14279-2 (alk. paper)
1. Delany, Mrs. (Mary), 1700-1788--Knowledge and learning.
2. Delany, Mrs. (Mary), 1700-1788--Friends and associates.
3. Great Britain--Intellectual life--18th century.
I. Laird, Mark. II. Weisberg-Roberts, Alicia.
III. Yale Center for British Art. IV. Sir John Soane's Museum.
 NX547.6.D45M77 2009
 745.54092--dc22

2009024157

Frontispiece: Detail of the front petticoat
panel, designed by Mary Pendarves, 1740–41,
silk embroidery on satin, 41⅜ × 69¼ in.
(105 × 176 cm). Private collection

Contents

Directors' Foreword: *Amy Meyers and Tim Knox* vii

Acknowledgments x

Introduction (1): Mrs. Delany from Source to Subject *Alicia Weisberg-Roberts* 1

A Theater of Mrs. Delany's Collages 20

Introduction (2): Mrs. Delany & Compassing the Circle: the Essays Introduced *Mark Laird* 28

[1] Mrs. Delany & the Court *Clarissa Campbell Orr* 40

[2] Mary Delany's Embroidered Court Dress *Clare Browne* 66

[3] Dressing for Court: Sartorial Politics & Fashion News in the Age of Mary Delany *Hannah Greig* 80

[4] The Theory & Practice of Female Accomplishment *Amanda Vickery* 94

[5] Mrs. Delany's Paintings & Drawings: Adorning Aspasia's Closet *Kim Sloan* 110

[6] Mary Delany: Epistolary Utterances, Cabinet Spaces, & Natural History *Maria Zytaruk* 130

[7] Mrs. Delany's Circles of Cutting & Embroidering in Home & Garden *Mark Laird* 150

[8] Mrs. Delany's Natural History & Zoological Activities: "A Beautiful Mixture of Pretty Objects" *Janice Neri* 172

[9] Novelty in Nomenclature: The Botanical Horizons of Mary Delany *John Edmondson* 188

[10] A Progress in Plants: Mrs. Delany's Botanical Sources *Lisa Ford* 204

[11] The "Paper Mosaick" Practice of Mrs. Delany & her Circle *Kohleen Reeder* 224

[12] An Intimate and Intricate Mosaic: Mary Delany & her Use of Paper *Peter Bower* 236

Afterword *Mark Laird* 248

Appendix
"Marianna" (1759) *Mrs. Delany, transcribed by Alicia Weisberg-Roberts* 250
Bibliography 263
Concordance *John Edmondson and Charles Nelson* 267
Index 274
Photographic Credits 283

To
Ruth Hayden
The Truest Judge
And Brightest Pattern
Of All the Accomplishments
Which Adorn these Pages
These Essays on
Mrs. Delany
And her
World
Are most humbly inscribed

Directors' Foreword

The exhibition *Mrs. Delany and her Circle* explores the relationship among natural history, art, and sociability. Mrs. Delany, who has long been known as a distinctive voice in the literature on the eighteenth century is here revealed in the full flower of her accomplishments. This exhibition asks questions about the nature of scientific practice, the value of accomplishment, and the place of the amateur, as well as about gender and class as constituent parts of one woman's life and practice.

The idea for an exhibition on Mrs. Delany arose from a meeting between Mark Laird and Ruth Hayden in 2004. Ruth Hayden's book, *Mrs. Delany, Her Life and Her Flowers* (1980) had done much to revive interest in Mrs. Delany, and was responsible for bringing her extraordinary botanical mosaics to a wider public, including those like Mark, with an interest in eighteenth-century gardening. In talking to Ruth and encountering Mrs. Delany's embroideries, Mark recognized that they provide a superb and under-exploited resource for reconsidering the place of floriculture in eighteenth-century life, and its intersection with a variety of spheres, including those of science, fashion, collecting, and the decorative arts. It is especially delightful that his conversations with Ruth have resulted in an exhibition at the Yale Center for British Art since the initial publication of Ruth's book was supported by the Center's founder, Paul Mellon, and Mrs. Paul Mellon has lent so generously to the current project from the Oak Spring Garden Library. It has been a great pleasure to consult with Ruth throughout the process of creating this exhibition and publication.

In crafting the project the curators and editors, Mark Laird and Alicia Weisberg-Roberts, have brought together an outstanding group of scholars. Through the workshops, symposia, and archival visits undertaken in pursuing research for the exhibition, a vibrant community of Delany scholars has taken shape. This volume and the exhibition represent the immediate fruits of their labors. We would like to extend our deepest thanks to Mark and Alicia and to the other contributors to this book: Clarissa Campbell Orr, Clare Browne, Hannah Greig, Amanda Vickery, Kim Sloan, Maria Zytaruk, Janice Neri, John Edmondson, Lisa Ford, Kohleen Reeder, Peter Bower, and Charles Nelson. All of the authors have undertaken considerable original research, drawing on their diverse fields of expertise with characteristic insight and bringing much fresh material to light.

We also would like to express our immeasurable gratitude to more than forty private individuals and public institutions; they have lent objects to this exhibition, enabling us to construct a truly representative picture of the intellectual richness, artistic brilliance, and personal charm of Mrs. Delany's world.

It is with great pleasure that we use the occasion of *Mrs. Delany and her Circle* to introduce an important group of botanical paper collages ascribed to the Hon. Booth Grey. William Booth Grey (1740–1802) was the brother-in-law of Henrietta Bentinck, daughter of the Duchess of Portland, and hence known to Mrs. Delany. These collages (ca. 1790), recently acquired by the Yale Center for British Art and made in a technique derived directly from that of Mrs. Delany, have broadened our sense of the scope of this particular practice of accomplishment. They also have provided an opportunity to make a close technical examination of late eighteenth-century paper mosaics. This research was undertaken by Kohleen Reeder, then Postgraduate Research Associate in Paper Conservation at the Center and now Book and Paper Conservator at the J. Willard Marriott Library, The University of Utah in Salt Lake City. Kohleen was supported in her work by the staff of the Department of Paper Conservation at the Yale Center for British Art and was offered invaluable technical assistance by Henry A. DePhillips Jr., Vernon K. Krieble Professor of Chemistry at Trinity College, Hartford, and Peter Bower, forensic paper historian and paper analyst.

This book also publishes for the first time the text of Mrs. Delany's 1759 "moral romance," *Marianna*, the manuscript of which is now in the collection of the Lilly Library, Indiana University, Bloomington. *Marianna* is Mrs. Delany's most extended and ambitious foray into fiction, and encapsulates the closely intertwined strands of female friendship, pedagogy, moralism, and natural philosophy that inform so many of her endeavors. Many of the key issues of eighteenth-century intellectual life were couched in the form of fantasy, and the publication of *Marianna* here expands our sense of Mrs. Delany's engagement with the literary culture of her time. Characteristically, Mrs. Delany's tale is also lovingly-wrought and good-humored, intended to entertain as much as instruct. We are particularly grateful to the Lilly Library for allowing Alicia Weisberg-Roberts to transcribe *Marianna* and present it here.

In the course of preparing for this exhibition, we have been aided greatly by the staff of the British Museum. In addition to extending their help and expertise to our curators and researchers at every point, the Museum staff has also digitized the entire corpus of the "Flora Delanica". This facilitated the research and preparation for this exhibition, proving the extraordinary benefits that making their vast collections electronically available affords to scholarship in many fields. In the present case, the improved accessibility of the botanical collages has enabled botanical analysis, an ongoing project begun by John Edmondson and Charles Nelson, whose first fruits are published here. An authoritative scientific catalogue of

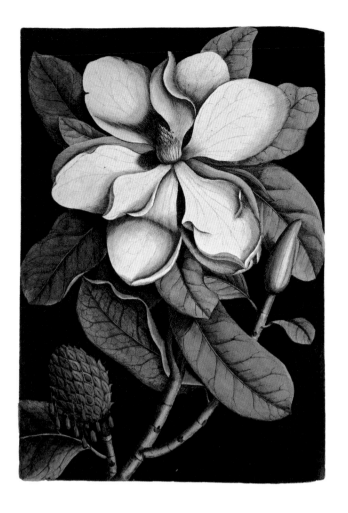

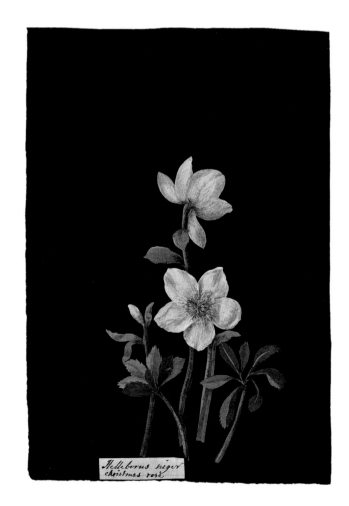

the near one thousand collages is a desideratum for the future. This would involve an expansion of the tasks already undertaken by John and Charles for this book including accurate transcripts of the master list itself along with recto labels and verso texts; accurate identification of species figured, with commentaries on any nomenclatural issues; supporting research into representations by contemporary botanical artists (including those in the Booth Grey collection) of the plants Delany delineated; and, more extensively, an analysis of the date and means of introduction into cultivation in Britain of the plants depicted in the collages.

It is hoped that by making available these and the many other works shown in *Mrs. Delany and her Circle* to the scholarly community, this exhibition and publication will inspire additional investigation into the many questions they raise. We are particularly hopeful that the archival and topographical material relating to Delville and Bulstrode, some of it reproduced for the first time, will act as a spur to further research on the lost landscapes that were so important to Mrs. Delany.

While staff members at both Sir John Soane's Museum and the Yale Center for British Art are thanked more fully in the acknowledgements, we would like to give credit here to certain individuals who have contributed in essential and significant ways to the exhibition and book. At Sir John Soane's Museum, Jerzy J. Kierkuć-Bieliński, Exhibitions Curator, has given invaluable assistance and facilitation; at the Yale Center for British Art, Theresa Fairbanks-Harris, Chief Paper Conservator, and her department, provided outstanding logistical and intellectual contributions to this project; Julia Marciari Alexander, formerly Associate Director of Exhibitions and Publications at the Yale Center for British Art, and now Deputy Director for Curatorial Affairs at the San Diego

Museum of Art, led the way through the initial challenges of mounting this exhibition; Eleanor Hughes, Assistant Curator in the Department of Exhibitions and Publications, carried forward that momentum through the exhibition and publication, overseeing logistics and support at both institutions, including securing loans for the exhibition and images for the publication. Finally, we extend our thanks to Derek Birdsall, R.D.I., for designing this beautiful book, and to our Publisher, Sally Salvesen of Yale University Press, for overseeing all of the processes that have brought it so elegantly into print.

Amy Meyers
Director, Yale Center for British Art

Tim Knox
Director, Sir John Soane's Museum

Figure 1: Mark Catesby after George Dionysius Ehret, 'Magnolia altissima', plate 61 from Catesby, *The Natural History of Carolina, Florida, and the Bahama Islands*, vol. 2 (London, 1743). Collection of Mrs. Paul Mellon, Oak Spring Garden Library

Figure 2: Thomas Robins the Elder, *Wildflowers, a Butterfly and a Fly*, ca. 1760, water- and bodycolor on paper, 11¾ × 8⅝ in. (29.8 × 22 cm). Collection of Mrs. Paul Mellon, Oak Spring Garden Library

Figure 3: Barbara Regina Dietzsch, *Christmas Rose* (Helleborus niger) *with Tortoiseshell Butterfly*, 18th century, bodycolor on black prepared paper, 11⅜ × 8¼ in. (28.9 × 20.9 cm). Collection of Mrs. Paul Mellon, Oak Spring Garden and Library

Figure 4: Mary Delany, 'Helleborus niger', 1773–82, collage of colored papers, with bodycolor and watercolor, 11 × 7⅜ in. (27.8 × 18.8 cm). British Museum, Department of Prints and Drawings (1897,0505.412)

Acknowledgments

Mrs. Delany and her Circle, both as a book and an exhibition, has benefited immeasurably from the support of many institutions and the expertise of many individuals. The editors and curators are deeply indebted to the friends and colleagues at the Yale Center for British Art, Sir John Soane's Museum, and elsewhere who have provided advice, enthusiasm, and much practical assistance.

This exhibition began in the spirit of generosity unfailingly demonstrated by Ruth Hayden and her extended family, who allowed us to document and study their Delaniana. Our first thanks go to Ruth as well as Robert Whytehead, Penelope J. W. Poullain, Priscilla Whytehead, Sue Hewitt, and others who wish to remain anonymous, but have generously agreed to share their collections.

At the Royal Collection we wish to express our gratitude to Sir Hugh and the Hon. Lady Roberts; at Historic Royal Palaces, to Lucy Worsley and to Joanna Marschner, to whom we owe special thanks both for sharing her invaluable knowledge of court dress and royal palaces and for hosting a gathering of the authors of this volume.

In following Mrs. Delany's peregrinations through the great houses she frequented we have been assisted by the curators of collections that she once knew. For their help in this regard we would like to thank Amanda Askari, Brendan Cole, and Emma Tate at Knowsley Hall, Merseyside; Dr. Kate Harris at Longleat House, Wiltshire; and Derek Adlam at Welbeck Abbey, Nottinghamshire.

In Great Britain and in the United States we have had the privilege of working with colleagues in the natural sciences who have invariably enriched the intellectual scope of this project. At the Hunterian Museum and Art Gallery, Glasgow we would like to thank warmly Geoff Hancock and Maggie Reilly. At the Natural History Museum, London, we are grateful to Mark Adams, Malcolm Beasley, Steve Cafferty, Andrea Hart, Mary Spencer Jones, Judith Magee, Jane Smith, Clare Valentine, and Kathie Way. At Chelsea Physic Garden, we would like to thank Rosie Atkins and her colleague Ruth Stungo. At the Royal Botanic Gardens, Kew, we were assisted by Christopher Mills and Lynn Parker, and at Painshill Park Trust by Karen Bridgman, Kathleen Clark, and Mark Ebdon. We received much helpful advice from staff at the LuEsther T. Mertz Library and the New York Botanical Garden, including Karen Daubmann, Todd Forrest, and Marc Hachadourian. We gratefully acknowledge the assistance of our colleagues at Yale's Peabody Museum, Susan H. Butts, Eric A. Lazo-Wasem, Raymond J. Pupedis, Lourdes M. Rojas, and Gregory J. Watkins-Colwell, as well.

We have been guided throughout the project by John Edmondson and his colleagues both at the World Museum Liverpool and at the Linnean Society of London. We are grateful, too, for the inexhaustible botanical acumen of Charles Nelson. Their contribution to the entire book in terms of rigorous scientific insights and editorial support cannot be overstated.

Research for this project was pursued in numerous libraries and archives. We are indebted to the staffs of these institutions, including those of the Beinecke Rare Book and Manuscript Library, Yale University; the British Library; the Heinz Archive of the National Portrait Gallery, London; and the Newport Reference Library. We are also grateful to the staff of Bernard Quaritch, Ltd. We would like to thank particularly Lisa Decesare and Judith A. Warnement at the Harvard University Herbaria; David J. Griffin at the Irish Architectural Archive; Margaret Powell, Cynthia Roman, Sue Walker, and the rest of the staff at the Lewis Walpole Library, Yale University; Saundra Taylor and Cherry Dunham Williams at the Lilly Library, Indiana University, Bloomington; and Brent Elliot and Annika Erikson Browne at the Lindley Library, Royal Horticultural Society.

This exhibition would not have been possible without the gracious support of the British Museum. Here, we are indebted to the enthusiasm of Neil MacGregor, the cooperation of Antony Griffiths, the expertise of Helen Sharp and Kim Sloan, and the invaluable contributions of Mark McDonald and the Merlin Scanning Team: Allan Chin, Christopher Coles, Barbara Freitas, Claudia Fruianu, and Nicoletta Norman. At the National Gallery of Ireland we benefited from both the assistance and the deep knowledge of Anne Hodge and Adrian Le Harival. In our research for this exhibition we were privileged to draw on the goodwill of numerous colleagues at a broad range of museums, including the staff of the Pierpont Morgan Library and the Museum of London. We would like to give special thanks to Clare Browne and Julius Bryant at the Victoria and Albert Museum, London; Alex Kidson at the Walker Art Gallery, Liverpool; V. Barwell at No. 1 Royal Crescent Museum, Bath; Sandy Nairne and Lucy Peltz at the National Gallery, London; and Peter Greenhalgh and David Scrase at the Fitzwilliam Museum, Cambridge. We would also like to thank our colleagues at the Yale University Art Gallery: John Stuart Gordon, Patricia E. Kane, Jock Reynolds, and David Ake Sensabaugh.

The editors and authors would also like to express their thanks to the following people, who have contributed to the individual conversations, symposia, panels and workshops which have formed and enriched this project: Brian Allen, Louisa Calé, Michele Cohen, Juilee Decker, Henry A. DePhillips Jr., Elizabeth Eger, the Knight of Glin, the Hon. Desmond Guinness, Craig Ashley Hanson, John and Eileen Harris, Tim Knox, Stephen Lloyd, Todd Longstaffe-Gowan, Julia Marciari Alexander, Amy Meyers, Lisa L. Moore, Victoria Munroe, Charles Nelson, William Palin, Molly Peacock, Claude Rawson, Jason Siebenmorgen, and Jane Wildgoose. We would also like to thank Lowell Libson for advice and logistical assistance.

Mrs. Delany and her Circle has been propelled by the exemplary staff of the Yale Center for British Art. The editors would like to thank without reservation Eleanor Hughes, Assistant Curator in the Department of Exhibitions and Publications; the intrepid Anna Magliaro, Publications Assistant; Diane Bowman, Senior Administrative Assistant; and Postdoctoral Research Associates, Jo Briggs and Andrea Wolk Rager, the latter of whom provided indispensible support in the final stages of the exhibition process. For their advice and support throughout we would like to express our gratitude to Cassandra Albinson, Associate Curator of Paintings and Sculpture; Gillian Forrester, Senior Curator of Prints and Drawings; Matthew Hargraves, Assistant Curator of Art Collections Documentation and Research; and to Scott Wilcox, Chief Curator of Art Collections and Senior Curator of Prints and Drawings, along with the staff of the Department of Prints and Drawings, especially John Monahan, Senior Curatorial Assistant, and Adrianna Bates, Curatorial Assistant. We would like to thank Elisabeth Fairman, both in her capacity as Senior Curator of Rare Books and Manuscripts and for her role as organizing curator for the installation entitled *Promiscuous Assemblage, Friendship, & the Order of Things*, by the artist Jane Wildgoose, that accompanies this exhibition at the Yale Center for British Art. We also would like to thank her colleagues Maria Rossi, Senior Curatorial Assistant, and Bekah Dickstein, Curatorial Assistant.

We owe a deep debt of gratitude to Kraig Binkowski, Head Librarian, and the entire staff of the Reference Library at the Yale Center for British Art for their incalculable contributions to this project. Our conception of the book and exhibition have been similarly aided by the staff of the Center's Research Department, including the former Head of Research, Michael Hatt; Associate Head of Research, Lisa Ford; and Imogen Hart, Postdoctoral Research Associate.

It has been a pleasure and an honor to work closely with the Center's Paper Conservation Department. We owe thanks to the entire staff, but would like particularly to mention Chief Conservator of Paper, Theresa Fairbanks-Harris; Associate Conservator, Dong-Eun Kim; Conservation Assistant, Mary Regan-Yttre; and Kohleen Reeder, formerly Postgraduate Research Associate and now Book and Paper Conservator at J. Willard Marriott Library, The University of Utah in Salt Lake City.

Special thanks go to Stephen Saitas, who designed the wonderful installation of the exhibition at the Center, and in the process did much to help the curators refine their vision of the project as a whole. We also would like to thank Installation Manager, Richard Johnson and the installation team at the Center, as well as Lyn Bell Rose, Senior Graphic Designer, and Elena Grossman, Graphic Designer, for their characteristically brilliant execution. We have had the pleasure of working with Jason Siebenmorgen on the special botanical installation that also accompanies the exhibition at the Center; our thanks go to him and to the many people at the institution who have made this part of the project possible.

We have been fortunate throughout this project to work with a number of extraordinary Yale undergraduates, including Rachel Cooke; Adam T. Gardener; and Diana Mellon, who joined our team as a Bartels fellow. Their assistance has been invaluable and their contribution palpable in every aspect of *Mrs. Delany and her Circle.*

As the editors, we would like to extend heartfelt and personal thanks to Mary Gladue, copy editor, Catherine Bowe, editorial coordinator, and Sally Salvesen, Publisher, at Yale University Press, London. If the reader finds elegance or good humor here, they are in large measure responsible. We would also like to thank John Hammond, whose wonderful photographs adorn many pages of this book.

The transferral of the exhibition to Sir John Soane's Museum, London, has been made possible by generous support from the Deborah Loeb Brice Foundation and Mrs. Shelby White via the Leon Levy Foundation. We would also like to thank Jerzy J. Kierkuć-Bieliński, Exhibitions Curator, at Sir John Soane's Museum, as well as Mike Nicholson and Claudia Celder of the Soane Development Office for their tireless work in securing funding.

Mark Laird
&
Alicia Weisberg-Roberts

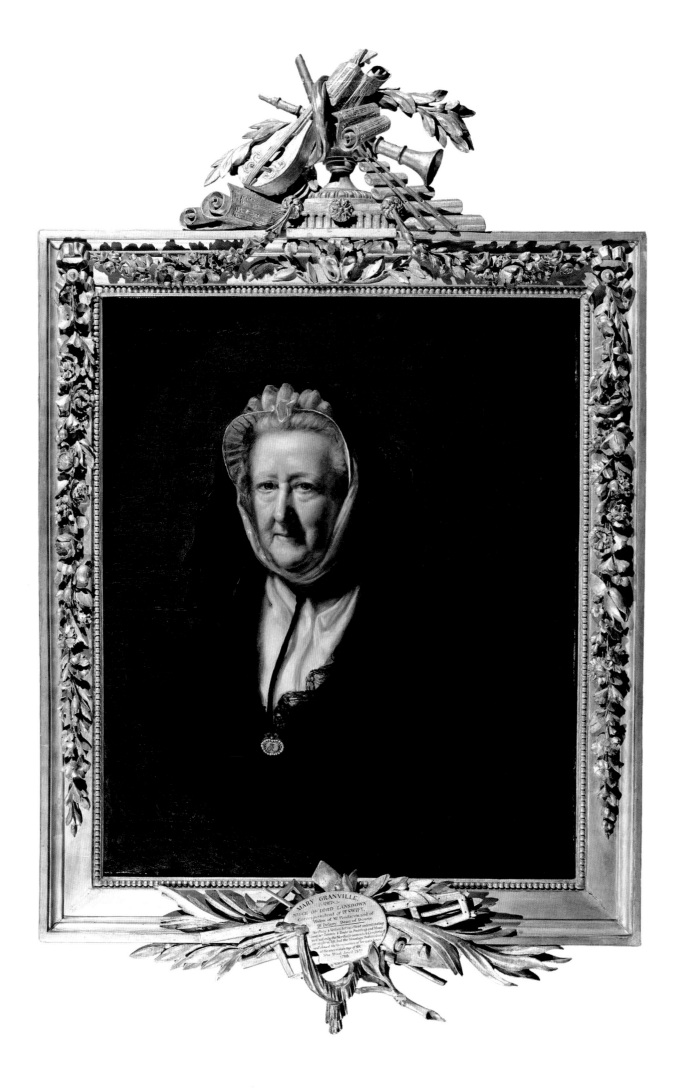

INTRODUCTION (1)

Mrs. Delany from Source to Subject

The subject of this book, and the exhibition that it accompanies, was born Mary Granville on 14 May 1700 at Coulston, Wiltshire, and died Mary Delany on 15 April 1788.[1] The daughter of a younger son of the Tory aristocracy, she ended her long life—which encompassed two marriages, two lengthy widowhoods, and extended periods of residence in England and Ireland—as a friend of Queen Charlotte and George III. Thanks to her social connections, her longevity, her artistic, scientific, and musical interests, and her many accomplishments, the "career" of Mrs. Delany involved her in a number of the culturally influential circuits of Georgian Britain, including that of the Court and the orbits of Alexander Pope, George Frideric Handel, Jonathan Swift, John Wesley, Samuel Johnson, and the Duchess of Portland. In her later years, she appeared to her contemporaries as a model of propriety and accomplishment, "the woman of fashion of all ages," in Edmund Burke's oft-quoted formulation.[2] Horace Walpole, who used this *bon mot* as the basis of the inscription on the frame he designed for the portrait of Mrs. Delany by John Opie (fig. 5), enrolled one of her collages among the "works of genius at Strawberry Hill by Persons of Rank and Gentlemen not Artists."[3] She left behind an exemplary reputation, a voluminous correspondence (published by Lady Llanover in the nineteenth century), Irish landscape gardens, an unpublished novella, and a formidable body of work in the media of oil painting, drawing, plasterwork, shellwork, featherwork, japanning, needlework, paper-cuts, and paper collages.[4] These last, which consist of nearly one thousand botanical "paper mosaics," are testimony to the extraordinary nexus of taste, scientific knowledge, and the distinctly female social persona that she came to embody (fig. 6).

Figure 5: John Opie, *Mary Delany*, 1782,
oil on canvas, 29½ × 24½ in. (74.9 × 62.2 cm).
National Portrait Gallery, London (1030)

Figure 6: Mary Delany, 'Convallaria majalis', 1776,
collage of colored papers, with bodycolor and
watercolor, 10¾ × 7⅛ in. (27.3 × 18.2 cm).
British Museum, Department of Prints and
Drawings (1897,0505.224)

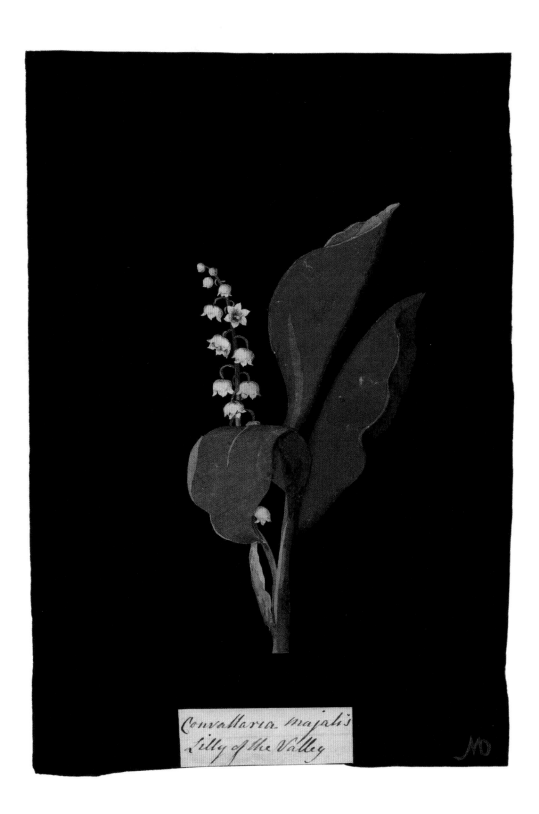

For modern historians of the eighteenth century and its material culture, Mrs. Delany has occupied a different role. Her multitude of epistolary friendships, her perspicacity in observing the world around her, and her assiduousness in setting down and communicating her experiences, have ensured her position as a frequently cited source on eighteenth-century British life. She has become, in a sense, a mirror of her times; her observations often appear in the guise of impersonal reportage or as generalized opinions.[5] In the process, much of the specificity of her outlook and experience has been muted. This book, and the exhibition it accompanies, constitute the first comprehensive, academic study of her life and the first attempt to present the full range of her work. By considering the full scope of Mrs. Delany's life and activities, the contributors to this volume and the curators of the exhibition have worked to re-embody her as a historical figure, not as the reflection of her times, but as a distinctive voice in the context of eighteenth-century society.

In spite of her influential position and social prominence, historians have often found it easier to say who Mrs. Delany was not rather than to define who she was. Her life and creative endeavors do not fit comfortably into the categories that often guide historical investigation. As a patron, her projects and resources were modest; unlike her great friend the Duchess of Portland, she was not principally a collector; though she wrote extensively, she never sought publication; intensely interested in natural history, she has not been identified as a natural historian by historians of science; and while she was connected to the Bluestockings by ties of friendship and family, she did not identify herself as one of them. Although she designed textiles and created botanical images, she was not a professional textile designer or botanical illustrator like her contemporaries Anna-Maria Garthwaite and Barbara Regina Dietzsch; and although she was an enthusiastic amateur, her aristocratic birth and status make it difficult to ascribe all of her practices to the rise of bourgeois feminine accomplishments.

Why have historians encountered such difficulty in assigning a place to Mrs. Delany, whose position seemed so natural to her contemporaries? At least part of the answer lies in the way the history of art and the history of science have defined their subjects and their relation to society at large. For Mrs. Delany, art and natural history were disciplines that nourished one another and, indeed, could be seen to proceed in tandem. Whereas the natural historians and botanical artists whom Mrs. Delany knew and beside whom she worked, including Georg Dionysius Ehret,

Daniel Solander, and John Lightfoot, are seen as having played an integral role in the advancement of Linnaean botany, Mrs. Delany's gender and amateur status have largely prevented her work from being considered alongside theirs. Traditional forms of historiography represent the progress of science as a succession of contributions by greater and lesser men whose work propels scientific knowledge across time in a succession of incremental leaps, discoveries, and refinements.[6] According to this conception of scientific progress, Mrs. Delany's role would be nugatory. More recent approaches to the history of science have questioned this narrow focus on incremental progress and the depiction of scientific inquiry as an endogenous and self-propelled process.[7] In this book we argue that scientific advancement takes place amid a cloud of technological, cultural, and social concerns, which play a determining role in shaping its course. According to this view, the horizontal diffusion of scientific knowledge and its interpenetration with society is as important to our understanding of scientific history as its vertical development in time. It is in light of this reconceptualization that the desirability of viewing scientific advances alongside cultural trends becomes apparent, and that Mrs. Delany's contribution becomes significant.

The artistic dimension of Mrs. Delany's work has also been obscured by the value judgments prevalent in much art-historical writing, which tends to undervalue women artists, amateurs, and the so-called minor arts.[8] Although Mrs. Delany's work has been exhibited and published as a signal representative of all of these categories, it has been inadequately theorized and under-studied by academic art historians. However, recent work by Kim Sloan and Ann Bermingham as well as the development of new approaches to the study of material culture have created a framework in which Mrs. Delany's productions can be better understood.[9] Traditional art history has focused on the work of (predominantly male) professional artists and on works in privileged media (such as painting and sculpture) that figured in the curricula of art academies and circulated in the art market and exhibitions of the time. This emphasis on professionally produced fine art has been a persistent feature even of many progressive approaches that have championed the relevance of social-historical and gender-based analyses to the history of eighteenth-century art. However, while the eighteenth century was a period in which the apparatus of the modern art world was formed, it was also a time in which amateurs, connoisseurs, and *virtuosi* engaged with art through

practice. The drawings, paintings, and many other kinds of objects that were produced by amateur practitioners are documents of an important process by which they constituted their cultural identities. Although these works seldom entered public exhibitions or national collections, they nonetheless were prized by their intended audience. Most of Mrs. Delany's work traveled within a cultural circuit that was neither commercial nor public (fig. 7). The retention and preservation of the fragments of her embroidery by her heirs and descendants is eloquent testimony to the kind of value—quite apart from aesthetic or monetary worth associated with such objects. However, the value of such affective and personal relations to works of art often evaporates entirely when they are removed from their intended niche. One of the tasks of this exhibition is to undertake a scholarly re-creation of the immediate context for the making and consumption of Mrs. Delany's art, so that its value to her contemporaries becomes once more fully apparent.

Mary Granville was born into a modestly well-off family whose senior branches commanded high social status, excellent connections, and political power. Descent from a poorer cadet line determined much of the course of her life. Her father, Bernard Granville, was the younger brother of George Granville, Lord Lansdowne, a Tory magnate in the reign of Queen Anne, whose Jacobitism led to his fall from favor, imprisonment in the Tower of London, and lengthy exile in Paris. Mary's early prospects suffered from these checkered circumstances. Between the ages of six and eight she was placed under the tutelage of Mlle Puelle, a Huguenot refugee who seems to have run a small, select school for girls. In describing her departure from this school, Mary mentions her precocious penchant for paper-cutting:

> I quitted my good and kind mistress with great sorrow, as well as Lady Jane Douglas (whose regard for me made her delight in all my little occupations; she would pick up the little flowers and birds I was fond of cutting out in paper, and pin them carefully to her gown or apron, that she might not tear them by putting them in her pocket; and I have heard of her preserving them many years after). She kept a partial remembrance of our early affection to the end of her life, though I never saw her from the moment of leaving school; but I received numberless proofs of her regard by messages and enquiries which were sent to me by every opportunity she could meet with.[10]

This girlhood anecdote introduces themes that would persist throughout Mrs. Delany's life, and

which the authors of this book address specifi-
cally: the exchange of handiwork to cement bonds
of friendship; the emphasis on the preservation
of such gifts; and the important role of corres-
pondence in framing and perpetuating these
exchanges. Subsequently, Mary was raised for
the most part in London, living with her aunt
and uncle, Lady Anne and Sir John Stanley, at
Whitehall, and educated in the expectation that
she would receive a court appointment. It was in
this milieu, at the age of ten, that Mary first
encountered Handel:

> *We had no better instrument in the house than*
> *a little spinnet of mine, on which that great*
> *musician performed wonders. I was much struck*
> *with his playing, but struck as a child, not a judge,*
> *for the moment he was gone, I seated myself to my*
> *instrument, and played the best lesson I had then*
> *learnt; my uncle archly asked me whether I thought*
> *I should ever play as well as Mr. Handel. "If I did*
> *not think I should," cried I, "I would burn my*
> *instrument!"*[11]

This "innocent presumption of childish igno-
rance" was transformed into a profound devotion
to the composer, shared by Mary's brother,
Bernard Granville, that would stretch beyond
Handel's lifetime.[12] Mrs. Delany's correspon-
dence remains an important source on the
reception and performance of Handel's music in
the eighteenth century. This period of privilege
and expectation gave way to uncertainty with the
death of Queen Anne in 1714. Under pressure
from Lord Lansdowne, Mary was married off,
disastrously, at the age of seventeen to a Cornish
MP, Alexander Pendarves, forty years her
senior.[13] As she wrote the autobiographical frag-
ments she composed in the 1740s,

> *I was married with* great pomp. *Never was woe*
> *drest out in gayer colours, and when I was led to*
> *the altar, I wished from my soul I had been led, as*
> *Iphigenia was, to be sacrificed. I was sacrificed.*
> *I lost, not life indeed, but I lost all that makes life*
> *desirable—joy and peace of mind... .*[14]

Figure 7: Firescreen, design and embroidery
attributed to Mary Pendarves, ca. 1740, silk thread
on satin, 9½ × 14¾ × 13⅜ in. (24 × 37.5 × 34 cm);
stand and frame, unknown maker, ca. 1800,
10⅝ × 14¾ in. (27 × 37.5 cm). Private collection

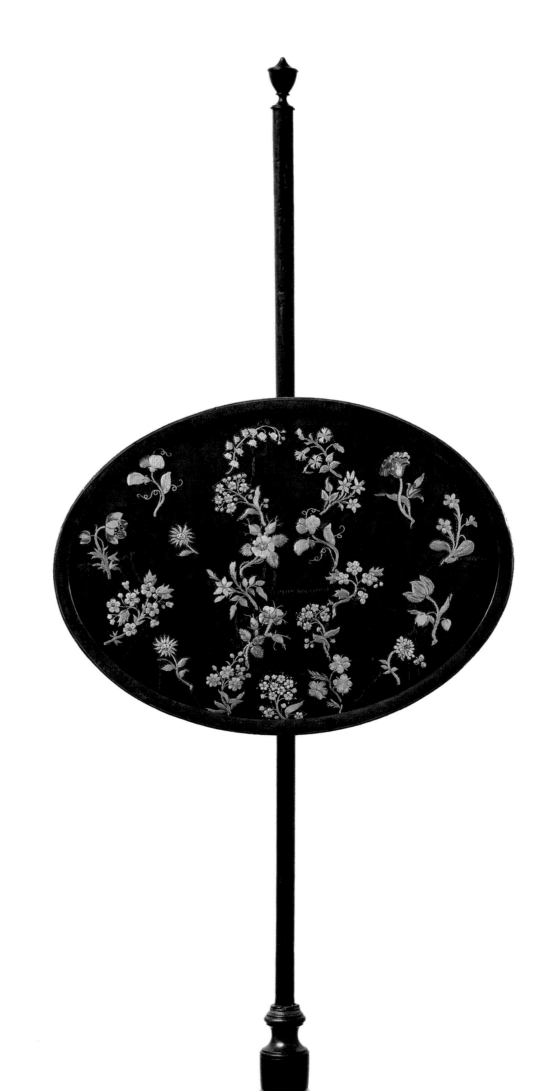

Initially, the couple lived at Pendarves's estate in Roscrow Castle, near Falmouth, Cornwall, but returned to London in 1721. Four years later, Pendarves's sudden death liberated her from this unrelentingly unhappy marriage, although it did not markedly increase her personal fortune. Nevertheless, in the next eighteen years the widowed Mrs. Pendarves traveled, attended court, and reported on numerous concerts, balls, and other entertainments in London life. In 1731, she visited Hogarth's studio in the company of the Wesley family and her close friend Anne Donnellan.[15] Anne was the daughter of the Lord Chief Baron of the Exchequer of Ireland and the sister-in-law of the Dr. Robert Clayton, the Bishop of Killala.[16] Utilizing these connections, the two women made a journey to Ireland lasting from September 1731 to April 1733. On this extended trip, Mrs. Pendarves wrote many letters, principally to her sister, Anne Granville, describing the congenial society she encountered there. She made a grotto, went sightseeing, and attended many theatricals, suppers, and assemblies.[17] Temporarily in mourning, Mary describes herself at one assembly seated at a table of "*absolute beauties:* I divided them, or rather tied them together, like a black ribbon in a garland of flowers… ."[18] During her sojourn she developed

longstanding friendships within the Anglo-Irish community, including Letitia Bushe and Jonathan Swift, with whom she maintained a cordial correspondence.[19] Her most decisive encounter, however, was with Swift's close friend, Dr. Patrick Delany, an Anglican cleric based in Dublin (fig. 8).[20] His imminent marriage to a widow of means did not prevent Mary from expressing her high regard for Dr. Delany to her sister, Anne. Comparing Delany to the already eminent Swift, she wrote that "Dr. Delany will make a *more desirable friend*, for he has all the qualities requisite for friendship—zeal, tenderness, and application… ."[21]

On her return to England in 1733, Mrs. Pendarves stayed with her mother and sister in Gloucestershire, with other relatives at Longleat, Wiltshire, with Lady Margaret Cavendish Harley, soon to become the second Duchess of Portland, at Bulstrode, Buckinghamshire, and at Lower Brook Street in London, where she kept a house at this date. Mary's wide-ranging correspondence reports on everything from the rehearsals of Handel's oratorios to the fashions worn at court. In a letter of 30 June 30 1734 she wrote to her sister:

> I have got a new madness, I am running wild after shells. This morning I have set my little collection of shells in nice order in my cabinet… the beauties of shells are as infinite as of flowers, and to consider how they are inhabited enlarges a field of wonder that leads one insensibly to the great Director and Author of these wonders. How surprising is it to observe the indifference, nay (more properly) stupidity of mankind, that seem to make no reflection as they live, are pleased with what they meet with because it has beautiful colours or an agreeable sound, there they stop, and receive but little more pleasure from them than a horse or a dog.[22]

Mrs. Pendarves's fascination with shells and conchology would prove enduring. She ornamented her own home and those of many friends with shellwork, often in floral patterns, built grottoes, and eventually became deeply engaged in the second Duchess of Portland's much more grandiose and systematic shell-collecting. But this early letter illustrates important elements of Mary's *habitus*: first, the quick leap from the visual appeal of the material at hand to the wonder of its divine complexity; second, the development of this idea in the form of a homily. Mary's pietism constantly reinforced her engagement with the decorative arts. It was imperative, and eminently laudable within this context, to depict the variety and intricacy of creation.

In the 1730s and early 1740s, Mrs. Pendarves circulated in the *beau monde* of court and aristocratic life, discussed by Clarissa Campbell Orr and Hannah Greig in this volume, as well as in literary and musical circles. Although the Bluestocking Circle would not meet formally until the 1750s, women who bridged these spheres were already becoming a feature of the cultural landscape.[23] The gold box commissioned by the Duchess of Portland from Christian Friedrich Zincke commemorates one of these earlier circles of learned and accomplished female friendship (fig. 9).[24] Its enamel miniatures show the four friends in costume: the Duchess of Portland as Flora; Mrs. Pendarves in a Lely-like velvet drape; Mary Howard, Viscountess Andover in a fur-trimmed ensemble, perhaps related to the dress "after Holler's Prints" that she and Mrs. Pendarves wore to a masquerade a few years later;[25] and Elizabeth Montagu, who described her own costume in a letter of April 1740 as "Anne Boleyn's dress."[26] Mary and the Duchess of Portland had known Elizabeth Montagu (later "Queen of the Blues") since her childhood.[27] In years to come, Mary would act as a friend and patron to older and younger women described as "bluestockings," including Frances Boscawen, Elizabeth Elstob, and Fanny Burney.[28] In her 1782 poem "Sensibility: An Epistle to the Honourable Mrs. Boscawen," Hannah More encompassed the aged Mary in her praise of this milieu:

> DELANEY shines, in worth serenely bright,
> Wisdom's strong ray, and virtue's milder light:
> And she who bless'd the friend, and grac'd the page
> Of Swift, still lends her lustre to our age,
> Long, long, protract thy light, O star benign!
> Whose setting beams with added brightness shine![29]

Nonetheless, in her thirties and forties, as both Mrs. Pendarves and Mrs. Delany, she was more fully at home in the tighter, golden circle described by the duchess's affections.

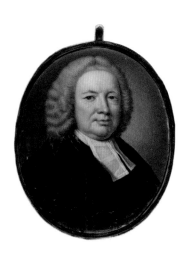

Figure 8: Attributed to Rupert Barber, *Dr. Patrick Delany*, recto dated 1740, verso dated 1768, enamel on copper, 1⅞ × 1½ in. (4.8 × 3.8 cm). National Gallery of Ireland, Dublin (3728)

Figure 9: Christian Friedrich Zincke, Gold box decorated with portraits of Margaret Cavendish, Duchess of Portland; Elizabeth Montagu; Mary Howard, Lady Andover; and Mary Pendarves, ca. 1740, enamel and gold, 16½ × 20½ × 9⅞ in. (42 × 52 × 25 cm). The Stuart Collection

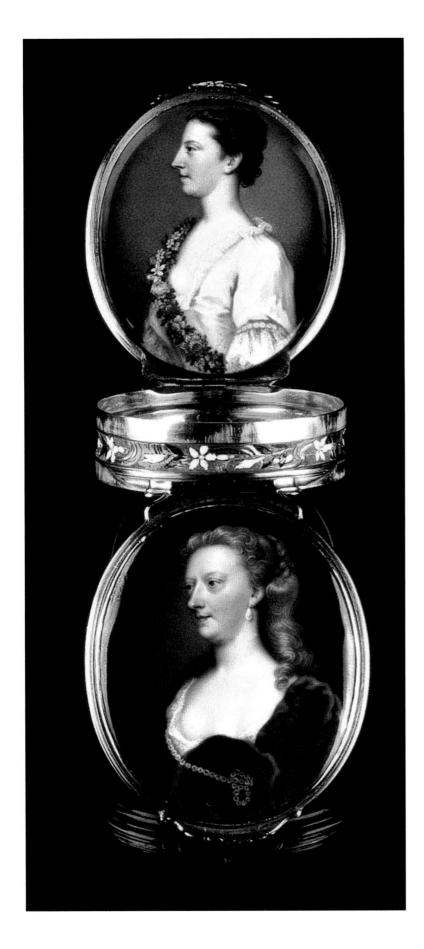
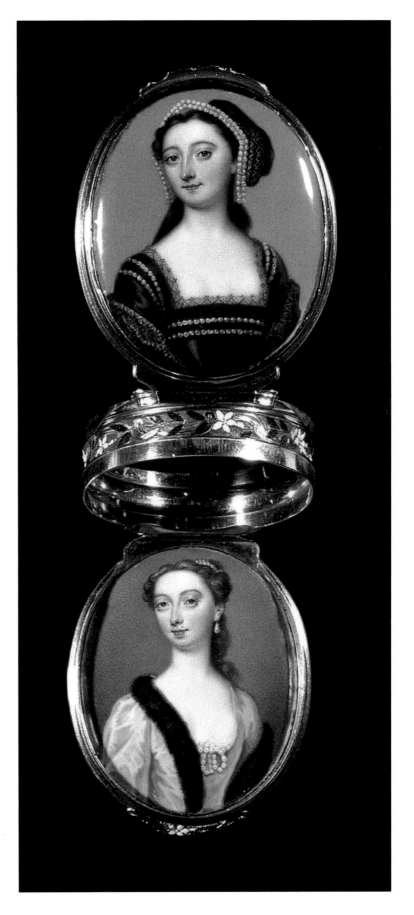

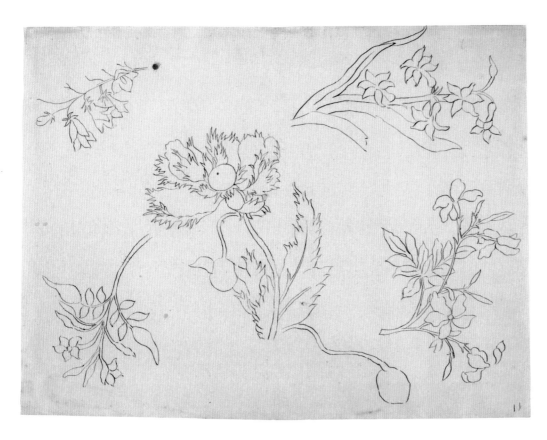

Figure 10: Mary Pendarves, ca. 1740, outline drawings of sprigs of flowers for embroidery. Private collection. They correspond to motifs in the petticoat panels and the apron (see figs. 11, 58, 61, and 66), and more generically to motifs in the firescreen and framed panel (see figs. 7, 24). The opium poppy (center) appears on the lower left of the apron. The jasmine (lower left) is similar to one in the top left of the apron. The harebell (upper left) can be seen in the top right of the front petticoat (see fig. 11, opposite). The hyacinth (upper right) is best represented in the top right of the back petticoat panel (see fig. 61). The jasmine (lower right) appears in reverse and ramified center right in the front petticoat (opposite).

Very close to the period of the execution of the enameled box in 1740–41, Mary, too, arrayed herself in flowers (figs. 10, 11). She designed a mantua to be worn at court featuring highly naturalistic, life-size flowers embroidered on black satin. The flowers, especially in candlelight, would have seemed to float on the receding black satin, evoking the rhetorical trope of nature's jewels. While the choice of blooms reflects a strong interest in florists' flowers such as tulips, carnations and auriculas, which were bred competitively in the eighteenth century, a repeated motif is the common lily-of-the-valley of woods and gardens. This unique and spectacular garment, which is analyzed by Clare Browne and others in this book, was unpicked in the late eighteenth or early nineteenth century and preserved in a variety of forms by Mrs. Delany's family.

In 1743, against the wishes of her family, Mrs. Pendarves married Dr. Patrick Delany, by then a widower himself. The next year, they settled at Delville, his small estate in the parish of Glasnevin, just north of Dublin. In this environment, with the support of her husband and a close circle of friends drawn from the Irish gentry and aristocracy, she was able to concentrate on her artistic works as never before. She built a workroom, decorated the ceilings with stucco work, and began to pursue oil painting. This period in Mrs. Delany's life was marked by an oscillation between images and ideas of perfect retirement and a heightened consciousness of her social responsibilities, both as the wife of a clergyman and as an exponent of the Anglo-Irish Ascendency. The latter took the form of an increasingly marked commitment to the promotion of "Irish Manufactures," a campaign that had its roots in the very late seventeenth century and was championed by Swift.[30] Mrs. Delany wore Irish stuffs to receptions at Dublin Castle, encouraging other ladies and gentlemen of rank to do the same, and assiduously promoted the more innovative productions of local industry.[31] She also produced numerous topographic drawings during this period, some showing such locales as the Giant's Causeway and others depicting local costumes and customs, which are discussed in depth in Kim Sloan's essay in this volume.[32]

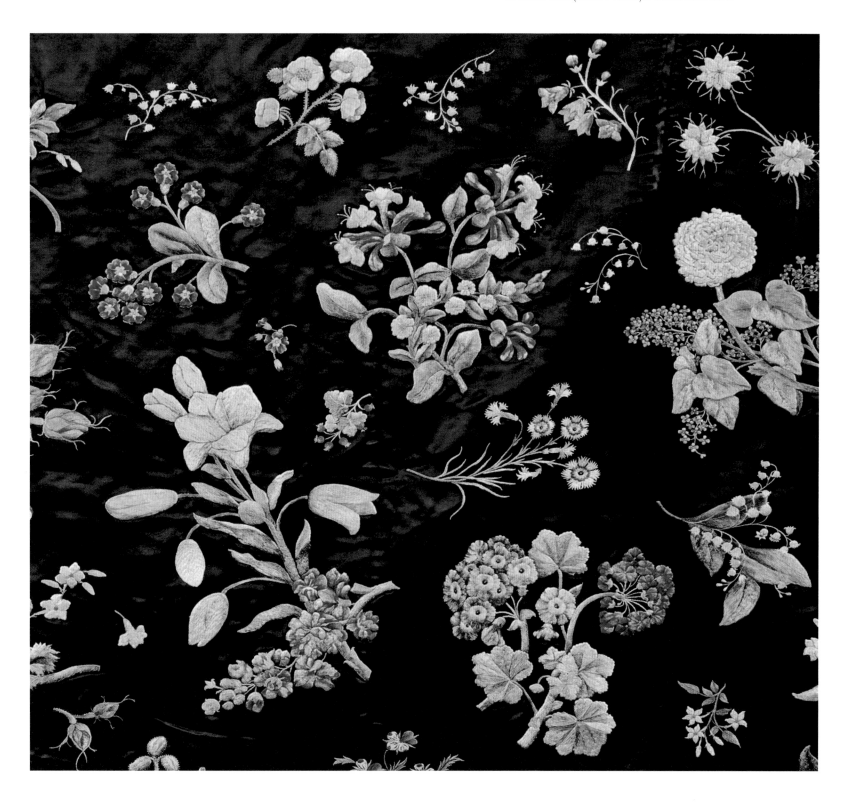

She collaborated with Dr. Delany on the ornamentation of the gardens at Delville, continuing at their residence in Downpatrick, Delany's parish seventy miles north of Dublin (fig. 12). Both had known and been influenced by Alexander Pope's picturesque and poetic gardens in Twickenham. Together with Swift, they introduced this new taste into their milieu in Ireland.[33] Delville was not large, but it was distinguished—and occasionally gently mocked—for its full complement of garden features. As Thomas Sheridan wrote in "A Description of Doctor Delany's Villa":

> *You scarce upon the borders enter,*
> *Before you're at the very center.*
> *A single crow can make it night,*
> *When o'er your farm he takes his flight;*
> *Yet, in this narrow compass, we*
> *Observe a vast variety;*
> *Both walks, walls, meadows and parterres,*
> *Windows and doors, and rooms and stairs,*
> *And hills and dales, and woods and fields,*
> *And hay and grass and corn it yields.*[34]

Although not as bijou as this verse implies, Delville was unmistakably inscribed with the signs of intimacy, withdrawal from society, and companionable introspection. This is how Mrs. Delany imagines it in a drawing from an album now held at the Lilly Library, University of Indiana, Bloomington (fig. 13). Facing a *cottage ornée* (which, incidentally, bears no resemblance to the actual Delville), Mrs. Delany writes: "A Cott in Blank—the Peacefull residense of your Faithfull MD when Years & infirmities forbid a Vagabond Life—Built In Idea at Delvile Dec.[r] 1744"[35] Privacy and enclosure, central to the pleasures offered at Delville, coexisted with the conceit that the landscape was densely populated by visiting friends and relations and absent correspondents. The intimacy of the garden was underlined not only by the hermitage-like "beggar's hut" and other picturesque seats, but also by the temple overlooking Dublin to the south (fig. 14).[36] Swift devised the inscription on the frieze, "Fastigia Despicit Urbis" (I look down on the roofs of the city). Mrs. Delany decorated the interior of the temple with shell- and pebble-work and set medallions with busts of Swift and Stella into the walls.[37] She used the idea of withdrawal from the metropole both as shorthand for removing oneself from moral contagion and censure, and as an evocation of an edenic *ménage*.

If the trope of retirement resonated with long-standing ideals of feminine piety and virtue, it also could be turned into a sign of female *virtu*. When George Montagu visited Mrs. Delany at Delville in 1761 he compared her to the great seventeenth-century *philosophe* and woman of letters Marie de Rabutin-Chantal, marquise de Sévigné. He wrote, "her place is an absolute Sévignade, her *chapelle, Notre Dame des Roches,* all fitted up and painted by her own hand, the stucco composed of shells and ears of corn the prettilyest disposed imaginable, and her way of life quite abstracted from the great world and given up to a few sensible friends."[38] Privacy, while it referred in part to an actuality of elite female sociability, increasingly functioned as a value projected into the public sphere. Understanding why this was either a necessary or desirable tactic requires us to consider the impact of both gender and class on the formation of amateurism in eighteenth-century Britain, and ultimately to question the teleology of accomplishment as a form of middle-class self-fashioning, without examination of ongoing practices of refinement in aristocratic contexts.[39] In her middle age, Mrs. Delany was able to mobilize much greater social and cultural capital than was available to middle-class exponents of accomplishment. This was sometimes

Figure 12: Mary Delany, *A View of Y.e Swift & Swans Island in Delville Garden*, dated "30 Dec. 1745," pen and ink and wash over graphite, 10⅜ × 14½ in. (26.3 × 36.7 cm). National Gallery of Ireland, Dublin (2722[24])

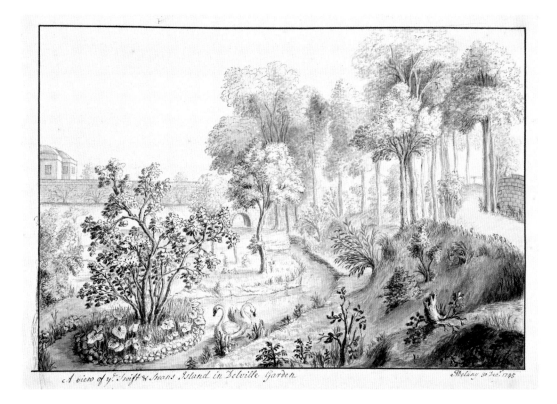

A view of y.e Swift & Swans Island in Delville Garden

M. Delany 30 Dec.r 1745

expressed as a difference in kind, as with the forms of patronage she was able to practice in Ireland, and sometimes by a difference in scale or intensity. As time went on, Mrs. Delany evoked the ideals of privacy and discretion in counterpoint to an increasingly ambitious series of projects, culminating with the "Flora Delanica," as she and others called the ten albums of collages, which required her to circulate in choice, but surprisingly various, milieux.

The period of Mrs. Delany's life that best illustrates this paradox of private life becoming public virtue arrived with her second widowhood. Following Dr. Delany's death in 1768, she returned to England, where her long-cherished association with the Duchess of Portland became her principal connection.[40] A visitor of Bulstrode, the duchess's estate, since the 1730s, Mrs. Delany now became a regular resident, spending a portion of each year there until the duchess's death in 1785. There Mrs. Delany entered a circle at once as intimate as her relationship with the duchess and as far reaching as the American Colonies and the South Seas. Along with the duchess's other properties in London and at Welbeck in Nottinghamshire, Bulstrode was a preeminent site for all facets of curiosity. The duchess's collections were astonishing in their breadth and depth: they contained antiquities such as the Portland Vase, *objets de vertù*, mineralogy, entomology, and, above all, conchology and botany. Curated by Daniel Solander and John Lightfoot, the duchess's chaplain, Bulstrode served as an incubator of Linnaean botany in England. It was also notable for its gardens and grounds. Ehret tutored the duchess's daughters and produced innumerable watercolors for the collection. The author and educator William Gilpin visited on his tour of 1776 and described its paradisiacal atmosphere in his *Observations Relative Chiefly to Picturesque Beauty* (1789):

Figure 13: Mary Delany, *A Cott in Blank – The Peacefull Residence of your Faithful MD, 1744*, 1744, pen and ink and gray wash over graphite. The Lilly Library, Indiana University, Bloomington, Indiana. This drawing is from an album compiled by Mary Delany between 1732 and 1760.

Figure 14: Garden temple at Delville. Irish Architectural Archives

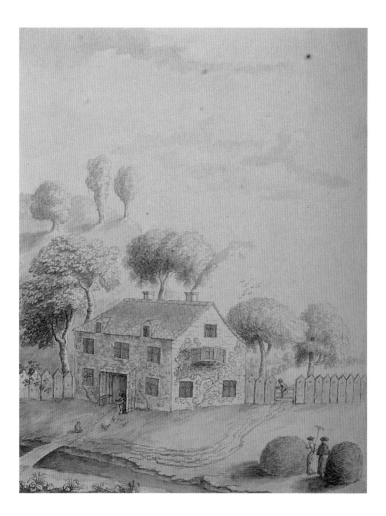

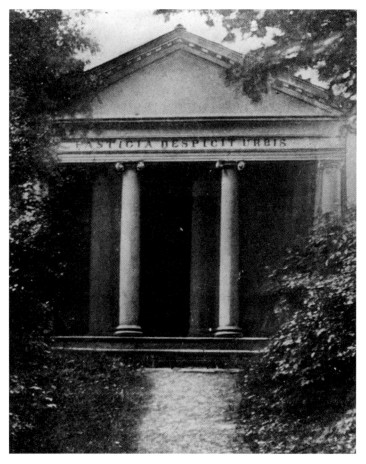

Behind the house runs the garden; where plants, and flowers of every kind, find their proper soil and shelter. One large portion is called the American grove; consisting of the plants of that continent. Here too the duchess has her menagery. She is fond of animals; and among many that are curious, incourages the very squirrels and hares to enjoy a state of perfect tranquillity. The squirrel cracks his nut at your elbow; and looks at you without dismay: while the hare, at her pleasure, takes her morning and evening gambols about the park, which she considers as her own domain.[41]

It was here that Mrs. Delany, long a lover and con-scientious observer of the natural world, engaged with the nascent sciences of its systemization (fig. 15). Already by 1769 she had prepared a manu-script adaptation of William Hudson's *Flora Anglica* (1762) as "A British flora after the sexual system of Linnaeus… Bulstrode, 1769." In 1772, Mrs. Delany began her most extraordinary proj-ect, characteristically in honor of the duchess.[42] Over ten years she created the "Flora Delanica," inventing, refining, and eventually propagating its technique. In a sense, however, her paper collages were a work through which she created

herself. In the practice of her craft she partici-pated in the heuristic enterprise of the duchess's household, but she also became an object of curiosity in her own right. After casting a some-what jaundiced eye on the duchess's Rubens and Snyders, Gilpin turns to an unexpected quarter:

Among the works of art at Bulstrode, which abounds chiefly with the curiosities of nature, we were favoured with the sight of one by Mrs. Delany, which we greatly admired. Mrs. Delany, is widow of the late Dr. Delany, dean of Down, one of the intimate friends of dean Swift. She is now seventy-six years of age, and enjoys her faculties in such vigour, that you find not the least faultering in any of them. The work of hers, which I allude to, is an herbal, in which she has executed a great number of plants, and flowers, both natives, and exotics, not only with exact delineation, and almost in their full lustre of colour, but in great taste. And what is the most extraordinary, her only materials are bits of paper of different colours.… These flowers have both the beauty of painting, and the exactness of botany: and the work, I have no doubt, into whatever hands it may hereafter fall, will long be considered as a great curiosity.[43]

A number of essays in this book investigate the materials, techniques, and social context of the "paper mosaics," but I would like to note here that their creation was a watershed not only in Mrs. Delany's life, but also in the reception of that life by her contemporaries. In 1750, Mrs. Delany had grudgingly consented to be the dedicatee of George Ballard's *Memoirs of Several Ladies of Great Britain Who Have Been Celebrated for Their Writings or Skill in the Learned Languages* (1752), writing to her sister from Ireland, "I confess it is what I dislike extremely, and have had a warm dispute with D.D. [Dr. Delany] about it this morning, but he insists upon it that I shall con-sent, as he thinks it will mortify the man if I refuse; I dare say it would not, and it is much more vexatious to me to consent—there is an air of vanity in it that hurts me."[44] In 1776, Mrs. Delany described herself as "mortified" by the first appearance of her correspondence in print, in a posthumous collection of Swift's letters.[45] However, the increasing renown of the "Flora Delanica" was already changing the terms in which Mrs. Delany's achievements were seen by herself and others.

In 1781 George Keate's "A Petition from Mrs. Delany's Citron-Tree, To Her Grace The Dutchess Dowager of Portland," set the tone for future encomia.[46] Writing from the point of view of the citron tree, Keate exclaims:

Figure 15: Pages 466v and 467 from Mary Delany, "A British flora after the sexual system of Linnaeus", 1769. Dumbarton Oaks Research Library and Collection, Rare Book Collection, Washington, D.C.

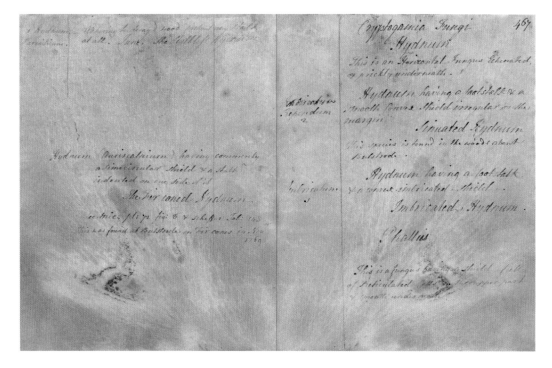

But a still happier Lot is mine!
For lo! your faithful Friend for me
Prepares a glorious Destiny;
She makes me on her Table rise,
And notes me with inquiring Eyes,
My Texture marks, my Form surveys,
And views me with parental Gaze,
Then with her artful Scissars traces
My Shape, my Colour, and my Graces,
Unlike what Poets give The Fates,
For theirs destroy, but her's creates!—
I see another Self—and start,
Shudd'ring with Wonder at her Art.—
'Tis done—and she hath seal'd my Doom,
And fix'd me in Eternal Bloom.
. . .

O could my Sister Plants, and Flow'rs,
That spring beneath your beauteous Bow'rs,
Before the Good DELANY stand,
And share the Magic of her Hand!
She'd give to others, as to me,
A Kind of Immortality![47]

Running to nine pages, the poem praises the graciousness of the duchess and the ingenuity of Mrs. Delany, as well as providing a high-flown autobiography of the citron, which had originated as a cutting from a specimen at Delville and had been replanted at Bulstrode. The whole, however, is framed as a record of a specific performance of Mrs. Delany's art. Keate annotates his text with the circumstances of its composition:

> *The Author having the honour of visiting*
> *BULLSTRODE, just as Mrs. DELANY had finished*
> *the Portrait of a branch of her favorite*
> *CITRON-TREE, and hearing the history of it, it*
> *excited in him the desire of commemorating an*
> *event, which gave him an opportunity of recording*
> *the Abilities of so amiable a Lady as Mrs.*
> *DELANY, and the discerning and attentive*
> *Friendship of so distinguished a Character as*
> *the Dutchess Dowager of PORTLAND.*[48]

As Keate dated the poem to 1778, it seems reasonable to identify it with Mrs. Delany's depiction of *Citrus medica* (fig. 16). Indeed, on examining the reverse of the collage, Mrs. Delany's notes offer confirmation of the incident. The collage was composed at Bulstrode, "Originally from / Delville & transported / to Bulstrode in ye / year 1769 / Mr & Mrs Keate" and dated "8th July 1778."[49] The poem enacts the specificity of Mrs. Delany's collages, a quality essential to their identification as works of natural history (Gilpin's "exactness of botany"). At the same time, the poem establishes a congruence between Mrs. Delany's virtues and those of her unique "herbal".

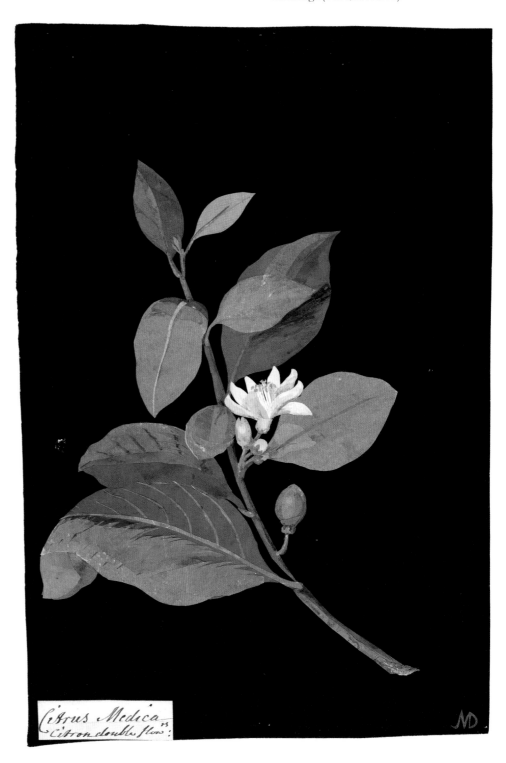

Figure 16: Mary Delany, 'Citrus Medica', 1778, collage of colored papers, with bodycolor and watercolor, 13⅞ × 9 in. (35.2 × 22.8 cm). British Museum, Department of Prints and Drawings (1897,0505.206)

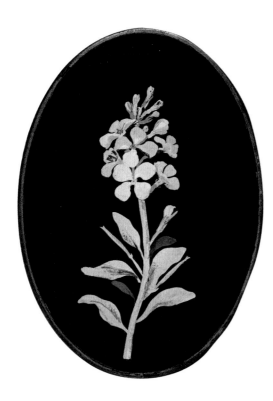

This critical trope establishes "a kind of immortality" fulfilling the requirements of feminine decorum, while at the same time transcending the limits that decorum sets on female fame. Keate underlines this in his footnote, subordinating Mrs. Delany's extraordinary talents to extraordinary character: "Though this accomplishment, as well as the many others she possesses, are but the Embellishments of a character, which all the engaging Virtues of Life have rendered respectable".[50]

By the time that Mrs. Delany brought the "Flora Delanica" to a close in 1782, it had brought her into the circle of George III, Queen Charlotte,

Figure 17: Mary Delany, *A Stem of Stock*, 1781, watercolor and bodycolor on paper, cut and pasted onto backing paper painted black, 9.8 × 6.7 in. (25 × 17 cm). The Royal Collection

and their children (fig. 17). Shortly after the Duchess of Portland's death in July 1785, she was installed in a house in close proximity to, and thus signaling intimacy with, the royal family.[51] She passed on her techniques and pastimes to the royal children and was able to act as a patron to members of her own family, like her grandniece Georgina Port, and other young persons. Most notably, she was instrumental in gaining Fanny Burney a place at court, but she also assisted in the advancement of artists.[52] As noted in the posthumous testimonial by her faithful retainer Mrs. Agnew *née* Astley, reproduced by Lady Llanover, Mrs. Delany "was never more happy than when

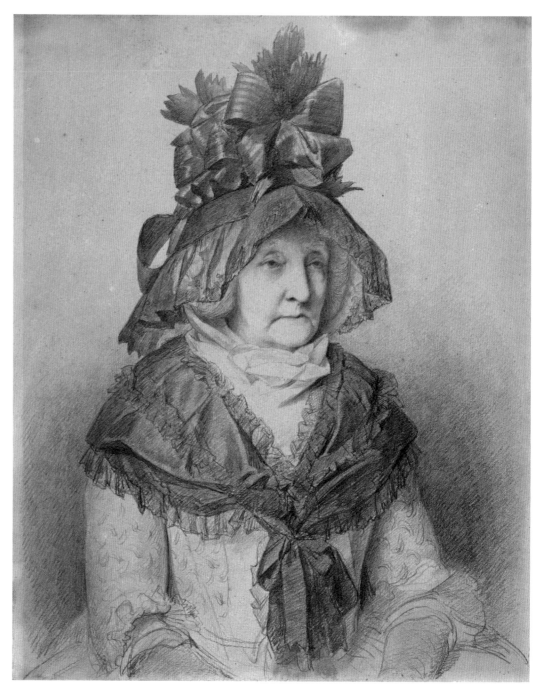

Figure 18: Thomas Lawrence, *Portrait of Mrs. Delany*, 1786–88, graphite and black chalk, 14⁵⁄₁₆ × 11⅛ in. (36.4 × 28.2 cm). Victoria and Albert Museum, London (E.580-1929)

she could bring into notice young artists who promised to excel. Opie and Lawrence owed her much."[53] Thomas Lawrence, who began his career as a child prodigy and whose talents were noted by Fanny Burney as early as 1780, worked at Windsor in the late 1780s. His sensitive portrait of Mrs. Delany in extreme old age dates from this time (fig. 18).[54] As a result of this prestigious and domestic connection to the royal family, the final three years of Mary's life became especially important to her nineteenth-century biographers.

In the 1780s and 1790s, the "Flora Delanica" remained her most prominent accomplishment, its technique publicized, often poetically, in a series of detailed footnotes and asides.[55] In November 1786, Mrs. Delany and Walpole exchanged a pretty series of compliments on his inclusion of her in the fourth edition of his *Anecdotes of Painting in England*.[56] Walpole had already mentioned Mrs. Delany's opus in the 1784 *Description of the Villa of Mr. Horace Walpole… at Strawberry-Hill*.[57] His letter of 28 November, sent with a presentation copy of the *Anecdotes*, flags the "the liberty he has taken" in volume 2, page 242: "The widow of Doctor Delany and correspondent of Swift; a lady of excellent sense and taste, a paintress in oil, and who, at the age of 75, invented the art of paper-mosaic, with which material coloured, she, in eight years, executed within twenty of a thousand various flowers and flowering shrubs, with a precision and truth unparalleled."[58] She answers complaisantly on the 30th that she is not "insensible of the honour done her in mentioning her name in so ingenious and valuable a work with so much delicacy as to reconcile her to a publication that would have been rather painful from any other hand."[59]

Erasmus Darwin dedicated a verse of *The Loves of the Flowers*, from his celebrated didactic epic, *The Botanic Garden* (1789–91), to a description of Mrs. Delany practicing her various crafts, surrounded by her "virgin train" of protégées (fig. 19):[60]

So now DELANY forms her mimic bowers,
Her paper foliage, and her silken flowers;
Her virgin train the tender scissars ply,
Vein the green leaf, the purple petal dye:
Round wiry stems the flaxen tendril bends,
Moss creeps below, and waxen fruit impends.
Cold Winter views amid his realms of snow
DELANY'S vegetable statues blow;
Smooth's his stern brow, delays his hoary wing,
And eyes with wonder all the blooms of spring.[61]

Delany, who uses paper to defeat time, makes her *entrée* at the end of the section on papyrus,

Figure 19: Henry Fuseli, *Flora Attired by the Elements*, 1791, graphite on laid paper, 8¾ × 6⅜ in. (22.2 × 16.2 cm), design for frontispiece to Erasmus Darwin, *The Economy of Vegetation*, 1791, Part 1 of *The Botanic Garden, a Poem. In two parts*. Yale Center for British Art, Gift of Lowell Libson

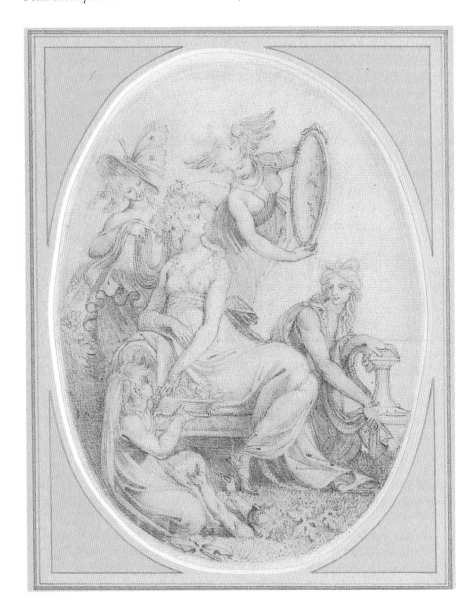

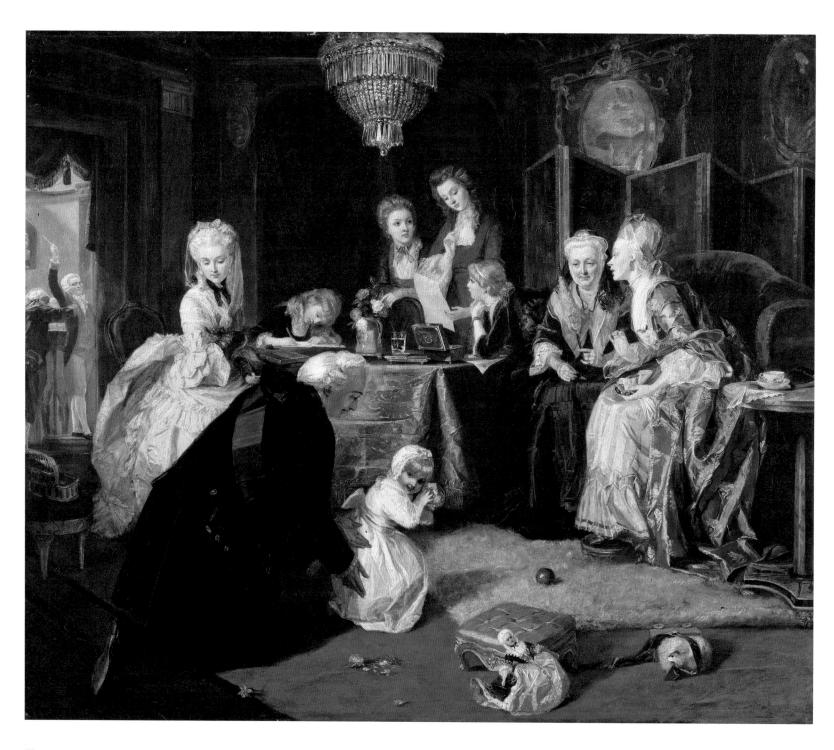

Figure 20: Henrietta Ward, *George III and His Family
at Windsor*, 1872, oil on canvas, 46.5 × 52.5 in.
(118 × 133.3 cm). National Museums Liverpool,
Walker Art Gallery (2960)

personified, according to the conventions of *The Botanic Garden*, as a goddess enthroned on the banks of the Nile, who grants immortality to the arts and sciences by facilitating the invention of letters, numbers, and musical notation.[62] The image of Spring blooming in Winter, an allusion to the continuation of Mary's talents into old age, as well as the vividness of her "mimic bowers," is succeeded by the image of the "Horologe, or Watch of Flora," a round of "æquinoctical flowers," which keep another kind of time.[63] In Darwin's conceit, Mrs. Delany's "curious Hortus siccus" forms a bridge between the linear time of culture and the cyclical time of nature.

The first biography of Mrs. Delany appeared five years after her death, in Kippis's *Biographia Britannica: or, The Lives of the Most Eminent Persons Who Have Flourished in Great Britain and Ireland* (1793).[64] In addition to substantial commentary on her painting, the text emphasizes the surpassing quality of the *Flora*, "which without any impeachment of the honour of this accomplished lady, might justly be called a *forgery* of Nature's works… and so imposing was her art, that she would sometimes put a real leaf of a plant by the side of one of her own creation, which the eye could not detect, even when she herself pointed it out."[65] However, in only a few short years, Mrs. Delany's reputation would shift away from her visual acuity and technical ingenuity and toward the role of royal memoirist and witness to the quaint customs of times past.

Some of Mrs. Delany's letters to Samuel Richardson appeared with his *Correspondence* of 1804, but the first publication of her letters as a correspondence in their own right occurred in 1820, with *Letters from Mrs. Delany (Widow of Doctor Patrick Delany) to Mrs. Frances Hamilton, from… 1779 to… 1788; Comprising Many Unpublished and Interesting Anecdotes of Their Late Majesties and the Royal Family London.*[66] Interest was further piqued in the 1840s by the immensely successful posthumous publication of Fanny Burney's *Diary and Letters* (1842–46), leading to a small flurry of periodical publications and the first account of Mrs. Delany's life intended for an American audience.[67] Through the first half of the nineteenth century there was a slow trickle of more and less substantial pieces in the periodical press, including newspapers and ladies' journals.

The single most important event in Mrs. Delany's historiography occurred in 1861–62, when Mrs. Delany's great-grandniece, Augusta Hall *née* Waddington, Lady Llanover, published six volumes of letters and other prose. A key figure in the nineteenth-century revival of Welsh language and culture, the indefatigable Lady Llanover, known as "the Bee of Gwent," was a woman of accomplishment almost as formidable as her ancestress.[68] Her stated aim in editing Mrs. Delany's letters was "to give a true account of a person whose name as 'Mrs. Delany' is still revered, and has been so for more than a hundred years, but of whom very little beyond that name is now remembered."[69] Although modern scholars have objected to its decidedly Victorian excisions and perorations, and we now know of a number of letters that it omits, the *Autobiography and Correspondence* is a monumental achievement of archival research and remains an indispensable resource.[70] In the 1860s, it galvanized interest in Mrs. Delany and made her life and letters accessible to a much broader public than ever before. About the same time, Lady Llanover facilitated the publication of *Specimens of Rare and Beautiful Needlework, Designed and Executed by Mrs. Delany and Her Friend the Hon. Mrs. Hamilton, Photographed from the Originals in the Possession of Lady Hall of Llanover.*[71] Articles, digests, and anecdotes appeared in the popular press, as the *Autobiography and Correspondence* provided a fresh source for the creation of new "histories" (fig. 20).[72] When Henrietta Ward exhibited *The Queen's Lodge, Windsor in 1786* at the Royal Academy in 1872, the catalogue provided an explanatory quotation derived from the *Autobiography and Correspondence*:[73]

> *The Queen had the goodness to make me sit down next to her… while the younger part of the family are drawing and working… the beautiful babe, Princess Amelia, bearing her part in the entertainment; sometimes playing with the King on the carpet…. In the* next *room is the band of music playing.* See 'Letters and Correspondence of Mrs. Delaney [sic]', ed. Lady Llanover.[74]

If readers took the hint and turned to the letter in the *Autobiography and Correspondence* they would have found the additional implied compliment in Mrs. Delany's description of Windsor Lodge, "which, altogether, exhibits such a delightful scene, as would require an Addison's pen, or a Vandyke's pencil, to do justice to it."[75] For Ward, who was patronized by Queen Victoria and tutored several of the royal children in drawing and painting, Mrs. Delany's familiar view of the monarchs at home provided a congenial subject with obvious parallels.[76] By depicting the ménage of George III and Queen Charlotte as replete with domestic virtue and familial affection, Ward's historical genre picture expressed contemporary mores.[77]

Ward's painting uses Mrs. Delany's letters as a vehicle for a sentimental return to the "last century," an epoch often viewed and depicted with nostalgia in the latter part of the nineteenth century.[78] While the tide of memoirs, correspondences, and collected works rose steadily, there was a growing consciousness that the physical traces of eighteenth-century lives were rapidly fading.[79] In August 1875, an anonymous correspondent for *All The Year Round* made a pilgrimage to "a very unfashionable suburb of Dublin," to commune with the "sunshine, perfume, melody, happy animal murmurs, and sweet laughs and sighs of human contentment… wafted to our senses by the breeze that flutters over the pages of the story of Mary Delany in her home at Delville."[80] Although "the house and grounds answer exactly to her description," they had become luxuriantly overgrown and "a broad-leaved, magnificent creeper mantles the bower window of the great parlour," filling "the 'projection' part of the room with a delicate green luster."[81] Mrs. Delany was the subject of numerous publications in the first half of the twentieth century, including books by George Paston (Emily Morse Symonds), R. Brimley Johnson, C. E. Vulliamy, and Simon Dewes (John St. Clair Muriel).[82] While these were primarily "arrangements" of the *Autobiography and Correspondence*, they were generally well-received and frequently praised by contemporary critics for making material of proven historical interest more readily available (and portable).[83]

Yet when Ruth Hayden published *Mrs. Delany: Her Life and Her Flowers* in 1980, no monograph had appeared on Mrs. Delany for forty years.[84] Hayden's work precipitated the revival of interest in Mrs. Delany. In its successive editions, it introduced much fresh material and reintroduced both popular and academic audiences to its subject's life and work. It provided the first catalogue of Mrs. Delany's collages, which opened up the possibility of botanical study.[85] The inclusion of numerous illustrations also made Mrs. Delany's work available for art historical study as never before; a development that was cemented by the exhibition of the collages at the Morgan Library in 1986.[86] While the Victorian authors who drew on Lady Llanover's *Autobiography and Correspondence* represented Mrs. Delany through a lens of nostalgia, the publication of *Mrs. Delany: Her Life and Her Flowers* not only refreshed her appeal, but also made possible her emergence as a subject for systematic study in a range of disciples. Many subsequent publications, including this one, would not have been possible without Hayden's work.

This fuller conception of Mrs. Delany's activities, which both corroborated and complicated

the limitations and possibilities outlined in her letters, enriched the work of scholars studying women and gender in the eighteenth century.[87] Her correspondence could now be seen as intertwined with her natural histories, needleworks, drawings, paper cuts and gardens.[88] Mrs. Delany has long occupied a special position in the historiography of Georgian Ireland, beginning with an extended discussion in Edward Malins and the Knight of Glin's *Lost Demesnes* (1976) and continuing through Angélique Day's thematically arranged *Letters from Georgian Ireland* (1991).[89] Moreover, she still provides commentary on the tastes of her age in works employing material culture approaches, including Toby Barnard's *Making the Grand Figure: Lives and Possessions in Ireland, 1641–1770* (2004), and *Gender, Taste, and Material Culture in Britain and North America, 1700–1830* (2006), edited by John Styles and Amanda Vickery.[90] In 2004, Alain Kerhervé published *Une épistolière anglaise du XVIIIᵉ siècle: Mary Delany (1700–1788)*, the first modern academic study of the correspondence.[91] His work establishes a place for Mary Delany in the cannon of early-modern epistolary writing; this book and exhibition have benefitted greatly from his diligence.

Acknowledgments

I would like to extend personal thanks to my parents, Ruth Weisberg and Kelyn Roberts; to my husband, Opher Mansour; and to his parents, Mina and Morris Mansour, for their support during this project.

Notes

1. She was known as Mary Granville from 1700 to 1717, Mrs. Pendarves from 1718 to 1743, and Mrs. Delany from 1743 until her death in 1788. The editors of this volume have chosen to use the surname Delany where this chronology is not at issue. This is not a neutral decision, but rather an acknowledgement of the mechanics of identity formation for women in eighteenth-century England and Ireland. Mrs. Delany and her contemporaries were conscious of the effects of the addition and erasure of family names. We hope that by reflecting these historical practices in our text the choices exercised by and limitations placed upon our subject will remain available to our readers.

2. Alain Kerhervé, *Une épistolière anglaise du XVIIIe siècle: Mary Delany (1700–1788)* (Paris: l'Harmattan, 2004), 31; Simon Dewes (John St. Clair Muriel), *Mrs. Delany* (London: Rich & Cowan, 1940), xi. On Walpole's frame and the commission of the Opie portrait, see Lady Llanover, ed., *The Autobiography and Correspondence of Mary Granville, Mrs. Delany*, 6 vols. (London: Richard Bentley, 1861–62), ser. 2, 3:497–98 and facing 502; and Jacob Simon, *The Art of the Picture Frame: Artists, Patrons and the Framing of Portraits in Britain* (London: National Portrait Gallery, 1996), 114. On John Opie's portrait *Mary Delany (née Granville)* (National Portrait Gallery, 1030), see Marcia Pointon, *Hanging the Head: Portraiture and Social Formation in Eighteenth-Century England* (New Haven and London: Published for the Paul Mellon Centre for Studies in British Art by Yale Univ. Press, 1993), 34–35; John Ingamells, *National Portrait Gallery Mid-Georgian Portraits, 1760–1790* (London: National Portrait Gallery, 2004), 138, and Lara Perry, *History's Beauties: Women and the National Portrait Gallery, 1856–1900* (Aldershot, UK, and Burlington, Vt.: Ashgate, 2006), 70–71.

3. Horace Walpole, "Book of Materials," 1759, Lewis Walpole Library, Farmington (49.2523), fol. 121.12; see also Cynthia Roman, "The Art of Lady Diana Beauclerk: Horace Walpole and Female Genius," in Michael Snodin, ed., *Horace Walpole's Strawberry Hill* (New Haven and London: Yale Univ. Press, 2009).

4. For lists of extant and attributed works, see Llanover, ed., *Autobiography and Correspondence*, ser. 2, 3:499–507; and Ruth Hayden, *Mrs. Delany: Her Life and Her Flowers* (London: British Museum Press, 2000), 188.

5. See, for example, Natalie Rothstein, ed., *A Lady of Fashion: Barbara Johnson's Album of Styles and Fabrics* (London: Thames & Hudson, 1987), 19, or Dorothy Stroud, *Capability Brown* (London: Faber & Faber, 1950), 86, 112.

6. Ann B. Shteir, *Cultivating Women, Cultivating Science: Flora's Daughters and Botany in England, 1760–1860* (Baltimore: Johns Hopkins Univ. Press, 1996), 7.

7. See Shteir, *Cultivating Women, Cultivating Science*; Kim Sloan and Andrew Burnett, *Enlightenment: Discovering the World in the Eighteenth Century* (Washington, D.C: Smithsonian Books, 2003); and Amy R. W. Meyers, ed., *The Culture of Nature: Art & Science in Philadelphia, 1740–1840* (New Haven and London: Yale Univ. Press, forthcoming).

8. See Kim Sloan, *'A Noble Art': Amateur Artists and Drawing Masters, c. 1600–1800* (London: British Museum Press, 2000), 7; and Hilary Pyle, "Artist or Artistic? The Drawings of Mary Delany," *Irish Arts Review* 4, no. 1 (Spring 1987): 27–32.

9. Sloan, *'A Noble Art'*; Ann Bermingham, *Learning to Draw: Studies in the Cultural History of a Polite and Useful Art* (New Haven and London: Published for the Paul Mellon Centre for Studies in British Art by Yale Univ. Press, 2000).

10. "From the Birth of Mary Granville to Her First Marriage, 1700–1717," in Llanover, ed., *Autobiography and Correspondence*, ser. 1, 1:3.

11. "From the Birth of Mary Granville to Her First Marriage," in Llanover, ed., *Autobiography and Correspondence*, ser. 1, 1:6.

12. See Robert Manson Myers, "Mrs. Delany: An Eighteenth-Century Handelian," *The Musical Quarterly* 32, no. 1 (January 1946): 12–36; Jacob Simon, ed., *Handel: A Celebration of His Life and Times, 1685–1759* (London: National Portrait Gallery, 1985), 184; Hugh McLean, "Bernard Granville, Handel and the Rembrandts," *The Musical Times* 126, no. 1712 (October 1985): 593–601; Hugh McLean, "Granville, Handel and 'Some Golden Rules,'" *The Musical Times* 126, no. 1713 (November 1985): 662–65.

13. On Pendarves, see Eveline Cruickshanks, David Hayton, and Stuart Handley, *The House of Commons, 1690–1715*, vol. 5 (Cambridge: Cambridge Univ. Press, 2002), 126–28.

14. "From Mary Granville's Marriage with Alexander Pendarves, Esq., of Roscrow, to His Death, 1717–1724–5," in Llanover, ed., *Autobiography and Correspondence*, ser. 1, 1:29–30.

15. Mary Pendarves to Mrs. Anne Granville, 13 July 1731, in Llanover, ed., *Autobiography and Correspondence*, ser. 1, 1:283.

16. On Anne Donellan, see Irene Q. Brown, "Domesticity, Feminism, and Friendship: Female Aristocratic Culture and Marriage in England, 1660–1760," *Journal of Family History* 7, no. 4 (Winter 1982): 410–11; Patrick Kelly, "Anne Donnellan: Irish Proto-Bluestocking," *Hermathena*, no. 154 (1993): 39–68. Ellen Harris, "Three Ladies of Handel's Will," *Newsletter of the American Handel Society* 15, no. 1–2 (April–August 2000): 1, 4–7; and Lisa L. Moore, "Queer Gardens: Mary Delany's Flowers and Friendships," *Eighteenth-Century Studies* 39, no. 1 (Autumn 2005): 49–70.

17. Mary Pendarves to Anne Granville, in Llanover, ed., *Autobiography and Correspondence*, ser. 1, 1:361, 363 (28 June 1732), 365–66 (4 July 1732), 374–77 (24–26 August 1732), 382 (6 September 1732).

18. Mary Pendarves to Anne Granville, 4 January 1733, in Llanover, ed., *Autobiography and Correspondence*, ser. 1, 1:392.

19. Mary Pendarves to Anne Granville, 4 January 1733, in Llanover, ed., *Autobiography and Correspondence*, ser. 1, 1:340; Jonathan Swift, *The Correspondence of Jonathan Swift, D.D.*, ed. David Woolley, 4 vols. (New York: P. Lang, 1999–2007), 3: 649. On Letitia Bushe, see S. J. Connolly, "A Woman's Life in Mid-Eighteenth-Century Ireland: The Case of Letitia Bushe," *The Historical Journal* 43, no. 2 (2000): 433–51.

20. On Patrick Delany, see Robert Hogan and Donald C. Mell, eds., *The Poems of Patrick Delany: Comprising Also Poems about Him by Jonathan Swift, Thomas Sheridan, and Other Friends and Enemies* (Newark: Univ. of Delaware Press, 2006), 21–50; Toby Barnard, "Delany, Patrick (1685/6–1768)," in H. C. G. Matthew and Brian Harrison, eds., *Oxford Dictionary of National Biography* (Oxford: Oxford Univ. Press, 2004); online ed., ed. Lawrence Goldman, January 2008, www.oxforddnb.com/view/article/7443 (accessed 13 December 2008); and Andrew Kippis, *Biographia Britannica, or, The Lives of the Most Eminent Persons Who Have Flourished in Great Britain and Ireland, from the Earliest Ages, …Collected from the Best Authorities, …and Digested in the Manner of Mr. Bayle's Historical and Critical Dictionary. The Second Edition, with Corrections, Enlargements, and the Addition of New Lives*, 5 vols. (London, 1778–93), 5:75–88.

21. Mary Pendarves to Anne Granville, 1733, in Llanover, ed., *Autobiography and Correspondence*, ser. 1, 1:402.

22. Mary Pendarves to Anne Granville, 30 June 1734, in Llanover, ed., *Autobiography and Correspondence*, ser. 1, 1:484–85.

23. Elizabeth Eger and Lucy Peltz, *Brilliant Women: 18th-Century Bluestockings* (London: National Portrait Gallery, 2008), 21.

24. "Will of The Most Noble, Princess Margaret Cavendish Duchess of Portland, Dowager," dated and proved 4 August 1785, Public Record Office, National Archives, cat. ref. PROB 11/1133: "I leave to Lady Andover my snuff box with the four Enamels by Zinke." The woman in a blue, fur-trimmed dress has generally been accepted as the Duchess of Portland on the basis of the resemblance to a miniature that was engraved by George Vertue after Christian Friedrich Zincke (National Portrait Gallery, NPG D14770) in which the duchess is wearing a similar (albeit white) fur-trimmed dress; see Richard W. Goulding, *The Welbeck Abbey Miniatures Belonging to His Grace the Duke of Portland… : A Catalogue Raisonné* (Oxford: Printed for the Walpole Society by the Univ. Press, 1916), 148, no. 205. Goulding reproduces a miniature of a similar type (152–53, no. 214), which he identifies with Anne

Donnellan's letter of April 1740, in which she states: "I saw the Duke and Duchess of Portland yesterday morning at Zincke's, where she and Mrs. Pendarves are sitting for their pictures"; see Emily J. Climenson, ed., *Elizabeth Montagu, the Queen of the Blue-stockings: Her Correspondence from 1720 to 1761*, 2 vols. (New York: E. P. Dutton & Co., 1906), 1:45. This means that the sitter in white, wearing a garland, has not been identified, although she is assumed to be a member of the duchess and Mrs. Delany's circle. She does not resemble Mary Howard, Viscountess Andover, whom, given the terms of the duchess's bequest, would seem to be the logical candidate, see *Fine Silver, Objects of Vertu and Portrait Miniatures Including the Frederick Joachim Collection, Part I*, sale cat. (London: Christie's, 8 March 1995), lot 21; *The Anton C. R. Dreesmann Collection: Gold Boxes, Objects of Vertu and Portrait Miniatures*, sale cat. (London: Christie's, 11 April 2002), lot 773; Eger and Peltz, *Brilliant Women*, 21. In her essay "'Surrounded with Brilliants': Miniature Portraits in Eighteenth-Century England," *Art Bulletin* 83, no. 1 (March 2001): 48–71, Marcia Pointon advances the theory that it may be a posthumous portrait of the sitter (63–64n73). The identification of the sitter in the blue fur-trimmed dress as the Duchess of Portland, made on the basis of her dress, jewelry, and facial features, is unsustainable in several respects. First, the figure wears none of the highly characteristic, identifiable pieces of jewelry that appear in several of Zincke's other, more securely identified images of the duchess. Second, the fur-trimmed dress may not represent an actual item of clothing but, like all the other costumes worn in the enamels on the gold box, may be instead Zincke's pattern. Third, the sitter in this miniature is blonde, whereas in all other portraits of the duchess as an adult she is shown with brown hair. The identification of the sitter as the Duchess of Portland therefore should be discounted. The sitter in the blue dress can be identified as Mary Finch, Viscountess Andover, however, whose portrait by Thomas Hudson (English Heritage, Ranger's House, Greenwich, inv. no. RH31) she resembles (see fig. 120 in this volume); see Julius Bryant, *London's Country House Collections* (London: Scala, 1993), 28, and Sloan, *'A Noble Art,'* 167–68, no. 118. Moreover, an identification of the remaining miniature, of the woman in the floral garland as a portrait of the duchess can now be advanced. Its unusually severe profile and classicizing dress have precedents in the bust and profile sculpted by Michael Rysbrack (see Gordon Balderston, "Young Lady Margaret Harley by Michael Rysbrack," *Sculpture Journal* 7 [2002]: 26–29), subsequently engraved by George Vertue (1727) (National Portrait Gallery, D14100) and drawn by George Perfect Harding (National Portrait Galley, D1170). The aptness of the guise of Flora cannot be overstated.

25. Anne Donnellan to Elizabeth Montagu, 11 February 1742, in Climenson, ed., *Elizabeth Montagu: Correspondence*, 1:102–3: "The Duchess, Lady Andover, and Pen have their tickets, poor Dash fears she will not have one. The Duchess is to represent 'Night,' and you know she has stars to adorn it, and make it bright as day. Lady Andover and Pen are to be dressed after Holler's Prints." On Mrs. Delany's correspondence with Lady Andover, see Kerhervé, *Une épistolière anglaise*, 130–37.

26. Elizabeth Montagu to Sarah Morris, April 1740, in Climenson, ed., *Elizabeth Montagu: Correspondence*, 1:47.

27. Duchess of Portland to Lady Throckmorton, 25 August 1740, in Llanover, ed., *Autobiography and Correspondence*, ser. 1, 2:95.

28. Sylvia Harcstark Myers, *The Bluestocking Circle: Women, Friendship, and the Life of the Mind in Eighteenth-Century England* (Oxford: Clarendon Press; New York: Oxford Univ. Press, 1990), 21.

29. Hannah More, *Sacred Dramas: Chiefly Intended for Young Persons: The Subjects Taken from the Bible: To Which Is Added, Sensibility, a Poem* (London: Printed for T. Cadell, 1782), 272.

30. See Helen Burke, "Putting on Irish 'Stuff': The Politics of Anglo-Irish Cross-Dressing," in Jessica Munns and Penny Richards, eds., *The Clothes That Wear Us: Essays on Dressing and Transgressing in Eighteenth-Century Culture* (Newark: Univ. of Delaware Press, 1999), 233–49; Jonathan Swift, "A Proposal That All the Ladies and Women of Ireland Should Appear Constantly in Irish Manufactures, Written in the Year 1729," in Jonathan Swift, *Volume XII of the Author's Works: Collected and Revised by Deane Swift, Esq. …* (Dublin: Printed by George Faulkner, 1765), 251–61.

31. See Llanover, ed., *Autobiography and Correspondence*, ser. 1, 1:333–34 (Mary Pendarves to Anne Granville, 17 January 1732), 334n1, ser. 1, 3:180–81 (Mary Delany to Anne Dewes, 9 December 1752).

32. See Ruth Hayden, "'A wonderfully-pretty rurality': Drawings by Mrs. Delany," *Irish Arts Review Yearbook* 16 (2000): 44–50.

33. Edward Greenway Malins and the Knight of Glin, *Lost Demesnes: Irish Landscape Gardening, 1660–1845* (London: Barrie and Jenkins, 1976), 31.

34. Hogan and Mell, eds., *Poems of Patrick Delany*, 86–87, and 123–24 (Laetitia Pilkington's "Delville, the Seat of the Rev. Dr. Delany").

35. Delany Mss., 1728–1760, volume of original drawings, Lilly Library, Indiana University, Bloomington.

36. James Howley, *The Follies and Garden Buildings of Ireland* (New Haven and London: Yale Univ. Press, 1993), 39–40.

37. Howley, *Follies and Garden Buildings*, 39–40; Malins and Knight of Glin, *Lost Demesnes*, 39. A woodcut of Mrs. Delany's decayed painting of Stella is reproduced in W. R. Wilde, *The Closing Years of Dean Swift's Life* (Dublin: Hodges and Smith, 1846), 121.

38. George Montagu to Horace Walpole, 1 October [1761], in W. S. Lewis and Ralph S. Brown, eds., *Horace Walpole's Correspondence with George Montagu*, 2 vols., *The Yale Edition of Horace Walpole's Correspondence*, vols. 9–10 (New Haven: Yale Univ. Press, 1941), 1:391.

39. Ann Bermingham, "Elegant Females and Gentlemen Connoisseurs: The Commerce in Culture and Self-Image in Eighteenth Century England," in Ann Bermingham and John Brewer, eds., *The Consumption of Culture, 1600–1800: Image, Object, Text* (London: Routledge, 1995), 509–48.

40. On Bulstrode, see Mark Laird, *The Flowering of the Landscape Garden: English Pleasure Grounds, 1720–1800* (Philadelphia: Univ. of Pennsylvania Press, 1999), 221–24, and Rebecca Stott, *Duchess of Curiosities: The Life of Margaret, Duchess of Portland*, exh. cat. ([S.I.]: Pineapple Press for The Harley Gallery, 2006).

41. William Gilpin, *Observations Relative Chiefly to Picturesque Beauty, Made in the Year 1776, on Several Parts of Great Britain…* , 2 vols. (London: Printed for R. Blamire, 1789), 2:188–89.

42. Hayden, *Mrs. Delany: Her Life and Her Flowers*, 155.

43. Gilpin, *Observations Relative Chiefly to Picturesque Beauty*, 2:190–91.

44. Mary Delany to Anne Dewes, 1 September 1750, in Llanover, ed., *Autobiography and Correspondence*, ser. 1, 2:590. On Ballard, see George Ballard, *The Memoirs of Several Ladies of Great Britain Who Have Been Celebrated for Their Writings or Skill in the Learned Languages, Arts, and Sciences*, ed. Ruth Perry (1752; repr. with new introduction, Detroit: Wayne State Univ. Press, 1985), 40–43; and Myers, *Bluestocking Circle*, 130–34.

45. Llanover, ed., *Autobiography and Correspondence*, ser. 2, 1:77 (Mary Delany to the Viscountess Andover, 4 September 1766), 166 (Mary Delany to Mary Dewes, 21 September 1768); Mary Pendarves to Jonathan Swift, in Jonathan Swift, *Letters, Written by the Late Jonathan Swift, D.D., Dean of St. Patrick's, Dublin, and Several of His Friends. From the Year 1703 to 1740. Published from the Originals; with Notes Explanatory and Historical, by John Hawkesworth, L.L.D.* (London: Printed for T. Davies, R. Davis, L. Davis, C. Reymers, and J. Dodsley, 1766), 3:237–39 ("Letter CCCLII": 22 April 1731), 246–49 ("Letter CCCLVI": 2 September 1736).

46. George Keate, *The Poetical Works of George Keate, Esq.*, 2 vols. (London: Printed for J. Dodsley, 1781), 2:257–65. On Keate, see Haydn Mason, "Keate, George (1729–1797)," in *Oxford DNB*, online ed., ed. Lawrence Goldman, October 2007, www.oxforddnb.com/view/article/15217 (accessed 5 December 2008). Mrs. Delany wrote about visiting the Keate family "museum" in 1779; see Mary Delany to Mary Dewes Port, 6 June 1779, in Llanover, ed., *Autobiography and Correspondence*, ser. 2, 2:433–35; see also Hayden, *Mrs. Delany: Her Life and Her Flowers*, 153.

47. Keate, *Poetical Works*, 2:263–65.

48. Keate, *Poetical Works*, 2:259.

49. BM 1897,0505.206, Citrus Medica. This incident is rehearsed in Kippis, *Biographia Britannica*, 91nC.

50. Keate, *Poetical Works*, 2:258.

51. Hayden, *Mrs. Delany: Her Life and Her Flowers*, 161. This was widely reported in the press at the time, see *London Chronicle*, no. 4567 (23 February 1786); *Morning Post and Daily Advertiser* (London), no. 4074 (24 February 1786); *Public Advertiser* (London), no. 16149 (24 February 1786); *Morning Herald* (London), no. 1665 (25 February 1786); and *Public Advertiser* (London), no. 16161 (10 March 1786).

52. Myers, *Bluestocking Circle*, 259–60.

53. Llanover, ed., *Autobiography and Correspondence*, ser. 2, 3:319.

54. I will discuss the attribution and provenance of this drawing in a forthcoming article.

55. "Lines Written, in 1782, by the Late Ingenious and Amiable Mrs. Delany, at the Time She Lost Her Sight," *Weekly Entertainer, or, Agreeable and Instructive Repository*, no. 576 (February 1794): 192. For the publication history of this poem, see Kerhervé, *Une épistolière anglaise*, 42–44.

56. Horace Walpole, *Anecdotes of Painting in England; with Some Account of the Principal Artists; and Incidental Notes on Other Arts; Collected by the Late Mr. George Vertue; and Now Digested and Published from His Original MSS. by Mr. Horace Walpole. The Fourth Edition, with Additions*, 4 vols. (London: Printed for J. Dodsley, 1786).

57. Horace Walpole, *A Description of the Villa of Mr. Horace Walpole: Youngest Son of Sir Robert Walpole, Earl of Orford, at Strawberry-Hill near Twickenham, Middlesex; with an Inventory of the Furniture, Pictures, Curiosities, etc.* (Strawberry Hill: Printed by Thomas Kirgate, 1784), 22.

58. W. S. Lewis, ed., *Horace Walpole's Miscellaneous Correspondence*, 3 vols., *The Yale Edition of Horace Walpole's Correspondence*, vols. 40–42 (New Haven and London: Yale Univ. Press, 1980), 3:180; Walpole, *Anecdotes of Painting in England*, 2:242.

59. Lewis, ed., *Walpole's Miscellaneous Correspondence*, 3:181.

60. Erasmus Darwin, *The Botanic Garden, Part II: Containing the Loves of the Plants, a Poem. With Philosophical Notes. Volume the Second*, 2 vols. (Lichfield: Printed by J. Jackson, 1789). On *The Botanic Garden*, see John Brewer, *The Pleasures of the Imagination: English Culture in the Eighteenth Century* (New York: Farrar Straus Giroux, 1997), 594–95; Shteir, *Cultivating Women, Cultivating Science*, 22–27; and Asia Haut, "Reading Flora: Erasmus Darwin's *The Botanic Garden*, Henry Fuseli's Illustrations, and Various Literary Responses," *Word & Image* 20, no. 4 (2004): 240–56.

61. Darwin, *Botanic Garden*, 2:61–62, which had circulated in manuscript for several decades previously.

62. Darwin, *Botanic Garden*, 2:58–61.

63. Darwin, *Botanic Garden*, 2:62–64.

64. Kippis, *Biographia Britannica*, 5:88–93.

65. Kippis, *Biographia Britannica*, 5:91. This text also tells us where the *Flora* was in the 1790s: with her nephew Court Dewes Esq.

66. Samuel Richardson, *The Correspondence of Samuel Richardson*, ed. Anna Laetitia Barbauld (London: Richard Phillips, 1804); *Letters from Mrs. Delany (Widow of Doctor Patrick Delany) to Mrs. Frances Hamilton, from… 1779 to… 1788; Comprising Many Unpublished and Interesting Anecdotes of Their Late Majesties and the Royal Family London* (London: Printed by A. Spottiswoode and R. Spottiswoode, 1820). The publication of *Letters from Mrs. Delany* led to a multitude of reviews and features in the periodical press; see, for example, "Anecdotes of the Late King and Queen," *The Edinburgh Magazine and Literary Miscellany* 86 (July 1820): 14–16; "Letters from Mrs. Delany to Mrs. Frances Hamilton, Containing Anecdotes of Their Late Majesties and the Royal Family," *The Edinburgh Magazine and Literary Miscellany* 86 (December 1820): 483–91.

67. Charlotte Barrett, ed., *Diary and Letters of Madame d'Arblay,… ed. by Her Niece* [Fanny Burney], 7 vols. (London: H. Colburn, 1842–46); Anne Katharine Curteis Elwood, *Memoirs of the Literary Ladies of England: From the Commencement of the Last Century* (Philadelphia: G. B. Zieber and Co., 1845), 12–17.

68. At the Eisteddfod held at Cardiff in 1834, she won the prize for an essay entitled "The Advantages Resulting from the Preservation of the Welsh Language and National Costume of Wales. Under the bardic name she coined for this occasion, Gwenynen Gwent (the Bee of Gwent), she became a major figure in the nineteenth-century revival of Welsh folk culture. On Lady Llanover, see Sian Rhiannon Williams, "Hall, Augusta, Lady Llanover (1802–1896)," in *Oxford DNB*; online ed., ed. Lawrence Goldman, October 2007, www.oxforddnb.com/view/article/39088 (accessed 8 December 2008); and Rachel Ley, *Arglwyddes Llanofer: Gwenynen Gwent* (Caernarfon: Gwasg Gwynedd, 2001). Lady Llanover's other works include *Good Cookery Illustrated. And Recipes Communicated by the Welsh Hermit of the Cell of St. Gover, with Various Remarks on Many Things Past and Present* (London: Richard Bentley, 1867). She also drew, providing illustrations for Jane Williams [called Ysgafell], *The Origin, Rise, and Progress of the Paper People, for My Little Friends* (London: Grant and Griffith, 1856); Augusta Waddington Hall, "Cambrian Costumes Dedicated to the Nobility and Gentry of Wales," 1830 (National Library of Wales, drawing vol. 299, PA8137). See Michael Freeman, "Lady Llanover and the Welsh Costume Prints," *The National Library of Wales Journal* 34, no. 2 (2007): 235–51; and Christine Stevens, "Welsh Costume and the Influence of Lady Llanover" www.llgc.org.uk/fileadmin/documents/pdf/Christine_stevens_S.pdf (accessed 8 December 2008).

69. Llanover, ed., *Autobiography and Correspondence*, ser. 1, 1:ix.

70. The difficulties of apprehending Mrs. Delany's life through Lady Llanover's lens are explored by Janice Farrar Thaddeus, "Mary Delany, Model to the Age," in Beth Fowkes Tobin, ed., *History, Gender & Eighteenth-Century Literature* (Athens: Univ. of Georgia Press, 1994), 113.

71. *Specimens of Rare and Beautiful Needlework, Designed and Executed by Mrs. Delany and Her Friend the Hon. Mrs. Hamilton, Photographed from the Originals in the Possession of Lady Hall of Llanover* (London: Dickinson Bros., ca. 1860).

72. See, among many other examples, "The Lives of Two Ladies," *Blackwood's Magazine* 91, no. 558 (April 1862): 401–21; "Mrs. Delany, or, A Lady of Quality of the Last Century," *Fraser's Magazine for Town and Country* 65, no. 388 (April 1862): 448–57; Lucy H. M. Soulsby, "Mrs. Delany," *The Overland Monthly*, ser. 2, 3 (1884): 283, 394; Ellen Gosse, "Of Paper Flowers," *Temple Bar, with Which Is Incorporated Bentley's Miscellany* 112, no. 445 (December 1897): 506–18; and also the chapter "Mary Delany: 'Queen Charlotte's Friend,'" in Gertrude Townshend Mayer, *Women of Letters*, 2 vols. (London: Richard Bentley and Son, 1894), 1:163–204.

73. On Ward's painting *George III and His Family at Windsor* (1872), exhibited as *The Queen's Lodge, Windsor in 1786* (Walker Art Gallery, Liverpool, inv. 2960), see Edward Morris, *Victorian & Edwardian Paintings in the Walker Art Gallery and at Sudley House: British Artists Born after 1810 but before 1861* (London: H.M.S.O., 1996), 459–61; Jane Sellars, *Women's Works: Paintings, Drawings, Prints, and Sculpture by Women Artists in the Permanent Collection, Walker Art Gallery, Liverpool, Lady Lever Art Gallery, Port Sunlight, Sudley Art Gallery, Liverpool* (Liverpool: National Museums and Galleries on Merseyside, 1988), 10, 47; Algernon Graves, *The Royal Academy of Arts: A Complete Dictionary of Contributors and Their Work from Its Foundations in 1769 to 1904*, 8 vols. (London: Henry Graves and Co., 1905–6), 8:139.

74. Morris, *Victorian & Edwardian Paintings*, 460–61; Elliott O'Donnell, ed., *Mrs. E. M. Ward's Reminiscences* (London: I. Pitman & Sons, 1911), 167–68.

75. Mrs. Delany to Mrs. Frances Hamilton, 9 November 1785, in Llanover, ed., *Autobiography and Correspondence*, ser. 2, 3:309.

76. Ward's composition relates formally, as well as thematically, to a number of well-known nineteenth-century historicist works, most notably Jean-Auguste-Dominique Ingres, *King Henri IV Playing with His Children as the Spanish Ambassador Enters*, 1817 (Musée du Petit Palais, Paris), and shares with them the strategy of incorporating historical visual sources, in Ward's case, Opie's portrait of Mrs. Delany (National Portrait Gallery, London, 1030), fig. 5 in this volume.

77. In the same Royal Academy exhibition of 1872, Ward's husband, Edward Matthew Ward, showed *The Return from the Flight* (current location unknown), which depicted the family of Louis XVI returning from their ill-fated flight to Varennes. See O'Donnell, ed., *Mrs. Ward's Reminiscences*, 171–72; Graves, *Royal Academy of Arts: Dictionary*, 8:134–35; see also Susan P. Casteras, *The Edmund J. and Suzanne McCormick Collection*, exh. cat. (New Haven: Yale Center for British Art, 1984), 92, no. 39. If we understand these two paintings as informal pendants, they represent positive and negative exempla of the relation between family, monarchy, and polity.

78. For an extended discussion of the ambivalence of this nostalgia, see B. W. Young, *The Victorian Eighteenth Century: An Intellectual History* (Oxford and New York: Oxford Univ. Press, 2007).

79. "Mrs. Delany," *Fraser's Magazine* 65, no. 388 (April 1862): 448: "There is a limit to the interest that can be taken in anybody that ever lived, and if the lives of all men and women which merit any record whatever were to be treated at the same length to which these memorials of Mrs. Delany have been suffered to extend, it is clear that the lives of the living would be entirely consumed in reading the lives of the dead...."

80. "Delville, in Two Parts," *All the Year Round: A Weekly Journal Conducted by Charles Dickens* 34 (1875), part 1, August 7, 445, part 2, August 14, 472.

81. "Delville, in Two Parts," part 2, August 14, 472.

82. George Paston (Emily Morse Symonds), *Mrs. Delany (Mary Granville): A Memoir, 1700–1788* (London: Grant Richards, 1900); R. Brimley Johnson, ed., *Mrs. Delany at Court and among the Wits: Being the Record of a Great Lady of Genius in the Art of Living...* (London: S. Paul & Co., 1925); Colwyn Edward Vulliamy, *Aspasia: The Life and Letters of Mary Granville, Mrs. Delany (1700–1788)* (London: G. Bles, 1935); and Dewes, *Mrs. Delany*. For more on this segment of the historiography, see Kerhervé, *Une epistoliere anglaise*, 558–59.

83. See, for example, S. G., "Literary Notes," *The Pall Mall Gazette* (London), no. 10917 (26 March 1900); "Worthy but Dull," *The Pall Mall Gazette* (London), no. 10973 (31 May 1900); "The Week: An Old-Time Society Lady," *The Leeds Mercury*, no. 19378 (12 May 1900); Andrew Lang, "Mrs. Delany," *Daily News* (London), no. 16868 (17 April 1900); Thomas MacGreevy, "Review of *Mrs. Delany* edited by R. Brimley Johnson," *The Connoisseur* (London) (July 1926): 179–80.

84. Hayden, *Mrs. Delany: Her Life and Her Flowers.*

85. This index was added to the second edition of Hayden's book, retitled *Mrs. Delany and Her Flower Collages* (London: British Museum Press, 1992), and has appeared in subsequent reprintings.

86. The Pierpont Morgan Library, New York, *Mrs. Delany's Flower Collages from the British Museum*, exh. cat. (New York: The Pierpont Morgan Library, 1986).

87. These include Irene Q. Brown, "Domesticity, Feminism and Friendship: Female Aristocratic Culture and Marriage in England, 1660–1760," *Journal of Family History* 7 (Winter 1982): 406–24; Myers, *Bluestocking Circle*; Pointon, *Hanging the Head*; Thaddeus, "Mary Delany, Model to the Age"; and Moore, "Queer Gardens: Mary Delany's Flowers and Friendships."

88. See Laird, *Flowering of the Landscape Garden*; Sue Bennett, *Five Centuries of Women & Gardens* (London: National Portrait Gallery, 2000), 65; Moore, "Queer Gardens: Mary Delany's Flowers and Friendships"; and Stott, *Duchess of Curiosities*.

89. See particularly the chapter "Jonathan Swift, Mrs. Delany and Friends," in Malins and Knight of Glin, *Lost Demesnes*, 31–52; Angelique Day, ed., *Letters from Georgian Ireland: The Correspondence of Mary Delany, 1731–68* (Belfast: Friar's Bush Press, 1991); Howley, *Follies and Garden Buildings*; and The Knight of Glin, David J. Giffin, Nicholas K. Robinson, *Vanishing Country Houses of Ireland* (Dublin: Irish Architectural Archive and the Irish Georgian Society, 1988), 28–29, 59, 66.

90. Toby Barnard, *Making the Grand Figure: Lives and Possessions in Ireland, 1641–1770* (New Haven and London: Yale Univ. Press, 2004); John Styles and Amanda Vickery, eds., *Gender, Taste, and Material Culture in Britain and North America, 1700–1830* (New Haven and London: Yale Univ. Press, 2006). See also Jo Dahn, "Mrs Delany and Ceramics in the Objectscape," *Interpreting Ceramics*, no. 1 (online journal), www.uwic.ac.uk/icrc/issue001/delany/delany.htm (accessed 8 December 2008); Alicia Weisberg-Roberts, "'Surprising Oddness and Beauty': Textile Design and Natural History between London and Philadelphia in the Eighteenth-Century," in Amy Meyers, ed., *The Culture of Nature: Art & Science in Philadelphia, 1740–1840*; and Stacey Sloboda, "Material Displays: Porcelain and Natural History in the Duchess of Portland's Museum" (paper presented at "Collecting across Cultures in the Early Modern World," Huntington Library, San Marino, Calif., 10–12 May 2007; publication forthcoming).

91. Kerhervé based the book on his thesis, "La correspondance de Mary Pendarves-Delany (1700–1788)" (Brest: PU de Rouen, 1994).

A THEATER OF Mrs. DELANY'S COLLAGES

A Theater of Mrs. Delany's Collages

The term "theater" has meanings beyond drama and the places associated with plays or spectacles, lectures, and medical or military operations. For example, books were often entitled "Theatrum" to convey an overview or display. "Theater" forms a motif in much that Mrs. Delany created at her Dublin home of Delville: from her 1746 "auricula stage" to her 1759 "bow closet" with its curtained prospect. She also drew the natural amphitheater of the Giant's Causeway.

In the context of her collages, however, "theater" is here applied with specific meaning: a universal collection. In 1640, John Parkinson had given his *Theatrum Botanicum. The Theater of Plantes* the subtitle: "An Universall and Complete Herball." In 1772, when Mrs. Delany came upon the novel device of imitating flowers, she was aware of that herbal tradition, which the Duchess of Portland sustained as an "English herbal." Just as the first botanic gardens had recreated the Garden of Eden as a universal living collection (with *hortus siccus* of dried plants for winter), so Mary Delany reassembled the parts of creation in a devotional-encyclopaedic way.

The staging of a group of twenty-four collages in the exhibition at the Yale Center for British Art, and seven in its incarnation at Sir John Soane's Museum, represents a microcosm of her near-1000 "Theater of Plants." At Yale three sections (4, 8 and 12 collages respectively) help define thematic spheres: wild and cultivated plants within Britain; transatlantic plant importations; and groups of exotics collected from the entire globe. At the Soane, the three locales of London, Bulstrode and Weymouth provide a framework.

The Wild & Cultivated in Britain
(Plates 1–4)

Four dramatically contrasting collages highlight the domestic in Mrs. Delany's "theatrical" compendium. Initiated in 1772/3, her work was intimately connected to the Duchess of Portland's collecting and cataloguing of England's flora. Although Mrs. Delany depicted the exotics of Bulstrode alongside native plants of field and pond, her contact with colonial floras increased dramatically in 1776 with new support from royal Kew.

The American Connection
(Plates 5–12)

Eight collages represent the importance of America as a leading source of ornamental and commercial plants. Trees and shrubs from Pennsylvania to Carolina gave rise to a new form of planting: the graduated "theatrical" shrubbery, modeled on staged displays (called an "American grove" at Bulstrode). In "theatrical" clumps, American herbaceous plants contributed to lengthening the flowering season. The plants range widely in geography and habitat, with 'Magnolia grandiflora' from the southeastern United States; 'Mirabilis longiflora' from the southwest and Mexico; and 'Catesbæa spinosa' from the Bahamas.

Plants from Across the Seven Seas
(Plates 13–24)

By the 1770s, "Foreigners" could include the odd plant from Australia and New Zealand. Thus, to the three continents of the original *theatrum botanicum* and America (the fourth), was added a fifth. Joseph Banks, who was accompanied by Daniel Solander on James Cook's voyage to "Terra Australis Incognita," was in charge of the Royal Gardens at Kew from 1773. Mrs. Delany thereby had access to global imports ranging from New Zealand and China to South America. Other private collectors – notably Drs. Pitcairn and Fothergill – joined nurserymen such as James Lee in supplying Mrs. Delany with additional species to those from Kew or Bulstrode, or from Lord Bute's estate at Luton. Twelve collages, flowering in the spectrum of the rainbow, represent the sum of collecting as it stood in 1782, on completion of her "Flora Delanica."

Note: The concordance on pages 267–273 provides the modern Latin and common names for the specimens depicted in Mrs. Delany's collages.

Plate 1: Mary Delany, 'Moss Province Rose', 1775, collage of colored papers, with bodycolor and watercolor, 10⅝ × 7½ in. (26.9 × 18.9 cm). British Museum (1897,0505.740)

Plate 2: Mary Delany, 'Nymphæa alba', 1776, collage of colored papers, with bodycolor and watercolor, 12⅞ × 8¾ in. (32.7 × 22.1 cm). British Museum (1897,0505.607)

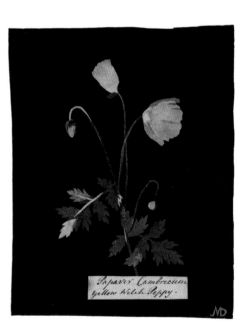

Plate 3: Mary Delany, 'Parnassia Palustris', 1776, collage of colored papers, with bodycolor and watercolor, 12⅜ × 8⅞ in. (31.3 × 22.6 cm). British Museum (1897,0505.650)

Plate 4: Mary Delany, 'Papaver Cambricum', 1774, collage of colored papers, with bodycolor and watercolor, 8 × 6¼ in. (20.1 × 15.9 cm). British Museum (1897,0505.646)

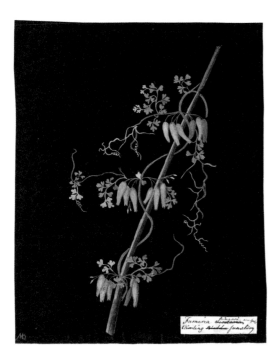

Plate 5: Mary Delany, 'Fumaria fungosa', 1776, collage of colored papers, with bodycolor and watercolor, 10½ × 8¼ in. (26.8 × 21 cm). British Museum (1897,0505.338)

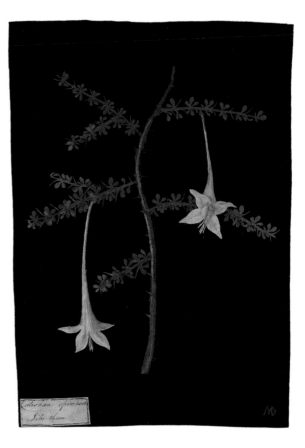

Plate 6: Mary Delany, 'Catesbæa spinosa', 1780, collage of colored papers, with bodycolor and watercolor, 13⅜ × 9 in. (34.1 × 22.7 cm). British Museum (1897,0505.168)

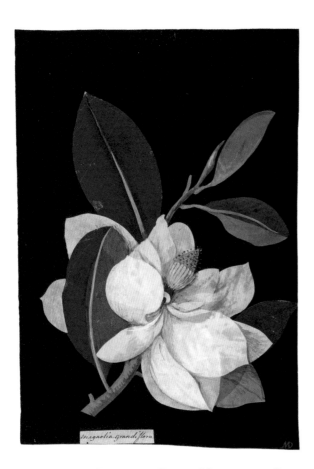

Plate 9: Mary Delany, 'Magnolia grandiflora', 1776, collage of colored papers, with bodycolor and watercolor, 13 ¼ × 9 ¼ in. (33.8 × 23.4 cm). British Museum (1897,0505.557)

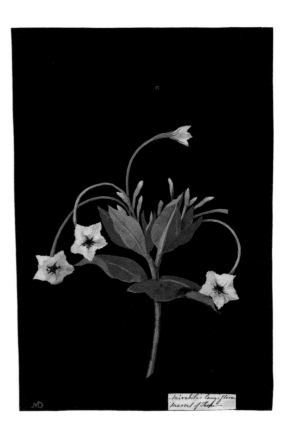

Plate 10: Mary Delany, 'Mirabilis longiflora', 1776, collage of colored papers, with bodycolor and watercolor, 12¾ × 8½ in. (32.3 × 21.6 cm). British Museum (1897,0505.587)

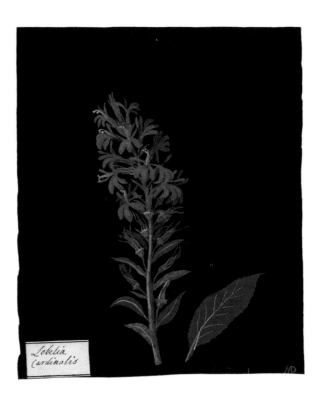

Plate 7: Mary Delany, 'Lobelia Cardinalis', 1780, collage of colored papers, with bodycolor and watercolor, 11⅛ × 9⅛ in. (28.3 × 23.1 cm). British Museum (1897,0505.529)

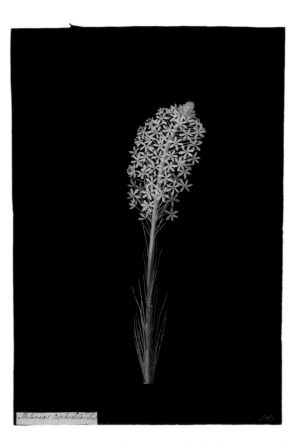

Plate 8: Mary Delany, 'Helonias Asphodeloides', 1777, collage of colored papers, with bodycolor and watercolor, 12⅞ × 8⅞ in. (32.8 × 22.4 cm). British Museum (1897,0505.416)

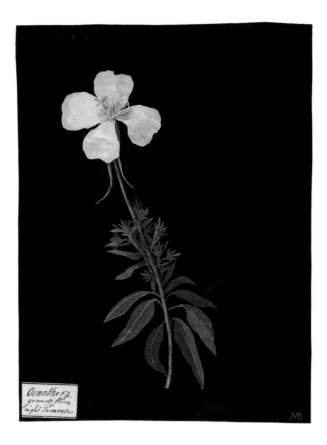

Plate 11: Mary Delany, 'Oenothera grandiflora', 1780, collage of colored papers, with bodycolor and watercolor, 12¾ × 9⅜ in. (32.3 × 23.9 cm). British Museum (1897,0505.610)

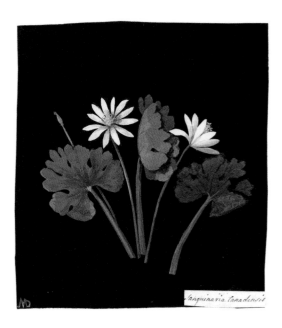

Plate 12: Mary Delany, 'Sanguinaria Canadensis', 1777, collage of colored papers, with bodycolor and watercolor, 9 × 8⅛ in. (23 × 20.7 cm). British Museum (1897,0505.766)

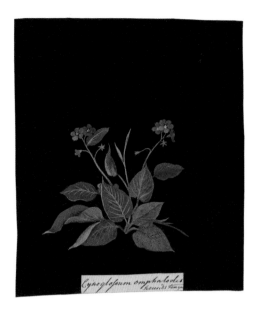

Plate 13: Mary Delany, 'Cynoglossum omphalodes', 1776, collage of colored papers, with bodycolor and watercolor, 8¾ × 7⅜ in. (22.3 × 18.7 cm). British Museum (1897,0505.260)

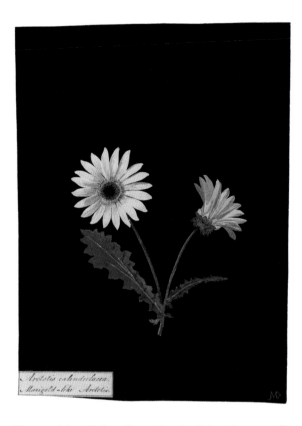

Plate 14: Mary Delany, 'Arctotis calendulacea', 1777, collage of colored papers, with bodycolor and watercolor, 12⅝ × 9¼ in. (32.2 × 23.5 cm). British Museum (1897,0505.83)

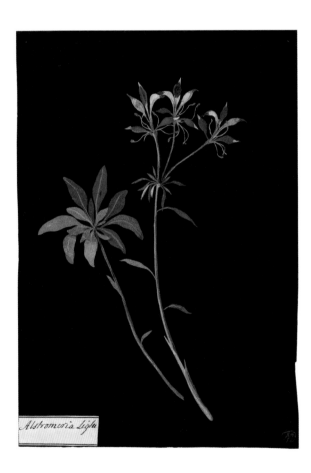

Plate 17: Mary Delany, 'Alstromeria Ligtu', 1779, collage of colored papers, with bodycolor and watercolor, 13⅝ × 9¼ in. (34.5 × 23.6 cm). British Museum (1897,0505.20)

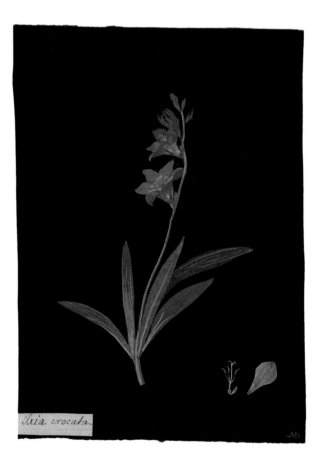

Plate 18: Mary Delany, 'Ixia crocata', 1778, collage of colored papers, with bodycolor and watercolor, and with sample flower parts, 13⅜ × 9⅜ in. (34.1 × 23.9 cm). British Museum (1897,0505.484)

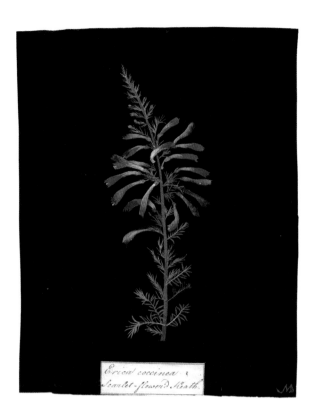

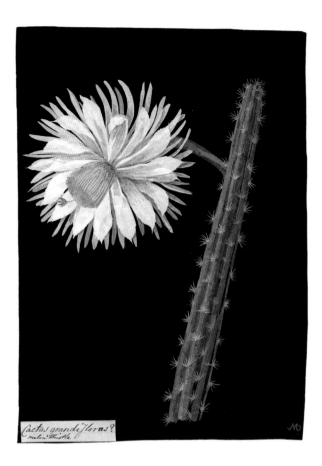

Plate 15: Mary Delany, 'Erica coccinea ?', 1776, collage of colored papers, with bodycolor and watercolor, 10⅜ × 8 in. (26.4 × 20.4 cm). British Museum (1897,0505.312)

Plate 16: Mary Delany, 'Cactus grandiflorus ?', 1778, collage of colored papers, with bodycolor and watercolor, 13⅝ × 9½ in. (34.5 × 24.2 cm). British Museum (1897,0505.133)

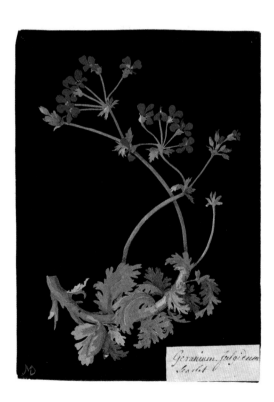

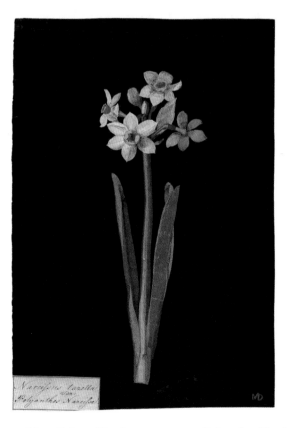

Plate 19 : Mary Delany, 'Geranium fulgidum', 1775, collage of colored papers, with bodycolor and watercolor, 9½ × 6⅝ in. (24.2 × 16.9 cm). British Museum (1897,0505.391)

Plate 20: Mary Delany, 'Narcissus tazetta var: Polyanthos Narcisse', 1776, collage of colored papers, with bodycolor and watercolor, 11⅝ × 7⅞ in. (29.5 × 20 cm). British Museum (1897,0505.598)

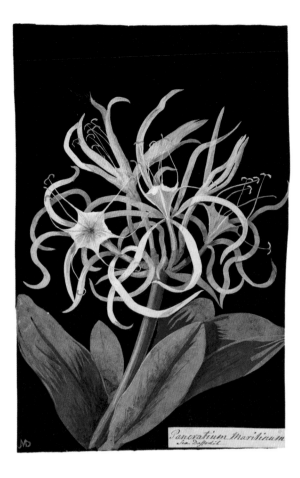

Plate 21: Mary Delany, 'Pancratium Maritinum', 1778, collage of colored papers, with bodycolor and watercolor, 13¾ × 8¾ in. (35 × 22.2 cm). British Museum (1897,0505.645)

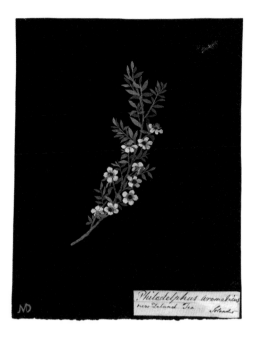

Plate 22: Mary Delany, 'Philadelphus aromaticus', 1778, collage of colored papers, with bodycolor and watercolor, 9⅞ × 7½ in. (25.1 × 19.2 cm). British Museum (1897,0505.661)

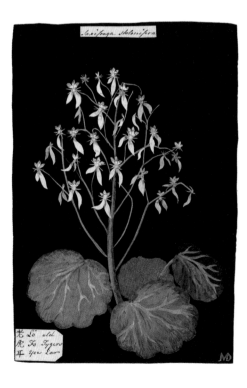

Plate 23: Mary Delany, 'Saxifraga stolonifera', 1775, collage of colored papers, with bodycolor and watercolor, and with a leaf sample, 10⅞ × 7⅛ in. (27.5 × 18.1 cm). British Museum (1897,0505.778)

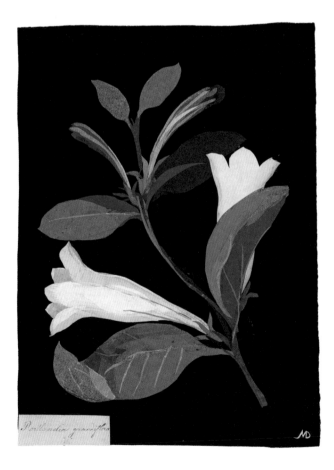

Plate 24: Mary Delany, 'Portlandia grandiflora', 1782, collage of colored papers, with bodycolor and watercolor, 13⅝ × 9¾ in. (34.5 × 24.6 cm). British Museum (1897,0505.692)

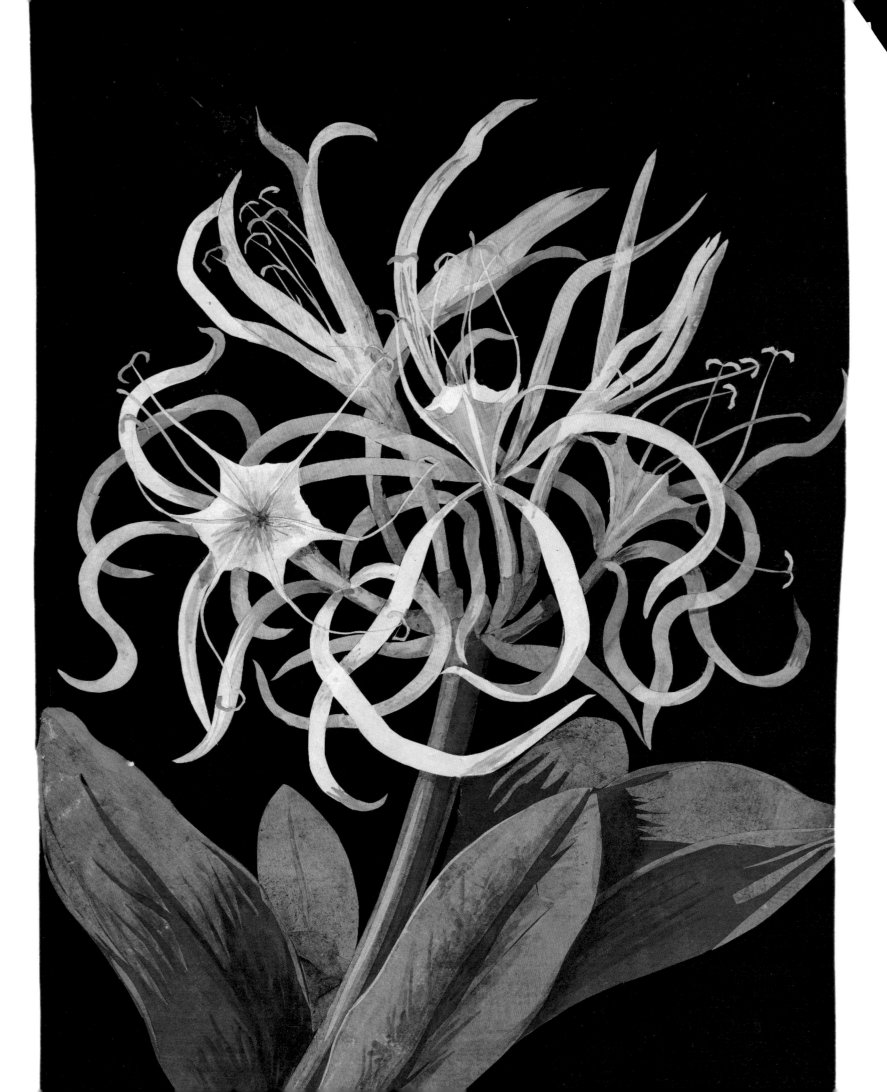

Figure 21: Mary Delany, 'Scarlet Geranium & Lobelia Cardinalis',
1773, collage of colored papers, with bodycolor and watercolor,
11¼ × 7¼ in. (28.7 × 18.3 cm). British Museum, Department
of Prints and Drawings (1897,0505.529*).
Inscribed on the verso is "first Essay" and "Bulstrode 1773".
The number 5 has been erased and replaced with 1. Hence this
may be the final version of the "essays" that began in October
1772. 'Scarlet Geranium' could be a cultivar of *Pelargonium
fulgidum* from South Africa. 'Lobelia Cardinalis' (top) grows
in eastern North America.

Figure 22: Janet Arnold, drawing based on a
mantua of ca. 1740 in the Welsh Folk Museum,
Cardiff Museums Service (23.189.1.2)

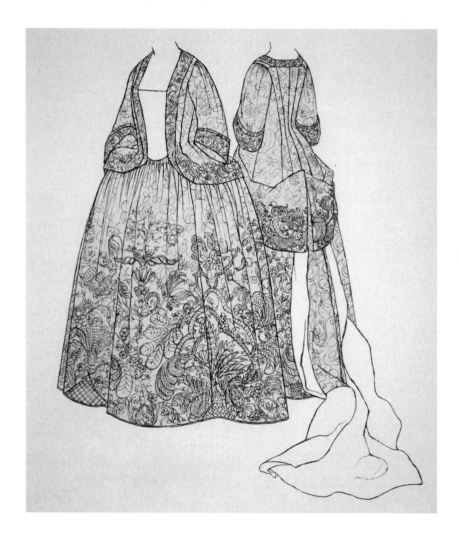

INTRODUCTION (2)

Mrs. Delany & Compassing the Circle: the Essays Introduced

The twelve essays in *Mrs. Delany and her Circle* range widely, but all contribute to an understanding of the mantua petticoat representing the first half of Mary's life, and the "paper mosaicks" that are the crowning achievement of the second. In planning the exhibition, we made the textile fragments—traditionally known in Ruth Hayden's extended family as the "court dress"—our starting point. A court dress, as Clare Browne explains in her essay, consists of three parts: the mantua (a fitted bodice extending into a train behind), the petticoat, and the stomacher (fig. 22). As it turns out, among the family's textile fragments, only the front and back of the petticoat of Mary's original court dress survive. Reassembling the whole dress as a conjectural "architecture" proves inseparable from reconstructing the social and political milieu in which it was worn. That court milieu, in turn, requires an understanding of Georgian urban topography, and cartographer John Rocque provides one useful basis for visualizing London's royal geography: St. James's Palace, Carlton House, Norfolk House, and Somerset House on the Thames (see fig. 43). Similarly, the circles in which Mrs. Delany composed the collages are reconstructed from our field notes of the near and far: observing her intimate working rituals with compass, scissor, and tweezer; following her among the hares of the pleasure ground at Bulstrode; traveling with her by coach in an orbit within twenty-five miles of London; and tracking her reception of collage plant specimens from Kew or Chelsea Physic Garden, plants that originally had come from the four corners of the globe. As architecture and urbanity frame the court dress, so her collages seem to be shaped by whole habitats: rural and urban gardens, the countryside at large, and the landscapes of exploration and colonization that reached as far as the South Seas (fig. 21).

Complicated as the textile evidence is, the petticoat appears fabric enough to bring to life a critical moment at the end of the first forty years of the life of Mary Granville (then Mary Pendarves). Clarissa Campbell Orr's essay shows how Mary's 1743 marriage to Patrick Delany terminated a long period of "paying court" in order to secure a royal appointment. Campbell Orr makes the key discovery that the widow Mary Pendarves, backed by her powerful family connections, aspired to a position in Princess Augusta's household: Woman of the Bedchamber. Such formal office remained elusive, however. The well-documented rift of 1738 between George II and Frederick Prince of Wales began to ease in 1740, and by 1741 contact between father and son had been restored. In this context, the "politics of dress," which Hannah Greig documents in her essay, gains impetus from the complementary work of Clare Browne, as well as from Clarissa Campbell Orr's narrative. Browne argues from the principal dress fragments that there are stylistic, technical, and circumstantial clues to suggest the mantua was worn at that politically sensitized moment when the ball at Norfolk House, residence of Frederick Prince of Wales, took place in February 1741. Mary Pendarves wrote to her sister of this occasion, inconveniently describing the Duchess of Queensberry's dress and all others but not her own (see fig. 23).[1] Mary's dress—conjecturally reassembled for the exhibition—is thus the stuff of hopes fashioned by her first forty years, as well as an emblem of the sartorial and political ups and downs of her generation.[2]

Figure 23: Detail of dress, ca. 1740, silk embroidered with silk and metal thread in long and short, satin and stem stitches, laid and couched work. Victoria and Albert Museum, London (114-1873). Elements of the design of this dress resemble the description of one worn by the Duchess of Queensberry in 1741.

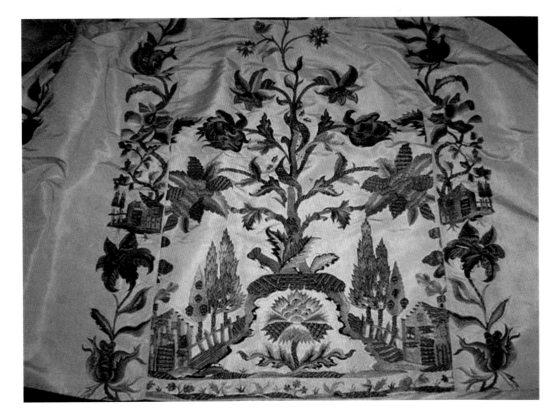

Figure 24: Framed textile panel, design attributed
to Mary Pendarves, ca. 1740, embroidered black
satin, 41.7 × 55.5 in. (106 × 141 cm). Private collection

The mantua's construction, the professional world in which the petticoat was embroidered, and the stylistic links to woven textiles are explored in Clare Browne's essay. Mary's other textile fragments—traditionally assumed to be part of the same "court dress" but now considered unrelated—await further research following textile conservation for the exhibition (fig. 24). Hannah Greig's essay, which affirms "dressing down," "dressing up," and "new dressing" as statements of political allegiance, raises questions about how a dress was perceived and reported to the world at large. She describes the "filtering" enfilade (ceremonial entry) that makes sense of the architecture of the dress, along with the melee that might, amusingly, confound it.[3] She asserts that reporting ahead of court occasions controlled political spin. Expenditure (depending on materials, labor, single or multiple use, and so forth) was one parameter for Mary Pendarves's mantua. The choice of black—a highly personal decision—was another, related to viewing in candlelight or in daylight, and to a host of other determining factors.

The lighting of the music room of Norfolk House as remodeled in 1751–56 (now in the Victoria and Albert Museum) is a case study in candle illumination, but it is apt to confuse, since this was not the Prince of Wales's Norfolk House.[4] Nonetheless, the remodeling marked a fundamental shift in architectural history, from the "formal" to the "social" house, a shift that Mary Delany witnessed.[5] Calculating how floral embroidery (with or without scintillating effects) would look on a black ground under candlelight (diffuse if mounted against mirrors, more occluded under chandeliers) was complex. It was one factor that Mary Pendarves surely pondered in the winter of 1740, along with the choice of contrasting colors and the selection of flowers. As I note in my essay, cultivated flowers—the florists' cultivars (auricula, tulip, hyacinth)—had assumed by the seventeenth century an important role in the iconography of court culture in France. Whether Mary's choice of the thistle had some symbolic dimension is conjectural and requires further research (along with careful dating of her flower motif designs on paper). More likely, the motif of British "wild" plants (the thistle intertwined with lesser bindweed) is intermixed with the predominantly English cultivated florists' flowers for sheer visual effect. However, Clarissa Campbell Orr, documenting the culture of the "alternative and auxiliary courts" (from Norfolk House to Bulstrode, and with imagery drawn from Elizabethan romance literature or from the seventeenth-century French court), suggests an

iconography of dress that is more than simply dressing up for political advancement.

In the introduction to *Gender, Taste, and Material Culture*, John Styles and Amanda Vickery offer another way of looking at the milieu in which the younger Mrs. Pendarves and the older Mrs. Delany crafted vita and persona. They argue, from Mark Girouard's study of "formal" to "social," that the rise of privacy and the blend of convenience came with an increasing specialization of spaces. This included the masculinized dining room and the feminized drawing room. Mrs. Delany's 1746 visit with the Duchess of Queensberry to Cornbury highlights, for example, the difference between Dr. Delany's "bold and handsome" dressing room and her own dressing room, "hung with the finest Indian paper of flowers and *all sorts of birds....*"[6] The dressing room, Styles and Vickery add, became "a metonym for close female companionship and an exquisite enlightened feminine sensibility."[7] Here are grounds for new exploration. Several essays in this volume (notably those by Amanda Vickery and Maria Zytaruk) consider the place of women in the home and in the garden or wider landscape. Vickery situates Mary Delany's craft activities within a broad interior social milieu: as creative expression; as solace (or even therapy) in coping with boring company and loneliness alike; and as a constructive investment in purpose, achievement, and amity within the households of men. Zytaruk locates Mrs. Delany more specifically in the interconnected spaces of Delville and Bulstrode, both outdoors and indoors. Just as—in the dialogue between art and nature—dressing room and closet were inseparable from grotto and garden room, so too the collages as elevated craft fluidly integrated new scientific imperatives with personal and social expressions through exchange and within the processes of artistic production.

John Cornforth's *Early Georgian Interiors* illustrates exquisite surviving interiors that help in the visualization of feminine space (fig. 25).[8] But his arguments are not limited by gender. First, he notes the increasing enthusiasm of gentlemen and ladies for flowers, gardens, and landscapes. This meant the translation of imagery drawn from natural history works by John Martyn, Georg Dionysius Ehret, and George Edwards into all aspects of decoration, from textiles and wallpaper to silver and porcelain (fig. 26). Second, he writes of the contribution of "amateurs and ladies" in ways that anticipate the "overlapping taste communities" discussed by Styles and Vickery.[9] Third, he adds: "The growth of the influence of ladies was paralleled by a growth of interest in comfort, intimacy and privacy, light

Figure 25: Chinese wallpaper, surviving in the dressing room, part of a scheme for the Great Apartment at Newhailes, late 1730s. Country Life Picture Library

Figure 26: Detail from painted toile by Andien de Clermont, probably commissioned by the Duke and Duchess of Northumberland for Syon House in the 1750s. Unknown location

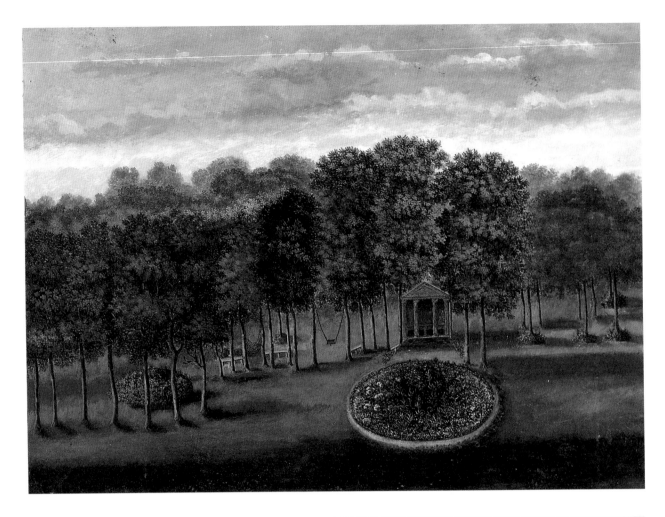

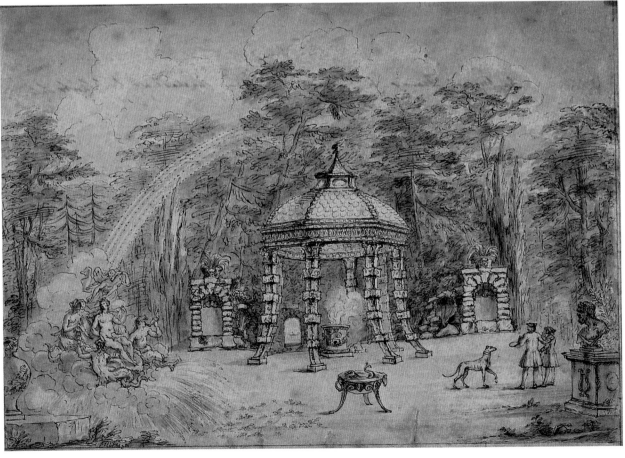

and informality in houses."[10] From that, it seems plausible to argue that the spread of the villa as the basic type of country house after 1740 had roots in "ways of living" as well as in the Palladian villa as such.

I have attempted in my essay to enlarge on Cornforth's "interlocking changes" of "living" in the context of the garden. The argument extends beyond the villa garden at Delville to larger landscapes, like Cornbury, that Mary Delany drew. In particular, the lost interiors of Cornbury beg the question whether dress and decor have parallels outdoors. What Thomas Robins the Elder recorded of the landscapes of Richard Bateman and Benjamin Hyett was gardening rich in flowers and furnishings (fig. 27). What Mrs. Delany sketched at Lord North's Wroxton was *chinoiserie*. While it is questionable whether, as John Cornforth claims, Wroxton's Chinese house influenced the design of the Chinese bed at Badminton (or, in turn, that William and John Linnell, working with the duchess, acted independently from architects William Kent and Thomas Wright), a confluence of roles is noteworthy: the amateur (lady or gentleman) working with craftsmen inside and out.[11] The documentation of the amateur, the artisan, and the lady in the amusements and science of horticulture awaits a new garden history linked to the history of natural history.[12] This might engender new ways of considering "the Picturesque," thus amplifying the shifts that have occurred in landscape studies from Hunt's pioneering works to my own *The Flowering of the Landscape Garden*.[13] How, for example, does William Kent's rendering of the Shell Temple and Grotto at Alexander Pope's villa (fig. 28) relate (beyond Kent's design of "Merlin's Cave" for Queen Caroline) to Mary Delany's representations of rocks, or her work in the duchess's "Cave" at Bulstrode (fig. 29)? (Further topographical studies of Delville and Bulstrode might help answer such questions.)

"Work" and "amusements" are the operative terms in Mary Delany's life, as Kim Sloan comments, whether applied to needlework, art, music, dress, and limning, or to such accomplishments as gardening and interior decorating. Further qualified as "innocent amusements," this avoidance of overzealous pursuits accords with what Janice Neri calls Mrs. Delany's heeding of comportment and etiquette in science. In *'A Noble Art'*,[14] Kim Sloan establishes a new way of looking at the place of amateur artists in botanical drawing and horticulture. Her essay in this volume elaborates on where Mrs. Delany's "work" fits within its visual culture. Mrs. Delany's ingenuity relates to the appellation *virtuoso* as well as to the art of limning. By the mid-eighteenth century, from being a complimentary appellation suited only to princely collectors, a *virtuoso* meant someone who collected not just objects but knowledge for its own sake. By the end of the century, with the declension of *virtuosi*, the "amateur" emerged as a person who loved and practiced one or more of the arts without expectation of payment. Yet Mrs. Delany, a consummate amateur, still used the term "virtù" when describing her efforts (with botanist John Lightfoot and artist G. D. Ehret) to classify and represent the natural world. The Duchess of Portland's estate, Bulstrode, provided the collections and the classificatory counsel of a "philosophical cabinet," as the essays by Janice Neri and Maria Zytaruk document. The exploration of Mrs. Delany's art and intellect as a *virtuosa* thus develops new perspectives in well-established categories: feminine amusements or accomplishments in relationship to philanthropy, industry, melancholy, *ennui*, and piety.[15] Amanda Vickery offers a broad context for looking at Mrs. Delany's productions, not in the language of "incarceration and powerlessness," but as a "map of the possible"—"a distaff version of gentlemanly virtuosity."

Figure 27: Anonymous, *"Temple Flower Garden" of Richard Bateman's Grove House, Old Windsor, Berkshire*, 1730s, mixed media on paper. Private collection

Figure 28: William Kent, *View of Grotto and Shell Temple at Twickenham, Alexander Pope's Garden*, 1730–48, pen and black and gray ink and brown wash, over graphite, 11⅜ × 15½ in. (28.9 × 39.5 cm). British Museum, Department of Prints and Drawings (1872,1109.878)

Figure 29: Mary Delany, *The cave at the end of Dovedale in Derbyshire*, 1753. National Gallery of Ireland, Dublin (2722 [49])

The cave at the end of Dovedale in Derbyshire. MD 1753

Some terms used by Mrs. Delany to describe her major production—the collages—are also appellations that go back in time. David E. Allen documents, for example, how the *hortus siccus*, first used by Luca Ghini in Italy in 1530s as a teaching device, was already applied as a term by the fifteenth century to albums of dried and labeled specimens; it would later be called a herbarium.[16] One tangentially connected term is relevant to Mary Delany's *hortus siccus*, though not used by her explicitly in relationship to her collages—"theater." "Theater" has two meanings in this particular context: one is concerned with structure (in the sense of "amphitheater"),[17] the other with forming a collection as a conspectus (fig. 30). Theater is a motif in much that Mrs. Delany created at Delville, from her 1746 "auricula stage" to her 1758/9 "bow closet" with its curtained prospect. Beyond staged effects, however, Mrs. Delany surely understood "theater" as an ideal

complete collection. As I have documented in *The Flowering of the Landscape Garden*, the "theatrical" manner of planting in shrubbery, modeled on staged flower theaters, was widespread by the 1750s and offered a way to display a complete collection of the newly fashionable American woody species. Thus, John Hill's *Eden: Or, A Compleat Body of Gardening* of 1757 (linked to his work at Kew, including his *Hortus Kewensis* of 1768 as forerunner of William Aiton's *Hortus Kewensis* of 1789) was an Edenic encyclopaedia matching the encyclopaedic living plantation, now completed by the addition of the American plants (which he would in turn feature in his *Twenty-five New Plants* of 1773).

By the mid-eighteenth century, then, what John Prest establishes in his book *The Garden of Eden* as a central impetus for the botanic garden was equally compelling for the pleasure ground of the landscape garden: and scientific herbaria were

evolving out of apothecary herbals. In 1640, John Parkinson had titled his book *Theatrum Botanicum, The Theater of Plantes*, with the subtitle "An Universall and Compleate Herball." The first botanic gardens re-created Eden as a universal living collection (essentially from what were considered the remnants from the Fall and Expulsion – the plants scattered to the four corners of the globe). This served physic and apothecary knowledge (medical and pharmaceutical practice).[18] The *hortus siccus* of dried plants sustained the Edenic ideal over winter, when many living plants were not growing and thus available for study.

Hence in 1772, when Mrs. Delany invented her novel way of imitating flowers, she would have been aware of these interlocking traditions of the "herbal" as theater and the *hortus siccus* as herbarium. She used both terms to describe her work, and the implications were at once religious and scientific. As Maria Zytaruk makes clear in

her essay, Mrs. Delany sustained the seventeenth-century understanding of natural history as devotional work when she appropriated Milton for the duchess's Linnaean projects: *"These are thy glorious works."* Installations accompanying the exhibition at the Yale Center for British Art and Sir John Soane's Museum—both in the form of living theaters—combine the two organizing principles, structural and encyclopaedic, as do the collage presentations in the exhibitions, which are arranged as staged display (see pp. 20–27).

Mrs. Delany's collages as a *hortus siccus* relate to at least one earlier model of a *virtuosa* collecting and employing embryonic taxonomies: the twelve-volume *hortus siccus* and two-volume florilegium (figs. 31, 32) of Mary Capel Somerset, first Duchess of Beaufort. The former was compiled at Badminton and Chelsea with the help of Dr. Hans Sloane, while Everhard Kick produced the florilegium at Badminton from 1703 to 1705.[19] The

hortus siccus, or true herbarium, involved the pressing and drying of plants as evidence on which botanists could determine species and name them. Mrs. Delany's paper *hortus siccus* (with occasional plant matter incorporated) was more akin to the lifelike representations of the florilegium (as discussed by Kohleen Reeder and Maria Zytaruk); it avoided the faded coloration in leaf and petal of many specimens in the herbarium. Naming her work "Flora Delanica" in 1781 (perhaps in step with public recognition), Mrs. Delany had created something of a hybrid, more florilegium than true herbarium.

The essays in this book thus portray science and art as complementary forms of endeavor within the spectrum of female accomplishment. Virtuosic collecting could go hand-in-hand with limning. The art of limning—associated early on with miniatures, needlework, and other decorative arts—was a sphere in which women were

Figure 30: Mark Laird, Reconstruction of an auricula theatre, 1996, watercolor, 8 × 11½ in. (20.3 × 29.2 cm). Collection of Mark Laird

Figure 31: First Duchess of Beaufort's *hortus siccus,* specimen of "Apocynum", in Sloane Herbarium, vol. 133, fol. 67. Natural History Museum, London

Figure 32: Everhard Kick (Kychious), florilegium (1703–5), vol. 1, fol. 14, including the "Apocynum" in the center, commissioned by the first Duchess of Beaufort at Badminton. Duke of Beaufort, Badminton

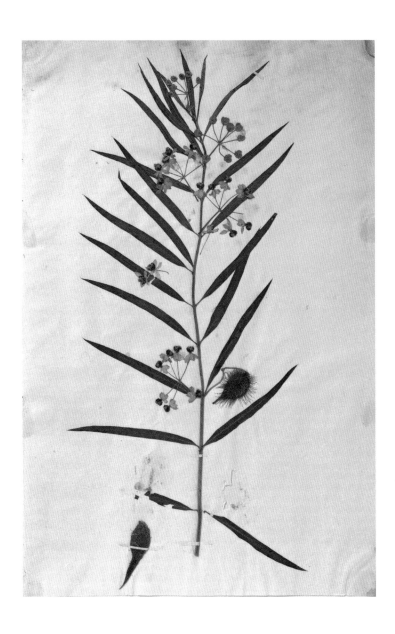

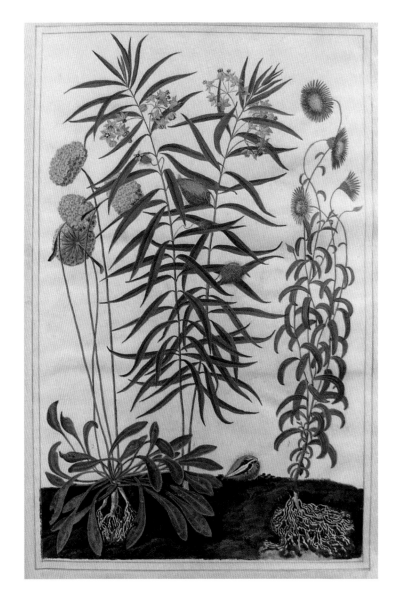

encouraged to share with husbands the virtues of the mind. By the early 1700s, the daughters of peers and *virtuosi* learned to limn or draw flowers and portraits from life and to copy oil paintings. As Kim Sloan documents, Mrs. Delany's education, grooming for court, and instruction in limning were formative. They equipped her for a life shared, within a companionate marriage, with ladies of distinction, notably the Duchess of Portland, and with women of varying degrees of rank who became identified as precursors of the Bluestockings. The use of nicknames such as Aspasia reveal a common ideal of virtue, moral as well as intellectual. An *album amicorum* (drawings by friends, kept in one album in a cabinet) evoked friendships through memory, much as a closet or grotto could do. The "friendship box" was a microcosm of such sharing (see fig. 9).

Figure 33: William Woollett, *A View of the Garden at Carlton House in Pall Mall, A Palace of Her Royal Highness the Princess Dowager of Wales*, ca. 1760, engraving, 14¾ × 21⅜ in. (37.5 × 54.3 cm). Yale Center for British Art, Paul Mellon Collection B1978.43.1073

This was the world of the amateur. But other communities of taste coexisted and overlapped. From Maria Sibylla Merian in Holland to Margaret Meen in England, women found a source of income in flower painting in the commercial marketplace.[20] Some were daughters who followed their fathers' trade, others were amateurs compelled to turn professional for financial reasons. In England, the explosion of print culture, organized in part through advance subscription, gave women, high and low, importance in the arts as subscribers as well as paid or amateur artists. The growing percentage of women subscribers to books of flowers and butterflies is a notable development from 1730 to 1750.[21] In the context of rank and gender, Mrs. Delany's aristocratic productions thus form an interesting counterpoint to professional cultures of horticulture and to middle-class self-fashioning. While John Lightfoot provided one link for Bulstrode to metropolitan scientific developments, Mrs. Delany came to depend on commercial nurserymen in London for many collage specimens.

By mid-century, London's coffeehouse culture had expanded beyond business and politics to include art, science, and literature.[22] It helped generate "horticultural culture."[23] Nurserymen furnished the Prince and Princess of Wales at Carlton House with exotics for groves and "theatrical" shrubberies (fig. 33), just as commercial theater, opera, and pleasure gardens entertained king, queen, and Prince of Wales.[24] From early on, "clubs" supported a burgeoning nursery trade, along with books on flowers and butterflies.

Georg Dionysius Ehret, an artist coming from the medico-botanical world, earned a living as tutor to the aristocracy (and as publisher of exotica and Lepidoptera). Through the patronage of the Duchess of Portland, he furthered his study of natives while helping create her "English herbal." His drawing instruction of the duchess's daughters, following a botanical (dissecting) method, formed a precedent for Mrs. Delany, whose native-*cum*-exotic collages used the knife in both deconstructive and reconstructive senses. Kohleen Reeder's reconstruction of how Mrs. Delany assembled a collage (simulated by the reproduction of the Delany 'Narcissus Poeticus' and the Booth Grey 'Geranium Macrorrhisum') details each step of a process within the material culture of the time.

If Mrs. Delany's nearly one thousand collages (like the 5,600 species in William Aiton's three-volume *Hortus Kewensis*, 1789) still epitomized the universalizing "theater" (the collections of physic garden and pleasure ground), the Booth Grey collection of botanical collages marked new developments after her death in 1788. As I suggest in my essay, these collages were assembled just at the point when collecting in the Antipodes and Alps would lead to specialization within horticulture and landscape gardening and to distinct disciplines within the natural sciences. John Edmondson places Mrs. Delany's collages at the cutting edge of a discipline that the Swedish naturalist Carl Linnaeus had revolutionized: botany (more than seven hundred of her collages carried names from two editions of his *Species Plantarum*). The generic name *Pelargonium*, used in the Booth Grey album but not by Mrs. Delany, shows, by contrast, how nomenclature was shifting by the time *Hortus Kewensis* was published in 1789. The dating of the Booth Grey collection to the 1790s on the basis of published nomenclature is confirmed by Peter Bower's paper analysis. From a reconstruction of the paper world of Mrs. Delany, Bower argues that her pioneering use of wove paper puts her in the company of Thomas Gainsborough. Her sheer skill and confidence in cutting without drawing places her within the caliber of the best of the Japanese cut paper artists.

Lisa Ford documents the significance of Kew (fig. 34) and Luton Hoo (both associated with Lord Bute), which emerged as major sources of Mary Delany's exotic specimens in 1776 (fig. 35). In effect, what had begun in the early botanic garden as the re-creation of paradise—reassembling the plants of a pre-lapsarian world into the four "quarters" (*theatrum botanicum*)—was becoming Kew's Edenic "theater" to Science and Empire. Yet Mrs. Delany's devotional art retained

the original meanings of the herbal, *hortus siccus*, or florilegium: the setting in order (out of "agreeable confusion"[25]) of God's creations, whether as a lore of physic or as a record of wonder in divine complexity: "It is impossible to consider their wonderfull construction of form and colour, from the largest to the most minute, without admiration and adoration of the great Author of nature," as she put it.[26] There was no room for vanity—as fashionable indulgence—in this formulation of collecting and cataloguing.

Maria Zytaruk, positioning Ehret in a role between the seemingly gendered poles of "virtuosity" and "vanity," shows that material culture provided an arena for female eloquence and creativity. The objects of modest indulgence exchanged among women took their place in spaces that were both private and intimate: the closet and the cabinet. In this sense, the grotto was an extension outward (using shells in assemblage rather than the rare specimens of the cabinet, as Janice Neri makes clear). Karen Lipsedge has documented the evolution of the "closet" from a sanctuary and "laboratory of the soul" to an external symbol of the individual's right to privacy.[27] It was a secret enclosure for writing, reading, and other forms of communion among women. While the closet at Delville fulfilled all these expectations within her second, harmonious marriage, the view outward to an

Figure 34: Thomas Richardson, *The Royal Gardens of Richmond and Kew, with the Hamlet of Kew, Part of the Royal Manor of Richmond. Taken under the Direction of Peter Burrell Esqr. His Majesty's Surveyor General by Thos. Richardson 1771*, 1771, drawing on vellum, 21 × 46⅝ in. (53.3 × 118.5 cm). British Library (Maps K.Top.41.16.k.2 TAB)

Figure 35: Mary Delany, 'Passiflora Laurifolia', 1777, collage of colored papers, with bodycolor and watercolor 13⅞ × 9½ in. (35.2 × 24.2 cm). British Museum, Department of Prints and Drawings (1897,0505.654)

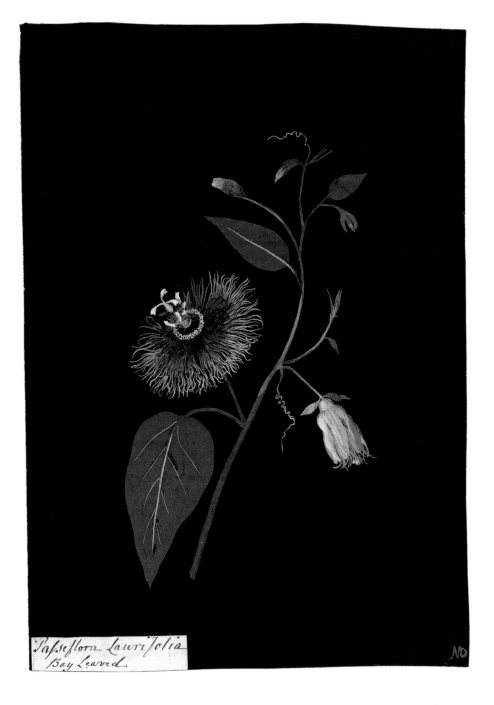

idyllic landscape brought solace during the wretchedness of her first, as Kim Sloan points out: "The closet was a private and personal space to which she could retreat from her unhappiness in her marriage… [it] was decorated with works of her own imagination and a portal to Elysium."

The restless decorating of closets at Delville mirrors the ever-changing dressing room of Bulstrode. Maria Zytaruk shows that the subdivision of space at Delville was linked to objects that moved across fluid boundaries between private and public. This included the grotto as interior space (though the exterior character had a "picturesque" sensibility, as Mary Delany's sketches of rocks in Ireland and Derbyshire show). A few representations of grand closets survive. Yet analogous paintings of privacy better summon up images of Mrs. Delany working by daylight and candlelight in her closet at Delville (or at St. James's Place): Joseph Highmore's set for *Pamela*, 1742–43, or Richard Morton Paye's candlelit *The Artist in his Studio* of 1783 (fig. 36).[28]

Exchange through letters, which is one focus of Maria Zytaruk's essay, takes on a different meaning in Lisa Ford's essay. By the time the collages had become Mrs. Delany's preoccupation, the exchange of plants complemented the back-and-forth of letters. Communication networks, expanded through improved roads and mail, are documented by Ford for London and the surrounding environs. The ubiquitous "chaise" carried Mrs. Delany through the sparsely populated landscapes, away from the bustle of London; it took the duchess to Weymouth and craggy Portland Bill. Letters abound with references to "franks" and the "penny post," which, as standardized under Ralph Allen, offered a genuine alternative to "franking" within Mrs. Delany's epistolary community.[29] Clarissa Campbell Orr, showing how, in later life, others paid court to Mrs. Delany (as age made her less able to socialize), also describes the "peripatetic lives" of the elite, alternating between town and country, between St. James's Place and Bulstrode. Ford, using collage inscriptions as a primary resource, has mapped these interlocking circles in terms of a social and geographical propinquity: from what had once been "overlapping taste communities" in decor, dress, and female accomplishment to new intellectual communities not confined by rank and gender.

The Duchess of Portland's Bulstrode provides one continuum of endeavor and milieu between the first half of Mrs. Delany's life and the second. The 1786 Portland Museum Sale Catalogue is the swan song of their joint venture, and several authors in this volume pay tribute to its importance (which awaits further exploration). The royal household also features prominently throughout Mary's long life. She eventually became friend to the monarch, and to a queen who was not above enjoying Mrs. Delany's orange pudding at an impromptu lunch. She was offered a "grace-and-favour" home in Windsor, with her rank and way of life sustained by the king augmenting her income. Still following a life of "singular ingenuity"[30] at the end of her second widowhood, she had the king's personal recognition, not the formal office she had striven for in her first widowhood. This was indeed appropriate recognition of her character, rank, and talents. While there are dangers in anachronistically reading too much into the inversion effected late in life—others "paying court" to Mrs. Delany—her creative ingenuity does offer perennial inspiration, one that is still recognized in our times. After all, she began her "life's work" at the age of seventy-three, and old age was her flowering.[31]

Figure 36: Richard Morton Paye, *The Artist in His Studio*, 1783, oil on canvas. National Trust, Bearsted Collection, Upton House, Warwickshire

Notes

1. Mary Pendarves to Anne Dewes, February 1741, in Lady Llanover, ed., *Autobiography and Correspondence of Mary Granville, Mrs. Delany*, 6 vols. (London: Richard Bentley, 1861–62), ser. 1, 2:146–49.

2. The dating of the dress to 1740/41 makes it coeval with Mary's "Autobiography," which was written about that time. See the first volume of Llanover, ed., *Autobiography and Correspondence*, ser. 1.

3. I would like to take this opportunity to thank Joanna Marschner for hosting a discussion at Kensington Palace of ceremony and the court dress in July 2008. This established the importance of the filtering enfilade. Ceremonial dress in general is covered in Nigel Arch and Joanna Marschner, *Splendour at Court: Dressing for Royal Occasions since 1700* (London: Unwin Hyman, 1987).

4. See John Cornforth's discussion of "Light and Hospitality" in *Early Georgian Interiors* (New Haven and London: Published for the Paul Mellon Centre for Studies in British Art by Yale Univ. Press, 2004), 129.

5. Mark Girouard, *Life in the English Country House: A Social and Architectural History* (New Haven and London: Yale Univ. Press, 1978), 194–97.

6. John Styles and Amanda Vickery, eds., *Gender, Taste, and Material Culture in Britain and North America, 1700–1830* (New Haven: Yale Center for British Art, 2006), 11, and Llanover, ed., *Autobiography and Correspondence*, ser. 1, 2:441.

7. Styles and Vickery, eds., *Gender, Taste, and Material Culture*, 11.

8. Cornforth, *Early Georgian Interiors*, see for example figs. 63, 68, and 327–29.

9. Styles and Vickery, eds., *Gender, Taste, and Material Culture*, 19.

10. Cornforth, *Early Georgian Interiors*, 209.

11. Cornforth, *Early Georgian Interiors*, 206: "While the Beauforts employed Kent on the exterior of Badminton and to design Worcester Lodge in the park, they also went to William and John Linnell to furnish the Chinese Bedroom, a contrast in mood that suggests the involvement of the Duchess." John Harris has pointed out (personal communication, November 2008) that the Chinese interior cannot be disassociated from Thomas Wright's chinoiserie as part of a thirty-year "spell" he cast over his patroness, the Duchess of Beaufort. The Chinese bed from Badminton is now in the Victoria and Albert Museum. See Mark Laird's discussion of Wright's 1750 plan for Badminton, which included a Chinese temple with umbrella awnings to shade auriculas displayed on steps, in Mark Laird, *The Flowering of the Landscape Garden: English Pleasure Grounds, 1720–1800* (Philadephia: Univ. of Pennsylvania Press, 1999), 128, 204–5. See also Janice Neri, "Cultivating Interiors: Philadelphia, China, and the Natural World," in Amy R. W. Meyers, ed., *The Culture of Nature: Art & Science in Philadelphia, 1740–1840*

(New Haven and London: Yale Univ. Press, forthcoming).

12. Mark Laird, *The Environment of English Gardening and Botanical Art, 1650–1800* (forthcoming).

13. "Picturesque" is a term with complex meanings, as John Dixon Hunt has made clear in his many publications. It is particularly problematic when applied to "plantings." See, for example, Mark Laird, "Ornamental Planting and Horticulture in English Pleasure Grounds, 1700–1830," in John Dixon Hunt, ed., *Garden History: Issues, Approaches, Methods* (Washington, D.C.: Dumbarton Oaks Research Library and Collection, 1992), 243–77. Later publications by Laird confirm and refine the idea of the geometry and linearity of a "Picturesque/Baroque" continuum. They document characteristics of plantings in the Georgian pleasure ground, with "theater" as the key motif. Despite the revisionist work of the past twenty years (including the replanting of Painshill), the label "picturesque" remains valid for delimiting the period of the dominant landscape garden and the shifting styles within that period (roughly 1720s–1820s). It is used occasionally in this volume to denote that period, as well as for ways of viewing and representing nature (see the essay by Maria Zytaruk and the discussion of "Theater" in this volume).

14. Kim Sloan, *'A Noble Art': Amateur Artists and Drawing Masters, c. 1600–1800* (London: British Museum Press, 2000).

15. Sloan, *'A Noble Art'*, 46.

16. David Elliston Allen, ed., *Naturalists and Society: The Culture of Natural History in Britain, 1700–1900* (Aldershot: Ashgate Variorum, 2001), 337.

17. The structure of the "theatrical" shrubbery and flowerbed is discussed in Laird, *Flowering of the Landscape Garden*.

18. See John Prest, *The Garden of Eden: The Botanic Garden and the Re-Creation of Paradise* (New Haven and London: Yale Univ. Press, 1981).

19. Douglas Chambers, "'Storys of Plants': The Assembling of Mary Capel Somerset's Botanical Collection at Badminton," *Journal of the History of Collections* 9, no. 1 (1997): 49–60.

20. Lucia Tongiorgi Tomasi, "'La femminil pazienza': Women Painters and Natural History in the Seventeenth and Early Eighteenth Centuries," in Therese O'Malley and Amy R. W. Meyers, eds., *The Art of Natural History: Illustrated Treatises and Botanical Paintings, 1400–1850* (Washington, D.C.: National Gallery of Art, 2008), 158–81.

21. See David Elliston Allen, *The Naturalist in Britain: A Social History* (1976; repr., Princeton, N.J.: Princeton Univ. Press, 1994), 24–25, and Keith Thomas, *Man and the Natural World: Changing Attitudes in England, 1500–1800* (London: Allen Lane, 1983), 282–84.

22. See John Brewer, *The Pleasures of the Imagination: English Culture in the Eighteenth Century* (London: HarperCollins, 1997), and Brian Cowan, *The*

Social Life of Coffee: The Emergence of the British Coffeehouse (New Haven and London: Yale Univ. Press, 2005). For a recent survey of the literary culture of the eighteenth-century coffeehouse, see Markman Ellis, ed., *Eighteenth-Century Coffee-House Culture*, 4 vols. (London: Pickering & Chatto, 2006).

23. Mark Laird, "The Culture of Horticulture: Class, Consumption, and Gender in the English Landscape Garden," in Michel Conan, ed., *Bourgeois and Aristocratic Cultural Encounters in Garden Art, 1550–1850* (Washington, D.C.: Dumbarton Oaks Research Library and Collection, 2002), 221–54.

24. Mark Laird, "The Congenial Climate of Coffeehouse Horticulture: The *Historia plantarum rariorum* and the *Catalogus plantarum*," in O'Malley and Meyers, *Art of Natural History*, 226–59 (including appendix, "The Club at the Temple Coffee House," by Margaret Riley).

25. Mary Delany to Miss Mary Dewes, 3 September 1769, in Llanover, ed., *Autobiography and Correspondence*, ser. 2, 1:238.

26. Mary Delany to Bernard Granville, 10 October 1774, in Llanover, ed., *Autobiography and Correspondence*, ser. 2, 2:40.

27. Karen Lipsedge, "'Enter into Thy Closet': Women, Closet Culture, and the Eighteenth-Century English Novel," in Styles and Vickery, eds., *Gender, Taste, and Material Culture*, 107–22.

28. See Charles Saumarez Smith, *Eighteenth-Century Decoration: Design and the Domestic Interior in England* (London: Weidenfeld and Nicolson, 1993), figs. 142, 315.

29. See Frank Staff, *The Penny Post, 1680–1918* (London: Lutterworth Press, 1964), 57–58, and Christopher Browne, *Getting the Message: The Story of the British Post Office* (Stroud, Gloucestershire: Alan Sutton, 1993), 31–34. See also James S. How, *Epistolary Spaces: English Letter-Writing from the Foundation of the Post Office to Richardson's Clarissa* (Aldershot, Hants, and Burlington, Vt.: Ashgate, 2003).

30. Bishop Hurd remembered her thus in the epitaph in the parish church, St. James's Piccadilly.

31. See Molly Peacock, "Passion Flowers in Winter," in David Foster Wallace, ed., *The Best American Essays, 2007* (Boston: Houghton Mifflin, 2007), 174–89.

[1]

Mrs. DELANY & THE COURT

In her seventies, which coincided with the seventies of her century, Mary Delany was known for her gentility, her probity, her artistry, and her longevity. This was the decade when she began her botanical paper collages, the high point of her creativity and the work for which she is now most known. She was never very rich, never a peeress or married to a peer, never a salaried courtier or a family power broker, nor a court wit, an influential patron of the arts, or charitable entrepreneur, even though all those roles were within the scope of women of her background and connection: many of her contemporaries performed one or more of them. Her protégé John Opie's celebrated portrait (fig. 37), which hung in Queen Charlotte's bedchamber at Buckingham Palace, depicts her as a serene elderly lady, the friend and companion of the Duchess of Portland and finally of George III and Queen Charlotte, as if life at a remove from the highest tier of power and influence had always been her goal.[1]

Yet in a sense this position represented failure. Mary Delany never obtained her initial goal of a formal office in any royal household in the four reigns she lived through; nor was her beloved second husband, Dean Delany, ever to obtain a bishopric, a position of particular consequence in eighteenth-century Ireland. This essay looks at her life in two parts—not the two formed first by her unhappy forced marriage to Alexander Pendarves and then her second, companionate one, but by her attempts, right up to this second marriage in 1743, to obtain court office, followed by her role in a more private sphere, as a wife, widow, aunt, godmother, and friend. Of course this is not to denigrate but to throw into relief her final position as the honored guest of the royal family. For in addition to courtiers, monarchs needed trusted friends with whom they could relax and enjoy some leisure, who were not conspicuously striving for power, influence, and provision for family and connections. As the Hon. Mrs. Walsingham observed to Mrs. Delany when the royal couple provided the Windsor house for her, by accepting the gift she gave the queen "one of the greatest and rarest of all pleasures, *having a friend for her near neighbour*! Such instances of friendship are rare in their Majesties exalted rank, and I congratulate *them*, on having felt a pleasure, so few of royal race have ever known."[2]

Courts and Courtiers

What did it mean to be a courtier in eighteenth-century England? And how realistic was it for young Mary Granville (subsequently, Mary Pendarves) to aspire to become one? The court had multiple roles. As a formal public institution it consisted of the Royal Household and its departments of the Lord Chamberlain, the Steward, and the Master of the Horse. These three departments provided essential services to the monarch, such as suitable company (Lords and Ladies of the Bedchamber, often referred to as Lords and Ladies in Waiting), protection (such as the Captains of the Yeomen of the Guard and the Gentleman Pensioners and, as an aspect of travel, the Masters of the Horse), and ceremony and entertainment (the province of the Lord Chamberlain). Cultural roles, such as Painter in Ordinary or Master of the King's Music, also came under the Lord Chamberlain's control. Some posts provided financial, legal, or medical services; others were more menial: cooks, messengers, laundresses, grooms. For a king, there were approximately ninety posts to fill that were neither professional nor menial; for a queen, there were forty. Appointment to the positions either helped poor gentry and younger sons and daughters of peers, or provided useful extra income to the ambitious or the wealthy but extravagant. Courtier service was also a family tradition: once the foot was in the door, subsequent generations would aim for further steps.

The political positions of the king's ministers evolved out of the households of the medieval monarchs and the functions of attendant feudal lords, such as the Chancellor of the Exchequer, which now oversees the state's money, not the king's personal finances. This meant that there had been a slow separation of what we now see as political roles from that of courtiers, and the separation was by no means complete in the eighteenth century. A man might serve as a Member of Parliament and also have a role in regular attendance on the king, as, say, Groom of the Chamber. Ambitious peers wanting to reach high political influence might find a stint as Master of the Horse in the king's or queen's household a useful stepping-stone to a more obviously political post, such as a Secretaryship of State. Conversely, some ministerial roles, such as the Lord President of the Council, were less aligned to political partisanship and suited to courtiers.[3]

In the wider sense, the court was a linchpin between elites and monarch, not just in its provision of personnel and services attendant on the monarch, but also in several other contexts: that of Parliament, the counties and cities, and the professions. All European eighteenth-century monarchical government can be described in terms of the various ways by which a ruler related to the elite. For Britain, the history of Mary Delany's century has been written in terms of the relationship between the monarch and the parliamentary elite; the dominant narrative has been about the growing power of the two houses of Parliament—the Lords and the Commons—in checking the power of the monarchy, together with the increasing influence of popular politics on national issues.[4] After the Restoration in 1660, the Stuart kings Charles II and later his brother James II had been suspected of wanting to follow their father's tendency to restrict Parliament. Whereas Charles II had adroitly managed Parliament, James had over-manipulated it, resulting in the now-famous invitation of seven leading peers and bishops to James's nephew and son-in-law, William III, to help them "restore their liberty." William's acceptance brought about the Glorious Revolution of 1688, welcomed in England but resisted in Ireland. Land confiscated from Irish Stuart loyalists—Jacobites—had been used to reward William's supporters, including his favorite and closest adviser, Willem Bentinck, first Earl of Portland.[5]

The Bill of Rights of 1689 clarified what kings could and could not do, and parliamentary support in raising money to fight the wars against Jacobites and their French supporters strengthened Parliament. But it would be a mistake to think that the monarch's powers had been

neutralized completely, like those of a modern constitutional monarchy. To the contrary: although needing to work cooperatively with both houses of Parliament, kings retained a lot of executive power, especially in war and foreign relations, as well as considerable powers of patronage—hence the importance of the court. It was an essential venue for political and social networking, to see and be seen, to know who was in and who was out, who might be ill and declining and who might step into dead men's shoes.[6] And since politicians were chosen from courtiers and were, in their way, courtiers themselves, the elite of eighteenth-century Britain can be understood in terms of a triangular set of relationships: between the monarch and his or her courtiers, the monarch and parliament, and parliament and the court. And hence, too, the significance of women, not in the stereotyped sense of using their "hidden charms" to gain favor as mistresses (though this was one way a few became important), but in a familial, and formal, context.

Families, not individuals, wielded power, and a salaried position in a royal household was one of the few jobs available at court for women at the time.[7] A family's chances of advancement could be assisted by women of wit, style, and what the eighteenth century called politeness, that is to say, a new, more relaxed code of polite and cultured behavior embracing old and new money and replacing a more formal hierarchy that had emphasized traditional rank. The chronically indolent and by no means abstemious Thomas Thynne, third Viscount Weymouth, owed his political advancement partly to his own aristocratic lineage but also to his wife's career as a courtier; she was the eldest daughter of Mary Delany's friend the second Duchess of Portland.[8] Women were integral to the maintenance of status and the advancement of their families, clients, and protégés.[9] The court was the main place in which the social dimension of politics was on display—literally and figuratively—and where men and women dressed for their parts.

The time of year when this was most apparent was autumn, when the law courts reconvened and the annual session of Parliament opened. The king would hold regular assemblies, or *levées*, at which he met the male members of the elite. The term was borrowed from the French custom of being in attendance on the king when he first arose, but in England the *levées* were held in the late afternoon. Usually they were held either at Kensington Palace, under the first two Georges, or at the Palace of St. James's, in George III's reign (fig. 38).

It was customary to attend court when some-

Figure 37: John Opie, *Mary Granville, Mrs. Delany*, 1782, oil on canvas, 30⅛ × 25⅛ in. (76.4 × 63.9 cm). The Royal Collection

Figure 38: Anonymous, *The Mall and St. James's Palace*, ca. 1740–50, oil on canvas, 29½ × 47¼ in. (74.9 × 120 cm). Yale Center for British Art, Paul Mellon Collection (B1981.25.555)

one had been given a new office—either in a royal household, in the government, or at a local level, such as the extremely significant role of Lord Lieutenant of a county. The Lord Lieutenant represented the king in that county for ceremonial and occasionally legal and military purposes, such as appointing Justices of the Peace and heading a county militia in emergencies. Bishops on appointment, and then on translation from one diocese to another, would attend court, as would lesser clerics; army and naval officers on appointment or promotion would attend court before going on active service and again—if they survived—on their return. Ministers going out of town to conduct family or public business would routinely attend a *levée* once back in London. The king's body language was attentively observed at *levées* as a barometer of individual political fortunes: whom did he find time to talk to, whom did he shun? In 1733 the first Earl of Falmouth (whose son Edward was the husband of Mrs. Delany's close friend Frances Boscawen), coined the expression of having been "rumped" when George II turned his back to the earl to show his displeasure that the earl, who had extensive political influence in Cornwall, was no longer supporting Walpole's ministry.[10]

Court attendance also punctuated the *rites de passage* of the aristocracy: young men were presented before going on the Grand Tour; and, along with their wives, on getting married; and, eventually, on the occasions of their children's emergence into society and marriage. Indeed, another function of the court was to act as a marriage market, presenting the entire pool of potential partners, not just a handful of county connections. With the temptation to join the Jacobite court until after the defeat of the Jacobites in 1746, it was particularly important for any family of consequence to put in an appearance before leaving the country in order to show loyalty to the regime. In 1744, Charles Stuart, the "Young Pretender" to the throne, landed in Scotland to claim the throne on behalf of his father (James, the "Old Pretender" and son of James II) and raised an army. George II immediately held a *levée* for the leading members of the peerage before they dispersed to their county seats to raise a militia to defend the country. Conversely, someone repenting Jacobite affiliation and wanting to demonstrate loyalty (or disassociate from a Jacobite parent) would attend court. Frances Boscawen was delighted when her son-in-law the fifth Duke of Beaufort signaled his family's move from Jacobite sympathy to Hanoverian loyalty and was rewarded with the post of Lord Lieutenant of Monmouthshire, the county adjoining

the family seat in Badminton, Gloucestershire—an honor "which it seems every head of his family enjoyed, except only those *who did not go to Court.*"[11]

Nor was it only peers themselves who attended; they also introduced their protégés in the church, the universities, and the wider world of letters, as well as their younger relatives in the army and navy. In a world in which patronage and influence held so much sway, almost everyone was paying court to someone else in a constantly fluctuating hierarchy. Eighteenth-century society was relatively fluid: primogeniture meant that younger sons, who had smaller inheritances than their privileged older brothers, had to find careers, and a stint as a royal page might help later with an army commission or a diplomatic posting, as the future diplomat and connoisseur Sir William Hamilton found. Mrs. Delany's letters show vivid examples of this fluidity between peers and gentry, and links between humbler folk to the learned professions, which conferred gentility on those, like Dean Delany, whose families were only yeoman farmers, although this fluidity was not acceptable to all. In addition to the regular court *levées*, held by a monarch for men only, a king with a living queen consort held receptions, or "drawing rooms," with men and women both present; court dress was required for all. Although George II's reign gives the impression of the declining importance of the court, partly because he was a widower after 1737, the king continued to hold *levées*, as well as hosting drawing rooms with the assistance of his daughter Princess Amelia, his daughter-in-law Princess Augusta, or even the Countess of Yarmouth, his last mistress. After giving birth, a queen also had her own regal version of a "lying-in," during which women would visit the mother and newborn and drink caudle—Queen Charlotte's large progeny provided fifteen such opportunities! There were also set-piece occasions with particularly lavish decorations and entertainments: the birthday of the king or queen, when it was customary to wear new clothes; a royal wedding; anniversaries of the monarch's accession; and other dates in the political calendar, such as anniversaries of the Restoration of the monarchy in 1660 and the Glorious Revolution of 1688.

A Well-Connected Lady
When Mary Delany (as the widowed Mrs. Pendarves) formulated an autobiographical account of her life in 1740, the opening paragraph identified her family's service to the Crown since the reign of Charles I, and the rank this could confer on them:

My father was grandson of Sir Bevil Granville, who was killed on Lansdown, in the year 1643, fighting for his king and country.... At the very moment he was slain, he had the patent for the Earldom of Bath in his pocket, with a letter from King Charles I. acknowledging his services.[12]

This title passed first to Mary's granduncle, who was Charles II's Groom of the Stole, and then to his daughter, Grace, created Countess Granville and Viscountess Carteret in her own right, who at age eight was betrothed to and eventually married George Carteret, a friend and fellow officer of John, Duke of Marlborough. She was a formidable matriarch who lived to be seventy-seven and was important in advancing Mary's interests. Their son John Granville, Lord Carteret, who succeeded to his mother's title as second Earl of Bath, was an important diplomat and statesman (fig. 39). Accustomed as the family was to being close to the Crown, he adjusted successfully to the Hanoverian dynasty on George I's accession in 1714.[13]

At least two of Lord Carteret's daughters linked Mary to several powerful court families. Georgina (fig. 40), the youngest by his first marriage, married the immensely wealthy Hon. John Spencer, brother of both the fourth Earl of Sunderland and the second Duke of Marlborough and the beneficiary of his grandmother Sarah Duchess of Marlborough's generosity. Georgina's son John, first Earl Spencer, built the exquisite Spencer House overlooking Green Park, near St. James's Palace, as a gift to his adored wife, Georgiana Poyntz, a diplomat's daughter. When they traveled to London after their private marriage at Althorp, their entourage numbered more than two hundred, a measure of their grand Granville ancestry. Their daughter, another Georgiana, was the famous fifth Duchess of Devonshire.[14] Georgina Carteret, who became Countess Cowper on her second marriage, to William, the second Earl Cowper, was a friend as well as a cousin to Mary, and a vivacious and characterful godmother to Mary's niece Mary Dewes and grandniece Miss Mary Georgina Port.

Primogeniture meant that, as a younger son of a younger brother, Mary's father, Bernard, possessed more capital in the wealth of his relatives than in his own right, but what capital! His older brother, Lord George Lansdowne, was a poet as well as a courtier and minister to Queen Anne.[15] Lord Lansdowne's marriage to the widowed Lady Mary Thynne, whose first husband was Thomas Thynne, first Viscount Weymouth, began the association of Mary's family with Longleat house

and its successive garden designs. George and Bernard were also related to the royal Stuarts through a network of cousins (fig. 42). They were the cousins of Jane Leveson-Gower, a baronet's daughter from the north of England who married her first cousin, Henry Hyde, second Earl of Rochester. And Rochester's cousins were none other than the Stuart princesses Mary and Anne, whose mother, Anne Hyde, was the first wife of James Duke of York, later James II (r. 1685–88). The Hydes were connected not only to the royal family, but also to the premier dukedoms of Ireland and Scotland. For instance, Mary's early playmate Catherine (Kitty) Hyde (fig. 41), Henry Hyde's daughter, married her second cousin Charles, third Duke of Queensberry, whose relatives included the Scottish dukes of Buccleugh, Gordon, and Hamilton.[16] Though these were distant cousins, the family connection was recognized in various ways, including mourning dress, which was worn in some degree even by distant relatives to acknowledge kinship. Mrs. Delany was always able to advise her family on the color and duration of appropriate clothes.[17]

The Leveson-Gower cousin who linked Mary to the Hydes was from a family that successfully rose from being mere baronets in 1700 to the rank of Marquis of Stafford by 1800 (see fig. 42). The first and second earls both married three times and produced a number of daughters, all of whom married extremely well. As a result, Mary had a large, ever-ramifying network of Leveson-Gower cousins. (On returning to England after her second widowhood, Mary cultivated her friendship with the Dowager Countess Gower, née Mary Tufton, whose home at Bill Hill was the source of the specimen for the collage 'Magnolia

grandiflora'.) Though by the 1770s those in the younger generation were distant from the original connection, they were still recognized as cousins. In 1774, for example, John Leveson-Gower, only son of the third marriage of the first Earl (to Mary Tufton), had a son by his wife, Frances, daughter of Frances Boscawen, who always referred to this grandson as Mrs. Delany's cousin. Mrs. Delany cut out paper hares and greyhounds for him and his cousins to play with when they were young.[18] Other Leveson-Gower connections included two daughters of the first Earl Gower, both of whom served as Vicereines of Ireland: the pleasant Frances, third Duchess of Dorset, and the rather grand, politically astute Gertrude, fourth Duchess of Bedford, a very able politician who kept the Bedford connection of politicians together until her son came of age.[19]

With connections like these it was entirely logical for Mary's parents to expect that she might become a Maid of Honour at court. This was an ideal position for a woman of good family who was not yet married or a peeress. Only peeresses were chosen for the higher-ranking position of Lady-in-Waiting, known formally as Lady of the Bedchamber. The main purpose of each role was to provide suitable female companionship to a female royal for public ceremonies as well as leisure. Maids of Honour had similar duties to Ladies of the Bedchamber, but they were unmarried girls, usually daughters or relatives of peers. The advantages of being a Maid of Honour were the salary (£300 per year, though some of this had to be used for suitable clothes for court occasions), lodging and board in the royal residences, plus close attendance on the consort and the opportunities that created for networking and

finding a good husband. An outstanding example of a Maid of Honour who used her position to advantage was Sarah Jenyns, a poor girl from a declining gentry family whose love match and strategic alliance with John Churchill led to her becoming Duchess of Marlborough, the richest woman in England at her death. Her younger daughters' dowries were paid by her royal mistress, Queen Anne. Sarah and her husband were politically connected to the Duchess of Portland's grandfather, Robert Harley, first Earl of Oxford, until the duke forced him out of office in 1708, fueling a lasting animosity.[20]

Figure 39: Studio of William Hoare, *John Carteret, 2nd Earl Granville*, ca. 1750–52, oil on canvas, 49½ × 39¾ in. (125.7 × 101 cm). National Portrait Gallery, London (1778)

Figure 40: Thomas Bardwell, *The Hon. Georgina Carteret, Later Mrs. John Spencer and Subsequently Lady Cowper*, ca. 1750, oil on canvas. The Collection at Althorp

Figure 41: Attributed to Charles Jervas, *Catherine Hyde, Duchess of Queensberry*, ca. 1725–30, oil on canvas, 50 × 39¾ in. (127 × 101 cm). National Portrait Gallery, London (238)

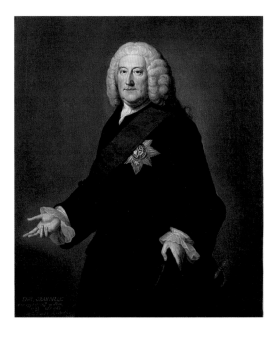

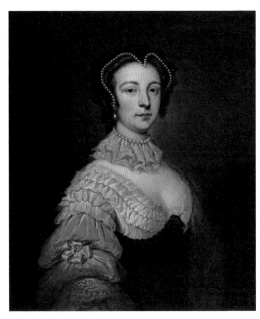

Figure 42: Family tree of the Granville, Hyde, and Leveson-Gower families.

GRANVILLE

Sir Bevill Granville d. 1643
for Charles I
at Battle of Lansdown

John 1st Earl of Bath

Hon. Bernard Granville

Hon. Bevill Granville

Grace, later Countess Granville and Viscountess Carteret m. George Carteret

George Granville, cr Lord Lansdowne 1713 m. Mary Villiers, widow of Thomas Thynne, 1st Viscount Weymouth *owner of Longleat*

Sir Bevill Granville

Bernard m. Mary Westcombe

Anne *Maid of Honour to Queen Mary* m. Sir John Stanley

Elizabeth *Maid of Honour to Queen Anne* d. unm.

John Carteret, 2nd Earl Granville and 2nd Earl of Bath, statesman m. (1) Frances Worsley

Bernard squire of Calwich, Staffs

Bevill

Mary m.(1) Alexander Pendarves m.(2) Patrick Delany DD

Anne m. John Dewes squire of Wellesbourne

Grace, later Lady Foley

Anne

Elizabeth, Maid of Honour to Princess Augusta of Wales

Mary m. John Port, squire of Ilam

Court *(Suitor of Mary Hamilton)*

John m. Harriet de la Bere

< sisters >

Bernard m. Anne de la Bere

Georgina Port,* stayed with Mary Delany Jan–July 1778–88

Grace, m. Lionel 3rd Earl of Dysart

Louisa, m Thomas Thynne, 2nd Viscount Weymouth

Frances, m. 2nd Marquis of Tweeddale

Georgina, m. (1) Hon John Spencer (2) William, 2nd Earl Cowper

*Christened Mary Ann (and sometimes referred to as "Miss Mary Port" in this book), she adopted the name Georgina in later life.

John Carteret m. (2) Hon Sophia Fermor

John, Viscount Spencer 1761 (Viscount Althorp and Earl Spencer 1765) m. Georgiana Poyntz

Sophia, m. William Petty, 2nd Earl of Shelburne, 1st Marquis of Lansdowne 1784

Thomas Thynne, 3rd Viscount Weymouth, 1st Marquis of Bath 1789 m. Elizabeth Bentinck, d of 2nd Duke of Portland

< sister of / siblings >

Georgiana Spencer, m. 5th Duke of Devonshire, brother of Dorothy Cavendish, m. William 3rd Duke of Portland

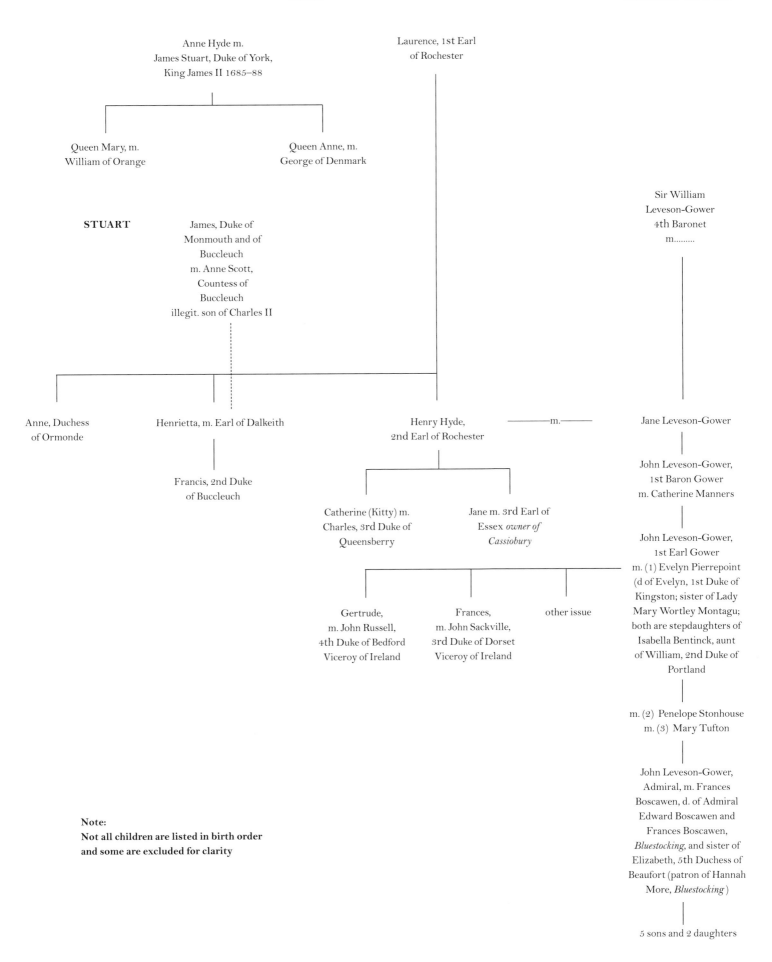

Anne Hyde m.
James Stuart, Duke of York,
King James II 1685–88

Laurence, 1st Earl
of Rochester

Queen Mary, m.
William of Orange

Queen Anne, m.
George of Denmark

Sir William
Leveson-Gower
4th Baronet
m.........

STUART

James, Duke of
Monmouth and of
Buccleuch
m. Anne Scott,
Countess of
Buccleuch
illegit. son of Charles II

Anne, Duchess
of Ormonde

Henrietta, m. Earl of Dalkeith

Henry Hyde,　　———— m. ————　　Jane Leveson-Gower
2nd Earl of Rochester

Francis, 2nd Duke
of Buccleuch

John Leveson-Gower,
1st Baron Gower
m. Catherine Manners

Catherine (Kitty) m.
Charles, 3rd Duke of
Queensberry

Jane m. 3rd Earl of
Essex *owner of
Cassiobury*

John Leveson-Gower,
1st Earl Gower
m. (1) Evelyn Pierrepoint
(d of Evelyn, 1st Duke of
Kingston; sister of Lady
Mary Wortley Montagu;
both are stepdaughters of
Isabella Bentinck, aunt
of William, 2nd Duke of
Portland

Gertrude,
m. John Russell,
4th Duke of Bedford
Viceroy of Ireland

Frances,
m. John Sackville,
3rd Duke of Dorset
Viceroy of Ireland

other issue

m. (2) Penelope Stonhouse
m. (3) Mary Tufton

John Leveson-Gower,
Admiral, m. Frances
Boscawen, d. of Admiral
Edward Boscawen and
Frances Boscawen,
Bluestocking, and sister of
Elizabeth, 5th Duchess of
Beaufort (patron of Hannah
More, *Bluestocking*)

5 sons and 2 daughters

Note:
**Not all children are listed in birth order
and some are excluded for clarity**

Figure 43: Detail of West End from John Rocque, *A Plan of London and Westminster, and Borough of Southwark* (London, 1747)

(a) Upper Brook Street where Mary lived as the widowed Mary Pendarves

(b) St James's Palace, where the court *levées* and drawing rooms were held

(c) Spring Gardens, where Mrs. Delany owned a house while married to Dr. Delany

(d) Whitehall, where the Duke and Duchess of Portland stayed when in London

(e) Somerset House, where Mary stayed with Sir John and Lady Anne Stanley as a young woman and later as the widowed Mrs. Pendarves

Closer to home were the examples of Mary's aunts—Elizabeth, who had been a Maid of Honour to Queen Anne, and Anne, wife of an Irish MP, John Stanley, whose father, Sir Thomas Stanley, was a baronet based near Dublin. In 1699, John obtained a baronetage for himself (as he was only a third son, he would not have inherited any title from his father) from the new monarch, William III, and was subsequently secretary to the Lord Chamberlain. The Stanleys and the Granvilles were both related to the Monck family in Ireland: the Cromwellian General Monck, cousin of the first Earl of Bath, had instigated the Restoration of the monarchy in 1660. As a former Maid of Honour to Queen Mary, Lady Stanley was in an excellent position to groom Mary and her sister, Anne (named in homage to the Stuart queens and their Hyde mother), to follow her career. The death of Queen Anne in 1714 just when this was to be formalized was unfortunate because, as George I was divorced from his wife, there were no positions for suitable women to fill in a con-

sort's household. The misfortune was multiplied when Mary Granville's uncle Lord George Lansdowne took his Stuart loyalty too far. Unlike the Carteret cousins who had accepted the transition from the Stuart to the Hanoverian dynasty, he looked to the exiled James II and his son, the Old Pretender. This compromised his younger brother, Mary's father. Lord Lansdowne even went to Paris for five years, to direct the Pretender's affairs there.[21]

Mary Granville's forced marriage in 1717/18 to the Cornish MP Alexander Pendarves, which took place when Mary was sent to stay at Longleat with Lord Lansdowne and his wife, was intended to provide financially for her as a poor relation, as well as to strengthen her uncle's political influence in north Cornwall, the county base of the Granvilles. Because Princes of Wales were given the revenues of the Duchy of Cornwall, Cornwall was also an area of royal influence. Although Hugh Boscawen, first Viscount Falmouth, had ensured Cornwall's loyalty to the

Hanoverians in 1713, Lord Lansdowne could hope, by nurturing his own personal following to preserve a core of Jacobite supporters, to welcome the Pretender if he returned and restrict loyalty to the new Hanoverian Prince of Wales. He must also have wanted to reward Mr. Pendarves, who had been imprisoned from 1715 to 1717.[22] As an MP's wife, Mary Pendarves might have been expected to help entertain her husband's political supporters and bolster his social standing in Cornwall, but her actual role seems to have been more low-key. However, her connections were helpful in securing the restoration of her husband's estates. As a young and beautiful wife in a libertine age, she guarded her reputation assiduously, remembering the advice of her aunt, "*avoid putting yourself in danger, fly from temptation, for it is always odds on the tempter's side.*"[23]

Courting the Early Hanoverians

After her husband died in 1725, Mary began to blossom and to enjoy her independence, even though, since she lived with her aunt and uncle, she was not always at her own disposal: "I do a thousand disagreeable unavoidable things, and I have it not to say I am mistress of my time, for I must comply with those I live with, which makes me lose some agreeable moments." However, she was not financially dependent, her fortune being "very mediocre, but… *at my own command.*"[24] Her husband had died intestate so her widow's jointure would have been only the traditional one-third portion of the estate's income. Whatever this amounted to, she might, in common with many genteel women at this time, have increased this income with judicious investment—usually with masculine advice—into the new banks and trading institutions that developed in the City of London after the Glorious Revolution.[25] Her aunt was Housekeeper of Somerset House—not a menial post but a managerial and honorable one, appointed by the Lord Chamberlain's office and worth £100 per annum—and she had an apartment with her aunt and uncle (fig. 43). Somerset House normally was endowed on a queen consort for her lifetime, but George I's heir George Prince of Wales and his wife, Caroline of Ansbach, lived at Richmond or at Leicester House in London.

The absence of a consort in George I's reign and the existence of grown children with a separate establishment and children of their own are not the only factors that until recently have led historians to talk of a declining court.[26] George I's court did not seem to be a cultural or social magnet; a queen could have helped preside over court entertainments and sociability. Moreover, George I did not particularly like ostentatious public ceremony, although he knew when it was politically useful to provide it. The Hanoverian era, with a succession of kings who had grown-up heirs with their own establishments, also brought with it the possibility of a "reversionary interest"— ambitious or frustrated courtiers, tired of waiting for preferment from the reigning monarch, looking to the next one.[27] The quarrels between each king and his heir only exacerbated this human tendency to look from the setting to the rising sun; more adroit—or patient—court families would endeavor to stay on good terms with both.

The routines of court enabled landed families with power bases in the counties to keep in touch with London life and its up-to-date goods and services, in contrast to the rural country seat and its seasonal rhythms and obligations but less sophisticated customs.[28] As a London resident Mary Pendarves could dispatch luxury goods— expensive teas, fine textiles, new music—to her mother and sister in Gloucestershire. If the court was not exactly in decline, it certainly was confronted with the array of new pleasures and places for the well-to-do that had a commercial basis: theaters, pleasure gardens, masquerades. Unlike those in Continental Europe, the English court no longer had its own theater; the royal family attended the commercial theaters given royal license—at Drury Lane and Covent Garden— and could be seen in the royal box by anyone in the audience. The pleasure gardens at Vauxhall and Ranelagh were open to the paying public, while the entrepreneur John James Heidegger organized masked dances on a more exclusive, subscription basis in rooms at the Haymarket theater.[29] Mary and her brother Bernard were both devotees of Handel's opera company, known as the Royal Academy of Music, which they patronized in preference to its rival, the Opera of the Nobility in Lincoln's Inn Fields.[30] The degree to which the commercialization of pleasure was competing with the court as a center of glamour or fashion is reflected in Mrs. Delany's account of the attention given by the newspapers to the

(e)

lying-in of the opera singer Mme Cuzzoni. The toilette her husband had given her and the new hangings in her bedroom generated much more publicity than the news of the Princess of Wales having given birth to her daughter Louisa.[31] A diva could outshine a princess.

London was also the main center of the book trade, which would expand rapidly throughout the century. Book publication was financed by patrons soliciting advance subscriptions to help a protégé, as well as by booksellers taking a commercial risk. Antiquarians could buy prints, coins, and objects of virtu; those interested in science could listen to lectures on Newtonian astronomy. Mary regretted being drawn away from a demonstration of an orrery (a clockwork model of the Newtonian solar system) by the obligation to stand in as proxy godparent to one of the Monck family.[32] George I's half-sister Mme Kielmansegg held a weekly salon for him to discuss the new philosophy.[33]

To accommodate the *bon ton*, town houses were being built and furnished as the West End expanded, to be owned or rented while the fashionable season lasted. Select musical evenings or river parties, such as the one Mary attended with Lady Harriot Harley, mother of Margaret, Duchess of Portland, were popular throughout the century.[34] Courtiers who lived in London year round had a "country" villa for respite and relaxation; the Stanleys, for example, owned Northend, in the village of Fulham a few miles away. "Northend has all the beauties of Arcadia—the trees, the water, the nightingales, the flowers all now are gay and serene… ."[35] The village of Chelsea was popular and genteel as well, especially for widows with rank but slender means; it had the added bonus of being near the Royal Hospital (for army veterans) and the Physic Garden, as well as some of the new plant nurseries.[36] The route along the Thames down to Kew, Richmond (and later Windsor, when George III resumed royal residence there), was also favored as a rural retreat. There were older Jacobean palaces, such as the grand Ham House, residence of Mary's cousin Lady Grace Dysart; Douglas House, in Petersham, where Kitty Queensberry lived; or newer houses, like those still standing in Richmond for the Maids of Honour (fig. 44). These country residences gave scope for new gardens to be designed; Mary II and William III had already given a royal stimulus to horticulture when the new wing of Hampton Court was built and its formal gardens created with the assistance of the first Earl of Portland, a connoisseur of the Anglo-Dutch style of gardens. Once the Spanish wars were over, in 1713, elite society could settle into new residences and embellish them.

Mary Pendarves was not in London and its rural hinterland just to enjoy the social and cultural pleasures of the capital; she was also doing her own networking in order to obtain a place at court for herself—or for her sister, who was not yet married and thus eligible to be a Maid of Honour. The succession in 1727 of George II and his wife, a couple more insistent on court ceremony than George I had been, opened up new prospects as they formed their respective households.[37] Dressing up to go out and be conversable became important "business," and friends and family contacts could be of great use. Mary's childhood friend Judith Tichborne became the third wife of the important Whig statesman

Figure 44: Detail from John Rocque, *Ten Miles Round London* (London, 1746)

(a) Alexander Pope's villa

(b) Ham House

(c) Douglas House

(a) (b) (c)

Charles, third Earl of Sunderland and son-in-law of the dowager Duchess of Marlborough. Mary occasionally borrowed some of Judith's jewels for such court occasions as Queen Caroline's birthday on 1 March 1728. Another useful companion was Lord Carteret's first wife, Frances Worsley. Mary helped design her dress for the court held in 1728 in honor of the king's birthday.[38]

It is not clear what post Mary was angling for; perhaps she was hoping to succeed her declining aunt at Somerset House (fig. 45), now endowed on George II's consort, Caroline (fig. 46). Alternatively, she might have wanted to be a Woman of the Bedchamber. Women who held this position (usually there was a roster of six, who served in rotation) earned £200 per annum plus had apartments in royal residences. A Lady of the Bedchamber, who earned £400, was a peer's daughter and/or wife and served on a rota, which meant it was possible for a peeress—like the Duchess of Portland's daughter Elizabeth, Lady Weymouth—to combine court duties with family responsibilities. Her chief purpose was to provide suitable company to her mistress at all times, especially during formal ceremonies and public appearances, and to assist in serving her meals when they were taken in public. This could entail a lot of standing around, given the etiquette of when a person could be seated in the presence of royalty, and thus was fatiguing.

Figure 45: Canaletto, *The Thames from the Terrace of Somerset House, Looking toward Westminster*, ca. 1750, oil on canvas, 15¼ × 28¼ in. (38.7 × 71.8 cm). Yale Center for British Art, Paul Mellon Collection (B1976.7.97)

Figure 46: Studio of Charles Jervas, *Caroline Wilhelmina of Brandenburg-Anspach*, 1727, oil on canvas, 86 × 50¼ in. (218.5 × 127.6 cm). National Portrait Gallery, London (369)

A Woman of the Bedchamber's duties entailed some help with dressing, such as handing the queen her shift, kneeling with a basin of water when she washed her hands, and giving her cups of chocolate, but it was not equivalent to being a personal maid. Full assistance with clothes, hair, and jewels was the job of maids; the higher-status salaried role of Dresser only involved handing a few clothes over to be put on. Woman of the Bedchamber was a role given to married women or widows of genteel status, such as Henrietta Howard (who was also George II's mistress, though not one who exercised political influence, which Caroline reserved for herself).[39] The fact that this role gave proximity to a queen in her most private spaces and times of day meant anyone holding it could establish a position of great confidence and friendship with her. Moreover, with such access a Woman of the Bedchamber could become a powerful patronage broker, even influencing who reached the monarch and what messages and petitions were delivered. Abigail Masham, a poor relation of Sarah Duchess of Marlborough, had been appointed through Sarah's influence to this position for Queen Anne. The duchess had seen her own influence as Mistress of the Robes and Keeper of the Privy Purse (responsible respectively for supervision of the king's or queen's wardrobe, including appointing suppliers, and the private funds of the sovereign or consort, but politically significant because of the extent of access to the royal presence) supplanted by someone in the ostensibly inferior position of Woman of the Bedchamber.[40]

In later years Mary Delany discussed the relative advantages and disadvantages of being a Woman of the Bedchamber—in contrast to being either a Maid of Honour or a Lady of the Bedchamber—when her Granville cousin Elizabeth gave up her position as Maid of Honour to Princess Augusta to become a Woman of the Bedchamber:

> she is young and handsome *enough still to grace a Court, but has not health to support the fatigue of so public an appearance, for which reason she is very discreet in desiring the change, which was granted very graciously; and the Princess told her she liked to have her so much nearer her person. The salary is the same, and the advantage of the clothes: and not being obliged to dress [i.e., to dress up when in public attendance], will be an equivalent to house-rent and board-wages, which was nearly two hundred pounds a-year, besides her salary.*[41]

Charlotte Clayton was the most influential of Queen Caroline's Women of the Bedchamber, a

position she had occupied ever since Caroline came to Britain as Princess of Wales in 1714, and the two women enjoyed a close friendship. She influenced ecclesiastical appointments as well as court ones, and Walpole believed that she later facilitated his rival Lord Carteret's access to the queen in 1735.[42] In an effort to help Mary find a position, Mary's Carteret relatives enlisted the formidable Dowager Countess Granville to approach Mrs. Clayton:

> *Yesterday I went to* Cour *with my Lady Carteret: it was excessively full, but I have some reward for my trouble, for the King asked me many a question. Mrs. Clayton, who was the person employed by my Lady Granville in the affair I told you of, has refused. I am mighty easy in the matter; but my cousins, who are very fond of me, insist upon my going another way to work; they say they are sure if it was only named to the King and Queen I should be accepted.*[43]

If they did put in a word for her it was to no avail, almost certainly because the queen kept her team of Maids, Ladies, and Women unchanged from her household when she was Princess of Wales, so there were no real vacancies when these positions were confirmed in 1728.[44] Furthermore, as one of the Bedchamber women was Bridget Carteret, a niece of Countess Granville's late husband, it might well have been thought by the queen and Mrs. Clayton that having one Carteret on the team was sufficient, although apparently there was no problem with Mrs. Clayton getting two of her Dyve relatives—Penelope and, a year later, Dorothy—appointed. At least Mary and her grand relatives knew not to commit the solecism of offering Mrs. Clayton cash in hand: when Viscountess Falmouth enclosed some bank notes with a request for a place as Lady in Waiting, emphasizing how useful her husband's electoral influence was, she immediately ruined her chances.[45]

This socializing could be heartless, brittle, and exhausting. When Mary's little cat (white with black spots, brought to Somerset House from Northend) was absent one November evening she was disproportionately upset:

> *Last night I returned from Court, cold and weary, with the expectation of finding a letter at home to recompense me for the toils I had endured; but, alas! I was sorely deceived, for I only found a room full of smoke, the wind and rain beating against my windows, my pussey lost (as I thought), but she was found. Well, into bed I tumbled about half an hour after one.*[46]

Mary repeatedly drew on the discourse of

friendship, that is to say on disinterested and trustworthy affection, as a balance to the way that court life fostered the manipulation of social contacts for advancement. When blood relations were also friends, as she and her sister and mother were, friendship was all the sweeter.[47] This was a motif of both classical literature and Christian sermons; Dr. Delany entertained the same views on the nature and importance of real friendship, so their meeting in 1731 was one of like minds.[48]

Alternative and Auxiliary Courts

Despite her failure to obtain a position with Queen Caroline, for most of the time between George II's accession in 1727 and her marriage in 1743 the widowed Mary Pendarves still hoped for a place at court, either for herself, her sister, or her two unmarried Lansdowne cousins. An important accomplishment for a courtier was mastery of French and familiarity with the literature, history, and memoirs of the seventeenth century, especially the "golden age" of Louis XIV, who reigned from 1643 to 1715. Much of the correspondence between Mary and her sister includes discussions of the French books they were reading, among them the chivalric romances of writers like Mlle de Scudéry, author of *Artamène, ou le Grand Cyrus* (1648–53), a ten-volume novel based on the ancient Persian king, and *Clélie* (1654–61), also ten volumes, with its "Carte du Tendre" mapping the stages of love's progress.[49] The high-flown sentiments and elaborate plots of these books, inspired by the sixteenth-century Italian romances by Ariosto or Tasso, profoundly affected the hearts and minds of the young women. It would not be an exaggeration to say that, though they were dealing with the eighteenth-century English court, they filtered and interpreted their experience of it through the imaginative and cultural world of the seventeenth-century French court. Mary's autobiography, which she began in about 1740, gives Italianate or fanciful pseudonyms to various personages: Mr. Pendarves became Gromio; Lord Baltimore, her charismatic but unreliable suitor, was The American Prince, or the basilisk; the Hanoverian envoy, Friedrich Ernest von Fabrice, who tried to seduce her, was Germanico. This literary world of ambition and intense but often thwarted passion is also the source of many of the plots in the Handel operas Mary and her brother loved.

Another imaginative courtly world was that of Elizabethan chivalry. The young Duchess of Portland and her friends read Sir Philip Sidney and Edmund Spenser at Bulstrode, and gave each other nicknames such as Aspasia (for Mary), the Queen (for the duchess), the Princess for Grace

Spencer (née Carteret), and Primrose, Violet, and Daisy for the three Lansdowne cousins.[50] In this taste for English Renaissance literature, they perhaps were partly inspired by the exquisite Elizabethan castle Bolsover, which was a Portland family possession. The Duchess of Portland's female friends constituted themselves as the imaginary Ladies-in-Waiting of a quasi-royal household—for Britain was not just a court-centered monarchy but also a "federation of country houses" in which the leading peers on their extensive estates were local centers of power, influence, and display. The duchess, with her Tory background, and the second duke, with his impeccable Whig connections, formed an apolitical partnership, loyal to the Whig settlement but devoted to collecting and connoisseurship rather than the pursuit of court or political office. The house and grounds at Bulstrode could easily seem another Arcadian retreat from ambition and worldly struggle.

In 1734 prospects for a court position for Mary's sister, Anne, brightened as George II's adult children got married and established their own households, together with appointments of Ladies of the Bedchamber, Maids of Honour, and so forth (fig. 47).[51] First was the wedding in 1734 of Anne, Princess Royal, to the Dutch prince William—an opportunity for Mary to wear court dress and observe the glittering throng. In response to Mary's letter describing this occasion, her sister said the dresses sounded like something from Mme de Scudéry, and inquired anxiously who the Maids of Honour were to be. When they were announced and her sister was excluded, Mary tried to cheer her by saying she would have been "the flower of the flock" and by making disparaging remarks about the appearance of those chosen. Arabella Herbert, for example, was dismissed as "ugly, *commonly called pretty*, that *might* have been married and *would not.*"[52] After this wedding the likelihood of Frederick Prince of Wales getting married increased, as did the formation of adult households for his sisters Caroline and Amelia. "I own I had *rather* fix you with Princess Caroline, but in an affair of this kind one must be contented with what one can get," Mary explained to her sister, especially as it was likely that any bride of Frederick's would be given married women as her attendants. Yet when the opportunity for a place with Princess Amelia came, Anne Granville refused it, ostensibly to stay with her mother but perhaps also because she felt temperamentally unsuited to exchange Gloucestershire for the metropolis.[53] Four years later she married John Dewes, a Derbyshire squire with a respectable lineage.

Mary Pendarves, on the other hand, was moving increasingly in Frederick's orbit. His marriage to Augusta of Saxe-Gotha in 1736 meant the increase of his household, the officers of which included many members of the Hamilton family, spearheaded by Lord Archibald Hamilton and his able wife and cousin, Jane Hamilton. Lady Jane combined the roles and the salaries of Mistress of the Robes, Groom of the Stole (effectively the Head of the Bedchamber department), and Lady of the Bedchamber, and their daughter Elizabeth was a Maid of Honour.[54] Lord Archibald's brothers included Charles Hamilton, the creator of the celebrated landscape garden of Painshill in Surrey, and George, first Earl of Orkney, the owner of the estate of Cliveden, which, following the alterations he initiated, in the 1720s/30s, was rented to the Prince of Wales from 1739 to 1751. Lady Archibald's many brothers included the Ireland-based Hon. and Rev. Francis, husband of Mary's future friend the botanical artist Dorothea Forth. Again, the Carterets mobilized their influence in trying to secure an appointment for Mary, and Countess Granville wrote, in commanding style, to Mrs. Clayton:

> *The uncertainty of the happiness of seeing Mrs. Clayton makes me set pen to paper, since common fame says we shall soon have a Princess of Wales, and my cousin Pendarvis [sic] presses me to recommend her to your favour, for a Bed-Chamber Woman in that Court. Pray give me leave to send her to wait on you.... I can answer for my relation that she will do you credit; her mind is full as well to be liked as her person. She was married at seventeen to a drunken monster, whom she behaved to without a fault, and since she has been a widow has made appear as right a conduct. In short, she is every way qualified for the station I desire for her.*

Figure 47: Martin Maingaud, *Princesses Anne, Amelia, and Caroline*, 1721, oil on canvas, 26½ × 31¼ in. (67.3 × 79.3 cm). The Royal Collection

Referring to her previous success in securing Bridget Carteret's appointment as a Maid of Honour to Queen Caroline, the countess continued, "Your making me a Maid of Honour, in the handsomest manner in the world, encourages me to hope you will make now a Bed-Chamber Woman to the Princess of Wales at my request."[55]

Why was Mary Pendarves again unsuccessful? It is likely that, given the range of court families to please in making these appointments, either the queen or Mrs. Clayton, or both, felt enough had been done for the Granvilles in giving one of the Maid of Honour positions in the queen's household to Bridget Carteret. There were always more petitioners for places than places to distribute. The Cornish interest, to which the Granvilles belonged, was always important to a Prince or Princess of Wales, but it was catered to by the appointment of Lucy Boscawen (whose brother had succeeded as Earl of Falmouth) as a Maid of Honour to Augusta. Moreover, Mrs. Clayton had additional Dyve relatives to provide for—her niece Charlotte Dyve, who had accompanied Princess Anne to the Netherlands in 1734 as a Dresser, was now promoted to be a Maid of Honour. Arabella Herbert, one of Anne Granville's rivals in 1734, now trumped Mrs. Pendarves in also becoming a Maid—whatever her looks, she had the advantage of being from a Welsh landed family, useful for German-born Princes and Princesses of Wales when they wanted to cultivate "Britishness."[56] Moreover, Arabella's brother became Frederick's Treasurer when the incumbent died in 1737.[57]

Jean-Baptiste van Loo's 1739 painting *Augusta, Princess of Wales, with Members of Her Family and Household* (fig. 48) suggests another way in which a Woman of the Bedchamber might be influential. The picture shows Princess Augusta, seated at the center, with Lady Archibald Hamilton on her right, holding Augusta's second son, Edward Duke of Kent, and the future George III seated in front of her on a table, on his mother's right. Behind Lady Hamilton is Arabella Herbert, now a Woman of the Bedchamber and also Governess to the eldest child, Princess Augusta, shown standing in front of her mother, holding her left hand.[58] The composition illustrates the hierarchy of a royal household and hints at its

Figure 48: Jean-Baptiste van Loo, *Augusta, Princess of Wales, with Members of Her Family and Household*, 1739, oil on canvas, 86¾ × 79 in. (220.3 × 200.7 cm). The Royal Collection

more intimate, familial dimension, one Mary might have enjoyed had she obtained the position she desired.

Soon after its establishment, Frederick's court became a rival to his father's, as well as the focus of the Patriot party's opposition to Walpole's dominance of domestic politics, a "reversionary interest" expressed most memorably in landscape terms by the garden at Stowe, with its statuary symbolizing the contrast between ancient and modern virtue, and obelisks celebrating British naval power.[59] Lord Carteret, excluded from high office by Walpole, was able to be sympathetic to Frederick's circle without damaging his rapport with the king. In 1737, however, a split between Frederick and his father resulted when Frederick had hastened his wife from Hampton Court to St. James's, after she had gone into labor, so that she could give birth in the capital. The king forbade his son to appear at court and made it clear that anyone who held a court or political position from him would forfeit it if they attended the rival court at Norfolk House, which the prince now rented.[60] This split presented a dilemma for statesmen, like Lord Carteret, who did not want to alienate the king and ruin their chances of future political advancement. As neither Lord Carteret nor Mrs. Pendarves had a position from George II, they were not subject to the ban on attending social events at Prince Frederick's court, but the problem of rival courts still dictated prudent behavior to the ambitious and their less important relatives, who needed to take their cue from the heads of their families.

In 1738 and 1739 Mary Pendarves spent a lot of time visiting her mother and sister in Gloucestershire, her brother at Calwich, and the duchess at Bulstrode, which might have been a tactical move on her part to avoid the crosscurrents of court politics. However, after some hesitation about socializing with Prince Frederick's circle when his relations with George II were so strained, she did attend the prince's birthday in 1739 in the company of Lady Grace Dysart, a daughter of Lord Carteret, and she was able to report to her sister, with evident relief, that reconciliation between father and son was imminent.[61] And Lord Carteret's association with the prince's support for the Spanish war in 1739, the main bone of political contention between the rival courts, meant it was acceptable for Mary Pendarves to make her only notable political intervention: when a group of ladies attached to Frederick's household, led by the redoubtable Kitty Queensberry, protested their exclusion from the Parliamentary gallery in which elite women with politically important husbands could

listen to debates in the Lords. This was not a feminist statement but a protest that women, accustomed to their families being in power, should enjoy normal participation in the social aspects of politics.[62] The following year, 1740, Mary again attended Prince Frederick's birthday with Lady Dysart, but for most of the year she was preoccupied with her sister's marriage to John Dewes and with the Portland circle. By 1741, the year of Prince Frederick's ball at Norfolk House, at which Mary wore her distinctive court dress embroidered with cultivated flowers on a dark background, the reconciliation of king and heir was virtually complete, and Lord Carteret had renewed hopes of high office as Walpole's power was waning. The Patriots, in concert with popular protest, had succeeded in making Britain enter the war with Spain, which had merged with British support for Maria Theresa to secure her Hapsburg inheritance, known as the War of Austrian Succession (1740–48). Whether Mary's choice of the thistle had some symbolic dimension (reflecting a more diffused, less factional patriotism, now that war was George II's policy too) appears pure conjecture. More likely, the motif of the British "wild" plants (the thistle intertwined with lesser bindweed) is intermixed with the predominantly English cultivated florists' flowers for sheer visual effect.

In 1742 there was a vacancy for a Woman of the Bedchamber to Augusta when Elizabeth Hamilton left, so this gave a new opportunity for Mary Pendarves to obtain a courtier position for herself or her Granville cousins, Elizabeth and Anne. She was worried that the second Viscount Weymouth, stepson of her uncle Lord Lansdowne and married to her Carteret cousin Louisa, was not giving enough financial support to his Granville half sisters Anne and Elizabeth, who were still unmarried.[63] Mrs. Pendarves and the rest of her family did succeed in getting Elizabeth Granville created a Maid of Honour to Princess Augusta, but failed to obtain anything for Anne Granville—or even to find her a husband.

There were a variety of levers to pull to get one of these appointments: Mary's Carteret cousins, Lord Carteret (now Secretary of State for the North), and his daughter Grace were involved, but the Duchess of Portland doubted their effectiveness. She explained in a letter to Mary's sister, Anne, that she had made a special appointment one Sunday with the "*Arch Dragon*," the Dowager Countess Granville, to find out whether rumors that Mrs. Pendarves would be appointed were true, and was furious to be told that Lord Carteret was too busy "*doing good to the nation*" by concentrating on the war against France and

Spain to be bothered with "such *a bagatelle as that.*" The duchess refrained from argument, saying only that "it was doing the *nation service* to put proper people about the Royal family," and suggested in her letter to Anne (now Mrs. Dewes) that she thought Mary's former suitor, Lord Baltimore, a confidante of Frederick and one of his Gentlemen of the Bedchamber, should be enlisted. Lord Baltimore recommended in turn that the Duke of Bedford lobby Frederick via the former's father-in-law, Mary's distant cousin Lord Gower.[64]

As there was only one Bedchamber vacancy, Elizabeth Granville's success seems to have been at the expense of Mary Pendarves. And perhaps Countess Granville's disparaging remarks to the duchess belied the fact that she was lobbying for Elizabeth Granville, who certainly had less income than Mrs. Pendarves. Nevertheless, it seems to have created no awkwardness, and Mary continued to be friendly with Augusta's circle. She was socializing in 1743 with one of Lady Archibald Hamilton's sisters, and planned to visit the exquisite Palladian villa Mereworth Castle with its chatelaine Lady Westmoreland, whose husband, the seventh Earl of Westmoreland, was one of Prince Frederick's closest advisors. But the visit was never made, for Dr. Delany (fig. 49)—a man she had met and liked twelve years earlier, on her first visit to Ireland—wrote proposing to her. Having observed his first year as a widower, he was now free to pursue his affection for Mary. He came to England, staying with George II's Master of Ceremonies, Sir Clement Cottrell Dormer, who had inherited the estate at Rousham, Oxfordshire, beautified by William Kent.[65] Mrs. Pendarves became Mrs. Delany and tried to use her well-honed skills as a courtier to advance her husband's career. She helped arrange for him to preach before George II at St. James's Chapel, and was pleased that he did not preach for a Bishopric but as a good Christian.[66] In 1754, these royal connections enabled him to dedicate his collection of *Sixteen Discourses* to Princess Augusta.[67]

The Irish Context
Mrs. Delany's first visit to Ireland, in 1731, is usually discussed as stemming from her friendship with Anne Donnellan, whose sister was married to Dr. Robert Clayton, an English-born clergyman who had become Bishop of Killala in Ireland (fig. 50).[68] He was a cousin by marriage to one of Queen Caroline's Women of the Bedchamber, Mrs. Clayton. Yet Mary already had her own family connections in Ireland, through the Stanleys and through her Lansdowne cousins. The

Figure 49: John van Nost the younger, *Patrick Delany*, marble bust, H. 28¾ in. (73 cm). Trinity College, Dublin

P.DELANY.D.D
Æ tat. LXXXIV

eldest, Grace Granville, had settled there as the wife of Thomas Foley, later first Lord Foley; their daughter, Grace, Countess of Clanbrasil, who had a London house in Mayfair, later helped entertain Georgina Port, Mary Delany's grandniece, during the English season. Mary also had kinship ties to the Portland family through their common relatives, the Moncks: the second Duke of Portland's sister, Isabella, was married to Henry Monck, who was grandnephew to Mary's uncle Stanley. On this visit Mary became familiar with a whole network of Percivals (the family of the Earls of Egmont), Ushers, and Donnellans, all with positions in the state, law, and the Church.[69]

Dublin had an extremely important role in the British state as the capital of the sister kingdom of Ireland.[70] However, as approximately sixty-seven percent of its population was Catholic and had resisted the supplanting of James II, the city also had the largest garrison in Europe. The Anglo-Irish minority that controlled the Irish parliament and the professions had to encourage loyalty and obedience to the new settlement, and of course the Church of Ireland was a vital part of this. Many of the bishops lived in a princely style and maintained a Dublin town house as well as a diocesan palace. Bishop Clayton had the largest freestanding town house in Dublin.[71] He and his wife became increasingly grand over the years, and Mrs. Delany's observations of them—prompted also by their neglect of the unmarried Anne Donnellan—more astringent.[72] Her private nickname for Mrs. Clayton was Cardinella. In 1752, when the bishop's lady insisted on taking her to the Viceroy's ball to celebrate William III's birthday, Mrs. Delany dryly told her sister it was only so Mrs. Clayton could display her splendid new dress in contrast to Mary's plainer one, and to show off her three footmen, dressed in Hanoverian green and Williamite orange to demonstrate her loyalties.[73]

The other important agency to encourage loyalty to the monarchy was thus the Viceroy—technically the Lord Lieutenant of Ireland. The viceregal court represented the absent monarch—no Hanoverian until George IV ever visited Ireland—so the entertainments held there, following the same court calendar as in England, were a venue for the Anglo-Irish elite to meet, network, and hunt for marriage partners like its grander counterpart in London.[74] Two of the more popular and successful viceroys in the century were Lord Carteret and Lord Chesterfield (whose wife—as the daughter of George I's morganatic wife—had Hanoverian blood).

When Mary first visited Ireland in 1731, Dublin was enjoying an economic resurgence, assisted by Irish parliamentary subsidies and bounties to improve the infrastructure and stimulate trade, the crafts associated with the building boom, and manufacturing—especially textiles.[75] The Royal Dublin Society, of which Dr. Delany was a founding member, was full of schemes for improvement.[76] By encouraging Irish materials in dress and furnishings, as Mrs. Delany did, women could be a part of this economic patriotism; indeed, the most important charitable entrepreneur in the city was a woman, Lady Arbella Denny, aunt of the second Earl Shelburne. Her exceptional role in stimulating silk, linen, and carpet production as well as energizing various charitable institutions was recognized by making her a member of the Royal Dublin Society and a freeman of the city. She was among the guests who later visited and admired the Delanys' home and garden at Delville, just outside Dublin.[77]

After her marriage Mrs. Delany attended balls, charitable concerts, and other entertainments with much less frequency. For one thing, she considered herself to be approaching old age, and her husband was sixteen years her senior; they both gloried in the polite domesticity suited to their means. But this was not the same as what would have been called in that period "domestic retirement"; it was a shift in the scale and locale of entertainment. After three dinners in a row with friends in February 1745, Mary explained to her sister

the sobriety of my own dwelling is much pleasanter to me than all the flirtations of the world; though the society of it I will always keep up to the best of my power, *as it is a duty incumbent on us to live sociably, and it is necessary to keep up good humour and benevolence in ourselves....*[78]

A certain degree of public entertainment was integral to her role as dean's wife, especially when she and her husband visited the Down diocese, usually in July or August, for him to preach, oversee church visits and repairs, and encourage the church's pastoral and educational role.[79] Mrs. Delany's contribution was to hold a "public day" every Monday, when she held open house for visitors, to be as agreeable as possible to all their friends, acquaintances, and parishioners, and to oversee the household arrangements of their home there.

This companionable Irish marriage did not mean she lost touch with doings back in England, however. Dean Delany had promised his wife that they would spend every third year in England, and the Duchess of Portland's desire was that two

Figure 50: James Latham, *Bishop Clayton and His Wife*, ca. 1740, oil on canvas. National Gallery of Ireland, Dublin (4370)

of those months would be spent with her.[80] The entire first year of their marriage was spent in England, followed by visits, usually from May to May, in 1746–47, 1749–50, and 1753–54. Dean Delany became embroiled in a lawsuit brought by his first wife's family, which was resolved only on appeal to the English House of Lords—the Lord Chief Justice, Lord Mansfield, proved a strong ally—in 1758. The Delanys spent from August 1754 to July 1758 in England, pending the agonizingly slow progress of the case, returning again in 1760–61, and 1763.[81]

On her first visit to England after marriage, Mrs. Delany attended courts for the birthday of both George II and the Prince of Wales in her capacity as a dean's wife, and in the company of the Duchess of Portland. As the country was at war and elaborate new clothes were eschewed as a frivolous extravagance, she bought only a "modest" dress of pale deer-colored background woven with purple flowers and white feathers.[82] On subsequent visits the letters suggest that Mrs. Delany did not go to drawing rooms herself, though she still wrote detailed reports to her sister on what people were wearing, and participated enthusiastically in all the preparations of clothes and jewels when the duchess presented her daughter Margaret at the birthday for the first time in 1754.[83] Despite the lawsuit being

distressing and expensive, forcing Mrs. Delany eventually to sell the house in Spring Gardens the dean had bought for her, the long interlude in England 1754–58 meant that she was able to keep up with family fortunes, the duchess's collections and improvements at Bulstrode, and such special events as the glittering presentation at court of her cousin Lady Cowper's son, the Hon. John Spencer, and his new bride, Georgiana Poyntz, whose outfits and jewels caused quite a stir. Dr. and Mrs. Delany strolled past one evening to see the progress on the construction of the Spencers' lavish new home, Spencer House. She was also invited to one of the grand entertainments at the newly rebuilt Norfolk House in 1756 (fig. 51).[84]

The Bulstrode Years (1768–85) and the Royal Family

When George III succeeded in 1760 Mrs. Delany was mainly resident in Ireland, looking after the increasingly infirm dean and her married goddaughter Sally Sandford, née Chapone, whose clerical husband was in sore need of preferment. After Dean Delany died in 1768, his widow settled into a routine of spending approximately half the year at Bulstrode and the rest in a small London house near St. James's Square, first at Thatched House Court, then at St. James's Place (fig. 52). Her friendship with the royal family

must therefore be understood in the context of the peripatetic lives they and the rest of the social elite led between the court at St. James's and their various country seats. The Christmas season would see a return to the country seat, where family would gather and servants and dependents be given some feasting and entertainment, but London would fill up again in January, when plays, operas, and private entertainments all flourished. After George III's birthday on 4 June, the town would empty again; the city got hotter and more unsanitary, horses were needed on the estates to pull the hay and corn carts for the harvest and able-bodied men and women—domestics, porters—could find seasonal work in the country into the autumn. One September in 1785 Mrs. Boscawen had to walk up and down St. James's Street as "no chairmen to be found, all gone to harvest or hopping" (hop-picking). The Duchess of Portland spent some time, either in August or July, sea-bathing in Weymouth or Margate, so Mrs. Delany would visit her niece at Wellesbourne, receive family visits in London, or take the air at Mrs. Boscawen's Colney Hatch suburban villa—or Bill Hill, Countess Gower's home, or Luton Hoo, the Butes' country seat—until the duchess was ready to reassemble at Bulstrode. In October or November, when Parliament and the law courts reconvened, there would be visits to London, but most of the remainder of the year, until just before or just after Christmas, would be spent on the country estate.[85] The royal family's country retreat was first at Kew, then after 1778 very largely at Windsor, only seven miles from Bulstrode.

The king and queen were very fond of Mrs. Delany and it is easy to see why. She was a substitute grandmother to each. Charlotte had lost her mother shortly before her marriage in 1761, when she was only seventeen, whereas Mary Delany had known both of George's parents, and probably had seen George III as a child at their London residence. He was thirteen when his father died, in 1751; his mother, Princess Augusta, lived until 1772. Mary Delany's cousin Elizabeth Granville remained a Woman of the Bedchamber to the end, and had become a friend of the king's sister, another Augusta. To a man who had been brought up in a close and secluded family, this familial knowledge must have been of personal significance. Mrs. Delany also represented continuity with the king's grandfather, and even his great-grandfather's times, again of no small moment to the newly established dynasty. Princess Amelia, the characterful surviving daughter of George II, lived until 1786 and made several visits to Bulstrode.[86] In addition to Mrs. Delany having

Figure 51: Thomas Bowles III, *A View of St. James's Square London*, 1768, engraving and etching, 10¼ × 15⅝ in. (26.1 × 39.8 cm). British Museum, Department of Prints and Drawings (1880,1113.2202). Norfolk House is situated at the extreme right of this view

A View of St James's Square London. | Vüe de la Place de St Jaques a Londres.

personal knowledge of the royal family and its courtiers, she was a source of information on etiquette, manners, and customs. The king, an ardent enthusiast of Handel's music, was even able to obtain via Mrs. Delany a loan of her late brother's 38-volume manuscript collection of the composer's music in order to assist Charles Burney in making a complete catalogue of his works.[87]

When in London, it was an easy step from her house to attend drawing rooms or other ceremonies at St. James's Palace, but she only did so rarely, considering herself too old to mingle in large gatherings. She sometimes found it too cold to go out for weeks at a time. Instead, she had a constant flow of family and friends who paid court to her and took a concerned interest in her, including two of her nephews, Court and Bernard

Dewes, who had helped her settle in. During the London season the Duchess of Portland regularly visited in the evenings; less often, Mrs. Delany would go the duchess's Whitehall house. Many of her other visitors or their relatives held court or ministerial positions, and these, together with her own family connections, kept her in touch with royal events and the doings of the *bon ton*. When the queen had her ceremonial lying-in at St. James's Palace after giving birth to Princess Mary in 1776, many of her visitors, after drinking the customary caudle, called on Mrs. Delany. One April evening in 1784 she was invited to the queen's house (now Buckingham House, as Somerset House had been rebuilt as government offices) and observed, "It was quieter than one of my own drawing-rooms; nobody there but the King and Queen, the 5 princesses, and Lady

Figure 52: Zachary Chambers, "A Numerical Register of all His Majesty's Leasehold Houses . . . between St. James's Street & Green Park, etc., 10 April 1769." National Archives, UK (MR1/271). Thatched House Court and St. James's Place lie just to the north of St. James's Palace (lower left). St. James's Square (with Norfolk House in the south-east corner) lies north of Pall Mall and Carlton House gardens (lower right)

Charlotte Finch," who was the sister of Lord Carteret's second wife.[88]

These old friends often provided continuity with the court of the late Frederick Prince of Wales: the North family, for example. As Francis North, first Earl of Guilford, who had been a Gentleman of the Bedchamber to Prince Frederick, and then Governor to the young George Prince of Wales observed to Mrs. Delany, "I have been in a course of taking a very sincere share in the joys and sorrows of the Royal family, for two generations."[89] Lord North's stepson, William Legge, second Earl of Dartmouth, was also a neighbor of Mrs. Delany in St. James's Square; Mary regarded him as the perfect English Christian gentleman, and the king esteemed his character highly.[90] The Norths and their connections were also keen gardeners: Lord North's daughter Louisa had become Lady Willoughby de Broke; her husband's country seat, Compton Verney, was in Warwickshire, near her father's country house at Wroxton and also the Wellesbourne estate of Mary's brother-in-law John Dewes, husband of her sister, Anne. All three country houses are represented in Mrs. Delany's work, either as a sketch or by a plant donated to her flower collages.

Another of Mary Delany's regular correspondents and visitors was Lady Bute (her mother was Lady Mary Wortley Montagu, whose sister had married into the Leveson-Gower family). She too provided specimens for the collages. Her husband, John, third Earl of Bute had assisted Princess

Augusta in creating Kew, and once he retired from politics, botany was one of his main pursuits. He advised Queen Charlotte on developments at Kew, and wrote botanical tables for her.[91]

Although the Duke and Duchess of Portland had not held royal household positions, their daughter Elizabeth did. She had become mistress of Longleat on her marriage to Thomas Thynne, the third Viscount Weymouth (subsequently first Marquis of Bath; fig. 53), whose mother, Louisa Granville, had been Mrs. Delany's cousin. The king hunted with Lord Weymouth and shared his astronomical interests; he was Master of the Horse to Queen Charlotte 1763–65 and also held various ministerial posts.[92] Lady Weymouth had a long career as a courtier, as a Lady of the Bedchamber and then Mistress of the Robes, so she was regularly resident in London or Windsor. Mrs. Delany's letters provide frequent glimpses of Lady Elizabeth and her growing family, right up to their being presented in turn and finding brides or husbands. Thus Mrs. Delany's connection to Longleat reached a third and fourth generation. Little Georgina Port, Mary's eldest grandniece who spent six months of each year with her dear Aunt Delany from the age of seven, went to dancing lessons and children's balls with a younger generation of Thynne children. In 1784 Georgina helped arrange a birthday dinner for her grandaunt and some of her closest friends, but it was curtailed because, in Georgina's own words,

Figure 53: Silhouettes by Mrs. Delany depicting a game of chess, probably with Thomas Thynne, third Viscount Weymouth, and Elizabeth Thynne, third Viscountess Weymouth, and her children, ca. 1750, Whatman laid paper cut out and adhered to secondary sheet of painted laid paper, 10¼ × 15½ in. (26 × 38 cm). Marquess of Bath, Longleat House, Wiltshire

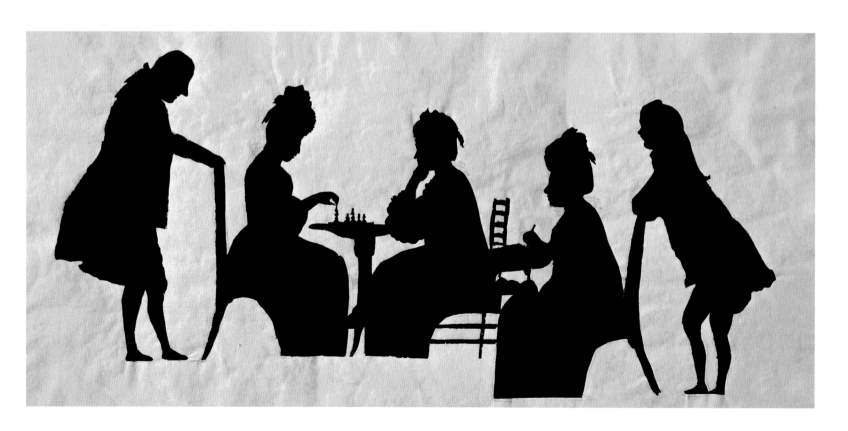

just before dinner-time there was a tap at the door, and who should enter, but Lady Weymouth just come from their Majestys to desire Mrs. Delany's company… to spend the rest of the evening… , and when they had been there a little time the Queen told Lady Weymouth to tye a string round my A. D's [Aunt Delany's] neck, and at the end of the string was the King's picture set in gold and diamonds, and the Q—n beg'd Mrs. Delany to accept it.[93]

Piety, Enlightenment and Education at George III's Court

Mrs. Delany's first epistolary comment on the king's accession (fig. 54) was "there *is* a pleasing prospect of our having a King that *will show* a proper regard to religion."[94] The moral tone he strove to maintain at court may explain why Sir George Monson left his post in 1758 as Groom of the Bedchamber after he married the divorcée Anne Hope-Vere, née Vane. He would have been aware that divorce and remarriage would not easily be condoned at the right-minded young prince's future court. Lady Anne was already established as a botanist before they left for India, and her botanical specimens were more welcome in England than her personal presence.[95] Mrs. Delany was as likely to see the royal couple when she worshiped at St. James's Chapel as at court occasions. Her sincere religious belief coupled with intellectual culture was exactly compatible with the king and queen. All wished to respect revealed religion as the ultimate source of truth while upholding moderation, to continue the privileged role of the Church of England, and to combine this with rational inquiry into the new sciences. The enlightenment of George III's court was in no way in conflict with scientific endeavor, since the book of God's works was seen as parallel to the book of God's word. As she wrote in 1774, while working on the collages: "Can we view the wonderful texture of every leaf and flower, the dazzling and varied plumage of birds, the glowing colours of flies, &c. &c., and their infinite variety, without saying, '*Wonderful and marvellous art thou in all thy works!*'"[96] Increasingly this would be seen as a bulwark against modern freethinking, that is to say, skepticism, deism, or even the atheism associated with the French philosophers. Mrs. Delany was delighted to meet the Scottish philosopher and poet James Beattie, who was considered to have successfully refuted Hume's skepticism.[97] When the Swiss-born philosopher and writer Jean-Jacques Rousseau visited Britain and became a friend and neighbor of Mary Delany's brother as well as the Duchess of Portland's "herborist," Mary

entertained reservations about his religious heterodoxy.[98] The king and queen had similar reservations. The queen's Reader, Jean-André DeLuc, would later argue that Rousseau, a fellow Genevan, had been too readily influenced by the Parisian philosophers, and that aspects of his philosophy were a bulwark against philosophical materialism. He praised George III as a defender of religious faith in a dangerously godless age.[99] Mrs. Delany's copies of religious art to adorn the private chapel at Delville was a domestic echo of the king's commissioning of Benjamin West to paint a series of pictures for the never-completed Windsor chapel dedicated to revealed religion.

Mrs. Delany's lifelong association with collectors and connoisseurs such as the Portland family and the duchess's parents, Lord and Lady Harley, made her integral to what can be seen as the "Enlightened Encyclopedism" of George III's reign. He was himself a bibliophile and numismatist, a collector of paintings and prints, and a scientific amateur. He rewarded and encouraged a number of encyclopedic projects in his reign, some of which were carried out at the University of Göttingen in the Hanoverian part of his domains.[100] Samuel Johnson, the great lexicographer, was given a pension; the musician Charles Burney dedicated his universal history of music to the queen; the queen's gynecologist, John Hunter, dedicated his study of female anatomy to the king, as well as being an assiduous collector of natural history who obtained some of the Portland specimens. Guided by Sir Joseph Banks, George's unofficial scientific advisor, the king sponsored the Pacific voyages of James Cook, who enlisted many of the natural historians and botanists patronized or hosted by the Duchess of Portland, among them Daniel Solander and father and son Reinhold and Georg Forster. After the duchess died, the king purchased John Lightfoot's herbarium as a gift for the queen, a keen botanist. With the help of DeLuc, she began a collection of dried plants pasted onto black paper, imitating the great paper collages of Mrs. Delany.[101] Given the number of specimens provided from Kew and from the circle of Mary Delany's friends and court connections, it can be seen as one of the encyclopedic projects supported by the court, assisted by the naval reach of British sea power to all corners of the globe.

Mrs. Delany described her London days as punctuated by "*Virtuosos* and *visiters*"—except when she shut herself away to finish a flower collage while a bloom lasted.[102] Some "virtuosi" had their own court credentials: the Rev. William Mason was a Royal Chaplain as well as a garden designer and man of letters; his most famous gar-

den was the "garden of sensibility" at Nuneham Courtenay. His curate Christopher Alderson later helped the queen to develop her garden at Frogmore, her ultra-private retreat in Windsor, where gardening helped allay her anxiety for her younger sons when they were all on active service against France after war began in 1793. Jacob Bryant, who was one of the friends close enough to be included in the birthday suppers for Mrs. Delany, was a classical and oriental scholar working on a complex historical analysis of comparative mythologies, which reinforced the central importance of Christianity as a revealed religion. His main patron was the fourth Duke of Marlborough but the king also gave him a cottage at Datchet, near Windsor.[103]

Figure 54: Allan Ramsay, *George III*, 1761–62, oil on canvas, 98 × 64 in. (248.9 × 162.6 cm). The Royal Collection

Mrs. Delany also helped develop as a *virtuosa* young Mary Hamilton, the niece of both the antiquarian and diplomat Sir William Hamilton and of Mrs. Delany's Irish friend Mrs. Francis Hamilton. The letters Mrs. Delany wrote to this young woman tell us much about the ripening friendship between them, and also of the frequent visits between the Bulstrode household and Windsor. Mrs. Delany hoped Mary might marry her eldest nephew, Court Dewes, a shy but very cultured man. She showed her how to systematize shells, as well as how to design trays to keep them in an orderly classification.[104] Mary Hamilton helped negotiate the sale of her uncle William's antique glass vase to the Duchess of Portland, now famous as the Portland vase.[105] On a visit to Bulstrode young Mary was shown many of the duchess's treasures, such as her Elizabethan miniatures, and the ladies shared with her their recollections of the court and personalities of Queen Anne's reign, such as Sarah Churchill, first duchess of Marlborough. The king and queen had themselves suggested that Mary Hamilton might help in the education of the royal children as a subgoverness; the king was kind and also talked with her about her relatives.[106]

Mary Delany was a discerning woman of letters who read the kind of morally serious albeit entertaining fiction and poetry that was accept-

Figure 55: Allan Ramsay, *Frances Boscawen*, 1747, oil on canvas. Trustees of the Titsey Foundation

able to the queen. The queen closely supervised the education of her daughters and this created many parallels and affinities with both Mrs. Delany and the Bluestocking circle. Though childless, Mary Delany had always exercised maternal affection. She had virtually adopted her goddaughter Sally Sandford, and she mothered her niece Mary Dewes after her beloved sister, Anne died in 1761. She had recommended that the aging female scholar Elizabeth Elstob be rescued from poverty and obscurity and be appointed governess to the young Portland children.[107] In this context, it is unsurprising that she gave the queen a copy of her moral fable, "Marianna," first written in 1759, a story emphasizing the need for young girls to follow the guidance of their parents and, later, their husbands.[108]

Mrs. Delany was friend to many Bluestockings, although she would have eschewed the label for herself. She was somewhat critical of Mrs. Montagu, "Queen of the Blues," who as a young girl had learned much from visits to Bulstrode; Mrs. Delany thought her a little pretentious and affected but approved of her charitable efforts as a rich widow and her patronage of Dr. James Beattie.[109] Mrs. Delany had also known one of the leading Bluestocking hostesses, Mrs. Vesey, in Ireland, but it was Frances Boscawen who became a closer friend after Mary Delany was widowed in 1768 (fig. 55). Mrs. Boscawen's late husband was a distinguished admiral, third son of the first earl of Falmouth, so she knew Mrs. Delany's Cornish relatives by the Pendarves marriage, and from time to time filled her in on their electoral fortunes.[110] It is probable Frances first met Mrs. Delany soon after 1742, when she married Admiral Boscawen, since her new sister-in-law, Lucy Boscawen, was a Maid of Honour to Princess Augusta and they were all mixing in the same circles. However, the acquaintance might have come about through two of Mrs. Boscawen's Evelyn relatives who had positions in the household: John Evelyn, who was a Groom of the Bedchamber to Frederick; and Mary Evelyn, one of the Women of the Bedchamber to Augusta. Frances Boscawen was an enthusiastic gardener who discovered she had inherited her great-granduncle John Evelyn's eye for tree planting when she and the admiral developed their estate at Hatchlands.[111] Mrs. Boscawen's son-in-law Admiral John Leveson-Gower reinforced links with the royal family when he commanded a ship on which Prince William served. Her other daughter Elizabeth married the fifth Duke of Beaufort and was a supporter of Hannah More, author of the poem that described the Bluestockings, *Bas Bleu.*[112]

Mrs. Delany was acquainted with many of the other personnel who helped the king and queen educate their children, and these contacts ripened into close friendships. For the princes, these included Richard Hurd, Bishop of Lichfield, not far from the Granville and Dewes estates on the Staffordshire/Derbyshire border, and the military engineer Leonard Smelt, a relative of Mrs. Montagu and admired by the king as a man much to his taste.[113] The governess of all the royal children was Lady Charlotte Finch, the maternal aunt of Sophia Carteret, Lady Shelburne. Lady Finch and Lady Cowper (the former Mrs. Spencer and Sophia's elder half aunt), between them recommended Miss Gouldsworthy as a royal sub-governess. Mary Delany was also friendly with two of Lady Finch's sisters, Lady Juliana Penn and Lady Louisa Clayton, a former Lady in Waiting to Princess Amelia. Lady Louisa resided at Windsor, where her daughter Emilia became a confidante of young Georgina Port.[114]

Mrs. Delany was charmed by the royal children and thought their parents had succeeded in making them polite. She recounted to Georgina Port how the Princess Royal and her sister Elizabeth had inquired after her and her tastes in books and added,

> I tell you *to show you how such manners become the highest rank, and tho' so far above us, they are not in* these particulars *unsuited to our imitation; for civility, kindness, and benevolence, (suitable to the different ranks of life,) are in every body's power, from the palace to the cottage, and I flatter myself that the seed I wish to sow will not be on barren ground....*[115]

Mrs. Delany was at one with the Bluestocking desire to create a form of society consisting of smaller groups with scope for sensible conversation, dominated by neither cards nor gossip. This was also the tone set by George III and Queen Charlotte in court circles, where only very small stakes at card playing were normal (the Duchess of Portland, who hardly ever played cards at all, was astonished when she won eight guineas one evening).[116] Mary Delany increasingly deplored the fast living of some of the younger members of the *bon ton* and their connections to the king's two brothers, who did not share his moral probity. She looked askance at the Duke of Gloucester's affair with Lady Grosvenor, aided and abetted by her sister Caroline Vernon, a Maid of Honour; made some rare catty comments on the Duchess of Cumberland, who maintained a gambling table at her house, and was disappointed that Georgiana Duchess of Devonshire had not set an example of reform to her contemporaries.[117]

Royal Friend

The extensive record of Mrs. Delany's life and accomplishments sheds enormous light on court circles across four reigns and as many generations, and illustrates the importance of the court as the fountain of patronage, as a cultural institution, and as a venue for the social and political elite. But it is also through her that we catch glimpses of the court as a home, and the royal family in their private moments. We see the king, always attentive to the elderly whether a duchess or a footman, helping Mrs. Delany and her friend to chairs at Bulstrode or at Windsor, and sitting down to talk to them; and young Prince Ernest struggling with a chair for the ladies that was almost as big as he was.[118] We see George returning to Windsor with his greyhounds on a dark December day as the light was fading, finding the two ladies leaving after a quiet visit to the queen—who had demonstrated her frame for making silk fringe to them—and insisting they stay an hour longer. The queen then urged them back into her sitting room, as it was warmer than that of the king, who was notoriously impervious to the chill of the old castle. We see him arranging for them to come in a chaise to Gerrard's Cross and witness the start of a stag hunt, which provoked Delany to reminisce about riding pillion to visitors one day when she was seventeen, and her horse spontaneously joined a cross country hunt. She arrived home drenched and hatless, with the hem of her pink dress ripped to shreds.[119] The queen, too, comes to life through Mrs. Delany's descriptions (fig. 56): with a smile urging the two elderly ladies to accept their seats from the king, as it is not often a king proffers a chair; looking miserable when she comes with her husband and four of the children on their first outing after losing baby Alfred; thoughtfully providing exquisite and useful gifts: a locket with her hair or a pocket book fitted with beautiful instruments to assist with the flora; looking attentively at Delany's chenille work and asking how she achieves her effects; examining the 'Flora Delanica' appreciatively; and assuring her that one of her grandnephews can have a nominated place at Christ's Hospital school.[120]

To the modern reader it might seem strange—even cruel—that the wealthy duchess bequeathed nothing but some chosen mementos to her friend. But this is to misunderstand both their friendship and aristocratic convention. It would have been unusual for a dowager to leave money outside of her family; landed wealth was always strictly settled at marriages, which provided at once for the bridal couple, the remaining dowager, and the children. The Duchess of Portland had already been in litigation with her son over her life interest in his inheritance and, unusually, remained at the family home of Bulstrode instead of moving to a dower house when she was widowed.[121] But aside from this Mrs. Delany was not and did not want to be a client, but a friend. As her maid-companion recalled, when she entertained in her London home, which the Duchess of Portland visited almost daily, it was always at her own expense—even to the costly tea that was served.[122] She knew in advance that the duchess's will would mention only the few souvenirs Mary had chosen, and Mary had reminded the duchess "that in *her* own family she [the duchess] had legitimate claims for [her wealth's] entire and exclusive appropriation." But Mrs. Delany's own will shows that her friend had lent her, unasked and interest-free, a loan of £400 for the purchase of the London house. The duchess must have been aware of the ruinously expensive lawsuit that had forced Mary to sell the London home Dean Delany had bought for her. However, her income as a widow (from both of her husbands) was insufficient for her to have a country home as well, and this is what the royal couple recognized when they offered her a house on St. Alban's Street, Windsor. She was therefore able to continue the winter/summer migration to London and Windsor, in synchronization

Figure 56: John Zoffany, *Queen Charlotte with Her Children and Brothers*, 1771–72, oil on canvas, 41⅜ × 50 in. (105.2 × 127 cm). The Royal Collection

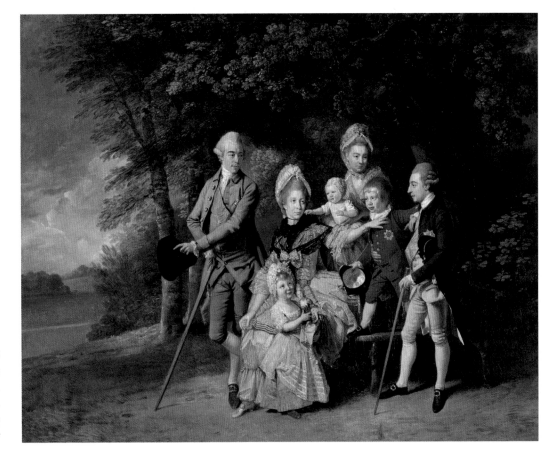

with her "illustrious neighbours."[123] The London house also held sad memories of departed friends, though she still had the regular company of her grandniece, Mary Ann Port, now making her own friends in Mrs. Delany's London and Windsor circle and increasingly attending concerts and assemblies.[124]

Mrs. Delany's encounters with the king and queen also became even more regular and more informal. She was always welcome to their quiet, decorous evenings after the regular promenade they made on the terrace. The queen, elder princesses, and Ladies in Waiting would sit at a table, always busy drawing, knotting, or sewing, with music playing—often Handel—in between conversation, and the king finishing the evening with an hour of backgammon played with some equerries. Once the queen visited during Mrs. Delany's lunch, quite unannounced, to prevent her from venturing out in bad weather later, and was treated to Mrs. Delany's orange pudding—the recipe of which she eagerly requested. Mrs. Delany also made visits—to Kew, where she stayed with Mrs. and Mrs. Smelt, and to Norbury Park, where she stayed with the Lock family.[125] Like her famous great-grandfather, she too died in royal service, for it was after an April visit to Kew that she caught a fatal cold, from which, exacerbated by the medical treatment of the day, she died quite unexpectedly after seeming to rally. And it was as a royal friend, not a salaried courtier, that Bishop Hurd remembered her in the epitaph for her parish church, St. James's Piccadilly:

She was a lady of singular ingenuity and politeness, and of unaffected piety. These qualities endeared her through life to many noble and excellent persons, and made the close of it illustrious by procuring for her many signal marks of grace and favour from their Majesties.[126]

Acknowledgments

No one researching Mrs. Delany can fail to acknowledge the Herculean labors of her great-grandniece Lady Llanover, who transcribed and edited the *Autobiography and Correspondence*. I would also like to thank Ruth Hayden for inviting me to her home in Bath and showing me her Delany collection; Amy Meyers and Amanda Vickery for inviting my participation in this book; Mark Laird and Alicia Weisberg-Roberts for their editorial role; and Nigel Aston, Toby Barnard, Thomas Biskup, Bob Bucholz, Elaine Chalus, Michèle Cohen, Fiona Harding, Hazel Mills, Hannah Smith, Naomi Tadmor, and Andrew Thompson for helpful discussions en route.

Notes

1. Lady Llanover, ed., *The Autobiography and Correspondence of Mary Granville, Mrs. Delany*, 6 vols. (London: Richard Bentley, 1861–62), ser. 2, 3:113–14n3; Jane Roberts, *George III & Queen Charlotte: Patronage, Collecting and Taste* (London: Royal Collection, 2004), 191.

2. Mrs. Walsingham to Mary Delany, 14 August 1785, in Llanover, ed., *Autobiography and Correspondence*, ser. 2, 3:270.

3. John Christopher Sainty and R. O. Bucholz, *Officials of the Royal Household, 1660–1837*, 2 vols. (London: Univ. of London Institute of Historical Research, 1997); Alan Marshall, *The Age of Faction: Court Politics, 1660–1702* (Manchester: Manchester Univ. Press, 1999); John M. Beattie, *The English Court in the Reign of George I* (Cambridge: Cambridge Univ. Press, 1967).

4. The extensive literature includes Geoffrey S. Holmes, ed., *Britain after the Glorious Revolution, 1689–1714* (London: Macmillan, 1969); J.C.D.Clark, *English Society, 1688–1832: Religion, Ideology and Politics during the Ancien Régime* (Cambridge: Cambridge Univ. Press, 2000); John Brewer, *The Sinews of Power: Money, War and the English State, 1688–1783* (London: Unwin Hyman, 1989); Nicholas Rogers, *Crowds, Culture, and Politics in Georgian Britain* (Oxford: Oxford Univ. Press, 1998); Kathleen Wilson, *The Sense of the People* (Cambridge: Cambridge Univ. Press, 1998).

5. Willem Bentinck's grandson was Margaret Harley-Cavendish's husband, the second Duke of Portland. Hugh Dunthorne and David Onnekink, "Bentinck, Hans Willem [William], first earl of Portland (1649–1709)," in H. C. G. Matthew and Brian Harrison, eds., *Oxford Dictionary of National Biography* (Oxford: Oxford Univ. Press, 2004), online ed., ed. Lawrence Goldman, October 2007, www.oxforddnb.com/view/article/2160 (accessed 15 February 2008).

6. Hannah Smith, *Georgian Monarchy: Politics and Culture, 1714–1760* (Cambridge: Cambridge Univ. Press, 2006); Clarissa Campbell Orr, ed., *Queenship in Britain, 1660–1837: Royal Patronage, Court Culture, and Dynastic Politics* (Manchester: Manchester Univ. Press, 2002); R. O. Bucholz, "Going to Court in 1700: A Visitor's Guide," *The Court Historian* 5, no. 3 (December 2000): 181–216.

7. Frances Harris, "'The Honourable Sisterhood': Queen Anne's Maids of Honour," *British Library Journal* 19, no. 2 (1993): 181–98; Anne Somerset, *Ladies-in-Waiting: From the Tudors to the Present Day* (London: Weidenfeld and Nicolson, 1984).

8. H. M. Scott, "Thynne, Thomas, third Viscount Weymouth and first marquess of Bath (1734–1796)," in *Oxford DNB*, online ed., ed. Lawrence Goldman, May 2005, www.oxforddnb.com/view/article/27425 (accessed 31 January 2008).

9. See Ingrid H. Tague, *Women of Quality: Accepting and Contesting Ideals of Feminity in England,*

1690–1760 (Woodbridge, Suffolk: The Boydell Press, 2002).

10. Sir Lewis Namier and John Brooke, eds., *The House of Commons, 1715–54*, 3 vols. (London: Secker and Warburg, 1985), 1:475–76.

11. Frances Boscawen to Mary Delany, 21 November 1771, in Llanover, ed. *Autobiography and Correspondence*, ser. 2, 1:376; see also Mary Delany to Mary Dewes Port, 1 December 1771, ser. 2, 1:379. For the Beauforts' ambivalent loyalty to the Hanoverians, see Philip Carter, "Somerset, Henry, second duke of Beaufort (1684–1714)," in *Oxford DNB*, online ed., ed. Lawrence Goldman, January 2008, www.oxforddnb.com /view/article/26010 (accessed 18 July 2008).

12. Llanover, ed., *Autobiography and Correspondence*, ser. 1, 1:1.

13. John Cannon, "Carteret, John, second Earl Granville (1690–1763)," in *Oxford DNB*, online ed., ed. Lawrence Goldman, May 2006, www.oxforddnb.com/view/article/4804 (accessed 31 January 2008).

14. Charles Spencer, *The Spencer Family* (London: Viking, 1999), 108–11; Llanover, ed., *Autobiography and Correspondence*, ser. 1, 3:399–402.

15. Eveline Cruickshanks, "Granville, George, Baron Lansdowne and Jacobite duke of Albemarle (1666–1735)," in *Oxford DNB*, online ed., ed. Lawrence Goldman, January 2008, www.oxforddnb.com/view/article/11301 (accessed 31 January 2008).

16. It is possible that Kitty's real father was her mother's cousin by marriage, Henry Boyle, Lord Carlton. Violet Biddulph, *Kitty, Duchess of Queensberry* (London: Ivor Nicholson and Watson, 1925), 11, 30–31.

17. Mary Delany to Anne Dewes, 28 December 1753, in Llanover, ed., *Autobiography and Correspondence*, ser. 1, 3:261–62; Naomi Tadmor, *Family & Friends in Eighteenth-Century England: Household, Kinship, and Patronage* (Cambridge: Cambridge Univ. Press, 2001).

18. E.g., Frances Boscawen to Mary Delany, 10 December 1787, in Llanover, ed., *Autobiography and Correspondence*, ser. 2, 3:464–65.

19. Elaine Chalus, *Elite Women in English Political Life, c. 1754–1790* (Oxford: Clarendon Press, 2005). A further Leveson-Gower connection was the famous Lady Mary Wortley Montagu, one of the leading wits of the Whig party; her sister Evelyn was married to John, first Baron Gower. Moreover, the sisters' stepmother, Isabella Bentinck, was an aunt of the second Duke of Portland.

20. Frances Harris *A Passion for Government: The Life of Sarah, Duchess of Marlborough* (Oxford: Clarendon Press, 1991), 350; see also Harris, "'The Honourable Sisterhood'"; and Somerset, *Ladies-in-Waiting*.

21. Cruickshanks, "Granville, George."

22. Romney Sedgwick, ed., *The House of Commons, 1715–1754*, 2 vols. (London: Published for the

History of Parliament Trust by H.M.S.O., 1970), 2:334.

23. Mary Delany to Mary Dewes, 1776, in Llanover, ed., *Autobiography and Correspondence*, ser. 2, 1:80.

24. Llanover, ed., *Autobiography and Correspondence*, ser. 1, 1:158 (Mary Pendarves to Anne Granville, 19 January 1728), 109 ("Letter XIV: Autobiography").

25. Susan E. Whyman, *Sociability and Power in Late-Stuart England: The Cultural Worlds of the Verneys, 1660–1720* (Oxford: Oxford Univ. Press, 2002); Rosemary O'Day, ed., *Cassandra Brydges (1670–1735), First Duchess of Chandos: Life and Letters* (Woodbridge: Boydell Press, 2007), introduction.

26. R. O. Bucholz, *The Augustan Court: Queen Anne and the Decline of Court Culture* (Stanford, Calif.: Stanford Univ. Press, 1993); John Brewer, *The Pleasures of the Imagination: English Culture in the Eighteenth Century* (London: Harper Collins, 1997). Bucholz would now describe the court as "at the centre, but not the centre" of English life (e-mail message to author, 24 August 2006). See also Smith, *Georgian Monarchy*; Hannah Smith, "The Court in England, 1714–60: A Declining Political Institution," *History* 90 (2005): 23–41; and Campbell Orr, ed., *Queenship in Britain.*

27. Nigel Aston, "The Court of George II: Lord Berkeley of Stratton's Perspective," *The Court Historian* 13, no. 2 (December 2008): 171–93.

28. Whyman, *Sociability and Power.*

29. Mary Pendarves to Anne Granville, 11 November 1727, in Llanover, ed., *Autobiography and Correspondence*, ser. 1, 1:145.

30. Ruth Hayden, *Mrs. Delany: Her Life and Her Flowers* (London: British Museum Publications, 1980), 37, 54.

31. Mary Pendarves to Anne Granville, 22 August 1725, in Llanover, ed., *Autobiography and Correspondence*, ser. 1, 1:117–18.

32. Llanover, ed., *Autobiography and Correspondence*, ser. 1, 1:277.

33. Isobel Grundy, *Lady Mary Wortley Montagu* (Oxford: Oxford Univ. Press, 1999), 88–89.

34. Mary Pendarves to Anne Granville, 14 July 1722, in Llanover, ed., *Autobiography and Correspondence*, ser. 1, 1:70.

35. Mary Pendarves to Anne Granville, 16 April 1728, in Llanover, ed., *Autobiography and Correspondence*, ser. 1, 1:167.

36. Ruth Perry, *The Celebrated Mary Astell: An Early English Feminist* (Chicago: Chicago Univ. Press, 1986).

37. Somerset, *Ladies-in-Waiting*, 203.

38. Mary Pendarves to Anne Granville, 4 March 1729, in Llanover, ed., *Autobiography and Correspondence*, ser. 1, 1:191.

39. Julius Bryant, *Henrietta Howard, Woman of Reason* (London: English Heritage, 1988).

40. Harris, *Passion for Government*; Somerset, *Ladies-in-Waiting*, 205–7, 217–18; Katherine Thomson, ed., *Memoirs of Viscountess Sundon, Mistress of the Robes to Queen Caroline, Consort of George II*, 2 vols. (London: Henry Colburn, 1847).

41. Mary Delany to Anne Dewes, 24 May 1756, in Llanover, ed., *Autobiography and Correspondence*, ser. 1, 3:429.

42. Philip Carter, "Clayton [née Dyve], Charlotte, Lady Sundon (c. 1679–1742)," in *Oxford DNB*, online ed., www.oxforddnb.com/view/article/5568 (accessed 7 August 2008).

43. Mary Pendarves to Anne Granville, 8 March 1729, in Llanover, ed., *Autobiography and Correspondence*, ser. 1, 1:195.

44. Institute of Historical Research, "Office-Holders in Modern Britain, Household of Princess Caroline 1721–27," www.ihrinfo.ac.uk/office/caroline.html (accessed 8 August 2008), and "Office-Holders in Modern Britain, Household of Queen Caroline 1727–37," www.ihrinfo.ac.uk/office/queencaroline.html (accessed 8 August 2008).

45. Thomson, ed., *Memoirs*, 1:316–17.

46. Mary Pendarves to Anne Granville, 19 November 1728, in Llanover, ed., *Autobiography and Correspondence*, ser. 1, 1:177.

47. Mary Pendarves to Anne Granville, in Llanover, ed., *Autobiography and Correspondence*, ser. 1, 1:147–48 (11 November 1727), 174–75 (18 June 1728).

48. Toby Barnard, "Delany, Patrick (1685/6–1768)," in *Oxford DNB*, online ed., ed. Lawrence Goldman, January 2008, www.oxforddnb.com/ view/article/7443 (accessed 31 January 2008).

49. E.g., Mary Pendarves to Anne Granville, in Llanover, ed., *Autobiography and Correspondence*, ser. 1, 1:146 (11 November 1727), 279–80 (5 August 1731), 362 (28 June 1732), 472 (28 May 1734).

50. Llanover, ed., *Autobiography and Correspondence*, ser. 1, 2:18, 118, 123, 182, 192.

51. Mary Pendarves to Anne Granville, 16 February 1734, in Llanover, ed., *Autobiography and Correspondence*, ser. 1, 1:428.

52. Mary Pendarves to Anne Granville, 28 March 1734, in Llanover, ed., *Autobiography and Correspondence*, ser. 1, 1:448.

53. Mary Pendarves to Anne Granville, in Llanover, ed., *Autobiography and Correspondence*, ser. 1, 1:500–501 (26 September 1734), 568 (17 August 1736).

54. Institute of Historical Research, "Office-Holders in Modern Britain, Household of Prince Frederick 1729–51," www.ihrinfo.ac.uk/office/fred.html (accessed 18 February 2008; hereafter cited as "Household of Prince Frederick"), and "Office-Holders in Modern Britain, Household of Princess Augusta 1736–72," www.ihrinfo.ac.uk/office/augusta.html (accessed 18 February 2008; hereafter cited as "Household of Princess Augusta"); Frances Vivian, *A Life of Frederick, Prince of Wales, 1707–1751: A Connoisseur of the Arts*, ed. Roger White (Lampeter, Wales: The Edwin Mellen Press, 2006); Angela Bolger, *The First Field Marshall & The King's Mistress* (Taplow: SGI-UK, 2002).

55. Thomson, ed., *Memoirs*, 1:323–24.

56. Christine Gerrard, "Queens-in-Waiting: Caroline of Anspach and Augusta of Saxe-Gotha as Princesses of Wales," in Campbell Orr, ed., *Queenship in Britain*, 143–61. Arabella's father was a landowner in Montgomeryshire and Lord Lieutenant of Shropshire; her brother later inherited the earldom of Powis from a recusant relative, having already been created Baron Herbert of Cherbury.

57. "Household of Prince Frederick."

58. Oliver Millar, *The Tudor, Stuart and Early Georgian Pictures in the Collection of Her Majesty the Queen*, 2 vols. (London: Phaidon Press, 1963), 1:178–79. The gentleman on Augusta's left is her vice-chamberlain, Sir William Irby, later Lord Boston. Delany thought his wife, the former Maid of Honour Albinia Selwyn, was fortunate in her choice. Llanover, ed., *Autobiography and Correspondence*, ser. 2, 2:245.

59. Christine Gerrard, *The Patriot Opposition to Walpole: Politics, Poetry, and National Myth, 1725–1742* (Oxford: Oxford Univ. Press, 1994).

60. Matthew Kilburn, "Frederick Lewis, prince of Wales (1707–1751)," in *Oxford DNB*, online ed., ed. Lawrence Goldman, January 2008, www.oxforddnb.com/view/article/10140 (accessed 4 March 2008).

61. Mary Pendarves to Anne Granville, 23 January 1739, in Llanover, ed., *Autobiography and Correspondence*, ser. 1, 2:29.

62. Mary Pendarves to Anne Granville, 3 March 1739, in Llanover, ed., *Autobiography and Correspondence*, ser. 1, 2:42–45.

63. He had been well inclined toward Mary herself, but she had steered him instead into a marriage in 1733 with her Carteret cousin Louisa, which resulted in a second generation of her family enjoying residence at Longleat. The match gave the young Viscount much needed happiness and domestic stability, though tragically it lasted only three years, as she died after a difficult pregnancy, leaving her husband deranged with grief. David Burnett, *Longleat: The Story of an English Country House* (Stanbridge, Wimborne, Dorset: Dovecote Press, 1988), 103–7.

64. Llanover, ed., *Autobiography and Correspondence*, ser. 1, 2:194–96 (Duchess of Portland to Anne Dewes, 20 September [1742]), 198 (Mary Pendarves to Anne Dewes, 12 November 1742).

65. Delany's host was the third in his family to be Master of Ceremonies to the monarch. Roderick Clayton, "Cottrell [Cotterell; later Cottrell-Dormer], Sir Clement (1686–1758), in *Oxford DNB*, online ed., ed. Lawrence Goldman, January 2008, www.oxforddnb.com/view/article/6399 (accessed 12 February 2008).

66. Mary Delany to Anne Dewes, 3 April 1744, in Llanover, ed., *Autobiography and Correspondence*, ser. 1, 2:[289].

67. Patrick Delany, *Sixteen Discourses upon Doctrines and Duties, More Peculiarly Christian; and Against the Reigning Vanities of the Age* (London: Printed for John and James Rivington, 1754).

68. Hayden, *Mrs. Delany*, 45.

69. Mary Pendarves to Anne Granville, 22 September 1731, in Llanover, ed., *Autobiography and Correspondence*, ser. 1, 1:288. Philip Percival's second wife was Martha Usher, whose first husband, Nehemiah Donellan, was Lord Chief Baron of the Exchequer. Her friend Anne Donnellan's mother was the second wife of Philip Percival, who was the younger brother of John, first Earl of Egmont, an Irish landowner and politician with English political ambitions. The brothers were educated and in the main resided in England, but during this 1731 visit Mary saw Philip's son and heir, John, Viscount Percival, make his maiden speech as an Irish MP. Fifteen years later he obtained a position in Prince Frederick's household and became a very significant advisor. Betty Wood, "Perceval, John, first earl of Egmont (1683–1748)," in *Oxford DNB*, online ed., ed. Lawrence Goldman, October 2006, www.oxforddnb.com/view/article/21911 (accessed 12 June 2008); and Clive Wilkinson, "Perceval, John, second earl of Egmont (1711–1770)," in *Oxford DNB*, online ed., ed. Lawrence Goldman, January 2008, www.oxforddnb.com/view/article/21912 (accessed 12 June 2008).

70. Toby Barnard, *A New Anatomy of Ireland: The Irish Protestants, 1649–1770* (New Haven and London: Yale Univ. Press, 2003); T. C. Barnard, "'Grand Metropolis' or 'The Anus of the World'? The Cultural Life of Eighteenth-Century Dublin," in Peter Clark and Raymond Gillespie, eds., *Two Capitals: London and Dublin, 1500–1840* (Oxford: Published for the British Academy by Oxford Univ. Press, 2001), 185–210.

71. C. D. A. Leighton, "Clayton, Robert (1695–1758)," in *Oxford DNB*, online ed., www.oxforddnb.com/view/article/5580 (accessed 15 February 2008). The house is described in Llanover, ed., *Autobiography and Correspondence*, ser. 1, 2:289, 305.

72. Mary Delany to Anne Dewes, in Llanover, ed., *Autobiography and Correspondence*, ser. 1, 2:394 (15 October 1745), 399 (23 November 1745), 422 (8 February 1746), 3:81–92 (26 January 1752).

73. Mary Delany to Anne Dewes, 2 November 1751, in Llanover, ed., *Autobiography and Correspondence*, ser. 1, 3:51–52, 80.

74. Timothy Mowl and Brian Earnshaw, *An Insular Rococo: Architecture, Politics and Society in Ireland and England, 1710–1770* (London: Reaktion Books, 1999), rely extensively on Mrs. Delany's letters to describe the Irish court.

75. Eoin Magennis, "Coal, Corn and Canals: Parliament and the Dispersal of Public Moneys, 1695–1772," in David W. Hayton, ed., *The Irish Parliament in the Eighteenth Century: The Long Apprenticeship* (Edinburgh: Edinburgh Univ. Press for the Parliamentary History Yearbook Trust, 2001), 71–86; Edith Mary Johnston, *Ireland in the Eighteenth Century* (Dublin: Gill and Macmillan, 1974), 90–94; John Turpin, *A School of Art in Dublin since the Eighteenth Century: A History of the National College of Art and Design* (Dublin: Gill and Macmillan, 1995) 10–11, 64.

76. M. Dunleavy, "Samuel Madden and the Scheme for the Encouragement of Useful Manufactures," in Agnes Bernelle, ed., *Decantations: A Tribute to Maurice Craig* (Dublin: Lilliput Press, 1992), 21–28; and James Livesey, "The Dublin Society in Eighteenth-Century Irish Political Thought," *Historical Journal* 47, no. 3 (2004): 615–40.

77. Beatrice Bayley Butler, "Lady Arbella Denny, 1707–1792," *Dublin Historical Record* 9, no. 1 (December 1946–February 1947): 1–20; Clarissa Campbell Orr, "Wives, Aunts, Courtiers: The Ladies of Bowood," in Nigel Aston and Clarissa Campbell Orr, eds., *An Enlightenment Statesman: Lord Shelburne in Context (1737–1805)* (forthcoming).

78. Mary Delany to Anne Dewes, 1 February 1746, in Llanover, ed., *Autobiography and Correspondence*, ser. 1, 2:418.

79. See, e.g., Llanover, ed., *Autobiography and Correspondence*, ser. 1, 2:579–90, for her summer visit of 1750.

80. Mary Delany to Anne Dewes, in Llanover, ed., *Autobiography and Correspondence*, ser. 1, 3:71 (3 January 1752), 250 (3 December 1753).

81. After that the dean was not well enough to make the journeys: in June 1767, though, wishing his wife to see her family, he made a valiant last trip, spent largely taking the waters in Bath.

82. Mary Delany to Anne Dewes, 15 January 1747, in Llanover, ed., *Autobiography and Correspondence*, ser. 1, 2:447.

83. Mary Delany to Anne Dewes, 10 November 1754, in Llanover, ed., *Autobiography and Correspondence*, ser. 1, 3:300, 302.

84. Mary Delany to Anne Dewes, in Llanover, ed., *Autobiography and Correspondence*, ser. 1, 3:399 (14–17 January 1756), 445 (27 September 1756), 409 (14 February 1756).

85. Frances Boscawen to Mary Delany, 9 September 1785, in Llanover, ed., *Autobiography and Correspondence*, ser. 2, 3:281–82.

86. See, e.g., Llanover, ed., *Autobiography and Correspondence*, ser. 2, 1:527 (Mary Delany to Viscountess Andover, 22 July 1774), 2:18–19 (Mary Delany to the Rev. John Dewes, 27 July 1774).

87. One volume was never returned, and Mrs. Delany was too polite to inquire what had befallen it! Llanover, ed., *Autobiography and Correspondence*, ser. 2, 3:248.

88. Mary Delany to Mrs. J. Dewes, 1 May 1784, in Llanover, ed., *Autobiography and Correspondence*, ser. 2, 3:213.

89. First Earl of Guilford to Mary Delany, 19 January 1786, in Llanover, ed., *Autobiography and Correspondence*, ser. 2, 3:338–39; for appointments, see Sainty and Bucholz, *Officials of the Royal Household*. Lord North was made Queen Charlotte's Treasurer in 1773 and died in office in 1790. His son Frederick, Lord North, was named after his godfather Prince Frederick, and had been wet-nursed with the future king George III. He served from 1770 to 1782 as

Prime Minister, ending the difficulties the king had had in forming a stable ministry. George Augustus, the Prime Minister's heir, was appointed in 1781 as Queen Charlotte's Secretary and Comptroller.

90. When Lord North's heir joined Charlotte's household, Lord Dartmouth's son, the Hon. William Legge, joined the household of the Prince of Wales. Peter Marshall, "Legge, William, second earl of Dartmouth (1731–1801)," in *Oxford DNB*, online ed., ed. Lawrence Goldman, January 2008, www.oxforddnb.com/ view /article/16360 (accessed 31 January 2008). Mary Delany to Anne Dewes, 6 July 1754, in Llanover, ed., *Autobiography and Correspondence*, ser. 1, 3:283.

91. Clarissa Campbell Orr, "Queen Charlotte, 'Scientific Queen,'" in Campbell Orr, ed., *Queenship in Britain*, 236–66; David P. Miller, "'My favourite Studdys': Lord Bute as a Naturalist," in Karl Schweizer, ed., *Lord Bute: Essays in Reinterpretation* (Leicester: Leicester Univ. Press, 1988), 213–39. The tables are illustrated in Roberts, *George III & Queen Charlotte*, 280.

92. Lord Lieutenant of Ireland, 1765–68; Secretary of State for Southern Department, 1768–70, 1775–79.

93. Georgina Port to Mrs. Anne Viney, 28 May 1784, in Llanover, ed., *Autobiography and Correspondence*, ser. 2, 3:215–16.

94. Mary Delany to Anne Dewes, 13 November 1760, in Llanover, ed., *Autobiography and Correspondence*, ser. 1, 3:614.

95. Janet Browne, " Monson [née Vane; other married name Hope-Vere], Lady Anne (c. 1727–1776)," in *Oxford DNB*, online ed., www.oxforddnb.com/view/article/57839 (accessed 26 February 2008); and T. H. Bowyer, "Monson, George (1730–1776)," in *Oxford DNB*, online ed., ed. Lawrence Goldman, May 2006, www.oxforddnb.com/view/article/18985 (accessed 26 February 2008).

96. Mary Delany to Mary Dewes, 4 October 1768, in Llanover, ed., *Autobiography and Correspondence*, ser. 2, 1:173.

97. Clarissa Campbell Orr, "The Late Hanoverian Monarchy and the Christian Enlightenment," in M. Schaich, ed., *Monarchy and Religion: The Transformation of Royal Culture in Eighteenth-Century Europe* (Oxford: Oxford Univ. Press, 2007), 317–42; Mary Delany to Mary Dewes Port, in Llanover, ed., *Autobiography and Correspondence*, ser. 2, 1:506 (28 May 1773), 521 (3 July 1773).

98. Mary Delany to the Viscountess Andover, 4 September 1766, in Llanover, ed., *Autobiography and Correspondence*, ser. 2, 1:76.

99. Clarissa Campbell Orr, "Charlotte of Mecklenburg-Strelitz, Queen of Great Britain and Electress of Hanover: Northern Dynasties and the Northern Republic of Letters," in Clarissa Campbell Orr, ed., *Queenship in Europe, 1660–1815: The Role of the Consort* (Cambridge: Cambridge Univ. Press, 2004), 368–402.

100. Roberts, *George III & Queen Charlotte*; Thomas Biskup, "The University of Göttingen and the Personal Union, 1737–1837," in Brendan Simms and Torsten Riotte, eds., *The Hanoverian Dimension in British History, 1714–1837* (Cambridge: Cambridge Univ. Press, 2007), 128–60.

101. John Gascoigne, *Joseph Banks and the English Enlightenment: Useful Knowledge and Polite Culture* (Cambridge: Cambridge Univ. Press, 1994); Campbell Orr, "Queen Charlotte, 'Scientific Queen,'" 236–66.

102. Mary Delany to Mary Dewes Port, 15 April 1776, in Llanover, ed., *Autobiography and Correspondence*, ser. 2, 2:209.

103. Campbell Orr, "Queen Charlotte as Patron: Some Intellectual and Social Contexts," *The Court Historian* 6, no. 3 (December 2001): 183–212.

104. Mary Delany to Mary Hamilton, 19 March 1781, in Llanover, ed., *Autobiography and Correspondence*, ser. 2, 3:9.

105. Hayden, *Mrs. Delany*, 128.

106. Llanover, ed., *Autobiography and Correspondence*, ser. 2, 3:154, 179; Elizabeth Anson and Florence Anson, eds., *Mary Hamilton, afterwards Mrs. John Dickenson, at Court and at Home: From Letters and Diaries, 1756–1816* (London: John Murray, 1925), 53.

107. Mary Pendarves to Anne Granville, 12 December 1738, in Llanover, ed., *Autobiography and Correspondence*, ser. 1, 2:13–14.

108. Llanover, ed., *Autobiography and Correspondence*, ser. 1, 3:580.

109. Sylvia Harstock Myers, *The Bluestocking Circle* (Oxford: Oxford Univ. Press, 1990); Llanover, ed., *Autobiography and Correspondence*, ser. 2, 1:506 (Mary Delany to Mary Dewes Port, 28 May 1773), 516 (Mrs. Chapone to Mary Delany, 13 June [1773]).

110. Frances Boscawen to Mary Delany, June 1784, in Llanover, ed., *Autobiography and Correspondence*, ser. 2, 3:218.

111. Cecil Aspinall-Oglander, *Admiral's Wife, Being the Life and Letters of The Hon. Mrs. Edward Boscawen from 1719–1761* (London: Longmans' Green and Co., 1940). Her garden walk had lilacs and laburnum (178), while in the park she was planting pines, laurels and poplars (261).

112. Anne Stott, *Hannah More: The First Victorian* (Oxford: Oxford Univ. Press, 2003).

113. Susan Hots, "Smelt, Leonard (*bap.* 1725, *d.* 1800)," in *Oxford DNB*, online ed., www.oxforddnb.com/view/article/25754 (accessed 12 February 2008).

114. For the context of Granville Penn's biblical studies, see Campbell Orr, "Late Hanoverian Monarchy and Christian Enlightenment."

115. Mary Delany to Miss Mary Port, 18 November 1781, in Llanover, ed., *Autobiography and Correspondence*, ser. 2, 3:71–72.

116. Mary Delany to Mary Dewes Port, 29 October 1779, in Llanover, ed., *Autobiography and Correspondence*, ser. 2, 2:479.

117. Stella Tillyard, *A Royal Affair: George III and His Troublesome Siblings*, (London: Chatto & Windus, 2006); Mary Delany to Mary Dewes, in Llanover, ed., *Autobiography and Correspondence*, ser. 2, 1:292 (22 July 1770), 507 (28 May 1773), 2:98 (19 January 1775), 114 (10 March 1775).

118. For George III's treatment of elderly servants, see Christopher Hibbert, *George III: A Personal History* (London: Penguin, 1998), 204–5; Llanover, ed., *Autobiography and Correspondence*, ser. 2, 2:372 (Mary Delany to Mary Dewes Port, n.d.), 474 (Mary Delany to Miss Mary Port, 10 October 1779).

119. Llanover, ed., *Autobiography and Correspondence*, ser. 2, 3:67 (Mary Delany to Miss Hamilton, 14 November 1781), 123–24 (Mary Delany to Frances Hamilton, 17 December 1782).

120. Llanover, ed., *Autobiography and Correspondence*, ser. 2, 2:372–73 (Mary Delany to Mary Dewes Port, n.d.), 3:107 (Mary Delany to Miss Mary Port, 1 September 1782), 2:495–96 (Mrs. Rea to Miss Mary Port, December 1779), 576 (Mary Delany to Mary Dewes Port, 8 November 1780); the pocket book is illustrated in Roberts, *George III & Queen Charlotte*, 71.

121. David Wilkinson, *The Duke of Portland: Politics and Party in the Age of George III* (London: Macmillan, 2003).

122. Llanover, ed., *Autobiography and Correspondence*, ser. 2, 3:317.

123. Llanover, ed., *Autobiography and Correspondence*, ser. 2, 3:272, 471, 484.

124. Llanover, ed., *Autobiography and Correspondence*, ser. 2, 3:471 (18 January 1788).

125. Mary Delany to Frances Hamilton, in Llanover, ed., *Autobiography and Correspondence*, ser. 2, 3:427–29 (25 December 1786), 472 (18 January 1788).

126. Llanover, ed., *Autobiography and Correspondence*, ser. 2, 3:481.

Clare Browne

[2]
MARY DELANY'S
EMBROIDERED COURT DRESS

Most historical textiles that have survived from previous centuries in private families and public collections are now anonymous, the identities of their original makers and wearers untraceable. Examples that do have a personal association can be valuable evidence of individual tastes, skills, or way of life. The embroideries associated with Mary Delany (and in particular as Mary Pendarves) have the potential to illuminate our understanding of aspects of her life; this is possible as long as our interpretation of them gives equal weight both to the physical evidence they retain, and to her own many references to textiles and clothing and the context of the society in which she lived.

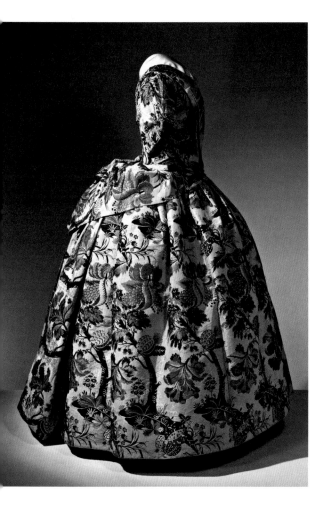

Anne Buck, the pioneering historian of eighteenth-century dress, observed astutely that "the view that dress expressed status in society was an unchallenged commonplace of the eighteenth century."[1] Within this environment Mary Delany dressed appropriately to her social standing and married or widowed state. She summed up her own attitude: "I keep within bounds, endeavouring to avoid all particularities of being *too much in* or out of fashion; youth and liveliness never prompted me to break through that rule, not considering I had graces enough of my own to carry off any extravagance... ."[2] It was an attitude she sustained toward others as well as herself. A typical comment comes from her description of a ball at Dublin Castle: "The two best-dressed women there were Mrs. Pomeroy and Miss Colley her sister... though not fine; and they had no *frippery whims in their heads,* which now prevail so much that *everybody looks mad!*"[3] Excesses in fashion provoked some of her most cutting observations, for example in her attitude toward hoops:

> [T]here is such a variety in the manner of dress, that I don't know what to tell you is the fashion; the only thing that seems general are hoops of an enormous size, and most people wear vast winkers to their heads. They are now come to such an extravagance in those two particulars, that I expect soon to see the other extreme of thread-paper heads and no hoops, and from appearing like so many blown bladders *we shall look like so many* bodkins stalking about.[4]

Mrs. Delany's attitude is also reflected in the detailed and prescriptive accounts of mourning she sent to her sister, Anne, regarding what should be worn under varying circumstances.[5] And with an aunt's concern for the essential respectability of her much-loved fourteen-year-old niece, Mary Dewes, she gave guidance for her emergence into society: "The *vanity* and *impertinence* of dress is always to be avoided, but a *decent* compliance with the fashion is less affected than any remarkable negligence of it."[6] She sometimes expressed intolerance, however, of the necessary effort

involved in keeping up such compliance—"We are to dine abroad Tuesday and Wednesday, to my sorrow; for I do hate the fuss of dressing, and unpacking all one's frippery."[7]

What we know of Mary Delany's own choice of clothing comes from two sources: her comments to her sister and other correspondents, and the surviving examples of embroidery that are associated with her. Some of the written evidence is lost, but there remain tantalizing, frustrating clues to it. For example, in one of her most elaborate descriptions of a court occasion (the February 1741 Prince of Wales's ball) and the fashions worn there, Mary wrote to her sister, "I told you [elsewhere] what my clothes were."[8] But when Mary does include descriptions of her clothes in the letters, they are splendidly evocative:

> I have got my wedding garment ready [for the wedding of Ann, eldest daughter of George II, to the Prince of Orange in 1734], 'tis a brocaded lutestring, white ground with great ramping flowers in shades of purples, reds, and greens. I gave thirteen shillings a yard; it looks better than it describes, and will make a show: I shall wear with them dark purple and gold ribbon, and a black hood for decency's sake.[9]

This must have looked much like the mantua shown in figure 57.[10]

Alongside the written descriptions in Mrs. Delany's letters is a group of embroideries passed by descent through her sister's family. One panel is an exceptional survival from the eighteenth century, of strikingly beautiful design and fine workmanship, preserved in almost pristine condition (fig. 58). Its existence has been known outside the family since nineteenth-century references to it in Lady Llanover's edition of *The Autobiography and Correspondence of Mary Granville, Mrs. Delany* and the circa 1860 volume of photographs *Specimens of Rare and Beautiful Needlework, Designed and Executed by Mrs. Delany and Her Friend the Hon. Mrs. Hamilton.*[11] The embroidery is worked in colored silk threads on a black silk satin ground, and the panel is among a

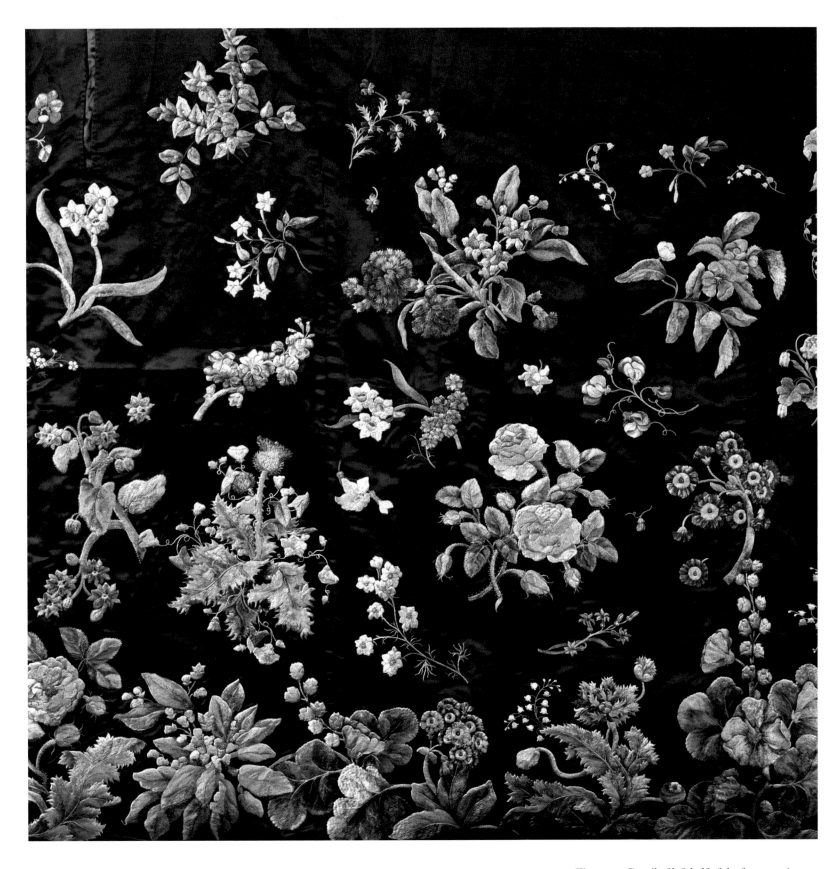

Figure 58: Detail of left half of the front petticoat panel, designed by Mary Pendarves, 1740–41, silk embroidery on satin, 41⅜ × 69¼ in. (105 × 176 cm). Private collection

Figure 57: Mantua, ca. 1735, brocaded silk.
Victoria and Albert Museum, London (T.324–1985)

Figure 59: Detail of Charles Philips, *Tea Party at Lord Harrington's House, St. James's*, 1730, oil on canvas, 40¼ × 49¾ in. (102.2 × 126.4 cm). Yale Center for British Art, Paul Mellon Collection (B1981.25.503)

Figure 60: Louis-Philippe Boitard after Bartholomew Dandridge, *Giving a HAND in a MINUET*, from François Nivelon, *The Rudiments of Genteel Behavior* (London, 1737), Plate 5. Beinecke Rare Books and Manuscript Library, Yale University

small number of embroidered pieces with the same coloring, all accepted since the nineteenth century as part of Mrs. Delany's "Court dress" as she both designed and embroidered them. They are taken as evidence of her exceptional skill in needlework and design. Is this conclusion justified, and can the fragments be reassembled and located within her life at court?

In her attendance at court, Mary Delany had to follow strict conventions of dress. Ladies wore clothes appropriate to this world of ceremony—formal, expensive clothes that were distinguished in a variety of ways from the fashionable dresses worn elsewhere.[12] During most of Mary's life, the court dress style was the mantua and petticoat, illustrated in a domestic, albeit grand, setting in figure 59. The mantua was a gown comprising a fitted bodice extending into a train behind, which at certain periods was worn looped up. Its bodice was closed at the front with a stomacher, a V-shaped panel that gave focus for elaborate decoration, and it was worn with a decorative petticoat, almost entirely revealed by the mantua's draping and usually cut extremely wide over the hips.[13] This great exaggeration of the lower part of the dress was achieved with whalebone hoops. The shape and scale of the court hoop was one of the hallmarks of English court dress. Jonathan Swift acutely highlighted their extravagance: "Have you got the whalebone petticoats amongst you yet? I hate them; a woman may hide a moderate gallant under them."[14] Mantuas were first worn by Englishwomen in the 1660s, as informal dress, but by the early eighteenth century they were accepted, and then became mandatory as suitable dress for wearing at court.

Mary Delany makes a number of comments regarding the complexity of getting dressed into, and then managing the wearing of, a mantua. Once the bodice had been put on, the train had to be arranged—"Yesterday (as my tail was pinning up) he came"[15]—and ladies not only had to walk but to dance in its complex drapery: "Lady Betty... *rehearsed* her clothes and jewels yesterday, and practised dancing with her train";[16] "Dash, by a mistake of her mantua-maker's was *spoiled for a dancer*" (fig. 60).[17]

The two embroidered panels in figures 58 and 61 correspond to the front and back of a mantua's petticoat; the first retains its pocket slits and traces of pleats that gathered it into the waist. Their color combination, with a wide range of colors on a black ground is extremely unusual. Mrs. Delany certainly wore black for mourning at the appropriate periods, as custom dictated, but that was black unrelieved by decoration. Among surviving patterned dress silks from the first half of the eighteenth century, only a tiny fraction have colors on a black ground, as lighter-colored grounds were overwhelmingly the choice in English taste and considered characteristic of English excellence. Those that are black are all thought to date from the 1730s, like the silk illustrated in figure 62. Much more typical are the

Figure 61: Back petticoat panel, designed by Mary Pendarves, 1740–41, silk embroidery on satin, 41⅜ × 69¼ in. (105 × 176 cm). Private collection

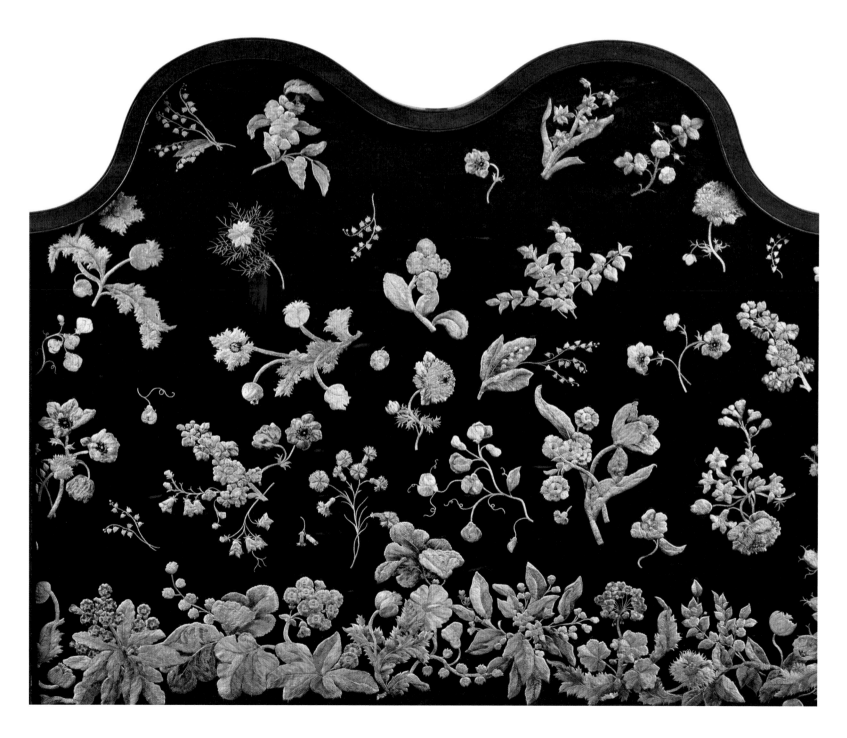

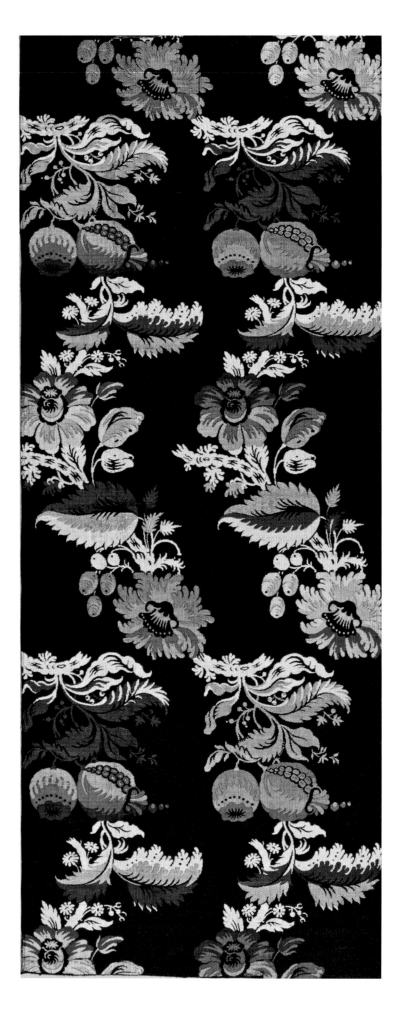

flowered silk gowns with a pale background to the flowers; such pale ground allows for great movement between shadow and light in the draped contours of the silk.

Included among the colors of her own gowns, Mary Delany mentioned green, scarlet, blue, pink, gold, brown, purple, and white in engaging combinations: "a flowered silk... on a pale deer-coloured figured ground; the flowers, mostly purple, are mixed with white feathers. I think it extremely pretty and very modest."[18] Not one of her non-mourning gowns was black, nor were those of the other ladies she described throughout her correspondence with a single exception, which allows the speculation that Mrs. Delany's black petticoat was worn underneath a lighter-colored mantua. At the January 1734 birthday celebration for the Prince of Wales she was "humbly drest in my pink damask" and Lady Huntingdon's petticoat was black velvet embroidered with chenille and gold, worn with a white satin gown (mantua).[19] This contrast of color and texture—black velvet petticoat with white satin bodice and train—is an extreme version of the liking for contrasting effect seen elsewhere: at the Prince of Wales's birthday celebration in 1740, for example, Lady Dysart wore a scarlet damask gown with white satin petticoat, alongside the Duchess of Bedford, whose "petticoat was green paduasoy, embroidered very richly with gold and silver and a few colours... the body of the gown white satin... ; there was abundance of embroidery, and many people in gowns and petticoats of different colours."[20]

If Mary Delany wore the black embroidered petticoat with a mantua of contrasting color,[21] the other embroidered fragments traditionally associated with her court dress could not have been incorporated into the same garment. These have all been mounted in glazed frames since the nineteenth century, preventing close examination for clues as to their original use. Like the panels illustrated in figures 58 and 61, they are also worked in colored silk threads on a black silk satin ground, and the resemblance of some of the larger flower sprigs in figure 63 to some of those in figure 58 suggests a similar design source for these particular motifs. But the disposition of the flowers is very different. It conforms more conventionally to the regularity of pattern repeat, working with the serpentine line defined by William Hogarth as the "Line of Beauty,"[22] in the way that the designer Anna Maria Garthwaite incorporated it into her designs for woven silks (fig. 64). Garthwaite, however, was constrained in her designs by requirements dictated by the mechanism of the loom, whereas hand embroidery has no such con-

Figure 62: Dress fabric, 1730s, brocaded satin. Abegg-Stifting, Riggisberg, Switzerland (3111)

Figure 63: Panel, design attributed to Mary Pendarves, ca. 1740, silk embroidery on satin, 44½ × 25 in. (113 × 63.5 cm). Private collection

Figure 64: Anna Maria Garthwaite, Design for woven silk, 1745, watercolor on paper, 16¾ × 10⅝ in. (42.6 × 27 cm). Victoria and Albert Museum, London (5983.7)

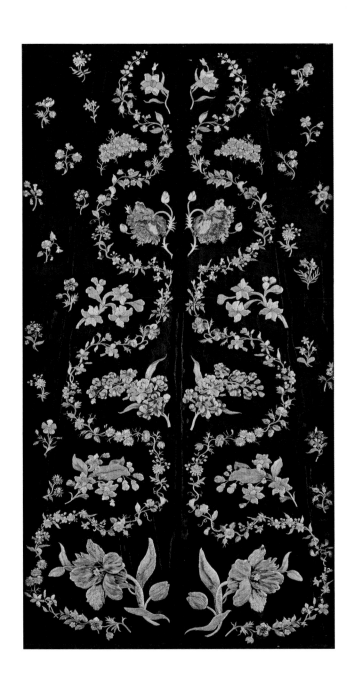

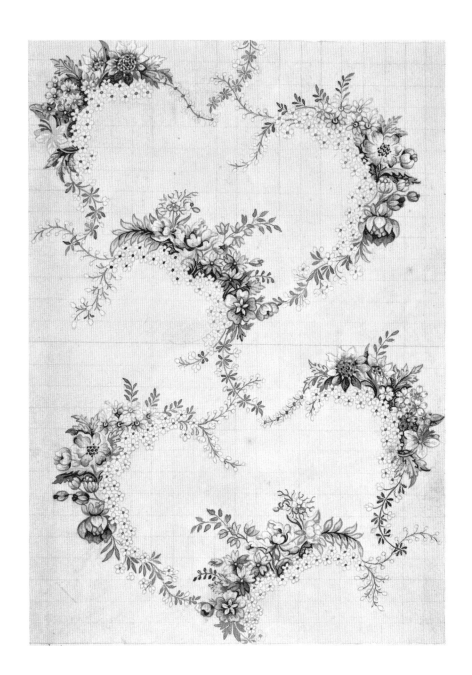

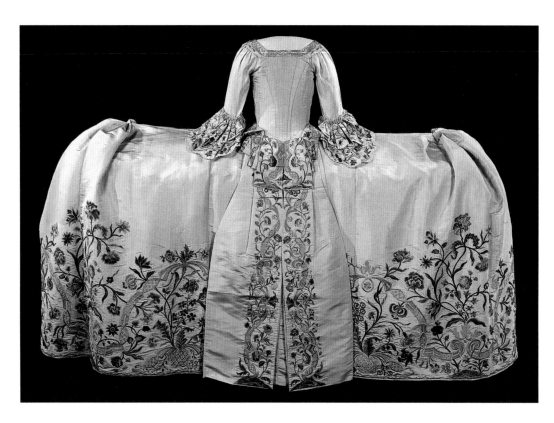

Figure 65: Mantua, mid-18th century, embroidered silk. Rijksmuseum Amsterdam (BK-1978-247)

Figure 66: Apron, designed by Mary Pendarves, ca. 1740, silk floss embroidery on silk grosgrain, 20½ × 40½ in. (52 × 103 cm). Private collection

straint, allowing for the possibility of creating a unique, non-repeating pattern throughout the surface. The embroidery is also less skilled than that on the petticoat panels (compare fig. 63 with fig. 58). If this fragment came from another mantua, the serpentine lines might have decorated a train, similar in form to that of a mantua in the Rijksmuseum, Amsterdam (fig. 65).

An apron associated with Mary Delany, also decorated with flowers of related design (fig. 66), and a stomacher of black velvet with embroidered flowers and applied silk lace (fig. 67) show that a combination of colors on black was sometimes the choice for dress accessories, when it might provide a dramatic contrast to the gown.[23] Another possibility is that the panel illustrated in figure 63 had a furnishing use. Embroidered satin was often used for fine furnishings in the early to mid-eighteenth century; for example, Houghton Hall, seat of Robert Walpole, listed a "satin suit of bed curtains wrought with gold and coloured silks" in its 1745 inventory, and Blenheim Palace a "couch of white satin richly embroidered in several colours" in 1740.[24]

Further suggestion that the fragments are not related to the petticoat shown (figs. 58, 61) comes from the description in Lady Llanover's *Specimens of Rare and Beautiful Needlework*, in which two details are illustrated and described: "These groups are on a petticoat of black satin,

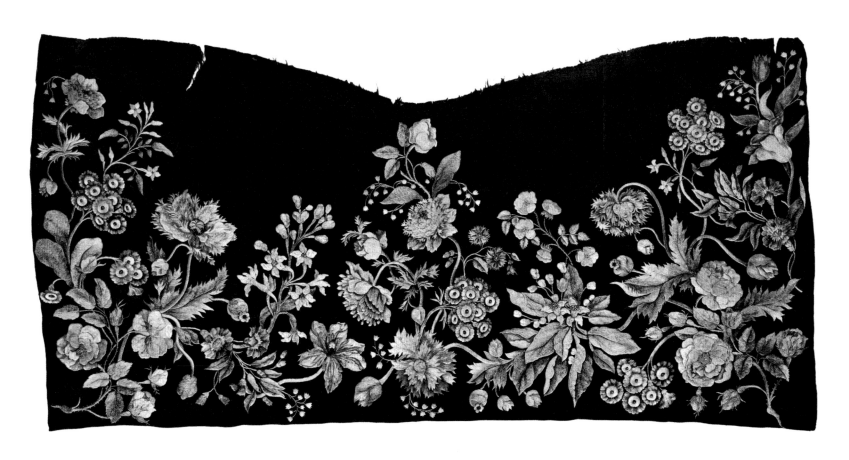

belonging to her Excellency Madame Bunsen, which is entirely covered with various flowers designed by Mrs Delany from nature and executed in embroidery of hard twisted silk of dazzling colours, but exquisitely shaded." No mention is made of other pieces comprising a mantua, but the description continues: "This petticoat was probably the one Mrs Delany wore at Norfolk House at a ball given by the Prince and Princess of Wales… and is mentioned in a letter of Mrs Delany's as being an occasion when the ladies invited vied with each other in rare inventions and beautiful designs for their hooped petticoats."[25]

The description also makes reference to a distinctive feature of the petticoat—the larger flowers do not appear at first to have been worked directly onto the satin. The interpretation from 1860 was that "Mrs Delany having a number of groups of flowers from nature already embroidered on another ground, appropriated them to the purpose of the Royal fete by cutting them out and laying them on black satin."[26] In fact, closer examination reveals that they are raised with padding, to give them a three-dimensional effect and enhance their realism, and the majority of the embroidery stitches thus do not come through to the back of the fabric.

This skilled technique would only have been in the repertoire of an experienced embroiderer, and is among a number of factors suggesting that the embroidery of the petticoat panels was the work of a professional, not Mary Delany herself. The profession of embroidery was one of the trades described by Campbell, in his *London Tradesman* of 1747:

It is chiefly performed by women; is an ingenious art, requires a nice taste in drawing, a bold fancy to invent new patterns, and a clean hand to save their work from tarnishing. Few of the workers at present can draw, they have their patterns from the pattern-drawer, who must likewise draw the work itself, which they only fill up, with gold and silver, silks or worsteds, according to its use and nature.… We make some good work; but fall short of the bold fancy in French and Italian embroidery: this I take to be chiefly owing to a want of a taste for drawing in the performers; they may go on in a dull beaten tract, or servily imitate a foreign pattern, but know not how to advance the beauty of the old or strike out any new invention worth notice.[27]

The process of creating embroidery for articles of dress was laid out in Smith's *Laboratory; or, School of Arts* (1756). Noting that embroidery in silk was not so much in vogue as it had been some years earlier (which corresponds to its popularity at court in the 1730s and 1740s), it continues:

[W]hat is done in that way is commonly in imitation of natural flowers, as nothing else can exceed it, on account of beauty and colours. The designs for this work are commonly drawn only with an outline, shadowed with Indian ink, then pricked with a needle, and pounced with charcoal dust, on white, and powdered white chalk upon dark or coloured grounds, and then drawn with a pen. The embroiderers being guided, by the shadowing of the pattern, how to proceed, pitch upon colours suitable to each flower or leaf, and work their shades accordingly.[28]

We know that from an early date Mary Pendarves was drawing flowers that could be used as embroidery motifs on clothing. In 1724 she wrote to her sister, Anne, in Gloucester: "You desire some sprigs for working a gown, which I will send you, though my fancy is not a good one."[29] In the preceding sentence Mary suggested that "in the country if it is more convenient to you" Anne need not observe the strict rules of mourning etiquette in her dress, and as an unmarried nineteen-year-old she could wear a gown decorated by herself on informal occasions. But Gloucester was far from London society and its fashions. For court occasions, Mary Pendarves "dressed myself in all my best array" as a matter of course. When she attended court for Queen Caroline's birthday on 4 March 1729 in the company of Lady Carteret, she was singled out by the queen: "She told me she was obliged to me for my pretty clothes, and admired my Lady Carteret's extremely; she [Lady Carteret] told the Queen that they were my fancy, and that I drew the pattern."[30] This comment allows two interpretations—that Mary Pendarves's embroidery designs were used either for her own clothes or for Lady Carteret's—but in either case it is her drawing that is being commended, not her embroidering of them; the designs must have been realized by a professional. In the same year Mary wrote from London to her sister, Anne, who was visiting Bath: "Your white satin came home last night, and is prodigiously pretty. I have sent it to be made, and shall send it to the Bath this week."[31] This is possibly another example of her own embroidery design passing through the hands of two professionals—the embroiderer to whom the white satin was consigned to be made "prodigiously pretty," and the mantua-maker who would make it up into a gown.

The evidence from her letters certainly shows Mary Delany to have practiced embroidery in the household projects typical for women of her class and generation, but it is evidence of industry rather than skill. Almost all of the references are to types of furnishing, sometimes in time-consuming joint projects with her sister: "[T]ell me how many pieces of cross-stitch I have left with you, and what grounds the borders have? I am determined, if possible, to finish my set of chairs against next year. Don't work at that which is wrong traced, I design it for a screen, and shall want the chairs first."[32] The articles of clothing that Mary and Anne worked were small, easy-to-handle accessories that could be undertaken in company: decorated tippets and "manteils" (types of small shoulder cape), handkerchiefs, muffs, and whitework aprons.[33] For the embroidered furnishings they undertook, Mary Pendarves rarely expressed the relish she evidently took in other handicrafts; when she was a younger woman at least, with less time for needlework, she might pay to have them completed. On 16 February 1744 she wrote to Anne: " I have bought your worsted and silk for my brother's chair that you are to work… . I could not meet with any work-women that would do it under two guineas and a half. The materials for working come to eighteen shillings."[34]

Figure 67: Stomacher, design and embroidery attributed to Mary Pendarves, ca. 1740, silk embroidery on velvet, 13¾ × 7⅞ in. (35 × 20 cm). Private collection

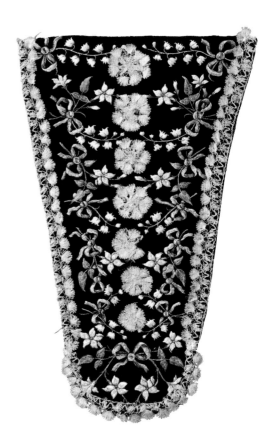

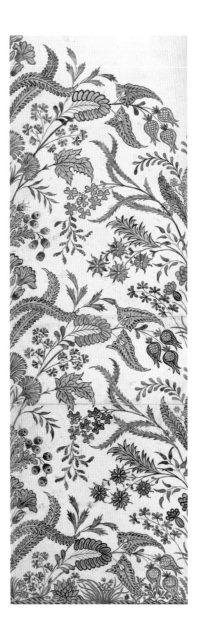

Figure 68: Dress fabric, ca. 1725, brocaded silk. Victoria and Albert Museum, London (T.18a-1969)

Figure 69: Anna Maria Garthwaite, Design for woven silk, ca. 1727, watercolor on paper. Victoria and Albert Museum, London (5970.46)

The most explicit reference Mary made in her letters to paying for the services of a professional embroiderer for her clothing occurs in her description of the Prince of Wales' ball at Norfolk House in February 1741. After a detailed description of the Duchess of Queensberry's clothes—which "pleased me best"—she commented, "I never saw a piece of work so prettily fancied, and am quite angry with myself for not having the same thought, for it is infinitely handsomer than mine, and could *not* cost *much more*... ."[35] So on that occasion she was wearing a mantua decorated with a pattern designed by herself but for which she had paid to have it embroidered. It is apparent from Mary's descriptions of court occasions in this period that elaborate embroidered decoration was a highly fashionable choice for court dress, and that woven silks copied their effects ("There were several very handsome flowered [i.e., drawloom-woven] silks, shaded like embroidery... ."[36]

It is also notable that the best of the embroiderers were not anonymous workers, but skilled craftswomen whose talent was admired and with whom customers like Mary Pendarves might form long associations. Among the well known was Mrs. Phoebe Wright, whose work Mary credited in a letter to her sister of 29 November 1742, on the occasion of the birthday of the Princess of Wales: "the finest clothes were Lady Caroline Lenox's, gold and colours on white, embroidered by Mrs. Wright."[37] Forty years later Mrs. Wright's work was still being singled out and celebrated: Miss Hamilton, visiting Mrs. Delany at Bulstrode in 1783, wrote in her diary on 4 December, "we went upstairs to yᵉ Dˢˢ in yᵉ drawing-room; yᵉ Dˢˢ brought me some of yᵉ late Mrs Wright's work to look at—a bird in worsted and flowers in silk on wᵗ sattinn... ."[38]

Another professional embroiderer whom Mary Delany mentioned by name was Jenny Glegg. In a letter of 3 December 1753, Mary

described the Duke of Portland wearing a coat of "dark mouse-coloured velvet, embroidered with silver; Jenny Glegg's work, and the *finest I ever saw....* ."[39] At the lavish wedding of Mr. Spencer to Miss Poyntz in January 1756, the bride's trousseau included "a pink satin with embroidered facings, and robings in silver done by Mrs. Glegg."[40] When Mary Delany described to her sister some good fortune that had come to a virtuous young woman—"little Polly, who lives with Mrs. Glegg"—she continued, "It is pleasant to see the young things we have known from infancy in a prosperous way,"[41] evoking the suggestion of a professional/client relationship between Mary and Mrs. Glegg lasting over many years. As providers of the fundamental means to be fashionable, it is not surprising that the tradespeople who supplied textiles and clothing were important in the lives of women like Mrs. Delany, and that trusting and affectionate relationships might develop. On 16 January 1747, Mrs. Delany was preparing to pay a morning visit to the Court of St. James; as she sat writing to her sister, Anne, her head was already dressed but she was still waiting for her mantua, which Mrs. Cob had promised to bring by twelve. As an aside (*"This is by the by"*), Mary Delany added that "she is I hope well married; her husband seems to have sense, and has promised me to be very kind to his wife."[42]

If Mary Pendarves wore her black satin petticoat to the Prince of Wales' ball in February 1741, it certainly would have stood out. Even accompanying a lighter-colored mantua, the black would have contrasted with the clothing of the other ladies present, whose choices were predominately white (led by the princess)—with one or two in violet, lemon, or pale pink—and decorated with copious amounts of colored silk embroidery, gold, and silver. Nevertheless, the naturalistically drawn flowers on the black petticoat would have been in keeping with a recurring fashion in English textile design in the previous three decades, and anticipated its full flowering in the 1740s.

The development of textile design in England through the first half of the eighteenth century can be followed most closely in the work of the Spitalfields master weaver and designer James Leman and the independent silk designer Anna Maria Garthwaite.[43] Both supplied silks, or the designs for them, to the leading mercers in London. English silks followed developments in French textile design closely, competing with imported silks in a highly lucrative market in which fashions changed season by season, but developing a characteristic interpretation that was more naturalistic than its original French inspiration. During the 1720s, Mary Pendarves would have been surrounded by woven and embroidered silks patterned with symmetrical and formal yet delicately drawn designs, like that of the circa 1725 silk (fig. 68) or the 1727 design by Garthwaite (fig. 69). Garthwaite's design has the layout of scattered flower sprigs above a bottom border of flowers and plants that had become a standard part of the repertoire of English embroidery from the later seventeenth century, seen most familiarly in crewelwork (fig. 70). By the 1730s, delicacy in the drawing of the individual motifs had given way to a bolder effect, the "great ramp-

Figure 70: Workbag, maker and designer unknown, 1712, crewelwork embroidery. Victoria and Albert Museum, London (T.205-1970)

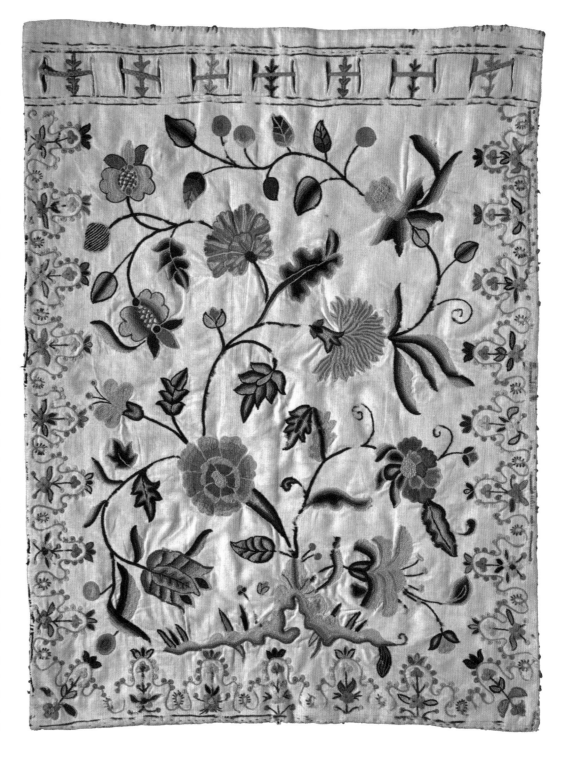

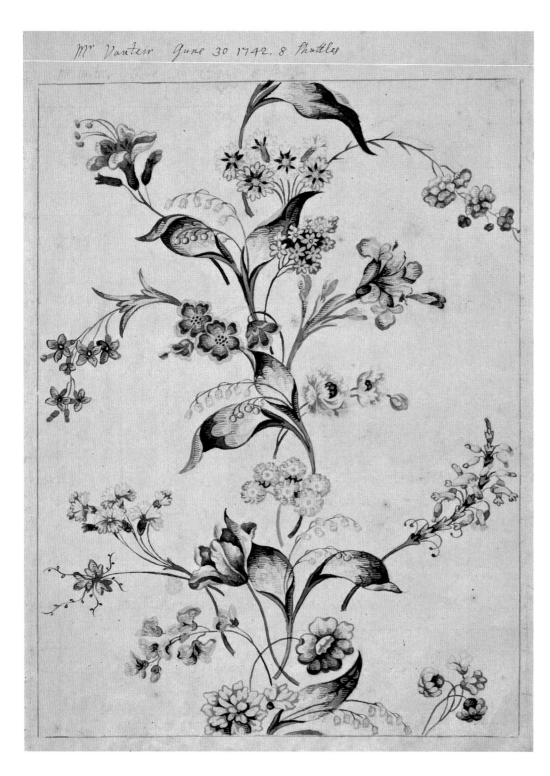

Figure 71: Anna Maria Garthwaite, Design for woven silk, 1742, watercolor on paper, 17½ × 10¾ in. (44.5 × 27.3 cm). Victoria and Albert Museum, London (5981.14)

ing flowers" of Mary Pendarves's 1733 brocaded lutestring (a type of woven silk) (see fig. 57). But greater realism in both woven and embroidered silks was also being pursued, through more sophisticated shading effects that could suggest three-dimensional form in flowers and fruit.[44] Mary wrote to her sister, Anne in 1733: "The work I design sending you is some I have ready drawn, but it must not be traced—traced work is very ugly, and quite out of fashion. You that have a knowledge of shading cannot be at a loss... ."[45]

In the 1740s, the depiction of flowers in both woven and embroidered dress fabrics reached a realism that has never been equaled. The black petticoat represents one end of the range, where the exquisitely depicted flowers are intended to appear as though they were freshly picked and simply scattered over the skirt; some of Garthwaite's designs aspire to the same effect, though constrained by pattern repeat, which her skill as a designer did its best to disguise (fig. 71). Rather more contrived is the embroidered petticoat of a mantua in the Museum of London that shows a similar profusion of naturalistic flowers, though implausibly all blooming from the same twining stem (fig. 72). And at the other end of the range is a mantua in the V&A on which realistically drawn garden flowers and florists' flowers spill out of elaborate rococo forms thickly encrusted with silver (fig. 73). Alongside the ostentation that such a mantua represents, Mrs. Delany could be self-deprecating: "The Duchess of Bedford's clothes were the most remarkably fine, though finery was so common it was hardly distinguished, and my little pretension to it, you may imagine, was easily eclipsed by such superior brightness." But of the same occasion she wrote to her sister that she "was told by critics in the art of dress that I was well dressed."[46] The understated exquisiteness of the black petticoat might represent the epitome of her highly personal interpretation of the extravagant fashions to which she had to conform. Although it demonstrated her artistry and individuality, its restraint, its lack of any gaudy or glittering detail, would have saved her from the reproach of inappropriate extravagance, and surely she would have been confident in the harmony of the appearance she created in it.

Figure 72: Petticoat from a mantua, 1740s, embroidered silk. Museum of London (83.844)

Figure 73: Mantua, ca. 1744, embroidered silk, 66⅞ × 70⅞ × 31½ in. (170 × 180 × 80 cm). Victoria and Albert Museum, London (T.260-1969)

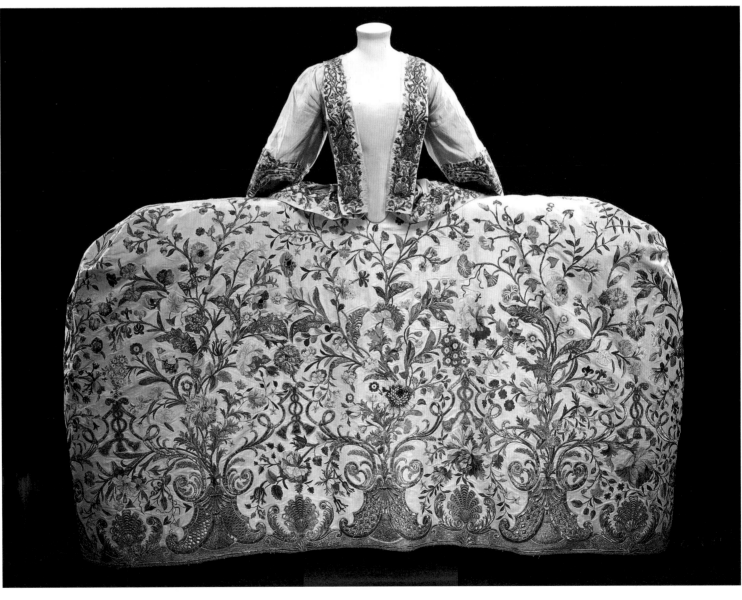

Acknowledgments

I am grateful to several friends and colleagues for advice and discussion concerning Mary Delany's court dress, in particular Joanna Marschner, Susan North, and Lesley Miller.

Notes

1. Anne Buck, *Dress in Eighteenth-Century England* (London: B. T. Batsford, 1979), 13.

2. Mary Delany to Anne Dewes, [probably August 1750], in Lady Llanover, ed., *The Autobiography and Correspondence of Mary Granville, Mrs. Delany*, 6 vols. (London: Richard Bentley, 1861–62), ser. 1, 2:580.

3. Mary Delany to Anne Dewes, 2 November 1751, in Llanover, ed., *Autobiography and Correspondence*, ser. 1, 3:52.

4. Mary Delany to Anne Dewes, 21 January 1747, in Llanover, ed., *Autobiography and Correspondence*, ser. 1, 2:449–50. "Winkers" seem to have been synonymous with "blinkers"—in Mary Delany's phrase, a type of headdress with wide sidepieces. The OED gives her citation as one of its few examples of usage. "Bodkin" is a long pin used in needlework or to fasten clothes or hair.

5. For example, her list of clothing appropriate for marking the death of Anne's brother-in-law, and the time periods appropriate for wearing different aspects of it, Mary Delany to Anne Dewes, 20 October 1747, in Llanover, ed. *Autobiography and Correspondence*, ser. 1, 2:478; for royal mourning at the death of George II, see Mary Delany to Anne Dewes, 28 October 1760, in Llanover, ed., *Autobiography and Correspondence*, ser. 1, 3:607.

6. Mary Delany to Anne Dewes, 2 February 1760, in Llanover, ed., *Autobiography and Correspondence*, ser. 1, 3:583.

7. Mary Pendarves to Anne Granville, 30 October 1732, in Llanover, ed., *Autobiography and Correspondence*, ser. 1, 1:387.

8. Mary Pendarves to Anne Dewes, February 1741, in Llanover, ed., *Autobiography and Correspondence*, ser. 1, 2:146.

9. Mary Pendarves to Anne Granville, 16 February 1734, in Llanover, ed., *Autobiography and Correspondence*, ser. 1, 1:428.

10. For a detailed description of the clothing of the royal couple and their guests, together with the furnishing of the Chapel Royal, see Natalie Rothstein, "God Bless This Choye," *Costume* 11 (1977): 56–72.

11. Llanover, ed., *Autobiography and Correspondence*; *Specimens of Rare and Beautiful Needlework, Designed and Executed by Mrs. Delany and Her Friend the Hon. Mrs. Hamilton; Photographed from the Originals in the Possession of Lady Hall of Llanover*, 2 vols. ([London]: Dickinson Bros., ca. 1860).

12. Nigel Arch and Joanna Marschner, *Splendour at Court: Dressing For Royal Occasions since 1700* (London: Unwin Hyman, 1987), 26–42.

13. For a detailed explanation of the mantua's construction, see Avril Hart and Susan North, *Historical Fashion in Detail: The 17th and 18th Centuries* (London: V&A Publications, 1998); Madeleine Ginsburg, "Ladies' Court Dress: Economy and Magnificence," in *The V&A Album 5* (London: De Montfort Publishing for the Associates of the V&A, 1986), 142–54; and Judith Dore, "The Conservation of Two Eighteenth-Century English Court Mantuas," *Studies in Conservation* 23 (1978): 1–14. See also the several detailed descriptions and scale drawings of surviving mantuas published by Janet Arnold, included in "Janet Arnold: List of Publications," *Costume* 34 (2000): 3–6.

14. Letter of 3 November 1711, quoted in Arch and Marschner, *Splendour at Court*, 37.

15. Mary Pendarves to Anne Granville, 17 November 1728, in Llanover, ed., *Autobiography and Correspondence*, ser. 1, 1:178.

16. Mary Delany to Anne Dewes, 10 November 1754, in Llanover, ed., *Autobiography and Correspondence*, ser. 1, 3:300.

17. Mary Pendarves to Anne Dewes, February 1741, in Llanover, ed., *Autobiography and Correspondence*, ser. 1, 2:148.

18. Mary Delany to Anne Dewes, 15 January 1747, in Llanover, ed., *Autobiography and Correspondence*, ser. 1, 2:447.

19. Mary Pendarves to Anne Granville, 23 January 1739, in Llanover, ed., *Autobiography and Correspondence*, ser. 1, 2:27–28.

20. Mary Pendarves to Anne Granville, 22 January 1740, in Llanover, ed., *Autobiography and Correspondence*, ser. 1, 2:71–72.

21. Another contemporary reference to this fashion for wearing gowns and petticoats of contrasting color was made by the wife of the British Consul at the Russian court in St. Petersburg in 1734: "The ladies were dressed in stiffened bodied gowns of white gauze with silver flowers; their quilted petticoats were of different colours, as every one fancied. I was pleased with a gentleman's description of a lady; on my not knowing which he meant, he said 'Celle-la avec le cotillon rouge' ["That one in the red petticoat"]." Jane [Mrs. William] Vigor, *Letters from a Lady, Who Resided Some Years in Russia, to Her Friend in England: With Historical Notes* (London: Printed for J. Dodsley, 1775).

22. William Hogarth, *The Analysis of Beauty: Written with a View of Fixing the Fluctuating Ideas of Taste* (London: Printed by J. Reeves for the author, 1753).

23. Decorative aprons were a usual part of ladies' dress in the mid-eighteenth century on all but the most formal occasions. Thirty-eight aprons were listed in the 1747 inventory of the second Duchess of Montague's clothing; see Sacha Llewellyn, "'Inventory of Her Grace's Things, 1747'—The Dress Inventory of Mary Churchill, 2nd Duchess of Montague," *Costume* 31 (1997): 49–67.

24. Tessa Murdoch, ed., *Noble Households: Eighteenth-Century Inventories of Great English Houses: A Tribute to John Cornforth* (Cambridge: John Adamson, 2006), 181, 281.

25. *Specimens of Rare and Beautiful Needlework*, vol. 2, no. 7.

26. *Specimens of Rare and Beautiful Needlework*, vol. 2, no. 7.

27. R. Campbell, *The London Tradesman: Being a Compendious View of All the Trades, Professions,*

Arts, Both Liberal and Mechanic, Now Practised in the Cities of London and Westminster… (London: Printed by T. Gardner, 1747), 153–54.

28. G. Smith, *The Laboratory; or, School of Arts* (London, 1756), 47.

29. Mary Pendarves to Anne Granville, 28 March 1724, in Llanover, ed., *Autobiography and Correspondence*, ser. 1, 1:96.

30. Mary Pendarves to Anne Granville, 24 March 1729, in Llanover, ed., *Autobiography and Correspondence*, ser. 1, 1:191. With uncharacteristic self-praise, she reckoned "[I] made a tearing show."

31. Mary Pendarves to Anne Granville, 16 September 1729, in Llanover, ed., *Autobiography and Correspondence*, ser. 1, 1:214–15.

32. Mary Pendarves to Anne Granville, 10 October 1737, in Llanover, ed., *Autobiography and Correspondence*, ser. 1, 2:6.

33. Mary Pendarves to Anne Granville, in Llanover, ed., *Autobiography and Correspondence*, ser. 1, 1:159 (29 February 1728), 424 (19 December 1733), 282 (13 July 1731), 425 (19 December 1733), and 587 (8 January 1737). They also occasionally made children's or charity clothes; see Mary Delany to Anne Dewes, in Llanover, ed., *Autobiography and Correspondence*, ser. 1, 3:214 (17 March 1753), 2:362 (16 June 1745).

34. Mary Delany to Anne Dewes, 16 February 1744, in Llanover, ed., *Autobiography and Correspondence*, ser. 1, 2:263–64. Fifteen years later, in peaceful surroundings at Delville and enthusiastic to decorate the chapel, Mary Delany gave an insight into her working method: "I am working coverings for the seats in chenille on a black ground, which gives it a gravity…. My pattern a border of *oak-branches, and all sorts of roses (except yellow)*, which I work without any pattern, just as they come into my head." Mary Delany to Anne Dewes, 15 September 1759, in Llanover, ed., *Autobiography and Correspondence*, ser. 1, 3:565.

35. Mary Pendarves to Anne Dewes, February 1741, in Llanover, ed., *Autobiography and Correspondence*, ser. 1, 2:147, 148.

36. Mary Pendarves to Anne Dewes, 29 November 1742, in Llanover, ed., *Autobiography and Correspondence*, ser. 1, 2:200.

37. Mary Pendarves to Anne Dewes, 29 November 1742, in Llanover, ed., *Autobiography and Correspondence*, ser. 1, 2:200. Mrs. Wright was also a designer for woven silks; see Natalie Rothstein, *Silk Designs of the Eighteenth Century in the Collection of the Victoria and Albert Museum, London* (London: Thames and Hudson, 1990), 20.

38. Llanover, ed., *Autobiography and Correspondence*, ser. 2, 3:154.

39. Mary Delany to Anne Dewes, 3 December 1753, in Llanover, ed., *Autobiography and Correspondence*, ser. 1, 3:250.

40. Mary Delany to Anne Dewes, 14 January 1756, in Llanover, ed., *Autobiography and Correspondence*, ser. 1, 3:399.

41. Mary Delany to Anne Dewes, 30 October 1754, in Llanover, ed., *Autobiography and Correspondence*, ser. 1, 3:296.

42. Mary Delany to Anne Dewes, 15 January 1747, in Llanover, ed., *Autobiography and Correspondence*, ser. 1, 2:447.

43. For extensive illustrations and descriptions of Leman's and Garthwaite's designs, see Rothstein, *Silk Designs*.

44. For extensive discussion of naturalism in textile design in this period, see Anna Jolly, *Seidengewebe des 18. Jahrhunderts / 18th-Century Silks*, vol. 2, *Naturalismus* (Riggisberg: Abegg-Stiftung, 2002). See also Clare Browne, "The Influence of Botanical Sources on Early 18th Century Silk Design," in Regula Schorta, ed., *Seidengewebe des 18. Jahrhunderts / 18th-Century Silks*, vol. 1, *Die Industrien in England und in Nordeuropa / The Industries of England and Northern Europe* (Riggisberg: Abegg-Stiftung, 2000), 34–35.

45. Mary Pendarves to Anne Granville, 16 February 1734, in Llanover, ed., *Autobiography and Correspondence*, ser. 1, 1:429.

46. Mary Pendarves to Anne Granville, 22 January 1740, in Llanover, ed., *Autobiography and Correspondence*, ser. 1, 2:71.

[3]

DRESSING FOR COURT:

Sartorial Politics & Fashion News in the Age of Mary Delany

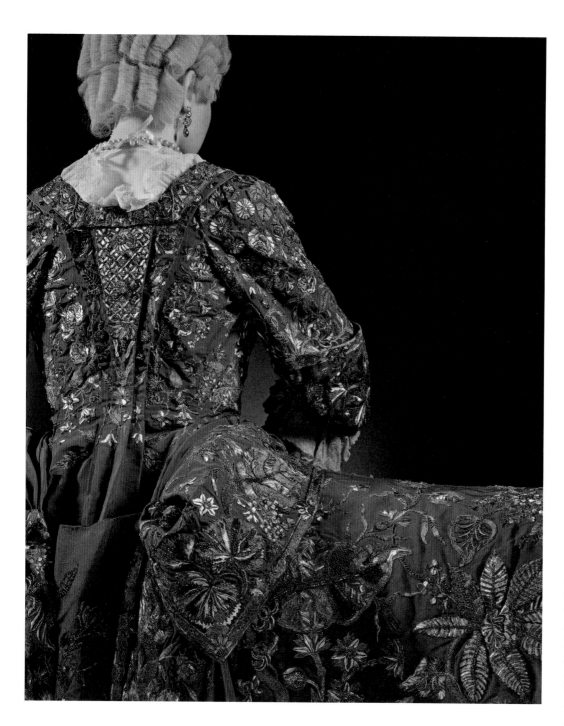

Figure 74: English court dress, 1740–45.
Victoria and Albert Museum, London (T.227&A-1970)

The fragments of what were believed to be Mary Delany's famous "court dress" have proved a tantalizing jigsaw. Despite some being remade into other items (such as firescreens) when passed down through generations, the association of the striking fabric pieces with the eighteenth-century court, family heritage, and Mrs. Delany herself has stood the test of time. As revealed in the previous chapter, the front and back petticoats have now been pieced together and confirmed to have belonged to a court dress of circa 1740–41. Clare Browne's illuminating research combined highly skilled analysis of the extant fragments with careful investigation of the context suggested by Delany's own correspondence and its rich references to clothing and court display. In spite of disjointed material evidence, Mary Delany's written words offered a valuable link between the partial form the surviving fabric currently takes and the possible appearance of the original dress.

Browne's research has shown Delany to be a ready and opinionated reporter of contemporary fashions, generating a commentary within which court dress is routinely referenced. Her letters of the 1720s, written while still Mary Pendarves, regularly detail the appearance of clothing shown at court. One, written to Anne Granville on 4 March 1728, is typical in its range. In it, she details the specific choices of color and cut made by various court personages, such as Lady Carteret's "green and gold, embroidered and trimmed," and the Princess Royal in "white poudesey, embroidered with gold and a few colours intermixed." Yet her commentary also includes explicit judgments on the success and reception of the displayed attire. While praising Lady Carteret's gown as "the finest there," she found Lady Hartford looked "whimsical and not pretty," and the Princess Royal's petticoat was "very handsome, but the gown looked poor." With regard to her own clothing, she noted that the queen commended her for the display that she made: "[S]he told me she was *obliged to me* for my pretty clothes, and admired my Lady Carteret's extremely... ."[1] Such a pattern of

commentary appears in Mary Delany's correspondence throughout the century.[2]

It might be considered a stroke of fortune that both as Mrs. Pendarves and as Mrs. Delany she chose to record her thoughts on court clothing, for without them it would be harder to reconstruct and understand the court mantua attributed to her. However, she was far from singular in her preoccupation. A similar epistolary practice can be identified in other collections of elite correspondence, wherein court dress appears as a routine point of reference between correspondents. In the 1730s, Lady Anne Campbell, for instance, received a four-page letter devoted entirely to court dress. The unknown sender (signed only "CB") carefully recalled the clothing worn by more than forty-five different figures seen at the birthday court of George II. Starting with the royals themselves, including the king "in scarlet and gold" and Princess Louisa "in a dark green velvet embroidered with gold," the register extended to courtiers, other nobles, and a handful of untitled attendees. Of the ladies, the Duchess of Dorset reportedly wore a gown "on purpose trim'd with old fashion'd gold net," Lady Anne Montagu "a silver trimming upon yellow sattin," and Lady Deloraine a gown embroidered with "material flowers without gold or silver" and declared "the handsomest" seen. Not all received the recorder's praise. The Duchess of Bolton's scarlet gown with green flowers was censured as "very abominable at St James's," Lady Pembroke's "dark green ground [with] yellow flowers" was panned for being "as thick as a board and ye ugliest thing" (despite costing forty shillings a yard), and the writer was perplexed by Lady Cardigan's eccentric attire, "with a sleeve of her own invention contrived to look as if her arms were pinion'd." Overall, the conscientious writer concluded that there were "a vast number of old clothes," with the exception of Lord and Lady Shannon, who both dressed "clean and new."[3]

While this particular letter stands out for the sheer number of garments catalogued, comparable content and detailed referencing can be found in many other sources. In the 1690s, Lady Frances Bathurst compiled notes for the Duchess of Marlborough on the dresses flaunted at the court of William III and Mary.[4] When Anne, Countess of Strafford, sent near daily letters from London to her husband (then a diplomat based in The Hague), clothing seen at Queen Anne's birthday balls and drawing rooms was a routine inclusion alongside political updates and family news.[5] Nor was such reporting a peculiarly female obsession. The Earl of Strafford received similar accounts from his brother, the Right Honorable Peter

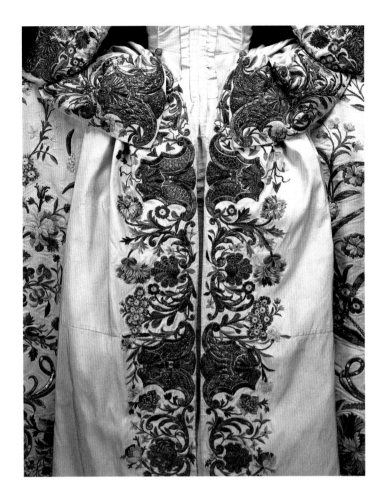

Wentworth, and throughout the 1730s and 1740s Lord Egmont noted in his diary each occasion when he and his family wore new clothes to the courts of George II and Frederick Prince of Wales. They also recorded the clothes worn by others.[6] Similar examples can be found as the century progressed. In the late 1740s, Lord Beauchamp received briefings from Lady Hertford that detailed the wardrobes of those appearing at court. During the 1770s, the letters that passed between the daughters and other family members of Jemima, Marchioness Grey of Wrest Park in Bedfordshire, were packed with references to clothing; court dresses were described as a matter of course.[7] Although monarchs came and went, a fascination with court attire appears as common to those who attended and sought news of William and Mary's 1690s court as it was to those who observed the Regency climate of the early 1800s (figs. 74–76).

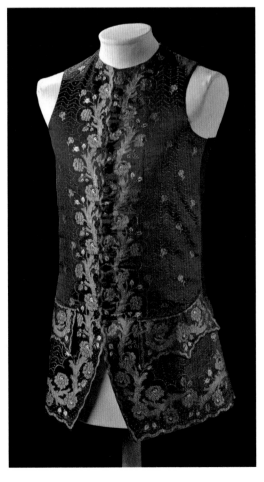

Figure 75: Woman's court dress, 1740–45, silk, embroidered with colored silk and silver thread, 66⅞ × 70⅞ × 31½ in. (170 × 180 × 80 cm). Victoria and Albert Museum, London (T.260&A-1969)

Figure 76: Man's brocaded silk waistcoat, 1760s. Victoria and Albert Museum, London (894-1864)

It is this practice of reporting court dress, revealed by Mary Delany but corroborated by a rich array of other contemporary textual sources, that this essay examines. In an age when the recipient paid to receive a letter—its price determined by the number of sheets of paper enclosed as well as by the distance it had traveled—these sartorial reports were surely valuable. But why was fashion information obtained from court so highly prized? What did the court displays at court signify to observers, and why were details of them circulated as significant epistolary news?

The answers to such questions might seem obvious. After all, it could be argued that costumed magnificence stands as the sine qua non of all court cultures and sartorial show is an unsurprising device used to honor a monarch and collectively project the sovereign's splendor and authority. However, it has been widely asserted that a distinguishing feature of the courts of eighteenth-century Britain was their marked failure to conform to this basic formula of court performance. Instead, it is a studied retreat from opulence, a repudiation of excess, and a distinct lack of splendor (caused by fiscal and political restraint) that stand in the foreground of classic narratives of the late Stuart and Hanoverian court history. Queen Anne's lackluster court has been conclusively investigated by Robert Bucholz, and a decided decline in royal spectacle has been widely cited as a characteristic of the century.[8] George III and Queen Charlotte were so famed for their frugality that James Gillray pilloried their tastes and caricatured their parsimonious lifestyle (figs. 77, 78). To be sure, their heir apparent, George Prince of Wales (later George IV) was notoriously flamboyant, but this excess and showmanship is the exception that proves the rule: a flurry of ostentation stimulated by political opposition and constitutional uncertainty, yet ultimately a short-lived extravaganza preceded and succeeded by monarchical sobriety and restraint.

Narratives of eighteenth-century social and political change have focused more often on areas of British culture that seemed to burgeon as the court declined. Influenced by Habermasian ideals of a public sphere, it has been the expansion of urban society, the proliferation of new sites of

Figure 77: James Gillray, *Toasting Muffins*, *Vide Royal Breakfast*, 1791, hand-colored etching and aquatint. Courtesy of The Lewis Walpole Library, Yale University (791.11.28.1)

Figure 78: James Gillray, *Frying Sprats*, *Vide Royal Supper*, 1791, hand-colored etching and aquatint. Courtesy of The Lewis Walpole Library, Yale University (791.11.28.2)

entertainments such as pleasure gardens and assembly rooms and precisely the non-courtly, commercial world that has attracted scholarly attention.[9] Recent revisionist work, such as that completed by Hannah Smith, has begun to argue for a more complicated story, one that integrates historians' portrayal of eighteenth-century cultural modernity with an ongoing and still significant court culture.[10] The picture now emerging is one that emphasizes the relationship between court and parliament, court and the state, and court and the wider public, rather than charting a narrative of uncontested monarchical decline. Moreover, this essay contends that it is possible to develop further this more nuanced analysis of eighteenth-century political and social change by looking at cultural symbols such as court clothing.

Just as the court as an institution has been given little space in accepted narratives of eighteenth-century change, so court dress has received similarly short shrift in current fashion and consumption histories of the period. If anything, court dress has been taken to symbolize all that eighteenth-century fashion was not. Historians have reveled in Georgian Britain's status as a new consumer society, and the democratizing potential of its expanding world of goods has attracted particular attention. It is now widely asserted that, rather than being driven by elite trendsetting and top-down taste, the diversification of consumable goods—from cheap and ready cottons to disposable wallpapers—allowed for spontaneous and individualized choices as well as collective displays of taste shaped as much by geography, age, religion, and gender as by social aspiration and the pursuit of status. No longer was the court or the elite the locus of cultural leadership. Trendsetters and designers instead operated in a profit-driven environment of mass production and consumer choice.[11]

Associated with the uniform of an elite and exclusive world, the form of court dress (for women at least) became increasingly isolated from current trends, and by the turn of the nine-teenth century, women's court dress appeared an arcane relic of a former age (fig. 79). In chronicles of eighteenth-century clothing, therefore, court dress is approached as a spectacular anomaly, intriguing for its excesses (in terms of fabric, skilled workmanship, and swollen shape) and eccentricity but difficult to fit into broader chronologies of vibrant fashion.[12]

In this context, a preoccupation with court dress throughout the century is more complicated than we might presume. This essay will revisit the reports of court clothing compiled by Mary Delany and her contemporaries in order to investigate the significance of court dress to eighteenth-century elite culture. Its concern is not to re-create the precise appearance of these garments, or to attempt to situate them within a history of fashion or style. Rather it is to understand why dress had such prominence in reports that focused on the court, and in what form, and with what intention, information about court clothing was distributed as news. To do this, the following analysis will look first at the main aspects of court dress singled out by commentators, and then at what such information signified to both writer and recipient.

Figure 79: J. Kennerley after Charles Hayter, "Records of Fashion 1809," hand-colored engraving from *Mrs. Fiske's Fashion and Court Elegance* (London, Printed by A. J. Valpy, Tooke's Court, 1812). Yale Center for British Art, Paul Mellon Collection

Mary Delany's letters reveal the inner workings of an influential system of sartorial politics. Court appearances often were interpreted by correspondents as meaningful political performances. Personal and collective allegiances were construed by commentators from the appearance of court clothing, and loyalty to the crown was mapped and measured through material show. So too were political protests, and court dress was interpreted as a barometer of discontent as much as of affiliation to the monarch. Perhaps most significantly, the attempts by correspondents to support, control, or challenge reports of court clothing show that the circulation of such information was itself politically charged.

From this perspective, then, we might usefully regard Mary Delany's epistolary accounts as a participation in a broader system of sartorial politics and information exchange, rather than as a fortunate yet coincidental interest in fashion. As Clarissa Campbell Orr reminds us in chapter 1, Mary Delany was no passive observer of an elite social world. She and her family were ambitious place-seekers, jockeying for position at court and trying to obtain a profile, through marriage or office, within the British elite. Against this background, her lengthy reports of court clothing become more comprehensible as a system of sociopolitical accounting: a means of mapping and monitoring the political climate of court through the unspoken signals of dress. This is not to suggest that Delany's interest in clothing was entirely removed from her other artistic pursuits. No doubt highly worked embroidered gowns captured her imagination as a skilled needlewoman, and the aesthetics of court attire were interpreted through her artist's eye. However, an understanding of the contemporary culture of letter writing in which her references to court dress were constructed illuminates the significance of court dress as a strategic political symbol.

Dressing for Court

Although the eighteenth-century court did not assert the same place in metropolitan entertainment and ceremony as had been commanded by royal rituals in Tudor and Stuart Britain, court attendance nonetheless remained a routine part of elite London life. Going to court provided a framework for elite social behavior that was based on longstanding tradition.[13] Presentations at court were the traditional markers of alterations in social identity, undertaken on reaching adulthood, on marriage, on promotion through the peerage, or entrance into a court or other official state position. Although few eighteenth-century formal presentation records survive, elite letters

reveal that presentation to the monarch, as well as subsequent routine participation in court events, was the norm.[14] When Lady Mary Grey entered fashionable society in 1774, her first appearance at court marked the beginning of her involvement in the whirl of metropolitan life. "I do not know whether Mama informed you," she wrote to her sister in 1774, "we made our appearance at Court last Thursday sevennight, and since then we have seen all that is to be seen."[15] However, many also recorded the obligation to participate in a courtly culture as a less attractive element of metropolitan culture, paling in comparison to the glamour of the opera, theater, and pleasure gardens. It is easy to extract quotes reflective of historian G. M. Trevelyan's famous assertion that the eighteenth-century court hosted events of "proverbial dullness."[16] The Duchess of Queensberry responded to expulsion from the court of George II (on account of her campaigning for subscriptions to support John Gay's anti-ministerial *The Beggar's Opera*) by thanking the king for relieving her from the tedium of court attendance.[17] The acerbic courtier Lord Hervey, who noted that "no Mill-Horses ever went in a more constant trac[k] or more unchanging Circle,"[18] found Kensington "the dullest of all dwellings."[19] Even for the loyal Mary Delany, participation in court events was at times more of a drudgery than a pleasure.[20]

Despite bemoaning their obligations, the elite recognized court as an integral part of eighteenth-century London life. The precise timetable of entertainments and ceremonies differed according to the politics and personality of each sovereign. In general terms, the standard sequence of events during the winter parliamentary season comprised Sunday church services (when the family processed with the attendants to the chapel at St. James's), *levées*, drawing rooms, and the celebration of royal birthdays. *Levées* tended to be held for important ministers, allowing them to forgather with the monarch in comparative seclusion. Under George III these meetings were all male and for government alone. Drawing rooms were larger affairs, often held three times a week, at which the nobility and gentry paid their respects to the monarch and showed themselves at court.[21] But it was the royal birthdays that formed the centerpiece of royal ceremony during the 1700s. The move toward celebrating dates personal to the reigning monarch, as opposed to dates particular to the principle of monarchy (such as important moments on the religious calendar or marking the anniversary of the Restoration), which was the emphasis of the Tudor and Stuart courts, is indicative of revised monarchical practice in

eighteenth-century Britain. A royal birthday celebration usually began with a church service in the morning, followed by an ode in praise of the monarch, penned by the Poet Laureate and set to music by the Master of Music. In late morning or early afternoon a drawing room would be held and, usually in the evening, a grand ball.[22]

Access to the royal courts in eighteenth-century Britain appears to have been policed using outwardly informal but nevertheless effective means. Appropriate dress, appropriate demeanor, and insider knowledge stood as the main requirements for entrance. In theory, anyone dressed genteelly was free to access the most public rooms of the London palaces (such as courtyards and entry rooms). However, to attend a formal event, such as a birthday drawing room, court-goers had to pass through an enfilade, which acted as a powerful filter, gradually removing all but the titled, the expected, and the invited.[23]

The gates to the royal palace stood as the first divisive boundary. Here public crowds gathered to watch the grandees pass to court in their finery. On occasion the pressures at the gates were alarming. In 1729 poor "young Miss Whitehead of Hampton" was wounded in the arm by a sentinel's bayonet as he tried to clear a path through the crowd so that she could access her sedan chair on departing from a drawing room.[24] One Samuel Saunderland found his pocket watch stolen in the crush of the mob who gathered at the gates on the birthday of the Prince of Wales in February 1751.[25] And even the aspiring, and occasionally aloof, politician George Canning could not resist joining the crowds in 1794 to watch the carriages pass by for a drawing room. With the gates monitored by court personnel and the courtyard beyond protected by a formal regiment of foot guards, only those clearly destined for the drawing room were allowed to pass through.

Court attendees left liveried servants and chairmen in the yard and proceeded on foot to a staircase in order to "ascend" to the presence of the monarch, entering the first room in the enfilade, the guard chamber. From there, the nobility passed through the presence chamber, then the privy chamber, and finally the "withdrawing room," where the monarch presided. (figs. 80, 81) At each stage, the credentials of attendees were checked by watchful courtiers responsible for filtering out those without rank or connection enough to progress. Given the small, interconnected world of the eighteenth-century elite, it is not hard to imagine that strangers would be noted quickly and their progress thwarted at such an event. In particular, access to

the final room—and therefore to the monarch's presence—was monitored by the monarch's high-ranking courtiers (gentlemen ushers at the door and their lords or ladies in waiting and Lord Chamberlain within the room), who likely had personal acquaintance with all others present. In his study of eighteenth-century court attendance, Robert Bucholz cites the experiences of diarist Dudley Ryder as indicative of the success of these procedures. Hopeful of participating in the birthday celebrations of George I, the ambitious Ryder dressed in his very best. He managed to gain access to the first room of the sequence through bluff, by feigning part of a noble's entourage, but thereafter found his access blocked by attentive gatekeepers.[26]

Despite the filtering imposed on the attendees by the enfilade, complaints about the crowds and crush of drawing rooms dominate contemporary recollections of key events. "Oh! Oh! Oh! My hips! My feet! My head!" cried Lavinia, Lady Spencer after attending court in 1792, "I am just returned from Court which was fuller than a birthday and lasted an eternity and Lady Ely nearly squeezed me flat against Mrs Ellis—but I saw the Dk (or could it be the Dss) of York & I saw young Mrs Hobbard, in short all the Genteel in London."[27] Similar hysteria echoes from the letters of others. In the 1780s Lady Louisa Stuart described the "frightful scene" of a court drawing room with "people crying and fainting and going into

The COURT at ST. JAMES'S.

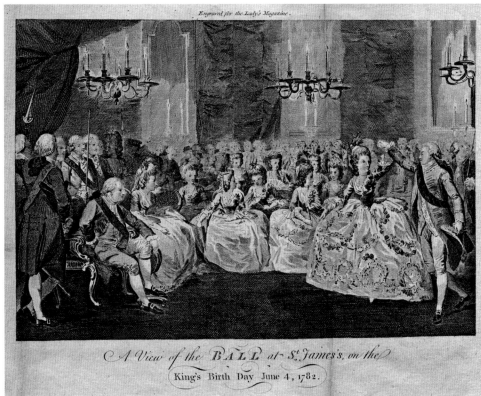

Engraved for the Lady's Magazine.

A View of the BALL at St. James's, on the
King's Birth Day June 4, 1782.

Figure 80: Artist unknown, *View of the Court at St. James's with the Ceremony of Introducing a Lady to Her Majesty*, 1766, etching with engraving. Courtesy of The Lewis Walpole Library, Yale University (766.0.13)

Figure 81: Artist unknown, *A View of the Ball at St. James's on the King's Birth Day June 4, 1782*, 1782, etching with engraving. Courtesy of The Lewis Walpole Library, Yale University (782.6.0.5)

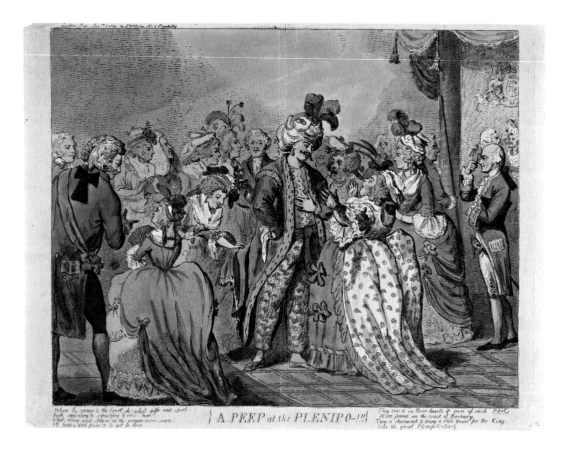

Figure 82: Issac Cruikshank, *A Peep at the Plenipo-!!!*, 1794, hand-colored etching. Courtesy of The Lewis Walpole Library, Yale University (794.1.1.9)

Figure 83: George Cruikshank, *Inconveniences of a Crowded Drawing Room*, 1818, hand-colored etching. Courtesy of The Lewis Walpole Library, Yale University (818.5.6.1)

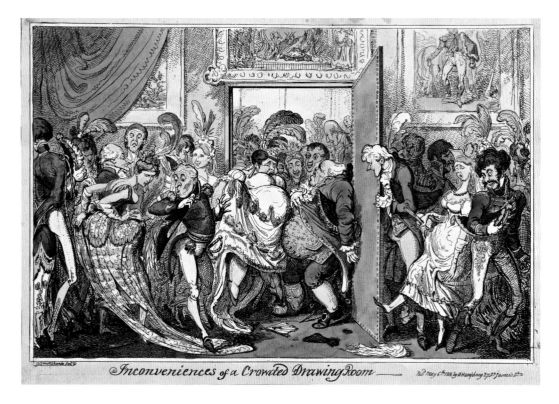

screaming fits" with Lady MacCartney lost to "violent hysterics" on her return home and Lady Mary Montagu, Lady Sydney, Lady Elizabeth Yorke, Mrs. Adair, and Miss Chaplin "fainting away.[28] In 1781 Mary Grantham found "heap and disorder" at a drawing room, and in the early 1800s Lady Sarah Spencer likened court crowds to a pack of cards.[29] (figs. 82, 83)

There are few records which reveal precisely how many attended the drawing rooms and numbers fluctuated year by year and throughout the season. However, the loss of Whitehall palace to fire in 1698 (with its sprawling twenty-three acres of central London accommodation), certainly had implications for the hosting of court entertainments during the 1700s. Throughout the period, the royal family was forced to make use of smaller palace accommodations, such as Kensington and St. James's, and (for the households of the Princes of Wales when separated from the court) even townhouses such as Leicester and Norfolk House. Space was at a premium. Yet, the gathering of crowds at the gates and within the palace walls is a reminder of the significant performative element of court attendance. The dresses that subsequently were reported in contemporary letters and the press had to make an impact in this environment, acting as a ticket for entrance but also proving successful and showy in a crowd, impressive in a crush, and able to wow from every angle.

Contemporary accounts reveal the striking investment made in the costumes commissioned for these occasions. Dressing for court was certainly an expensive undertaking. Anne, Countess of Strafford confessed to a £100 price tag for her court dress purchased in 1711, and the Duchess of Hamilton's dress, purchased in 1752, cost almost as much as her husband's brand new and luxuriously fitted sedan chair.[30] Such bills are breathtaking, far higher than expenditure on any other item in an elite wardrobe.[31]

In one regard, therefore, court clothing was a straightforward advertisement of financial standing. However, the investment was not simply in capital. Contemporary letters reveal that, as the planning and commissioning of garments could take many months, an investment of time was as indispensable as currency. This was particularly true for major court events, such as a royal birthday. The Countess of Strafford began preparing her gown for Queen Anne's birthday a full four months in advance, commissioning her husband to obtain a velvet for the dress from Holland.[32] When the Earl and Countess of Sutherland decided (somewhat reluctantly) to make the long journey to London in order to show themselves

at the new court of George III in 1761, their London-based acquaintances, the Erskines, warned against appearing in the London court without allowing enough time to prepare. With only two months to go before the Sutherlands were due in the capital, Lady Erskine stressed the urgency of deciding on their clothes: "I beg you would send me any commissions by the first post which you have to give about cloaths…. Every mortal is making up fine cloaths for the wedding, and the silks are already risen considerably in their price."[33] Lord Erskine sent further alerts with the reprimand that unless swift attention were paid to clothing "Lady Sutherland may as well walk amongst the Rocks at Dunrobin … for none would know her," and she would only be remembered as the "woman whose Robes and dress so ill fitted her person."[34] (fig. 84)

The selection of silk was the most straightforward part of the process of procuring a court dress. Women's court mantuas were extensively trimmed with additional brocade, lace, and flounces, all of which took time to source. So it was that, while her husband worried about the underlying velvet, the Countess of Strafford paid particular attention to her trimmings, scouring London for a "gold trimming which everybody will allow to be the finest they ever see."[35] In 1781, Hester Thrale loaded a court dress with no less than £65 worth of trimmings.[36] Indeed, to concentrate expenditure on trimmings was perhaps the more sensible investment. As Lady Anson explained to Jemima, Marchioness Grey, trimmings were transferable and might be recycled in a way that the court dress itself could not: "[I]f your ladyship would have your sleeves with ruffles which is the fashion, would you trim them with a Gold Blonde round the bottom, and up the seams ruffles, train etc would not come to above 14 or 15£ and would trim a Sack after the Birthday was over."[37] Lady Arundell's "plain silver close lace" trimming worn on a court dress in the 1730s was noted for being so easily removed that one commentator declared, "if it had been upon anybody reckoned to be a little covetous I should have thought it design'd to be converted next day into a coat for ye Husband."[38] (fig. 85)

It was not only fabric trimmings that were selected for court clothing and easily transferred between garments at a later date. Jewelry contributed to the show of court attire and the addition of diamonds in particular (or imitation cut stone and paste) was common sartorial practice for the elite. Mary Delany (then Mrs. Pendarves) repeatedly borrowed jewelry from the Countess of Sunderland to adorn her court clothing in the late 1720s and early 1730s.[39] The

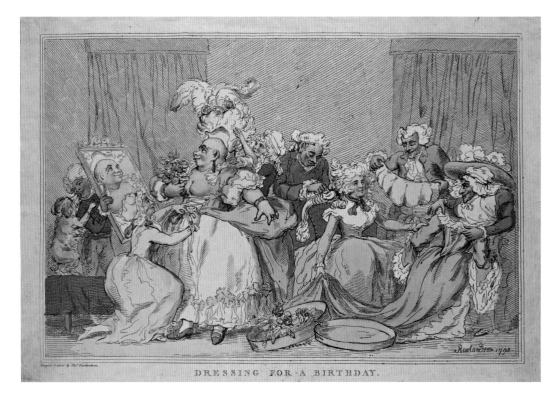

DRESSING FOR A BIRTHDAY.

Figure 84: Thomas Rowlandson, *Dressing for a Birthday*, 1790, hand-colored etching. Courtesy of The Lewis Walpole Library, Yale University (790.4.0.1+)

Figure 85: Sleeve of a woman's court mantua, 1775–85. Victoria and Albert Museum, London (T.13-1952)

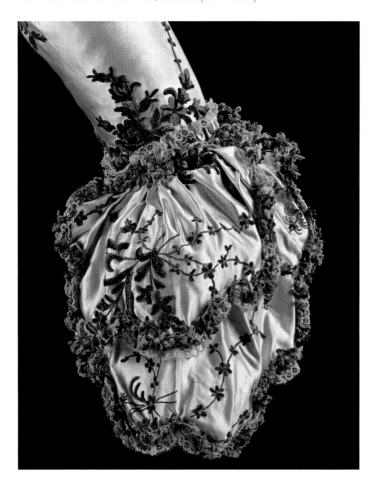

Countess of Strafford loaded her court dress with the Strafford family diamonds for her first appearance at court after marriage in 1711. In 1768, Sarah, Lady Cowper lent her diamond stomacher to Lady Spencer, "which, added to her own jewels, made her very brilliant";[40] and, in 1773, Amelia D'arcy wore the diamonds belonging to the family of the Duke of Leeds at court to broadcast her forthcoming marriage to the duke's son and heir, Francis Godolphin Osborne, Marquis of Carmarthen.[41] Sequins also contributed to the eye-catching shimmer, and velvet and striped silks were cut to dazzle. Birthday drawing rooms and balls in particular involved evening, candle-lit entertainments, and textiles and trimmings were selected to sparkle in the diffused light, yet the transferable nature of many of the sparkling accessories highlights that these displays were momentary and transitory. (figs. 86, 87)

One form of decoration, however, was more permanent: embroidery. The few court dresses that survive intact today tend to have detailed embroidery rather than detachable trimmings, no doubt because they were harder to remake into other garments once their specific court obligations had passed. The permanence of embroidery is surely significant, suggestive of a particularly high investment in court show unmatched by gowns dressed with transferable trimmings. Perhaps ornately embroidered gowns, such as Mary Delany's dress, should be approached from this perspective. Given her artistic fame, the striking embroidery of the dress has been presumed to be an example of her own skilled workmanship. Now it is clear from Clare Browne's essay that it is not, although it certainly reflects her personal interest in needlework.[42] Some contemporary embroidered pieces were known to be intensely personal productions. The embroidered waistcoat sported by Lord Parker to court in 1792, for example, was reported in *The Times* as "being the work of Lady Parker's leisure hours."[43] However, a man's embroidered waistcoat was easily worn again, outside the court and with a different level of dress. Moreover a waistcoat of straightforward shape and manageable size was a comparatively simple canvas for the skilled amateur. The peculiar shape and vast scale of a woman's mantua was not. Therefore, if compared to a standard court mantua (made, say, of Spitalfields silk and temporarily dressed with lace, tassels, flounces, and jewels), an embroidered gown probably would take longer to create. Furthermore, its more fixed form and less mercurial qualities communicated a high level of commitment to clothing that was to be worn only at court.

Reporting Court Dress: Politics and Spin

To invest in clothing was, of course, a signal of respect for royalty. Mary Pendarves made the link explicit when she recorded the queen's polite regard for the "obligation" Mary had shown through her finery. Similarly, in 1732, Lord Egmont noted his decision to take the opportunity to "honour" the king when he purchased a new suit, and comparable references to honor and obligation are frequent in epistolary descriptions of court attire. The commissioning of an expensive item of clothing to wear at court was decoded generally as an expression of loyal allegiance to the crown, although some personal accounts reveal that "dressing new" could be used strategically by some to mask political intentions at sensitive moments, or to offset potentially damaging rumors of political affiliation. In certain circumstances, then, a material show of loyalty functioned as an elaborate masquerade.

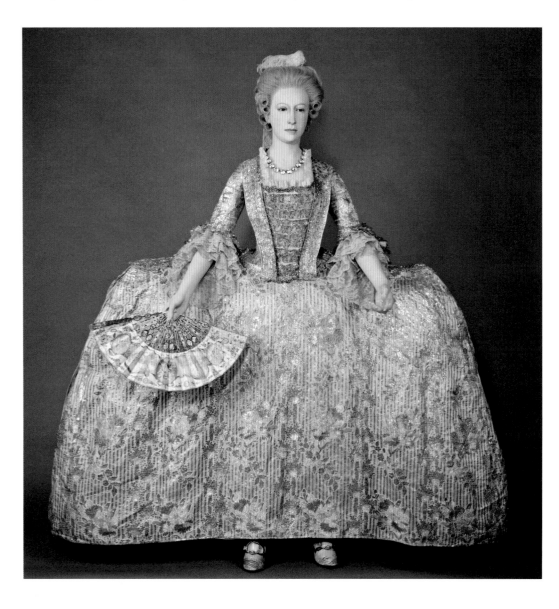

Figure 86: Court mantua, believed to have belonged to Lady Rockingham. Historic Royal Palaces

In 1716, for example, the Earl of Bristol used the linkage between new clothing and court loyalty to quell rumors that his lengthy stays away from London represented a snub to court party politics. Writing to his London-based wife from self-imposed retirement at the family seat in Ickworth, he urged her to appear new-dressed at court, turning to poetry to finesse his command. "[Since] your finery is come from France," he explained, "you cannot with any good grace stay in Town and not appear on the Birth-night, which I desire you woud do, to shew them:

Our loyalty is still the same,
Whither it wins or loose the game
True as the diall to the sun,
Altho it be not shind upon."[44]

Nor was metropolitan tittle-tattle groundless. In 1717, the Earl of Bristol followed the Prince of Wales's court into political opposition. In 1716, however, he was clearly not yet ready to publicize his leanings toward opposition. Using his wife as a proxy representative (dressed new to suggest allegiance) can be interpreted as strategic camouflage, damping down speculation while preserving maneuvering room for the earl.

With the potential for subtle political machinations to influence court displays, it is no wonder that attempts to monitor and interpret accurately the preponderance of new clothing emerged as a central strand of commentary throughout the century. Sartorial shows at court were minutely scrutinized in a bid to measure the relationship between various factions of the political elite and the monarch. For example, early in Queen Anne's reign, Lady Scarborough wrote to the Duchess of Marlborough on the subject of court dress. Town rumor had reached Scarborough that the duchess was to appear in new clothes at court. "I take this opportunity to tell you deare Lady Dutchess [that] I am very glad to heare you talk of being drest on ye birthday," Lady Scarborough explained, "and wish you may make many for ye same purpose, and if you have use of such cloathes this yeare, I verily believe you may have so for many to come."[45] Here, intelligence that the Duchess of Marlborough was making new clothes for court was taken as a signal of her allegiance to Anne's court and, moreover, of her favor in those circles. The Duchess of Marlborough's influence early in Queen Anne's reign has been carefully mapped by Frances Harris, and the split that later developed between them is widely acknowledged as a notable shift in the climate of court politics.[46] Lady Scarborough's letter to the duchess congratulating her on the expectation

that she was to be "drest on ye birthday" acknowledged her initial move toward a powerful position of court favorite.

Self-conscious and strategic show was an important element of court attendance, and receiving praise from the monarch for a new-made garment was the object of many seeking favor and looking to advertise their allegiance to the crown. The Countess of Strafford was explicit in her quest to make a gown that others would regard as "fine." When her appearance at court proved successful (the queen publicly praised the countess for her attire), the earl promptly reimbursed his wife for the cost of her gown..[47] A system of pre-court appearances allowed members of the elite to ensure that acquaintances were fully apprised of their court finery and able to glean detailed information about garments, regardless of whether or not those same observers also attended court. Mrs. Ann Donelan wrote to express her gratitude to her elder brother, Lord Strafford (the son of the Countess of Strafford cited above) for allowing his daughter to visit and show her clothes and jewelry prior to a court attendance in the 1730s.[48] Similarly, Lady Jane Coke recorded a visit made to Lady Betty Germain in 1752, "where great numbers came to show themselves."[49]

Such reports suggest these pre-court rituals were carefully stage-managed. To be invited to such a show was a mark of favor bestowed on certain family members and acquaintances, and also offered the opportunity for a select audience to glean specific information about the clothing worn, information that was later circulated in their correspondence. Many of the letters that detailed a number of court garments in an extensive report probably were compiled on the basis of a pre-court showing rather than from what was seen at the crush of the court drawing room itself. The care taken to ensure that reliable correspondents would receive information about the clothing worn and then broadcast that information to a broader audience testifies to the cultural significance of court attire to this elite community.

Significantly, however, the commissioning and display of carefully crafted court clothing was utilized not just to convey loyalty. The wearing and—as important—the subsequent reporting of court dress was deployed to advance a range of agendas. In this regard it often was used as an overt signal of political opposition as much as an advertisement of affiliation to court. For example, by 1712 the relationship between the Duchess of Marlborough and Queen Anne had soured, and the Marlboroughs increasingly were associated

with the (loosely Whig) political opposition. It is striking that reports of court clothing referenced this change in the political climate. As the opposition Whigs began to cluster into a viable political group, sympathetic writers attempted to spin reports of court attendance to imply that the court and its political affiliates were losing ground. The Right Honorable Peter Wentworth explained the situation to his diplomat brother, the Earl of Strafford: "The Whigs are pleased to give out that there was but very odd figures at Court of the Birthday… . They gave out before that there wou'd be very little company, and 'twas said the Queen wou'd not come out; but," he reassured his brother, "there was as much fine cloaths as ever."[50]

The Countess of Strafford also wrote to clarify press reports and detailed the Whigs' attempts to boycott court events, noting that "none of the Whigg Ladys now ever goes to Court because the Queen shall not have a full Drawing room & they give out that nobody goes near her." Despite the political wrangling, the countess reassured her husband that court events remained "fine." Perhaps alarmed by the political uncertainty, it is notable that the queen's ambassadors all chose this moment to send expensive fabrics from their postings abroad for their wives and female acquaintances to wear to court. The countess reported to her husband that "Lord Bullinbrock has given his Lady for today the finest manto and petecoat that be could had in France & Sir J Hammond has sent the Duchess of Grafton a very fine won."[51] A countermove to shore up court ceremony apparently was launched by the queen's own officeholders and ministers. Moreover, while the Whigs peddled stories that court support was waning, the Tories responded in equal measure with claims that the Marlborough opposition were so extreme and unconstitutional that they were audaciously setting up a court of their own, whose attendees would wear new clothing designed to honor the Marlboroughs and snub the queen. Once again, Peter Wentworth worked through the complexities of the partisan reports for his brother's benefit:

'Twas talk't of as if the Duke of M— intended
to make a ball that night at his house, but when
he found how it was took as a sort of vying with
the Court, he let it alone, but the Dutchess of
Marlborough did send to several Ladies to invite
them to a danceing a Friday night. I know some
ladies she invited, but that morning there was
papers cry'd about the Street as representing it a
design to sett up for themselves, that there was
several people that had made cloath for that day
that had not for the birthday; so they put off their

Ball but sent to all the Ladies they had invited there wou'd be no danceing but that the Dutchess wou'd be at home, and shou'd be glad to see any of them that wou'd come.[52]

Although they denied the rumors, the Marlboroughs would not have been the first to engineer an opposition "court" that encouraged the wearing of new clothes to undermine rather than honor the monarch. As Robert Bucholz notes, the opposition Whigs attempted to generate an alternative ceremonial calendar in 1703 that challenged the celebrations of the Tory-dominated court. For example, in November of that year, the Kit-Kat Club (a Whig club) determined to commemorate the birthday of the previous monarch, William III, rather than that of Queen Anne. The

Figure 87: Detail of man's waistcoat, 1760–69, silk and linen. Victoria and Albert Museum, London (1571&A-1904)

Whig nobles gathered at the club to toast the former king and made it known that they were wearing new clothes to celebrate the event, an honor traditionally bestowed only on the current monarch.[53]

Following the Hanoverian succession, the existence of an adult heir apparent allowed for the creation of an alternative court around which political opposition could rally. In this context, we find that clothing was routinely deployed by the elite to display political preference. In the 1730s, the relationship between the Prince of Wales and George II was fragile and disintegrating. By 1737, the prince had broken from court and he and his new wife were banished from St. James's. In the years prior to this break, however, those attending the court used court birthdays and appearances to register their opposition or affiliation to different factions of the royal household. In 1734, for example, Lord Egmont noted that he had made new clothes for the Prince of Wales's birthday, when previously he had recorded ordering new clothing only for the birthdays of the king and queen. While he made certain that his family appeared at the king's court dressed new, Egmont himself appears to have been irregular in his attendance. As early as April 1731, Egmont noted that the king had looked "cool" because he "did not go often enough to Court," and the queen's vicious rebuke to Egmont's wife, recorded in 1736—"tis so long since I have seen you I thought you were dead"—illuminates the uncertain ground on which the Egmonts stood at court.[54] Though his diary does not state his intentions explicitly, that Egmont commissioned clothes to honor the Prince of Wales's birthday certainly seems to have been an action loaded with significance. If it was not a direct slur against the official court, it may have been an attempt to garner favor from the heir apparent when recognition from the current monarch was less forthcoming.

Armed with this understanding of the potential significance of court display, a more nuanced reading of Mary Pendarves's own accounts might be possible. For example, her explicit reference to a decision to appear "humbly drest" to the Prince of Wales's birthday court of 1739 might have been motivated by a concern not to appear overly supportive of the errant heir as much as by any personal modesty.[55] Dressing down could be as strategic as dressing up. Against this background, her choice of an impressive, embroidered gown only a year later appears all the more remarkable. Dating the dress to 1740 or 1741, Clare Browne has posited that it was worn to the birthday ball of the Prince of Wales at Norfolk House

in February 1741. Newspapers represented the birthday celebrations as particularly impressive that year. The *London Evening Post* reported:

> *Yesterday being the Celebration of the Birth-Day of his Royal Highness Frederick Prince of Wales, there was a most splendid Appearance of the Nobility and Gentry at Norfolk House, to pay their Compliments to their Royal Highnesses on the Occasion, and at Night there was a Ball. The same Night there were grand Illuminations, Bonfires &c and a Course of the finest fireworks that has been for some years were play'd off in St James's Square and several barrels of beer were given to the populace.*[56]

The birthday celebrations had been deferred for a month until the Princess of Wales had completed her lying-in (following the birth of the Princess Elizabeth). Furthermore, by this date the political rupture between the Prince of Wales's Norfolk House and the king's court had passed, and the relationship between the monarch and his heir was improving. Indeed, by the summer of 1741 the prince had left Norfolk House. He never returned fully to the court of his father. However, the potential political tensions were diffused by the prince's long-term use of a country property, Cliveden, instead of a central London base. At a juncture when the political divisions between the courts were easing, is it possible that Mary Pendarves felt less obliged to dress down and more able to show her loyalty to the crown at the court of the Princes of Wales as well as at that of the monarch?

The choices made by the elite in their court clothing were unquestionably a serious business, and strategic displays were orchestrated by the loyal and disloyal alike. The possibility that dress played a particular role in both the breaking and making of the relationship between the monarch and the Prince of Wales in the 1730s and 1740s is perhaps further supported by evidence from the closing years of the century. Here again, the political elite responded to the fluctuating relationship between a frail George III and his dissolute son, and used dress as a tool in that battle. During George III's illness, Whig politicians had flaunted their support for the Princes of Wales and his Regency campaign. On the king's recovery, overt displays of loyalty were demanded from all to celebrate his health. As *The Times* noted in June 1789, "even the forlorn, melancholy, disappointed Members of The Party" presented themselves at court to celebrate the king's recovery and "dressed up their countenance so as to give the appearance, however they might be destitute, of the spirit, of loyalty."[57]

The most extreme Whigs nonetheless found ways to accessorize their sartorial displays with messages of opposition, while ostensibly bowing to the authority of the crown. On 30 May 1789, for example, many of "his Majesty's particular friends" attended a gala held by the French ambassador dressed in the "Windsor uniform."[58] This was, however, an intra-party event and it was noted that "those Noblemen distinguished in the opposite Party… did not wear any uniform." In a comparable fashion, the women associated with government politicians wore "nearly the same dresses as at the Queen's gala" except, that is, for high-profile Whig hostesses such as the Duchess of Devonshire, who were recorded as eschewing the Windsor-inspired costumes worn by others, preferring their own personal (unspecified) style.[59] At a ball held by the Duchess of Gordon when the king's health was clearly improving, Lady Carlisle, Lady Caroline Howard, and Lady Villiers nevertheless took the opportunity to advertise their support for the Prince of Wales, flaunting his feathers and *ich dien* motto on their caps.[60] An attempt by the Whigs to orchestrate a collective display of political opposition at the court birthday in 1792 was thwarted by the vigilance of His Majesty's Customs. Having commissioned their clothing in France, the Whigs were to wear new clothes but of foreign manufacture. However, most were held at Dover as illegal imports and thus the clothes (and the challenge they would have suggested) were kept away from court. In a report weighted in support of the government, *The Times* archly noted it to be "astonishing the Nobility will suffer the anxiety and run the hazard of disappointment when it is an acknowledged fact that the *best dresses* which appeared at court *were entirely of English manufacture*."[61]

* * *

Mary Delany herself summarized the standard eighteenth-century rubric that clothing fit social station: "Dress ought always to be suited to the situation and circumstances of the person. The *appearance* of great economy, where economy *is required*, is *most respectable*, where it is not, it is reproachable… ."[62] Clearly for those attending court, situation and circumstance demanded a full and spectacular sartorial show. This show was far more than empty spectacle. An investigation of contemporary letters and their preoccupation with court dress reveals a system of reporting that extended beyond the reiteration of cut, color, and style. In an epistolary context, court dress was defined by more than its place within, or distance from, contemporary fashions. Rather,

when reported, the clothing worn was interpreted as a meaningful signal of political display, read by observers both as a general measure of the political climate and also as an active component in the creation of political identities. This is not to suggest that the aesthetics of personal choice and changing fashion preferences had no role in the sartorial system surrounding court show. Long-running correspondences describing protracted shopping practices, the fingering of trimmings and distribution of samples, the careful consideration of fabrics and the use of proxy shoppers and advisors to reach decisions about the final formulation of court clothing. All testify to the multiplicity of agendas involved in dressing for court. As this essay has sought to illuminate, however, the roots of this ongoing preoccupation with court clothing were powerfully political.

Court clothing, particularly when interpreted and translated by witnesses to court events, was equally a communicator of political climate and sentiment. In this regard, studying the reports of court dress provides historians with a unique frame of reference from which to investigate the particular constitutional circumstances of the long eighteenth century. It appears to have been precisely because of the uncertain nature of relationships among crown, government, palace, and parliament during the eighteenth century that court dress and the interpretation of courtly display became so overtly politicized. When dressing for court, elite figures broadcast their position in a political system, comprising a newly established constitutional monarchy whose rules and expectations were universally unresolved. Behind the closed baize doors of the court drawing room ran a fault line between traditional and emerging systems of governance. For the elite to shun court entirely was an extreme statement of opposition that few were ready to make. However, it was possible for elite figures to display degrees of opposition through their sartorial choices. By selecting foreign-made fabrics, by wearing old instead of new (or new instead of old), or even by loading a dress with trimmings better suited for another garment, the clothing worn to court provided a means to articulate a more nuanced relationship to monarchy and state than has previously been recognized. Of course, the political potential of such choices may not always have been the concern of the wearer. Crucially, though, it was politics that was foregrounded in court dress reports and, in consequence, such reports offer a dense lexicon to a complicated but hitherto unexplored system of consumer politics.

Acknowledgments
I am grateful to Mark Laird, Amy Meyers, and
Alicia Weisberg-Roberts for their editorial
interventions and comments at the London
workshops. Clare Browne, Clarissa Campbell Orr,
Quintin Colville, Joanna Marschner, Kate Retford,
Giorgio Riello, and Amanda Vickery offered
invaluable supporting references and critical
readings. I discussed early ideas on this topic at the
"Fashion in the Age of Louis XIV" conference held
at the Clark Library, Los Angeles, in June 2005;
my thanks to Kathryn Norberg for inviting me
to participate in that event.

Notes
1. Mary Pendarves to Anne Granville, 4 March
 1729, in Lady Llanover, ed., *The Autobiography
 and Correspondence of Mary Granville, Mrs. Delany*,
 6 vols. (London: Richard Bentley, 1861–62),
 ser. 1, 1:191.
2. See, for example, Llanover, ed., *Autobiography
 and Correspondence*, ser. 1, 1:99 (Mary Pendarves
 to Anne Granville, 30 May 1724), 2:447 (Mary
 Delany to Anne Dewes, 15 January 1747),
 and 3:471 (Mary Delany to Anne Dewes,
 22 November 1757).
3. "CB" to Lady Anne Campbell (wife of William
 Wentworth, second Earl of Strafford), undated,
 Add. MSS 22256, fol. 50, British Library.
4. For example, Frances Bathurst to the Duchess
 of Marlborough, 20 October [1692], Add. MSS
 61455, British Library.
5. Letters from Anne, Countess of Strafford, to
 Thomas Wentworth, first Earl of Strafford
 (second creation), 1711–36, Add. MSS
 22256–22257, British Library.
6. See, for example, Peter Wentworth to his brother
 the Earl of Strafford, 12 January 1712, in James
 J. Cartwright, ed., *The Wentworth Papers,
 1705–1739: Selected from the Private and Family
 Correspondence of Thomas Wentworth, Lord Raby,
 Created in 1711 Earl of Strafford, of Stainborough,
 Co. York* (London: Wyman, 1883), 247; "Journals
 of the First Lord Egmont, 1730–1747," Add.
 MSS 47060–46071, British Library.
7. See, for example, Lady Hertford to Lord
 Beauchamp, 21 November 1742 and 21 January
 1743, in Helen Sard Hughes, ed., *The Gentle
 Hertford: Her Life and Letters* (New York:
 Macmillan Company, 1940), 225, 234; see,
 for example, Richmond, 11 June 1774
 (L30/11/123/22), Mary Grey to her sister
 Amabel Polwarth, 20 January 1779
 (L30/11/133/68), and Mary Grantham to
 Countess de Grey, 20 January 1781
 (L30/11/240/13), all Wrest Park Papers (Lucas
 Archive), Bedfordshire and Luton Archives and
 Records Office.
8. Robert O. Bucholz, *The Augustan Court: Queen
 Anne and the Decline of Court Culture* (Stanford,
 Calif.: Stanford Univ. Press, 1993); J. M. Beattie,
 "The Court of George I and English Politics,
 1717–1720," *English Historical Review* 81, no. 318
 (January 1966): 26–37; Eveline Cruickshanks, ed.,
 The Stuart Courts (Stroud: Sutton, 2000), 9–10.
9. From the perspective of court history,
 R. Malcolm Smuts notes that from the late
 seventeenth century fashionable urban society
 "grew rapidly and expanded in ways that the
 crown could never entirely control." See R.
 Malcolm Smuts, *Court Culture and the Origins
 of a Royalist Tradition in Early Stuart England*
 (Philadelphia: Univ. of Pennsylvania Press,
 1999), 58.
10. Smith's important revisionist account of the
 court suggests that eighteenth-century court
 culture was more nuanced and integrated within
 the wider public and political culture than classic
 narratives imply. See Hannah Smith, *Georgian
 Monarchy: Politics and Culture, 1714–1760*
 (Cambridge: Cambridge Univ. Press, 2006).
11. For the past decade or more, eighteenth-century
 consumption has been a major concern of social
 and economic historians. An insightful collection
 of scholarly approaches to the field was edited by
 John Brewer and Roy Porter in the mid-1990s,
 and remains a keystone text; see John Brewer and
 Roy Porter, eds., *Consumption and the World of
 Goods* (London: Routledge, 1993). John Brewer's
 discussion of the significance of a new
 commercial culture to the eighteenth-century
 British arts has been similarly influential; John
 Brewer, *The Pleasures of the Imagination: English
 Culture in the Eighteenth Century* (Chicago: Univ.
 of Chicago Press, 2000). For a more recent set of
 reflections on the significance of eighteenth-
 century consumer society, see John Styles and
 Amanda Vickery, eds., *Gender, Taste, and Material
 Culture in Britain and North America, 1700–1830*
 (New Haven: Yale Center for British Art, 2006).
12. Anne Buck's surveys of the history of dress
 are among the most comprehensive and
 wide-ranging. In her chronicle, court dress is a
 spectacular moment of history, and stands as the
 chapter preceding the rise of cottons and a new
 move toward the democratizing of trends; Anne
 Buck, *Dress in Eighteenth-Century England*
 (London: B. T. Batsford, 1979). Court dress has
 been singled out for study in its own right—see,
 for example, Nigel Arch and Joanna Marschner,
 *Splendour at Court: Dressing for Royal Occasions
 since 1700* (London: Unwin Hyman, 1987), and
 Philip Mansel, *Dressed to Rule: Royal and Court
 Costume from Louis XIV to Elizabeth II* (New
 Haven and London: Yale Univ. Press, 2005)—
 but these have not yet been fully integrated
 into social or fashion history narratives. Susan
 Vincent's recent study has called for a more
 methodologically sophisticated approach to the
 study of elite dress in particular and an awareness
 of the political and cultural nuances of elite
 fashion choices. Her important study currently
 stops in the late seventeenth century, but many
 of the methodological questions raised might be
 usefully applied to the eighteenth century;
 see Susan Vincent, *Dressing the Elite: Clothes in
 Early Modern England* (Oxford: Berg, 2003).
 See also David Kuchta, *The Three-Piece Suit
 and Modern Masculinity: England, 1550–1850*
 (Berkeley: Univ. of California Press, 2002).
13. Leonore Davidoff, *The Best Circles: Society,
 Etiquette, and the Season* (1973; repr., London:
 Cresset Library, 1986), 14.
14. More detailed records survive for the nineteenth
 century and have been examined by Nancy
 Ellenberger to map the changing social status
 of those presented at court during Queen
 Victoria's reign. See Nancy W. Ellenberger,
 "The Transformation of London 'Society' at
 the End of Victoria's Reign: Evidence from the
 Court Presentation Records," *Albion* 22, no. 4
 (Winter 1990): 633–53.
15. Mary Grey to Amabel Polwarth, 17 December
 1774, Wrest Park Papers, L30/11/123/31,
 Bedfordshire and Luton Archives and Records
 Service.
16. George Macaulay Trevelyan, *English Social
 History: A Survey of Six Centuries, Chaucer to Queen
 Victoria* (London: Longmans, Green, 1942), 338.
17. The Duchess of Queensberry certainly portrayed
 herself as unmoved by her exile. Writing to the
 king, she claimed, "the Duchess of Queensberry
 is surprised and well pleased that the King hath
 given her so agreeable a command as to stay from
 Court, where she never came for diversion, but to
 bestow a great civility on the King and Queen."
 See John Hervey, *Memoirs of the Reign of
 George the Second: From His Accession to the Death
 of Queen Caroline*, 2 vols. (London: John Murray;
 Philadelphia: Lea and Blanchard, 1848), 1:142.
 For the Duchess of Queensberry, see Rosalind
 K. Marshall, "Douglas, Catherine, duchess of
 Queensberry and Dover (1701–1777)," in H. C. G.
 Matthew and Brian Harrison, eds., *Oxford
 Dictionary of National Biography* (Oxford: Oxford
 Univ. Press, 2004), online ed., ed. Lawrence
 Goldman, October 2006, www.oxforddnb.com/
 view/article/7876 (accessed 15 March 2009).
18. The original letter can be found in the Clayton
 papers at the Beinecke Library, Yale University,
 see Letters to Charlotte Clayton, Lady Sundon,
 Osborne FC.110 1/2; see Lord Hervey to Mrs.
 Clayton, 31 July 1733, Suffolk Records Office,
 Hervey Papers, 941/47/4.
19. Lord Hervey to his mother, 29 June 1732, Suffolk
 Records Office, Hervey Papers, 941/47/2.
20. See Clarissa Campbell Orr's essay in this volume,
 p. 50.
21. Newspapers advertised the dates on which
 drawing rooms would be held. The 23 November
 1717 *Original Weekly Journal*, for example,
 reported "a with-drawing room is order'd to be
 kept at court every Monday, Wednesday and
 Friday night during the winter." In 1722, the
 Prince of Wales held two drawing rooms each
 week at Leicester House, and three per week
 were held by the king at St. James's; *Post Boy*,
 11 October 1722. On 27 December 1790, *The
 Public Advertiser* reported that the royal family,
 though based primarily at Windsor, stayed a few
 nights each week at Kensington to enable the
 queen to hold a St. James's Drawing Room on
 Thursday and the king to host a *levée* for
 ministers each Friday morning (see also, for
 example, *Woodfall's Register*, 29 December 1790).

22. *The Weekly Journal, or, British Gazetteer*, 2 June 1722, gave a full report of the progression of Birthday celebrations:

> *Monday being the Birth-Day of His Most Sacred Majesty King GEORGE, who then enter'd into the 63d year of his age… the Morning was usher'd with ringing of Bells, and at one o'[c]lock the Guns on the Tower Wharf were fired to the Number of 62, being the exact Number of His Majesty's Years, after which they fired all round the Lines and Ramparts. There was a Drawing Room at Court crowded with a splendid Appearance of the Nobility and Foreign Ministers to compliment His Majesty, as did also their Royal Highnesses the Prince and [P]rincess of Wales, and after the Birth-Day Song as usual, there was an illustrious Ball, at which were also present the Prince and Princess of Wales, so that the greatest Court was made, as has been seen in any Reign past.*

23. Robert Bucholz has investigated the procedures and principles that determined access to the eighteenth-century courts. See Robert O. Bucholz, "Going to Court in 1700: A Visitor's Guide," *The Court Historian* 5, no. 3 (December 2000): 191.

24. *Flying Post; or, the Weekly Medley*, 15 March 1729.

25. See "William Harvey, Theft, Pocketpicking, 27 February 1751," ref. no. t17510227-23, Old Bailey Proceedings Online, www.oldbaileyonline.org/browse.jsp?ref=t17510227-23 (accessed 12 February 2009).

26. Bucholz, "Going to Court in 1700," 195.

27. Lavinia, Countess Spencer to Earl Spencer, 19 April 1792, Althorp MSS 75928, British Library.

28. R. Brimley Johnson, ed., *The Letters of Lady Louisa Stuart* (London: John Lane, 1926), 69.

29. See Mary Grantham to Amabel, Lady Lucas, 20 January 1781, Wrest Park Papers, L30/11/240/13, Bedfordshire and Luton Archives and Records Service; Hon. Mrs. Hugh Wyndham, ed., *Correspondence of Sarah Spencer, Lady Lyttelton, 1787–1870* (London: J. Murray, 1912), 2.

30. The Countess of Strafford to the Earl of Strafford, [1711], Add. MSS 22226, fol. 48, British Library; Accounts of Duke and Duchess of Hamilton, 2177, bundle 426, no. 532, National Register of Archives, Scotland.

31. Lady Louisa Stuart, for example, suggested a gown for "full dress" might cost £24, whereas a court gown would cost more than £70. Lady Louisa Stuart to Lady Portalington, 30 March 1789, in Johnson, ed., *Letters of Lady Louisa Stuart*, 96.

32. Countess of Strafford to the Earl of Strafford, November to 11 December 1711, Add. MSS 22226, fols. 40, 42, British Library. The word "cloaths" in its eighteenth-century usage referred to more than undesignated fabrics; it was used specifically to denote high-end, expensive textiles associated with elite dress. I am indebted to Giorgio Riello for drawing my attention to this.

33. Lady Erskine to Mary Countess of Sutherland, 17 July 1761, Correspondence of Mary, Countess of Sutherland (née Maxwell), Sutherland MSS Dep 313/716, Letter 13, National Library of Scotland.

34. Lord Erskine to Lord Sutherland, 8 August 1761, Sutherland MSS Dep 313/716, Letter 11, National Library of Scotland.

35. Countess of Strafford to the Earl of Strafford, 29 January 1712, Add. MSS 22226, fol. 79, British Library.

36. Hester Lynch Thrale Piozzi to Frances Burney D'Arblay, 11 January 1781, in Charlotte Frances Barrett, ed., *Diary and Letters of Madame D'Arblay*, 7 vols. (London: H. Colburn, 1842–46), 2:7.

37. Marchioness Grey from Lady Anson, 1753, Wrest Park Papers, L30/9/3/41, Bedfordshire and Luton Archives and Records Service.

38. Lady Anne Campbell (wife of William Wentworth, Earl of Strafford), undated, Add. MSS 22256, fol. 50, British Library.

39. Mary Pendarves noted, "I dressed myself all in my best array, borrowed my Lady Sunderland's jewels, and made a tearing show." Mary Pendarves to Anne Granville, 4 March 1729, in Llanover, ed., *Autobiography and Correspondence*, ser. 1, 1:191.

40. Countess Cowper to Mary Dewes, 16 October 1768, in Llanover, ed., *Autobiography and Correspondence*, ser. 2, 1:186.

41. Hannah Greig, "Leading the Fashion: The Material Culture of London's *Beau Monde*," in Styles and Vickery, eds., *Gender, Taste, and Material Culture*.

42. See Clare Browne's essay in this volume, p. 73.

43. *The Times*, 19 January 1792 [issue 2207], p. 2, col. A.

44. Lord Bristol to Lady Bristol, 26 October 1716, in *Letter-Books of John Hervey, First Earl of Bristol: With Sir Thomas Hervey's Letters during Courtship & Poems during Widowhood, 1651 to 1750*, 3 vols. (Wells: Ernest Jackson, 1894), 2:34.

45. Frances, Countess of Scarborough, to Sarah, Duchess of Marlborough [1708–1710], Add. MSS 61456, fol. 66, British Library.

46. Frances Harris, *A Passion for Government: The Life of Sarah, Duchess of Marlborough* (Oxford: Clarendon Press, 1991).

47. Anne Countess of Strafford to the Earl of Strafford, 8 February 1712, Add. MSS 22226, fol. 290, British Library. For an account of the Straffords' concern to curry royal favor and the respective successes and disappointments experienced by different family members, see Bucholz, *Augustan Court*, 139–40, and 242 for an account of Queen Anne's own attitude to dress and sartorial choices.

48. Ann Donelan to Lord Strafford, 13 October 1733, Add. MSS 22228, fol. 322, British Library. Ann was the wife of James Donelan and should not be confused with the unmarried Anne Donnellan with whom Mary Delany visited Ireland in 1731.

My thanks to Clarissa Campbell Orr for her assistance with this biographical information.

49. Florence A. Monica Rathborne, ed., *Letters from Lady Jane Coke to Her Friend, Mrs. Eyre at Derby, 1747–1758* (London: S. Sonnenschein, 1899), 123.

50. Peter Wentworth to the Earl of Strafford, 12 January 1712, published in Cartwright, ed., *Wentworth Papers*, 247.

51. The Countess of Strafford to the Earl of Strafford, February 1713, Add. MSS 22226, fol. 288, British Library. Henry St. John, first Viscount Bolingbroke (1678–1751), was Secretary of State between 1710 and 1714. At the date of the Countess of Strafford's letter, he was in Paris negotiating terms of peace with France. "Sir J. Hammond" is likely a reference to Anthony Hammond (1668–1738), who was deputy paymaster of British forces serving in Spain at this date. He was elected Knight of the shire for Huntingdonshire in 1695 and was married to Lady Jane Hammond, daughter of Sir Walter Clarges, first Baronet.

52. Peter Wentworth to his brother the Earl of Strafford, 12 January 1712, in Cartwright, ed., *Wentworth Papers*, 248.

53. Bucholz, *Augustan Court*, 226. A description of the Marlborough incident is also treated by Bucholz (227–28).

54. See, for example, journal entries for 3 April 1731 (Add. MSS 47061), 1 November 1732 (Add. MSS 47062), and 21 January 1734 and 1 March 1734 (Add. MSS 47064), all British Library. For more on Lord Egmont and his connection to Mary Delany, see Clarissa Campbell Orr's essay in this volume, p. 55.

55. Mary Pendarves to Anne Granville, 23 January 1739, in Llanover, ed., *Autobiography and Correspondence*, ser. 1, 2:27.

56. *London Evening Post*, 31 January 1741.

57. *The Times*, 5 June 1789 [issue 1172], p. 2, col. B.

58. The men's Windsor Uniform—dark blue suit with scarlet collar and cuffs, gilded buttons and braid—was introduced to the court of George III in 1779.

59. *The Times*, 30 May 1789 [issue 1168], p. 2, col. C. The report is repeated in *Felix Farley's Bristol Journal*, 6 June 1789.

60. Lady Stafford to George Leveson Gower, Thursday, 12 February 1789, in Castalia [Rosalind Campbell Leveson-Gower], Countess Granville, ed., *Lord Granville Leveson Gower (First Earl Granville): Private Correspondence, 1781 to 1821*, 2 vols. (London: J. Murray, 1916), 1:14.

61. *The Times*, 19 January 1792.

62. Mary Delany, unfinished "Essay on Propriety," 3 August 1777, written for her grandniece, Georgiana Port, in Llanover, ed., *Autobiography and Correspondence*, ser. 2, 2:310.

[4]

THE THEORY & PRACTICE
OF FEMALE ACCOMPLISHMENT

The gentlewoman Mary Delany is familiar to any student of the decorative arts, since she combined a diverse art practice with voluminous opinionated correspondence. For all her familiarity, however, Delany is worth revisiting, for as a well-connected, twice-widowed, financially independent woman, she offers, in the range of her crafts, a map of the possible. Mrs. Delany's hands were ever busy, even "between the coolings of her tea," according to her admiring second husband.[1] She wrote and illustrated a novella, designed furniture, painted, spun wool, made shellwork, featherwork, silhouettes, invented the entirely new art of botanical collage, and was an embroiderer of great artistry, designing her own compositions and relishing painterly effects in embroidery silks. She was celebrated for her botanical accuracy, her artistic power, and her versatility. For Kim Sloan, Mary Delany and her peers represent a distinctive culture; unusually well-educated, supported by liberal-minded menfolk, and connected at court, these women occupied their time industriously and innocently and displayed that they were of enlightened taste.[2] Plainly Mrs. Delany was unusual in her independence, resources, childlessness, connections, and sheer talent, but her activities demonstrate the breadth that women's amateur artistry could achieve at its fullest. From cut paper on chimney boards and shellwork on frames to embroidery on all sorts of furnishings, there can have been few objects at Delville and the houses of her friends that did not bear Mrs. Delany's personal stamp. In the diversity of her artistic practice and the intellectual concerns they referenced, she offers a distaff version of gentlemanly virtuosity.

Yet history has been unimpressed by women's decorative efforts. For art historians, the accomplishments of Georgian women—regarded as neither useful nor art—have generally been a source of disappointment. Masterpieces like Delany's flower collages are written off as "the genteel work on an old lady to be compared, say, with samplers,"[3] while the tendency to disparage women's abilities in botanical illustration today exposes "the indelible taint that [such] accomplishments still carry."[4] Even positive discussions have rarely characterized women's efforts in ways that would commend them to modern sympathies.[5] Feminist art historians have been ambivalent as well, uncertain whether "in embracing activities like flower painting or quilt making as women's separate but equal artistic heritage, we risk reinforcing the hierarchy of values in art history and art practice that has worked to marginalize these activities as craft."[6]

The domestic context of female decorative work has ensured its low prestige. A persistent tradition arising out of British and American women's history emphasizes female incarceration in the separate sphere of home sometime in the later seventeenth, eighteenth, or early nineteenth centuries (chronologies vary), and sees aesthetic endeavor within a domestic setting as gilding on the cage. We are still haunted by Thorstein Veblen's satirical characterization of the ladies of the leisure class of 1890s New York, for whom the leisured display of taste could "serve little or no ulterior end beyond showing that she does not need to occupy herself with anything that is gainful or that is of substantial use."[7] Be warned, sniffs Germaine Greer, if you insist on viewing Delany's paper mosaics at the British Museum, as "you could end up profoundly depressed by yet more evidence that, for centuries, women have been kept busy wasting their time."[8] For Ann Bermingham, the rise of the accomplished woman "went along with the domestic confinement of women and the increasing tendency to transform the home into an aestheticized space of commodity display… ."[9] An accomplished woman was an object of conspicuous consumption, and accomplishments were an exhibitionary strategy in the polite marriage market, a subliminal form of advertising in the drawing room.[10] In short, women decorated the doll's house, to the applause of the new economic man. However, in counterpoint, revisionist social histories of women and gender have resisted the language of incarceration and powerlessness, examining the home instead as a site of administrative work and expertise.[11] From this perspective, the extensiveness of "amateur" handicrafts and the array of meanings attached to them suggest that female decoration was more central to Georgian culture than history and art history have so far allowed. Doubtless, Georgian women were persistently marginalized, ridiculed, and rebuffed when they endeavored to pursue what became increasingly tightly defined as the fine arts. Nevertheless, their decorative craftwork deserves more serious consideration than some of those who dismiss it as second-rate art have been prepared to offer.

Delany belonged to the top two percent of the social pyramid and her talent was exceptional, yet she was no solitary performer whose art arose sui generis before an astonished society. Horace Walpole celebrated thirty ladies of his acquaintance for their artistic skills, from modeling in wax, terra-cotta, marble, and amber to copying paintings in silk, watercolors, oil, and in miniature.[12] Handicrafts were an utterly conventional female practice. Their extent can be estimated through scattered commentary on contemporary practice in surviving letters, diaries, and travelogues, via the evidence of the crafted objects themselves, which survive in museum collections, and through fragmentary glimpses in print, criminal records, business records, and inventories of the commercial and educational culture that supported these practices. Personal manuscripts suggest that female decorative work was inescapable among the landed and amid professional, manufacturing,

and mercantile families with pretensions to politeness. The miscellany of anonymous craftwork in local and national museums indicates at the very least the geographical spread of domestic accomplishment. It is rare to find absolutely no specimens of women's work in country houses open to the public. Where crafted objects can be linked to specific individuals, their makers are usually privileged. Some provenanced museum objects are worked to a high standard, such as a lovely cream silk apron gracefully embroidered with English garden flowers by Miss Rossier for Miss Rachel Pain on her marriage to her brother circa 1736 (fig. 88). Distinguishing between amateur decoration and professional work can be difficult. Mrs. Delany's own maxim was that "the ornamental work of gentlewomen ought to be superior to bought work in design and taste, and their plain work the model for their maids."[13] The survival of women's decorative work, both anonymous and authored, demonstrates at the very least that families valued women's objects enough to preserve them for posterity, as in Mary Delany's case.[14]

Surviving objects may give the impression that amateur crafting was the preserve of the leisured, but in fact the social depth of female handicraft awaits research. The traditional window into the homes of the middling has been the probate inventory, though craft equipment has not been a concern of inventory studies. Occasional detailed private inventories among the middling have registered art tools and sewing kits as unremarkable personal possessions. However, the fact that handicraft equipment was so inexpensive also reduced the likelihood of it being noticed by the appraisers. The Manchester spinster Jenny Scholes, who died in 1768 at age twenty-two, left an array of tackle for accomplishments—15 painting pots, 9 brushes, 11 bobbins, a knitting sheath and cotton for knitting, a knotting shuttle, netting silk and cat gut, brass thimbles, beads and wire, 17 artificial flowers, and "a few patterns for working"—but she was the niece of a wool merchant and an heiress.[15] My survey of the wills and inventories of eighty single women in the diocese of York from two decades—the 1710s and the 1780s—has uncovered only one woman with sewing equipment, and she was also middling: the widow Charlotte Bingley, sister-in-law of a surgeon, kept a quilting frame in her back chamber in Rotherham in 1780, valued at two shillings.[16]

Decorative work by women of modest means can be glimpsed in criminal records. In 1750, Joseph Woodward, a London joiner, had a framed

Figure 88: Detail of a silk apron, embroidered by Miss Rossier, ca. 1736. Museum of London (37.178/2). She depicts as repeated motifs mostly summer garden flowers: roses (lower left and right), a poppy (center), heartsease (lower center), *Convulvulus tricolor* (left and right of poppy, but with arrow-head leaves that are unrelated), and a *Primula* species of spring (top)

Figure 89: *Bodice-Coat Flannel the Bottom Worked*, 1759. London Metropolitan Archives (A/FH/A/9/1/143, Foundling no. 12843). Crude embroidered decoration on the bodice coat that was left with an infant boy at the London Foundling Hospital.

sampler stolen from his parlor, which adjoined the workshop at Red-Lyon Court.[17] The extent to which very poor women adorned their homes is obscure, though suggestive are the scraps of fabric mothers left with their abandoned infants at the gates of the London Foundling Hospital. Many of these were simply embroidered with the baby's name or sometimes a crude decoration, from which we might infer a poor woman's desire, however futile, to ornament domestic life (fig. 89).

For every celebrated female amateur there was an army of women for whom craft skills furnished a livelihood, as teachers, tutors, educational authors, and occasionally exhibitors. Decorative handicraft was an inescapable feature of the curricula of commercial schools for girls.[18] Plain sewing was required of female servants, the largest single occupational category for women in the period. The seamstress was an archetypal laboring woman, millinery and mantua-making the quintessentially feminine businesses.[19] Expert sewing alone was no guarantee of a prosperous livelihood. "It is too well known, how small a value is set on women's work, so that the cleverest at the needle can scarcely earn subsistence," warned Mrs. Hannah Robertson, a widow who in the 1770s and 1780s made her living practicing and teaching sewing in Edinburgh, York, Manchester, London, and Northampton. She recommended a wider craft knowledge as a better hedge against adversity for respectable girls: "Any girl capable of painting, japanning, gum flowers, pongs, &c will always find employment among fashionable people, and especially in towns of trade and commerce."[20] How far professional craftswomen went in adorning their own things is an unresearched matter. Sarah Hurst, a tailor's daughter who served in her father's shop in Horsham, Sussex, in the 1760s, took in embroidery "work" for local ladies, as well as ruffles for her sweetheart and handkerchiefs for friends, but she also made herself a highly wrought gauze apron.[21]

We can also gauge something of the scope of amateur decorative work from the vigor of the commercial culture it spawned. Practical manuals explaining the new handicrafts proliferated, such as Mrs. Artlove's *The Art of Japanning, Varnishing, Pollishing, and Gilding* of 1730, and Hannah Robertson's manual *The Young Ladies School of Arts*, published in the 1760s, which explained a medley of "curious" crafts, from casting pictures in isinglass to making artificial coral for grottoes.[22] Embroidery kits and patterns were available from at least the 1500s (though the ablest, like Mary Delany, were adept at designing their own). Hannah Robertson claimed her school-*cum*-shop on the Strand was "the first of the kind in London for various works of fancy," but by the 1800s great metropolitan emporia bestrode the applied arts, among them Ackerman's Repository of Art on the Strand and the Temple of Fancy on Rathbone Place. Both promised an Aladdin's cave of art materials and prefabricated kits, contrived to feed and inflame the demand for amateur art and craft (figs. 90, 91).[23]

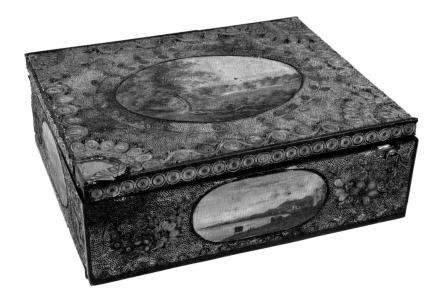

Figure 90: A wooden box, decorated on the outside with paper quill work and watercolors, no date. Museum of London (NN 18716). Inside are small interlocking boxes, each covered with a different kind of prefabricated kit commercially produced by suppliers like the Temple of Fancy in the early nineteenth century.

Figure 91: Ribbon embroidery on the inside of the lid of the workbox in fig. 90. Museum of London

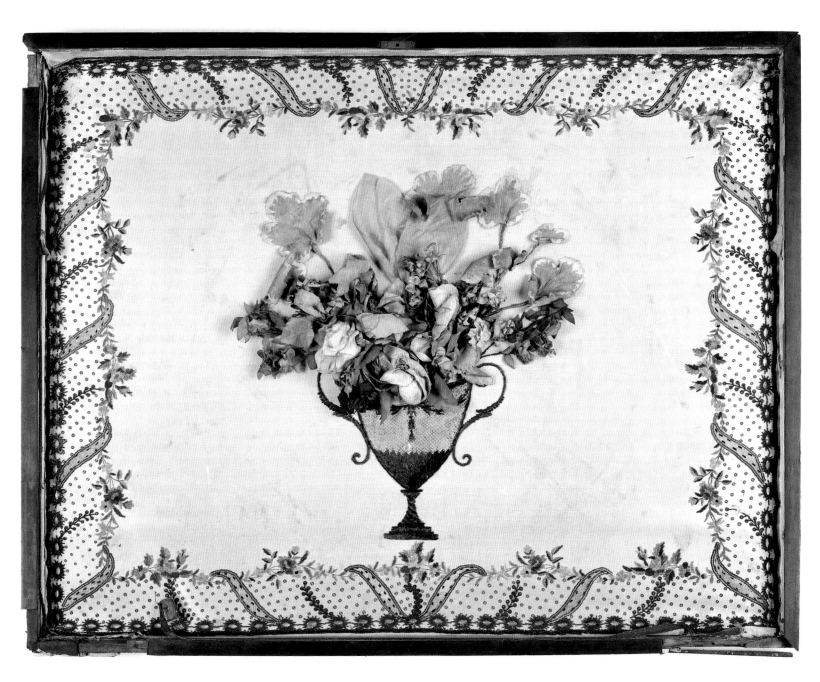

Cabinetmakers were also alive to commercial opportunities. The show cabinet was a well-established masterpiece (sought out by Delany for her "beauties"), but the cabinetmaker's ingenuity was unleashed on the humble workbox as well. Workboxes were constructed from inexpensive woods like deal but also from mahogany, rosewood, satinwood, and even sandalwood, veneered with ivory or tortoiseshell, inlaid with marketry, lacquered, or covered in Morocco or Russian leather. Stuart workboxes were often decorated with a lady's own stumpwork. Exquisite Georgian workboxes referenced the exotic in their materials and motifs, but boxes in the shape of rustic cottages—a form which reinforced the domesticity, innocence and old-fashioned virtue of sewing—were also popular (figs. 92, 93). Decorative frames and elegant tables were targeted at the polite craftswoman, such as the tambour table, which swiveled on a pillar (the better for a lady "to execute needlework by").[24] The upholsterer James Brown of St. Paul's Churchyard, London, had a steady trade in ladies' craft paraphernalia. For example, in December 1785 he furnished to Mrs. Bacon Foster of Church Street, Kensington, a satinwood inlaid workbox, at £1-11-6, and "a square tambour frame on a claw to turn on a ball, coverd with baize, quite plain."[25] Craft paraphernalia became familiar domestic furniture, corresponding in finish to the other cabinetwork in the parlor and advertising that there was a polite but domesticated lady in the house (fig. 94).

Figure 92: Marquetry workbox made by Gillows of Lancaster for Miss Elizabeth Giffard of Nerquis Hall, near Mold, Flintshire, Wales, in 1808, exotic woods. Judges' Lodgings Museum, Lancaster, Lancashire County Museums Service (LANMS.2006.8). The box is inlaid with a geometric pattern of 72 different woods from various parts of the world, including Asia, Europe, the Americas, and Australia.

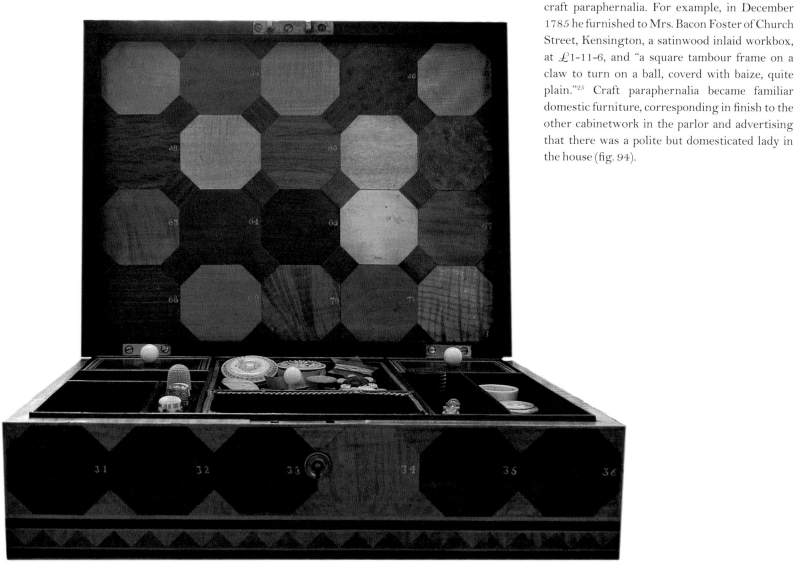

The pervasiveness of domestic decoration is apparent, but how do we account for its inescapability in noble, polite, and middling culture? Primarily it must be said that no woman was ever criticized for picking up a sewing needle, an archetypally female instrument so forged in femininity that, like the distaff and the spindle, it could stand as an emblem for woman herself. Needlework, known simply as "work," was the Ur domestic craft for women, enjoined by God. Tailoring was a masculine trade, and occasional boy's samplers can be found, but no male householder expected to do his own plain sewing. Only sailors and soldiers sewed for themselves; the former sometimes produced woolwork pictures as souvenirs. Outside such closed male communities and the tailor's workshop, a gift for fancy sewing could imperil a man's sexual identity.[26] Male amateur embroiderers were rare. Needlework had a long-standing appeal for conservative commentators, as it was an indoor, sedentary activity that enforced passive stillness and implied patient service. If a girl was sewing, she could not be gadding about, or writing, or even surreptitiously reading novels. Nor would she be idly lounging. Sewing was used as a tool for the inculcation of uncomplaining femininity in girls, with set tasks—from pin cushions and samplers to mirror frames and caskets—leading them through a repertoire of stitches and training them in acceptance of the idea that life was an odyssey of toil and subordination. In fact, embroidery was so implicated in traditional femininity that the repudiation of sewing was almost axiomatic for some feminist rebels and remains so to this day. On the other hand, while the seamstress's hands were busy, who was to say that her mind was not flying free? As Rozsika Parker argued more than twenty years ago, "eyes lowered, head bent, shoulders hunched—the position signifies repression and subjugation, yet the embroiderer's silence, her concentration also suggests a self-containment, a kind of autonomy." For Parker, embroidery offered covert power and considerable pleasure for women "while being indissolubly linked to their powerlessness."[27] Embroidery was used to cultivate submissive femininity in women, but women could use embroidery to find artistic and even radical expression and thereby negotiate the constraints of femininity. Thus the significance of fancy needlework for women was deeply paradoxical.

The claim of domestic ornament to righteousness was archaic; after all, the Almighty ordered the curtains of the tabernacle to be richly embroidered. The high value placed upon women's handicraft in biblical and patriarchal exegesis

Figure 93: Painted workbox in the shape of a cottage, late 18th century, wood. Victoria and Albert Museum, London

Figure 94: Artist unknown, *The Fair Lady Working Tambour*, 1764, mezzotint. Courtesy of The Lewis Walpole Library, Yale University (764.0.11). An elegantly dressed woman is shown working at a small tambour frame.

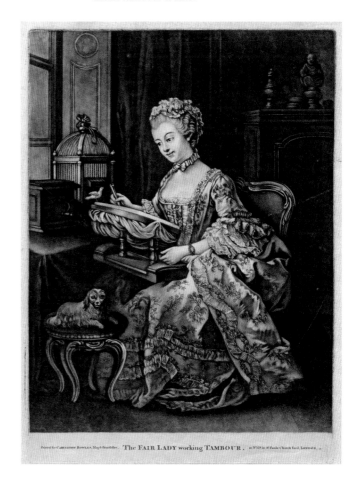

Figure 95: Embroidered linen sheet supplied by Ann, Countess of Derwentwater, to her husband, the Jacobite leader James, third Earl of Derwentwater, while he was imprisoned prior to his execution for treason in 1716. Museum of London (34.63). An example of a woman's work as a final service to her husband. The stitching reads "The sheet off my dear dear lord's bed in the wretched Tower of London February 1716 Ann of Darwent Waters."

gave reason enough for the godly and the cynical to decorate the home. Female craft dignified the patriarchal home.[28] Samuel Richardson's radiant Protestant heroine Clarissa Harlowe was the very embodiment of modern conduct book perfection and admired by Mrs. Delany.[29] It is worth remembering that Clarissa was celebrated by her friends as much for her fine needlework, letter-writing, serious reading, and music as for her moral self-containment. When her objectionable family removed her drawings and the pieces once "shown to every body… for the magnifying of [her] dainty finger-works" in order to punish her, they revealed themselves philistine as well as mercenary.[30]

Virtually all royal ladies embroidered, and many pursued significant artistic enthusiasms. The irreproachable Queen Charlotte, who practiced and was known to admire ladies' work, received an array of crafted gifts from loyal subjects.[31] The stamp of royal approval was unequivocal. Beyond the reach of court, occasional remarks divulge the pride that men could take in

female artistry, though it is unclear whether they admired the objects themselves or relished the acquiescent humility and service such objects could be seen to embody. In 1722, a Northumberland curate listed needlework—along with piety, beauty, and money—among the assets of a potential bride. Her dowry included "materials for a room, that is hangings, bed, window curtains and a dozen chairs, all her own work," proving that she was "frugal" and "most laborious" as well as rich.[32] Decorative projects demonstrated a tangible virtue and dutiful commitment to family (figs. 95, 96). Marchioness Grey took little pleasure in her sewing but clearly felt she had to do it. "Morning occupation breaking brains over Worke, or relieving them with harpsichord," she confessed in 1745.[33] Perhaps women used craft to perform their servitude to men, but female care could be an offering of good will too. It is hard not to see a baby's name embroidered on a quilt as a gesture of tenderness.

More modishly, women's ornaments, "so very pretty and curious," personified the studied ingenuity and virtuosity that fascinated polite taste. The house of Mrs. Pendarves (later Delany) was acclaimed by friends and family as "a little abstract of all sorts of ingenuity," and "the cabinet of curiosities, for it is full of prettiness and ingenuity."[34] Descriptions of an unusual decoration or interior padded out many a letter and travel journal. On a visit to an associate in 1762, a Yorkshire gentleman John Courtney was ceremoniously shown a room decorated by the daughter of the house with needlework landscapes "so vastly fine that at a very little distance I took it for very choice painting, all in fine proportion, and charming colours… as great curiositys as anything I ever saw."[35]

Artistic talent inspired the creation of decorative domestic projects for some experts—Mary Delany being the superlative exemplar. However, genius was not given to the majority who pursued crafts as a fashionable recreation. The vivacious Mary Warde of Squerries Court, Kent, was every inch the modish Miss of the 1740s. "I have been very busy all this summer at a piece of shellwork," she boasted to a shyer northern cousin in 1743. "It is a very fashionable Employment & a great amusement, & a fancy like yours would display itself to as much advantage as on a *yellow petticoat*."[36] One suspects that, if shellwork had not been "a very fashionable Employment," Warde's fancy would have lain dormant.

A major defense of accomplishments from both traditionalists and liberals was essentially negative—that they kept women occupied and so stopped them getting up to anything worse. The

Figure 96: Waistcoat panel. Victoria and Albert Museum, London (T.68a-1919). The pattern is marked out but the embroidery is incomplete.

soul-destroying tedium of life at home is taken for granted in this literature. Wettenhall Wilkes preached in 1740 that women should always be blamelessly employed, to counteract the tedium of this life, "a desart of wild and empty Wastes," and to leave no vacancy whatsoever for idle or dangerous thoughts. Similarly, Dr. Gregory believed innocent pastimes helped women tolerate "the many solitary hours [they] must necessarily pass at home," and with luck discouraged self-sufficient women from "continually gadding abroad in search of amusement." With a touch more sympathy, Hester Chapone recommended accomplishments for "filling up agreeably those intervals of time, which too often hang heavily on the hands of a woman, if her lot be cast in a retired situation." Maria Edgeworth also accepted accomplishments as "resources against ennui," but argued that, as "women are peculiarly restrained in their situation, and in their employments, by the customs of society," this was no mean benefit. Illusionless, Edgeworth concluded "every sedentary occupation must be valuable to those who are to lead sedentary lives."[37] In this assessment, then, accomplishments were a support to sanity.

The deadliness of boring company was often harder to bear than loneliness. Women whose families pretended to politeness had little choice but to submit to visiting. Sewing was one of the few activities that could be performed in company without reproach. Thomas Jefferson stressed this advantage when writing to his daughter Martha at school in Paris in 1787: "In dull company and in dull weather, for instance, it is ill-manners to read, it is ill-manners to leave them; no card playing there among genteel people—that is abandoned to blackguards. The needle is then a valuable resource."[38] Sewing offered an aloof self-possession in the midst of clamor. When the Chutes of the Vyne, in Hampshire, saw the tenants on rent day in the 1800s, the ladies of the family were expected to grace the proceedings: "Each tenant came in by turns, called farmer so and so, talked and grumbled, whilst Aunt C and myself worked."[39] Sewing demonstrated a venerable housewifery to the tenantry, as befitted an old-fashioned, hospitable country family, but it also helped the women endure a long evening of patronage. Not all crafts were equally portable. Mary Anstey complained to Elizabeth Montagu that her featherwork screen progressed slowly as it demanded isolation: "Could I carry it with me into company as one does a piece of knotting it would soon be finished." The cleaner crafts gave women something to do in the drawing room when they had no choice but to display their company manners.[40]

The pursuit of recreations was a widely recognized antidote to ennui, which, left unchecked, could bring on "melancholia," a feared malady that led even to the sin of self-murder. The depressive spinster Gertrude Savile used her needlework as a form of occupational therapy in the 1730s. A resentful dependent on her mother and brother, and excruciatingly shy, gauche, sour, and melancholic, Savile found almost her only relief in needlework projects: "My tent is my most elligant Diversion, and all I shall ever be fitt for… . Mother and Aunt went near 4, the Maids after them. I stair'd out of the window a little. Tent till dark." Needlework seemed here to dignify and justify solitude, but Savile also saw it as one of the few means available to quieten her own torturous inner monologue: "Sat Oct 26 tent 2 hours Morn (which I knew was most parnicious). But better than sitt still and let my own mellancholly thoughts lead me to madness)." She worked pockets and made patchwork and tent-work screens, chair covers, and backs, drawing her own designs and copying from prints. An ongoing task was a psychological necessity, and Savile feared the intermission between projects: "Tis a misfortune I have done my Screen. I can't live so much alone without that sort of work… ." Perhaps she apprehended that a life measured out in wool was no life, but she firmly believed that she was unfit for all but retirement. Looking back on 1728, she concluded: "Seldom went out… . I begun a Tent Work Screen; finished it in about 5 months. Besides I know not what I did to keep me from Madness."[41] Savile's furious needle held both insanity and society at bay (fig. 97).

Precious scraps of evidence suggest that decorative work played a role in long illnesses and convalescence. Mary Hartley was a very feeble young woman who lived in lodgings in Winchester and Bath in the 1780s with her nurse. Confined to bed with a gangrenous foot in 1784, and suffering a terrifying series of minor amputations, Mary embarked on a painted fire screen on satin for her brother to present to the queen.[42] The screen was adorned in pain, and wrought in sad, often drugged, isolation. The view from the window was Mary's chief entrée to the world. At least her work might go to court, even if she could barely leave the house.

By contrast, there are copious examples of the rich social context of craft for many women. The prolific Mary Delany's paper collages were rarely worked in isolation. The collages were begun at Bulstrode in the company of the Duchess of Portland, inspired by botanists and botanical artists. The two middle-aged women pursued their interests side by side. Back in December

1757, Delany had written that, while she was making shellwork frames, the duchess was turning amber, then "At candlelight, cross-stitch and reading gather us together."[43] Needlework married perfectly with reading aloud. The fictional "Lady Lizard" of the Guardian (1713) furnished a gallery with couches and chairs, embroidered by herself and her daughters while hearing all of Dr. Tillotson's sermons twice over.[44] On a family visit in the 1790s, Anna Larpent, a civil servant's wife, and her sister took turns reading aloud and working on a cross-stitch chair.[45] It was common for ladies to embark together on shared projects. When Mrs. Delany visited the bluestocking Mrs. Vesey in 1751, her hostess "had a whim to have Indian figures and flowers cut out and oiled, to be transparent, and pasted on her dressing-room window in imitation of painting on glass, and it has a very good effect; we go again next Friday to finish what we began last week." Delany designed patterns for her wide acquaintance, and advised on the projects of her friends: "the mosaick pattern with cloth work round, will be prettier than the flower pattern for your window-curtains." In 1750 she asked her sister, Anne Dewes, "Have you put up your shell-work over the chimney, and painted it? and how does it look?"[46] Even in the 1790s, Lady Frances, daughter of the Earl of Ailesbury, was gratified to be asked to assist Lady Devonshire in "working furniture for one of her rooms in Hanover square."[47] The frequency with which female handicrafts were given as gifts suggests both the prestige put upon them and the power they had to connect women. Appreciation of a personal production is a leitmotif of female correspondence.[48]

Female sociability, female communities, and often female retirement were all associated with handicraft. As "Queen of the Blues," the leading hostess of the first generation of bluestockings, Elizabeth Montagu was celebrated for her championing of learned sociability. Widow of one of the richest men in England, Mrs. Montagu used her vast coal fortune to build Montagu House, in Portman Square. To the designs and decorations of Angelica Kauffman, Robert Adam, and "Athenian" Stuart, she added a feather-room for her feather-art creations. Inspired by the example of the Duchess of Portland, whom she had supplied with exotic feathers via her brother in India years before, the feather-work screens depicted flora and fauna in every shade. "From ye gaudy peacock to ye solemn raven, we collect whatever we can," Montagu reported in 1781. The screens were ten years in the making, overseen by her forewoman Betty Tull: "Maccoas she has transformed into Tulips, Kingfishers into

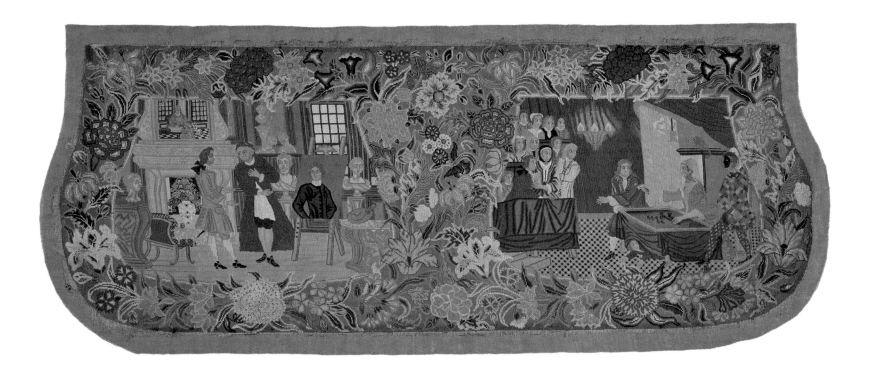

Figure 97: Settee seat cover, 1728–40, embroidery on canvas in wool and silk, mostly in tent and cross stitch, adapted from a printed engraving. Victoria and Albert Museum, London (T.473–1970)

Figure 98: A frieze of feathers in the drawing room at A la Ronde, Devon, made by the spinster cousins Jane and Mary Parminter, using the feathers of game birds and chickens, 1790s. National Trust

Figure 99: A shell-encrusted surround to a window in the Shell Gallery at A la Ronde, Devon, made by the spinster cousins Jane and Mary Parminter, 1790s. National Trust

bleu bells by her so potent art." The finished extravaganza was celebrated for its gorgeous exuberance: "the Birds put of their ev'ry hue To dress a room for Montagu." In June 1791, Queen Charlotte and the princesses came to pay homage to the room.[49] Elizabeth Montagu's craft was vivid and ostentatious as befitted the opulence of Montagu House, her "palace of chaste elegance," the stage of her extraordinary sociability, and a landmark of the London social scene.

In pointed contrast, Mrs. Montagu's retiring sister Sarah Scott, scarred by smallpox and a disastrous brief marriage, lived in relative seclusion in lodgings outside Bath in the 1750s. Yet she too fostered female community, but on a far plainer scale than her sister. With her companion, the sickly Barbara Montagu, Scott also embarked on decorative projects, which involved crafting compositions from natural forms. Instead of exotic peacock feathers and rare nautilus shells, the couple drew mostly on materials that cost nothing, and performed the work themselves. They made elaborate frames from "gilded cones corn acorns poppy heads & various evergreens with flowers & leaves in lead & some fruit in pipe makers clay."[50] Betty Rizzo argues that the sisters developed two rival versions of community, and that their differing crafts were one expression of the contrast. Scott's community could be read as a critique of her sister's, centering as it did on the poor not the grand, on self-abasement not showing off.[51] While Montagu spent a fortune on her screens, Sarah Scott and Lady Barbara transformed nature's autumnal bounty into domestic decorations. Indeed, in the utopian all-female community of Scott's novel *Millenium Hall* (1762), the inmates of the model school learned wood-carving, engraving, turnery, perspective, drawing, painting, as well as harpsichord, embroidery, and plain sewing. Consequently, they were able to raise the drooping spirits of a poor widow by refurbishing her house. They hung papers, framed drawings in shellwork and covered her plain cabinets with dried seaweed landscapes. For the widowed mother of five, the house, so "prettily adorned" with its neat little flower garden, represented the revival of hope.[52] Here women's ornaments "pretty and curious" expressed a modest decorative frugality befitting self-effacing and charitable femininity, but also gave heart at home when brightness was most wanting.

A luxuriant display of craftwork is characteristic of self-consciously women-only interiors. The link between female design and decorative crafts was clear to the observant Londoner Anna Larpent on her polite travels in the 1790s. She was impressed by the "very neat square house"

belonging to a Mrs. Hardinge in Kent, thinking it "compact & pretty." But "what renders it more interesting is that Mrs H built it herself without an architect, with Country workmen.... It is furnished with needlework—drawing—furniture painted up by ye Miss Hardinges with great taste & ingenuity—Made of oughts & ends—yet really with Effect as well as Economy."[53] Thrift and ingenuity in interior decoration are here the hallmarks of a virtuous female taste. Deliberate attempts at separatist female living—at Plas Newydd, the gothicized "low roofed cot" of the ladies of Llangollen, Wales; at à La Ronde, in Devon, the sixteen-sided home of the spinster cousins Jane and Mary Parminter—were characterized by an inveterate culture of flamboyant female ornamentation, suggesting the spinsters were consecrated to a domestic cloister of curiosities and craft (figs. 98, 99).

It was rare for the display of craftwork to be overwhelming, but it made a discreet mark in most polite homes. Architects and designers preferred women's crafts to be isolated in a particular room. Sheraton advised excluding such ornaments from the dining room and the drawing room, but they could be displayed safely in the less formal parlor or breakfast room with other juvenilia.[54] However, the account books of the London upholsterer James Brown reveal that women's work was often luxuriously framed, so it could be exhibited to advantage alongside the best mahogany furniture.[55] Besides, the attention of polite tourists was often drawn to ladies' work in drawing and sitting rooms as well as bedrooms and dressing rooms, so, in this, the prescriptions of architects and designers were made to be flouted.

Accomplishments evolved over Mary Delany's lifetime as aesthetic tastes shifted. The variety and inventiveness of her own practice exemplify the exuberant fertility of decorative accomplishments. The early dominance of needlework was challenged from the 1730s by the fashion for shellwork, japanning, collage, silhouettes, and the like, but also, toward the end of the eighteenth century, by sketching, watercolors, and domestic music (fig. 100). "Our great grandmothers distinguished themselves by truly substantial tent-work, chairs and carpets, by needlework-pictures of Solomon and the queen of Sheba," which were now all consigned to the garret, remembered Maria Edgeworth in 1798: "Cloth-work, crape-work, chenille-work, ribbon-work, wafer work… have all passed away in our own memory."[56] Swiftly changing fashions in craft meant that women's work was especially apt

Figure 100: A shellwork vase, probably made at Pelling Place, Old Windsor, Berkshire, by Mrs. and Miss Bonnell, 1779–81, 35 × 21¼ × 14⅛ in. (89 × 54 × 36 cm). Victoria and Albert Museum, London (W.70-1981)

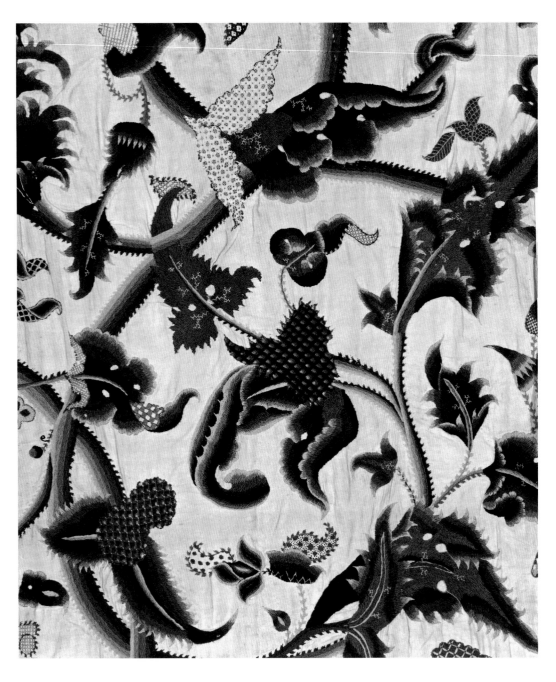

Figure 101: Detail of a crewelwork bed curtain, 1700–1715. Victoria and Albert Museum, London (353 to I-1907). This is an example of the heavy embroidery on hangings deemed old-fashioned by the 1790s.

to date. "One is seldom partial, I think, to ladies work of this kind, as it generally carries the date of the age it was perform'd in," concluded Mrs. Lybbe Powys on the bed hangings made by the late mistress of a Buckinghamshire mansion.[57]

Certain forms came to be seen as archaic, bathed in a glow of nostalgia or melancholy. In 1796, a wistful Thomas Gisborne saw a mastery of the "mysteries of cross-stitch and embroidery," the "sciences of pickling," and the "family receipt book" as the measure of female perfection in the "last age."[58] Crewelwork and stumpwork inevitably brought to mind Stuart housewifery, and implied that the makers were industrious, possibly dull, countrywomen (fig. 101). Hangings often were taken to symbolize woman's lot in yesteryear, and raised a shudder in some observers. *The Spectator* was an early opponent, depressed by "tedious drudgeries in needlework, as were fit only for the *Hilpa's* and the *Nilpa's* that lived before the Flood."[59] Hannah More disliked the objects women fashioned in 1799 (scorning the wax flowers and cut-paper ornaments that littered the parlors of pretentious farmers' daughters), but allowed that modern productions were at least superior to the "hangings of hideous tapestry and disfiguring tent-stitch," created by "the good housewives of the last century," who "wore out their joyless days in adorning the mansion house" in very bad taste.[60] While, from the distance of centuries, we might view women's crafts as interchangeable, to their practitioners there was a world of difference between a 1670s set of crewelwork curtains, a 1740s shellwork frame, a 1790s painted screen, and an 1820s penwork chair. Dusty needlework seemed as remote to the Regency commentator as seaweed landscapes and hair jewelry appear to us.

Eighteenth-century educationalists seized on "accomplishments" as a handle for discussions of female roles, potential, and learning. However, there was no unanimity even on what counted as an accomplishment, let alone whether they should be promoted, tolerated, or banned. For Hannah More no word was more "abused, misunderstood, or misapplied, than the term accomplishments."[61] The positive definition of accomplishment was a faculty or quality attained by study and practice that completed or perfected a person for society, adding delicacy of taste and elegance of manners to accuracy of knowledge and correctness of thought. However, "accomplishments" became for critics a debased term, a shorthand for "superficial acquirements" that pretended to complete an education that did not exist. By the 1790s, accomplishments became a hook on which to hang an attack on female educa-

tion and modern femininity for feminist critics and educational reformers both radical and Tory.

A misreading of the polemical attack on accomplishments has overdetermined the way historians have approached the subject. The gloomy tale of a decline in useful domestic work in the gaudy face of fashionable accomplishments was but one line of discursive attack. In fact, even in the good old days of seventeenth-century housewifery, virtuosa ladies might be lambasted for exhibitionism. The possibility that needle-women were motivated by the sin of pride and a desire to flaunt themselves, not to honor God, was an old chestnut. Besides, a Stuart embroidery has no more inherent utility than a japanned box of the Regency. Both were forms of domestic adornment, which was ever a female responsibility, often a focus of honor, and sometimes a source of pleasure.

Whether the contradictory and often incoherent debate on accomplishments tempered the practice and domestic reception of craft is moot. It is unlikely that More and Wollstonecraft had more ideological purchase than the Old Testament. The evidence surveyed here, from letters and diaries to account books and the objects themselves, reveals that decoration of the home by female hands remained a thoroughly orthodox practice (plain sewing and embroidery were still inescapable female performances in the 1800s). Indeed, were it not so, it is hard to imagine the *gemütlich* Queen Charlotte devoting herself to decorative work in the 1790s. Women's crafts remained a fitting crown to a righteous domestic life.[62]

Handicrafts were virtuous when they enriched a well-ordered, smoothly managed household. The key to success lay in being seen to balance housewifery and accomplishment, as here in an approving report on a young bride who had induced her clerical lover to renounce a college fellowship to marry her in 1819: "Certainly his looks do her great credit—and her good sense knows how to become the prudent domestic Wife in which character she shines as much as when in her Boudoir surrounded by her various collection of shells, feathers, and paintings of her own performance."[63] This sensible Circe could parade both sober housekeeping and elegant accomplishment.

Men valued women's productions highly enough to pay for them to be framed expensively in mahogany, suggesting that gentlemen appreciated ladies' work far more than modern historians have done. The assumed worth of women's ornamental projects suffers by an implied comparison with men's sturdy public employments, yet the practices of noble, gentry, and genteel women were not dissimilar from those of English gentlemen who lived quietly on their inheritance pursuing a range of interests from collecting, horticulture, and botany to polite science and literature. It is quite wrong to suppose that privileged women filled their empty lives with decorative nonsense while their menfolk put away such things. Active leisure was ever the mark of the gentleman. Sir William Hamilton embraced an interest in gardening because, "As one passion begins to fail, it is necessary to form another; for the whole art of going through life tolerably in my opinion is to keep oneself eager about anything. The moment one is indifferent on s'ennuie, and that is a misery to which I perceive even kings are often subject."[64] Thus, while a Mrs. Freeman was commended by Mrs. Lybbe Powys for her embroidered furniture, her husband was noted for the elegant cases of fossils, shells, and ores, "in which Mr Freeman is curious and has a fine collection."[65] The sensible were expected to have resources to draw upon, what might today be termed a cultural hinterland, to help tolerate the doldrums and reverses of existence. Projects held the menace of time at bay.

Women's crafts were productions of supreme individuality. Handworks were individual in material, aesthetic, customary, and even in legal terms. Raw materials were worked to produce something unique, and even shop-bought kits were never assembled in exactly the same way. Drawing and design, selection of color, and adaptation of patterns all manufactured an aesthetic display that was absolutely personal. "My own work" was a routine identification made by female victims of theft. And even among the highest nobility, women's craft helped to define and defend personal property against the devouring maw of the estate. Sarah Duchess of Marlborough's meticulous inventory of the goods at Blenheim, drawn up in 1740 when she was in property dispute with her grandson, reveals how personal labor on an object could mark it as paraphernalia—those individual accoutrements that could not be swallowed up by the patrimony. "A white Indian Stitched Bed made with fringe which is the Duchess of Marlboroughs All things belonging to that Furniture the Trusts but all the fringe is the Duchess of Marlbro's own Work & therefore is hers"—as much her own as the valences "of very rich Embroidery which was made of the Duchess of Marlboroughs Clothes."[66] The wily duchess used her needle to colonize property and enlarge the territory of her paraphernalia. In placing their manual work upon something, women from high to low stamped it as their very own. And marks of individuality were no mean achievement in the hierarchical household.

Authorized by God and hallmarked by royalty, decorative work could claim impeccable credentials. A devout Anglican, Mrs. Delany had a deep reverence for nature, and saw the hand of God in the faultlessness of natural forms. She reflected that "the beauties of *shells* are as *infinite as of flowers*, and to consider how they are inhabited enlarges a field of wonder that leads one insensibly to the great Director and Author of these wonders."[67] Delany's crafts could be read as a strengthening of her faith. Women crafted safe in the knowledge that they were fulfilling God's will and producing something of prestige to boot. Idleness was inexcusable in a woman. Occasionally she doubted the moral worth of her recreations, worrying in letters that she was frittering away her time "with amusements of no real estimation," and compared her storeroom unfavorably with her sister's: "Mine fits only an idle mind that wants amusement; yours serves either to supply your hospitable table, or gives cordial and healing medicines to the poor and the sick." Celebrity provoked some soul-searching: "When people commend any of my performances I feel a consciousness that my time might have been better employed."[68] Yet these remarks partake more of conventional humility than real misgivings. Craft was a socially acceptable outlet for creative expression. The process itself was constructive. Craft functioned as therapy for the distracted and solace for the wounded. Decorative projects offered women a sense of purpose and resulted in a lasting achievement. They offered an innocent remedy for the tediousness of domestic life, though often the torture of tiresome company was harder to bear than loneliness. Handicraft operated within a supremely social milieu for many, being particularly associated with friends, female communities, and often female intellectual retirement. In families, the collection of objects on which women made their mark created a nest of meanings within the houses of men.

Acknowledgments

The research for this analysis was undertaken on a Leverhulme Research Readership. For criticism I thank Michele Cohen, Hannah Greig, Mark Laird, Charlotte Mitchell, Amy Meyers, Clarissa Campbell Orr, John Styles, and Alicia Weisberg-Roberts. For showing me embroidery and fancywork in the V&A and Museum of London, I am indebted to Clare Browne, Edwina Ehrman, and Sarah Medlam.

Notes

1. Quoted in Ruth Hayden, *Mrs. Delany: Her Life and Her Flowers* (London: British Museum Publications, 1980), 91.

2. Kim Sloan, *'A Noble Art': Amateur Artists and Drawing Masters, c. 1600–1800* (London: British Museum Press, 2000), 46.

3. This was the regretful conclusion of Paul Hilton, curator of the collages at the British Museum, in his preface to Hayden, *Mrs. Delany*, 14.

4. Ann Bermingham, *Learning to Draw: Studies in the Cultural History of a Polite and Useful Art* (New Haven and London: Published for the Paul Mellon Centre for Studies in British Art by Yale Univ. Press, 2000), 224.

5. See "Ladies Amusements," in John Fowler and John Cornforth, *English Decoration in the 18th Century* (London: Barrie & Jenkins, 1974), 253.

6. Bermingham, *Learning to Draw*, 202; Linda Nochlin, "Why Have There Been No Great Women Artists?" in Linda Nochlin, *Women, Art and Power and Other Essays* (New York: Harper & Row, 1988), 145–76; Griselda Pollock and Rozsika Parker, *Old Mistresses: Women, Art, and Ideology* (New York: Pantheon Books, 1981), 58–59.

7. Thorstein Veblen, *The Theory of the Leisure Class: An Economic Study in the Evolution of Institutions* (New York: Macmillan, 1899), 82.

8. Germaine Greer, "Making Pictures from Strips of Cloth Isn't Art at All—But It Mocks Art's Pretentions to the Core," *The Guardian*, 13 August 2007, available at www.guardian.co.uk /artanddesign/2007/aug/13/art (accessed 4 February 2009).

9. Ann Bermingham, "Elegant Females and Gentlemen Connoisseurs: The Commerce in Culture and Self-Image in Eighteenth Century England," in Ann Bermingham and John Brewer, eds., *The Consumption of Culture, 1600–1800: Image, Object, Text* (London: Routledge, 1995), 509.

10. Bermingham, *Learning to Draw*, 183, 186.

11. Amanda Vickery, "Golden Age to Separate Spheres: A Review of the Categories and Chronology of English Women's History," *Historical Journal* 36, no. 2 (1993): 383–414.

12. Horace Walpole, "Ladies and Gentlemen Distinguished by Their Artistic Talents," in *Anecdotes of Painting in England*, 5 vols. (New Haven: Yale Univ. Press, 1937), 5:228–40.

13. Lady Llanover, ed., *Autobiography and Correspondence of Mary Granville, Mrs. Delany*, 6 vols. (London: Richard Bentley, 1861–62), ser. 2, 3:507 (appendix).

14. Llanover, ed., *Autobiography and Correspondence*, ser. 2, 3:503 (appendix).

15. Inventory of Jenny Scholes of Manchester, spinster, 1768, Wills proved at Chester, WCW/1768/Scholes, Lancashire Record Office. I thank Madeleine Ginsburg for bringing this inventory to my attention.

16. Will of Charlotte Bingley, Doncaster, 1780, York wills, Borthwick Institute for Archives, The University of York.

17. "John Woodward, Theft," December 1750, ref. no. t17501205-42, Old Bailey Proceedings Online, www.oldbaileyonline.org/browse.jsp?ref=t17501 205-42 (accessed 25 February 2008).

18. Dorothy Gardiner, *English Girlhood at School: A Study of Women's Education through Twelve Centuries* (Oxford: Oxford Univ. Press, 1929); Hannah Woolley, *The Gentlewomans Companion, or, A Guide to the Female Sex* (London: Printed by A. Maxwell for Edward Thomas, 1675), 7; Inventory for Rebecca Weekes, late of Deptford Strand, 1730, Prerogative Court of Canterbury, PROB 3/29/215, The National Archives, Kew, Richmond, Surrey, Public Record Office.

19. Peter Earle, "The Female Labour Market in London in the Late Seventeenth and Early Eighteenth Centuries," *Economic History Review*, ser. 2, 42 (1989): 328–52; Nicola Phillips, *Women in Business, 1700–1850* (Woodbridge, Suffolk: Boydell Press, 2006).

20. Hannah Robertson, *The Young Ladies School of Arts*, 2nd ed. (Edinburgh: Ruddinan, 1767), ix. A pong appears to have been a kind of decorative posy or garland.

21. Susan C. Djabri, ed., *The Diaries of Sarah Hurst, 1759–1762: Life and Love in Eighteenth Century Horsham* (Horsham: Horsham Museum Society, 2003), xxiv.

22. Other instructional publications on these activities include John Stalker and George Parker, *A Treatise of Japanning and Varnishing* (London, 1688); *Arts Companion, or, A New Assistant for the Ingenious*, 3 parts (London, 1749); George Brookshaw, *A New Treatise on Flower Painting, or, Every Lady Her Own Drawing Master* (London, 1797); and B. F. Gandee, *The Artist, or, Young Ladies' Instructor in Ornamental Painting, Drawing &c.: Consisting of Lessons in Grecian Painting, Japan Painting, Oriental Tinting, Mezzotinting, Transferring, Inlaying and Manufacturing Ornamented Articles for Fancy Fairs* (London: Chapman and Hall, 1835).

23. Hannah Robertson, *The Life of Mrs. Robertson, (a Tale of Truth as Well as of Sorrow): Who, though a Grand-daughter of Charles II, Has Been Reduced, by a Variety of Very Uncommon Events, from Splendid Affluence to the Greatest Poverty. And, After Having Buried Nine Children, Is Obliged, at the Age of Sixty-Seven, to Earn a Scanty Maintenance for Herself and Two Orphan Grand-children, by Teaching Embroidery, Filligree, and the Art of Making Artificial Flowers* (Derby: Printed by J. Drewry, 1791), 31.

24. Thomas Sheraton, *The Cabinet Dictionary: Containing an Explanation of All the Terms Used in the Cabinet, Chair & Upholstery Branches…* (London: W. Smith, 1803), 316.

25. Account book of James Brown, 29 St. Paul's Churchyard, London, upholsterer, 1784–88, Chancery Masters Exhibits, C107/109, The National Archives, Public Record Office.

26. See, for example, Thomas Baker, *Tunbridge-Walks: or, The Yeoman of Kent: A Comedy* (London: Printed for Bernard Lintott, 1703), 21.

27. Rozsika Parker, *The Subversive Stitch: Embroidery and the Making of the Feminine* (London: Women's Press, 1986), 10.

28. Margaret J. M. Ezell, *The Patriarch's Wife: Literary Evidence and the History of the Family* (Chapel Hill: Univ. of North Carolina Press, 1987), 187.

29. Mary Delany to Anne Dewes, in Llanover, ed., *Autobiography and Correspondence*, ser. 1, 2:523, 561.

30. Samuel Richardson, *Clarissa; or, The History of a Young Lady*, 9 vols. (1747–48; London: Chapman & Hall, 1902), 3:305.

31. Queen Charlotte's Diaries, 26 August 1789, 11 September 1789, 15 September 1789, Royal Archives. I thank Edwina Ehrman for these references.

32. John Crawford Hodgson, ed., *Six North Country Diaries* (Durham, Eng.: Publications of the Surtees Society, 1910), cxviii, 164–65.

33. See Anne Buck, *Dress in Eighteenth-Century England* (London: B. T. Batsford, 1979), 203.

34. [Mrs. Donnellan], "Aspasia's Picture, Drawn by Philomel, in the Year 1742," in Llanover, ed., *Autobiography and Correspondence*, ser. 1, 2:179; Anne Granville to Mrs. Granville, 1737, in Llanover, ed., *Autobiography and* Correspondence, ser. 1, 1:590.

35. Susan Neave and David Neave, eds., *The Diary of a Yorkshire Gentleman: John Courtney of Beverley, 1759–1768* (Otley, West Yorkshire: Smith Settle, 2001), 52.

36. M. Warde, Squerries, Kent, to Mrs. Stanhope, 17 August 1743, Spencer Stanhope Collection, Sp St 6/1/50, West Yorkshire Archive Service (Bradford).

37. Wetenhall Wilkes, *A Letter of Genteel and Moral Advice to a Young Lady* (Dublin: Printed by E. Jones for the author, 1740), 121; John Gregory, *A Father's Legacy to His Daughters*, 2nd ed. (London, 1774), 51–52; Hester Chapone, *Letters on the Improvement of the Mind: Addressed to a Young Lady*, 2 vols. (London: Printed by H. Hughs for J. Walter, 1773), 2:118; Maria Edgeworth and Richard Lovell Edgeworth, *Practical Education*, 2 vols. (London: J. Johnson, 1798), 1:522–23.

38. Quoted in Parker, *Subversive Stitch*, 136.

39. Trevor Lummis and Jan Marsh, *The Woman's Domain: Women and the English Country House* (London: Viking, 1990), 105.

40. Mary Anstey to Elizabeth Montagu, 1752, Elizabeth (Robinson) Montagu Papers, Mo 108, Huntington Library, San Marino, California.

41. Alan Saville, ed., *Secret Comment: The Diaries of Gertrude Savile, 1721–1757* (Nottingham: Thoroton Society of Nottinghamshire, 1997), 107, 112, 114, 154. Tent stitch is a simple, diagonal embroidery stitch executed on open-net canvas, characteristically used to fill areas in a pattern.

42. Ann Toll, servant of Mary Hartley, writing on her mistress's behalf to David Hartley, 12 October 1784, Hartley Papers, D/EHy,F100/2/28, Berkshire Record Office.

43. Mary Delany to Anne Dewes, 29 December 1757, in Llanover, ed., *Autobiography and Correspondence*, ser. 1, 3:473.

44. *The Guardian*, no. 155 (8 September 1713).

45. Anna Larpent's Diary, vol. 1, 1790–95, fol. 153v, Huntington Library, HM 31201, San Marino, California.

46. Mary Delany to Bernard Granville, 11 June 1751, in Llanover, ed., *Autobiography and Correspondence*, ser. 1, 3:39–40; Mary Delany to Anne Dewes, 30 June 1750, in Llanover, ed., *Autobiography and Correspondence, ser. 1*, 2:561.

47. Lady Frances, London, to Earl of Ailesbury, Tottenham Park, 1794, Ailesbury of Savernake Papers, 1300/3199, Wiltshire and Swindon Archives.

48. Lady Wallingford to Earl of Banbury, 1 November 1780, Papers of the Knollis Family, Earls of Banbury, 1M44/7/34, Hampshire Record Office; Lady Wallingford to Earl of Banbury, 22 February 1783, Papers of the Knollis Family, Earls of Banbury, 1M44/7/43, Hampshire Record Office.

49. Elizabeth Robinson to Duchess of Portland, 3 December 1736, Elizabeth (Robinson) Montagu Papers, Mo 264, Huntington Library, San Marino, California; Elizabeth Eger, "Luxury, Industry, and Charity: Bluestocking Culture Displayed," in Maxine Berg and Elizabeth Eger, eds., *Luxury in the Eighteenth Century: Debates, Desires, and Delectable Goods* (Basingstoke: Palgrave Macmillan, 2003), 199.

50. Sarah Scott to Elizabeth Montagu, 1752, Elizabeth (Robinson) Montagu Papers, Mo 5223, Huntington Library, San Marino, California.

51. Betty Rizzo, "Two Versions of Community: Montagu and Scott," in Nicole Pohl and Betty A. Schellenberg, eds., *Reconsidering the Bluestockings* (San Marino, Calif.: Huntington Library, 2003), 193–214, 199.

52. Sarah Scott, *A Description of Millenium Hall and the Country Adjacent…* (1762; repr., London: Virago, 1986), 7, 149.

53. Anna Larpent's Diary, vol. 1, 1790–95, fol. 77, Huntington Library, HM 31201, San Marino, California.

54. Sheraton, *Cabinet Dictionary*, 219.

55. Entries for Mrs. Belloncle, 21 January 1785, the Reverend Dodwell, 24 January 1785, Mrs. Gillow, 7 February 1788, in James Brown account book, 29 St. Paul's Churchyard, London, upholsterer, 1784–88, Chancery Masters Exhibits, C107/109.

56. Edgeworth and Edgeworth, *Practical Education*, 2:530.

57. Emily J. Climenson, ed., *Passages from the Diaries of Mrs. Philip Lybbe Powys of Hardwick House, Oxon., A.D. 1756–1808* (London: Longmans, Green, 1899), 147.

58. Thomas Gisborne, *An Enquiry into the Duties of the Female Sex* (London, 1797), 18–19.

59. *The Spectator*, no. 609, 20 October 1712.

60. Hannah More, *Strictures on the Modern System of Female Education: With a View of the Principles and Conduct Prevalent among Women of Rank and Fortune*, 3rd ed., 2 vols. (London: Cadell and Davies, 1799), 1:111–12; Michèle Cohen, *Fashioning Masculinity: National Identity and Language in the Eighteenth Century* (London: Routledge, 1996), 65.

61. More, *Strictures*, 1:73.

62. For example, Anna Larpent's Diary, vol. 1, 1790–95, fol. 14, Huntington Library, HM 31201, San Marino, California.

63. S. Tatham, Southall, to Mr. and Mrs. Bradley, Slyne, 21 July 1819, Dawson-Greene Papers, DDGr C3, Lancashire Record Office.

64. Cited in Sloan, *A Noble Art'*, 46.

65. Climenson, *Passages*, 147.

66. Tessa Murdoch, ed., *Noble Households: Eighteenth-Century Inventories of Great Houses: A Tribute to John Cornforth* (Cambridge: J. Adamson, 2006), 281, 277.

67. Mary Pendarves to Anne Granville, 30 June 1734, in Llanover, ed., *Autobiography and Correspondence*, ser. 1, 1:485.

68. Mary Delany to Anne Dewes, 6 October 1750, in Llanover, ed., *Autobiography and Correspondence*, ser. 1, 2:601.

[5]

Mrs. DELANY'S PAINTINGS & DRAWINGS:
Adorning Aspasia's Closet

The essays in this book explore many ways of assessing the reputation of Mrs. Delany: as a craftswoman with many accomplished skills in embroidery, shellwork decoration, and cut paper; as an active participant in court circles; as a botanist and landscape gardener; and as a correspondent in the eighteenth-century epistolary world. The purpose of the present essay might at first appear to be to examine her work in the other sphere of activity to which she devoted a great deal of her time—as a painter and draftswoman. This presents a unique problem, however, in that although she painted and drew, she never described herself as an artist or painter and instead referred to these activities as her "work" or "employment," the same terms used to describe her needlework, or as "amusements" or "performances," the same words she used to describe her music. She never referred to herself as an artist for the basic reason that artists or painters were professionals who made their living from their art.

For Mary Delany, no matter how long she spent or how hard she applied herself, painting and drawing were "innocent amusements." As she explained in 1753 in a letter to her sister describing how she spent time with the young people who visited her at Delville:

I think it prudent in a moderate degree to encourage in young people an inclination to any innocent amusement, and am happy when I find they have a turn for any art or science; the mind is active, and cannot always bend to deep study and business, and too often bad company and bad ways are the relaxations sought; to guard against that, nothing is so likely as any amusement that will not tire, and that requires application to bring any perfection, and of course must prevent that idleness which at best *makes them* very insignificant. *I agree with Mr. Dewes, that an immoderate love to music may draw young people into many inconveniences: I would therefore confine it as much as I could to an amusement, and never allow it to be their business. Painting has* fewer objections, *and generally* leads people into much better company."[1]

Thus, when assessing Mrs. Delany's paintings and drawings, we must not examine them through a narrow art-historical perspective, comparing her work to that of professional artists, examining stylistic influences, techniques, chronological development, and making connoisseurial judgments; instead, we must approach them in the spirit in which they were made, examining the social, cultural, physical, philosophical, and emotional situations and discourses that conditioned and defined them.[2]

Ladies and Gentlemen Distinguished by Their Artistic Talents

In order to place ourselves more firmly in the discourse of Mrs. Delany's contemporaries, no more appropriate introduction could be provided than that of Horace Walpole, an enthusiastic friend and admirer who designed the frame and epitaph for her 1782 portrait by John Opie (see fig. 5). The frame included a palette, easel, pencils, and brushes, and the epitaph celebrated her "Piety and Virtues, her excellent Understanding, and her Talents and Taste in Painting and Music."[3] In writing about "Ladies and Gentlemen Distinguished by Their Artistic Talents" in his *Anecdotes of Painting, &c.*, Walpole described her as follows:

Mrs. Delany, born Granville, married to Mr. Pendarvis, and then to Dean Delany, painted in oil and crayons, worked finely; executed 500 plants in paper mosaic, which she invented at near 80; and which she taught to Miss Jennings of Shiplake. A few of Mrs. Delany's letters to Dr. Swift are published with his. In 1785 on the death of her friend the duchess of Portland, the king gave Mrs. Delany a pension of 300l. a year and a house at Windsor. She died in 1788, aged 88.[4]

In fact Walpole's assessment, in spite of its context, is not an art-historical one and thus is closer to a modern perspective: the salient facts of interest to both being the men to whom she was connected; her paper mosaics, including their numbers (double what Walpole recorded) and her age when she made them; her correspondence with the English satirist Jonathan Swift; and her

aristocratic and royal connections. Beyond noting that her pictures in oils and crayons were "worked finely," he did not comment further on their quality. Regarding the "artistic talents" of several correspondents or friends of Mrs. Delany, he enthused with more characteristic hyperbole: the turned ivory flowers of the daughters of the Duchess of Portland were "moveable by the breath"; the etched and drawn landscapes of Mary Hartley of Bath were "in very good taste"; while the Reverend William Gilpin's written travels were "in excellent style" and his "drawn views, in a still better style, of most of the places he mentions." He noted that Mrs. Walsingham painted in oil and that the Reverend William Mason's altarpiece of the Good Samaritan for the church of his friend the Earl of Harcourt at Nuneham was "well designed and well coloured; though there are faults in the drawing of the wounded man, and a want of expression in both figures; but the landscape is excellently conceived and disposed, and the picture is a great curiosity being not only the first, but the only performance of Mr. Mason in oil."[5]

Walpole clearly was willing to forgive "Ladies and Gentlemen" for what he might have deemed failings in a professional artist. His purpose in including them in his history of English art based on the notebooks of George Vertue was to provide a history that did not consist of just a list of the names of artists and their works, but to show how dependent the English school was on the patronage of monarchs and their subjects who were also collectors, patronage that was vital to the development of a national school of painting. By including these *amateurs* (using the eighteenth-century sense of the word as "lovers of arts") in his history, Walpole was underlining the role encouraged for English gentlemen ever since the seventeenth century, and now also for their wives and daughters: as virtuous and civic-minded men and women of taste, collectors, and connoisseurs, who could provide a cultural foundation upon which the artists and the nation as a whole might build.[6]

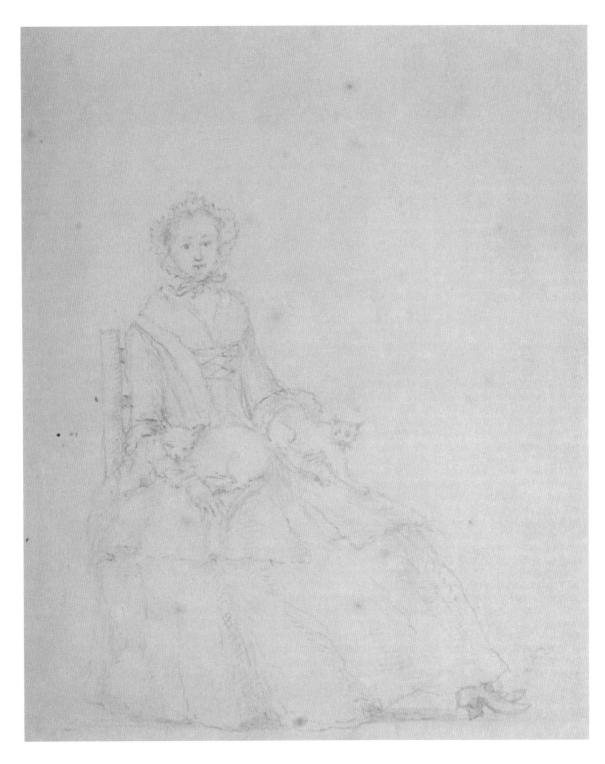

Figure 102: Mary Delany, *Delville fireside 27 Feb^y 1750/51*, 1750–51, graphite. The Lilly Library, Indiana University, Bloomington, Indiana. This drawing is from an album compiled by Mary Delany between 1732 and 1760.

Taking Delight in a Closet: Cutting Paper and Viewing Landscape

Having briefly placed Mrs. Delany's painting and drawing within the context of her contemporaries, we need to look more closely at why and when she painted and drew, and where. Were there particular circumstances in her life and situation that made these activities possible and desirable? What did she produce, and what did she do with her works? Were painting and drawing as normal a part of a woman's education as reading, writing, and needlework, or were they exceptional accomplishments encouraged by her destined position at court? Learning to draw usually preceded learning to paint, but in her autobiography and correspondence she mentions "little drawings" only briefly, and then with greater regularity describes her cut paper, caricatures, painting in oils, and portraits in crayons, all before she attempts to draw landscapes. Mary Delany is known to have made approximately seventy-two pictures in oils and crayons, fifty-four of which were located by Lady Llanover.[7] In describing Mary Delany's works, her editor did not mention albums of landscape drawings, and although the paintings were listed she did not really describe them, concentrating instead on Mary's shellwork, needlework, and collages. Now more than one hundred surviving landscape drawings, kept together in albums compiled by her and her friends, far exceed surviving works in oils.

The earliest account of any of her amusements is found in the "Autobiography" describing her early years, which Mary Delany wrote in about 1740 for her friend Margaret Cavendish, the Duchess of Portland, in the form of a series of long letters. She recounted that she had been educated in French, history, the classics, music, and needlework before joining her aunt in Whitehall in order to be trained for a position in Queen Anne's household. After the death of the queen, when Mary was about sixteen, her family lost favor at court and retired to Buckland Manor in Gloucestershire. There she "took great delight in a closet I had, which was furnished with little drawings and cut paper of my own doing; I had a desk and shelves for my books."[8] The house was adorned with fine china and prints and its front faced the Vale of Evesham, which was, according to her, "the finest vale in England":

At some distance on the left hand was a rookery; on the right a little clear brook run winding through a copse of young elms (the resort of many warbling birds), and fell with a cascade into the garden, completing the concert. In the midst of that copse was an arbour with a bench, which I often visited, and I think it was impossible not to be pleased with so many natural beauties and delights as I there beheld and enjoyed around me.[9]

Written around 1740 to describe a scene remembered from her youth twenty-five years earlier, she employed the language of someone already familiar with describing a landscape of sensibility—one that combines sight, sound, and emotions. Indeed, by the time of her writing she was already attempting to create a visual transcript of such landscapes in her drawings (fig. 103). In those early pictures she depicts the rolling hills, trees, houses, and gardens of her friends, often portraying herself immersed in the landscape, reveling in the sounds of barking dogs, chatting shepherds, lapping water, and breezes, and in the companionship of her new husband, shown at her side (fig. 104).

The North-East view of Newark near Glocester

Mendarves f: 1740

In a similar fashion she described the view from the closet by her bedroom in the home of her first husband, Alexander Pendarves, at Roscrow in Cornwall: "I never saw so beautiful a spot… surrounded by pleasant meadows… gardens and orchards entirely covered the hill, so that to every eye which beheld it at a distance the whole appeared a garden, and in great bloom at its proper season."[10] The closet was a private and personal space to which she could retreat from her unhappiness in her marriage and be transported through looking out upon an idyllic scene, employing the contemplation of landscape views and flower garden. Her closet was thus a place of retreat, decorated with works of her own imagination, and a portal to Elysium. It is a trope that we shall find recurs in her letters throughout her life, nearly always associated with the objects, amusements, people, thoughts, and views she held most dear.

In 1721 Mary Pendarves joined her husband in London. Her life was still fairly proscribed and references to cut paper and drawing are found only with reference to her sister, Anne Granville,

in Gloucester. About a year after Alexander Pendarves died, Mary wrote to Anne: "I am very glad you have taken a fancy to drawing, you will find a great deal of entertainment in it. By the time I shall make you a visit, you will be able to be my mistress… ."[11] Although it is clear that both sisters are drawing in the 1720s, references to the activity in their letters are few and vague.[12] Mary Pendarves did give an extended critique of some cut-paper landscapes by her sister: "[Y]ou must take more pains about the trees and shrubs, for no white paper must be left, and the leaves must be shaped and cut distinctly round the edges of the trees; most of the paper I have cut has cost me as much pains as if it was white paper."[13] It is worth noting here the popularity of this type of work throughout the century, not only black-on-white silhouettes of people but finely cut white paper and vellum vignettes, landscapes, still lifes, and watch papers.[14] The Countess of Burlington and her daughters were particularly adept, and Mary claimed that her great friend Lady Andover was so skilled at cutting landscapes that a magnifying glass was needed to see them properly.[15]

Figure 103: Mary Pendarves, *The North-East view of Newark near Glocester*, 1740, pen and gray ink and wash, 8½ × 13¼ in. (21.6 × 33.7 cm). National Gallery of Ireland, Dublin (2722[2])

Figure 104: Mary Delany, *A View of Hanbury Pools in Worcestershire*, 1743, pen and gray ink and wash over graphite, 9⅛ × 14½ in. (23.1 × 36.9 cm). National Gallery of Ireland, Dublin (2722[16])

A view of Hanbury Pools in Worcestershire MDelany. 1743

Figures 105, 106: Letitia Bushe, *Landscape with "Le Tombeau de Latitia"* and *Italianate Landscape*, 1731, pen and brown ink. The Lilly Library, Indiana University, Bloomington, Indiana. These drawings are part of a group of fifty-one executed by her friends and Mary Delany, who gathered them together in an album between 1732 and 1760. Both images were probably copied from prints.

Drawing, painting, and crayons began to play a prominent role in Mary's life beginning in the 1730s and are mentioned frequently in her correspondence. The increase in references coincides with her friendship with Anne Donnellan, with whom she stayed in Richmond in 1730 and whose portrait with the Wesley family she watched being painted by William Hogarth. Mary had also persuaded Lady Sunderland to have her portrait done by Hogarth instead of by the enamelist Zincke.[16] She explained to her sister:

> *I think he takes a much greater likeness, and that is what I shall value my friend's picture for, more than for the excellence of the painting. Hogarth has promised to give me some instructions about drawing that will be of great use,—some rules of his own that he says will improve me more in a day than a year's learning in the common way. When he has performed his promise I will communicate to my dearest sister, though that will not be politic, for you excel me now, and when I have delivered up my arms you will vanquish me quite, but this is the only instance where I shall have more pleasure in being excelled than in excelling, as my own performance can never give me so much delight as yours will.*[17]

There is no further evidence of any drawing lessons from Hogarth, but their mutual exchange of anything that might improve each other's work, and the language of modesty and delight in viewing excellence and being excelled, reflects the closeness of the sisters through this shared activity, which bound them while they were physically separated.

Shortly after Mrs. Donnellan was painted by Hogarth, Mary accompanied her to Dublin, where she met the Claytons (Robert Clayton was bishop of Killala), Dean Swift, Swift's friend Dr. Patrick Delany, and Letitia Bushe, the independent daughter of a government official at Dublin Castle.[18] Mary found the company so congenial she extended her stay from six months to eighteen, spending much of her time with Letitia, who suffered badly from smallpox while they were there, and rejoined the company in February 1732. In a letter to her sister from this date, Mary recalled:

> *I believe I told you she has a fine genius for painting; she is hard at work for me, she paints both in oil and water-colours. I have enclosed you a little scrap of her drawing, which she scratched out by candlelight in a minute. I hope you draw sometimes. I fancy if you copied some landscapes, and did them in Indian ink, you would like it*

better than faces. I am sure, with very little application, you would do them very well; but copy only from the best prints.[19]

Miss Bushe wrote regularly while Mary was at Killala decorating a shell grotto, and enclosed a drawing with each letter. Mary gathered the drawings into a volume, probably the small album now in the Lilly Library Manuscript Collections, Indiana University, Bloomington.[20] The first page is inscribed "M. P: /Stephens Green/ 1st Dec:[r] 1732." The album contains maps of Greece and Italy and landscapes copied from prints by Letitia Bushe and similar drawings by Dr. Donnellan, by Elizabeth Wesley from Meath, and by the Irish peer Lord Percival (Viscount, later first Earl of Egmont), all from the early 1730s (figs. 105–108). The second half of the album contains drawings added in the 1740s: Lady Catherine Hamner's sketch of Mary Delany at her easel painting; drawings by Letitia Bushe of places she visited in England on her visit in 1743; a full-length pencil self-portrait by Mary Delany seated by her fireside at Delville with her cats on her lap, from 1750–51 (fig. 102); copies of landscape prints by Miss H. Viney and Mrs. Carey; lovely red chalk drawings by Mary's cousin Lady Weymouth, who lived at Longleat; and a watercolor portrait by Mrs. Ward after the Flemish painter Van Dyck. The album ends with a drawing by Mrs. Delany of a cottage covered with ivy; she inscribed the drawing: "A Cott in Blank—the Peacefull residense of your Faithfull MD when Years & infirmities forbid a Vagabond Life—Built In Idea at Delvile Dec:[r] 1744" (fig. 13).

A further inscription on the cover indicates the album was given by Mary to her sister's daughter Mary Port, who passed it on to her own daughter, and eventually it was inherited by Lady Llanover. It was thus an *album amicorum*, a means of remembering and keeping one's friends close, and a pastime in itself—arranging and mounting the drawings onto the album pages and inscribing them. Like a miniature portrait, the album was a treasure to be kept in a cabinet in a closet, to be taken out and enjoyed as a meaningful substitution when a family member or friend could not be present for an intimate conversation in person. Lady Andover created similar albums, with works by herself, her young family, and such friends as Letitia Bushe and Mary Delany; these albums, now at Kenwood, are discussed below. Many similar albums, lovingly assembled by women in the eighteenth century, survive in the attics or libraries of country houses, but with the creators long gone and their letters, unlike Mrs. Delany's, not easily accessible, the meanings and memories

Figure 107: Dr. Donnellan, *Landscape with Ruins*, ca. 1732, pen and brown ink. The Lilly Library, Indiana University, Bloomington, Indiana. Drawing from an album compiled by Mary Delany between 1732 and 1760. The image was probably copied from a print.

Figure 108: Elizabeth Wesley, *Head of an Old Woman*, 1733, pen and ink. The Lilly Library, Indiana University, Bloomington, Indiana. Drawing from an album compiled by Mary Delany between 1732 and 1760. The image was probably copied from a Rembrandt print.

Figure 109: Mary Pendarves, *A View of Bulstrode Park*, 1741, pen and ink and wash drawing on hand-made laid paper, 5⅛ × 7¹/₁₆ in. (13 × 18 cm). Private collection

Figure 110: Mary Delany after Rosalba Carriera, *Portrait of Rosalba Carriera*, 1739, pastel on paper laid down on canvas, 11⁷/₁₆ × 9¾ in. (29 × 24.7 cm). Private collection

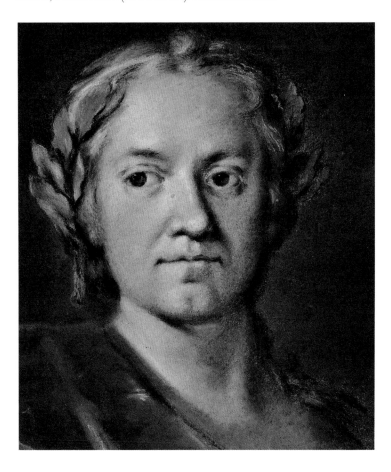

they held are difficult to reconstruct, or are lost altogether. Some have been broken up and their sheets sold individually, such as the albums of drawings Letitia Bushe made on her visit to London, Bath, and Bristol in 1743, which at one time were with a set of Mrs. Delany's drawings of Ireland.[21]

Mary and Mrs. Donnellan toured Ireland during their stay in 1731–32, describing the houses and gardens they visited. Yet Mary did not mention drawing while traveling, nor do any of her drawings from the 1730s survive, although in January 1733 she sent her sister a self-portrait by Miss Bushe, commenting that "there's something about the mouth that does her great injustice, for she has graces and sweetness which does not appear in her shadow; but she did it for you, and I would send it: the nose and eyes resemble her."[22] Through this gift of her portrait drawn by herself, Letitia Bushe was being literally "drawn" into Mary's closest circle of family and friends, held together through correspondence, shared "work" experiences while apart, and the exchange of gifts that resulted from that work.

Mary returned to England in the summer of 1733 and in October sent a letter to Swift containing a sketch of a cottage in which he had once stayed on the grounds of Lord Bathurst's park at Cirencester: "It is now a venerable castle, and has been taken by an antiquarian for one of King Arthur's 'with thicket overgrown grotesque and wild.' I endeavoured to sketch it for you, but I have not skill to do it justice."[23] Corresponding with a known literary figure, Mary cannot rely on her own words alone to do justice to the scene, and falls back instead on her own art, being careful to be modest and not make any claims that it might succeed where her words fail.

In the following year, back in London and on visits to Bulstrode, the Duchess of Portland's house, there was an explosion in lessons of all sorts. She wrote to her mother in June 1734,

> *Lady Dysart goes on extremely well with her drawing; she has got to crayons, and I design to fall into that way. I hope Mr. [Arthur] Pond will help me too, for his colouring in crayons I think* the best *I have seen of any English painter—it tries my eyes less than work [needlework], and entertains me better;* I aim at everything, *and will send you a sample of what I am about, but I don't design to colour till I am more perfect in my drawing. I tried one landscape, and find it so easy, that I am almost tempted to stick to that sort of drawing.*[24]

We know of one landscape view, taken from nature at Bulstrode Park, that is dated 1741

(fig. 109). But as no landscapes by Mary from the 1730s have been found, we might conclude that the landscapes to which she referred are copies of landscape prints, as that was the usual method for learning to draw from nature. At that time Mary was mostly occupied in making copies of old master paintings, which she gave to her uncle Sir John Stanley. They were probably done in colored chalks or crayons (pastels), which typically followed once a pupil was used to copying prints in pencil or pen and ink. One that has survived, a copy of Rosalba's late *Self-portrait* (the original is now in the Academia, Venice), was drawn in crayons in 1739 and later promised to her sister (fig. 110: "Rosalbo after an original done by herself by Mary Pendarves 1739"). She also gave her uncle a copy of a large Madonna, "the best thing I have done," and an Apollo.[25] In 1736, when she was visiting Bulstrode, she wrote that they had a variety of amusements, including reading, "working" (embroidery), drawing, and perusing prints.[26] Instruction was ongoing: on 21 June 1737 the Duchess of Portland wrote that she had already received two lessons from "Mr Lens," and by the end of the decade, when Mary was in London, she met regularly with "Goupy" for lessons in crayons.[27]

These tantalizing glimpses into the lessons received by Mary and her friends raise as many questions as they answer. Precisely what form did the lessons take, and were they for painting in oil, gouache or bodycolor, chalk, crayons, or ink wash? And which Goupy came to the house to teach her—Louis (c. 1674–1747) or his nephew Joseph (c. 1689–c. 1769)?

Louis painted miniatures and portraits in oil and worked in crayons, bodycolor, and watercolor; he taught the Earl of Burlington and his wife and daughters as well as other aristocratic patrons.[28] Lady Burlington does not appear frequently in Mary's letters, but one of her most accomplished portraits in oils was of Margaret Harley, later the Duchess of Portland, and she was best known for her portraits in crayons that hung at Burlington House.[29] The nephew Joseph Goupy had a fashionable clientele for his small copies in bodycolor of old master paintings, particularly for Frederick Prince of Wales; he taught drawing to various members of the royal family and was also a scene painter and engraver (fig. 111).[30] Joseph usually is cited as Mary's teacher, but a letter Mary sent to the Duchess of Portland from Delville on 14 February 1748/9 suggests otherwise: ". . . I thought [Francis] Hayman the best master I knew of, but am not sure he will teach. My *poor dear Goupy, are you gone?* I am sure you have left nothing like you behind you—so

modest, quiet civil, honest, and an *incomparable master!* forgive this eulogium, but my heart would vent itself, and your Grace *knew* his worth."[31] Given that Louis Goupy died in December 1747 and his collections sold in 1748, it seems far more likely that it was Louis, not Joseph, who had been Mary's long-time instructor.

There is no further record of Hayman teaching the Duchess of Portland or Mrs. Delany. Bernard Lens has often been described as having taught Mrs. Delany, but the only specific reference to him in the correspondence is to "Mr. Lens," which occurs in the letter from the Duchess of Portland of 1737 cited above. We cannot be certain to which Mr. Lens she refers, although most likely it is Bernard Lens III (1682–1740), a miniature painter whose works filled the cabinets at Bulstrode. He may have been teaching the duchess to paint or to limn small copies of old masters or portraits in miniature, which is what he taught the Duchess of Marlborough and the daughters of Sir Hans Sloane,[32] or he could have been teaching her to draw landscapes in ink and wash, which is what he taught Horace Walpole, the Duke of Cumberland and Princesses Mary and Louisa, and Lady Helena Percival, the daughter of the Earl of Egmont, in the 1720s–30s.[33] Between 1733 and 1736, Lens etched for the royal family a drawing manual of landscapes with

Figure 111: Joseph Goupy after Salvator Rosa, *Rocky Landscape with a Blasted Tree*, 1680–1770, bodycolor, heightened with white, 7⅛ × 8¾ in. (18 × 22.3 cm). British Museum, Department of Prints and Drawings (Gg,3.365)

Figure 112: Bernard Lens III, title-plate to *A New Drawing Book for yᵉ Use of His Royal Highness yᵉ Duke of Cumberland, Their Royal Highness the Princess Mary, and Princess Louisa*, 1735, black ink with gray wash, 9⅜ × 13⅛ in. (23.8 × 34.1 cm). British Museum, Department of Prints and Drawings (1872,1012.3659-3676)

Figure 113: Bernard Lens III, *A North View of the City of Bath*, 1718–19, pen and black ink with gray wash, 9⅜ × 13⅜ in. (23.8 × 34.1 cm). British Museum, Department of Prints and Drawings (1853,0409.76)

buildings, figures, and fortifications (fig. 112). A pen-and-ink drawing by the Duchess of Portland of a coastal fortress after one of his engravings, inscribed "learn't 3 months" and dated 1738, indicates she was able to continue her lessons with him and that they were probably lessons in drawing landscapes in the monochromatic topographical style in which Lens and his brothers excelled (fig. 113).[34] In general, the pattern was set by the royal family, and women of the court followed suit: Goupy and Lens both taught the younger princesses drawing; Philip Mercier had taught their aunts, Princesses Anne and Caroline, to copy his paintings in oil, which is what Mary was concentrating on in the 1730s and 1740s.[35]

Letters written in the 1730s by and about Mary Pendarves in London and at Bulstrode were filled with accounts of her copying various paintings. In 1743, she married the widowed Dr. Delany, and they traveled through England visiting friends for a year before going on to Ireland. After she settled in at Delville in 1744, her correspondence was once again filled with references to copies she made of various works; these compositions are recorded in the list of seventy-two paintings in oils and crayons in the appendix to Lady Llanover's edition of Mary's letters.[36] They include portraits of family members, such as her parents and aunt and uncle, which she painted for other members of the family, as well as copies of portraits by Anthony van Dyck, Peter Lely, and Peter Paul Rubens and religious compositions after Guido Reni, including a large Madonna and Child for the chapel at Delville. A "Transfiguration" with several figures she had to paint twice over and she reported that it had "cost" her a total of forty-six days, sitting five hours per day, by the time she finished in February 1753.[37] The oil portrait of Sally Chapone was finished in 1756.[38]

More than twenty years had passed since her first letter about Lady Dysart learning to draw in crayons from Arthur Pond and Mary's wishes to "aim at everything" and her hopes that he would be able to assist her. Like Goupy and Lens, Pond had many pupils both within the circle of women at court and on its fringes, where Mary, her sister, the Duchess of Portland, Letitia Bushe, their friends the Dashwoods, and Lady Dysart moved. Returning Grand Tourists amongst their families and friends had brought back their portraits in crayons by Rosalba Carriera and Quentin de la Tour and the 1730s and 1740s were the height of the popularity of this type of smaller, less expensive form of portraiture in London. Pond, George Knapton, and many others had sitters in London or traveled to country houses to draw portraits and often gave lessons to their sitters. A portrait

in oil of Rhoda Delaval (later Astley) attributed to Arthur Pond shows her at work on a head in crayons, a medium in which he had begun to give her lessons in 1747 (fig. 114).[39] She wears a white satin dress and holds the crayons in a box with compartments on her lap, drawing in the flesh colors on a black chalk sketch on blue paper of a the head of an old master figure. Crayons are a very friable medium, messy to use, and must be framed and glazed when they are finished or will be easily smudged: Pond's portrait was a formal one, meant to provide Delaval with the attributes of an *amateur* rather than depicting her actually at work.[40]

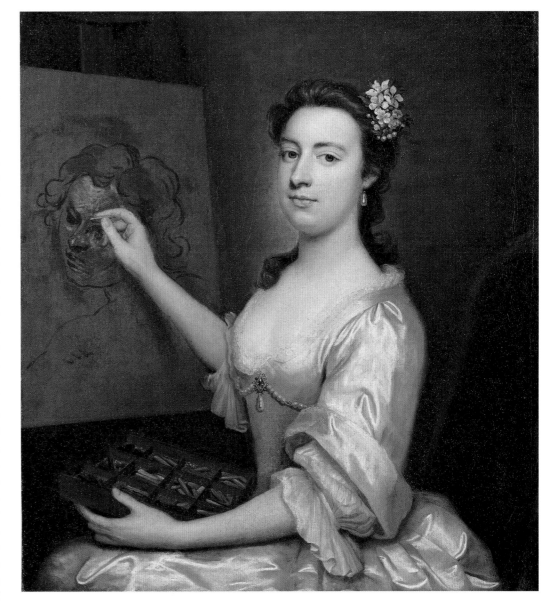

Figure 114: Attributed to Arthur Pond, *Rhoda Delaval*, ca. 1750, oil on canvas, 30¼ in. × 27 in. (76.8 × 68.6 cm). National Portrait Gallery, London (5253)

Aspasia and Her Circle

The women to whom Pond, Goupy, and Lens gave lessons were not uniformly from one social class—the court and its aristocratic circles—but included independent women, like Letitia Bushe, and women whose families were not of the old landed gentry but of newly acquired wealth and estates, like Rhoda Astley. What united these women, apart from their desire to learn to paint or draw, was that they were the products of a more modern Lockean form of education than most of their peers, being taught languages and the classics in translation, given lessons in music as well as art, and supported and encouraged in these less traditional feminine pursuits by their fathers, brothers, or husbands, who themselves were often intellectually or culturally more active than their peers. In their letters to each other, the women in this group felt free to share and discuss the books they read as well as their common interests and achievements; above all, they encouraged each other, forming a less intellectually zealous but nevertheless cohesive group that was, in some ways, a model for the later Bluestockings.[41]

That they perceived themselves in this way is evident in part from the affectionate names they gave each other in their letters: Silena, for Mary's sister Anne; Maria, for the Duchess of Portland, whose Christian name was Margaret; and Philomel, for Anne Donnellan.[42] These names are not recorded in their letters but date from the early 1740s, when Mary was writing her autobiography for the duchess and in it referred to herself as Aspasia. Lady Llanover noted that this was "a favourite appellation of the period, where beauty and accomplishments were united, without reference to its being inapplicable from other circumstances,"[43] but this was a decidedly Victorian interpretation of a name and character that held quite different meanings for women in England in 1740. The historical original bearer of this name was a courtesan in Athens, "more celebrated for her talents than her virtue," who became the lover and then wife of Pericles:

> [She] excited as much admiration by the accomplishments of her mind as the beauty of her person. She was a proficient in rhetoric, and was well versed in philosophy and political science;

> and even the wise Socrates (such were the manners of the time) did not think it misbecame him to cultivate an acquaintance with her, and receive lessons from her. Her house was frequented by persons of character, who even brought their wives to be her auditors.[44]

In 1731, George Stubbes published *A Dialogue on Beauty in the Manner of Plato [between Socrates and Aspasia, Occasion'd by Her Sitting for Her Picture]*, which was intended

> as a not uninstructive Entertainment for young Ladies, even of the highest Rank. To engage them to read it, I have endeavoured to give the beautiful Nymph in the Dialogue every Accomplishment, every Ingenuity, agreeable to a refined Education. To shew them with how much Ease they may enter into the Reasoning Part of it, I have avoided giving her the least Tincture of Philosophy, the least Degree of Knowledge, unsuitable to her early Age or Sex. A mere Readiness of Apprehension, and an ingenuous Desire to be informed, lead her on with Pleasure thro' a System of Beauty entirely new to her, and discover to her View the secret Foundations of Moral Excellence.[45]

Most significant, however, are the extensive discussions of Aspasia in the *Athenian Letters*, published in 1741–43 by Philip and Charles Yorke (with assistance by Catherine Talbot, who was known to Mary's circle),[46] in which Aspasia is described as

> one, in whom are united the highest endowments of mind and body; the utmost brightness of parts, and beauty of person; the one heightened and recommended by all that ease and grace, which travel and acquaintance with the best company bestow; the other improved by a careful use of all those advantages, which a free converse with all the celebrated wits of Greece could give her. Her thoughts were not confined within the narrow province of domestic business, nor laid out in acquiring those more showy and superficial accomplishments, which too often engage the whole attention of that sex. She had gained an early acquaintance with every part of useful literature; but her favourite studies, to which she had devoted more care and pains, were philosophy and politics.[47]

Mary was thus associating herself during her first widowhood with someone celebrated not for being a courtesan, which all eighteenth-century allusions to her gloss over, but for combining wit and beauty, intelligence and grace; someone not confined to domestic accomplishments, at which

she was competent, nor interested in showy and superficial ones, but through her wide reading, travels, and many acquaintances was able to converse intelligently and set an example for others. These characteristics were emphasized in Anne Donnellan's descriptive essay "Aspasia's Picture, Drawn by Philomel, in the year 1742" which she wrote at Bulstrode for the Duchess of Portland: "An *innate modesty*, an *early prudence*, and a *discerning judgment* to know what was right, *with virtue*, and only to follow what her judgment approved,—these were the qualities that have carried her through the gayest companies, the most dangerous scenes, with an unsullied fame, and have made even those who would have undermined her virtue pay homage to it."[48] She went on to relate how Mary's artistic accomplishments also reflected to Aspasia's credit:

To this imperfect sketch of her mind I must add something on her many accomplishments and her great ingenuity; and here we should wonder how she has found time to make herself mistress of so many ingenious arts, if we did not consider that dress and the adorning of the person that takes up so great a part of that of most of our sex, only employs so much of hers as the exactest neatness requires, and that she has an activity of mind that never lets her be idle, as all her hours are employed either in something useful or amusing. She reads to improve her mind, not to make an appearance of being learned; she writes with all the delicacy and ease of a woman, and the strength and correctness of a man; she paints and takes views of what is either beautiful or whimsical in nature with a surprising genius and art.[49]

Figure 115: Mary Delany, *Two Chained Hunting Dogs*, ca. 1740, graphite, 6½ × 6⅜ in. (16.4 × 16.1 cm). National Gallery of Ireland, Dublin (2722[3])

Figure 116: Mary Delany, *A Dog Chasing Wild Fowl*, signed and dated 1741, pen and ink and wash, 8¾ × 11½ in. (22.2 × 29.3 cm). Inscription: "after an Italian Picture. ye original as big as ye Life." National Gallery of Ireland, Dublin (2722[5])

Figure 117: Mary Delany, *Landscape with a Couple by a Stile*, 1745–46, pen and ink and wash, 14½ × 18½ in. (36.2 × 46 cm). Inscription: "M Delany inv: 6 March 1745." National Gallery of Ireland, Dublin (2722[90])

Although Mary was collecting landscapes by her friends and drawing her own in the 1730s, the earliest ones by her to survive are in an album in the National Gallery of Ireland (figs. 115-119). The album, which contains eighty-nine drawings, was in the Francis Wellesley collection—also the source of the beautiful drawn portrait of Mrs. Delany by Lawrence (see fig. 18)—but it is not clear whether it was inherited or purchased by him.[50] The album pages are approximately 14 × 18 inches (36 × 46 cm) and the drawings are carefully mounted, framed with pen-and-ink lines, and inscribed, signed, and dated (the dates range from 1740 to 1773). It is probably the album Mrs. Delany was referring to when she wrote from

Delville on 4 January 1745/6: "I have now finished my three and thirtieth drawing for my book, and am reduced to the fruit of my imagination. I have made one landscape after my own whim, which is a favorite of the Dean's. But his partiality takes… place of his judgment."[51] At the end of the album are four imaginary landscapes, dated from 16 January to 6 March 1745/6, which contain all the elements of the landscape of memories she retreated to when alone in her closet: the Vale of Evesham from her childhood and the Elysian and Virgilian landscapes created by her friends and family on their country estates. Waterfalls and rolling hills, picturesque bridges, gothic ruins and churchyards, rivers, dells, and ponds, maids and goatherds, and a young country couple at a stile—

all create an idyllic, dreamlike vision of what was and what might have been (fig. 117).

In 1753, Mary wrote to her sister, the intended eventual recipient of the album: "I will certainly bring my book of drawings, ashamed of having added so little to it. You know I cannot have a greater pleasure than employing my pen or pencil for you. The book is yours; I only keep it to fill it, which I will do as fast as I can."[52] Often mentioned only in passing in her correspondence, landscape drawings were evidently a lighter diversion from the more serious and focused attention Mary paid to her painting in oils during the 1740s–50s. Her letters were full of references to her oils, mostly copies of old master paintings borrowed from neighbors and intended for the house and chapel at Delville or as gifts for friends.[53]

Although that type of painting was done indoors and required a studio, it seems quite likely that the more than eighty monochromatic landscapes of particular places were at least begun, if not completed, while out of doors in front of the view. Many of the landscapes feature Mrs. Delany herself, occasionally accompanied by her husband but sometimes alone, with her paper and pencil or brush, recording her love of and immersion in the landscape and the pleasurable activity of interpreting it (figs. 118, 119). The earliest drawings were made in 1740, when her sister married John Dewes of Bradley Oak in Worcestershire, and continued over the next three years while visiting the newlyweds, her brother at Calwich in Staffordshire, and other friends around Gloucestershire and Herefordshire. After her marriage to Dr. Delany in 1743, they toured the same friends and family for a year before heading for Dublin in 1744. At this point, then, the landscapes had very personal and familial associations, which continued in the drawings of Delville and the dean's other residence, Hollymount in County Down. They were landscapes of affection, intended to convey her sentiments in a visual record of her own home and garden; others record places of interest, ruins, gardens, views encountered on tours of Ireland and on visits to England, to Derbyshire and Oxfordshire, to Kenwood and Warwick, and her returns to Calwich in 1756, 1758, and 1767. The latest dated drawing in the album, *Thorp Cloud, Dovedale, Derbyshire, from the Top of Ham Moor*, was drawn in 1773, reflecting a gap of six years.[54]

Figure 118: Mary Delany, *The Arbour Oak at Bradley in Worcestershire Belonging to Mr. Dewes*, 1743, pen and ink and wash over graphite, 9⅛ × 13⅞ in. (23.1 × 35.3 cm). National Gallery of Ireland, Dublin (2722[12])

Figure 119: Mary Delany, *A View of ye Lake at Seaforde Belonging to Mathew Forde Esqr in ye County of Down Ireland*, 1750, pen and ink and wash over graphite, 9⅞ × 15⅜ in. (25.1 × 39 cm). National Gallery of Ireland, Dublin (2722[46])

In all of these drawings there is a remarkable consistency in style and approach to the landscape—remarkable in that there is little development or improvement in drawing ability or technique over the course of this thirty-year period. But these drawings were not made in order to become a better artist; they were drawn out of love and pleasure in the landscape and to convey her sentiments and a visual idea of a place

Figure 120: Thomas Hudson, *Mary Howard, Viscountess Andover*, 1746, oil on canvas, 50⅛ × 34¾ in. (127.4 × 88.3 cm). English Heritage, Iveagh Bequest, Kenwood

to her sister. The style was probably learned during a few lessons, most likely with Bernard Lens, whose topographical drawing style hers most resembles in its focus on the placement of the elements of the landscape (trees and shrubs, buildings, and figures) and the brush technique used for foliage and grass in particular. Her lessons with Pond and Goupy were probably concerned with copying old masters in crayons. Drawing landscape from nature is quite different and far more difficult than copying flowers, paintings, or prints. Nature requires interpretation; it cannot simply be copied, especially by an amateur who does not have the skill and techniques of a professional artist.

Mary seldom mentions using watercolor; her landscapes are all monochromatic, washed and painted with gray or brown ink over a faint pencil sketch. There is a gradual loosening in technique as her skills developed, from a reliance on detailed pen-and-ink drawing in the early works—which are then built up with wash but include no attempt at sky—to later landscapes that are drawn almost entirely in wash over a faint pencil sketch, with only a few details in the foreground picked out in pen and brown ink. Once she found a method that suited her, she did not alter it greatly. As she was working mainly out of doors, her tools would be limited to pen and ink and brush, which explains in part why her landscapes are limited in color to brown or gray wash: watercolors were not yet available in cakes and the shell containers for the various colors required the stability of a table.[55] It was normal during this period to draw landscapes in monochromatic ink wash—the Lens family and Alexander Cozens, the two most popular teachers of landscape up to 1770, did not use color in their own landscapes, and Paul Sandby in the 1750s and William Gilpin and John Robert Cozens in the 1780s restricted their palettes to monochromatic blues, grays, or browns when sketching out of doors. All of these factors help explain why Mary's landscapes, in particular, look less accomplished than her botanical work or the painted copies she made from the works of others.

Mary Delany did not write of continuing lessons in landscape during the next three decades. Her style most closely resembles the landscapes created by Letitia Bushe and Lady Andover, both of whom shared her enjoyment in drawing landscapes. We have already seen that she collected the work of the Letitia and other friends in an *album amicorum*, which she eventually presented to her niece, and that she owned many other landscapes by Letitia of her views in Ireland and England from the 1740s. Lady Andover's landscapes survive in two albums now at Kenwood

that include works by herself, her family, and friends, as well as by Alexander Cozens, one of their drawing masters.[56] In 1747, George Vertue described Lady Andover as "a most ingenious lovely agreeable Lady. a great Lover of curious works & drawing. Some her Ladyship shewd me views taken by herself: drawn in ink & pencil—mighty well,"[57] and Thomas Hudson celebrated her talents in a 1746 portrait in which he depicted her drawing with a porte crayon (fig. 120). Lady Andover's style of drawing in these albums dating from the late 1740s and the 1750s is so close to Mary Delany's that at least one of the unsigned drawings might in fact be by Delany (figs. 121, 122). Many were drawn at Albury, where Lady Andover lived, but a marine view of an imaginary rocky arch was drawn Bulstrode on 2 December 1757. Lady Andover's *album amicorum* did once contain two very slight sketches by Mrs. Delany—one of a circular thatched hut, the other of a flower—but for some reason they have been removed.

Another album of drawings, this time of flowers, merits brief mention in this context, as it appears to fall into this group of albums put together for friends, or drawn in their company. The collections at Longleat, with which Mary Delany had a familial connection, include nine framed silhouettes of family members, cut out of white paper and mounted on black paper backing, that have been attributed to her. Also at Longleat is the album in which are mounted thirty-seven watercolors of flowers and five bouquets drawn in bodycolor (gouache) on vellum which was attributed to Mrs. Delany when it was catalogued in the 1950s and labeled "Flower Paintings/ ? the work of Mrs Delany" (see fig. 149). It is not known why the cataloguer considered the album to be possibly her work—whether it was found with papers that indicated this, whether it had always had this attribution, or whether her connection with the house was known and her authorship, as someone known for botanical work, deduced. They are well drawn, although not of the quality of a professional botanical artist of the time, and the bouquets in vellum seem to be carefully composed combinations of the individual flower studies drawn on separate sheets in watercolor. The style of drawing and the paper's watermark are both appropriate for a date in the mid-eighteenth century, and some of the drawings seem to relate to Mrs. Delany's embroidered flowers. However, lacking firmly attributed watercolors of flowers by her to compare them with, the attribution of the works in this album to Mary Delany must remain unconfirmed.

Figure 121: Possibly by Mary Delany, *Three Women and Cow*, undated, ink on paper, 11⅜ × 12⅝ in. (29 × 32 cm). English Heritage, Iveagh Bequest, Kenwood

Figure 122: Mary, Lady Andover, *Woman with Basket or Coracle*, undated, ink on paper, 12⅛ × 15 in. (31 × 38 cm). English Heritage, Iveagh Bequest, Kenwood

Returning to Mary Delany's landscapes in the album in Dublin, several of the compositions are repeated in versions in other collections, indicating she made copies for other friends as gifts. They tend to be the views of more famous places, the Giant's Causeway, Kenwood, Dovedale, etc. But others in the album created for her sister are much more personal, with more familial meaning for her sister, depicting Anne Dewes' or their brother's homes and gardens, or Mary's companionable relationship with her husband and her affection for the landscapes they created together at Delville and Hollymount (figs. 123, 124).

Figure 123: Mary Delany, *A Seat in Wood Island at Holly-mount*, 1745, pen and ink and wash over graphite, 14¼ × 10⅜ in. (36.1 × 26.5 cm). National Gallery of Ireland, Dublin (2722[27])

A Seat in Wood Island at Hollymount

M Delany 28 June 1745

Aspasia's "most delightful" Closet

Some of the most telling drawings in the album are views taken from Mrs. Delany's closet window. Settling into her marriage and Delville in the 1740s, Mary continued to refer to her closets as inner sanctums from which she often enjoyed verdant views. The closet within her bedroom was described as "most delightful. I have a most extensive and beautiful prospect of the harbour and town of Dublin and a range of mountains of various shapes."[58] A week later, in July 1744, she wrote:

I shall be glad when I have time for sketches, but I believe that can hardly be this year; I have had twenty visitors already, and have returned but two.... There are several prettinesses I can't explain to you—little wild walks, private seats, and lovely prospects. One seat particularly I am very fond of, in a nut grove, and "the beggar's hut," which is a seat in a rock; on the top are bushes of all kind that bend over: it is placed at the end of a cunning wild path, thick set with trees, and it overlooks the brook, which entertains you with a purling rill. The little robins are as fond of this seat as we are: it just holds the Dean and myself, and I hope in God to have many a tête-à-tête there with my own dear sister.[59]

Closets were not only a place from which one might look out on the world—they were also places where one could retire with one's own thoughts, or have private conversations with close friends, such as the "lovely and ingenious… and agreeable companion" Letitia Bushe. In 1750, Mary wrote that "D.D. dined in Dublin at Lord Grandison's, and left Bushe and me to a tête-à-tête in my closet."[60] The closet was where intimate friendships with women could be conducted, friendships that "provided an alternative outlet for emotional needs and energies, free of the complex web of economic and social considerations that surrounded relations between men and women."[61]

Mary soon found she needed another closet, because not only did she read and write letters there, she also did her work there, and there was insufficient room for the things she wanted to have nearby. She shared with her sister plans to create a sort of inner sanctum cum treasury:

I am going to make a very comfortable closet;— to have a dresser, and all manner of working tools, to keep all my stores for painting, carving, gilding, &c.; for my own room is now so clean and pretty that I cannot suffer it to be strewed with litter, only books and work, and the closet belonging to it to be given up to prints, drawings, and my collection of fossils, petrifactions, and

minerals. I have not set them in order yet; a great work it will be, but when done very comfortable. There is to my working closet a pleasant window that overlooks all the garden, it faces the east, is always dry and warm. In the middle of the closet a deep nitch with shelves, where I shall put whatever china I think too good for common use, but trifling and insignificant is my store-room to what yours is! Mine fits only an idle mind that wants amusement; yours serves either to supply your hospitable table, or gives cordial and healing medicines to the poor and the sick. Your mind is ever turned to help, relieve, and bless your neighbours and acquaintance; whilst mine, I fear (however I may sometimes flatter myself that I have a contrary disposition), is too much filled with amusements of no real estimation; and when people commend any of my performances I feel a consciousness that my time might have been better employed.[62]

It is revealing how Mary visualizes particular rooms as appropriate for specific activities: moving from public, to private and personal, to intimate spaces and from looking outward at the landscape and drawing or other work, to communication with friends via tête-à-têtes or writing letters, to creating a small and intimate display of treasures. More revealing is the wider context, the moral valuation she places on the use she makes of these spaces. She indicates her own virtues fall short of those of her sister—Mary's so-called amusements are for her own pleasure and the enjoyment of her friends, whereas Anne's benefit a much wider public—although this assessment of the moral worth of her work must be taken with a pinch of circumspection, given that the language of sensibility required modesty when describing one's achievements. Throughout the 1750s Mary often noted that her landscapes were not "well enough done for an engraver to work after," or she described them as

"an imperfect sketch" of the places described or a "little scratch not worthy to be called a sketch."[63]

Mary was still refining her closets in 1758: "My closet is just hung with crimson paper, a small pattern that looks like velvet; as soon as dry I shall put up my pictures;" and "my flower-garden, which is under my dressing-room window…. My bed-chamber is very large, comfortable, with pleasant views and the bow closet! I have now completed it by two looking-glasses that fill the side panels of the bow window, and reflect all the prospects. You would say indeed I am greedy of prospect were you to see it, *not to be contented* without those reflectors; the glasses reach within a foot of the cornice of the ceiling, and are fastened up with double knots of gilded rope".[64]

Figure 124: Mary Delany, *A view of part of yᵉ little Grove of evergreens at Delville wᵗʰ. yᵉ Country beyond it & Bay of Dublin*, 1744, graphite and pen and ink and wash, 9⅞ × 14⅜ in. (25.2 × 36.4 cm). National Gallery of Ireland, Dublin (2722[22])

A view of part of yᵉ little Grove of evergreens at Delville wᵗʰ. yᵉ Country beyond it & Bay of Dublin. MDelany 1744

Landscapes require a discourse concerning viewing, imitating, and copying nature, but they also bear a close relationship to "Aspasia's closet" with its connotations of personal pleasures, often the result of enjoyable solitary or shared viewing of nature through a verbal description framed by words in a letter, a real view framed by a window, or a drawn view framed by a drawn line border.

Landscapes, closets, drawings, and other "amusements" require elements of imagination combined with experience and reality. All of these elements were fused in the novella *Mariana*, written and illustrated by Mary Delany in 1759 in which her own experiences of life, friendship, family, and marital happiness informed the sensibilities expressed in the story. Just as without Aspasia her closet is just a room, she similarly often places herself, the "amateur" lover of landscape, in the foreground of her landscape drawing, using her own figure to mediate her—and the viewers'—reaction to nature.

After her marriage to Dr. Delany, Mary often depicted her husband at her side, representing the man who shared, supported, and sometimes guided her endeavors. Pericles to her Aspasia, Dr. Delany sang her praises in a letter to her sister on 25 December 1755, a letter he intended to have published with two or three others as examples for emulation to set before other young women:

She soon became mistress of her pen, in every art to which a pen could be applied. She wrote a fine hand in the most masterly manner. She drew, she designed with amazing correctness and ability! the noblest and most varied landscapes came as easily and exactly under the mastery of her imagination and eyes, as the meanest objects into those of another, and she could delineate them, in the utmost perfection of drawing, with more dispatch than a common hand could scrawl or scribble.... She employed in various works of genius, particularly in the study and practice of painting, in which she singularly excelled, insomuch that she never copied a picture from any master in which she did not equal, and often outdo, the original.[65]

In the eyes of her family and contemporaries, it was Aspasia's own gifts that enabled her to excel the masters of the past and to be such a paragon in her present.

Acknowledgments

I would like to thank Amy Meyers for inviting me to contribute an essay to this marvelous project. I am grateful to the editors, Alicia Weisberg-Roberts and Mark Laird, for their helpful advice, information about and images of Mrs. Delany's works in various private and far-flung collections, and particularly for their careful editing and patience. I would also like to thank Anne Hodge and Adrian Le Harivel at the National Gallery of Ireland, Laura Houliston at Kenwood, and Kate Harris at Longleat for their very kind assistance and advice during my visits.

Notes

1. Mary Delany to Anne Dewes, 17 February 1753, in Lady Llanover, ed., *The Autobiography and Correspondence of Mary Granville, Mrs. Delany*, 6 vols. (London: Richard Bentley, 1861–62), ser. 1, 3:206–7.

2. For extensive discussions of these issues, see Kim Sloan, *'A Noble Art': Amateur Artists and Drawing Masters, c. 1600–1800* (London: British Museum Press, 2000), 212–17; and Kim Sloan, "Industry from Idleness?: The Rise of the Amateur in the Eighteenth Century," in Michael Rosenthal, Christiana Payne, and Scott Wilcox, eds., *Prospects for the Nation: Recent Essays in British Landscape, 1750–1880* (New Haven and London: Published for the Paul Mellon Centre for Studies in British Art by Yale Univ. Press, 1997), 285–305.

3. Ruth Hayden, *Mrs. Delany and Her Flower Collages*, new ed. (London: British Museum Press, 1992), 170. The spelling is from Walpole's original draft, reproduced in Llanover, ed., *Autobiography and Correspondence*, ser. 2, 3: opp. 499.

4. Frederick W. Hilles and Philip B. Daghlian, eds., *Anecdotes of Painting in England [1760–1795], with Some Account of the Principal Artists; and Incidental Notes on Other Arts; Collected by Horace Walpole; and Now Digested and Published from His Original Mss.*, vol. 5 (New Haven and London: Yale Univ. Press; London: Oxford Univ. Press, 1937), 236.

5. Hilles and Daghlian, eds., *Walpole Anecdotes*, 230, 236, 238.

6. See Kim Sloan, "Sir William Hamilton's 'Insuperable Taste for Painting,'" *Journal of the History of Collections* 9, no. 2 (1997): 205–7.

7. "List of Pictures Painted by Mrs. Delany in Oils and Crayons," in Llanover, ed., *Autobiography and Correspondence*, ser. 2, 3:499–507.

8. "Letter II: Autobiography," in Llanover, ed., *Autobiography and Correspondence*, ser. 1, 1:15.

9. "Letter III: Autobiography," in Llanover, ed., *Autobiography and Correspondence*, ser. 1, 1:18.

10. "Letter VI: Autobiography," in Llanover, ed., *Autobiography and Correspondence*, ser. 1, 1:37.

11. Mary Pendarves to Anne Granville, 9 and 11 February 1725, in Llanover, ed., *Autobiography and Correspondence*, ser. 1, 1:103.

12. Mary Pendarves to Anne Granville, in Llanover, ed., *Autobiography and Correspondence*, ser. 1, 1:197 (14 March 1729), 201 (13 March 1729), 233 (Christmas Day 1729). A letter from Mary Pendarves to Anne Granville dated 5 August 1731 (ser. 1, 1:280) includes what the Lady Llanover believed to be a description of a portrait by Mary in pastels or "crayons" of her sister, but it is not clear whether the portrait was by her or someone else and its present location is not known.

13. Mary Pendarves to Anne Granville, 20 December 1729, in Llanover, ed., *Autobiography and Correspondence*, ser. 1, 1:230.

14. Sloan, *'A Noble Art'*, 64–67. A watch paper is round and fits inside the lid of a watch.

15. Sloan, *'A Noble Art'*, 214. See also Mark De Novellis, *Pallas Unveil'd: The Life and Art of Lady Dorothy Savile, Countess of Burlington (1699–1758)*, exh. cat. (Twickenham: Orleans House Gallery, 1999), 17; and Hayden, *Mrs. Delany*, 134.

16. The present location of these paintings is not known.

17. Mary Pendarves to Anne Granville, 13 July 1731, in Llanover, ed., *Autobiography and Correspondence*, ser. 1, 1:283–84.

18. For more on Letitia Bushe (ca. 1705–1757), see S. J. Connolly, "A Woman's Life in Mid-Eighteenth-Century Ireland: The Case of Letitia Bushe," *The Historical Journal* 43, no. 2 (2000): 433–51.

19. Mary Pendarves to Anne Granville, 3 February 1732, in Llanover, ed., *Autobiography and Correspondence*, ser. 1, 1:336.

20. Mary Pendarves to Anne Granville, 7 August 1732, in Llanover, ed., *Autobiography and Correspondence*, ser. 1, 1:370, 374 (editor's note describing the volume).

21. "The Collection of the Late Dudley Snelgrove, F.S.A.," sale, Sotheby's, London, 19 November 1992, lots 232–36. These drawings by Letitia Bushe are now in various collections, including those of Ruth Hayden, Desmond Guinness, and the Victoria Art Gallery, Bath.

22. Mary Pendarves to Anne Granville, 4 January 1733, in Llanover, ed., *Autobiography and Correspondence*, ser. 1, 1:393.

23. Mary Pendarves to Jonathan Swift, 24 October 1733, in Llanover, ed., *Autobiography and Correspondence*, ser. 1, 1:421.

24. Mary Pendarves to Anne Granville, 30 June 1734, in Llanover, ed., *Autobiography and Correspondence*, ser. 1, 1:485.

25. Mary Pendarves to Mrs. Granville, 12 April 1735, in Llanover, ed., *Autobiography and Correspondence*, ser. 1, 1:534; see also Mary Pendarves to Anne Granville, 26 September 1734 (ser. 1, 1:498, 501): "Mr Goupy staid so late with me that day, that by the time I was dressed, 'twas three o' the clock.... I have finished my Apollo, and given it to Sir John Stanley, who was much pleased with it."

26. Mary Pendarves to Catherine Collingwood, 25 October 1736, in Llanover, ed., *Autobiography and Correspondence*, ser. 1, 1:574.

27. Duchess of Portland to Anne Granville, 21 June 1737, in Llanover, ed., *Autobiography and Correspondence*, ser. 1, 1:609, and Mary Pendarves to Anne Granville, 26 March 1739 (ser. 1, 2:49).

28. L. H. Cust, "Goupy, Louis (*c.* 1674–1747)," rev. Emma Rutherford, in H. C. G. Matthew and Brian Harrison, eds., *Oxford Dictionary of National Biography* (Oxford: Oxford Univ. Press, 2004), online ed., ed. Lawrence Goldman, May 2008, www.oxforddnb.com/view/article/11160 (accessed 28 March 2008).

29. For Louis Goupy's teaching of Lady Burlington and her family, see De Novellis, *Pallas Unveil'd* (in which the portrait of the young Margaret Harley, later Duchess of Portland, appears as no. 83, fig. 11), and Sloan, *A Noble Art*, no. 168.

30. Sheila O'Connell, "Goupy, Joseph (1689–1769)," in *Oxford DNB*, online ed., ed. Lawrence Goldman, May 2008, www.oxforddnb.com/view/article/11159 (accessed 28 March 2008); see also C. Reginald Grundy, "An Action Brought against Joseph Goupy, 1738," *Walpole Society* 9 (1920–21): 77–87.

31. Mary Delany to Duchess of Portland, 14 February 1749, in Llanover, ed., *Autobiography and Correspondence*, ser. 1, 2:505.

32. Sloan, *A Noble Art*, nos. 27–30.

33. Sloan, *A Noble Art*, nos. 43, 44, 73.

34. The drawing by the Duchess of Portland was in the collection of Dudley Snelgrove, but its current location is unknown; a photo of it is in the Paul Mellon Centre Photographic Library, London.

35. See Jane Roberts, *Royal Artists: From Mary Queen of Scots to the Present Day* (London: Grafton, 1987), 54–57.

36. "List of Pictures Painted by Mrs. Delany in Oils and Crayons," in Llanover, ed., *Autobiography and Correspondence*, ser. 2, 3:499–502.

37. Mary Delany to Anne Dewes, 24 February 1753, in Llanover, ed., *Autobiography and Correspondence*, ser. 1, 3:209.

38. Mary Delany to Anne Dewes, 1 April 1756, in Llanover, ed., *Autobiography and Correspondence*, ser. 1, 3:419.

39. See Louise Lippincott, *Selling Art in Georgian London: The Rise of Arthur Pond* (New Haven and London: Published for the Paul Mellon Centre for Studies in British Art by Yale Univ. Press, 1983), 38–47.

40. See Jacob Simon, "The Production, Framing and Care of English Pastel Portraits in the Eighteenth Century," *Paper Conservator* 22 (1998): 10–12.

41. See Sloan, "Industry from Idleness," 291–94.

42. Phil, Philomel, and Philomela were her pseudonyms for Anne Donnellan (also sometimes called Sylvia). Philomela was a daughter of the legendary King Pandion of Attica and renowned for her beauty. Her sister was married to King Tereus of Thrace and they had a son. King Tereus kidnapped and raped Philomela, then cut out her tongue and secretly imprisoned her so she could not tell anyone what he had done. She wove a picture of her tale into a cloak to tell her sister of her fate. This led to her freedom and retribution. See *Metamorphoses of Ovid* (6.504–674), trans. and intro. Mary M. Innes (1955; repr., Harmondsworth, Middlesex: Penguin Books, 1983), 146–52.

43. "Letter VI: Autobiography," in Llanover, ed., *Autobiography and Correspondence*, ser. 1, 1:40n2.

44. John Aikin et al., comps., *General Biography, or, Lives, Critical and Historical, of the Most Eminent Persons of All Ages, Countries, Conditions, and Professions, Arranged According to Alphabetical Order*, 10 vols. (London: Printed for G. G. and J. Robinson, 1799–1815), 1:431.

45. George Stubbes, *A Dialogue on Beauty, in the Manner of Plato* (London: Printed by W. Wilkins, 1731), vi–vii.

46. A drawing labeled "Miss Talbot" was once in the album in the Lilly Library, Indiana University, Bloomington. Talbot encouraged the Bluestocking Elizabeth Carter in her translations of the works of Epictetus, see Lucy Peltz, "Living Muses: Constructing and Celebrating the Professional Woman in Literature and the Arts," in Elizabeth Eger and Lucy Peltz, *Brilliant Women: 18th-Century Bluestockings*, exh. cat. (London: National Portrait Gallery; New Haven: Yale Univ. Press, 2008), 73–74.

47. Philip Yorke (Earl of Hardwicke), Charles Yorke, et al., *Athenian Letters; or, The Epistolary Correspondence of an Agent of the King of Persia, Residing at Athens during the Peloponnesian War…*, ed. Thomas Birch, 4 vols. (London: Printed by James Bettenham, 1741–43), 2:25–28 (letters 126 and 127).

48. "Aspasia's Picture, Drawn by Philomel, in the Year 1742," in Llanover, ed., *Autobiography and Correspondence*, ser. 1, 2:176–77 (written by Anne Donnellan for the Duchess of Portland and later given by her to Anne Dewes).

49. "Aspasia's Picture," in Llanover, ed., *Autobiography and Correspondence*, ser. 1, 2:178–79.

50. Purchased by National Gallery of Ireland at the Francis Wellesley sale, Sotheby's, London, 28 June–2 July 1920, lot 209). Each page has been described and reproduced (although very small) in Adrian Le Harivel, *Illustrated Summary Catalogue of Drawings, Watercolours, and Miniatures* (Dublin: National Gallery of Ireland, 1983). Many of the images are reproduced in Angélique Day, ed., *Letters from Georgian Ireland: The Correspondence of Mary Delany, 1731–68* (Belfast: The Friar's Bush Press, 1991). The album has been most extensively discussed in Hilary Pyle, "Artist or Artistic? The Drawings of Mary Delany," *Irish Arts Review* 4, no. 1 (Spring 1987): 27–32.

51. Mary Delany to Anne Dewes, 4 January 1746, in Llanover, ed., *Autobiography and Correspondence*, ser. 1, 2:410.

52. Mary Delany to Anne Dewes, 28 April 1753, in Llanover, ed., *Autobiography and Correspondence*, ser. 1, 3:226.

53. See the series of extracts relating to her painting in Day, ed., *Letters from Georgian Ireland*, 270–78.

54. National Gallery of Ireland, Dublin, Delany album, 2722(86).

55. Watercolors and inks were in powdered form and had to be mixed with water and gum arabic. Colors were sometimes sold by colormen in shells first and, from the later 1770s, in cake form we know today; see Lynda Fairbairn, ed., *Paint and Painting: An Exhibition and Working Studio Sponsored by Winsor & Newton to Celebrate Their 150th Anniversary*, exh. cat. (London: Tate Gallery, 1982), 35–40. For an idea of the equipment required for painting in watercolors, see Paul Sandby's drawings of a young woman painting in watercolors at a table in the 1770s, in the Yale Center for British Art, New Haven, and in the Royal Library, Windsor (see Sloan, '*A Noble Art*', 232–33).

56. Andover albums, Suffolk Collection, English Heritage, Iveagh Bequest Kenwood, Hampstead, London. The albums contain drawings by relatives and friends of the families of William Howard, Lord Andover (1714–1756) and his wife, Mary (née Finch, daughter of second Earl of Aylesford), and their children—Henry (later twelfth Earl of Suffolk), Frances Howard (m. Richard Bagot 1783), and Catherine—as well as works by the families of Courtney, Finch (Aylesford), Dashwood, and Lord Guernsey.

57. George Vertue, "Notebooks, V," *Walpole Society* 26 (1937–38): 154.

58. Mary Delany to Anne Dewes, 12 July 1744, in Llanover, ed., *Autobiography and Correspondence*, ser. 1, 2:309.

59. Mary Delany to Anne Dewes, 19 July 1744, in Llanover, ed., *Autobiography and Correspondence*, ser. 1, 2:314, 316.

60. Mary Delany to Anne Dewes, 29 May 1750, in Llanover, ed., *Autobiography and Correspondence*, ser. 1, 2:548.

61. Connolly, "A Woman's Life," 451.

62. Mary Delany to Anne Dewes, 27 October 1750, in Llanover, ed., *Autobiography and Correspondence*, ser. 1, 2:600–601.

63. Mary Delany to Anne Dewes, in Llanover, ed., *Autobiography and Correspondence*, ser. 1, 3:253 (9 December 1753), 442 (19 September 1756), 521 (8 October 1758), and 124 (21 May 1752).

64. Mary Delany to Anne Dewes, in Llanover, ed., *Autobiography and Correspondence*, ser. 1, 3:527 (1758), and 530–31 (30 December 1758).

65. "Character of Maria by Dr. Delany, Sent as a Christmas Present to Mrs Dewes," sent 25 December 1755, in Llanover, ed., *Autobiography and Correspondence*, ser. 1, 3: 387–88, 392. The letter was never published by Dr. Delany, however, because Mary's modesty would not allow it.

Figure 125: James Stuart, *A Closet at Wimbledon Park,*
Surrey, ca. 1732. RIBA Library Drawings Collection

Figure 126: John Talman, *A Cabinet of Curiosities,*
ca. 1700. Victoria and Albert Museum, London

[6]

MARY DELANY:

Epistolary Utterances, Cabinet Spaces & Natural History

Writing from Dublin in 1747, Mary Delany addressed these lines to her sister, Anne Dewes:

> *I have a new cabinet with whole glass doors and glass on the side and shelves within, of whimsical shapes, to hold all my beauties. One large drawer underneath for the register drawer, and my little chest of drawers I have placed in my closet within my bedchamber, from whence I send you this letter. How blest should I be could we have a tête-à-tête in it with you! it is calculated for that purpose, being retired from all interruption and eaves-droppers.*[1]

Mrs. Delany's excitement at her new acquisition is tempered by her longing for her sister's presence at her Irish estate, Delville. Her contemplation of the natural history cabinet—a structure that permits both display and secrecy—leads her to imagine conversing with her sister, conspiratorially, in the closet. The word "calculated" betrays her delight in staging withdrawal to intimate closet spaces and signals the difficulties inherent in erecting such boundaries. As Michael McKeon has argued, the early modern period had a particular "capacity for further subdivision" within private spaces.[2] Mrs. Delany's letter delineates the process and artifice of retiring into increasingly smaller, interconnected domestic interiors. With its tiny chest of drawers, her closet also functioned as a miniature version of her bedchamber, in which, presumably, her larger cabinet stood. The compartmentalization required by the drawers of the cabinet and chest, and by collecting itself, mirrors the division of interior space. In her organization of the bedchamber and closet, she reconfigured the architectural tradition of the virtuoso cabinet.[3] James Stuart's 1757 design for a closet at Wimbledon Park, Surrey (fig. 125) helps us to visualize the closet as a site of ornamentation, display, and some sociability; the pastoral painting hung in the shallow niche behind the settee reinforces the associations between closet and retirement. The function of the closet as a repository for pictures, books, and decorative objects ties this space to the continental model of the cabinet of curiosities.[4]

At the beginning of the eighteenth century, John Talman produced a design for a cabinet of curiosities (fig. 126) that integrates the European antecedents of the modern museum into the manor house. Horace Walpole's cabinet room at his residence, Strawberry Hill (fig. 127), was one of the fullest eighteenth-century translations of such continental models of collecting: the virtuoso's pictures, antiquities, miniatures, and bronzes were preserved in a highly ornamented space with multiple shelves and niches. Like Mrs. Delany, who placed a new glass cabinet within her bedchamber and a smaller chest of drawers within her closet, Walpole subdivided his collecting space by including within it a wooden display cabinet. Thus the curious visitor had to negotiate an additional boundary, which marked the public/private division within Walpole's repository. Taken together, these examples caution us against assigning too strictly such a category as "private" to cabinet and closet spaces. The image of Mrs. Delany's letter migrating from her closet to the wider social world of epistolary space forces us to consider how the natural history

Figure 127: John Carter, *Tribune at Strawberry Hill*, ca.1789, watercolor, 23¼ × 19½ in. (59.2 × 49.5 cm). Courtesy of The Lewis Walpole Library, Yale University

cabinet, itself intimately tied to letter writing, embodied numerous, more public processes of exchange.[5] The natural history specimens preserved in her cabinet were the stuff of complex epistolary, economic, and social transactions.

When Mrs. Delany admires the "whimsical shapes" of her new cabinet's shelves, she foregrounds the interplay between art and nature that is characteristic of the eighteenth-century cabinet of curiosities. The cabinetmaker's inventive workmanship competes with nature's own designs—the richly patterned shells Mrs. Delany calls her "beauties." In his influential work on the production and transformation of space, Henri Lefebvre writes that a rose "does not know it is beautiful, that it smells good, that it embodies a symmetry of the nth order." In other words, "Nature's space is not staged." For Lefebvre, a rose in nature, because of its uniqueness, is a "work" rather than a "product." Nature furnishes "the resources for a creative and productive activity" by the social world.[6] My intention here is to explore how Mrs. Delany "staged nature" in various epistolary and material spaces. How, for example, did her acquisition and display of a new tiled cockleshell from the West Indies, represent, paradoxically, both a commodification of nature and a desire to stage the object's uniqueness?[7] How did she try to replicate and extend the artifice she located in nature? And how did the epistolary form and specific objects, to use Lefebvre's language, permit her to "produce" the spaces of natural history?

Mrs. Delany's voluminous correspondence offers an opportunity to expand on and to refine some of the dominant currents in the recent scholarship on the history of science and material culture. Drawing on Lefebvre and Michel Foucault, scholars increasingly have turned their attention to the spaces of natural history. In 1991, Adi Ophir and Steven Shapin analyzed works that seek to establish the "situated character" of scientific knowledge.[8] Dorinda Outram has examined the culturally constructed opposition between the "unbounded" spaces of the field naturalist and the "sedentary naturalist's study."[9] Miles Ogborn and Charles Withers recently have asserted that "the eighteenth-century public sphere was a matter of connected geographies: of production, movement and spaces of consumption." The "geographies of the home," in particular, require deeper investigation.[10] Alongside this mapping of the spaces of science, energies unleashed by the ever-expanding field of material culture have resulted in a greater interest in the literary apparatus of object exchange. John Styles and Amanda Vickery point out that letters often "helped shape taste at a

distance," while Marcia Pointon's study of eighteenth-century consumer Elizabeth Harley's correspondence elucidates the power of language to construct, as well as to represent, objects.[11]

This paper extends the work on the geographies of science and on "the discourse of possessions."[12] Epistolary space, I suggest, functions as an important site in its own right for natural history inquiry.[13] Scrutinizing domestic geographies, I will examine Mrs. Delany's accounts of her furnishing and decorating various domestic spaces (closets, workrooms, grottoes, gardens), and I will trace how individual objects were transferred, for example, from her cabinet to grotto, or from her garden to workroom. As Mrs. Delany instructed her relatives in their collecting pursuits and built the Granville family collections, we apprehend how the flow of objects through space and language maintained such relationships. Objects also moved between the intimate spaces of the home and more "public" sites of natural history and polite culture, including the Duchess of Portland's Bulstrode with its museum, botanic garden, and menagerie. Mrs. Delany's letters trace the pathways among her collections, those of the duchess, and such "global" natural history sites as the Chelsea Physic Garden, Kew Gardens, and Joseph Banks's house at Soho Square. As objects moved between these spaces, they were subject to various processes of translation—linguistic, artistic, social, and taxonomic. Mrs. Delany's designation of her new cabinet's large drawer as the "register drawer" signals that the concretizing of objects in language, that an inventory of nature, serves a symbolic as well as a practical function. Arjun Appadurai has urged material culture scholars to "follow the things themselves, for their meanings are inscribed in their forms, their uses, their trajectories." For Appadurai, fashion, domestic display, and collecting constitute "diversions" of the commodity from its original context.[14] This essay, then, tells the story of the diverted commodity or, if we adopt Lefebvre's model, of the imaginative and social transformation of the "works" of nature into "products."

Commodities as Exchange and Familial Bonding within Epistolary Culture
In Mrs. Delany's correspondence, absence and longing are negotiated and marked by natural objects. Referring to the exchange of letters as "broken" conversation, she used material objects to fill in gaps of epistolary space.[15] In 1736, for example, she thanked her sister for "the orange flower & variegated Mirtle," pleased that "they still perfume my Pocket."[16] Reciprocating Anne's

gift, she promised in 1750 to send from her Delville greenhouse "an orange-leaf and a yellow Indian jessamine of my own raising; I wish they may not lose their sweetness before they kiss your hands."[17] The hope that flowers and leaves would not lose their aromas too quickly is emblematic of the precariousness of relationships at a distance. Elsewhere in the letters, delicate colored dust from a butterfly's wings symbolizes fragile family ties.[18] In 1751, Mary set her relationship with her sister in the context of material culture: "How often do I delude myself with agreeable visions. We walk together from room to room, I show you all my stores of every kind." Her imaginings of her sister touring her workroom, library, and garden evaporated when reality intruded: "and instead of enjoying your presence I am addressing a letter to you that must go, by sea and land, hundreds of miles before it kisses your hands."[19] Although the representation here of letter writing as a poor substitute for personal contact is conventional, her imagery of "stores" and accumulation shows how strongly intimacy is bound up with and located in material things.

Mrs. Delany's correspondence narrates a seemingly endless chain of requests for goods, confirmations of objects sent, anxieties about the whereabouts of shipments, and queries on the condition and acceptability of a box's contents. Periods of residence in London enabled her to supply her family in Gloucester and elsewhere with luxury foodstuffs: oranges, chocolate, tea, macaroons, lavender, marmalade, and Indian sweetmeats. Textiles and other household furnishings also figure prominently, with scraps of gauze, lace, chenille, chintz, silk, and wallpaper wending their way to her sister from London and Ireland. In her study of the eighteenth-century diarist Elizabeth Shackleton, Amanda Vickery shows the limitations of social emulation and conspicuous consumption as explanatory models of eighteenth-century female consumption, while Pointon's analysis of Elizabeth Harley scrutinizes the symbolic significance of requests and exchanges of commodities within a long-distance marriage.[20] Mrs. Delany's self-appointed role as an arbiter of taste supplements these case studies of consumer behavior, as do her intense curiosity about nature, her collecting activities, and her ties to leading naturalists and famous botanical gardens. I will examine three related facets of Mrs. Delany's engagement with material culture: first, how commodities bridged the distance between herself and her family; second, how instruction of family members in the use of objects secured social positions; and third, how natural objects were transformed into the stuff of memory and science.

A letter sent from London to her sister, Anne, dated 5 October 1727, establishes the range of goods for which Mrs. Delany acted as intermediary. A box contains one "fine" damask tablecloth, a dozen napkins, three japanned boards, "a pair of China salts which you may think old fashion but it is the new mode and all Salt Sellers are now made in that manner," three cakes of lip salve, a "Solitary ring which begs the Honour of embracing one of your fingers, the Motto will inform you from whom it comes," tea snuff, mustard flour, and candlesticks. She concludes with the plea: "I desire as soon as possible after your receiving the things an account how every thing is liked."[21] In 1734, she wrote: "I have this day sent your Box; with your new & old stays, some flower seeds from Lady Sunderland; three caps for Mama. & I have tried to get the violet comfits but no such thing is to be met with, and your fan which is mounted with an Indian paper, no others are now worn, & the sticks are too weak for any other kind of Paper."[22] These miniature inventories make clear that she was not simply fulfilling requests for luxury or semi-luxury commodities from the capital; she was actively shaping the taste of her correspondents at home. She is firm that the pair of "China" saltcellars is au courant and that her sister's fan must be refurbished with fashionable and elegant "Indian" paper (fig. 128). Novel Eastern wares or European substitutes, such as the japanned boards in imitation of Asian lacquerware (fig. 129), dominate the goods sent to Gloucester.[23] The purchase of tablecloths and candlesticks helped to ensure her family's respectability, while the fan marked her sister's refinement in polite society.

Material objects also evoke the body and, further, the body located in specific domestic interiors. The epistolary description of domestic items purchased allowed Mrs. Delany to imagine her sister and mother and, by extension, herself in the family dining room. Such sensual commodities as the lip salve, tea snuff, and the aromatic delicacy of violet comfits, together with the engraved ring (itself an object of emotional import), brought Mrs. Delany even closer to her distant family members. These objects had a natural association with the intimate spaces of the dressing room or bedchamber and with moments of indulgence and, perhaps, quiet reflection.

If the acquisition of commodities for family and the representation of these in epistolary space were meant to collapse geographical distance, Mrs. Delany also constructed scenarios in which she and her sister (and later her niece) collaborated to "produce" things. Epistolary labor preceded the execution of these decorative

Figure 128: Fan, oriental design with rococo, 1720–30. Victoria and Albert Museum, London (2259-1876)

Figure 129: Japanned box, 1740–70, papier mâché, 2¼ × 5½ × 2¾ in. (5.7 × 14 × 7 cm). Victoria and Albert Museum, London (W.44&A-1923)

projects. In the eighteenth century, japanning and shellwork were among polite female accomplishments. In September 1729, Mary informed her sister that "every Body is Mad about Japan work." By late December that year, she wrote again: "I am going to do Boxes for a Toylet. I will send you a Box and some varnish but as to the laying of the ground I doubt [not] you will find it difficult unless I could show you the way which I hope next summer to accomplish." Her authority in decorating toilette boxes and covers for dressing tables no doubt was enhanced by her association with the Duchess of Portland; almost four decades later, Mrs. Delany apologized for sending her niece a "long recipe for a Toylet."[24] In 1750, extending her expertise to shell work, she offered her brother, Bernard, "a good cargo of grotto shells." This followed a *dazzling show* that Mrs. Delany had made in her cabinet from a new shipment of shells and from those she had brought to Delville.[25] In 1756, she offered her sister "a box of rubbish" (the shells she rejected for her own collections) to add a shell cornice on the top of her cabinet, but urged her to wait until they could "consult together."[26] Anne's grotto and shell cornice, then, are linked materially with Mrs. Delany's cabinet of shells. It is worth underscoring that toilette boxes, decorated cabinets, and grotto work connote more private spaces of withdrawal. As we will see, they are aligned with Mrs. Delany's account of the new bow closet at Delville and to epistolary processes more generally.[27] She even portrayed grotto work as an alternative means of fulfilling epistolary obligations.[28] Epistolary utterances activated her dream of a reunion with her family. The exchange of objects thus reinforced intimacy and helped to visualize future face-to-face contact among family members.[29] Ostensibly on the basis of Mrs. Delany's special knowledge, a project was deferred until they could "consult together." Objects, then, have the capacity to inspire and to absorb imaginative and material forms of labor.

Natural Productions as Social Currency
The 1734 reference to flower seeds from Lady Sunderland points to the garden projects, often bound up with social imperatives, that Mrs. Delany initiated with her family through epistolary exchange. In 1759, the botanist Peter Collinson wrote movingly to thank his colonial correspondent Cadwallader Colden for sending seedlings of a "little Spruce, Firr, & a Larch": "They are Now grown pretty Trees, & this year I transplanted them out of the Nurssery where they may grow & make a figure & be Memorials of our Friendship."[30] This image of nurturing

illustrates how seed exchange and transplantation functioned both as analogues and mechanisms for connecting distant spaces, and for representing social ties. Hence in 1744, when Mrs. Delany sent her sister seeds from the Oxford Physic Garden, she instructed her "to divide with my brother those that are for the natural ground, and those for hot-beds are all your own, and some of the produce I bespeak for Delville, and hope you will sow them there with your own dear hands."[31] While the seeds originated from a celebrated institution (enhancing their desirability), they also became the stuff of private family spaces, a bond between the siblings. Her designation of the seeds "for Delville" forged a direct pathway to her Irish house from the family's English gardens. Thus, two constants in her correspondence are Mrs. Delany's longing for her sister's presence through material objects and imagined acts of labor, and her use of seed exchange to foster intimate connections and continuities. In 1777, Mrs. Delany promised Anne's daughter, Mary Dewes Port, that she would send her a packet of seeds from a "Mr. Bromton," later asking her, "did you sow the feather grass seed & does it appear yet?" At Bulstrode, copying exotics from Kew Gardens, Mrs. Delany "longs to show [Mary] the progress [she] has made."[32] If visits are all too fleeting, the relative permanence of botanical projects mitigates the lack of personal contact. At the same time, ephemeral flowers suggest a poignant metaphor for sometimes delicate family relationships.

By circulating natural objects, Mrs. Delany attempts to solidify social relations between her own family and the Duchess of Portland. The flow of objects, which she carefully initiated and maintained, integrated them in the natural history enterprise at Bulstrode. The duchess's celebrated museum encompassed "all the Three Kingdoms of Nature, the *Animal*, *Vegetable*, and *Fossil*," and famously took thirty-eight days to be sold at auction.[33] Mrs. Delany urged her familial correspondents to contribute to Bulstrode's various collections. In 1753, for example, she inquired of Anne: "Is not the odd plant in the corner of your garden the ladies slipper? if it is, 'tis a *rare plant*, and the Duchess… shall be much obliged to you for a plant."[34] Similarly, Mary Dewes Port, in Derbyshire, contributed to the grotto at Bulstrode: "we also fix'd upon a Place in the Cave for the Ilam Fossils which are much admired."[35] Mrs. Delany reinforced the importance of her gifts of spar and mundic by saying, "you know how pleasant it is to offer a mite to our Dear, kind, & much honour'd Duchess." These donations were divided among the duchess, Mrs. Delany, and the botanist John

Lightfoot. In this way, the objects were also subsumed in Rev. Lightfoot's taxonomical schemes. In 1774, Mrs. Delany reassured her niece that her "little offering[s] of Fosils have the honour of being deposited in [the duchess's] cabinet."[36] Near the end of the decade, her grandniece, Miss Mary Port, began to fulfill this set of social obligations. At every step, "aunt Delany" underscored the significance of these gestures and affirmed her grandniece's ability to identify novel objects: the duchess "has placed your little tiny rarity in a fine Japan Cabinet," she wrote in 1779. When one of Miss Mary Port's donations duplicates a shell in the Bulstrode grotto, the duchess preserved the specimen in "the choice cabinet." The next year, Mrs. Delany informed her grandniece that the duchess had "added many little companions to the shell known by the name of Miss Ports shell." According to the hierarchies of natural history collecting, then, an object, by being displayed or held in a cabinet, achieved the status of a curiosity. The social position of the donor was assured as well. Underlining the object's taxonomic and social value, the duchess assembled a subcollection around "Miss Ports shell." In 1781, Mrs. Delany relayed to Mary the duchess's "many thanks of yr. Elegant letter & the Chrysalis, which is taken care of."[37] In this context, "taken care of" might signify that the chrysalis was allowed to hatch into a living butterfly for the edification and amusement of the curious at Bulstrode.

Clearly, it was Mrs. Delany's hope that, as family objects entered Bulstrode's grottoes, cabinets, and gardens, they would solidify social relations with the duchess. She wrote in 1775, for example, that Bernard Granville's scarlet geranium was in "high beauty" in Bulstrode's kitchen garden.[38] At play here is Lefebvre's distinction between unique "works" and their transformation through social processes into "products." The recontextualization of the geranium at Bulstrode moves the object from the natural to the social realm, with the flower embodying the ties between the Granvilles and the duchess. Similarly, Mary's gift is known as "Miss Ports shell." In Susan Stewart's model, the collector is not merely engaged in passive consumption but "generates a fantasy [in which he becomes] producer of those objects, a producer by arrangement and manipulation."[39] I would argue that Mrs. Delany, through her collecting and curatorial activities and those that she orchestrated, did achieve the status of "producer." Of course, she literally produced an array of objects: ornaments, textiles, and collages. While exploiting the social currency of natural objects, she trained her family in accurate forms of natural history knowledge-gathering. When-

ever possible, she contributed to her sister's "Bulstrode herbal."[40] After receiving a box of specimens from Mary Dewes Port, Mrs. Delany admonished her: "you must inform us of their Birth and Parentage, particularly of some brown moss like substance that was pack'd into the largest Cockle." The material adhering to the shell "has puzzled even Mr. Lightfoot… you must be very Minute in your account nothing less can satisfye such accurate enquirers."[41] Her insistence that her niece note the precise location and date of her specimens shows the inseparability of social and scientific decorum. By using the language of genealogy—"birth" and "parentage"—she made the staging of nature in collections an effective means of staging her own family. She constructed a family mythology rooted firmly in nature, using the epistolary genre to activate and sustain such exchanges. Mary Dewes Port's chrysalis was enclosed with an "elegant letter," which is the literary apparatus for assigning new contexts of production and consumption to such objects. These letters reveal how the "unbounded" spaces of nature often were already sculpted by quite specific social, epistolary, and scientific imperatives.

* * *

The frontispiece to the Duchess of Portland's sale catalogue features an artful chaos of *naturalia* and *artificialia* (fig. 130). Like Mrs. Delany's closet at Delville, the duchess's museum comprises multiple cabinets, cupboards, and sets of shelves for storage and display. Shells await placement in the drawers of a small collector's cabinet, and boxes of moths and other insects are propped up against vases and folio albums of natural history drawings. Delicate coral is perched atop the famous Barberini vase (which came to be known as the Portland Vase), and a mirror multiplies views within the cabinet, thereby amplifying the wonder produced by such spaces. Beneath the mirror are botanical specimens pressed in paper and additional volumes of drawings. Stuffed birds, framed in boxes, are also preserved in the profuse collection. In 1742, Elizabeth Montagu teased the duchess about her ever-expanding museum:

So many things there made by art and nature,
so many stranger still, and very curious, hit off
by chance and casualty. Shells so big and so
little, some things so antique, and some so new
fashioned, some excellent for being of much use,
others so exquisite for being of no use at all;
accidental shapes that seem formed on purpose;
contrivances of art that appear as if done
by accident.[42]

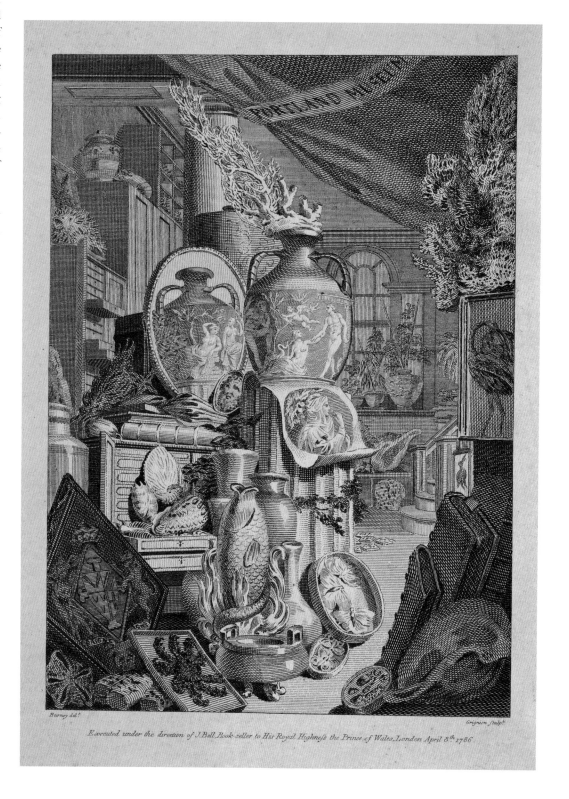

Figure 130: Charles Grignion after Edward Francis Burney, engraving, frontispiece to John Lightfoot, *A Catalogue of the Portland Museum* (London, 1786). Beinecke Rare Book and Manuscript Library, Yale University

APHACA *Lob. Icon. 70*

Figure 131: "Aphaca", plate XLIII from Philip Miller,
*Figures of the Most Beautiful, Useful, and Uncommon
Plants . . .*, vol. 1 (London, 1760). Yale University,
Harvey Cushing/John Hay Whitney Medical Library

Montagu captured how the cabinet extended *lusus naturae* (the sport of nature) by exhibiting figured stones and patterned shells alongside examples of human ingenuity, notably the Portland Vase. She also discerned the luxuriousness inherent in such collecting enterprises. If nature has not practiced restraint in its self-adornment, the duchess's cabinet stands almost as a monument to luxury itself. As Montagu observed, the Portland Museum is ironically "a great abundance that furnishes nothing."[43] Porcelain, for example, is diverted from its commodity path by the collection. The term "contrivance" and the visual details of the frontispiece, which highlight the posing of the cabinet's objects, underscore the theatrical dimension of such eighteenth-century collections. In other words, the museum mirrors the randomness of nature. The duchess's museum performs the task of staging of nature; the frontispiece depicts a self-conscious transformation of nature into a theater of wonder.

In the context of recent scholarship, Mrs. Delany's construction of her bow closet at Delville and her decoration of various grottoes provide important cases of staging nature. If, by the late eighteenth century, "the functions of the closet, the study, and the cabinet had been sufficiently separated out" as part of a concomitant drive to divide household from workplace,[44] as McKeon asserts, Mrs. Delany's letters document the continued enmeshing of domestic and "scientific" spaces earlier in the century. Despite being carefully curated,[45] and despite its links to global and institutional natural history sites such as the British Museum, Bulstrode seems to lag behind processes of spatial division. Lawrence Klein argues forcefully that notions of the "public" were embedded in sociability; domestic settings did not, therefore, always connote "spending time in private."[46] The duchess's natural history gatherings at Bulstrode, which Mrs. Delany calls "the philosophical cabinet," reveal the accommodation of scientific pursuits within polite accomplishments. In the eighteenth century, "cabinet" still retained its political meaning as a group of persons who met in the private chamber of the sovereign, and Mrs. Delany deployed this term to highlight both the extraordinary nature of the meetings at Bulstrode and their connection to museum culture.[47] While the sociability of these meetings marked them as "public," she viewed participation in the circle's activities as a form of retirement from more public spheres.[48]

In the mid-eighteenth century, Philip Miller, Peter Collinson, and Elizabeth Montagu all address, from different perspectives, the en-

croachment of fashion and the polite arts on natural history. From 1755 to 1760, Philip Miller published three hundred copperplate engravings to illustrate the plants described in *The Gardeners Dictionary*.[49] In this work, which promised to illustrate not just "curious" plants, but ones that were "useful in Trades [and] Medicine," a drawing of "Aphaca" appeared (fig. 131).[50] According to Miller, "there is little Beauty in the Flowers of this plant to recommend it," yet he included the plate "as there is a natural Looseness in the trailing of Branches, which renders it proper for Ornaments in Needle-work, or for printing on Linens."[51] In this description, Miller acknowledges the growing audience for floral pattern books, such as those published by Augustin Heckle in 1759 and Matthias Lock in 1769.[52] In 1751, Collinson thanked the Nürnberg physician and botanist Christopher Jacob Trew for his patronage of natural history publications but qualified his gratitude with the following rebuke:

> *The curious Here very deservedly admire the Elegance & Beauty of the Flowers and Fossills etc in this New Methode of Colouring them so Exactly after the Life, but it is with regret wee see the Shells so mixed together, as if intended for Pictures for Ornament for Ladies Clossetts. Had they been intended for the improvement of Natural History, every Genus & Species should have been Classed by themselves.*[53]

Collinson's critique of Trew's work, that it seems like a pattern book for the polite arts, is of a piece with Miller's assessment of "Aphaca". Writing to Anne Donnellan in 1749, Mrs. Montagu enclosed some small feathers for her Irish friend to "finish [her] a rose." As she explained: "It is now grown the fashion to borrow ornaments for cabinets and dressing-rooms of birds and fishes, and vanity and virtuosity go hand in hand."[54] Her letter dates exactly from the middle of a period rich in publications on engraved English ornament, particularly pattern books for the rococo style.[55]

In short, whereas Miller self-consciously accommodated new commercial imperatives into his publications and Collinson begrudged the appropriation of nature for closet ornaments, Montagu clearly delighted in the translation of motifs from nature into decor. Ehret, who instructed the Duchess of Portland's daughters in flower painting, forms a bridge between these arguments about nature and ornamentation. His influence on British and continental porcelain has been documented. During its "Red Anchor" period (1754–56), the Chelsea porcelain factory produced a series of botanical plates bearing images by Ehret and other artists from Miller's *Figures…* .[56] It was not simply the botanical specimens in Ehret's engravings that were considered novel by the porcelain designers. What made them the stuff of commodity was Ehret's elegant and accurate visual translation of these plants. Scientific, aesthetic, and commercial values coalesce in the Chelsea "Hans Sloane" plates (fig. 132). Miller and Collinson represent taxonomic natural history as threatened perhaps by the demands of fashion and novelty. Efforts to systematize nature should not be undermined by the appetite to consume nature in new material forms, specifically, in ladies' closets, cabinets, and grottoes.

Figure 132: Chelsea Porcelain Factory, "Hans Sloane" plates, ca. 1755, porcelain, diam. 9⅛ in. (23.2 cm). British Museum Department of Prehistory and Europe (1940,1101.64; 1940,1101.65; 1940,1101.66)

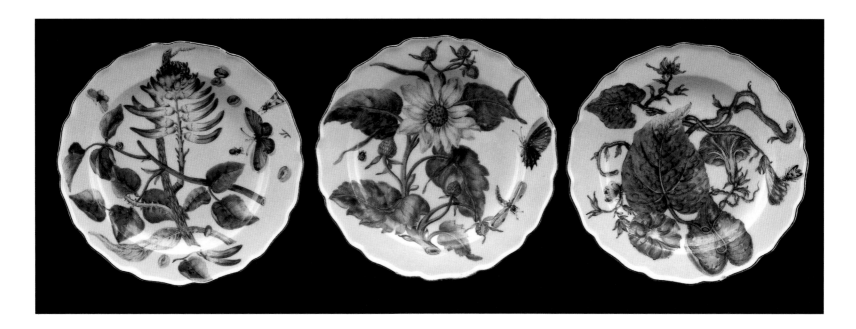

Mrs. Delany's furnishing of enclosed spaces became a language through which she could communicate her longing for distant family members. In 1744, she wrote excitedly to Anne about "preparing pleasant apartments to *receive each other by turns.*"[57] At first, her feelings of dislocation were conveyed by her decision in 1744 to remodel her "English room" at Delville.[58] By 1750, however, more enamored of Dublin wares, she had "done up a little apartment, hung it with blue-and-white paper, and intend a bed of blue-and-white linen—*all Irish manufacture… .*"[59] It was also in 1750 that she announced her intention to "make a very comfortable closet" at Delville. The processes of subdividing private spaces are made clear in Mrs. Delany's decision to separate rooms and things, and in her awareness that boundaries erected between spaces were likely to collapse. In her closet, she planned

> to have a dresser, and all manner of *working tools, to keep all my stores for* painting, carving, gilding, &c.; for my own room is now so clean and pretty that I cannot suffer it to be strewed with litter, only books and work, and the closet belonging to it to be given up to prints, drawings, and my collection of fossils, petrifactions, and minerals. I have not set them in order yet; a great work it will be, but when done very comfortable.[60]

Considering the location of her "working closet" in more detail, she wrote that it had "a pleasant window that overlooks all the garden, it faces the east, is always dry and warm. In the middle of the closet is a deep nitch with shelves, where I shall put whatever china I think too good for common use… ."[61] According to this scheme, the new closet, or "store-room" as she called it in the same letter, would house her working tools: brushes, enamels, crayons, paper, glue, carving tools, ingredients for varnishes, and the like.

Preserved in her bedchamber's closet was her collection of natural curiosities, which provided, in addition to taxonomic information, motifs for her artistic projects. Subdividing her new closet, Mrs. Delany's shelves of fine china display ingenuity in translating nature into art. As a site of collection, her closet inscribes a boundary between the "common" and the "curious." At the same time, the presence of china in her "working closet," even if not for everyday use, still evokes notions of domesticity. Her desire to set her natural curiosities in order might reflect an impulse to separate natural rarities from artistic ones (the china), and the tools of japanning and shellwork from the sites of such industry. It is not altogether

clear whether, by her "own room," she signified her bedchamber and dressing room or some other library/workspace. At the very least, objects and patterns seem destined to migrate between the cabinets and closets and rooms that Mrs. Delany described. The boundaries that her map articulates begin to appear less and less distinct.

References to her closet's "deep nitch" and garden views anticipate her scheme of 1758–59 to design a bow closet at Delville. *The Oxford English Dictionary* quotes Mrs. Delany to document the emergence in the mid-eighteenth century of "bow closet" to signify "a closet in the recess in the wall of a room."[62] This type of closet was named after the curved bow or bay window around which it was constructed. As we will see, spaces of withdrawal such as the bow closet had affinities with the early museum. Seeking to enhance the landscape and celestial views from her bow window, Mrs. Delany incorporated display techniques from the cabinet of curiosities. On 30 December 1758, she announced to her sister:

> My bed-chamber is very large, comfortable, with pleasant views and the bow closet! I have now completed it by two looking-glasses that fill the side panels of the bow window, and reflect all the prospects. You would say indeed that I am greedy of prospect were you to see it, not to be contented *without those reflectors; the glasses reach within a foot of the cornice of the ceiling, and are fastened up with double knots of gilded rope.*[63]

Mrs. Delany had already informed Anne a week earlier that she need not purchase some previously requested "Birmingham boxes" because "the toilette they were to stand on is banished from the bow closet."[64] By removing the toilette table, she signaled that the space was not for dressing or for the various forms of self-ornamentation usually associated with the closet. Rather, her placement of mirrors to frame the window establishes a link to the frontispiece of the sale catalogue for the Portland Museum (see fig. 130). Moreover, by multiplying views and objects the mirrors increased the wonder and drama already associated with a cabinet of curiosities. With her phrases "greedy of prospect" and "*not to be contented* without," Mrs. Delany appropriated the discourse of luxury alluded to in the frontispiece. Here she expressed her insatiable appetite for new views of nature, even designing the window sashes like a stage's curtain, to better set off nature's performance.

Among the details to emerge about the closet was that it was hung with crimson paper "that looks like velvet," and embellished by "festoons with shell-flowers, *chained up* with silver shells."

The closet was furnished with couches and stools, for which Mrs. Delany designed silk chintz covers with a "mosaic ground." A letter in which was enclosed the fringe from the seat covers allowed Anne to be included in this project and instructed her in this particular knotting technique.[65] Durable yet fashionable red flock (textured) wallpaper in imitation of velvet appeared in the 1730s and, a decade later, incorporated the style of French rococo.[66] If she used paper that imitated velvet for her bow closet, she spared no expense for the windows themselves: "I was so nice about my bow window, that I *sent to England* for *good glass,* and have had the sashes new made in the *narrow* way, which makes them much pleasanter; indeed, the prospect they open to ought to have every advantage."[67]

A letter from November 1759 underscores the social function of the bow closet. It was a place to which Mrs. Delany and her visitors "adjourned" after taking tea in the drawing room. There, she and Sarah Chapone "voted away the candles to enjoy the moon in her full lustre"; the next evening, with Mrs. Frances Hamilton and her daughter, Mrs. Delany again viewed the lunar "prospect within doors."[68] Her bow closet, then, was hardly a private space; it was a miniature theater. With its ornamental furnishings and its manipulation of nature, the closet facilitated sociable yet intimate conversation. Her arrangement of the bow closet is analogous to other artistic processes (sketching and drawing) that seek to frame nature in a "prospect," or a "pictorial representation of a scene."[69] In fact, in August 1759, Mrs. Delany generated a lovely view of Dublin Harbour and the gardens at Delville as seen through the bow window (fig. 133). It is not surprising to find that her bow closet was roughly contemporary with notions of picturesque gardening.[70] Further, the mirrors that she relied on in the closet to heighten nature's effects put one in mind of that device of the picturesque, the "Claude glass"—a small black convex mirror used by artists and travelers of the later eighteenth century to reflect a view.[71]

The bow closet, with its carefully constructed sociability and striking views of nature, suggests parallels to the eighteenth-century grotto—an imitation of a rocky cave ornamented with shellwork and used as a retreat. Mrs. Delany's struggle to balance solitude and society emerges in her decoration of both closet and grotto spaces. In 1732, she imagined herself as lily-of-the-valley, which, as she described it, is "retired, lives in shade, wraps up itself in its mantle, and gently reclines its head as if ashamed to be looked at, not conscious how much it deserves it."[72] The image

of the flower modestly shrouding itself, along with the phrase "as if ashamed," betrays the artifice that is characteristic of most declarations of retirement. Almost a decade later, in an allusion to Milton, Mrs. Delany wrote of her wish to live where the "Penseroso [contemplative] and Allegro [joyful] will be so blended."[73] Her grotto accommodated her desire to have a secluded space to pursue her collaborative natural history and decorative arts activities. As Gaston Bachelard observes, the very architecture of the shell instructs us in the "virtues of repose."[74] Decorating a "cave" for the duchess at Bulstrode, she was "entertained with the Black Bird of the Grott," which she fed in between reading Racine's letters.[75] Writing to Swift in 1736, she had already aligned her grotto work in Sir John Stanley's garden at North End with the life of a hermit.[76] If her decoration of the grotto at North End was a solitary pursuit, her grotto labors (collecting shells and affixing them imaginatively to the interiors of caves) at the Bishop of Killala's house in Ireland suggested conviviality and exchange. In the natural grotto that she ornamented with shells, Mrs. Delany displayed "the elegancy of [her] fancy."[77] The landscape at Delville, with its castle ruins and extensive views, inspired her to continue with her grotto projects. Underneath the castle she discovered "a cave that opens with an arch to the terrace-walk, that will make a very pretty grotto...."[78] Her grottoes, like her family's various gardens, were a series of interconnected spaces. Shells that she collected in Ireland were used to decorate the grotto at North End, and a grotto design that she created for her brother at Calwich was adapted for Delville.[79]

In its affinities with the collection, the grotto required investment in the social world. Mrs. Delany exploited family ties and her proximity to the duchess in order to acquire exotic shells from the East and West Indies.[80] In 1755, she attended an auction of rare shells, and by 1779, when her status as a collector of shells was assured, she received a quantity of shells as a bequest.[81] Perhaps the most famous eighteenth-century grotto, that of Alexander Pope at Twickenham (fig. 134), best illustrates how the grotto, though often represented as a site of withdrawal, was nevertheless the product of social relations. In 1745, Pope's gardener John Serle published an account of the materials used to decorate the grotto, which reads like the catalogue for a cabinet of curiosities—marble obtained by Joseph Spence from the legendary Egerian Grotto near Rome, "brainstones" (fossils that seemed to resemble the brain) from Philip Miller at Chelsea, and stones from the Giant's Causeway in Ireland from Sir Hans

Figure 133: Mary Delany, *A View of Part of Dublin Harbour and Deville Garden from the Bow Window in Mrs. Delany's Closet*, 3 August 1759, ink, graphite, and wash on paper. National Gallery of Ireland, Dublin (2722 [64])

Figure 134: John Serle, "A Perspective View of the Grotto," from *A Plan of Mr. Pope's Garden* (London, 1745). Beinecke Rare Book and Manuscript Library, Yale University

Sloane.[82] As John Dixon Hunt points out, Pope conceived of his grotto as a "museum" and virtuoso's study, and, as a result, its interior is a social map to the collectors, Grand Tourists, garden designers, and botanists of the day.[83]

The associations between an eighteenth-century grotto and a museum are evident in Thomas Wright's publication in 1758 of the second book of his *Universal Architecture*, which offered "six original designs of Grottos." Mrs. Delany's name appears in the list of subscribers. Two of Wright's designs integrate the cabinet of curiosities within the grotto space. Design "K" describes a grotto that can be elegantly "adapted for a Repository or Musæum of Shells." The "decoration without" includes a combination of "delicate" shrubs and trees (cedar, cypress), and "variegated," "common," and "curious" flowering shrubs (eglantine, honeysuckle). Enclosed by a glass and double door, the grotto ideally would have marble pavement and be lit from above. In this design, the exterior decoration of the grotto—a tableau of botanical curiosities—mirrors the interior display of a collection of rare shells. Design "L" (fig. 135) calls for a greater elevation in order to furnish a "pleasing prospect." Free from damp, this grotto, "if properly dress'd with shells, Fossils, and Ores, with a tesselated Pavement of Mosaic

Work," will "draw the Attention of the Curious."[84] That shells might lose their luster in the grotto concerned Mrs. Delany. Her praise of the intricate Goldney Grotto in Bristol was tempered by her dismay "at the shells *sacrificed there*, and exposed to the ruin of damp and time," whereas a cabinet, she observed, "would have preserved their beauty for ages... ."[85] The title that Wright assigned to design "L"—"an artificial Grotto, principally design'd as an Object terminating in a romantic View"—conveys how this grotto was not for conservation or withdrawal but rather, incorporating elements of the picturesque, was formulated specifically to attract visitors.

About a decade after Wright's grotto plans appeared, Hannah Robertson reinforced the links between grottoes and museums by appending to her instructions to women on shellwork "a description of some beautiful Shells to be seen in the Cabinets and Grottos of the Curious." Robertson cultivated the taste of her readers for exotic and expensive shells; the ground of the "Admiral shell" from the East Indies was of "the brightest elegant yellow, finer than that of Siena marble." At the same time, Robertson hit upon the most attractive quality of shells (specifically, butterfly and tulip shells): their imitation of other works of nature. Should such exotic specimens be beyond

Figure 135: Thomas Wright, "Design L" from *Universal Architecture. Book II. Six Original Designs of Grottos* (London, 1758). Yale Center for British Art, Paul Mellon Collection

one's means, Robertson offered techniques for varnishing and coloring the white, coarse shells of Scotland, "to make them appear like the foreign." The shells of Aberdeen, tinged with brazilwood, could be transformed into shell flowers and festoons.[86] Doubtless it was their potential for design that caused Mrs. Delany to invest such time in shells. The specimens that she collected at the Giant's Causeway and during other travels, and the shells that came to her through social networks, were diverted to her collector's cabinet, to her and her sister's grottoes as decoration, or to her closet and dressing room as ornaments.[87] Bernard Palissy, the Renaissance ceramicist, designed garden "chambers" that translated the textures of the shell into the grotto.[88] While Palissy labored to imitate the form of the shell, Mrs. Delany seemed, at times, to imitate not nature but art. Describing the neat execution of her grotto at Delville, she wrote: "I am filling a nitch with a mosaic of shells and the compliment paid it two days ago was, that '*it was very like Irish stitch.*'"[89] Of course, as Robertson makes clear in her account of the Chinese snail—"which has a green and black embroidery on a dark brown ground"—nature was the first artist.[90]

Pursuing Paradise and Virtu: The Experimental Cabinet at Bulstrode

In order to explore further the connections among nature, space, and ornamentation, let us now turn to the philosophical cabinet at Bulstrode. While this estate did not function as a "center of calculation" in the model of Joseph Banks's Soho Square and Kew Gardens, Bulstrode was certainly more than a "node" in natural history networks.[91] Captains of East India trading ships, fossil collectors, and such celebrated botanists as Philip Miller and John Lightfoot all strove to "lay [their] prizes at her Grace's feet."[92] The image of Bulstrode as a destination for naturalists,[93] a collection of collections, is reinforced by Mrs. Delany's account of the duchess and Rev. Lightfoot "taking the grand tour round her Graces Dominions in search of materials for Philosophick speculation."[94] Botanical materials and knowledge flowed swiftly among Bulstrode and Kew, the Chelsea Physic Garden, and the famous garden of physician and naturalist John Fothergill at Upton in Essex. There, Mrs. Delany wrote in 1779 of having "cramm'd [her] Tin box with Exoticks."[95] After the return of James Cook's *Endeavour* expedition in 1771, she journeyed with the duchess to Banks's house at Soho Square to study the botanical curiosities and pictorial views from Tahiti. She was particularly impressed by a transparent flower that hosted "a little blue par-

rot, not bigger than a bullfinch."[96] Mrs. Delany's instructions in 1774 to Mary Dewes Port to be "very minute" in her account of natural history specimens were the result of her familiarity with the empirical techniques promoted by Banks and others.

Mrs. Delany's letters portray Bulstrode at both the center and the periphery of natural history. Direct pathways and points of connection existed between Bulstrode and the major natural history and botanical institutions of the day. Daniel Solander catalogued the British Museum's natural history collections while also acting as curator of the duchess's cabinets.[97] Nevertheless, it is the domestic setting of Bulstrode that permeates the accounts of its natural history enterprises. New mineral specimens arriving at Bulstrode "enriched" the duchess's "dressing room and cabinets."[98] Curiosities in spar were assigned to the enclosed spaces at Bulstrode and their ornamental and taxonomic functions seem to overlap. The duchess alternated between "philosophical studies" and spinning wool, and Mrs. Delany moved from decorating the "garden room" to organizing drawers of fossils.[99] In a letter of 1769, she described "her Grace's Breakfast room, which is now the repository of sieves, pans, platters, &c. filled with all the productions of that Nature, are spread on Tables, Windows, chairs, which with books of all kinds, (open'd in their usefull places) make an agreeable confusion."[100] The term "repository," a word that still denoted museum in the eighteenth century, suggests that the new function of the breakfast room was as a temporary cabinet for mycological curiosities. Just as the frontispiece of the Portland Museum sale catalogue represents curiosities in artful poses, Mrs. Delany's account of precariously balanced kitchen pans and opened books constitutes the staging of a scene. That the duchess's breakfast room was transformed into a laboratory because it was the season for collecting fungi represents a conflation of domestic and workspace more akin to that of the early modern alchemist than to our notion of eighteenth-century science.[101] An undated manuscript in the duchess's hand lists "Fungi of the different Genera which do not seem to be described either by Ray or Linnaeus," testifying to the rigorous taxonomic program at Bulstrode.[102] Thus, the open spaces of fieldwork and the built environments of the laboratory and the museum, as well as the improvisational nature of science, all find expression at Bulstrode.

Bulstrode's breakfast room offers a convenient point of comparison with English Bluestocking salon culture. Unlike the "new ideals of public

sphere conversation" that structured the assemblies hosted by Montagu and others, there was no such pretense when Mrs. Delany characterized Bulstrode's natural history gatherings.[103] In 1771, she wrote disappointedly of the curtailment of botanical activities, because "company not worthy to be admitted into the Philosophical Cabinet have been in the way."[104] With the term "cabinet," Mrs. Delany conveys both the sociability and the exclusivity of these meetings. In contrast, she found Bluestocking occasions, in which furniture was arranged in a stiff semicircle, inhospitable to social intercourse.[105] This critique of Montagu's "formal formidable circle" came just a few months before she wrote of the "agreeable confusion" in the duchess's breakfast room, where mycological investigators "don't know whether they sit or stand."[106] For Delany, it was the unstructured domestic setting, where books, objects, and individuals jostle for space, that produced unfettered and fruitful conversation.

It was also in 1771 that Mrs. Delany distinguished between the empirical pursuits at Bulstrode (such as mineralogy) and the "ways of fine Ladies in the grand mond! Who live in the midst of discord unattentive to every object of real Beauty, & no less so, to every Duty of Life."[107] Rehearsing the seventeenth-century argument that natural history was devotional work, she aligned Milton with the Linnaean projects at Bulstrode: "The Dss of P. has been setting in scientifick order all her ores and minerals, of which she has a most beautiful collection, and makes the best use of her treasures by considering them, as Milton does—'*These are thy glorious works,*' &c."[108] Mere accumulation does not celebrate God's creations: they must be classified and contemplated. The activities of Bulstrode's philosophical cabinet were positioned, then, against the *grand monde*'s propensity for transitory pleasures and its indifference to the intricacies of the natural world. The Bluestockings were a social subset of the *grand monde*, and a group to which Mrs. Delany was adjacent if not actually a member. According to Elizabeth Eger, the Bluestockings' relationship to discourses of luxury was a complicated one; Montagu worked hard to yoke together industry, charity, and luxury.[109] Bluestocking conversation, Eger contends, was a mechanism for translating "public spirit into the home."[110] While Mrs. Delany censured the *grand monde*'s frivolity, nowhere in her correspondence does she mount a sustained defense of Bulstrode's luxury. Scattered throughout her letters are accounts of ornamenting a "gothic cell" with amber, ivory, jet, and mother-of-pearl, of the duchess's "barberies turned in amber," and of an

Figure 136: First Duchess of Beaufort's *hortus siccus*, in Sloane Herbarium, vol. 131, fol. 8. Natural History Museum, London. In its use of fold-out compartments for specimens the duchess's *hortus siccus* can be compared to the exhibits in Ashton Lever's museum (see fig. 139) and suggests one of the ways in which Mrs. Delany's botanical collages might be arranged as a collection.

ear of barley wrought in similarly luxurious materials.[111] More than four decades before Montagu began her celebrated feather screens, the duchess planned and then abandoned her own "*grand design* for feathers."[112] These luxurious projects, inspired by curiosity about nature's materials and their potential for transformation by labor and the imagination, were distinct from the *grand monde*'s temptations to false beauty.

More than once, Mrs. Delany referred to Bulstrode as an Eden to which she retreated from London and its social exigencies. As the widowed Mrs. Pendarves, she lamented in 1740: "my Joys in this earthly Paradise are almost over, I have but one more week of Happiness to come; then like our first Parents I shall be turn'd [out] into a World of Confusion, where noise and variety of impertinence will take the place of all Rational pleasures."[113] The newly widowed Mrs. Delany complained in 1769 of the impertinence of a London visit by Lady Weymouth: she and the duchess are forced to leave Bulstrode "in the midst of haymaking, botanizing, *roses* and Mr. Lightfoot *too*."[114] John Lightfoot is thus part of her Arcadian portrait. A few years later, she returned to the trope of Bulstrode as a "paradise" that offered materials for "*every branch* of virtû."[115] While rational conversation and intellectual inquiry were prized at Bulstrode, the philosophical cabinet was not simply a country-house equivalent of Mrs. Montagu's Bluestocking gatherings at Hill Street and Portman Square. The cabinet's exclusivity, its unstructured spaces of conversation, and its grounding in empirical inquiry set it apart from English salon culture. Perhaps because they harbored no "public" intellectual and charitable programs, the members of Bulstrode's cabinet felt little need to differentiate between its taxonomic projects and its more luxurious pursuits, or between domestic and scientific spaces.

"Hints Borrowed from Nature": Mrs. Delany's Hortus Siccus and the Leverian Museum

In 1782, as Mrs. Delany's eyes continued to fail, she found it easier "to attempt a flower now and then" than to compose a letter, "as the white paper dazzles my eyes."[116] For Mrs. Delany, the botanical collage became an alternative means by which to communicate her knowledge and vision of nature. Each collage embedded a series of material and social exchanges that determined which botanical species were transformed into collages. Her inscription for the collage 'Dracæna terminalis,' for example, indicates that the physician William Pitcairn donated it from his famous botanic garden at Islington. She affixed both Latin and common names to the collage and noted

that it was made at St. James's Place in April 1780.[117] The spaces of fieldwork, the conversation and study spaces of Bulstrode's experimental cabinet, Kew's royal spaces, and the spaces of Mrs. Delany's workroom and closet all collapse in an individual collage.[118] Her "paper mosaics" thus bring together several strands of her engagement with collecting and the staging of nature.[119]

To begin with, her use of the term "Hortus Siccus" to describe the collages aligns her project squarely with the model of the collection.[120] The conventions of the herbarium (fig. 136) survive in the plant material that Mrs. Delany incorporated

in such collages as 'Pyrus Cydonia' (fig. 137). Influenced, perhaps, by Ehret's method of dissecting botanical specimens before illustrating them, her placement of actual leaves alongside slices of paper recalls their common organic origins.[121] As early as 1743, Montagu lauded Mrs. Delany's abilities to "record" and to "represent" the natural world: "your Drawing Room boasts of Eternal Spring, nature blooms there when it languishes in Gardens."[122] Like the damp grottoes where shells are "sacrificed," gardens waste nature. In contrast, cabinets, visual and decorative arts, and botanical collages approximate the splendor of

Figure 137: Mary Delany, 'Pyrus Cydonia', 1776, collage of colored papers, with bodycolor and watercolor, and leaf sample, 12 × 8⅜ in. (30.4 × 21.4 cm). British Museum, Department of Prints and Drawings (1897,0505.720). The leaf sample is on the lower right adjacent to the quince.

Figure 138: Mary Delany, 'Fumaria fungosa', 1776, collage of colored
papers, with bodycolor and watercolor, 10½ × 8¼ in. (26.8 × 21 cm).
British Museum, Department of Prints and Drawings (1897,0505.338)

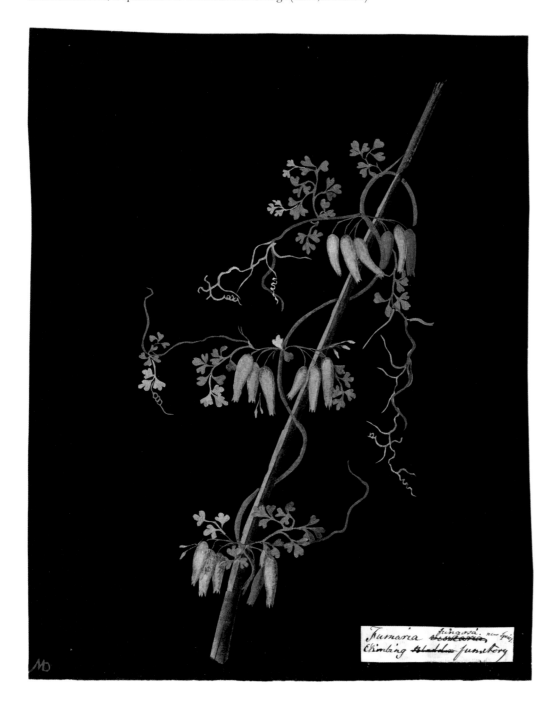

paradise. As with the Portland Museum's juxta-
position of *naturalia* and *artificialia*, Mrs. Delany's
collages, not least in their use of plant material,
leave one to decide whose ingenuity, nature's or
humankind's, is superior. While a collage over-
comes the herbarium's tendency to fade, the
presence of dried plant material is an elegiac re-
minder of the fallen natural world and its
mutability.

At about the same time that Mrs. Delany
announced that she had "invented a new way of
imitating flowers," in a letter to her niece dated
4 October 1772, the French mineralogist Abbé
Hauy delivered instructions to the Royal Acad-
emy of Sciences in Paris for making a *hortus
siccus*.[123] Hauy's technique, made public in 1785,
provides additional context for Mrs. Delany's
collages. Observing that flowers "soon lose their
colours in an herbal, and assume others, quite dif-
ferent from those bestowed of them by nature,"
Hauy applied watercolor paint to fine paper in the
same shade of nature's colors. Dipping the plant's
leaves in wine spirits, Hauy rendered them
"whitish transparent membranes." Using var-
nish, these were then laid on top of the colored
paper. Pressing another sheet of paper over the
flower, Hauy waited until the artificial colors
seeped through the membranes. Afterward,
he cut the paper around the new artificial
flower petals and affixed them to the plant using
gum arabic. According to Hauy, this method suc-
ceeded in "preserving the lustre for many years"
of the violet, geranium, and the common poppy.[124]
This dismantling and reviving of plants paral-
leled Ehret's reconstituting of specimens. Like
Mrs. Delany, Hauy was invested in producing
botanically accurate images through the reuse of
plant material. Hauy may well have conceived of
his technique as the assembling of a mosaic, and
was no doubt delighted by his ability to empty a
plant of its color and then paint it again with more
permanence than could nature itself.

Mrs. Delany's collages extend self-con-
sciously the artifice identifiable in nature and, in
this way, give expression to the relationship be-
tween ornament and natural history that Philip
Miller negotiated in his comments about the
aphaca. The rococo drew upon marine and other
natural motifs, and Mrs. Delany's 'Fumaria
fungosa' (fig. 138) and 'Passiflora Laurifolia' (see
fig. 35) are mediated by this dominant design
style.[125] That the rococo is itself an imitation of
nature signals to us that the collages, in their
reinvention of nature, often embody several
interconnected processes of imitation. In 1786,
William Gilpin, author on the picturesque, wrote
to Mrs. Delany on the subject of Ashton Lever's

London museum (fig. 139), an institution that she had visited five years earlier.[126] Gilpin linked the paper mosaics to Lever's cabinet of curiosities and addresses the subject of nature's artifice. According to Gilpin, Lever "has endeavoured to array his birds to ye. best advantage, by placing ym. in white boxes round his rooms, & when you enter, you are presented with a succession of rooms, still multiplied by a mirror at ye. end, every where invested with these little white apartments." In Gilpin's letter, we find a connection to the frontispiece of the Portland Museum sale catalogue: the theatrical use of a mirror to extend the wonder of nature's works. Mrs. Delany's placement of mirrors in her bow closet to enhance the "lunar prospect" offers a further parallel. Lever's use of the mirror commodifies the unique works of nature into exhibits of the museum. Unimpressed with the effect, Gilpin found Lever's "rooms are so light, yt. his birds wd. detach ym. selves from any ground." As a solution, Gilpin mused "what a gorgeous display of birds would some of those little splendid touches of nature's pencil exhibit, if they were set off by some deep shadow behind?" With the collages in mind, however, Gilpin hastened to add that he was not proposing to "array a room full of birds, as you do yr. flowers, in black." Although Gilpin approved fully of her choice of a black ground, it was only because her flowers were exhibited "one after another." If they were "spread, like Lever's boxes, over ye whole superficies of a room," they would likely appear "too dismal." According to Gilpin then, Mrs. Delany had "arranged [her] flowers with infinitely more taste, than [Lever had] arranged his birds."[127] In visualizing her collages as specimens in a cabinet of multiple compartments, Gilpin helped to define them as a visual translation of the eighteenth-century models of collecting and display that Mrs. Delany witnessed at Bulstrode and those she practiced at Delville within her own closets and cabinets.

Finally, Gilpin's use of the words "nature's pencil" recalls Peter Collinson's concept, dating from the 1740s, of planting as a "means of painting with Living Pencils."[128] For Collinson, the gardener must look upon the forest and its individual species, with their different shades and potential for contrast, as both a model and a palette for his designs. In other words, writes Collinson, the gardener must follow "Hints Borrowed from Nature."[129] When Gilpin suggested that Lever soften the glaring effect of his white ground by adding a "deep shadow," we understand the ways in which Gilpin saw the museum's task as an extension or complement of nature's own artistry. Or can Gilpin view nature only

Figure 139: Sarah Stone, *Interior of Leverian Museum; View as It Appeared in the 1780s*, 1835, watercolor, 15¾ × 16¾ in. (40 × 42.6 cm). British Museum, Department of Africa, Oceania, and the Americas (Am2006,Drg.54)

Figure 140: Mary Delany, unnamed tulip cultivar, 1782, collage of colored papers, with bodycolor and watercolor, 13⅛ × 9⅛ in. (33.5 × 23.1 cm). British Museum, Department of Prints and Drawings (1897,0505.866*). The collage was completed in 1782 by a Miss Jennings.

Figure 141: Mary Delany, 'Dracæna terminalis', 1780, collage of colored papers, with bodycolor and watercolor, 14⅛ × 9 in. (35.8 × 22.8 cm). British Museum, Department of Prints and Drawings (1897,0505.297)

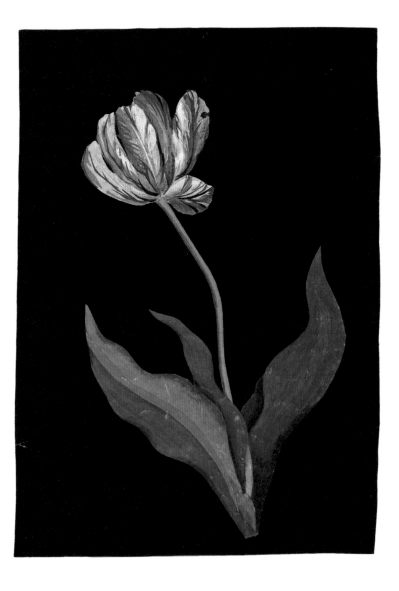

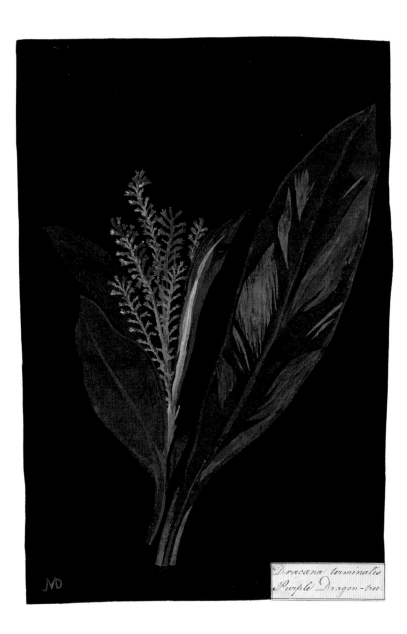

through the lens of the picturesque? When Mrs. Delany "borrowed hints" from nature, she did so in the context of such pre-picturesque visual traditions as Dutch still life painting. The composition and shading of her 'Pyrus Cydonia' (see fig. 137) and the painterly quality visible in the petals of her collage of a tulip cultivar (fig. 140) and in the leaves of her 'Dracæna terminalis' (fig. 141) demonstrate how her collages amplified what she would have interpreted as the brush strokes of nature.

In this essay, then, I have tried to show the ways in which nature's space both was and was not staged. At Bulstrode and Deville, it was in interconnected spaces—the breakfast room, the dressing room, the closet, the grotto, and the garden room—that nature, through collecting, display, and taxonomy, was "told" how it embodied symmetry, beauty, and order. Like their imitations in textiles and china, plants, seeds, and shells offered a language through which Mrs. Delany could express feelings of dislocation and her social aspirations for family members. While Miller and Collinson represent Linnaean classification as an intervention in the flight of nature to ornament cabinets and closets, Mrs. Delany's paper mosaics articulate an easy integration of new scientific, social, and aesthetic imperatives. These delicate yet enduring works remind us that eighteenth-century science was a continuing dialogue between nature and art. Nature offered itself to Mrs. Delany as a living palette for human ingenuity.

Acknowledgments
The author thanks Peter Bower, John Edmondson, Elizabeth Eger, Lisa Ford, John Harris, Mark Laird, Amy Meyers, Charles Nelson, Janice Neri, and Alicia Weisberg-Roberts for suggestions and references. The author is also indebted to the helpful staff of the Newport Reference Library, of Manuscripts and Special Collections at the University of Nottingham, and especially of the University of Calgary's MacKimmie Library. As Mrs. Delany's correspondence awaits a modern scholarly edition, the author has consulted the manuscript originals of the letters wherever possible.

Notes
1. Mary Delany to Anne Dewes, [possibly 11 July] 1747, in Lady Llanover, ed., *The Autobiography and Correspondence of Mary Granville, Mrs. Delany*, 6 vols. (London: Richard Bentley, 1861–62), ser. 1, 2:471.
2. Michael McKeon, *The Secret History of Domesticity: Public, Private, and the Division of Knowledge* (Baltimore: Johns Hopkins Univ. Press, 2005), 220.
3. For the development of the virtuoso cabinet within the early modern country house, see Mark Girouard, *Life in the English Country House: A Social and Architectural History* (New Haven and London: Yale Univ. Press, 1978), 170–78.
4. The most recent and comprehensive account of the cabinet of curiosities is Arthur MacGregor's *Curiosity and Enlightenment: Collectors and Collections from the Sixteenth to the Nineteenth Century* (New Haven and London: Yale Univ. Press, 2007).
5. On the ways in which the private closet, as a site for letter writing, connects this space to the exterior world, see Karen Lipsedge, "'Enter into thy Closet': Women, Closet Culture, and the Eighteenth-Century English Novel," in John Styles and Amanda Vickery, eds., *Gender, Taste, and Material Culture in Britain and North America, 1700–1830* (New Haven and London: Yale Univ. Press, 2006), 107–22.
6. Henri Lefebvre, *The Production of Space*, trans. Donald Nicholson-Smith (Oxford: Blackwell, 1991), 70.
7. Mrs. Delany informed her sister that the shell "weighs above a hundred weight," was "vulgarly called 'the Lion's Claw,'" and "at this instant looks most magnificent under my cabinet," Mary Delany to Anne Dewes, 16 March 1751, in Llanover, ed., *Autobiography and Correspondence*, ser. 1, 3:27.
8. Adi Ophir and Steven Shapin, "The Place of Knowledge: A Methodological Survey," *Science in Context* 4, no. 1 (1991): 4.
9. Dorinda Outram, "New Spaces in Natural History," in Nicholas Jardine, James Secord, and Emma Spary, eds., *Cultures of Natural History* (Cambridge: Cambridge Univ. Press, 1996), 261.
10. Miles Ogborn and Charles W. J. Withers, "Introduction: Georgian Geographies?" in Miles Ogborn and Charles W. J. Withers, eds., *Georgian Geographies: Essays on Space, Place, and Landscape in the Eighteenth Century* (Manchester: Manchester Univ. Press, 2004), 4. As the editors rightly contend (10), in order to grasp the significance of the domestic sphere and its influence on other geographical and intellectual spaces, we must first ascertain how specific objects were acquired, used, and displayed in the home.
11. Styles and Vickery, "Introduction," in *Gender, Taste, and Material Culture*, 26; Marcia Pointon, *Strategies for Showing: Women, Possession, and Representation in English Visual Culture, 1665–1800* (Oxford: Oxford Univ. Press, 1997), 15–57. Pointon illustrates (22) how epistolary descriptions of material things, especially when the goods are in transit or lost, become a means, like the objects themselves, by which to initiate or to reinforce intimate connections.
12. Pointon, *Strategies for Showing*, 16.
13. While Outram argues for knowledge-gathering as "movement *through* space", she does not acknowledge the crucial role of the epistolary genre in this epistemological model; Outram, "New Spaces in Natural History," 255.
14. Arjun Appadurai, "Introduction: Commodities and the Politics of Value," in Arjun Appadurai, ed., *The Social Life of Things: Commodities in Cultural Perspective* (Cambridge: Cambridge Univ. Press, 1986), 5, 28.
15. Mary Delany to Anne Granville, 30 May 1724, Newport Public Library, Wales, Granville Letters (hereafter NPL, GL), vol. 1. In thinking about the role of objects as a "filling-in" of epistolary space, I am building upon Susan Stewart's analysis of collecting as the self's ornamentation of the physical environment with things; Stewart, *On Longing: Narratives of the Miniature, the Gigantic, the Souvenir, the Collection* (Durham, N.C.: Duke Univ. Press, 1993), 157.
16. Mary Delany to Anne Granville, 17 August 1736, NPL, GL, vol. 2.
17. Mary Delany to Anne Dewes, 28 December 1750, in Llanover, ed., *Autobiography and Correspondence*, ser. 1, 2:635.
18. Mrs. Delany relied on the same tokens of memory and intimacy when she wrote in 1772 that Mary Dewes Port's "sweet violet is deposited in [her] Pocket book." Mary Delany to Mary Dewes Port, 2 January 1772, NPL, GL, vol. 3. After her grandniece Miss Mary Port visits Bulstrode, Mrs. Delany sends her "some butter-flies in a round Box, which I hope will come safe with yr Bureau." Mary Delany to Mary Port, 6 June 1779, NPL, GL, vol. 6.
19. Mary Delany to Anne Dewes, 12 January 1751, Llanover, ed., *Autobiography and Correspondence*, ser. 1, 3:5.
20. Amanda Vickery, "Women and the World of Goods: A Lancashire Consumer and Her Possessions, 1751–81," in John Brewer and Roy Porter, eds., *Consumption and the World of Goods* (London: Routledge, 1993), 274–301; and Pointon, *Strategies for Showing*, 15–57.

21. Mary Delany to Anne Granville, 5 October 1727, NPL, GL, vol. 1.

22. Mary Delany to Anne Dewes, 2 March 1734, NPL, GL, vol. 2.

23. For an analysis of the impact of Eastern goods in the period, see Maxine Berg, *Luxury and Pleasure in Eighteenth-Century Britain* (Oxford: Oxford Univ. Press, 2005), 46–84.

24. Mary Delany to Anne Granville, 9 September 1729 and 25 December 1729, NPL, GL, vol. 1. In 1760, the duchess was at work on twelve toilettes. Mary Delany to Anne Dewes, 19 December 1760, in Llanover, ed., *Autobiography and Correspondence*, ser. 1, 3:621; Mary Delany to Mary Dewes, 23 April 1767, NPL, GL, vol. 4.

25. Mary Delany to Bernard Granville, 17 June 1750, in Llanover, ed., *Autobiography and Correspondence*, ser. 1, 2:557.

26. Mary Delany to Anne Dewes, 24 May 1756, in Llanover, ed., *Autobiography and Correspondence*, ser. 1, 3:430.

27. On 23 June 1780, for example, Delany thanked her grandniece Miss Mary Port "for your kind letter which I receiv'd and read at the Grotto yesterday," NPL, GL, vol. 6.

28. Mary Pendarves to Anne Dewes, 23 April 1741, in Llanover, ed., *Autobiography and Correspondence*, ser. 1, 2:150.

29. In 1749, Delany expressed disappointment when a planned grotto project with her sister failed to be executed. Mary Delany to Anne Dewes, 4 September 1749, in Llanover, ed., *Autobiography and Correspondence*, ser. 1, 2:514.

30. Alan W. Armstrong, ed., *'Forget not Mee & My Garden . . .': Selected Letters, 1725–1768, of Peter Collinson, F.R.S.* (Philadelphia: American Philosophical Society, 2002), 216.

31. Mary Delany to Anne Dewes, 30 March 1744, in Llanover, ed., *Autobiography and Correspondence*, ser. 1, 2:286.

32. Mary Delany to Mary Dewes Port, 26 October 1777, NPL, GL, vol. 5.

33. [John Lightfoot], *A Catalogue of the Portland Museum, Lately the Property of the Dutchess Dowager of Portland, Deceased…* (sale, London: Skinner, 24 April 1786), iii.

34. Mary Delany to Anne Dewes, 28 December 1753, in Llanover, ed., *Autobiography and Correspondence*, ser. 1, 3:263.

35. Mary Delany to Mary Dewes Port, 19 November 1771, NPL, GL, vol. 3.

36. Mary Delany to Mary Dewes Port, 28 October 1774 and 18 November 1774, NPL, GL, vol. 5.

37. Mary Delany to Miss Mary Port, 6 June 1779, 10 October 1779, 21 September 1780, and 20 June 1781, NPL, GL, vol. 6.

38. Mary Delany to the Rev. John Dewes, 8 May 1775, in Llanover, ed., *Autobiography and Correspondence*, ser. 2, 2:124.

39. Stewart, *On Longing*, 158.

40. Mary Delany to Anne Dewes, December 1754, in Llanover, ed., *Autobiography and Correspondence*, ser. 1, 3:308.

41. Mary Delany to Mary Dewes Port, 28 October 1774, NPL, GL, vol. 5. Two years later, Mrs. Delany presses her niece for details about this specimen; Mary Delany to Mary Dewes Port, 5 August 1776, NPL, GL, vol. 5.

42. Matthew Montagu, ed., *The Letters of Mrs. Elizabeth Montagu*, 4 vols. (1809–13; repr., New York: AMS Press, 1974), 2:134–35.

43. Montagu, ed., *Letters of Mrs. Elizabeth Montagu*, 2:135.

44. McKeon, *Secret History of Domesticity*, 226, 220.

45. See Hugh S. Torrens, "Natural History in Eighteenth-Century Museums in Britain," in R. G. W. Anderson, ed., *Enlightening the British: Knowledge, Discovery, and the Museum in the Eighteenth Century* (London: British Museum Press, 2003), 82.

46. Lawrence E. Klein, "Gender and the Public/Private Distinction in the Eighteenth Century: Some Questions about Evidence and Analytic Procedure," *Eighteenth-Century Studies* 29, no. 1 (Autumn 1995): 104–5.

47. *Oxford English Dictionary*, s.v. "cabinet."

48. See section below, "Pursuing Paradise and Virtu: The Experimental Cabinet at Bulstrode," for Mrs. Delany's sometimes ambivalent relationship with the *grand monde* and her desire to withdraw from its sphere.

49. Philip Miller, *Figures of the Most Beautiful, Useful, and Uncommon Plants Described in The Gardeners Dictionary…* , 2 vols. in 3 bks. (London: Printed for the author, 1760).

50. This is the *Lathyrus aphaca* or yellow vetchling.

51. Miller, *Figures of the Most Beautiful*, 1: bk. 1, at v, 29.

52. Augustin Heckle, *The Florist, or, An Extensive and Curious Collection of Flowers, for the Imitation of Young Ladies, Either in Drawing or in Needle-Work* (London: J. Bowles and Son, 1759); and Matthias Lock, *A New Book of Foliage for the Instruction of Young Artists* (London: A. Webley, 1769).

53. Armstrong, ed., *'Forget not Mee & My Garden'*, 155. Trew was one of Ehret's most important patrons; see Gerta Calmann, *Ehret: Flower Painter Extraordinary; an Illustrated Biography* (Oxford: Phaidon, 1977), 24–33.

54. Montagu, ed., *Letters of Mrs. Elizabeth Montagu*, 3:98.

55. Michael Snodin locates the flourishing in England of the rococo printed pattern book between the mid-1730s and the 1770s, see "Who Led Taste?" in Michael Snodin and John Styles, *Design and the Decorative Arts: Britain, 1500–1900* (London: V&A Publications, 2001), 224.

56. Calmann, *Ehret*, 99.

57. Mary Delany to Anne Dewes, 10 March 1744, in Llanover, ed., *Autobiography and Correspondence*, ser. 1, 2:279.

58. Mary Delany to Anne Dewes, 23 September 1744, in Llanover, ed., *Autobiography and Correspondence*, ser. 1, 2: 330.

59. Mary Delany to Anne Dewes, 15 July 1750, in Llanover, ed., *Autobiography and Correspondence*, ser. 1, 2: 569.

60. Mary Delany to Anne Dewes, 6 October 1750, in Llanover, ed., *Autobiography and Correspondence*, ser. 1, 2:600.

61. Mary Delany to Anne Dewes, 6 October 1750, in Llanover, ed., *Autobiography and Correspondence*, ser. 1, 2:600–601.

62. *Oxford English Dictionary*, s.v. "bow closet." References to Mrs. Delany's bow closet will be documented as group below.

63. Mary Delany to Anne Dewes, 30 December 1758, in Llanover, ed., *Autobiography and Correspondence*, ser. 1, 3:530–31.

64. Mary Delany to Anne Dewes, 23 December 1758, in Llanover, ed., *Autobiography and Correspondence*, ser. 1, 3:530.

65. Mary Delany to Anne Dewes, in Llanover ed., *Autobiography and Correspondence*, ser. 1, 3:527 (1758), 544 (31 March 1759), 542 (24 March 1759).

66. Gill Saunders, *Wallpaper in Interior Decoration* (London: V&A Publications, 2002), 55, 57.

67. Mary Delany to Anne Dewes, 11 August 1759, in Llanover, ed., *Autobiography and Correspondence*, ser. 1, 3:563.

68. Mary Delany to Anne Dewes, 10 November 1759, in Llanover, ed., *Autobiography and Correspondence*, ser. 1, 3:574.

69. *Oxford English Dictionary*, s.v. "prospect." For a recent discussion of the links among landscape design, scenes, and painting, see John Dixon Hunt, *The Picturesque Garden in Europe* (London: Thames & Hudson, 2002), esp. 62–65.

70. See also the entry for "the picturesque" in Patrick Goode and Michael Lancaster, eds., *Oxford Companion to Gardens* (Oxford: Oxford Univ. Press, 1986), 431. For full-length studies of this design style, see John Dixon Hunt, *Gardens and the Picturesque: Studies in the History of Landscape Architecture* (Cambridge, Mass.: MIT Press, 1992) and Hunt, *Picturesque Garden in Europe*. Hunt's assertion in *Gardens and the Picturesque* (4) that the picturesque taste functions as "a mode of processing the physical world for our consumption or for our greater comfort" is especially relevant to our discussion of Mrs. Delany's bow closet.

71. For Claude glass and the picturesque, see Hunt, *Gardens and the Picturesque*, 174–75.

72. Mary Pendarves to Anne Granville, 30 March 1732, in Llanover, ed., *Autobiography and Correspondence*, ser. 1, 1:344–45.

73. Mary Delany to Anne Granville, 23 April 1741, NPL, GL, vol. 2.

74. Gaston Bachelard, *The Poetics of Space*, trans. Maria Jolas (Boston: Beacon Press, 1994), 125.

75. Mary Delany to Anne Dewes, 22 July 1770, NPL, GL, vol. 3.

76. Mary Pendarves to Jonathan Swift, 2 September 1736, in Llanover, ed., *Autobiography and Correspondence*, ser. 1, 1:570.

77. Mary Delany to Anne Granville, 6 September 1732, NPL, GL, vol. 1. For a discussion of Mrs. Delany's grotto work and female friendship, see Lisa L. Moore, "Queer Gardens: Mary Delany's

Flowers and Friendships," *Eighteenth-Century Studies* 39, no. 1 (2005): 49–70.

78. Mary Delany to Anne Dewes, Delville, 19 July 1744, in Llanover, ed., *Autobiography and Correspondence*, ser. 1, 2:315. Hunt observes that ruins were an essential element in the picturesque imagination in the eighteenth century; *Gardens and the Picturesque*, 179.

79. Llanover, ed., *Autobiography and Correspondence*, ser. 1, 1:570 (Mary Pendarves to Jonathan Swift, 2 September 1736), and ser. 1, 2:315 (Mary Delany to Anne Dewes, 19 July 1744).

80. Mary Delany to Anne Dewes, 25 February 1744, in Llanover, ed., *Autobiography and Correspondence*, ser. 1, 2:272.

81. Llanover, ed., *Autobiography and Correspondence*, 3:332 (Mary Delany to Anne Dewes, 22 February 1755), ser. 2, 3:409–10 (Mary Delany to Mary Dewes Port, 27 February 1779).

82. John Serle, *A Plan of Mr. Pope's Garden, as It Was Left at His Death: With a Plan and Perspective View of the Grotto* (London: R. Dodsley, 1745), 7, 9.

83. John Dixon Hunt, "Pope's Twickenham Revisited," *Eighteenth-Century Life* 8, no. 2 (1983): 30–31.

84. Thomas Wright, *Arbours & Grottos: A Facsimile of the Two Parts of Universal Architecture (1755 and 1758)*, with a catalogue of Wright's works by Eileen Harris (London: Scolar Press, 1979).

85. Mary Delany to Anne Dewes, 17 November 1756, in Llanover, ed., *Autobiography and Correspondence*, ser. 1, 3:449.

86. Hannah Robertson, *The Young Ladies School of Arts: Containing a Great Variety of Practical Receipts, in Gum-Flowers, Filligree, Japanning, Shell-Work, Gilding… Also, a Great Many Curious Receipts, Both Useful and Entertaining, Never Before Published*, 2nd ed. (Edinburgh: Printed for the author, 1767), 150, 152–53, 17.

87. Mary Delany to Anne Dewes, 5 January 1759, in Llanover, ed., *Autobiography and Correspondence*, ser. 1, 3:534.

88. Bachelard, *Poetics of Space*, 130–31.

89. Mary Delany to Bernard Granville, 11 June 1751, in Llanover, ed., *Autobiography and Correspondence*, ser. 1, 3:39.

90. Robertson, *Young Ladies School of Arts*, 18.

91. See David Philip Miller, "Joseph Banks, Empire, and 'Centers of Calculation' in Late Hanoverian London," in David Philip Miller and Peter Hanns Reill, eds., *Visions of Empire: Voyages, Botany, and Representations of Nature* (Cambridge: Cambridge Univ. Press, 1996), 21–37.

92. Mary Delany to the Right Hon. Viscountess Andover, 16 August 1772, in Llanover, ed., *Autobiography and Correspondence*, ser. 2, 1:448.

93. See, for example, Mary Delany to Anne Dewes, in Llanover, ed., *Autobiography and Correspondence*, ser. 1, 3:262 (28 December 1753), 309 (December 1754).

94. Mary Delany to Anne Dewes, 14 June 1770, NPL, GL, vol. 3. The experimental cabinet at Bulstrode usually included Mrs. Delany, Rev. Lightfoot, Linnaeus's pupil Daniel Solander,

Ehret, and members of the duchess's family.

95. Mary Delany to Mary Dewes Port, 17 April 1779, NPL, GL, vol. 6.

96. Mary Delany to Bernard Granville, 17 December 1771, in Llanover, ed., *Autobiography and Correspondence*, ser. 2, 1:384.

97. For Solander's appointment to the British Museum in 1763, see Bengt Jonsell, "Linnaeus, Solander and the Birth of a Global Plant Taxonomy," in Anderson, ed., *Enlightening the British*, 93. In 1765, Collinson wrote to Linnaeus of Solander's twin duties at the British Museum and at Bulstrode's museum; Armstrong, ed., *'Forget not Mee & My Garden'*, 262.

98. Mary Delany to Mary Dewes Port, 19 November 1771, NPL, GL, vol. 3.

99. Mary Delany to Mary Dewes Port, 19 November 1771, NPL, GL, vol. 3; Mary Delany to Mary Dewes, 17 September 1769, NPL, GL, vol. 4.

100. Mary Delany to Mary Dewes, 3 September 1769, NPL, GL, vol. 4.

101. See McKeon's discussion of pictorial representations of early modern alchemy in *Secret History of Domesticity*, 212–16.

102. Papers of Margaret Bentinck, Duchess of Portland, Portland Welbeck Collection, PwE, item 63, University of Nottingham.

103. Deborah Heller, "Bluestocking Salons and the Public Sphere," *Eighteenth-Century Life* 22, no. 2 (1998): 59–82.

104. Mary Delany to Anne Dewes, 15 July 1770, NPL, GL, vol. 3.

105. Heller, "Bluestocking Salons," 70.

106. Mary Delany to Mary Dewes, in Llanover, ed., *Autobiography and Correspondence*, ser. 2, 1:204 (February 1769), 238 (3 September 1769).

107. Mary Delany to Mary Dewes Port, 19 November 1771, NPL, GL, vol. 3.

108. Mary Delany to the Rev. John Dewes, 27 July 1774, in Llanover, ed., *Autobiography and Correspondence*, ser. 2, 2:19.

109. Elizabeth Eger, "Luxury, Industry, and Charity: Bluestocking Culture Displayed," in Maxine Berg and Elizabeth Eger, eds., *Luxury in the Eighteenth Century: Debates, Desires and Delectable Goods* (Basingstoke: Palgrave Macmillan, 2003), 190–204.

110. Elizabeth Eger, "'The noblest commerce of mankind': Conversation and Community in the Bluestocking Circle," in Sarah Knott and Barbara Taylor, eds., *Women, Gender, and Enlightenment* (Basingstoke: Palgrave Macmillan 2005), 290.

111. Mary Delany to Anne Dewes, in Llanover, ed., *Autobiography and Correspondence*, ser. 1, 3:345 (12 March 1755), 473 (29 December 1757).

112. Mary Pendarves to Mrs. Catherine Collingwood, 25 October 1736, in Llanover, ed., *Autobiography and Correspondence*, ser. 1, 1:574. For a discussion of Montagu's feather screens, see Eger, "Luxury, Industry, and Charity," 199.

113. Mary Delany to Lord Oxford, New Year's Day 1739, Portland Papers at Longleat House (microform, British Library), fol. 228v.

114. Mary Delany to the Viscountess Andover, 1 July 1769, in Llanover, ed., *Autobiography and Correspondence*, ser. 2, 1:221.

115. Mary Delany to the Rev. John Dewes, 9 July 1778, in Llanover, ed., *Autobiography and Correspondence*, ser. 2, 2:363, 364.

116. Mary Delany to Mary Dewes Port, 29 September 1782, NPL, GL, vol. 6.

117. Mary Delany, 'Dracæna terminalis' (1780), Prints and Drawings, British Museum, 1897, 0505.297.

118. As Kim Sloan notes, Mrs. Delany received eighty-four plants for collages from Banks at Kew; Kim Sloan, *'A Noble Art': Amateur Artists and Drawing Masters, c. 1600–1800* (London: British Museum Press, 2000), 64.

119. Mrs. Delany used the term "paper mosaics" in a letter to Anne Viney, 31 October 1779, NPL, GL vol. 6.

120. Mary Delany to Mary Dewes Port, 28 October 1774, NPL, GL, vol. 5.

121. Calmann, *Ehret*, 67.

122. Elizabeth Montagu to Mary Delany, December 1743, NPL, GL, vol. 2.

123. Mary Delany to Mary Dewes Port, 4 October 1772, NPL, GL, vol. 3.

124. Abbé Hauy, "Observations on the Manner of Making a Hortus-Siccus," in Edward Donovan, *Instructions for Collecting and Preserving Various Subjects of Natural History; as Animals, Birds, Reptiles, Shells, Corals, Plants, &c.…* (London: Printed for the author, 1794), 81–82.

125. Mary Delany, 'Passiflora Laurifolia' (1777), British Museum, Department of Prints and Drawings, (1897, 0505.654). Amy Meyers made this observation in the Delany authors' workshop, London, British Museum, July 2007.

126. Mary Delany to Miss Hamilton, 18 April 1781, in Llanover, ed., *Autobiography and Correspondence*, ser. 2, 3:14.

127. William Gilpin to Mary Delany, 8 May 1786, Bodleian MS. Eng. Letters, b. 27, fols. 53–54, Bodleian Library.

128. Armstrong identifies this concept of Collinson's in a letter from September 1741, in *'Forget not Mee & My Garden'*, 160. For the ways in which Lord Petre fulfilled Collinson's picturesque ideals, see Douglas Chambers, *The Planters of the English Landscape Garden* (New Haven and London: Yale Univ. Press, 1993), 103–19.

129. Peter Collinson to Philip Southcote, 9 October 1752, in Armstrong, ed., *'Forget not Mee & My Garden'*, 159.

[7]

Mrs. DELANY'S CIRCLES OF CUTTING & EMBROIDERING
in Home & Garden

In Mrs. Delany's lifetime, genteel women spent more time in the garden, as in the home generally, than did men.[1] Lacking professional outlets in landscaping, their domesticity turned to gardening among female accomplishments.[2] Mrs. Delany's various flower-based works, which represent an elevated version of domestic arts, thus raise intriguing questions about women and the garden. First, was there a connection between what might be called the culture of textiles (related to fashion) and "dressing up" the garden through horticulture? Second, did decorative efforts in the home affect how women considered art and nature?[3] Third, was professional instruction in botany and drawing key to their amateur scientific pursuits?[4] And fourth, did circles of female virtuosity offer help to male naturalists in turn, as men's social activities in natural history struggled mid-century?[5]

In garden history, Mrs. Delany usually appears marginal to the visionary pronouncements of Alexander Pope, or to the pioneering works of William Kent at Carlton House and Stowe. In December 1743, for example, she makes a cameo appearance, journeying with the Duchess of Portland to the Duchess of Kent's Remnans,[6] where (significantly, we are told) designer Thomas Wright and garden-maker Richard Bateman were visiting.[7] As horticulture came under the assiduous eyes of women, however, it seems reasonable to assume that Mrs. Delany played a star role in the theater of female gardening lore. From that premise, this essay opens with the first question and its corollaries. Did Mrs. Delany and her circle draw upon embroidery in dress as a source of horticultural effect? Or were their textiles influenced by changes in professional garden design, including the so-called enameling of "carpet"?

Textiles and "Dressing Up" the Garden

When Mary Granville was born in 1700, garden art had enjoyed a long association with embroidery. Imitating embroidered silks, the *parterre de broderie* at the court of Louis XIV was the finest patterning in box.[8] *Broderie*, however, was vanishing in England at the time of Queen Anne's death in 1714, when Mary's immediate family retired from court life. At the new family home of Buckland in Gloucestershire, she would discover nature's embroidery. She absorbed the sound-pattern of birds warbling in concert with purling brook.[9]

At the time of her visit to Longleat in 1717/18, the plain lawns of the *parterre à l'angloise* had replaced *parterre de broderie*.[10] Indeed, by 1712, in an influential essay in *The Spectator*, Joseph Addison had written a few lines that went beyond mere horticultural dressing:

> *But why may not a whole Estate be thrown into a kind of Garden by frequent Plantations?… If the natural Embroidery of the Meadows were helpt and improved by some small Additions of Art,… a Man might make a pretty Landskip of his own Possessions.*[11]

And so it was that, by the 1720s, the ha-ha, or sunk fence, began to link the plain lawns of Longleat to Addison's embroidered meadows. This was the first step toward the English landscape garden. In time, the circuits of pleasure ground and park would replace the axial planning of geometric gardens.[12]

At Longleat, Mary's uncle, Lord Lansdowne, enjoyed another pattern: the enamel of flower borders (fig. 142). The term "enamel" had sustained an even longer association with gardening. Poets, like Edmund Spenser or Joshuah Sylvester after Du Bartas, wrote of enamel as the mythical *ver perpetuum*, or perpetual spring:

> *A climate temp'rate both for cold and heat, Which dainty* Flora *paveth sumptuouslie With flower Ver's innameld tapistrie.*[13]

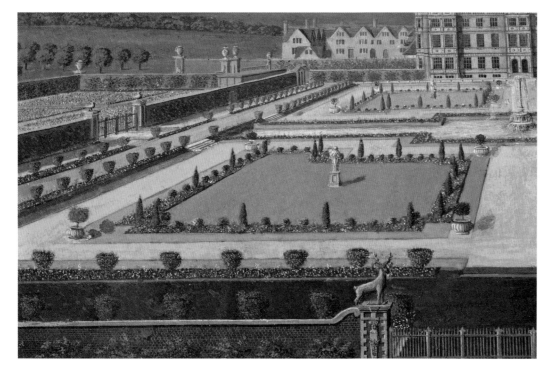

Figure 142: Detail from Robert Thacker, *Great Parterre at Longleat*, post-1684, oil, showing the "enamel" of flower borders. Marquess of Bath, Longleat House, Wiltshire

Over time, the flower border would be likened to "the enamelled mixture of all the colours."[14] Mary celebrated enameling in this sense when she wrote to her sister Anne from Delville on 20 August 1748:

> My flower-garden, which is now just under my eye, is a wilderness of flowers, the beds are overpowered with them, and though the enamelled look they have is rich and pretty, I believe it will be advisable to have the different sorts of flowers appear rather more distinct.[15]

In effect, the wilderness had come into her garden, much as Addison had taken the garden into the field. Hence at Delville, Dr. Delany—and later Mrs. Delany—realized Addison's ideal of a man making a pretty picture of his whole estate. As she wrote: "These fields are planted in a *wild way* with *forest-trees and with bushes*, that look so naturally you would not imagine it the work of art."[16] She described birdsong as one of nature's patterns in garden art:

> Our garden is now a wilderness of sweets. The violets, sweet briar, and primroses perfume the air, and the thrushes are full of melody and make our concert complete. It is the pleasantest music I have heard this year, and refreshes my spirits without the alloy of a tumultuous crowd, which attends all the other concerts. Two robins and one chaffinch fed off D.D.'s hand as we walked together this morning. I have been planting sweets in my "Pearly Bower"—honeysuckles, sweet briar, roses and jessamine to climb up the trees that compose it, and for the carpet, violets, primroses, and cow[s]lips [see figs. 143, 144].[17]

And so it was that, for a "carpet" or sward, the words "embroidery" and "enamel" became synonymous. For example, the Countess of Hertford wrote to Lady Luxborough in May 1748 how "our Lawns and Meadows are enamelled with a Profusion of Daisies and Cowslips."[18] Lady Luxborough, corresponding with William Shenstone, preferred the term "embroidery."[19] Mrs. Delany saw Spenser's "Garden of Adonis"

Figure 143: Mary Delany, 'Primula veris', 1775, collage of colored papers, with bodycolor and watercolor, 10⅝ × 7⅜ in. (27 × 18.8 cm). British Museum, Prints and Drawings (1897,0505.704)

Figure 144: Mary Delany, *A view of y^e Beggars hut in Delville garden*, 1745, pen and gray ink and wash over graphite on paper, 10⅜ × 14½ in. (26.3 × 36.7 cm). National Gallery of Ireland, Dublin (2722 [23])

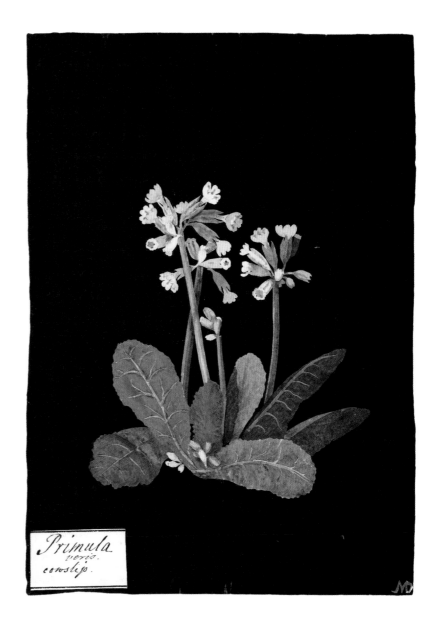

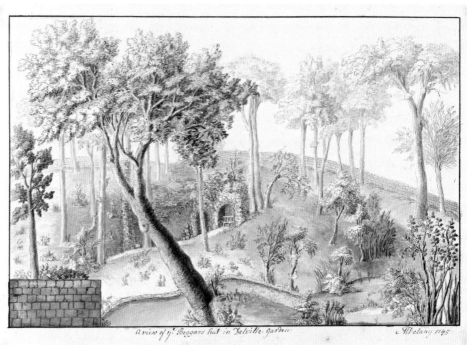

Figure 145: Mary Delany, *A view of y^e improvements in y^e Stone quarry at Cornbury the seat of the Earl of Clarendon in Oxfordshire 15 Nov^r 1746*, 1746, pen and gray ink and wash over graphite, 14½ × 18⅛ in. (36.2 × 46 cm). National Gallery of Ireland, Dublin (2722 [41])

Figure 146: Mary Delany, *The Indian Seat at Wroxton*, undated, pen and gray ink and wash over graphite on paper, 10½ × 16⅛ in. (26.7 × 41 cm). National Gallery of Ireland, Dublin (2722 [83])

in wild honeysuckle and roses on tree trunks, "embroidered with woodbine and the '*flaunting eglantine.*'"[20]

As an analogy to garden design, Mrs. Delany's 1741 description of two dresses, contrasted with the Duchess of Queensberry's dress, is worth considering. Architectural and artificial motifs—festoons, pillars, vases, latticework, and flowerpots—characterized the foundation of the former two, whereas the petticoat of the latter represented the hills and honeysuckle-entwined trees of the early landscape garden:

> *I will proceed to give you an account of our doings at Norfolk House... My Lady Scarborough was in violet-coloured satin, the petticoat embroidered with clumsy festoons of nothing at all's supported by pillars no better than posts, the gown covered with embroidery, a very unmeaning pattern, but altogether very fine.... Lady M. Tufton white embroidered with garlands and flower-pots of flowers mixt with a great deal of silver....*
>
> *The Duchess of Queensbury's clothes pleased me best; they were white satin embroidered, the bottom of the petticoat brown hills covered with all sorts of weeds, and every breadth had an old stump of a tree that run up almost to the top of the petticoat, broken and ragged and worked with brown chenille, round which twined nastersians, ivy, honeysuckles, periwinkles, convolvuluses and all sorts of twining flowers....*[21]

Was the duchess's dress inspired by gardens like Cornbury, Oxfordshire, or the garden by the dress (à la *broderie*), or were motifs (for example, a "stump") lifted from drawing conventions?[22] It is hard to know; the "twining flowers" could be simply a modified Tree of Life motif. In 1746, however, Mary Delany, having enjoyed her feminine chinoiserie dressing room, described Cornbury's distinctive rockwork:

> *I never saw any spot of ground more beautiful than the park. I have taken a sketch of one part, which was originally a stone quarry, and is now improved into the wildest prettiest place you can imagine—winding walks, mounts covered with all sorts of trees and flowering shrubs, rocks covered with moss....*[23] (see fig. 145)

While images of Chinese gardens remain a contested influence on the English garden, the rocks, flowers, and birds of chinoiserie décor surely played a role in how a lady thought of "dressing up" the garden.[24] That English chinoiserie had become associated early on with the furnishing of ladies' rooms was especially significant as women furnished the grove with exotics amid nature's

embroidery.[25] Mary Delany's 1746 and 1754 views of Wroxton (fig. 146), and her many sketches of rocks in Derbyshire and Ireland, reveal a unified sensibility (fig. 147). While she herself created little that was explicitly oriental (other than japanning), she was surrounded by chinoiserie, from the Chinese menagerie pavilion at Bulstrode to the Chinese aviary at Kew.[26]

Her corpus of views of groves and rockwork (and chinoiserie), evoking the rusticities of the Duchess of Queensberry's dress, are amplified by written accounts.[27] On 11 June 1745, Mary wrote to her sister Anne from Hollymount, the Delanys' other home, north of Dublin:

> *About half a mile off is a pretty wood which formerly was enriched with very fine oaks and several other forest trees (it covers a hill of about twenty acres); it is now only a thicket of the young shoots from their venerable stocks, but it is very thick, and has the finest carpeting of violets, primroses, and meadow sweet, with innumerable inferior shrubs and weeds, which make such a mass of colouring as is delightful. But thorny and dangerous are the paths, for with these sweets are interwoven treacherous nettles and outrageous brambles! but the Dean has undertaken to clear away those usurpers….*[28]

In other words, how much was "cut out" or left and how much was "embroidered" amounted (within a companionable marriage) to a fine balance of art and nature. As William Shenstone put it to Lady Luxborough, there was always the danger of adding too much to natural beauties, such that the conceit became evident: "I have been embroidering my Grove with Flowers, till I almost begin to fear it looks too much like a *garden*."[29]

In this sense, some men understood the horticultural give-and-take of "dressing up." Indeed, a group of amateur garden designers—William Shenstone to Joseph Spence—styled the new flowery landscape; and Richard Bateman's pioneering way with flowers had explicit associations with chinoiserie.[30] Moreover, much of what Mary Delany drew of the Delville garden was already fashioned by Dr. Delany in the style of Pope and Addison before his bride's arrival in 1744.[31] Perhaps, then, "amateur gardening culture" was as important as any specific female "textile culture." Could Mrs. Delany have found inspiration, for example, in Thomas Robins the Elder's painting of Bateman's Grove House, Old Windsor? Robins's frames of flowers and shells recall *pietre dure* or japanning, and all such decorations on a black ground (fig. 148).[32]

Figure 147: Mary Delany, *a view of Matlock with the Cascade*, 1743, pen and gray ink and wash over graphite on paper, 9 × 14½ in. (22.8 × 36.9 cm). National Gallery of Ireland, Dublin (2722 [19])

Figure 148: Thomas Robins the Elder, Prospect of *Buenos Aires the Seat of Benjamin Hyett Esq. near Panswyke* [Painswick House] *Gloucestershire*, 1748, watercolor and bodycolor on vellum, 18¾ × 23¾ in. (47.6 × 60.3 cm). Private collection

Figure 149: Attributed to Mary Delany, *Bouquet of Flowers*, undated, watercolor with bodycolor, folio 7 in a flower album. Marquess of Bath, Longleat House, Wiltshire

If nature was frequently brought into the house for decoration and studies in natural knowledge, so too fashion and the trappings of the house were brought into nature. What Mrs. Delany called her "walking-dress" was of course far removed from the elaborate silk embroidery of "court dress."[33] Nevertheless, encounters between the patterned silk of dress or shoe and grass carpet were everyday moments when nature set off art. Silk shoes involved a particular calculus for women, who wore "clogs" (overshoes) on any circuit walk in inclement weather.[34] Whole domestic settings entailed a different balance of art and nature. Here women were singularly engaged. For example, in June 1750 Mrs. Delany took interior accoutrements into the garden at Delville to create a *concert champêtre*:

> *We have discovered a new breakfasting place under the shade of nut-trees, impenetrable to the sun's rays, in the midst of a grove of elms, where we shall breakfast this morning; I have ordered cherries, strawberries, and nosegays to be laid on our breakfast-table, and have appointed a harper to be here to play to us during our repast... .*[35]

Meals were regularly taken from the house into garden rooms, which offered protection. Mary, visiting her friend Mrs. Vesey on 30 June 1750, wrote to her sister Anne:

> *Found breakfast prepared for us in Mrs. Vesey's dairy, and the table strewed with roses; just as we were in the midst of our repast came in Lady Caroline Fox, Mr. Fox, Mrs. Sandford, and Master Fox—a fine rude boy, spoiled both by father and mother... . It rained furiously; so we fell to work making frames for prints.*[36]

While flowers were strewn on tables, the table-cloths were embroidered with flowers in imitation thereof. The patterns were mutually reinforcing. They suggest that the garden, as an ephemeral setting, could draw upon all the decorative arts in which women were so accomplished. Decking the home and the table belonged in that repertoire, and the indoor *fête champêtre* made rooms into gardens.[37]

Types of table decoration reflected changes outside. The simple board of earlier times—formal pyramids of fruit and sweetmeats around a vase—was replaced in the 1740s with a more ornate yet "natural" decoration: numerous small vases, or entire make-believe gardens, with only a few porcelain dishes of fruit and sweetmeats. Horace Walpole observed in 1753 that the previ-

ous "jellies, biscuits, sugar plums and creams" of dessert had "long since given way to Turks, Chinese and Shepherdesses of Saxon china … wandering on the table, unconnected, among groves of curled paper and silk flowers," while "meadows of cattle of the same brittle materials spread themselves over the whole table, cottages rose in sugar and temples in barley sugar."[38]

Mary Delany was witness to such altering tastes, for example at the newly redecorated Norfolk House, whose circuit rooms altered the enfilade of ceremonial gatherings.[39] On 18 February 1756, William Farrington described the assembly there:

> I dined with the Duke and Duchess.…. After a very Elligant Dinner of a great many dishes, the Table was Prepar'd for Desert [sic], which was a beautiful Park, round the edge was a Plantation of Flowering Shrubs and in the middle a Fine piece of water, with dolphins spouting out water and Dear [sic] interspersed irregularly over the Lawn….[40]

By the early 1750s, following William Shenstone and Lady Luxborough, the term "shrubbery" described a new, fashionable feature of the pleasure ground. Hence, what Farrington called as a "Plantation of Flowering Shrubs" (a "shrubbery") began to challenge the dominance of groves. Mrs. Delany perhaps knew of the shrubbery style by 1752, when she wrote of a Mr. Tighe visiting Charles Hamilton's "Pains-Hill," one of the pioneering sites of shrubbery design.[41] Moreover, in 1760, when she returned to Longleat, she found that the landscape gardener Lancelot "Capability" Brown had been at work: "There is not much alteration in the house, but the gardens are no more! they are succeeded by a fine lawn, a serpentine river, wooded hills, gravel paths meandering round a shrubbery, all modernized by the ingenious and much sought after Mr. Brown!"[42]

A shrubbery, like a menagerie, could be both decorative and instructive. Instruction in shrubbery was linked to the "theatrical" arrangement, in which a collection (or complete compendium) of specimens was displayed in a graduated hierarchy: the theater (see pp. 20, 34).[43] While this left room for women to learn about the hierarchic arrangement of Linnaean botany, it was not always conducive to the decorative and instructional gardening that women enjoyed. The fact that the Duchess of Portland's pleasure ground resisted Brownian improvement indicates her priorities lay elsewhere: in the virtues of collecting, cataloguing, or creating an herbal or herbarium.[44]

For Mrs. Delany, who had Spenserian groves and an "auricula theater" (rather than Brownian shrubbery), the flower garden remained a place to develop the art of limning.[45] The flower album at Longleat (traditionally attributed to her) is an example of limning within that genre of feminine aristocratic production.[46] The individual portraits of lily-of-the-valley or orange blossom are similar to drawings she prepared for her embroidery. The bouquets—with rose, purple sweet pea, lily-of-the-valley, and yellow jasmine among other flowers (fig. 149)—fall below the standard of professional flower painters, notably G. D. Ehret and Thomas Robins the Elder. Yet they are comparable to amateur works both before and during her lifetime. Elizabeth Capel, for example, painted Flowers in a Vase in 1662, which, as Kim Sloan has pointed out, equates with Dutch still lifes and the work of Alexander Marshal.[47] Elizabeth's descendant Mary Capel Forbes, who was instructed by Ehret, painted flowers from the 1750s to the 1770s. And Lady Sarah Fetherstonhaugh produced a whimsical watercolor about 1750 in which the chorister of the grove perches amid animals and plants (fig. 150).

Akin were all the amateur arts of brush, needle, and thread: an embroidered basket of flowers; a nature print of flowers and foliage; a design of fruit and flowers in a chinoiserie vase; a hand bouquet with ribbons; flowers arranged in vases as a garniture along the mantelpiece, or in bough pots in the fireplace; and, above all, the art of japanning, which could represent flowers on a black lacquer ground.[48]

Mary Delany's embroidery with scattered flowers recalls japanned furniture as much as Robins's frames. Her petticoat border resembles the shell cornice for the Delville chapel, or her nature prints, or flower garlands for festive interiors. Those garlands would mimic the swags and festoons of architectural plasterwork. The fact that in 1751 Mrs. Delany delightedly reported her niche of shells compared to "Irish stitch" points to a borrowing of aesthetics among different handicrafts.[49]

Figure 150: Lady Sarah Fetherstonhaugh, *Plants and Animals in a Landscape*, ca. 1750, watercolor. National Trust, Uppark, Sussex

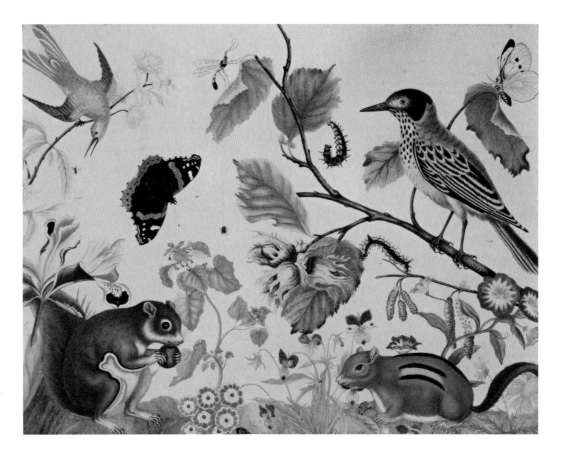

Yet embroidery also borrowed from the garden. For example, pinks in applied silk lace on a velvet stomacher recall edging, while her repeat motifs suggest florists' flowers against black soil. The auricula theater that Mrs. Delany made in her nine-pin alley likewise displayed repetitive blooms against a black cloth. This was more than just the trope of nature's jewels or stars in heaven, or a borrowing from still-life art against a dark ground.[50] Here she rendered the "distinct" individuality of the florist's bed (which she would later perfect in collage portraiture) as opposed to the enameled ensemble of the flower border (see fig. 142).[51] Like other florists' flowers—hyacinths, tulips, carnations—auriculas were sometimes named after distinguished people and thus had status at court.[52] For example, among the auriculas of distinction that decorated the subscribers' page of Robert Furber's illustrated catalogue *Twelve Months of Flowers* (1730; fig. 151) are the cultivars 'Potters Queen Caroline', 'Prince Frederick', 'Princess Amelia', 'Princess Caroline', 'Prince of Orange', 'Earl of Derby', 'Lord Willoughby of Brook', and 'Lady Walpole'. It seems possible that the petticoat's representation of the "cultivated" and the "British" had resonance, much as the choice of the rose and orange blossom symbolized the union of the Princess Royal and Prince William of Orange in 1734.[53]

A lifelike rendering of botanical detail in a scatter on open ground is what Mrs. Delany's petticoat shares with woven English silks, for example those of Anna Maria Garthwaite (discussed by Clare Browne in her essay in this volume). Naturalism within a rococo idiom was the distinctive English contribution to a trade otherwise dominated by France.[54] Botanical works by Maria Sibylla Merian, Mark Catesby, and G. D. Ehret inspired stylized motifs.[55] By contrast, Mrs. Delany's embroidery contains cultivated flowers but not the newly imported exotics such as the *Kalmia* or *Dodecatheon* of Catesby and Ehret. Her motifs were sweet peas, auriculas, tuberose, and lily-of-the-valley (the cultivated flowers of the Longleat album), yet her verisimilitude matched the best of English floricultural art. English textiles, thus botanically varied from stylized to lifelike, reflect the rise of a metropolitan horticultural milieu in which women played a significant role as patrons.[56] Mary Pendarves and the Duchess of Queensberry, for example, subscribed to Furber's *Twelve Months of Flowers*.[57] Ehret was central to that new milieu, as teacher and publishing entrepreneur. Significantly, though, it was aristocratic patrons such as the Duchess of Portland who allowed him to work outside the commercial marketplace, to draw the less fashionable natives as well as the voguish exotics.

Professional Instruction and the Amateur Culture of Limning and Botany

Mrs. Delany's intimate contact with Georg Dionysius Ehret came after he began teaching the daughters of the aristocracy. The 1750s and 1760s are thus transitional: first, because Mary Delany saw the master instructing his "Scholaren"; second, because she saw the research method behind the master's work, which involved botanical dissection.

On 10 December 1753, while at Bulstrode, she

Figure 151: Subscribers' page from Robert Furber, *Twelve Months of Flowers: From the Collection of Robt. Furber, Gardiner at Kensington/ Designed by Pieter Casteels; Engraved by Henry Fletcher* (London, 1730). Dumbarton Oaks Research Library and Collection, Rare Book Collection, Washington D.C. The dedication is to Frederick Prince of Wales and the Princess Royal, and subscribers, including "Mrs Pendarvis" and the "Duchess of Queensbury."

wrote to her sister Anne of the Duchess of Portland's daughter: "You would be surprised to see the improvement Lady Betty Bentinck has made in her drawing; I think she comes *very near* Ehret; she has copied one of the fishes out of my book most exactly… ."[58] By 1768, fostered by the Duchess of Portland, Ehret painted "above *a hundred and fifty English plants*." As Mrs. Delany observed, "now they are collected together their beauty is *beyond* what we have notion of, particularly the water plants!"[59] His effective aggrandizement of the duchess's "English herbal" is apparent from the decoratively displayed "Ivy leaved Toadflax" of 1765 (fig. 152).

John Lightfoot—"botanical master"—was helping the duchess and Ehret complete this English "herbal." Ehret was searching for "curiosities in the fungus way,"[60] which had led him in 1763 to *Phallus impudicus* at Bulstrode. Nearly ten inches high, it "emitted a strong foetid smell like unto a Carcass" (fig. 153). That James Bolton of Halifax (who visited Bulstrode in 1779 and probably taught drawing to Mrs. Delany's grandniece Georgina) dedicated his groundbreaking mycological work *Icones fungorum* (1786; see fig. 179) to the duchess suggests the centrality of these branches of natural history in Bulstrode life.[61]

Mary Delany's account of Bulstrode in the autumn of 1769 gives an idea of how this extensive pursuit of natural knowledge (a form of virtu) sat comfortably with domesticity and the entertainments of her London life. The new system of Linnaean taxonomy led directly to the "English herbal" and the collages (as John Edmondson explains in his essay in this volume). Yet, such virtu came without any diminution in the pleasures of leisure, the divertissements of handicraft:

> *Mr. Lightfoot and botany go on as usual; we are now in the chapter of* Agaricks *and* Boletus's, *&c. &c., this being the time of their perfection, and her Grace's breakfast-room, which is now the repository of sieves, pans, platters, and filled with all the productions of that nature, are spread on tables, windows, chairs, which with books of all kinds, (opened in their useful places), make an agreeable confusion; sometimes, notwithstanding twelve chairs and a couch, it is indeed a little difficult to find a seat! but your inquiries are indefatigable, and I don't know whether they sit or*

Figure 153: Georg Dionysius Ehret, "Phallus Found at Bulstrode Nov. 12 1763", sketch in watercolor and graphite on paper, fols. 229–230 of large Ehret volume in Botany Library, Natural History Museum, London

Figure 152: Georg Dionysius Ehret, "Antirrhinum CYMBALARIA", 1765, watercolor on vellum. Royal Horticultural Society, London, Lindley Library. The watercolor was once part of the Portland Museum; it was sold in 1786.

Figure 154: Georg Dionysius Ehret, *Study of English Wildflowers of Field and Wood*, 1767, graphite and watercolor and bodycolor on vellum, 10 × 6¾ in. (25.3 × 17.1 cm). Fitzwilliam Museum, Cambridge (PD. 113-1973.19).

Figure 155: Mary (née Capel) Forbes, copy of Ehret's *Study*, with "Pheasant Eye" and a peacock butterfly added, 1768, watercolor and graphite on vellum. Fitzwilliam Museum, Cambridge (PD.106-1973)

stand! *Mr. Lightfoot, poor man, immersed in law, was obliged yesterday to leave* virtu *for lawyers, so we had laid our plan for the day…. There were pot pouris to be made, great preparations for the garden room, and the many little matters which our happy leisure would allow us, to fill up chinks. We sat down comfortably to dinner, first course ended—second almost—when said her Grace, looking most earnestly at the road in the park, with a countenance of dismay,—"A* coach and six*! My Lord Godolphin—it is his livery, and he always comes in a* coach and six, *take away the dinner—will you have any apricot tart? what will they think of all these* great puff balls?*"*[52]

The smells of fish and meats (just consumed) and apricot tart (about to be consumed) would thus fuse with the scents of fungi, potpourri, and body perfumes.

Horace Walpole appears among the first to publicize the idea of potpourri in the mid-1760s,

after going with William Cole to visit Thomas Gray in 1763.[63] He was attentive to how art and nature combined in interiors, just as artifice could be taken out into the garden. In August 1773 he wrote to Lady Ossory, "my house is a bower of tuberoses." The practice of bringing pots and tubs indoors was widespread by 1770, and coaxing double hyacinths into early blooming in water in a glass or in ceramic vessels (forcing) had been illustrated by 1752. Thus forcing plants over winter could have been the source of some of Mrs. Delany's collages—for example, the 'Narcissus tazetta var: Polyanthos Narcisse' dated just after her confinement in the deep freeze of London in January 1776. Whether the 'Reseda odorata', dated 10 February 1778, was kept in a greenhouse or displayed indoors in a ceramic pot is unclear, but either way scents pervaded interior spaces.[64]

The Duchess of Portland had hothouses for tropical exotics, which heightened exposure to intense perfumes. Indoors, virtuosic science and

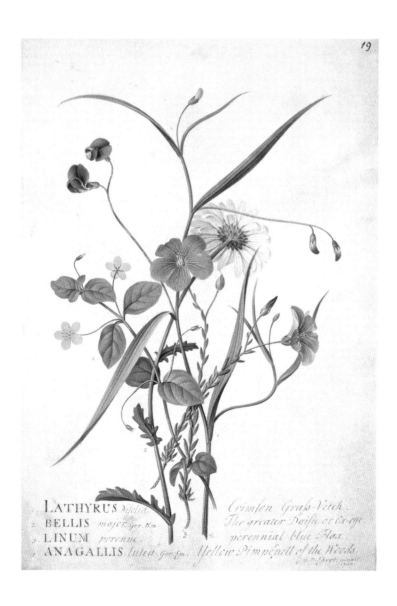

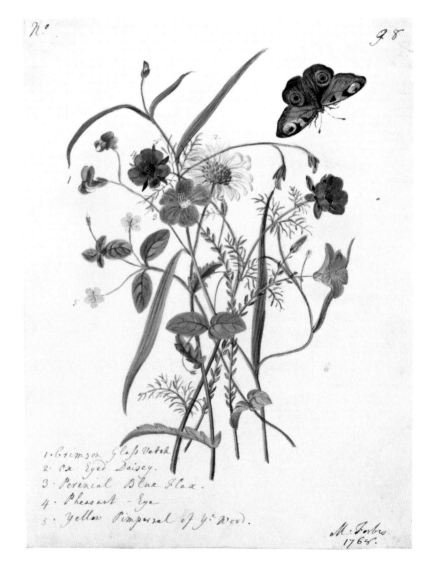

art alternated with moments of spinning or "bagatelles" with needle. The influence of the duchess, which began in the later 1730s, intensified in the late 1760s when the newly widowed Mrs. Delany came under the sway of the "philosophical cabinet" of Lightfoot and Ehret. Mrs. Delany began an English adaptation of William Hudson's *Flora Anglica* (1762) on 18 October 1769. After all, she was now surrounded by the productions of the natural world: plants, birds, butterflies, rocks, shells, and—transported inland far from their home—batches of small sea creatures. Within the manuscript are notes; for example, on page 466, verso—under "The Fir coned Hydnum," a fungus—she wrote: "this was found at Bulstrode on fir-cones, in November 1769."[65] She wrote piously to her niece:

> *Surely an application to natural beauties must enlarge the mind? Can we view the wonderful texture of every leaf and flower, the dazzling and varied plumage of birds, the glowing colours of flies, &c. &c., and their infinite variety, without saying, "Wonderful and marvellous art thou in all thy works!" And this house, with all belonging to it, is a* noble school *for such contemplations!*[66]

It was after the hot months of summer 1772, while at the "noble school" of Bulstrode, that Mrs. Delany made a momentous discovery. The Duchess of Portland had been in Weymouth, from where she wrote to Mrs. Delany on 19 July: "I have been packing twenty kinds of sea-plants, besides sea-weeds, so that I am as busy as possible."[67] The duchess returned with a wealth of natural productions. Then a "bite of a gnat" or "something more venemous" incommoded Mrs. Delany on a September visit to Francis Lord North's Wroxton.[68] Resorting to a "large slipper" instead of a shoe, she was stranded. Circuit walks were circumscribed that October. Working on a few "bagatelles" of needlework, she let slip casually in a letter to her niece: "I have invented a new way of imitating flowers."[69]

This "new way" clearly drew upon all Mrs. Delany's past accomplishments: gardening at Delville, which applied the landscape skills she had learned from various drawing masters; limning, japanning, and flower painting; and, above all, cutting paper in a tradition that stretched back to the late sixteenth century.[70] Yet the professional example of Ehret provided an impulse in two ways that can be documented. First, Ehret gave a template for painting local wildflowers as well as exotics, as is most evident in the work of Mary Capel Forbes.[71] Thus in 1768, following exact copies of Ehret's "Hypericum

Androsemum Tutsan" and "Thea Thee Tree", Mary Forbes copied Ehret's composite study (signed and dated 1767). It shows four natives, to which she added what she labeled "Pheasant Eye" and what is clearly a peacock butterfly (see figs. 154 and 155). By comparison, her own inventions were sometimes more quaint than accomplished (fig. 156). Second, Ehret's occasional use of a dark ground (going back to "Magnolia grandiflora", ca. 1737) has a Bulstrode connection.[72]

Figure 156: Mary (née Capel) Forbes, "a Cabbage-Leaf filled with Field Flowers", 1764, watercolor and graphite on vellum. Fitzwilliam Museum, Cambridge (PD.106-1973.14)

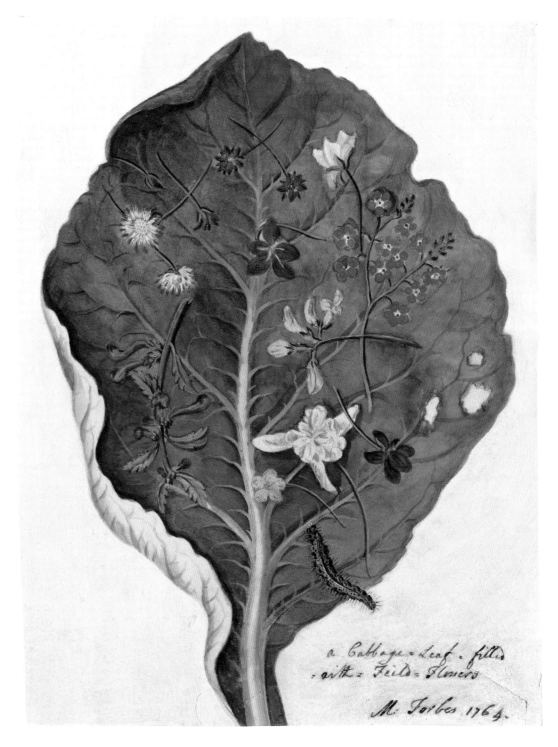

In the Portland Museum sale of 1786, number 135 in lot 2770 appears to refer to his "Astrantia foliis quinquelobis" and "Reseda Aegyptiaca" of 1755, which is on a dark brown background (fig. 157).[73] As Ehret had written to Dr. Trew for several "Dietzsch" paintings, it is likely he drew inspiration from the style of the Dietzsch family in Nuremberg, who used a signature black ground.[74] This is a key link, for it is possible Mrs. Delany knew the "Astrantia and Reseda" firsthand, as well as Ehret's "Echinopus [sic] major" of 1757 (fig. 158), which is also on a dark ground.[75]

Mrs. Delany's Collages, Female Virtuosity, and Male Societies of Natural History

Mary Delany seems to have produced approximately twenty collages in 1774, when a round of excursions stand in counterpoint to the days spent at Bulstrode.[76] While the duchess was at Weymouth, for example, Mrs. Delany was between London and Bill Hill, Lady Gower's home near Reading. In September 1774, she and the duchess were at Luton Park, the seat of Lord and Lady Bute. The itinerant season of 1774 thus set a

pattern for 1775–82, when outer-metropolitan circuits produced corresponding collages. Yet Bulstrode remained central to collage production throughout. With John Lightfoot in residence, it was "still *among ten thousand eminently bright.*"[77] Here was the sunshine of patronage: "a source of comfort and encouragement to a very wide circle of naturalists at a period when organized, cooperative endeavour hardly existed."[78]

Some initial portraits reflected the duchess's project—the "English herbal," including Weymouth seaside plants—but the majority were not English plants.[79] Among those natives dated 1774 are oxeye daisy, Welsh poppy, and sea campion. Her 'Chrysanthemum Lucanthemum' (oxeye daisy) is still common on basic soils, and blooms in Bulstrode's pastures throughout summer. Her 'Sea Campion', by contrast, is more likely to have been brought from Weymouth. And her 'Papaver Cambricum', or Welsh poppy (fig. 159), could have come from Lightfoot's expeditions to Wales or Cornwall, but it also might have been in the Bulstrode garden.[80]

Figure 157: Georg Dionysius Ehret, "ASTRANTIA foliis quinquelobis…" with "RESEDA Aegyptiaca", 1755, watercolor and bodycolor on vellum, 10⅛ × 7 in. (25.7 × 17.8 cm). Fitzwilliam Museum, Cambridge (PD.431-1973)

Figure 158: Georg Dionysius Ehret, "ECHINOPUS [sic] major", 1757, bodycolor, point of brush, pen, and gold on vellum, 9¾ × 6¹³⁄₁₆ in. (22.4 × 17.4 cm). The Pierpont Morgan Library, New York. Purchase (1978.8:21)

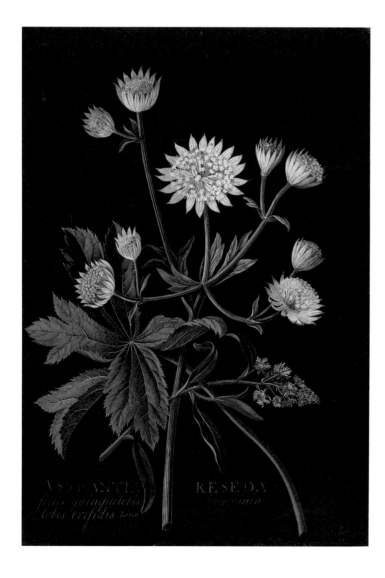

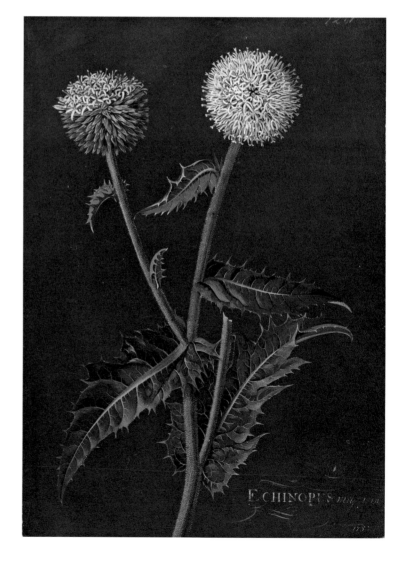

Apothecaries had long been studying the native flora. For example, William Curtis launched his *Flora Londinensis* as "demonstrator of plants" at Chelsea Physic Garden.[81] *Flora Londinensis* was intended to illustrate, through life-size portraits, the plants growing within ten miles of London, for example in the flower-rich meadows of Battersea. The first part appeared in May 1775. These early hand-colored engravings were by William Kilburn, who was followed by James Sowerby and Sydenham Edwards. Kilburn's drawing of the bee orchid, for example, exhibits a precision that is a hallmark of his work.[82] Mrs. Delany's collage of that same orchid ('Ophris apifera', dated June 1779) is inferior by comparison (see figs. 194, 195 in John Edmondson's essay in this volume). This is the distinction between professional botanical art and the work of an *amateur*, which Kim Sloan discusses in her essay.

The "curiosity of Florists" was threatening the survival of species such as the orchid, according to Curtis's entry on the bee orchid.[83] Possession had become a compulsion. This was of concern to Curtis as an apothecary, for whom botanical excursions—the so-called Simpling Day or "General Herbarizing"—had been key to learning.[84] Such learning built on printed as well as oral and visual knowledge, going back to the first published local flora: the catalogue of Thomas Johnson, *Enumeratio Plantarum in Ericeto Hampstediano* (1632). The pure value of natural history was replacing the applied value of plants to medicine. In this respect, *Flora Anglica* by London apothecary William Hudson followed the great botanist John Ray, as well as later scientists bringing Linnaeus's methods to an English audience. Benjamin Stillingfleet's *Miscellaneous Tracts* (1759) was a key introduction to Linnaean knowledge.[85] Not least, publications in English brought taxonomy to women. The Duchess of Portland's "English herbal" was thus part of a much wider movement. She was caught up in the desire to know, not simply by a compulsion to possess.

The duchess subscribed to Curtis's *Flora Londinensis*, and the apothecary in turn thanked her in his catalogue of 1783 for donating plants to his London Botanic Garden at Lambeth. Lord Bute was part of this venture, being a subscriber to the Botanic Garden and to *Flora Londinensis*, whose publication he helped finance when Curtis was in difficulties. Hence Curtis dedicated the first volume to Bute.[86] John Lightfoot exchanged letters with Curtis, promising plants and seeds that the duchess had in her collections.[87] Lightfoot thus acted as an intermediary of knowledge, doubtless bringing the works of Hudson and Stillingfleet to the Bulstrode circle. And

Benjamin Stillingfleet was indirectly responsible for the name of that group of women—the Bluestockings—to which Mrs. Delany and the duchess were loosely affiliated. Horace Walpole referred to their parties as "petticoteries."[88] Yet their support to natural history paralleled that from Princess Augusta and Queen Charlotte.[89] Mrs. Delany was an infrequent visitor. As she put it: "I went by invitation to Mrs. M., the *witty* and *the lean*, and found a formal formidable circle! I had a *whisper* with Mrs. Boscawen, another with Lady Bute, and *a wink* from the Duchess of Portland— *poor diet* for one who loves a plentiful meal of social friendship."[90]

Beyond Ehret and Lightfoot and the "philosophical cabinet" of Bulstrode, the influences were colonial as much as parochial. In 1776, for example, Kew assumed a dominant role as supplier of specimens. Mary Delany had represented exotics from the outset: 'Radbeckia [sic] laciniata… and 2 varieties of China Aster'; 'Scarlet Geranium & Lobelia Cardinalis' of 1773; and the 'Geranium macrorhizon' of 1773. Of those twenty

or so dated 1774, more than half were introduced to cultivation from outside Britain. In this respect, Mary Delany perhaps took inspiration from plant representations intended for Joseph Banks's *florilegium* of the South Seas; for she had written on 17 December 1771 to her brother, Bernard Granville of Calwich, Staffordshire: "We were yesterday together at Mr. Banks's to see some of the fruits of his travels, and were delighted with paintings of the Otaheitie plants, quite different from anything the Duchess *ever* saw, so they must be very new to me!"[91]

Figure 159: Mary Delany, 'Papaver Cambricum', 1774, collage of colored papers, with bodycolor and watercolor, 7⅞ × 6¼ in. (20.1 × 15.9 cm). British Museum, Department of Prints and Drawings (1897,0505.646)

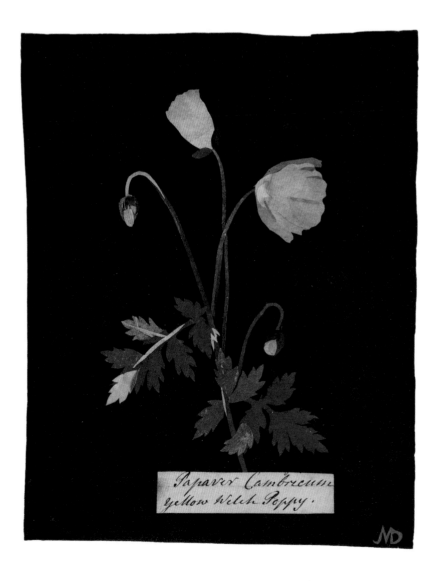

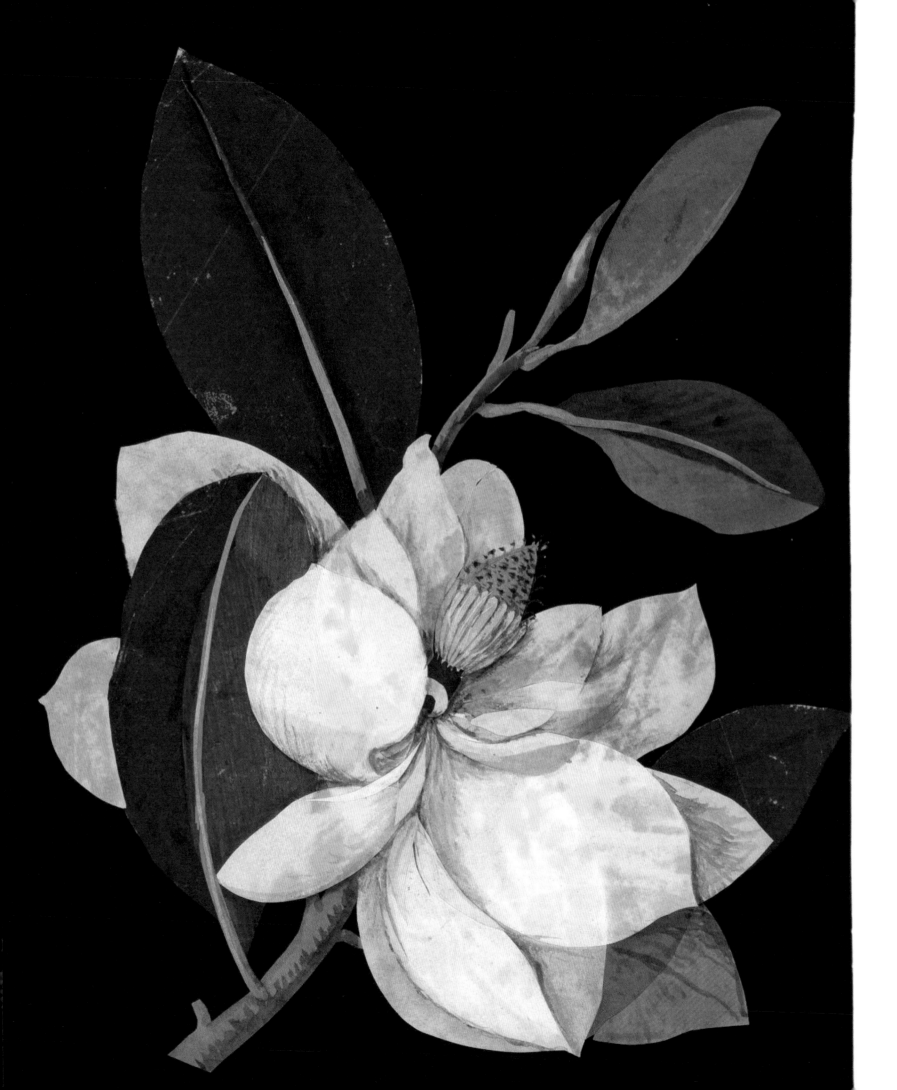

In the summer of 1776, moving beyond Bulstrode, Mrs. Delany came into contact with Joseph Banks's Kew. As John Harris has argued, the conversion at Kew from a "Desart" into an "Eden" in the space of a mere six years (1757–63) must be attributed primarily to Lord Bute, under patronage of the Dowager Princess Augusta and with respective inputs from Robert Greening, John Haverfield, and William Aiton.[92] Doubtless John Hill contributed to its development as well, though his role has never been fully clarified. The novelty of creating a self-contained enclosure for exotic plants and birds—three loosely linked spaces outside the main pleasure ground—was highly innovative, and shares something in common with the duchess's menagerie and botanic garden at Bulstrode. Clearly Mrs. Delany's exposure to the royal collections reinforced her prior interest in the Duchess of Portland's exotics.

In August 1776, moreover, while the duchess was at Weymouth, Mary Delany was at Lord and Lady Bute's Luton. The garden furnished two South African exotics for the collages 'Hemanthus coccineus' and 'crinum africanum'. Her collage of the North American 'Fumaria fungosa' (fig. 138) is noteworthy, for here she used a plant with a provenance other than the place of composition. It seems reasonable to assume that she brought it with her to Bill Hill in a tin box (vasculum) from Luton, and turned it into the portrait inscribed "23rd August 1776 / Bill Hill." The splendid 'Magnolia grandiflora' (fig. 160) followed. The American colonies were soon lost, but American plants retained cachet. The perennial verdure of *Magnolia grandiflora* remained supremely coveted.

Earlier that August, the king and queen had come to Bulstrode from Windsor with the duchess's daughter, Lady Weymouth, who was Lady of the Bedchamber to the queen.[93] Mrs. Delany recorded: "Lady Weymouth was sent by the Queen to desire I would bring the *hortus-siccus*."[94] Joseph Banks, in charge at Kew from 1773, might have been Mrs. Delany's contact on the 24/25 June 1776, which is the date on 'Eryngium alpinum'. But now, presumably encouraged by the queen's interest in the *hortus siccus*, Banks was expected to supply Mrs. Delany liberally from the royal collections. By October 1777, Mrs. Delany acknowledged as much in writing to her niece: "I

Figure 160: Detail of Mary Delany, 'Magnolia grandiflora', 1776, collage of colored papers, with bodycolor and watercolor, 13¼ × 9¼ in. (33.8 × 23.4 cm). British Museum, Department of Prints and Drawings (1897,0505.557)

am so *plentifully* supplied with the hothouse here [Bulstrode], and from the Queen's garden at Kew, that natural plants have been a good deal laid aside this year, for foreigners, but not less in favr."[95] Yet, while the balance of natives to exotics was shifting by 1776, she never forgot the ideal of a theatrical compendium. She was experimenting with form and extending her knowledge of plant structures and of how plants were cultivated and classified. That exploration continued in 1777. For example, while still in London in May, she worked on 'Arctotis calendulacea', a depiction of the specimen that had come from Dr. Pitcairn in Islington. William Pitcairn, a physician, set up his botanic garden in Islington in 1775. That spring, with the physician-cum-gardener Dr. John Fothergill, he had commissioned Thomas Blaikie to journey to the Swiss Alps in search of plants.[96] Albrecht von Haller's *Historia stirpium indigenarum Helvetiae inchoata* (1768) was one stimulus for the expedition. Joseph Banks gave Blaikie his terms of employment. By November 1775, well over four hundred packets of seeds and plants had been dispatched to London. Of these, more than forty were later credited in Aiton's *Hortus Kewensis* as Pitcairn/Fothergill or Blaikie introductions. Mary Delany made a collage labeled 'Lepidium Alpinum' (dated 14 October 1777) using a Kew specimen, one of the Pitcairn/Fothergill introductions of 1775.[97]

The interest in cultivating alpine plants thus developed in tandem with the duchess's engagement with natives and is coincident with William Curtis's construction of rockwork at Chelsea Physic Garden in 1773. It was one among multifarious new directions in cultivating specialized floras, but still within a universalizing "theater." Pitcairn was growing exotics from North America, Africa, and Asia. The date 8 May 1777, for example, is inscribed on Mrs. Delany's collage 'Mitella diphylla', a North American plant that came from Pitcairn's Islington garden. His Chinese plant was the model for her collage 'Olea odoratissima', which is dated 26 May 1777. Along with such exotics, alpines soon spread through the nursery trade and private collections. The collage dated 26 May 1777, for example, suggests that Mr. Booth Grey provided her with the plant that modeled for her 'Rododendron Ferrugineum'.

Writing to her niece in October 1777, "Aunt Delany" explained her industry, which *virtuosi* had always understood as a social duty to avoid ennui or melancholy:[98]

Now I know you smile, and say what can take up so much of A. D.'s time? No children to teach or play with; no house matters to torment her; no

books to publish; no politicks to work her brains? All this is true, but idleness never grew in my soil, tho' I can't boast of any very useful employments, only such as keep me from being a burthen to my friends, and banish the spleen; and therefore, are as important for the present use as matters of a higher nature.[99]

As evidence of industry (and perhaps of Kew's increasing stimulus), October 1777 was her most productive month—she seems to have composed portraits almost daily.[100] On 1 October and into that first week, the days were mild (as records, among them Gilbert White's journals, indicate). Her 'Aster cordifolia', for example, is dated 2 October, which is about when this North American perennial would bloom outdoors at Bulstrode. Other collages of late-flowering, hardy perennials from the Bulstrode borders were 'Aster Dumosus', 'Carthamus cæruleus', 'Centaurea moschata', 'Potentilla recta', and 'Sigesbeckia occidentalis'. The date inscribed on her 'Gordonia Lasianthus', 6 October 1777, suggests that this North American tree bloomed on that day; but this was under glass. Most of the remaining collage plants were "hothouse" species. For example, the eggplant ('Solanum Melongena') appears to have fruited as late as 8 October, although its blossoms were probably depicted earlier. Plants arriving from Kew included Blaikie's alpine (her 'Lepidium Alpinum') and the southeastern Asian plant (her 'Phlomis Zeilanica', dated 31 October). Her 'Passiflora rubra'—a tropical—is dated 17 October, her 'Rubus Cæsius' (the native dewberry) is dated the 21st, and her 'Phlomis Leonurus' (from the Cape of Good Hope) was composed on some unrecorded day that month. Here the four continents of the old *theatrum botanicum* were compressed into a single month of blooming.

The effect, however, is somewhat deceptive and not unlike the artifice of still life. The 'Lepidium' and 'Rubus Cæsius' does not usually bloom in October. Hence her 'Lepidium' remains a mystery, and it must be assumed that it was initiated at some other time. Her 'Rubus Cæsius' must have been composed initially in the summer when the flowers were out; the fruiting branch was clearly added later, after the fruit appeared that autumn. Here is circumstantial evidence, then, that the inscribed date is more likely the date of completion (*post quem*) than the date of composition. Even allowing for the fact that at least one collage must have been substantially composed before October 1777, the productivity of the month was exceptional. That Mrs. Delany also worked industriously despite visitors is suggested by the inscription on 'Physalis cretica',

which is dated 13 October 1777. It portrays what was among a first consignment of Kew plants that month. Lady Gower, whose name is inscribed on the verso (although she clearly is not the donor) paid a visit on the 13 October, as Mrs. Delany recorded in that letter to her niece of 20 October 1777 describing the importance of Kew.[101] In short, we have a picture of intense application over a single day as well as during the entire month: "I do my best to fill up the time (still spared me) in the best manner I can," she wrote to Mary Port, her niece, in that same letter of 20 October 1777.

On occasion, Mary Delany's making of a collage correlates with her own visits to places. This was the case with 'Crinum asiaticum', dated 12 May 1780, which added a plant of the Far East to her theatrical compendium. Mrs. Delany

explained how she came upon it at the nursery of James Lee, which now rivaled Kew for exotics. She wrote to her niece of a visit there on 11 May with her grandniece, Georgina:

I am but just returned from a pleasant tour this morning with y.' dear child.... We went to Lee's at Hammersmith, in search of flowers, but only met with a crinum, a sort of Pancratium; from thence returned to Kensington, bought cheesecakes, buns, &c. a whole 18 pennyworth; from thence to a lane that leads to Brompton, bought nosegays; and are now came home hungry as hawks....[102]

On that occasion, domestic matters held up the composition until the day after the nursery visit, but otherwise nothing stopped the flow of work, which is best appreciated as a "theatrical compendium" (see plates 1-24 of "Theater"). A composite of the seasons 1778/9 represents the range, diversity, and provenances of the "theater": 'Amygdalus Persica', a double-flowering peach from Barnes, where her waiting-woman Mrs. Astley lived (dated 25 April 1778; fig. 161); 'Amygdalus Nana', a dwarf almond from Lord Willoughby's "Marsh garden" (1 May 1778); Mrs. Boscawen's 'Cheiranthus cheiri'—a bloody wallflower—from Glanvilla (2 May 1778); 'Melia Azedarch', a bead tree from Lord Dartmouth at Blackheath (5 May 1778); two different carnations from Mrs. Dashwood (3 June 1778), another from the queen (17 August 1778), and a Jersey pink from General Conway of Park Place ('Dianthus caryophyllus a variety Jersey Pink', 8 September 1779); 'Cassia Marylandica' from Lord Mansfield of Kenwood (23 September 1778); and 'Mimosa arborea', which was associated with Richard Bateman at Old Windsor (28 September 1779).[103] Each had an association (the latter conceivably a memento mori, as Lisa Ford explains in her essay in this volume). As a compendium, then, the album was more than a botanical theater. It was a theater of the living and lost—all the people she wished to hold close or remember in some way.

On 17 September 1781 Frances Boscawen wrote to Mary Delany: "I congratulate you on completing your 9th admirable vol.: their *duration* will be equal to that of the *oak*, with which you close them so *properly*, and so like *a good* English woman. *If* English women (in return) *were but like you!*"[104] Mrs. Delany had not forgotten her English plants. Most of the British orchids, for example, had their portraits done between 1776 and 1780, the most intensive period of collage production (almost three-quarters dating from those five years). This engagement with native species continued up to the last: for

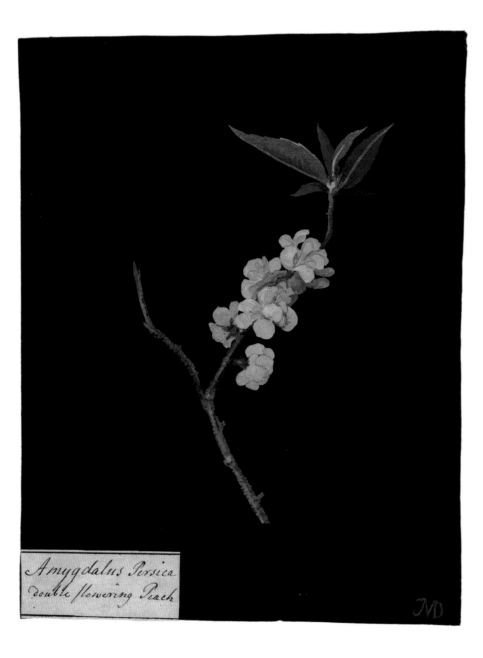

Figure 161: Mary Delany, 'Amygdalus Persica', 1778, collage of colored papers, with bodycolor and watercolor, 9¾ × 7½ in. (24.7 × 19 cm). British Museum, Department of Prints and Drawings (1897,0505.40)

example, 'Lathyrus pratensis' (7 September 1782), 'Trifolium pratense' (26 September 1782), and 'Tormentilla reptans' (9 October 1782), the last fully dated collage. By contrast, among the final works was 'Portlandia grandiflora' (9 August 1782) from Kew, which was named after her dear friend the Duchess of Portland (see plate 24 in "Theater"). Here was the associative plant portrait *par excellence*.

One American genus illustrates what Mrs. Delany's collages mean to garden history today. Her 1774 'Phlox Carolina' demonstrates that the species introduced to cultivation through Mark Catesby (and first illustrated in Martyn's *Historia plantarum rariorum*, 1733) was still cultivated in the 1770s. (It apparently died out thereafter, before reintroduction by John Fraser in 1810, as William Curtis claimed in *Botanical Magazine*.)

By 24 April 1779, she had worked on her 'Flox [sic] divaricata', which, coming from Chelsea Physic Garden, proves it was grown under William Curtis/William Forsyth, even though no specimen came to the Royal Society from Philip Miller. By 11 August 1781 she had completed 'Phlox undulata' at Bulstrode. This species, as described by Aiton in *Hortus Kewensis*, is now considered to be merely a variant of *Phlox paniculata*.[105] Perhaps the most significant collage, however, is 'Phlox suaveolens' (dated 10 June 1776; fig. 162). Along with the Booth Grey collage (fig. 163), it appears to be a rare representation of the white phlox that Peter Collinson cultivated about 1766. Like *P. divaricata*, this white-flowered phlox—now considered to be a variant of *P. maculata*—probably came from John Bartram in Philadelphia.[106] That three of these

Figure 162: Mary Delany, 'Phlox suaveolens', 1776, collage of colored papers, with bodycolor, watercolor, and leaf sample, 10½ × 6¼ in. (26.6 × 15.8 cm). British Museum, Prints and Drawings (1897,0505.667)

Figure 163: Attributed to Booth Grey, 'Phlox suaveolens', ca. 1790, collage of cut paper with watercolor on laid paper prepared with watercolor, 10¼ × 6½ in. (26 × 16.5 cm). British Museum, Department of Prints and Drawings (2008,7111.1)

four were growing in the Duchess of Portland's garden at Bulstrode is testament to her collecting zeal, which made her the equal of Lord Bute at Luton and Banks at Kew.[107] Mrs. Delany wrote from Bulstrode on 9 June 1776: "I have made an appointment for to-morrow with a very fair lady called 'Lychnidea.' If I neglect her, she will shut herself up, and I shall see her no more." This fair white "Lychnidea" (*Phlox suaveolens*) was "true to her appointment," and the punctilious Mary Delany duly set to work on 10 June.[108]

The role the duchess played in offering private patronage to a wide circle of naturalists in the absence of "cooperative endeavour"—that is, between the coffeehouse clubs circa 1700–1725 and the restoration of societies after 1760—is indisputable.[109] Support also came from the Bluestockings, the Dowager Princess of Wales, and Queen Charlotte. It is clear that Mrs. Delany achieved something equally significant after 1768 as she crafted a new persona in her second widowhood. Back in 1740/1, she had paid court in her mantua under candlelight. Her petticoat was with "'strewn' with flowers" as in Spenser or a *fête champêtre*.[110] Her decision to have embroidered the many cultivars that came with the pedigree of court nomenclature may suggest something about her quest for formal recognition, which she would pull off so gloriously on another occasion.

By 1782, as eyesight failed, she had found her perennial luster. Working as a widow into old age, in partnership with amateurs and professionals (from botanical artists to botanists to nurserymen), she made art and science out of the feminine realm of horticulture, while never forgetting the "buns" and "nosegays" of domesticity. Her collages thus represent not merely the sum of circles of kinship and friendship but the circuits of association, which amount to cultural geography: a local walk around Bulstrode, or Hammersmith and Kensington; an outer-metropolitan orbit from Kew to Windsor to Bill Hill, Bulstrode, and Luton; the colonial transatlantic trade; and the imperial circumnavigation of the globe. All the while, the collages remained for her a devotional pursuit, drawing on lineages of virtuosity as much as artistry with needle and knife. Her *hortus siccus* had "duration," unlike the shrubbery's adaptation of theater for the transitory realm of the pleasure garden.[111] It held to the eternity of the old Edenic *theatrum botanicum*, the setting in order (from Bulstrode's "agreeable confusion") of God's creations, whether as a lore of physic or as a record of wonder in divine complexity.

After Mrs. Delany

At the time of Mrs. Delany's death in 1788, botany and horticulture were shifting to new ground. Aiton's *Hortus Kewensis* established a datum for some 5,600 species (fig. 164), including information on introduction and provenance.[112] In addition to the 2,100 British species, there were 1,400 from Continental Europe, nearly 700 from North American, more than 700 from South Africa, yet a mere 50-odd plants from the Indian subcontinent, 50 from China, and fewer than 10 from Japan. The next twenty years would be notable for the influx from South America, China, and Australia.[113] Mrs. Delany's collages thus represent a very substantial, though not exhaustive, record of cultivation before that influx. The Booth Grey collection, by contrast, hints at what came in the 1790s. As John Edmondson reveals in his essay, there were profound taxonomic shifts occurring at the end of the century.

In 1787, despite a limp response to his *Flora Londinensis*, William Curtis embarked on a second major publication. *Botanical Magazine*, directed to the public taste for ornamental exotics, was a commercial success. Selling some three thousand copies at 1s. per issue, it brought Curtis "pudding," as he put it, whereas *Flora Londinensis* had brought only "praise."[114] The dialogue between natives and exotics that Mrs. Delany's collages represent (on the "theatrical" model of Ehret and Robins before her) would tip toward the exclusivity of new exotics from China and South America.

William Kilburn, having worked from 1775 on the natives of *Flora Londinensis*, went back into the textile industry, leading a successful campaign for a bill against plagiarism (1787). His album of designs, dating from 1788 to 1792, includes "seaweed patterns" that evoke the collecting trays the Duchess of Portland brought from Weymouth.[115] In uniting the cultures of flower and fabric (stylistically anticipating the tastes of subsequent generations), he sustained the vision behind Mrs. Delany's virtuosic productions.

In 1799, Lady Elizabeth Lee redesigned her flower garden at Hartwell after her brother's celebrated "'Elysée" at Nuneham Courtenay (the source for Mrs. Delany's May 1780 'Hyacinthus orientalis ophir'—a double yellow-flowered hyacinth).[116] Princess Augusta's 1760s aviary flower garden at Kew, which took impetus from Carlton House, appears an inspiration to both Nuneham and Hartwell, and a forerunner of Queen Charlotte's projects. Hence it is possible to trace influences throughout Mrs. Delany's long life, from William Kent's work for the Prince of Wales at Carlton House in the mid-1730s to Lord

Harcourt's Nuneham of the 1770s and Horace Walpole's ambition for a flower garden at Strawberry Hill—his 'Flora Nunehamica' of 1777.[117]

The horticultural acumen that Jane Loudon, Gertrude Jekyll, and Vita Sackville-West would later demonstrate was thus foreshadowed by Mrs. Delany (the *virtuosa*) and Lady Elizabeth Lee (the plants woman). Yet landscape gardeners, sometimes working for women clients, maintained firm control until new cross-gender partnerships of parity occurred about 1900 (notably Gertrude Jekyll and Edwin Lutyens). In 1816, for example, Humphry Repton, appropriating the domain of flowers that women had always understood, patronizingly explained a plan of a flower garden to a lady in a published letter.[118] In his 1806 proposal for the Prince of Wales at Brighton (fawningly sent to the prince's mistress, Mrs. Maria Fitzherbert, for approval),[119] Repton invoked Lord Bacon's idea of a garden for every month: "a perpetual garden, enriched with the production of every climate."[120] However visionary these designs were, he had to admit to knowing little of horticulture, and had to seek help from his old friend and distinguished botanist, James Edward Smith, in the rudiments of botany.[121]

Through glasshouse technology, hybridization, and the influx of subtropical plants, it proved possible by the 1840s to realize Repton's dreams of enameled tapestry in "perpetual spring" (notably through "bedding out"). The masses of bedding plants, raised under glass, had a "glare" similar to the new dresses in aniline dyes such as mauve (1856) and magenta (1859).[122] The structure of those crinolines mirrored Victorian glasshouse frames. Yet, when Lady Llanover's *The Autobiography and Correspondence of Mary Granville, Mrs. Delany* came out in 1861–62, the arts of couture and horticulture had no exponent to match Mrs. Delany. In these twin capacities of cutting and embroidering, she remained (and remains) the unrivaled doyenne—in Edmund Burke's words, "the highest bred woman in the world, and the woman of fashion of all ages."[123]

Figure 164: James Sowerby, "Strelitzia Reginae", 1787, watercolor over graphite, study for the engraving in William Aiton, *Hortus Kewensis*, vol. 1 (1789). Natural History Museum, London, Botany Library (Bauer Unit E, shelf 4)

Tab. 2.

Strelitzia Regina vol. 1. pag. 285.

J.ᵉ Sowerby delt. 1787.

Acknowledgments

In writing this essay I have benefited from the support of the collaborative team at Yale, and the generosity of all my colleagues in Britain and North America who contributed to the volume. In particular, I would like to thank Clarissa Campbell Orr, who gave unstinted help to the project; Kim Sloan and colleagues at Prints and Drawings, British Museum, who agreed to put the collages on a digital database; and John Edmondson and Charles Nelson for exemplary scientific, historical, and editorial help. John and Eileen Harris were kind enough to review the draft of this essay. Maria Zytaruk gave me useful commentary. Ruth Hayden, providing the impulse for the show, deserves special praise for starting the cataloguing of the collages and for welcoming the new research to complement her study of Mrs. Delany. This essay is dedicated to the memory of my friend of Yale and Oxford Matt Schaffer (1948–2006).

Notes

1. See Mark Laird, "The Culture of Horticulture: Class, Consumption, and Gender in the English Landscape Garden," in Michel Conan, ed., *Bourgeois and Aristocratic Cultural Encounters in Garden Art, 1550–1850* (Washington, D.C.: Dumbarton Oaks, 2002), 236–39. Significant gardening was often accomplished when women outlived husbands (e.g., the first and fourth Duchess of Beaufort, Princess Augusta, and the second Duchess of Portland). This increases the differential. Mrs. Delany's collages are thus important as products of widowhood.

2. See Clarissa Campbell Orr's essay in this volume, which covers "professional" opportunities for women.

3. These first two questions are intimately related to what John Cornforth discussed in an architectural context in *Early Georgian Interiors* (New Haven and London: Yale Univ. Press, 2004).

4. For the background to this question, see Kim Sloan, *'A Noble Art': Amateur Artists and Drawing Masters, c. 1600–1800* (London: British Museum Press, 2000).

5. This question is prompted by the contention in David Elliston Allen, *The Naturalist in Britain: A Social History* (1976; repr., Princeton, N.J.: Princeton Univ. Press, 1994), 12, that the "years between 1725 and 1760 are largely a blank for British natural history," as languishing formal societies were replaced by mere circles of correspondents.

6. Now Beaumont College, Old Windsor, Berkshire.

7. Mary Delany to Anne Dewes, 14 December 1743, in Lady Llanover, ed., *The Autobiography and Correspondence of Mary Granville, Mrs. Delany*, 6 vols. (London: Richard Bentley, 1861–62), ser. 1, 2:239. This argument is put forward by Eileen Harris, in Thomas Wright, *Arbours & Grottos: A Facsimile of the Two Parts of Universal Architecture (1755 and 1758)*, with a catalogue of Wright's works by Eileen Harris (London: Scolar Press, 1979).

8. Jan Woudstra, "What Is Edging Box? Towards Greater Authenticity in Garden Conservation Projects," *Garden History* 35, no. 2 (2007): 229–42.

9. See Kim Sloan's essay in this volume, and especially the account of the Vale of Evesham on pp. 112, 122.

10. Thacker's view, post-1684, can be compared to those in *Britannia Illustrata, or, Views of Several of the Queen's Palaces, as Also of the Principal Seats of the Nobility and Gentry of Great Britain*, engraved by Johannes Kip from drawings by Leonard Knyff (London: Sold by David Mortier, 1707), which suggests parterre alterations.

11. *The Spectator*, no. 414 (25 June 1712), quoted in John Dixon Hunt and Peter Willis, eds., *The Genius of the Place: The English Landscape Garden, 1620–1820* (Cambridge, Mass.: MIT Press, 1988), 142. The "Musick of the Birds," "*The Purling Stream*," and a striving for a "Similitude" in art and nature are themes that Mrs. Delany takes from Addison.

12. Mark Girouard, *Life in the English Country House: A Social and Architectural History* (New Haven and London: Yale Univ. Press, 1978), 210–11.

13. Guillaume de Salluste Du Bartas, *His Divine Weekes and Workes*, trans. Joshuah Sylvester (London: Humfrey Lownes, 1605), as quoted in John Prest, *The Garden of Eden: The Botanic Garden and the Re-Creation of Paradise* (New Haven and London: Yale Univ. Press, 1981), 66.

14. A.-J. Dezallier d'Argenville, *La théorie et la pratique du jardinage*, new ed. (Paris: J. Mariette, 1722), 258: "le mêlange émaillé de toutes sortes de couleurs." See Janice Neri's essay in this volume for a discussion of enamel in another context.

15. Mary Delany to Anne Dewes, 20 August 1748, in Llanover, ed., *Autobiography and Correspondence*, ser. 1, 2:500. The idea of each flower as distinct, on the model of a florist's border or the auricula theater (as opposed to the decorative border), corresponds to her embroidery patterns, and perhaps anticipates the singular collages. This is discussed below.

16. Mary Delany to Anne Dewes, 19 July 1744, in Llanover, ed., *Autobiography and Correspondence*, ser. 1, 2:315–16.

17. Mary Delany to Anne Dewes, 29 March 1746, in Llanover, ed., *Autobiography and Correspondence*, 2:432.

18. Thomas Hull, ed., *Select Letters between the Late Duchess of Somerset, Lady Luxborough… and Others…*, 2 vols. (London: J. Dodsley, 1778), 1:68.

19. Lady Luxborough (Henrietta Saint-John Knight), *Letters Written by the Late Right Honourable Lady Luxborough to William Shenstone Esq.* (London: J. Dodsley, 1775), 98, 200.

20. Mary Delany to Anne Dewes, 11 June 1745, in Llanover, ed., *Autobiography and Correspondence*, ser. 1, 2:361. Edmund Spenser, *The Garden of Adonis* (1590): "And in the thickest couert of that shade,/ There was a pleasant arbour, not by art,/ But of the trees owne inclination made,/ Which knitting their rancke braunches part to part,/ With wanton yuie twyne entrayld athwart,/ And Eglantine, and Caprifole emong." See fig. 123 in Kim Sloan's essay in this volume.

21. Mary Pendarves to Anne Dewes, February [1741], in Llanover, ed., *Autobiography and Correspondence*, ser. 1, 2:146–47. Mary Tufton is the later Dowager Countess Gower.

22. John Cornforth (*Early Georgian Interiors*, 4) argued that dress might have influenced upholstery interiors, but since both involve textiles the interrelationships are quite different from those in the garden. See Kim Sloan's essay in this volume, and in particular her fig. 2, which shows stumps overgrown with vegetation as the foreground of the view of Hanbury Pools. These are clearly contrivances, taken from

seventeenth-century precedents and adapted as "picturesque" aids. They could then have migrated into textile designs.

23. Mary Delany to Anne Dewes, 30 October 1746, in Llanover, ed., *Autobiography and Correspondence*, ser. 1, 2:443. Lord Cornbury was Kitty Queensbury's brother. She inherited Cornbury on his death, in 1753, and thus has no direct role in making the quarry garden of the 1740s.

24. See David Jacques, "On the Supposed Chineseness of the English Landscape Garden," *Garden History* 18, no. 2 (Autumn 1990): 180–91.

25. David M. Mitchell, "The Influence of Tartary and the Indies on Social Attitudes and Material Culture in England and France, 1650–1730," in Anna Jolly, ed., *A Taste for the Exotic: Foreign Influences on Early Eighteenth-Century Silk Designs* (Riggisberg, Switzerland: Abegg-Stiftung, 2007), 41–42.

26. See Janice Neri's essay in this volume and her essay "Cultivating Interiors: Philadelphia, China, and the Natural World," in Amy R. W. Meyers, ed., *The Culture of Nature: Art & Science in Philadelphia, 1740–1840* (New Haven and London: Yale Univ. Press, forthcoming).

27. A study of her views of Calwich, Wroxton, Cornbury, and Delville might yield further insights.

28. Mary Delany to Anne Dewes, 11 June 1745, in Llanover, ed., *Autobiography and Correspondence*, ser. 1, 2:360. See Cornforth, *Early Georgian Interiors*, 253–72.

29. Michael Charlesworth, ed., *The English Garden: Literary Sources and Documents*, 3 vols. (East Sussex, U.K.: Helm Information, 1993), 2:183.

30. John Harris, "Some Imperfect Ideas on the Genesis of the Loudonesque Flower Garden," in Elisabeth B. MacDougall, ed., *John Claudius Loudon and the Early Nineteenth Century in Great Britain* (Washington, D.C.: Dumbarton Oaks, 1980), 55–57; John Harris, "A Pioneer in Gardening: Dickie Bateman Re-assessed," *Apollo*, n.s., 138 (October 1993): 227–33. In October 1768, Mrs. Delany visited Bateman at his Old Windsor estate, where she found the house converted from "the Indian to the Gothic." See Mary Delany to Anne Dewes, 10 October 1768, in Llanover, ed., *Autobiography and Correspondence*, ser. 2, 1:176. Bateman is discussed further in Lisa Ford's essay in this volume.

31. Dr. Delany's formative role is described in Edward Greenway Malins and The Knight of Glin, *Lost Demesnes: Irish Landscape Gardening, 1660–1845* (London: Barrie and Jenkins, 1976), 36–39.

32. For the background to Robins's topographical work, see John Harris and Martyn Rix, *Gardens of Delight: The Rococo English Landscape of Thomas Robins the Elder*, 2 vols. (London: Basilisk Press, 1978). For japanning, see Maria Zytaruk's essay in this volume.

33. Mary Delany to Anne Dewes, 26 July 1744, in Llanover, ed., *Autobiography and Correspondence*, ser. 1, 2:320.

34. Frances Boscawen wrote to Mary Delany on 19 October 1772: "never go without clogs (tho' they should pinch you)… ," in Llanover, ed., *Autobiography and Correspondence*, ser. 2, 1:473.

35. Mary Delany to Anne Dewes, 22 June 1750, in Llanover, ed., *Autobiography and Correspondence*, ser. 1, 2:558.

36. Mary Delany to Anne Dewes, 30 June 1750, in Llanover, ed., *Autobiography and Correspondence*, ser. 1, 2:563.

37. Todd Longstaffe-Gowan, *The London Town Garden, 1700–1840* (New Haven and London: Published for the Paul Mellon Centre for Studies in British Art by Yale Univ. Press, 2001), 173. For Mrs. Delany's shellwork candlesticks as "opulent table display," see Janice Neri's essay in this volume.

38. Quoted from Mary Rose Blacker, *Flora Domestica: A History of Flower Arranging, 1500–1930* (London: National Trust, 2000), 101.

39. See Girouard, *Life in the English Country House*, 195–98, and Clarissa Campbell Orr's essay in this volume.

40. Quoted in Blacker, *Flora Domestica*, 101.

41. Mary Delany to Anne Dewes, 21 May 1752, in Llanover, ed., *Autobiography and Correspondence*, ser. 1, 3:125.

42. Mary Delany to Anne Dewes, 8 November 1760, in Llanover, ed., *Autobiography and Correspondence*, ser. 1, 3:611.

43. See Mark Laird, *The Flowering of the Landscape Garden: English Pleasure Grounds, 1720–1800* (Philadelphia: Univ. of Pennsylvania Press, 1999).

44. The duchess's park at Bulstrode was adjusted to the new Brownian ideals, however. On 9 June 1757, Mrs. Delany wrote to her sister Anne of the following changes:

> *Great works are going on; the horse-shoe gravel walk with great slopes and a place in the bottom for water (which fronted the house), that could never be made to answer its purpose, is all thrown down, and a lawn is to be substituted in its place, that will fall with a hanging level towards the park, and open a very fine and agreeable view to the house. Besides the satisfaction the owners will have in making so advantageous an alteration, they have the much higher delight of maintaining such numbers of industrious people; fifty men are now at work with carts and horses before the windows, which affords a constant amusement; the work cannot be completed till next Michaelmas twelvemonth.*

Llanover, ed., *Autobiography and Correspondence*, ser. 1, 3:459–60. I am grateful to Janice Neri for this reference. See her discussion of Peter Collinson at Bulstrode in the 1760s in this volume.

45. Sloan, *A Noble Art*, ("Learning to Limn"), esp. 45–46.

46. For a discussion of the attribution, see Kim Sloan's essay in this volume.

47. Sloan, *A Noble Art*, 48.

48. Many of these are all illustrated in chapter 3 of Blacker, *Flora Domestica*, 68–113, esp. pls. on pp. 85, 88–93, 99, 103, 108 and 110. See also Jan Woudstra, "The Use of Flowering Plants in Late Seventeenth- and Early Eighteenth-Century Interiors," *Garden History* 28, no. 2 (Winter 2000): 194–208.

49. Mary Delany to Bernard Granville, 11 June 1751, in Llanover, ed., *Autobiography and Correspondence*, ser. 1, 3:39.

50. Mark Laird, "Parterre, Grove, and Flower Garden: European Horticulture and Planting Design in John Evelyn's Time," in Therese O'Malley and Joachim Wolschke-Bulmahn, eds., *John Evelyn's "Elysium Britannicum" and European Gardening* (Washington, D.C.: Dumbarton Oaks, 1998), 214; Ada V. Segre, *The Gardens at San Lorenzo in Piacenza, 1656–1665* (Washington, D.C.: Dumbarton Oaks, 2006), 54.

51. See note 15 above.

52. Elizabeth Hyde, *Cultivated Power: Flowers, Culture, and Politics in the Reign of Louis XIV* (Philadelphia: Univ. of Pennsylvania Press, 2005), esp. 85–88; see also Mark Laird, "James Maddock's 'Blooming Stage' as a Microcosm of Eighteenth-Century Planting," *Garden History* 24, no. 1 (Summer 1996): 78 and fig. 2.

53. Natalie Rothstein, "God Bless This Choye," *Costume* 11 (1977): 56, 58.

54. Natalie Rothstein, *Silk Designs of the Eighteenth Century in the Collection of the Victoria and Albert Museum, London: with a Complete Catalogue* (Boston: Little, Brown, 1990), 48; Clare Browne, ed., *Silk Designs of the Eighteenth Century from the Victoria and Albert Museum* (London: Thames and Hudson, 1996), 8.

55. Clare Browne, "The Influence of Botanical Sources on Early 18th-Century English Silk Design," in Regula Schorta, ed., *Seidengewebe des 18. Jahrhunderts: Die Industrien in England und in Nordeuropa / 18th-Century Silks: The Industries in England and Northern Europe* (Riggisberg: Abegg-Stiftung, 2000), 27–38.

56. Browne, "Influence of Botanical Sources," 28–29: "Of the five 18th-century silk designers in Spitalfield whose work has been identified we know that four had a noted interest in natural history, or direct contact with its enthusiasts, namely Joseph Dandridge, John Vansommer, James Leman, and Anna Maria Garthwaite." See also Mark Laird, "The Congenial Climate of Coffee-House Horticulture: The *Historia plantarum rariorum* and the *Catalogus plantarum*," in Therese O'Malley and Amy R. W. Meyers, eds., *The Art of Natural History: Illustrated Treatises and Botanical Paintings, 1400–1850*, Studies in the History of Art, 69 (New Haven and London: Yale Univ. Press, 2008), 226–59, including appendix by Margaret Riley.

57. See Laird, "Culture of Horticulture," 246–47.

58. Mary Delany to Anne Dewes, 10 December 1753, in Llanover, ed., *Autobiography and Correspondence*, ser. 1, 3:254.

59. Mary Delany to Mary Dewes, 4 October 1768, in Llanover, ed., *Autobiography and Correspondence*, ser. 2, 1:173.

60. Mary Delany to Mary Dewes, 17 September 1769, in Llanover, ed., *Autobiography and Correspondence*, ser. 2, 1:240. Ehret's drawings and written account are in the Botany Library of the Natural History Museum, London.

61. John Edmondson, *James Bolton of Halifax* (Liverpool: National Museums and Galleries on Merseyside, 1995); Charles Nelson, "James Bolton's Botanical Paintings and Illustrations, and His Association with Georg Ehret," *The Naturalist* 106 (1981): 141–47. For a discussion of Bolton, see Janice Neri's essay in this volume.

62. Mary Delany to Mary Dewes, 3 September 1769, in Llanover, ed., *Autobiography and Correspondence*, ser. 2, 1:238–39.

63. For Gray's recipe as given to William Cole for his Bletchley parsonage, see Robert Wyndham Ketton-Cremer, *Thomas Gray* (Cambridge: Cambridge Univ. Press, 1955), 198. There are fuller references in the Times Literary Supplement, 30 March 1951, identifying a recipe from Cole's notebooks, British Library, Add. MS.5825, fols. 283b, 284b. I am indebted to Mavis Batey for these references.

64. For forcing and forcing vessels, see Patricia F. Ferguson, "The Eighteenth-Century Mania for Hyacinths," *The Magazine Antiques* 151 (June 1997): 845–51, and Mark Laird, "Theatres of Flowers: The Art and Science of Eighteenth-Century Floral Displays," in Gerda van Uffelen and Erik de Jong, eds., *Text of the Clusius Lectures, 1997* (Leiden: Clusiusstichting, 1997); pots of *Reseda odorata* will be displayed at the Sir John Soane Museum, when the exhibition opens in February 2010, and that might throw light on methods of cultivation.

65. Llanover, ed., *Autobiography and Correspondence*, ser. 2, 1:243; see Ruth Hayden, *Mrs. Delany and Her Flower Collages* (1980; new ed., London: British Museum Press, 1992), 188. The manuscript is now at Dumbarton Oaks. I am grateful to Therese O'Malley for drawing my attention to its location.

66. Mary Delany to Mary Dewes, 4 October 1768, in Llanover, ed., *Autobiography and Correspondence*, ser. 2, 1:173.

67. Duchess of Portland to Mary Delany, 19 July 1772, in Llanover, ed., *Autobiography and Correspondence*, ser. 2, 1:445.

68. Mary Delany to the Rev. John Dewes, 5 September 1772, in Llanover, ed., *Autobiography and Correspondence*, ser. 2, 1:454.

69. Mary Delany to Mary Dewes Port, 4 October 1772, in Llanover, ed., *Autobiography and Correspondence*, ser. 2, 1:469. Kohleen Reeder gives a more detailed account of the momentous discovery in her essay in this volume.

70. See Sloan, *A Noble Art'*, 64–67.

71. Mary Capel Forbes (1722–1782) was the daughter of the third Earl of Essex and his first wife, Jane Hyde (sister of the Duchess of Queensbury). Her flower paintings, created while under instruction from Ehret, date from 1756 on. She married Admiral Forbes in 1758. Her half-sister, Elizabeth Capel, was a less distinguished amateur flower painter. Their distant relative was Mary Capel Somerset, first Duchess of Beaufort. I am grateful to David Scrase and Clarissa Campbell Orr for help with these references.

72. See Lucia Tongiorgi Tomasi, *An Oak Spring Flora: Flower Illustration from the Fifteenth Century to the Present Time; a Selection of the Rare Books, Manuscripts, and Works of Art in the Collection of Rachel Lambert Mellon* (Upperville, Va.: Oak Spring Garden Library, 1997), 190–92, and, for Thomas Robins the Elder's flowers on dark-brown ground, 193–94.

73. Gerta Calmann, *Ehret: Flower Painter Extraordinary* (Boston: New York Graphic Society, 1977), 112.

74. See David Scrase, *Flower Drawings* (Cambridge: Cambridge Univ. Press, 1997), 44–45 (Barbara Regina Dietzsch), 46–47 (Margaret Barbara Dietzsch), and 74–75 (Friedrich Kirschner). See also David Scrase, *Flowers of Three Centuries: One Hundred Drawings & Watercolours from the Broughton Collection*, exh. cat. (Cambridge: Fitzwilliam Museum; Washington, D.C.: International Exhibitions Foundation, 1983), 18 (Johann Christoph Dietzsch).

75. Now in the Pierpont Morgan Library, it appears to have been in lot 2768 of the Portland Museum sale catalogue of 1786. See Calmann, *Ehret*, 116.

76. This figure is based on the information in Ruth Hayden's published list, but could be subject to revisions when a complete scientific analysis of the collages is undertaken by John Edmondson and Charles Nelson.

77. Mary Delany to the Viscountess Andover, 14 September 1774, in Llanover, ed., *Autobiography and Correspondence*, ser. 2, 1:542. A comparison is made with Lord and Lady Bute's Luton.

78. Allen, *Naturalist in Britain*, 25.

79. 'Pisum Marinum' is one collage with a specific "Weymouth" provenance.

80. The Welsh poppy, *Meconopsis cambrica*, grows in the southwest of England as well as in Wales, so it was possibly among "new plants" from excursions to Cornwall and Wales. Nurserymen also cultivated it, so the provenance of the specimen portrayed in this early composition of 1774 (on a shiny back ground and labeled no. 9) is ultimately uncertain.

81. Mark Laird, *William Curtis: Demonstrator of Plants at Chelsea Physic Garden, 1772–1777* (London: Chelsea Physic Garden, 1987).

82. Wilfrid Blunt and William T. Stearn, *The Art of Botanical Illustration: An Illustrated History*, rev. ed. (Woodbridge, Suffolk: Antique Collectors' Club, 1994), 218–19.

83. "The great resemblance which the flower bears to a Bee, makes it much sought after by Florists, whose curiosity indeed, often prompts them to exceed the bounds of moderation, rooting up all they find, without leaving a single specimen to chear the heart of the Student in his botanic excursions." William Curtis, *Flora Londinensis, or, Plates and Descriptions of Such Plants as Grow Wild in the Environs of London*, 2 vols. (London, 1775–98), 2, s.v. "Ophrys apifera."

84. Allen, *Naturalist in Britain*, 5–7.

85. Allen, *Naturalist in Britain*, 37.

86. I am grateful to Kath Clark for this information. See W. Hugh Curtis, *William Curtis, 1746–1799* (Winchester: Warren and Son, 1941). See Blanche Henrey, *British Botanical and Horticultural Literature before 1800: Comprising a History and Bibliography of Botanical and Horticultural Books Printed in England, Scotland, and Ireland from the Earliest Times until 1800*, 3 vols. (London: Oxford Univ. Press, 1975), 2:65–70, 3:28–29; and, for the complicated history of *Flora Londinensis*'s publication, see Jane Quinby, comp., *Catalogue of Botanical Books in the Collection of Rachel McMasters Miller Hunt*, 2, part 2, *Printed Books, 1701–1800*, comp. Allan Stevenson (Pittsburgh: The Hunt Botanical Library, 1961), 389–412.

87. I am indebted to Kath Clark for this information.

88. For the role of the Court after the accession of George III, see Allen, *Naturalist in Britain*, 43, 38.

89. See Mark Laird, "This Other Eden: The American Connection in Georgian Pleasure Grounds, from Shrubbery & Menagerie to Aviary & Flower Garden," in Meyers, ed., *Culture of Nature*.

90. Mary Delany to Mary Dewes, February 1769, in Llanover, ed., *Autobiography and Correspondence*, ser. 2, 1:204–5.

91. Mary Delany to Bernard Granville, 17 December 1771, in Llanover, ed., *Autobiography and Correspondence*, ser. 2, 1:384.

92. William Chambers, *Plans, Elevations, Sections, and Perspective Views of the Gardens and Buildings at Kew...* (London: Printed by J. Haberkorn for the author, 1763). For Kew, see Ray Desmond, *Kew: The History of the Royal Botanic Gardens* (London: The Harvill Press with The Royal Botanic Gardens, Kew, 1995), and John Harris, "Sir William Chambers and Kew Gardens," in John Harris and Michael Snodin, eds., *Sir William Chambers: Architect to George III* (New Haven and London: Yale Univ. Press in association with the Courtauld Gallery, Courtauld Institute of Art, 1996).

93. See Clarissa Campbell Orr's essay in this volume.

94. Mary Delany to the Viscountess Andover, 12 August 1776, in Llanover, ed., *Autobiography and Correspondence*, ser. 2, 2:251.

95. Mary Delany to Mary Dewes Port, 20 October 1777, in Llanover, ed., *Autobiography and Correspondence*, ser. 2, 2:326.

96. Patricia Taylor, *Thomas Blaikie (1751–1838): The "Capability" Brown of France* (East Linton, East Lothian: Tuckwell Press, 2001).

97. Taylor, *Thomas Blaikie*, 232.

98. Sloan, *A Noble Art'*, 46.

99. Mary Delany to Mary Dewes Port, in Llanover, ed., *Autobiography and Correspondence*, ser. 2, 2:327.

100. The total for the month is calculated to be around or just over thirty. However, since the dating of the collages awaits detailed analysis by Edmondson and Nelson, this might be subject to revision. Some collages have no specific day attached, so compiling an accurate day-to-day tally is not possible.

101. Mary Delany to Mary Dewes Port, 20 October 1777, in Llanover, ed., *Autobiography and Correspondence*, ser. 2, 2:326: "Last Monday Lady Gower made us a morning visit… ."

102. Mary Delany to Mary Dewes Port, 11 May 1780, in Llanover, ed., *Autobiography and Correspondence*, ser. 2, 2:519.

103. See Lisa Ford's essay in this volume, which details the sites and their owners.

104. Frances Boscawen to Mary Delany, 17 September 1781, in Llanover, ed., *Autobiography and Correspondence*, ser. 2, 3:52.

105. Edgar T. Wherry, *The Genus Phlox* (Philadelphia: [Associates of the Morris Arboretum of the Univ. of Pennsylvania], 1955), 120.

106. Wherry, *Genus Phlox*, 113.

107. Laird, *Flowering of the Landscape Garden*, 221. In fact, the duchess had five types of phlox delivered from Gordon's nursery in 1752. John Harvey made the following cautious identifications, which are listed by Laird in *Flowering of the Landscape Garden*: "1 Early Lychnidea [*Phlox divaricata*], 1 Tall sweet scented (Lychnidea) [*Phlox ? maculata*], 1 Broad leaved (Lychnidea) [*Phlox ? paniculata*], 1 Mill. 1 (Lychnidea) [*Phlox glaberrima*], and 1 Mill. 2 (Lychnidea) [*Phlox carolina*]."

108. Mary Delany to Mary Dewes Port, 9 June 1776, in Llanover, ed., *Autobiography and Correspondence*, ser. 2, 2:223. Kohleen Reeder reconstructs how that "appointment" worked in her essay in this volume.

109. Allen, *Naturalist in Britain*, 25, and, for the restorative of active societies, 37–42.

110. Edmund Spenser, *The Faerie Queene* (1590): "A large and spacious plaine, on euery side/ Strowed with pleasauns, whose faire grassy ground/ Mantled with greene, and goodly beautifide/With all the ornaments of *Floraes* pride." For the imaginative courtly world of Elizabethan chivalry, see Clarissa Campbell Orr's essay in this volume. For the dating of the mantua, see Clare Browne's essay in this volume.

111. See Laird, *Flowering of the Landscape Garden*, 168, quoting Walpole, who claimed that shrubs were past their best within two decades.

112. Desmond, *Kew*, 107.

113. Mark Laird, *Sir Joseph Banks Botanist, Horticulturist and Plant Collector: Associations with Chelsea Physic Garden* (London: Chelsea Physic Garden, 1988).

114. See Laird, *William Curtis*.

115. Ada K. Longfield, "William Kilburn (1745–1818) and His Book of Designs," *Irish Georgian Society Bulletin* 24, nos. 1–2 (January–June 1981). I am grateful to Clare Browne for this reference. A paper on Kilburn scheduled to appear in a forthcoming volume entitled *Curtis's Botanical Magazine* will provide more information. I am grateful to Charles Nelson for this information.

116. Charles Boot, ed., *Flowers in the Landscape: Eighteenth Century Flower Gardens and Floriferous Shrubberies*, papers from the seminar held at Hartwell House, Buckinghamshire, 19–20 June 2006 (Buckinghamshire: Bucks Gardens Trust, 2007).

117. See Laird, *Flowering of the Landscape Garden*, 175, and Laird, "This Other Eden."

118. Stephen Daniels, "Gothic Gallantry: Humphry Repton, Lord Byron, and the Sexual Politics of Landscape Gardening," in Michel Conan, ed., *Bourgeois and Aristocratic Cultural Encounters in Garden Art, 1550–1850* (Washington D.C.: Dumbarton Oaks, 2002), 324–25.

119. Daniels, "Gothic Gallantry," 324.

120. Quoted in Stephen Daniels, *Humphry Repton: Landscape Gardening and the Geography of Georgian England* (New Haven and London: Published for the Paul Mellon Centre for Studies in British Art by Yale Univ. Press, 1999), 197.

121. Mark Laird, "*Corbeille, Parterre* and *Treillage*: The Case of Humphry Repton's Penchant for the French Style of Planting," *Journal of Garden History* 16, no. 3 (July–September 1996): 165; see also Mark Laird, "From Bouquets to Baskets," *The Magazine Antiques*, n.s., 157 (June 2000): 932–39.

122. Simon Garfield, *Mauve: How One Man Invented a Color that Changed the World* (New York: W. W. Norton, 2000), 78. Hippolyte Taine wrote of the offensive effect of "gowns of violet silk with dazzling reflections, or of starched tulle upon an expanse of petticoats stiff with embroidery."

123. Hayden, *Mrs. Delany and Her Flower Collages*, 129, quoting what Dr. Johnson heard Edmund Burke say.

⌈8⌉

Mrs. DELANY'S NATURAL HISTORY & ZOOLOGICAL ACTIVITIES:
"A Beautiful Mixture of Pretty Objects"

In Mrs. Delany's unpublished novella, *Marianna*, the title character experiences trials and tribulations befitting an eighteenth-century heroine. After venturing too far down the garden path she becomes lost and eventually finds herself in a cave by the sea. She is captured by pirates and taken aboard their ship, where she meets a mysterious but handsome stranger. Although all ends well for Marianna—she enters into a good marriage arranged by a wise and kindly aunt-like older friend—the message of the romance is clear: Marianna's troubles are the direct result of disobedience. She was allowed to pick flowers in the garden but expressly forbidden by her parents to venture beyond the stile at the end of the lawn. One day, however, Marianna was picking flowers

> when an uncommon & Beautifull butterflie, fix'd
> on a flower she was going to gather; she cryed out
> in an extacy.... I must catch this lovely, pretty
> creature; but nimble as she was it flew from flower,
> to flower, too quick for her to gain the prize she
> wanted; at last, after some pursuit... the butterflie
> flew over the stile, at the end of the Lawn, and
> Marianna almost with as much swiftness
> followed: when she had chased it a few yards,
> & she thought herself sure of catching it, it took
> wing again, & by a succession of short flights,
> drew her quite out of sight of the fatal Stile.

By the time she realized her mistake it was too late, and Marianna's misadventures had begun (see fig. 262).

Like the protagonist of her novella, Mrs. Delany saw the natural world as filled with innumerable delights and treasures. However, as Marianna's story shows, it was also important to Mary Delany, and her contemporaries, that the study of nature be undertaken with proper comportment. One should not be overzealous in such pursuits, certainly not to the point of forgetting the admonitions of one's family or the rules of etiquette. The links among the study of nature, elegant living, and proper behavior are key fea-

tures of Mrs. Delany's life and activities, as well as essential for understanding the broader culture in which scientific pursuits took place in eighteenth-century England. In this essay, I explore aspects of Mrs. Delany's natural history and zoological activities as the union of the scientific and the aesthetic. In particular I discuss their intersection within the decorative arts practices at which she was so skilled. In focusing on natural history and zoology rather than botany, this essay does not directly address Mrs. Delany's botanical paper mosaics. However, in examining the earlier history of Mrs. Delany's engagement with the study of nature, I seek to contribute to an understanding of the broader artistic, scientific, and cultural context from which her paper mosaics emerged.

The elegant way of life valued by Mrs. Delany and her social class encompassed beautifully appointed quarters decorated with embroidered bed hangings and seat cushions, painted firescreens, fine china, gilt silver food services—among many other types of objects—and of course, the art of fine dressing. Throughout her life, she was involved in making and designing objects for interior and exterior spaces at her own residences and those of others. Often elaborate in construction, these objects usually featured motifs and materials relating to her interest in the natural world. For Mrs. Delany, elegant interiors were coextensive with elegant exteriors, the fluid border between them constantly traversed by this diligent and curious student of nature. Many of her projects, including the paper mosaics, were undertaken at Bulstrode, the country estate of her close friend the Duchess of Portland. Although Bulstrode was crucial in shaping Mrs. Delany's intellectual and artistic pursuits, she had already developed a rich and varied range of activities. Thus, the first section of this essay addresses Mrs. Delany's work prior to her residence at Bulstrode; the second examines how such work was affected by her immersion in the cultural and intellectual life of Bulstrode after 1768.

Crafting Nature and Cultivating Friendship in Ireland and England, 1730s–1750s

Projects that merged decorative arts and natural history were central to Mary Delany's life at Delville. Like the Duchess of Portland, she was an avid collector of shells. Shells, fossils, and minerals were key ingredients in grottoes, and during her life she worked on a number of encrusted garden rooms in Ireland and England.[1] She used shells in the plasterwork decoration of her home and to decorate small objects.[2] She began collecting shells in her teenage years, and by the 1730s pursued them with great zeal:

> I have got a new madness, I am running wild
> after shells. This morning I have set my little
> collection of shells in nice order in my cabinet,
> and they look so beautiful, that I must by some
> means enlarge my stock; the beauties of shells
> are as infinite as of flowers....[3]

She expanded her collection, which grew to include fossils and minerals. By 1750, her collection of shells, fossils and minerals had become so extensive that she had to establish a separate room for her specimens, "for my own room is now so clean and pretty that I cannot suffer it to be strewed with litter, only books and ⌈needle⌉work, and the closet belonging to it be given up to prints, drawings, and my collection of fossils, petrifactions, and minerals."[4]

The two decades spanning 1730–50 were a period of intense grotto activity. As Mary Pendarves, her earliest recorded involvement with making grottoes dates to a trip she took to Ireland in the early 1730s with her friend Anne Donnellan. They visited Donnellan's sister, who was married to the Bishop of Killala, and designed and built a grotto overlooking the sea on the grounds of the bishop's estate.[5] After her return to England in 1733, Mary visited Alexander Pope's grotto at Twickenham and worked on her own grotto at her uncle's house at Northend. She also mentions working on a grotto for her brother

at Calwich Abbey, a project she may have continued after her move to Ireland in 1744 (fig. 165). Shellwork was a central focus for both the interior and exterior at Delville—especially for the grotto she began in the mid-1740s, in which shells would have featured prominently as part of the decorative program. In a letter to her sister in 1744, Mary Delany describes the proposed site:

> About half way up the walk there is a path that goes up that bank to the remains of an old castle (as it were), from whence there is an unbounded prospect all over the country: under it is a cave that opens with an arch to the terrace-walk, that will make a very pretty grotto; and the plan I had laid for my brothers at Calwich (this being of that shape, though not quite so large) I shall execute here.[6]

Grottoes in the eighteenth century were conceived as outdoor rooms in which the inhabitants could enjoy pleasing views of the surrounding landscape. Mrs. Delany's small grotto was envisioned as a place for both solitary contemplation and interludes with her husband or close friends, as well as a space in which skilled handiwork, design, and specimens of shells, fossils, and minerals could be admired. In that sense, the grotto was an extension of elegant interior design. Yet it also offered an outdoor sanctuary to enjoy quiet and solitude, contemplating the beauties of nature and human ingenuity.[7] This emphasis on elegant but casual social interaction for small groups is also evident in the grotto Mrs. Delany later designed for the Duchess of Portland at Bulstrode (fig. 166). Few visual or written records survive, but the planning began as early as 1743. During a visit to Bulstrode in December that year, Mary Delany wrote to her sister that the duchess "intends to build a grotto in the hollow that you have a sketch of, and I am to design the plan for it."[8] The completed grotto was recorded in drawings of ca. 1780 by the Swiss artist Samuel H. Grimm. It shows several chairs set in the grotto's entryway. An inner chamber is visible beyond these chairs, from which the view of the grounds could be enjoyed through the framing device of the two arched entryways. The view would have been further enhanced when the newly planted trees in the foreground grew to maturity, providing additional privacy to those visiting the grotto while at the same time framing the landscape with leafy greenery.

Mrs. Delany's grottoes featured interiors that were most likely covered with shells, fossils, and rocks, as was the custom of the day. Barbara Jones has written on the general taste: "Some grottoes were started as huge show-cases for collections of

Figure 165: Mary Delany, *a view of the Bridge & Grotto at Calwich*, 1756, pen and gray ink and wash over graphite. National Gallery of Ireland, Dublin (2722 [82])

Figure 166: Samuel Hieronymus Grimm, *Grotto in the Park at Bulstrode*, ca. 1780. British Library (Add. MS 1553710, fol. 14)

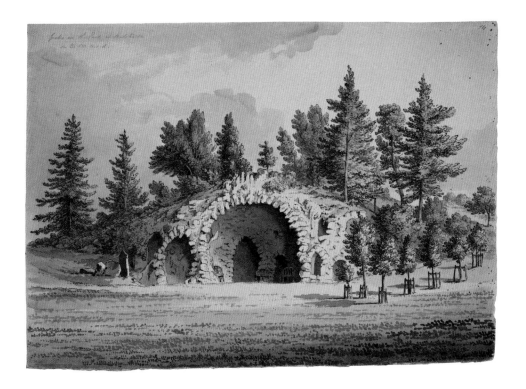

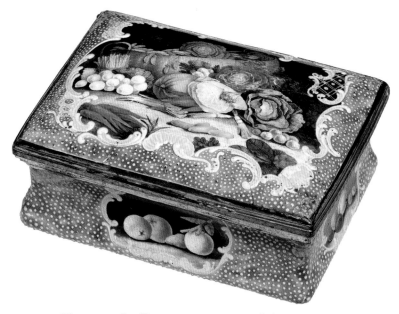

Figure 168: Snuffbox, ca. 1765–75, enameled copper with chased gilt-metal mounts. Victoria and Albert Museum, London (C.470-1914)

Figure 167: Mary Delany, *A Modern Lady*, 1744, graphite on paper. Private collection

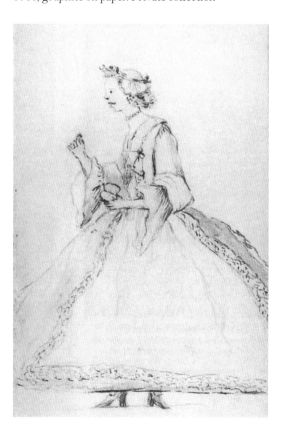

Figure 169: Mary Delany, *Hostess at Leicester* [with] *A green drake Fly*, 1744, graphite on paper. Private collection

fossils and strange petrifications, but even the most fashionable and frivolous ones aimed at variety, and had lists of specimens to guide the visitor."[9] There was a distinction between the shells and fossils used for grottoes and other decorative shellwork and those collected and displayed as specimens in cabinets. Large quantities of readily available shells—collected at the seashore or purchased from dealers—were favored for encrusting the walls and ceilings of a grotto, whereas rare individual shells were reserved for display in the cabinet.[10] Constructing grottoes and creating shellwork for interiors were usually group activities; collecting for the specimen cabinet was a solitary endeavor, or undertaken with one or two others. The aesthetic effect of the grotto depended on the visual spectacle of abundantly massed shells, whereas interior shellwork formed decorative elements that offered the viewer the opportunity to admire the individual shells as well as the skilled handiwork of the artist. The specimen of a particular shell, fossil, or mineral offered an even more narrowly focused viewing experience. All constituted distinct areas of social and intellectual engagement. The grotto or cave figured as an important site in Mrs. Delany's imaginative landscape—it was, after all, the site of her fictional heroine Marianna's departure from civilized society. She used the term "Cave" for the Bulstrode grotto. It also embodied the idea of the natural world as a place bounded by the rules of culture yet offering a refuge from the demands of a rarefied social world.

Throughout her life, Mrs. Delany embarked on a number of projects that mingled decorative arts aesthetics and natural history practice. These pursuits increased in scale and scope when she moved to Ireland in 1744 after her marriage to Patrick Delany in 1743. Having her own home allowed her to work on large projects of her own design and to cultivate friendships both near and far through such projects. The drawings and notes she kept in a pocket sketchbook during her journey from London to Ireland just after her marriage reflect some of the major themes that would occupy her at her destination. In a sketch of "A Modern Lady," she notes the details of the woman's hairstyle and dress, and is especially attentive to the object the woman holds in her left hand, a snuffbox (fig. 167). The object seems to have caught Mrs. Delany's eye because of its hinged lid, a newly fashionable design. Previously, snuffboxes had removable lids, which necessitated the use of two hands—one to hold the lid, the other to hold the box—thus making removing a pinch of snuff awkward. That problem was solved

in the 1740s with the incorporation of a hinged lid, and these highly popular items were often beautifully decorated in enamel with brilliant colors (fig. 168).[11] The jewel-like hues of enameled surfaces are evoked in another section of the sketchbook, where Mrs. Delany describes a garden as "enameled and perfumed with a variety of sweet flowers."[12] On another page, she pairs a drawing of "A green drake Fly" with one of a "Hostess at Leicester" (fig. 169). The pocket sketchbook thus combines Mrs. Delany's interests in fashion, the natural world, and physical engagement with small collectible objects, three areas that would form the basis of her activities at Delville and later at Bulstrode.

During the 1740s and 1750s, Mrs. Delany studied nature among a network of correspondents and friends, most of whom were women. She encouraged her sister, Anne Dewes, in her pursuit of natural history, often sending her shells and plants with household items and decorative objects, along with gifts and messages for other friends:

> I am glad Lady A. Coventry liked the shell work I have sent you by Mrs. Mountenay, (a lady that lives with Miss Frankland), the twelve tea napkins you desired, a little box of odd shells that I think you have not (amongst them the harp shell and two small whole scollops), and three old smocks for cut out work.[13]

Lady Anne Coventry was a friend of Mrs. Delany's to whom she also sent shells and books, sometimes using her sister as an intermediary. In 1749 Mary asked Anne to apologize to Lady Coventry for her, and to

> let her know that I have not been unmindful of the book of shells I mentioned to her, but there is not one to be had at this time; the bookseller I had mine of says he expects some over from France soon, and has promised I shall have the first that comes, which I will take care to send to Lady Anne Coventry by the first opportunity.[14]

A few years later she asked her sister for information from a book owned by Lady Coventry: "Pray send me the title-page you copied from Lady Anne Coventry's fine book of printed plants."[15]

Literary historian Lisa L. Moore has shown that such friendships formed part of Mrs. Delany's participation "in a self-conscious community of intimate women friends in the cosmopolitan cultures of eighteenth-century London and Dublin."[16] She "conceived of many of her innovations at Delville as making space for her women friends."[17] One very close friend in Ireland was Mrs. Dorothea Forth Hamilton, who

helped her with sorting shells. They also worked on embroidery projects together as part of enjoyable companionship at Delville. Mrs. Hamilton was also a talented artist who specialized in painting flowers and insects.[18] Mrs. Delany mentions a book of Mrs. Forth Hamilton's drawings, most likely owned by either Mrs. Delany or the Duchess of Portland, which served as a model for drawing lessons for one of the duchess's daughters. In 1753, Mrs. Delany wrote to her sister that "Lady Betty Bentinck has begun to copy Mrs. Hamilton's roses, and I believe will do them very well."[19] Earlier in the same month, Mrs. Delany likened Betty Bentinck's drawings to those of Georg Dionysius Ehret: "You would be surprised to see the improvement Lady Betty Bentinck has made in her drawing; I think she comes *very near* Ehret; she has copied one of the fishes out of my book most exactly, and it is one that has the most work in it."[20]

A recently rediscovered silk stomacher may have been the product of Mrs. Forth Hamilton's

and Mrs. Delany's collaboration (fig. 170). The stomacher probably dates from the 1740s and consists of a single piece of cream-colored silk on which pairings of flowers and insects have been drawn in brown ink or dye.[21] The monochromatic drawings are extremely subtle in their gradations of tone, and appear to have been built up through very short, fine pen strokes. The drawings on the stomacher are framed by light penciled lines that in several instances truncate the leaves or stems of plants. It does not appear that the insects and flowers pictured on the stomacher correspond to any published illustrations; more likely they were based on original drawings. However, the insects do bear some stylistic similarities to those depicted by Ehret in his *Plantae et papiliones rariores* (1748–1759; see fig. 171).[22] Clearly, more research is needed.

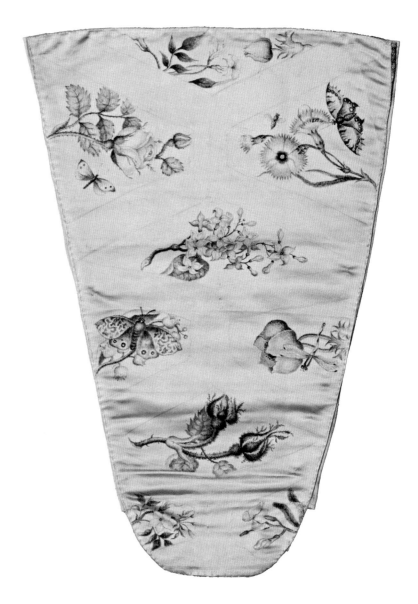

Figure 170: Stomacher, design attributed to Dorothea Forth Hamilton, ca. 1740s, silk satin with ink. Private collection

Figure 171: Tab. 10 from Georg Dionysus Ehret,
Plantae et papiliones rariores (London, 1748–59).
Library of the Arnold Arboretum, Harvard
College Library

Mrs. Delany herself was probably not the source, since her one known drawing of an insect differs stylistically from the stomacher insects. "A green drake Fly" (see fig. 169) of 1744 depicts a species of mayfly in profile. Although it is a rough sketch, it possesses a degree of anatomical detail that is lacking on the stomacher. None of the stomacher insects possesses legs, for example, and the wings of the small insect shown near the butterfly are of an odd shape, perhaps shown upside down. However, the insect and flower compositions on the stomacher appear of a piece with Mrs. Forth Hamilton's other work, known mostly to us now through written descriptions. Writing from Delville in 1750, Mrs. Delany mentioned, for example: "Mrs. F. Hamilton has just finished a little piece of flowers and butterflies for Mrs. H. Hamilton that is *really exquisite…* ."[23] Lady Llanover adds the following note to this letter: "The Editor possesses some of Mrs. Forth Hamilton's works in painting and embroidery which she gave Mrs. Delany… . She excelled equally in flowers and insects, which she generally represented together."[24] Llanover also describes a white silk apron given as a gift to Mrs. Delany from Dorothea Forth Hamilton:

> *Among the remaining collection of Mrs. Delany's own unrivalled needlework, is a white silk apron, (also) intended for a hoop, given to her by her friend Mrs Hamilton, and which was so exquisitely painted and so perfectly preserved that it is probable it never was worn, but kept as a work of art. The border is entirely composed of sprays of jessamine, each different from the other, yet forming a complete whole, filled up and interspersed with insects, among which are moths and butterflies, bees, dragon-flies, ladybirds, and even a small snail with its shell is introduced. The whole is painted in grays… .*[25]

The correspondence between style and content of the images on the apron and those on the stomacher strongly suggests that the stomacher images were the work of Mrs. Forth Hamilton. They certainly collaborated on other needlework projects, such as those Mrs. Delany describes in a letter from 1759: "Our present works as follows: I am working the cover of a stool, Mrs. Hamilton is working a rose in the back of the chenille chair, she has already done a marygold and convolvulus."[26] After Mrs. Delany left Ireland in 1768, she continued to correspond with the Hamilton family, and wrote the following after the death of Mrs. Forth Hamilton:

> *Every scrap of ingenuity produced and bestowed by our late unequalled friend is treasured up most carefully: if a duplicate of* flower *or* insect *comes*

to your hands, *when you are indulging your attention with them,* may I beg it, *if a more worthy suppliant has not been before me?*[27]

Even twelve years after she had left Ireland, Mrs. Delany still treasured her friend's drawings and needlework, and the presence of these material objects played an important part in maintaining her friend's memory.

The stomacher is a reminder of the connections between a small-scale project and the broader context of studying and representing insects in eighteenth-century England. Numerous illustrated publications from this period reflect how the topic of insects intersected with the natural history and decorative arts interests of Mrs. Delany and her circle. Some publications included plates dedicated to specific patrons (such as the Duchess of Portland), and the illustrations usually were executed with the precision and attention to visual effect that appealed to the tastes of this audience: for example, G. D. Ehret's *Plantae et papiliones rariores* (see fig. 171).[28] In Europe, insects had appeared in a wide range of visual representations from the beginning of the sixteenth century, and their connection to the decorative arts and embroidery had a history dating to the seventeenth century. The German artist-naturalist Maria Sibylla Merian, for example, combined visual strategies drawn from needlework and other decorative arts practices with natural history illustration in her book on the insects of Surinam.[29] The frontispiece to the second edition of Merian's book (fig. 172), published in 1719, presents the author amid putti assistants who make clear the idea that insects are to be understood as objects for refined tastes and elegant interiors.[30]

Although they were often far away from one another in the years prior to 1768, Mrs. Delany's friendship with the Duchess of Portland was also sustained through their shared interest in creating nature-themed objects to decorate the exteriors and interiors of their homes.[31] They pursued these activities during Mary Delany's visits to Bulstrode, and she continued them when she was at home in Ireland. The Duchess of Portland had a strong imaginary presence at Delville, where an outdoor portico was decorated in her honor. In a letter to her sister from 1745, Mrs. Delany describes her progress decorating the portico with a shell-encrusted chandelier, which she refers to as a "lustre":

My shell lustre I wrote you word I was about, was finished ten days ago and everybody liked it. 'Twas a new whim and shows the shells to great advantage. I had fixed it up in my portico, which

is dedicated to the Duchess of Portland; but the damp weather made the cement give and I have been obliged to bring it into the house, and it now hangs in my work-room and shows to more advantage.[32]

A few years later, in December 1749, Mrs. Delany began another shell lustre while she was visiting Bulstrode. This one was intended as a gift for the Duchess of Portland. Her sister participated in the construction of the shell lustre from afar, sending mussel shells. Mary Delany also acquired other items to complement the lustre. She took a trip "to Mr. Dufour's, the famous man for paper ornaments like stucco, [where she] bespoke a rose for the top of her Grace of Portland's dressing-room, where the shell lustre is to hang… ."[33] After finishing the lustre at the end of December, Mary informed her sister that she had begun a new shellwork project for the duchess: "I have begun a pair of candlesticks, for her, but fear I shall hardly finish them, as not a flower is yet made."[34] She makes no further mention of the candlesticks. When the shell lustre was later damaged beyond repair, she decided to create a new one from its remains. She was assisted by her friend Mrs. Hamilton, who designed a fixture for hanging the new lustre. It consisted of "an imitation of carving with shells and pasteboard, to be fixed on the ceiling to hide the pulley, and for the line to come through that holds the lustre… ."[35] However, three years later she found that the condition of the duchess's lustre had deteriorated due to the wood not having been properly conditioned, and spent a day making repairs.[36]

Figure 172: Frontispiece to Maria Sibylla Merian, *Dissertatio de generatione et metamorphosibus insectorum Surinamensium*, 2nd ed. (Amstelaedami: apud J. Oosterwyk, 1719). Houghton Library, Harvard College Library (Typ 732.19.567.PF)

Figure 173: John or William Cafe, London,
One of a pair of candelabra, 1757, gilded silver.
Private collection

These objects would have been enjoyed in the same milieu as another elaborate nature-themed project that occupied both the Duke and the Duchess of Portland during the 1750s and 1760s: an ornate silver-gilt dessert service (fig. 173). Work on this dessert service was started in 1756–57 by either John Cafe (who died about 1757) or his brother William, London silversmiths. It was added to over the following nine or ten years by silversmiths Daniel Smith and Robert Sharp, whose work seems to have incorporated pieces by the Cafes. The dessert service was commissioned by the duke and features imagery that could have been drawn from his wife's natural history collections.[37] A pair of candelabra in the form of tree trunks crawls with snails, moths, beetles, caterpillars, and other insects.[38] Other pieces include dessert dishes in the forms of leaves with snails, lizards, bees, and fruit atop them, while the handles of serving knives and ladles take the form of shells and coral. It is easy to imagine Mrs. Delany's shellwork candlesticks, if they ever were completed, forming part of an opulent table display in which objects from the natural world mingled with these finely wrought imitations of natural specimens.[39]

Mrs. Delany and the Scientific Community at Bulstrode

The cultivation of friendship through making, studying, and exchanging objects of art and science would continue at Bulstrode from 1768 to 1785, during Mrs. Delany's second widowhood. The duchess and she also spent much time together in London. Mrs. Delany was part of the duchess's circle of friends who took part in artistic activities such as drawing and painting, shellwork, embroidery, lathe turning, and feath- erwork.[40] Bulstrode was both a model of elegant living and an important site for the study of nature in eighteenth-century England; the late 1750s–1770s were marked by increased scientific, horticultural, and landscaping activities. In 1757, major changes were made to Bulstrode's land- scape, most notably the removal of a long avenue leading to the house and its replacement with an oval lawn. The new lawn served as a stage for the daily performances of Bulstrode's natural bounty. Mrs. Delany described the lawn as a feeding area for the animals that lived on the grounds, who arrived every evening for their food. She also noted that the lawn was kept pleasantly spotless by the servants.[41] A drawing of the estate by Grimm from 1781 shows several deer on the oval lawn, with the house and other buildings in the background (fig. 174). In the lower right corner three figures are engaged in conversation on the

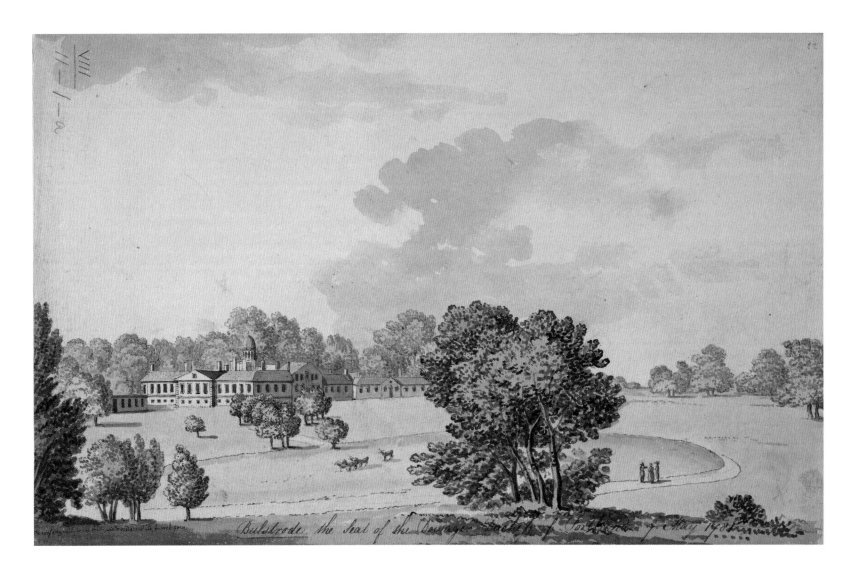

road surrounding the lawn; two are women, who direct their attention to a male figure gesturing toward them with his arm. Grimm's many topographical drawings sometimes included figures associated with the locale he depicted, so it is possible that the two female figures are meant to represent the duchess and Mrs. Delany with one of the many visitors to Bulstrode.[42]

Bulstrode was a destination for members of the scientific community from at least the 1750s, when two prominent botanists are recorded as making visits. The Quaker linen merchant, plant collector, and gardener Peter Collinson spent a week at Bulstrode in July 1757 at the invitation of the Duke of Portland.[43] A visit three years earlier from the horticulturist Philip Miller could have been associated with the new landscaping. Mrs. Delany was present for Miller's visit, but found him somewhat vain: "[W]e have had the great Mr. Miller, of Chelsea, here for some days.... He is a well-behaved man, but does not seem to want a good opinion of himself... ."[44] Her comment conveys the social environment of Bulstrode, where good manners and sociable behavior were appreciated and expected. Bulstrode was not unusual in this respect, however. Proper etiquette was essential in the transatlantic culture of scientific collecting and exchange in which Collinson and Miller played key roles. At times the intersection between sociability and the practice of science took material form at Bulstrode, as Mrs. Delany noted in a letter from 1768. In anticipation of a visit from distinguished guests, the Duchess of Portland, "out of the abundance of her politeness, intending to entertain in a superlative manner," purchased a set of cards for playing the popular card games quadrille and loo. The guests never arrived, and the cards remained in place until the duchess needed them for another purpose: "Fossils were examined, and sorted, a loud cry for patty-pans all exhausted, the *choice cards* were seized upon for the purpose.... What would the princely guests have thought when their spirits and hopes were high about engaging in *dear quadrille* or *delightful loo* to have had such a damp?"[45]

Figure 174: Samuel Hieronymous Grimm, *Bulstrode*, ca. 1781, ink wash on paper, 6⅞ × 10⅜ in. (17.4 × 26.3 cm). British Library (K Top Vol. 8, 11.1.a)

Figure 175: Tab. 15 from John Ellis, *The Natural History of Many Curious and Uncommon Zoophytes…* (London: B. White and Son, 1786). British Library. The duchess's specimen is no. 1 and the magnified polype is no. 2.

Figure 176: *Madrepora pileus*, Ellis and Solander, 1786, dried coral native to S.E. Asia, 9 in. (23 cm) in length. Hunterian Museum & Art Gallery, University of Glasgow

Peter Collinson made additional visits to Bulstrode in 1762 and 1763, and the duchess dined at his home at Mill Hill in 1768.[46] It was at this dinner that the duchess was introduced to the work of the American artist and naturalist William Bartram. She asked Collinson to send money to Bartram for drawings of shells for her. Collinson wrote to Bartram that, if the duchess liked his work, "She will give Orders to keep drawing on until all the Shells are Drawn."[47] Her collection of shells was becoming famous as the largest in England. Her passion for shells extended to other types of marine life, as is evidenced by her interactions with the zoologist John Ellis. Ellis's particular interest was in zoophytes (animals that resemble plants), and he made important contributions to the debates about the nature of these creatures (figs. 175, 176). He may have come to the duchess's attention as a result of his 1755 publication *An Essay towards a Natural History of the Corallines*, a popular book published in several editions.[48] The illustrations were made after original drawings by Ehret, who was instructing the duchess's daughters in botanical illustration at the time. Ellis sent an illustration of barnacles to the duchess in 1759 and appears to have acted as her agent in procuring shells and corals from Norway.[49] Ellis died in 1776, but his other major contribution to natural history—*The Natural History of Many Curious and Uncommon Zoophytes*—appeared posthumously, in 1786. The book was completed by the Swedish botanist and naturalist Daniel Solander, who worked as curator for the Duchess of Portland's collections in the 1770s and 1780s. Solander and Ellis mention specimens in the duchess's collections, such as the Bare-Headed Gorgonia (fig. 175). It was described as "an elegant Sea-Shrub… brought from the West Indies… at present in the superb cabinet of her Grace the Dutchess Dowager of Portland, who was so obliging as to give me the specimen represented in the plate, where one of the cells and the polype is magnified."[50] Ellis also mentioned specimens of madrepore—or coral—in the duchess's collections, an object at home in both the natural history cabinet and the grotto (fig. 176).[51] Mrs. Delany describes madrepores as being displayed alongside fossils in the Bulstrode grotto, carefully noting their scientific name. After touring some recent plantings on the estate, she and the duchess

> ended with the Cave, where the Duchess has
> directed a plantation of some trees on the right
> hand, which will be a great improvement. We also
> fixed upon a place in the Cave for the Ilam fossils,
> which are much admired, especially the great

rock which is covered with coral, scientifically called Madrepores.[52]

In addition to providing access to her collections, the duchess also funded scientific research, publications, and voyages to collect new specimens. The Reverend John Lightfoot entered the duchess's employment in 1767, serving as chaplain and curator of her collections of plants and shells. Lightfoot accompanied Thomas Pennant on a botanical trip to Scotland and the Hebrides in 1772, where they collected plants that Lightfoot later described in his 1777 book *Flora Scotica*, which was published at the expense of Pennant and dedicated to the Duchess of Portland (fig. 177). With funding from the duchess, Lightfoot also accompanied Joseph Banks on a voyage to Wales in 1773 for the purpose of collecting plants.[53] Lightfoot worked closely with Mrs. Delany on her own collections and in instructing her in natural history. She greatly enjoyed his company and that of his collaborator Pennant: "To-night or to-morrow we shall be *illuminated* by the two celebrated philosophers—Mr. Pennant and Mr. Lightfoot, and *virtû* will be in its full glory."[54] In the 1770s, Lightfoot also seems to have assisted Mrs. Delany in obtaining specimens for her collection of shells, fossils, and minerals. These had become increasingly difficult for her to obtain due to the high prices they commanded, and he seems to have attempted to supply her with new specimens from his own collecting trips. Lightfoot took a trip to Cornwall in 1774, after which Mrs. Delany relates that he brought "*several* curious *wild plants*; but much disappointed with not having been able to get any of the curious minerals; and so was I, for he told me if he succeeded I should come in for a little share: no amusement gives me so much pleasure as my shells and fossils…."[55]

In the 1770s, the duchess and Mrs. Delany began studying mosses, lichens, and fungi, an interest that had begun with Ehret and Lightfoot. Writing in September 1769, Mrs. Delany reported: "en attendant we have Mr. Ehret, who goes out in search of curiosities in the fungus way, as this is now their season, and reads us a lecture on them an hour before tea, whilst her Grace examines all the celebrated authors to find out their classes."[56] Back in 1763, Ehret had recorded *Phallus impudicus* at Bulstrode, and in 1769 Mrs. Delany noted a "Fir-Coned Hydnum" in her manuscript adaptation in English of William Hudson's *Flora Anglica* (see fig. 15). Two years later, the duchess pursued collecting in this area with her customary zeal. On a trip to Buxton in 1771, she received and requested specimens from

Mrs. Delany:

A thousand thanks for the giant throatwort; it is gone to London with a large cargo from hence. I fancy I left the umbilicated lichen at Ilam. Will you be so good to let me know, for I can't find it, which I am very sorry for. My dearest friend, will you be so kind to get me some more? It grows on the rocks in the caves.[57]

Figure 177: Plate XXXII from John Lightfoot, *Flora Scotica; or, A Systematic Arrangement, in the Linnaean Method of the Native Plants of Scotland and the Hebrides*, vol. 2 (London: B. White, 1777). British Library

At the age of seventy-one, Mrs. Delany apparently was fit enough to visit caves and search the rocks for specimens of lichen. By the late 1770s, the duchess had come into contact with James Bolton, whose enthusiasm for studying and collecting fungi, lichens, and mosses was matched by his artistic skill (fig. 178).[58] Though today little known outside the field of mycology, Bolton's publications on ferns and fungi are considered

pioneering works. A recent biographer describes Bolton as "one of the more accomplished English artist-illustrators" of the late eighteenth century and acknowledges his "international reputation as a naturalist during his lifetime."[59] Bolton had corresponded with the duchess prior to his visit to Bulstrode in 1779.[60] Bolton might have been put into contact with the duchess by Ehret, with whom he appears to have had an association.[61]

Bolton published two major works, *Filices britannicae; an History of the British Proper Ferns* (1785–90) and *An History of Funguses Growing about Halifax* (1788–91).[62] Although the book on fungi appeared several years after the death of the duchess, her support of it may have been crucial for bringing it to completion. The duchess was a patron of both James Bolton and his brother Thomas, and she was still alive when James completed the first section of his manuscript. John Edmondson believes that she was "almost certainly the project's sponsor."[63] In his handwritten preface to the manuscript, dated September 21, 1784, Bolton described the parish of Halifax as "a Natural Botanic Garden," particularly rich in

fungi. During the summer of 1784, he "made up this first fasciculus with a view of Laying it at the Feet of the greatest and best Judge, and the noblest and most generous enco[u]rager of Natural History now alive in Great Britain... the Noble Duchess of Portland."[64] The manuscript's title page no doubt would have appealed to the duchess (fig. 179). Representative specimens of different types of fungi are suspended from a delicate ribbon that encircles the text, linking the specimens and labeling them. Apart from two words in the title and the hand-drawn frame, which are done in red ink, the images are made up entirely of gray and brown tones. In its monochromatic treatment of the plants, subtle gradations of tone, and careful shading, the Bolton title page shares many similarities with the white silk stomacher owned by Mrs. Delany (see fig. 170). It is possible that the stomacher was finished with ribbon trim around the flower and insect drawings, which would have unified the overall composition in a manner similar to the ribbon in Bolton's drawing. This impulse to embed the study of nature within the material and

Figure 178: James Bolton, *Marsh Gentian with* (clockwise) *a shell, a butterfly, a moth* (possibly a vapourer moth) *and a Pine Chafer* (ca. 1775–85), gouache with touches of gold over graphite on vellum, 8¾ × 16¾ in. (22.4 × 17.4 cm). The Pierpont Morgan Library, New York. Purchase (1978.9:1)

Figure 179: James Bolton, decorative second title page of vol. 2 of "Icones Fungorum Circa Halifax Sponte Nascentis", 1786, vol. 2 ([Halifax, England], 1784–92). Special Collections, National Agricultural Library

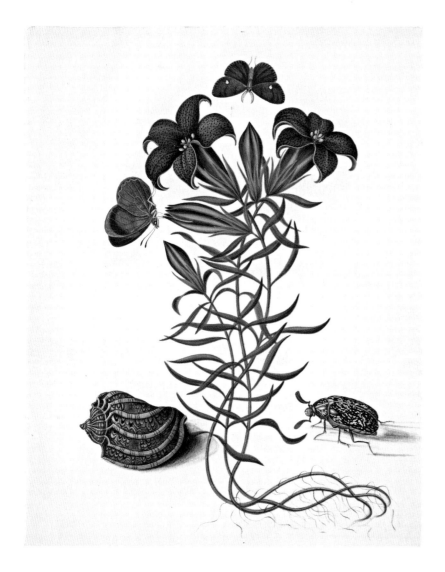

visual culture of refined aristocratic life was characteristic of both Mrs. Delany's practice and the scientific culture of Bulstrode. Bolton's visual style surely would have appealed to her, especially given the strong likelihood that he was employed by her as drawing master for her grandniece Georgina Port.[65]

Bolton's publication was not the only one to have an association with the duchess. In 1771, just returned from their journey to the South Pacific on Captain James Cook's first voyage, Joseph Banks and Daniel Solander visited Bulstrode. A few weeks later, Banks invited the duchess and Mrs. Delany to visit him at his home in London. Mrs. Delany's account of viewing the natural history and botanical drawings made on the voyage is the earliest indication of Banks's intention to issue a major botanical publication from the voyage, a project that would not be completed in his lifetime.[66] Also present at this meeting was Daniel Solander, who was curator of Banks's natural history collections and later appointed as curator of the duchess's shell and insect collections. Solander's work for the duchess seems to have been directed toward a large publication project, which was left unfinished when he died suddenly from a stroke in May 1782. As patrons of Solander, the duchess and Banks both had a keen interest in the fate of his research on shells, but they disagreed as to how to proceed. The duchess favored publishing Solander's research right away, with editing of the manuscripts conducted by Lightfoot. Banks felt strongly that Solander's manuscripts should not be published in their unfinished state and requested that she at least have Solander's notes printed in a different script, to distinguish them from Lightfoot's work. Although she agreed to this, the publication on shells never appeared and the duchess died a few years later.[67]

Solander's research on shells is now known to conchologists mostly through the sale catalogue of the duchess's collections, which was compiled by Lightfoot (fig. 130).[68] Her collections and knowledge of shells are also commemorated by Thomas Martyn in his *Universal Conchologist* (fig. 180): "In this branch of science her Grace's superior knowledge is as well known as it is eminently demonstrated, in the critical arrangement of this immense cabinet, which altogether justifies the very great expence of time and money employed in the formation of it."[69]

Figure 180: Plate 19 from Thomas Martyn, *The Universal Conchologist . . .* (London, 1784): "Checkered Mitre Mitra Tessellata rrr [=very rare] Duchˢ Dowaʳ of Portland". Museum of Comparative Zoology, Harvard College Library

Figure 181: *Cymbiola aulica aulica.* Natural History Museum, London

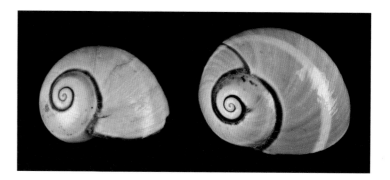

Figure 182: *Polymita picta* (Born, 1758), a Cuban endemic species, purchased by Dr. John Hunter at the Portland Museum sale in 1786. Hunterian Museum & Art Gallery, University of Glasgow

Mrs. Delany, who was engaged with the world of scientific and horticultural publishing as a subscriber rather than as patron,[70] looked to decorative opportunities with plants and shells. For example, she subscribed to Philip Miller's colored plates from his *Figures of the Most Beautiful, Useful, and Uncommon Plants*.[71] Plates such as these were often framed and displayed on walls, forming part of the decorative program of nature-themed interiors. Shells were a primary motif in Rococo interior design as well as of central importance to the natural history interests of the duchess and Mrs. Delany.[72] In such ways, Mary Delany's lifelong interest in the study of nature intersected with interior design, fashion, and the making of handcrafted objects, which featured birds as well as insects, plants, and shells. Pheasants and other birds abounded on the grounds of Bulstrode, and in one instance Mrs. Delany incorporated one of them, a pet parrot, into an embroidered chenille seatcover.[73]

Birds, like flowers and the other innumerable delights of the natural world, were a key feature of Mary Delany's enjoyment of the idyllic landscape at Bulstrode, which she noted in the following letter to her sister: "A pretty and uncommon scene is now before me on the lawn: a flock of sheep, shepherd and dog at a little distance, and in the foreground (to talk like a painter) fifteen or sixteen hares *feeding with peacocks and guinea-fowl*, that make a beautiful mixture of pretty objects...."[74] The duchess also had a menagerie at Bulstrode. The menagerie pavilion was described by Richard Pococke in 1757: "The Dairy is adorn'd with a Chinese front, as a sort of open Summer house."[75] In 1755 Mary Delany drew two creatures there: the "Java Hare"; and the "Fort St. Davids Bull," otherwise known as a zebu (figs. 183, 184). The menagerie was as much an aviary, with birds ranging from the Java sparrow to the Numidian crane.[76] On 18 July 1773 Mrs. Delany drew an exotic bird—"The Secretary" (fig. 185)—at Kenwood, residence of the first Earl of Mansfield, suggesting a continued involvement with ornithology and zoology as part of her broader interest in the natural world as a site for both study and elegant entertainment. In each of these drawings, the delicate lines and soft forms of the animals show them as refined creatures suited to the rarefied atmosphere of Bulstrode and other estates, while at the same time Mrs. Delany's presentation of them as specimens removed from context makes them suitable for display in the context of natural history drawings and publications.

Mrs. Delany also was closely connected to what today would be considered "mainstream" science: the new methods of classification introduced by Linnaeus. Several documents point to Mrs. Delany's active involvement with Linnaean methods, one of which is a 474-page manuscript in her hand that bears the title "A British flora after the sexual system of Linnaeus" (1769; see fig. 15).[77] According to Lady Llanover:

> In another part of this volume are ten sheets superscribed "Mrs. Delany, Bulstrode, 4th December, 1778," with 39 drawings of the crystalline forms of minerals, and the names of 54 species of the "Systema Lapidum" of Linnæus, with 12 pages of English descriptions of them, all by Mrs. Delany's own hand.[78]

Unfortunately, the drawings are no longer with the manuscript and their present location is unknown, but the record of the drawings and the manuscript together show that Mrs. Delany was well versed in the principles of Linnaean classification.

Figure 183: Mary Delany, *Java Hare drawn from the Life by M$^{rs.}$ Delany at Bulstrode 1755*, 1755, ink on paper. Private collection

Another document that reflects Mrs. Delany's engagement with Linnaean methods is a volume in the British Library titled *A Catalogue of Plants Copied from Nature in Paper Mosaick, finished in the year 1778, and disposed in alphabetical order, according to the... names of Linnæus*. The British Library gives Mary Delany as the author of the volume, and her monogram appears on the title page; it also bears the bookplate of Joseph Banks. The book is a catalogue of Mrs. Delany's paper mosaics and includes an alphabetical list of her plants with their Linnaean names. Approximately thirty plants are noted as being "new species," whereas others bear the designation "doubtful," "probable," and "non descript." It is possible that this volume was issued privately, perhaps in collaboration with Banks, whose home served as a publishing workshop during this period. A 1797 catalogue of Banks's library lists the Delany *Catalogue of Plants* in his collection,[79] and Banks sent Mrs. Delany plants from the Royal Gardens at Kew for her paper mosaics.[80]

* * *

At Bulstrode, Mrs. Delany was immersed in a rich intellectual environment in which she was able to pursue her unique approach to studying the natural world she had begun earlier in her life. Her botanical paper mosaics, embroidery, shellwork, and other works show that she was unusually adept at transforming natural specimens into elegant visual images, environments, and objects. During the last decades of her life she incorporated this passion for studying nature, collecting specimens, and making beautiful objects into the new ways of describing and classifying the natural world that were associated with Linnaean methods. Although the products of Mrs. Delany's artistic and scientific explorations were exceptional in their originality, it is important to understand her achievements in the context of the scientific practices and concerns of the period. Her work took place mostly in domestic contexts, being deeply embedded within practices associated with elite domestic life. Yet the natural history and botanical work of Mrs. Delany, the Duchess of Portland, and their associates cannot be categorized as merely hobbies or leisure-time activities any more than can the work of Joseph Banks or other better-known figures. The merging of artistic and scientific pursuits by Mrs. Delany and her circle reflects an important facet of the wide variety of private and public contexts in which the study of nature took place in eighteenth-century England.

Figure 184: Mary Delany, *Fort S^t. Davids Bull - drawn from the Life by M^rs. Delany at Bulstrode 1755*, 1755, ink on paper. Private collection

Figure 185: Mary Delany, *The Secretary*, 1773, ink on paper, 9 × 7¼ in. (22.9 × 18.7 cm). Private collection

Notes

1. On the history of grottoes in England, see Barbara Jones, *Follies and Grottoes*, 2nd ed., rev. (1953; London: Constable and Company, 1974), and Tim Knox, "The Artificial Grotto in Britain," *The Magazine Antiques* 161, no. 6 (June 2002): 100–107. For grottoes in Ireland, see James Howley, *The Follies and Garden Buildings of Ireland* (New Haven: Yale Univ. Press, 1993).

2. C. P. Curran, *Dublin Decorative Plasterwork of the Seventeenth and Eighteenth Centuries* (London: Tiranti, 1967), 21–23. Curran provides several illustrations of Mrs. Delany's shellwork for the interior of Delville, photographed before Delville was demolished in 1951.

3. Mary Pendarves to Anne Granville, 30 June 1734, in Lady Llanover, ed., *The Autobiography and Correspondence of Mary Granville, Mrs. Delany*, 6 vols. (London: Richard Bentley, 1860–61), ser. 1, 1:484–85. On Mrs. Delany's early interest in shells, see Ruth Hayden, *Mrs. Delany: Her Life and Her Flowers* (London: British Museum Publications, 2000), 26.

4. Mary Delany to Anne Dewes, 6 October 1750, in Llanover, ed., *Autobiography and Correspondence*, ser. 1, 2:600.

5. See Edward Malins and the Knight of Glin, *Lost Demesnes: Irish Landscape Gardening, 1660–1845* (London: Barrie and Jenkins, 1976), 41.

6. Mary Delany to Anne Dewes, 19 July 1744, in Llanover, ed., *Autobiography and Correspondence*, ser. 1, 2:315.

7. The grotto's function was a corollary to the spaces of intimacy Mrs. Delany created inside her home. These are discussed in more detail by Maria Zytaruk in her essay in this volume.

8. Mary Delany to Anne Dewes, 9 December 1743, in Llanover, ed., *Autobiography and Correspondence*, ser. 1, 2:238.

9. Jones, *Follies and Grottoes*, 149–50.

10. Knox, "Artificial Grotto in Britain," 104.

11. See the discussion of a snuffbox dating to 1765–75 currently in the Victoria and Albert Museum (C.470-1914), http://collections.vam.ac.uk/ objectid/O77934.

12. The pocket sketchbook is now in a private collection; see Ruth Hayden, "A Wonderfully Pretty Rurality," *Irish Arts Review Yearbook* 16 (2000): 44–50. Mrs. Delany made frequent use of the term "enamelling" in describing the natural world, especially flowers. For discussion of the links between enameling and embroidering in her work, see Mark Laird's essay in this volume.

13. Mary Delany to Anne Dewes, 7 July 1750, in Llanover, ed., *Autobiography and Correspondence*, ser. 1, 2:566.

14. Mary Delany to Anne Dewes, 4 December 1749, in Llanover, ed., *Autobiography and Correspondence*, ser. 1, 2:527.

15. Mary Delany to Anne Dewes, 10 December 1753, in Llanover, ed., *Autobiography and Correspondence*, ser. 1, 3:255.

16. Lisa L. Moore, "Queer Gardens: Mary Delany's Flowers and Friendships," *Eighteenth-Century Studies* 39, no. 1 (Fall 2005): 50.

17. Moore, "Queer Gardens," 54. Mrs. Delany's interior decorating activities are discussed within the broader context of eighteenth-century England in Katherine Sharp, "Women's Creativity and Display in the Eighteenth-Century British Domestic Interior," in Susie McKellar and Penny Sparke, eds., *Interior Design and Identity* (Manchester: Manchester Univ. Press, 2004), 10–26. See also Maria Zytaruk's essay in this volume.

18. Lady Llanover identifies Dorothea Forth Hamilton as "daughter and co-heir of James Forth, of Redwood, King's County, Esq., better known under the name of Mrs. Hamilton, whose paintings of flowers and insects are unrivalled. She married, in October, 1733, the Hon. and Rev. Francis Hamilton, son to the Earl of Abercorn." Llanover, ed., *Autobiography and Correspondence*, ser. 1, 1:319. For a discussion of the Hamiltons, see Clarissa Campbell Orr's essay in this volume.

19. Mary Delany to Anne Dewes, 21 December 1753, in Llanover, ed., *Autobiography and Correspondence*, ser. 1, 3:258.

20. Mary Delany to Anne Dewes, 9 December 1753, in Llanover, ed., *Autobiography and Correspondence*, ser. 1, 3:252. The book with fishes referred to here is probably the same as the "book of paintings of fish" Mrs. Delany left to the Duchess of Portland in her will of 1778; "Appendix," in Llanover, ed., *Autobiography and Correspondence*, ser. 2, 3:483.

21. For further discussion of the dating of the stomacher and its construction, see Clare Brown's essay in this volume.

22. Georg Dionysius Ehret, *Plantae et papiliones rariores, depictae et aeri incisae* ([London]: The author, 1748–59).

23. Mary Delany to Bernard Granville, 22 September 1750, in Llanover, ed., *Autobiography and Correspondence*, ser. 1, 2:593.

24. Mary Delany to Bernard Granville, 22 September 1750, in Llanover, ed., *Autobiography and Correspondence*, ser. 1, 2:593n1.

25. "Appendix," in Llanover, ed., *Autobiography and Correspondence*, ser. 2, 3:506.

26. Mary Delany to Anne Dewes, 5 January 1759, in Llanover, ed., *Autobiography and Correspondence*, ser. 1, 3:534.

27. Mary Delany to Mrs. Frances Hamilton, 17 November 1780, in Llanover, ed., *Autobiography and Correspondence*, ser. 2, 2:578.

28. Ehret dedicated his illustration of the ginger plant (plate XIV) in his *Plantae et papiliones rariores* to the Duchess of Portland. Notable eighteenth-century illustrated books on insects published in England include Eleazar Albin, *A Natural History of English Insects* (London: Printed for the author, 1720); Dru Drury, *Illustrations of Natural History*, 3 vols. (London: Printed for the author, 1770–82); Moses Harris, *The Aurelian: A Natural History of English Moths and Butterflies, Together with the Plants on Which They Feed* (London: Printed for the author, 1766); Benjamin Wilkes, *The English Moths and Butterflies: Together with the Plants, Flowers, and Fruits Whereon They Feed, and Are Usually Found* (London: Printed for the author, 1749). See David Elliston Allen, *The Naturalist in Britain: A Social History* (1976; repr., Princeton: Princeton Univ. Press, 1994), 22–44.

29. Maria Sibylla Merian, *Metamorphosis insectorum Surinamensium* (Amsterdam: Printed for the author, 1705).

30. For further discussion of Merian's decorative arts and natural history activities within the context of earlier visual representations of insects, see Janice Neri, *The Insect and the Image: Visualizing Nature in Early Modern Europe, 1500–1700* (forthcoming). The connections between female patrons and entomological pursuits are discussed in Mark Laird, *The Environment of English Gardening, 1660–1800* (forthcoming).

31. According to Katherine Porter, Mrs. Delany and the Duchess of Portland exchanged many letters during Mrs. Delany's residence in Ireland, but "very little of their correspondence from this or any other period has been preserved." Katherine Porter, "Margaret, Duchess of Portland" (PhD diss., Cornell University, Ithaca, N.Y., 1930), 72.

32. Mary Delany to Anne Dewes, 3 October 1745, in Llanover, ed., *Autobiography and Correspondence*, ser. 1, 2:391.

33. Mary Delany to Anne Dewes, 17 December 1749, in Llanover, ed., *Autobiography and Correspondence*, ser. 1, 2:532.

34. Mary Delany to Anne Dewes, 22 December 1749, in Llanover, ed., *Autobiography and Correspondence*, ser. 1, 2:533.

35. Mary Delany to Anne Dewes, in Llanover, ed., *Autobiography and Correspondence*, ser. 1, 2:602–3 (13 October 1750), and 592–93 (22 September 1750): "I have pulled my old lustre to pieces, and am going to make one just like the Duchess's."

36. Mary Delany to Anne Dewes, 21 December 1753, in Llanover, ed., *Autobiography and Correspondence*, ser. 1, 3:258.

37. Rebecca Stott, *Duchess of Curiosities: The Life of Margaret, Duchess of Portland*, exh. cat. (Welbeck, U.K.: The Harley Gallery, 2006). I am grateful to Derek Adlam, curator of the Portland Collection at The Harley Gallery, for making available the checklist of items on display for the "Duchess of Curiosities" exhibition.

38. Stott, *Duchess of Curiosities*, 5. Pieces from this dessert service are also described in James Garrard, *A Catalogue of Gold and Silver Plate: The Property of His Grace the Duke of Portland, with Pen and Ink Sketches of the Arms, Crests, and Mottoes, and Full Description, and Date of Each Piece* (London: The Chiswick Press, 1893).

39. See Mark Laird's essay in this volume for further discussion of table decorations.

40. Porter, "Margaret, Duchess of Portland," 106–7. On the Duchess of Portland's patronage of natural history, see Allen, *Naturalist in Britain*, 25–26. For a discussion of featherwork, see Maria Zytaruk's essay in this volume.

41. Porter, "Margaret, Duchess of Portland," 145. Mary Delany to Miss Mary Port, 1 August 1779, in Llanover, ed., *Autobiography and Correspondence*,

ser. 2, 2:449. For a details of the Duchess of Portland's flower gardens and the evolution of Bulstrode as a pleasure ground, see Mark Laird, *The Flowering of the Landscape Garden: English Pleasure Grounds, 1720–1800* (Philadelphia: Univ. of Pennsylvania Press, 1999), 221–24. See also Sally Festing, "The Second Duchess of Portland and Her Rose," *Garden History* 14, no. 2 (Autumn 1986): 194–200.

42. For further information on Grimm, see Rotha Mary Clay, *Samuel Hieronymus Grimm of Burgdorf in Switzerland* (London: Faber and Faber, 1941), and J. H. Farrant, "Sussex Depicted: Views and Descriptions, 1600–1800," *Sussex Record Society* 85 (2001): 45–50.

43. Porter, "Margaret, Duchess of Portland," 201.

44. Mary Delany to Anne Dewes, December 1754, in Llanover, ed., *Autobiography and Correspondence*, ser. 1, 3:309.

45. Mary Delany to Lady Andover, 24 November 1768, in Llanover, ed., *Autobiography and Correspondence*, ser. 2, 1:192.

46. Porter, "Margaret, Duchess of Portland," 201.

47. Alan W. Armstrong, ed., *"Forget not Mee & My Garden…" : Selected Letters, 1725–1768, of Peter Collinson, F.R.S.* (Philadelphia: American Philosophical Society, 2002), 282 (letter of 18 July 1768). See also Joseph Kastner, *A Species of Eternity* (New York: Knopf, 1977), 83.

48. Paul F. S. Cornelius and Patricia A. Cornelius, "Ellis, John (c. 1710–1776)," in H. C. G. Matthew and Brian Harrison, eds., *Oxford Dictionary of National Biography*, (Oxford: Oxford Univ. Press, 2004), online ed., ed. Lawrence Goldman, May 2005, www.oxforddnb.com/view/article/8703 (accessed 13 February 2008).

49. Porter, "Margaret, Duchess of Portland," 216.

50. John Ellis, *The Natural History of Many Curious and Uncommon Zoophytes Collected from Various Parts of the Globe…* (London: B. White and Son, 1786), 88.

51. Ellis, *Natural History of… Zoophytes*, 159, t.45.

52. Mary Delany to Mary Dewes Port, 19 November 1771, in Llanover, ed., *Autobiography and Correspondence*, ser. 2, 1:374.

53. Jean K. Bowden, *John Lightfoot, His Work and Travels, with a Biographical Introduction and a Catalogue of the Lightfoot Herbarium* (Kew: Bentham-Moxon Trust, Royal Botanic Gardens; Pittsburgh: Hunt Institute for Botanical Documentation, Carnegie Mellon Univ., 1989).

54. Mary Delany to the Viscountess Andover, 3 May 1771, in Llanover, ed., *Autobiography and Correspondence*, ser. 2, 1:337.

55. Mary Delany to Bernard Granville, 10 October 1774, in Llanover, ed., *Autobiography and Correspondence*, ser. 2, 2:39.

56. Mary Delany to Mary Dewes, 17 September 1769, in Llanover, ed., *Autobiography and Correspondence*, ser. 2, 1:240.

57. Duchess of Portland to Mary Delany, 12 September 1771, in Llanover, ed., *Autobiography and Correspondence*, ser. 2, 1:358–59.

58. James Bolton's painting is in the Morgan Library and Museum, New York (1978.9:1), with others.

59. John Edmondson, *James Bolton of Halifax* (Liverpool: National Museums & Galleries on Merseyside, 1995), foreword.

60. Edmondson, *James Bolton*, 2. Bolton's brother Thomas, who was an artist and shared his interest in botany and natural history, also sent specimens and drawings to the duchess (5–6).

61. Edmondson, *James Bolton*, 2–4. There is no evidence that Ehret and Bolton met, but Bolton copied a number of Ehret's drawings. E. C. Nelson, "James Bolton's Botanical Paintings and Illustrations, and His Association with Georg Ehret," *The Naturalist* 106 (1981): 141–47.

62. In addition to his published works, Bolton left many collections of drawings, details of which can be found in Edmondson, *James Bolton*, passim.

63. Edmondson, *James Bolton*, 39. The duchess's patronage of James and Thomas Bolton is also discussed in Nelson, "James Bolton's Botanical Paintings," 145.

64. As quoted in Edmondson, *James Bolton*, 39–40. Since the duchess died before the book appeared in print, Bolton dedicated the published version to the Earl of Gainsborough. The duchess also might have provided specimens to Bolton; see P. J. Roberts and N. W. Legon, "Fungal Specimens of James Bolton at Kew," *Kew Bulletin* 58 (2003): 759–61.

65. Nelson, "James Bolton's Botanical Paintings," 146n1.

66. The project was recently published as the *Banks' Florilegium: A Publication in Thirty-four Parts of Seven Hundred and Thirty-eight Copperplate Engravings of Plants Collected on Captain James Cook's First Voyage round the World in H.M.S. Endeavour, 1768–1771*, 34 parts (London: Alecto Historical Editions and the British Museum [Natural History], 1980–90). For more on the drawings and publication history of *Banks' Florilegium*, see Judith A. Diment et al., eds., *Catalogue of the Natural History Drawings Commissioned by Joseph Banks on the Endeavour Voyage, 1768–1771, Held in the British Museum (Natural History)*, vol. 1, *Botany: Australia*, Bulletin of the British Museum (Natural History), Historical Series, vol. 11 (London: British Museum, 1984).

67. The disagreement appears in letters exchanged between the Duchess of Portland and Joseph Banks in June 1782; State Library of New South Wales, Series 74.04 (Banks to Portland, 10 June 1782) and Series 72.134 (Portland to Banks, 12 June 1782).

68. On the authorship of the Portland sale catalogue and its relationship to Solander's research, see S. P. Dance, "The Authorship of the Portland Catalogue (1786)," *Journal of the Society for the Bibliography of Natural History* 4 (1962–68): 30–34, and E. Alison Kay, "The Reverend John Lightfoot, Daniel Solander, and the Portland Catalogue," *Nautilus* 79, no. 1 (July 1965): 10–19.

69. Thomas Martyn, *The Universal Conchologist: Exhibiting the Figure of Every Known Shell, Accurately Drawn, and Painted after Nature, with a New Systematic Arrangement*, 4 vols. (London: Printed for the author, 1784).

70. Subscribing to such publications was an important element in Mrs. Delany's immersion in a "metropolitan culture of horticulture," as evidenced by her subscription (as Mary Pendarves) to Robert Furber's *Twelve Months of Flowers*, discussed in Mark Laird's essay in this volume.

71. Llanover, ed., *Autobiography and Correspondence*, ser. 1, 3:333. The plates were available by subscription from 1755, and later published as Philip Miller, *Figures of the Most Beautiful, Useful, and Uncommon Plants Described in The Gardeners Dictionary*, 2 vols. (London: Printed for the author, 1760).

72. On the history of shell collecting in Europe, see S. Peter Dance, *A History of Shell Collecting*, rev. ed. (Leiden: Brill, 1986). For Rococo interior design and motifs from nature, see Katie Scott, *The Rococo Interior: Decoration and Social Spaces in Early Eighteenth-Century Paris* (New Haven: Yale Univ. Press, 1995), and Emma C. Spary, "Rococo Readings of the Book of Nature," in Marina Frasca-Spada and Nicholas Jardine, eds., *Books and the Sciences in History* (Cambridge: Cambridge Univ. Press, 2000), 255–75.

73. "We have just breakfasted, and the little Jonquil parrot with us; it is the prettiest good-humoured little creature I ever saw. The chaise is at the door, we are going to consult about the cave." Mary Delany to Mary Dewes, 6 September 1768, in Llanover, ed., *Autobiography and Correspondence*, ser. 2, 1:161.

74. Mary Delany to Mary Dewes, 4 October 1768, in Llanover, ed., *Autobiography and Correspondence*, ser. 2, 1:172.

75. John D. Hunt and Peter Willis, eds., *The Genius of the Place: The English Landscape Garden, 1620–1820*, 2nd ed. (Cambridge, Mass.: MIT Press, 1990), 267.

76. Sally Festing, "Menageries and the Landscape Garden," *Journal of Garden History* 8, no. 4 (October–December 1988): 104–17.

77. For discussion of this manuscript in the context of the introduction of Linnaean classification in England, see Mark Laird's essay in this volume. For further discussion of Mrs. Delany's taxonomic background, see John Edmondson's essay in this volume.

78. Llanover, ed., *Autobiography and Correspondence*, ser. 2, 1:243. The manuscript, without the mineral drawings, is now in the Dumbarton Oaks Research Library and Collection. My thanks to Linda Lott, Librarian, Rare Book Collection, for her assistance in determining that the drawings are no longer bound with this manuscript, and to Richard Hatchwell for information regarding the mineral drawings.

79. Jonas Dryander, *Catalogus bibliothecae historico-naturalis Josephi Banks regii a consiliis intimes Baroneti, balnei, equitis, regia societatis praesidis… 3. Botanici.*, 5 vols. (London, 1797), 3:69.

80. Hayden, *Mrs. Delany*, 136.

[9]

NOVELTY IN NOMENCLATURE:
The Botanical Horizons of Mary Delany

Horace Walpole, the fourth Earl of Orford, was loaned a copy of William Gilpin's *Remarks on Forest Scenery* by Mrs. Delany in January 1782.[1] In a letter to William Mason, he wrote: "Mrs Delany has lent me another most pleasing work of Mr. Gilpin—his 'Essay on Forest Trees' considered in a picturesque light. It is perfectly new, truly ingenious, full of good sense in an agreeable style, and void of all affectation."[2]

Those words could apply equally to the patient work of creating botanical collages. In concept, Mary Delany's works were "perfectly new"; I know of no precedent for creating such a faithful record using colored tissue paper. "Truly ingenious" is also appropriate, as great skill was shown in selecting plant material for illustration; and the popularity of the collages among visitors to the British Museum attests to their "agreeable style." To be "void of all affectation" would be high praise indeed, given the circles in which Mrs. Delany moved, but I believe this to be so. She appears to have pursued her botanical studies for no reason other than personal satisfaction.

To appreciate the significance of Mrs. Delany's botanical collages, one needs to understand the state of botanical knowledge in the latter half of the eighteenth century. The science of botany was in flux, largely thanks to the Swedish naturalist Carl Linnaeus, who revolutionized the naming and classification of plants. Gone were the unwieldy, long-winded descriptive phrase-names of the pre-Linnaean era, such as *Quamoclit pennatum, erectum, floribus in thyrsum digestis* Dillenius (see fig. 203, as *Ipomopsis rubra* (L.) Wherry); instead, terse, memorable binomials were coming into use (compare fig. 202). A *binomial* is a combination of the generic and specific epithets that form the scientific name of a species. Together with an *authority*—the name of the author who first published the new name—the binomial passes muster as a nomenclatural label. For example, Mrs. Delany's first-numbered collage is labeled 'Acanthus spinosus'; *Acanthus* is the

generic name, and *spinosus* the specific one. The epithet "spinosus" may apply to one of several genera (for example, *Catesbaea spinosa*, its ending changed to agree with the gender of the genus to which it is attached), but a generic name can apply to only one entity. *Acanthus spinosus* L. (short for Linnaeus) is still the accepted name today.

Latin, as the universal language of botany in the eighteenth century, was capable of assimilating names from many other world languages, as with some of Thunberg's Japanese discoveries. A few of Mrs. Delany's collages have captions citing Chinese names (see, for example, fig. 200), and some are even written in Chinese characters, such as that for 'Saxifraga stolonifera' (see plate 23 in "Theater").

Linnaeus's great work *Species Plantarum* had been published in Stockholm in 1753.[3] Although its impact was initially muted, by 1762 its concise method of naming species began to be adopted in England and beyond. Some practitioners, however, such as the artist Georg Dionysius Ehret (fig. 186) continued to caption their botanical drawings with long phrase-names throughout the 1760s. *Flora Anglica* of 1762, compiled by the pharmacist William Hudson of Kendal, was the first work published in England to employ the binomial system.[4] The popularity of this work, which rapidly superseded Sir John Hill's *The Vegetable System*, was such that it soon changed hands for more that twenty times its original price of seven shillings.[5] Hudson served as *Praefectus et praelector* of the Chelsea Physic Garden from 1765 to 1771 and published a second edition of his *Flora* in 1778. It was the 1762 edition that Mrs. Delany used when she began her English adaptation of the *Flora* as a manuscript at Bulstrode in 1769 (see fig. 15).

Another early work in which Linnaeus's binomial system was adopted was published by the Quaker botanist James Jenkinson in 1775.[6] This was adapted from Linnaeus's *Species Plantarum* and *Genera Plantarum*, and gives precise locations

for plants growing around Yealand in Lancashire. Such works were the forerunners of a host of local Floras adopting the Linnaean system, which listed the plants to be found in a British county. One such Flora, that of Buckinghamshire, written by George C. Druce and published in 1926, drew heavily on Mrs. Delany's records of Bulstrode rarities.[7]

Not content with revolutionizing the scientific *naming* of plants and animals, Linnaeus introduced a second innovation: he proposed a new method of *classifying* the plant kingdom. This was his "sexual system," which employed a simple method of counting the number of stamens and pistils in a flower. The method enabled a non-expert to assign the plant to one of twenty-six classes named after the number of sexual parts, such as Monandria Monogynia (with one stamen and one pistil) or Pentandria Digynia (with five stamens and two pistils). Although artificial in that it failed to group plants according to their natural affinities, it served a very useful purpose in helping people learn how to classify plants. It was soon popularized in England by the nurseryman James Lee.[8] Lee was to supply specimens to Mrs. Delany as subjects for her collages in the late 1770s and early 1780s, as Lisa Ford discusses in this volume. It was only in the early nineteenth century that Linnaeus's system was superseded by a more natural arrangement, based on overall relationships.

Linnaeus's third innovation was to rationalize the terminology applied to the description of plants. To him we largely owe the dialect known as "botanical Latin," which differs in significant respects from the language of classical times. By improving communication of the attributes of plants through written descriptions, Linnaeus made the scientific description of plants more accurate, defining terms more precisely and outlawing ambiguous expressions.

Mary Delany must have been familiar with Linnaeus's sexual system, as were those in the

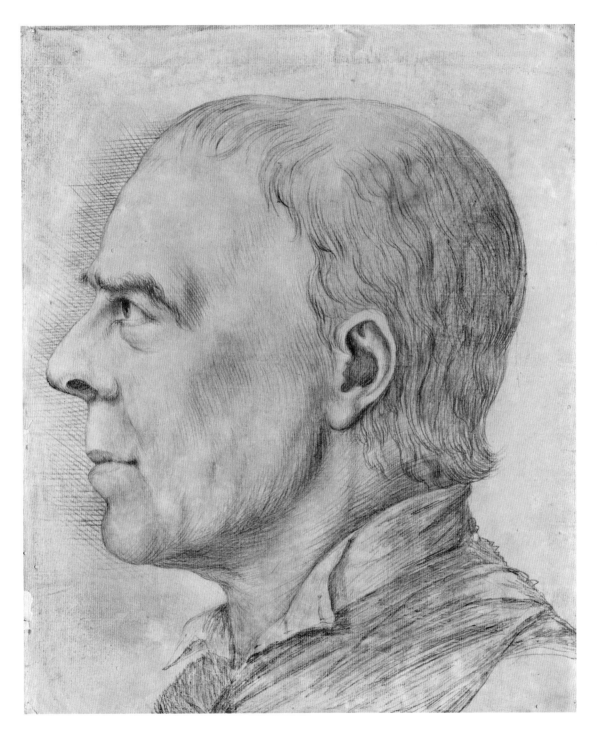

Figure 186: Georg Dionysius Ehret, *Self-Portrait*, ca. 1750,
graphite on laid, handmade paper laminate with watermarks,
15⁹⁄₁₆ × 12½ in. (39.5 × 31.8 cm). Chelsea Physic Garden, London

circle of botanists in which she moved. One such enthusiast—John Stuart, third Earl of Bute—published his *Botanical Tables* circa 1785 "solely for the amusement of the fair sex" and only twelve—or, according to one account, sixteen—copies were printed.[9] He makes it clear that his purpose was to interpret the Linnaean system of classification with the help of figures drawn by his artist, the German-born John Miller. We know from the annotations on the reverse sides of some of the Delany collages that Lord Bute supplied Mrs. Delany with plant specimens from 1776 onward.[10] Volume 9 of Bute's *Botanical Tables* includes "Some observations on the terms employed in botany," the illustrations for which were adapted, with only minor modifications, from those in Miller's *An Illustration of the Termini Botanici of Linnaeus* (1789).[11]

The inspiration for the adoption of Linnaeus's binomial system in England may initially have come from the German-born botanical artist Georg Dionysius Ehret, who illustrated Linnaeus's *Hortus Cliffortianus* in 1737 before settling in England as a botanical artist and art teacher.[12] Ehret was also responsible for the first version of a table illustrating Linnaeus's sexual system (fig. 187), which Linnaeus copied without acknowledgment in his own publications. There is evidence, from the early work produced by Ehret before his encounter with Linnaeus in Holland, that he already took notice of the finer details of the parts of a flower in his drawings.[13] A collection of Ehret's work from his early adult career in Germany titled *Deliciae Botanicae* (formerly in the Earl of Derby's Knowsley library and now in the collections of National Museums Liverpool) includes paintings where the flowers are represented separately (fig. 188).

Figure 187: Georg Dionysius Ehret, *Tabella of Linnaeus's Sexual System*, 1736, ink, watercolor, and graphite on paper. Natural History Museum, London

Figure 188: "Yucca aloifolia". An illustration from a volume of Ehret's watercolor studies titled *Deliciae Botanicae* (ca. 1732), prepared while he was still in Germany and before he encountered Carl Linnaeus. National Museums Liverpool (LIV.1991.32)

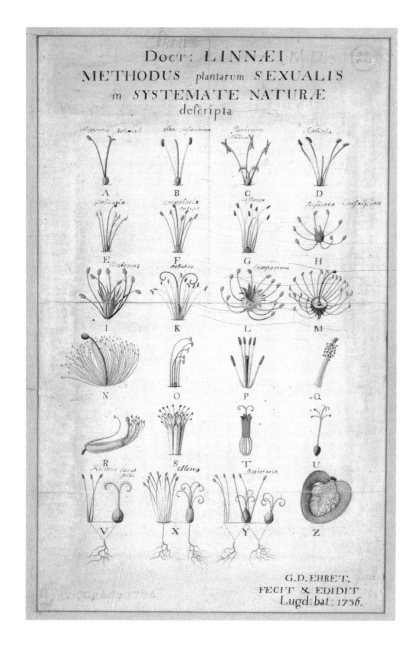

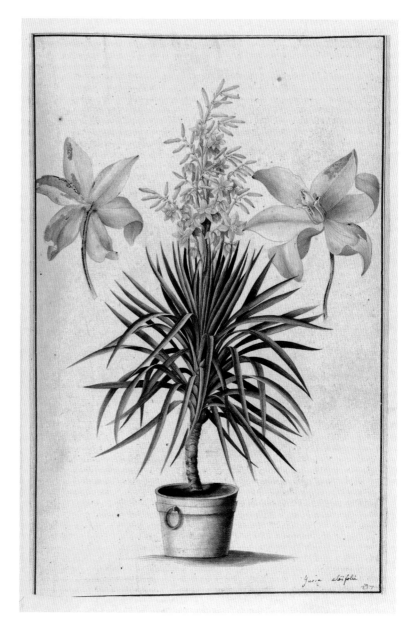

Ehret was a regular visitor to Bulstrode, working as an art teacher to the young ladies. He doubtless enjoyed the company of such enthusiastic botanists as Mrs. Delany, the Duchess of Portland, and the duchess's resident chaplain, the Rev. John Lightfoot (fig. 189), who owed his living at Uxbridge to her patronage.

Another major botanical figure in Mrs. Delany's circle, Dr. John Fothergill (fig. 190) was a physician by training and a botanist by inclination.[14] Fothergill was a friend and correspondent of the Duchess of Portland, so it is unsurprising to discover that he was the source of several plants figured by Mrs. Delany. Fothergill allowed John Miller to illustrate plants from his private botanical collection at Upton, East London. The resulting work, *Illustratio systematis sexualis Linnaei*, was published over the period 1770–77, which both precedes and overlaps with the period when Mrs. Delany began to compose her botanical collages.[15]

Mary Delany's friendship with the Dowager Duchess of Portland led to a convergence of interest in natural history. Access to original plant material, usually but not always named, was crucial to the process of composing such a wide range of collages. In creating nearly a thousand, mostly from garden subjects, Mrs. Delany perhaps unwittingly established an important record of plants then in cultivation in England. The dates of their first introduction are recorded in William Aiton's *Hortus Kewensis* of 1789. Aiton (fig. 191), a native of Hamilton, Lanarkshire, came to work with Philip Miller at Chelsea Physic Garden in 1754. He was recommended to Princess Augusta in 1759 as being well equipped to transform the royal gardens at Kew into a botanic garden of international standing. He spent the rest of his career at Kew, and in the book's dedication to George III he reveals that it was compiled in leisure moments over a period of more than sixteen years. In this work he was assisted by Sir Joseph Banks's librarian and field assistant, Daniel Carlsson Solander (fig. 192), whose unpublished manuscript names often appear on Mrs. Delany's collages tagged "Solander" or "Solandri." Solander's successor, Jonas Carl Dryander, also assisted in the preparation of *Hortus Kewensis*, but his input largely took place after Mrs. Delany had completed her collages. Even so, some of the species she illustrated would be named by Dryander, and, along with many others named by Solander and Aiton, were validly published for the first time in *Hortus Kewensis*.

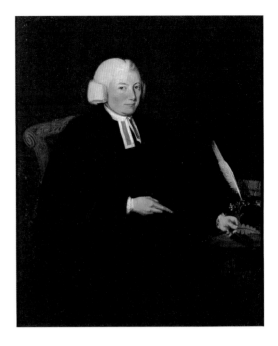

Figure 189: Artist unknown, *Rev. John Lightfoot*, oil on canvas, 50 × 40 in. (127 × 102 cm). Linnean Society of London (C12939)

Figure 190: *Dr John Fothergill*, oil on canvas, 82 × 50 in. (208 × 127 cm). Ackworth School, West Yorkshire. Fothergill founded Ackworth School in 1779; a plan of the school's garden is displayed on the table

Figure 191: Originally attributed to J. Zoffany, *William Aiton*, ca. 1780s, oil on canvas. Royal Botanic Gardens, Kew

Figure 192: *Daniel Carlsson (later Charles) Solander (1733–1782), Sir Joseph Banks's Assistant and Later Librarian*. Linnean Society of London

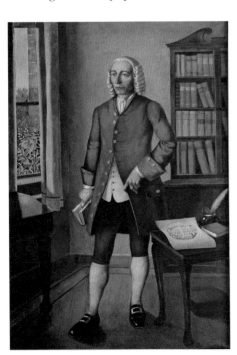

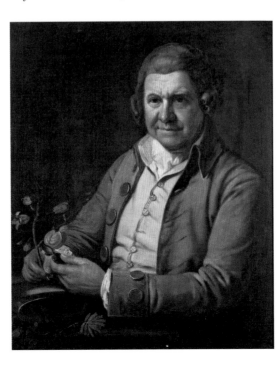

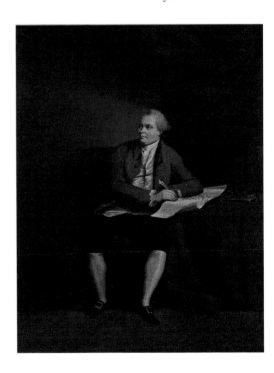

Figure 193: Mary Delany, 'Primula Veris elatior',
1777, collage of colored papers, with bodycolor and
watercolor, 12⅜ × 8⅝ in. (31.4 × 22 cm). British
Museum, Department of Prints and Drawings
(1897,0505.705)

Figure 194: Mary Delany, 'Ophris apifera', 1779,
collage of colored papers, with bodycolor and
watercolor, 11⅝ × 7⅝ in. (29.6 × 19.5 cm).
British Museum, Department of Prints and
Drawings (1897,0505.620)

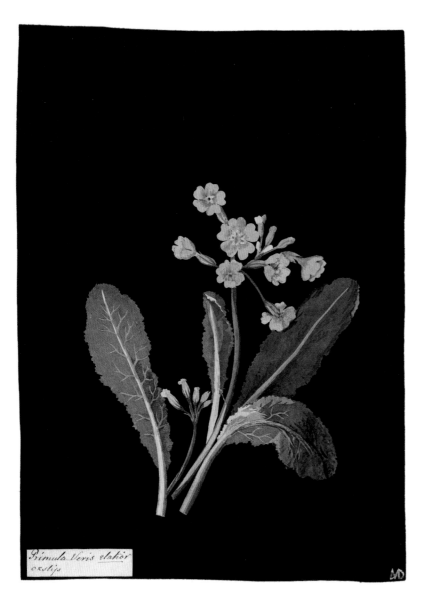

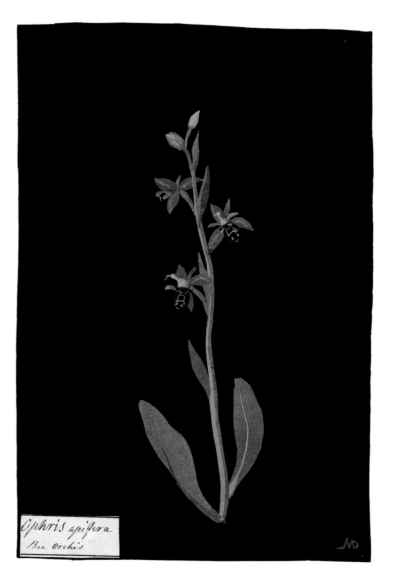

The botanical names used by Mary Delany were mainly those published by Carl Linnaeus in *Species Plantarum* (1753). Indeed nearly seven hundred of the collages represent plants that were named in the first edition, and a further forty-five in the second edition, accounting for more than 75 percent of the names. Thirty-two more were first named in volume 2 of Linnaeus's *Systema Naturae* (1758),[16] the first edition of this work to employ binomial nomenclature, including *Portlandia grandiflora* (see plate 24 in "Theater"), which commemorates the Duchess of Portland.

Mary Delany did occasionally apply species names to her collages that Linnaeus had treated only as varieties. For example, her 'Primula veris elatior' (fig. 193) and 'Primula vulgaris acaulis' were regarded as varieties of *Primula veris* in the first edition of *Species Plantarum*. It was due to Sir John Hill that they were elevated to the rank of species. Hill worked for the eighth Baron Petre of Thorndon Hall, whose *hortus siccus* (now in the Sutro Library, San Francisco) he arranged. Hill also had family connections with a former owner of Bulstrode, as described by Druce.[17] Hill treated the primrose, now known as *Primula vulgaris* Hudson, as *P. acaulis* L. (published in 1754 in a thesis defended by Linnaeus's pupil Grufberg). However, it was argued by Richard Brummitt and Desmond Meikle that the typographic inconsistency of the thesis invalidated the new combination, leaving Hudson's name to stand.[18] The collage shown in fig. 193 probably represents the false oxlip, not true oxlip. Mark Gurney, a *Primula* specialist, suggested this identification because of the shape of the inflorescence, with long straggly pedicels, and the rather small rounded flowers. False oxlip is a naturally occurring hybrid between cowslip (*P. veris*) and primrose (*P. vulgaris*). Philip Miller, in his *Gardeners' Dictionary* (8th ed., 1768) named it *Primula* x *polyantha*.

Only nine of the names on Mrs. Delany's collages were for species described for the first time in Hudson's *Flora Anglica*; for example, her 'Ophris apifera' (the bee orchid, fig. 194). The nine include several plants native to the area around Bulstrode, such as her 'Epilobium ramosum', the great willowherb. Some, like her 'Sparganium ramosum' branched bur-reed, are not particularly garden-worthy and could have been gathered in the wild. On the other hand, there is evidence that the Duchess of Portland cultivated natives in her "botanic garden" at Bulstrode, as discussed by Mark Laird in this volume. Druce long ago pointed out the difficulty of determining native from cultivated material. The threat posed to native species by collectors bringing them into cultivation had been identified by William Curtis in his description of the bee orchid in *Flora Londinensis* (fig. 195): "The great resemblance which the flower bears to a Bee, makes it much sought after by Florists, whose curiosity indeed, often prompts them to exceed the bounds of moderation, rooting up all they find, without leaving a single specimen to chear the heart of the Student in his botanic excursions."[19]

Figure 195: William Kilburn, *Ophrys apifera*, watercolor drawing for William Curtis, *Flora Londinensis*, vol. 1 (London, 1777 [1775]), pl. 66. Royal Botanic Gardens, Kew

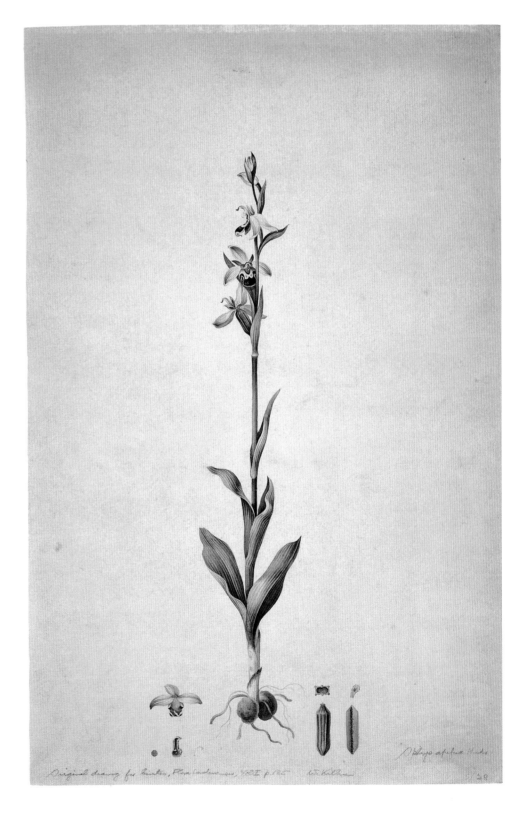

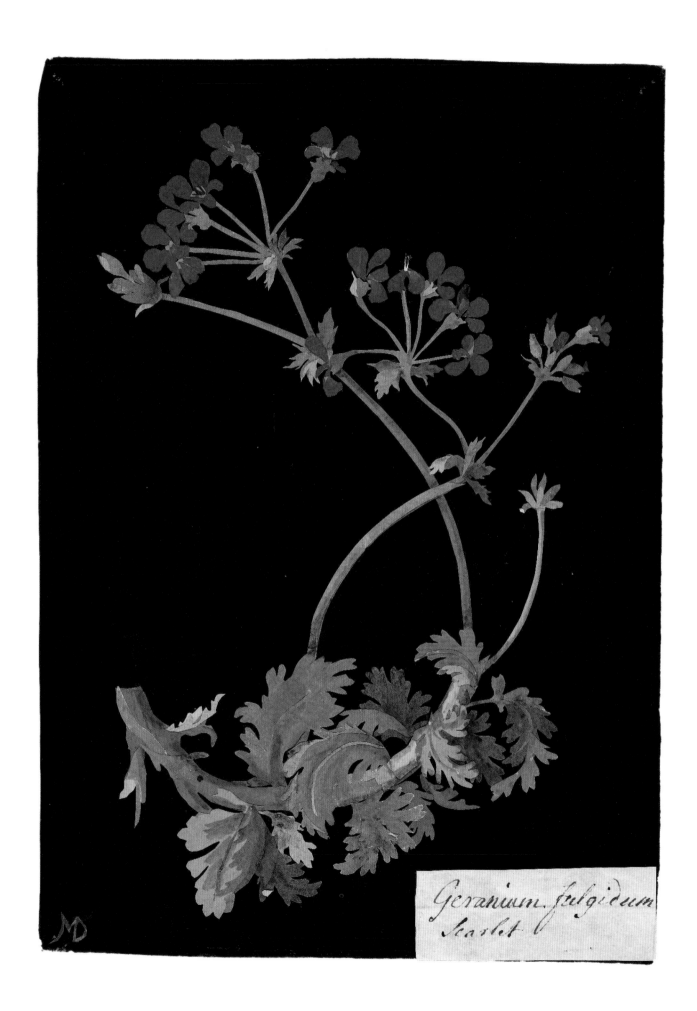

Geranium fulgidum
Scarlet

Mary Delany's fondness for cranesbills and their relatives is demonstrated by the fact that she made no fewer than thirty-six collages of them (the largest single group). Under the generic name *Geranium*, she included species mostly from southern Africa that are now placed in the genus *Pelargonium*. An example is her 'Geranium fulgidum' of 1775 (fig. 196), now known as *Pelargonium fulgidum*. This genus was first distinguished and named by Charles Louis L'Héritier de Brutelle in order to accommodate those plants previously included in *Geranium* having irregular flowers and only 5–7 fertile stamens, the rest being reduced to anther-less filaments. L'Héritier's treatments of these species were first published in Aiton's *Hortus Kewensis* of 1789.[20] Although a manuscript of his work on this group (with plates issued in Paris in 1787/88, e.g. a depiction of *Pelargonium quercifolium*, fig. 197) had been circulating among British botanists, it was not published as *Geraniologia* in L'Héritier's lifetime and indeed it was only at the posthumous sale of his library in 1802 that printed copies first came to light. The names for South African Geraniaceae illustrated in the Booth Grey collages, discussed below, did employ *Pelargonium*, which came into general use after 1789.

Several of Mrs Delany's collages were annotated only with unpublished names. During her lifetime, the rules of nomenclature were rudimentary (although the principle of priority of publication determining validity was broadly accepted). She was evidently happy to quote names that were in use in horticulture even if they had never been properly published. Some of these were Daniel Carlsson Solander's names, which had been attached to plants brought back from Australasia and the South Pacific by Captain James Cook's first circumnavigation of 1768–71. An example can be found in the collage she prepared in 1778 of 'new Zeland Tea,' which she annotated 'Philadelphus aromaticus Solander' (see plate 22 in "Theater"). This name was first mentioned in Solander's manuscript titled "Primitiae florae Novae Zelandiae", and remained unpublished until 1789 when it appeared in Aiton's *Hortus Kewensis*. In 1775, following Cook's second circumnavigation, the botanist Johann Reinhold Forster published a new genus *Leptospermum* to accommodate this plant, and it became the valid name of the genus. Solander's species name 'aromaticus' was a later invalid synonym of Forster's, with the result that the New Zealand tea tree, called "Manuka" by the native Maori, is now known as *Leptospermum scoparium*. It was rapidly propagated by British horticulturists, and was offered for sale by Robert Anderson, nurseryman of Edinburgh, only a couple of years after the conclusion of Cook's first voyage.[21]

Many other plants figured in Mrs. Delany's collages were sourced from Kew; indeed there are 76 collages annotated with this provenance, the largest category from a total of 190 provenanced records. In general, their nomenclature accords with that published in 1789 in Aiton's *Hortus Kewensis*. One example is *Vaccinium diffusum*, which was (according to Aiton) introduced to Kew in 1765 by John Cree (the elder), who collected plants in Carolina in the 1760s before returning to found a nursery at Addlestone near Chertsey.[22] Cree is known to have supplied many new plants to Princess Augusta at Kew, including *Vaccinium amoenum*, which he had growing at Addlestone in 1785. This species was figured as one of the Booth Grey collages.

Figure 196: Mary Delany, 'Geranium fulgidum', 1775, collage of colored papers, with bodycolor and watercolor, 9½ × 6⅝ in. (24.2 × 16.9 cm). British Museum, Department of Prints and Drawings (1897,0505.391)

Figure 197: Louis Fréret, *Pelargonium quercifolium*, from Charles Louis L'Héritier de Brutelle, *Geraniologia* (plates issued in Paris, 1787–88), t. 14. Library of the Gray Herbarium, Harvard College Library

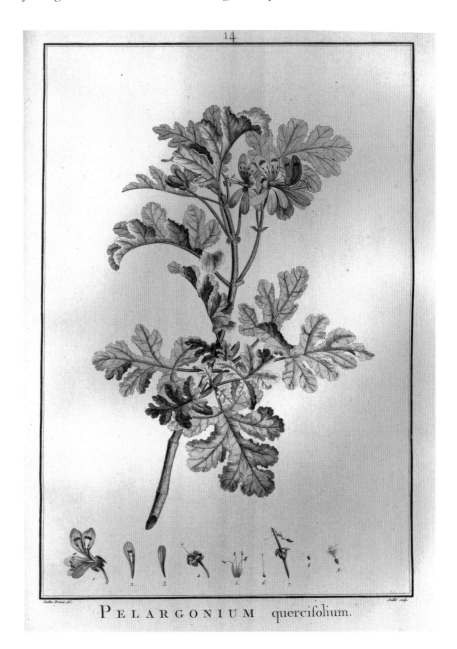

PELARGONIUM quercifolium.

Not all the plants portrayed in her collages were of royal provenance. Some of them had been introduced to cultivation in England by the Duchess of Portland. For example, according to *Hortus Kewensis*, *Allium inodorum*, a native of Carolina, was first introduced by the duchess in 1776, five years before Mrs. Delany composed a collage of that species. Furthermore, Lisa Ford's essay demonstrates how the duchess quickly acquired newly introduced species, for example a *Pelargonium* brought back to Kew from the Cape by Francis Masson in 1774. As with *Allium inodorum*, there is a gap of only four years between first cultivation and first representation in a collage. There was also her 'Geranium trigonum'—portraying a new species from the Cape that is identified in the inscription as having been named by Solander. *Phlox* was one North American genus in which the duchess had superlative collections, as noted by Mark Laird in his essay in this volume. 'Phlox suaveolens' is an example, illustrated by both Mrs. Delany and the artist of

the Booth Grey collages. Mrs. Delany used a specimen gathered from the duchess's garden, whereas the Booth Grey specimen perhaps came from some related family collection.[23]

Other exotics were illustrated first in *Hortus Kewensis* and later made the subject of a collage by the artist of the Booth Grey collages. An example is *Calceolaria fothergillii* (fig. 198). This was, according to Aiton, introduced into cultivation in 1777 by Dr. John Fothergill from the Falkland Islands, probably from Captain James Cook's second voyage. Although the Booth Grey collage is undated, it must have been compiled after that date; Fothergill died in 1780, only three years after the plant was first cultivated in England. The plants in his botanic garden at Upton were catalogued in that same year by J. C. Lettsom.[24] The Booth Grey collage closely resembles the illustration of this species in *Hortus Kewensis* (fig. 199), but this might be coincidental and does not mean it was copied from the same source.[25]

Figure 198: Attributed to Booth Grey, 'Calceolaria Fothergilea', ca. 1790, watercolor collage on laid paper prepared with watercolor, 10½ × 7¼ in. (26.7 × 19.1 cm). Yale Center for British Art, Paul Mellon Fund

Figure 199: Daniel McKenzie after James Sowerby, *Calceolaria Fothergillii*, engraving, in William Aiton, *Hortus Kewensis*, vol. 1, 30, t.1 (1789). Natural History Museum, London

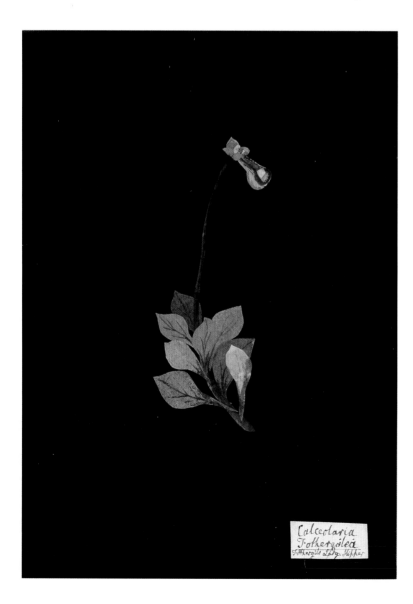

In a few cases Mrs. Delany gave the plant in one of her collages a name that had never been published. One example is her 'Olea odoratissima Soland.' (fig. 200) of 1777, which was based on a specimen supplied by Dr. William Pitcairn (fig. 201), a physician at St. Bartholemew's Hospital in London from 1750 to 1780. Pitcairn employed botanical collectors in both East and West Indies, and was a friend of Dr. John Fothergill; like Fothergill, Pitcairn had a botanic garden from which he supplied specimens to Chelsea Physic Garden.[26] He also supplied dried plants to Sir Joseph Banks, which, as Daniel Solander was Banks's curator, offers an explanation as to why the plant should bear an unpublished Solander name. The plant depicted in 'Olea odoratissima Soland.' has been identified as *Osmanthus fragrans*, published in 1790 in *Flora Cochinchinensis* along with the genus *Osmanthus* itself. Both *Osmanthus* and *Olea* belong to the olive family (Oleaceae).

Another example of Mrs. Delany using an unpublished name is her 'Erinus venustus', which was prepared from material supplied by Lee & Kennedy's nursery at Hammersmith.[27] The plant in the collage appears to be *Selago ovata* L'Héritier ex Aiton, the oval-headed selago, which was illustrated in William Curtis's *Botanical Magazine* in 1793.[28] According to Aiton's *Hortus Kewensis*, the plant was introduced to cultivation in Britain in 1774 by Francis Masson, who was one of the principal suppliers of plant material from South Africa to Lee & Kennedy's nursery. The citation "L'Héritier ex Aiton" indicates that the name was first suggested for this plant by L'Héritier, and was later validated by Aiton in 1789, when *Hortus Kewensis* came out. It is plausible that her 'Erinus venustus' (which was not a member of the genus *Erinus*), was a working name applied by Masson to the same plant to which L'Héritier later assigned the name *Selago ovata*. Until recently the genus *Erinus* has been regarded as a member of the figwort family (Scrophulariaceae), but following the modern APG II classification it is now placed within the plantain family (Plantaginaceae).

The illustrations in L'Héritier's *Sertum Anglicum* ("an English Wreath") were, as its title indicates, based largely on plants seen in cultivation at Kew in 1786–87.[29] During the period up to 1789, before the publication of Aiton's *Hortus Kewensis* and L'Héritier's *Sertum Anglicum*, the South African species now placed under *Pelargonium* were all included in the Linnaean genus *Geranium*. As mentioned above, L'Héritier's posthumously published work *Geraniologia* appeared in 1802, although the plates are dated 1787 and 1788 and were published in 1792.[30] *Geraniolo-*

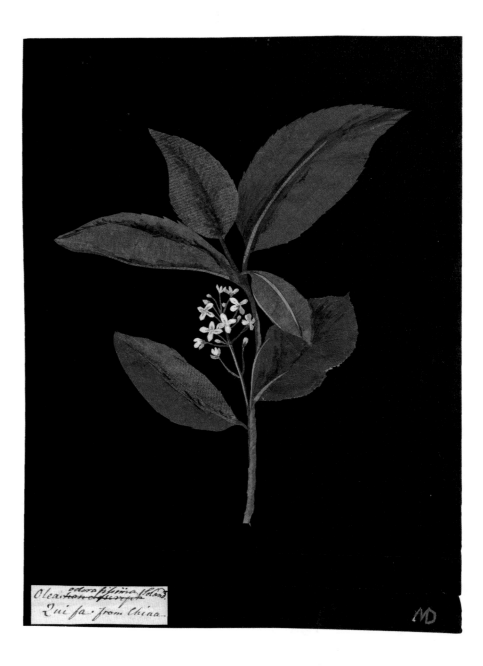

Figure 200: Mary Delany, 'Olea odoratissima Soland.', 1777, collage of colored papers, with bodycolor and watercolor, 9¼ × 7 in. (23.6 × 17.7 cm). British Museum, Department of Prints and Drawings (1897,0505.615)

Figure 201: Sir Joshua Reynolds, *Dr. William Pitcairn*, 1777, oil on canvas. Royal College of Physicians of London

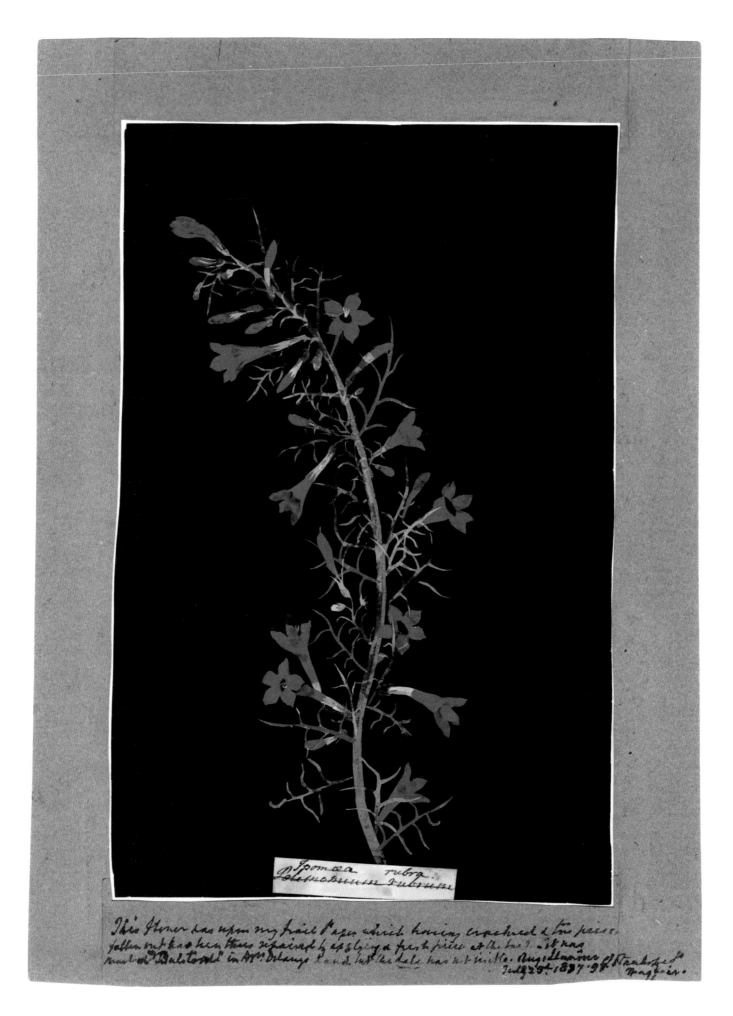

Ipomœa rubra.
Polemonium rubrum

This flower was upon my frail Paper which having cracked & two pieces
fallen out has been thus repaired by supplying a fresh piece at the back. it was
marked "Baletoski" in Mrs. Delanys hand but the date has not visible. Miscellaneous of Stanhope St.
July 29th 1897. 98. of Stanhope St.
Wagner.

gia was a work based on drawings by the highly accomplished botanical artists Pierre Joseph Redouté and Claude Aubriet and others. Proof sheets of the text had been circulated to Sir Joseph Banks under the title *Compendium geraniologium*. Due to the application of the rule of priority in publication, many of L'Héritier's names are now regarded as superfluous because the species to which they refer had already been named by Aiton and others.

Sertum Anglicum was not the only work published by L'Héritier; he was also responsible for *Stirpes novae aut minus cognitae* ("New and little-known plants") published in 1785. In 1780 Mrs. Delany composed her 'Oenothera grandiflora' (see plate 11 in "Theater"), a name published by L'Héritier without a description. The epithet may be attributable to Solander, since it was his account that was published by Aiton in *Hortus Kewensis*, where it was validated with a description. In his introduction Aiton explains: "References are frequently made to the works of M. L'Heritier, under Plants of which he has not yet published either descriptions or figures; these are taken from communications this gentleman frequently made, during the course of printing, of every thing he had prepared for the press. But, as the public will in due time be put into possession of the whole, little need be said on this subject."[31] This may be a reference to L'Héritier's *Sertum Anglicum*, the text of which was published in early January 1789, prior to the appearance of *Hortus Kewensis*. However, *Sertum Anglicum* failed to provide a description of *Oenothera grandiflora*, and it was only on the appearance of Aiton's work that the name became validly published.

Mrs. Delany's collage of that species was compiled in October 1780, well before publication of the first of L'Héritier's works. The name might have been given to her by Solander, who died in 1782. Solander was a frequent visitor to Bulstrode, and receives several mentions in Mrs. Delany's correspondence.[32] It is said by Aiton to have been first introduced to cultivation in Britain by Dr. John Fothergill in 1778; her collage thus might be the earliest illustration of that species. Her source material, however, was from Chelsea Physic Garden, not from the Upton garden of Dr. Fothergill (who died on December 26, 1780). All five of her collages based on material supplied by Dr. Fothergill were prepared between 8 and 17 April 1779.

In a few cases, the correct name of the plant portrayed in a collage has been crossed out and replaced by an incorrect name. An example is 'Ipomoea rubra', which originally was annotated 'Polemonium rubrum' (fig. 202). This latter binomial includes the correct generic name for the plant, as it belonged to the genus *Polemonium* in the phlox family (Polemoniaceae), not *Ipomoea* in the bindweed family (Convolvulaceae). The plant, now known as *Ipomopsis rubra* (L.) Wherry, had long been in cultivation in England and was illustrated in 1732 (fig. 203). Linneaus cited the polynomial *Quamoclit pennatum, erectum, floribus in thyrsum digestis* used by J. J. Dillenius in his *Hortus Elthamensis* of 1732 as a synonym.[33] The mount of this collage also bears an interesting annotation written in the hand of Lady Llanover, referring to some paper conservation treatment applied in 1827:

> *This flower was upon my frail Paper which having cracked in two pieces, fallen out has been thus repaired by applying a fresh piece at the back—it was marked "Bulstrode" in Mrs Delany's hand but the date was not visible. Aug.: Llanover, Stanhope St., Mayfair, July 25th 1827.*

Figure 202: Mary Delany, 'Ipomœa rubra', undated [1772–82], collage of colored papers, with bodycolor and watercolor, 11⅛ × 7¼ in. (28.1 × 18.4). British Museum, Department of Prints and Drawings (1897,0505.685)

Figure 203: John Jacob Dillenius, *Quamoclit pennatum, erectum, floribus in thyrsum digestis*, reproduced in Dillenius, *Hortus Elthamensis* (London, 1732), 2: 321, t. 241, fol. 312. Linnean Society of London

Lobelia pubescens
Downy Cardinal-flower

As previously mentioned, one of the more re-markable aspects of the Delany collages is that some of them feature plants only just introduced to cultivation in England. One such species is *Lobelia pubescens* Dryander, which was first imported in 1780 when William Paterson collected it in South Africa for Mary Eleanor Bowes, Countess of Strathmore and Kinghorne. Prior to the death of her first husband, Lord Strathmore, in 1776, she purchased Stanley House in Chelsea and stocked her hothouses with plants brought from the Cape of Good Hope. Mary Delany's collage 'Lobelia pubescens' (fig. 204) was composed at St. James's Place in 1781, just one year after its introduction, using material sent from Kew.

Another plant that appears to have been figured close to its date of introduction is the Japanese member of the sage family (Lamiaceae) named *Ocimum rugosum* Thunberg, first published in his *Flora Japonica* in 1784.[34] The collage originally labeled 'Ocymum non descript' (fig. 205) was composed in October 1777, just after Thunberg's fifteen-month stay on Dejima island (1775–76). This amounts to something of an enigma, as the seeds brought back would have had to produce flowers the following season (unless the plant were introduced at some earlier date) and Mrs. Delany would have had to get hold of that flowering specimen immediately. In any event, the plant is now known as *Plectranthus japonicus* (Burm.) Koidz. It is a medicinal plant that in Thunberg's day would have been readily available for purchase from Japanese herbalists. There is no reference to this species in Aiton's *Hortus Kewensis* (1789).

Two of the collages feature plants with a close connection to the Duchess of Portland. The first is 'Portlandia grandiflora' (see plate 24 in "Theater"); the binomial was coined by Carl Linnaeus and published in his *Systema Naturae* (1758). He adopted the generic name published by Patrick Browne in *Civil and Natural History of Jamaica* (1756). Kew was the source of the living material. The second collage with a Portland family connection is of 'Lady Stamford's Rose'. Mary, Dowager Countess of Stamford, was the widow of George Grey, fifth Earl of Stamford and a relative of the Duchess of Portland's late husband. The collage was composed at Bulstrode in 1775. There

Figure 205: Mary Delany, 'Ocymum rugosum', 1777, collage of colored papers, with bodycolor and watercolor, and with leaf sample, 10 × 7½ in. (25.5 × 19 cm). British Museum, Department of Prints and Drawings (1897,0505.609)

Figure 204: Mary Delany, 'Lobelia pubescens', 1781, collage of colored papers, with bodycolor, watercolor, and leaf sample, 10 × 8 in. (25.3 × 20.3 cm). British Museum, Department of Prints and Drawings (1897,0505.530)

is evidence in the Portland correspondence that rosebuds were sent from Welbeck to Bulstrode. Lady Stamford is known to have had a rose garden at her Cheshire residence, Dunham Massey.

A later group of collages attributed to the Hon. Booth Grey, and probably compiled with help from the daughters or other relatives of the Duchess of Portland, can be dated to the 1790s on both botanical and paper evidence (see Peter Bower's essay in this volume). Most are labeled with names recognizable from the Delany collages, but there are shifts of genus (*Geranium* to *Pelargonium*) as previously noted. A few are annotated with names that were published after the death of Mrs. Delany, such as *Cynanchum hirsutum* Vahl.[35] This album of collages and its authorship, though discussed in more detail in the essays by Peter Bower, Lisa Ford, and Kohleen Reeder, merits further research.

Despite the wide-ranging geographical scope of Mrs. Delany's selections, and the significance attached to them in terms of nomenclature, natural history, and horticulture, it is the local flora of Bulstrode and its wider environment that deserve attention in conclusion. In the words of Druce (1926) "these figures thus prepared by Mrs Delany at Bulstrode might rank as the first evidence of their occurrence in the county [of Buckinghamshire], as they were executed from 1773–83, only it is difficult to say which were garden and which native species." Druce goes on to list the names and dates of the presumed native (and a few introduced) species that are known to occur in the vicinity of Bulstrode. He then comments, "The collection is really an extraordinary exhibition of industry, combined with refined taste and unwearied patience. Some of the sheets are quite beautiful."[36] Druce's assessment has stood the test of time.

Acknowledgments
First and foremost I am indebted to Dr. Charles Nelson, who has read earlier drafts of this chapter and suggested many improvements. I would like to express my gratitude to Amy Meyers for offering me the opportunity to contribute to this project, and to Mark Laird and Alicia Weisberg-Roberts for their valued editorial support and guidance. The staff of various institutions have kindly provided assistance, most notably the British Museum (Kim Sloan and Joseph Sharples), the Linnean Society of London (Gina Douglas and Lynda Brooks), the Garden History Society (Charles Boot and Sarah Rutherford), the Lindley Library of the Royal Horticultural Society (Annika Browne), Liverpool Athenaeum (Vincent Roper), National Museums Liverpool (Wendy Atkinson and Donna Young), the National Portrait Gallery's Heinz Archive and Library, Nottingham University Library (Special Collections), and the Herbarium and Library of the Royal Botanic Gardens, Kew. Thanks are also due to the Earl of Derby for providing access to the library at Knowsley Hall, and to his curator, Emma Tate, for her generous hospitality; to John Lebeter, bursar of Ackworth School; and to Mark Gurney.

Notes

1. William Gilpin, *Remarks on Forest Scenery, and Other Woodland Views (Relative Chiefly to Picturesque Beauty) Illustrated by the Scenes of New-Forest in Hampshire. In Three Books...*, 2 vols. (London: Printed by R. Blamire, 1782). See Maria Zytaruk's essay in this volume for a discussion of William Gilpin and Mrs. Delany.

2. Horace Walpole to William Mason, 10 January 1782, in Peter Cunningham, ed., *The Letters of Horace Walpole, Earl of Orford*, 9 vols. (London: Henry G. Bohn, 1861), 8:141.

3. Carl Linnaeus, *Species Plantarum*, facsimile of the 1st ed.; introduction by W. T. Stearn, 2 vols. (1753; London: Ray Society, 1957–59).

4. William Hudson, *Flora anglica: Exhibens plantas per regnum angliae sponte crescentes, distributas secundum systema sexuale...* ([London]: Impensis auctoris, 1762).

5. John Hill, *The Vegetable System, or, A Series of Experiments and Observations Tending to Explain the Internal Structure, and the Life of Plants...*, 26 vols. (London: The author, 1759–75), vols. 1 and 2.

6. James Jenkinson, *A Generic and Specific Description of British Plants, Translated from the Genera et Species Plantarum of the Celebrated Linnaeus...* (Kendal: T. Caslon & J. Ashburner; Lancaster: A. Ashburner; London: Hawes, Clark & Collins, 1775).

7. George Claridge Druce, *The Flora of Buckinghamshire, with Biographical Notices of Those Who Have Contributed to Its Botany during the Last Three Centuries* (Arbroath: T. Buncle and Co., 1926), xc–xci.

8. James Lee, *An Introduction to Botany: Containing an Explanation of the Theory of That Science; Extracted from the Works of Dr. Linnaeus; with Twelve Copper-plates, Two Explanatory Tables, an Appendix, and Glossary*, 4th ed., corrected, with additions (London: Printed for J. F. and C. Rivington, L. Davis, and others, 1788).

9. John Stuart, Earl of Bute, *Botanical Tables, Containing the Different Familys of British Plants, Distinguished by a Few Obvious Parts of Fructification Ranged in a Synoptical Method...*, 9 vols. (London: The author, 1785); James Britten, "Lord Bute and John Miller (Bibliographical Notes LXIII)," *The Journal of Botany British and Foreign* 54 (1916): 84–87. For a discussion of the dispersal of the original sets of tables and material, see M. H. Lazarus and H. S. Pardoe, "Bute's *Botanical Tables*: dictated by Nature," *Archives of Natural History* 36, no. 2 (2009): 277–98.

10. See Lisa Ford's essay in this volume.

11. John S. Miller, *An Illustration of the Termini Botanici of Linnaeus* (London: The author, 1789).

12. Gerta Calmann, *Ehret, Flower Painter Extraordinary: An Illustrated Biography* (Oxford: Phaidon, 1977). See also Mark Laird's essay in this volume.

13. Annika Erikson Browne, "Georg Dionysius Ehret: A Glimpse into the Golden Age of Botany," in Mary J. Morris and Leonie Berwick, eds., *The Linnean Legacy: Three Centuries after His Birth* (Oxford: Wiley-Blackwell, 2008), 85–96, available at www.linnean.org/fileadmin/images/Linnean/Special_Issue_8_-_The_Linneaen_Legacy.pdf (accessed 23 January 2009).

14. John Coakley Lettsom, *Memoirs of John Fothergill, M.D. &c.*, 4th ed. (London: Printed for C. Dilly, 1786); Betsy C. Corner and Christopher C. Booth, eds., *Chain of Friendship: Selected Letters of Dr. John Fothergill of London, 1735–1780* (Cambridge, Mass.: The Belknap Press of Harvard University Press, 1971).

15. John S. Miller, *Illustratio systematis sexualis Linnaei (An Illustration of the Sexual System of Linnaeus)...* (London: The author, 1770–77). Despite his generosity to Miller, Fothergill did not approve of Miller's decision to dedicate the work to him, and copies were recalled in order that the offending dedication could be expunged.

16. Carl Linnaeus, *Caroli Linnaei... Systema naturae per regna tria naturae...*, vol. 2, *Vegetabilia. Editio decima, reformata* ([Stockholm]: Laurentii Salvii, 1759).

17. Druce, *Flora of Buckinghamshire*, liii.

18. Richard K. Brummitt and Desmond Meikle, "The Correct Latin Names for the Primrose and the Oxlip, *Primula vulgaris* Hudson and *P. elatior* Hill," *Watsonia* 19 (1993): 183.

19. William Curtis, *Flora Londinensis, or, Plates and Descriptions of Such Plants as Grow Wild in the Environs of London*, 2 vols. (London, 1775–98), 2, s.v. "Ophrys apifera."

20. William Aiton, *Hortus Kewensis, or, A Catalogue of the Plants Cultivated in the Royal Botanic Garden at Kew*, 3 vols. (London: George Nicol, 1789), 2:417–31.

21. William Harris, "The Domestication of New Zealand Plants," in Michael R. Oates, ed., *New Zealand Plants and Their Story: Proceedings of a Conference Held in Wellington, 1–3 October 1999* (Wellington: Royal New Zealand Institute of Horticulture, 2001).

22. Enid J. Willson, *Nurserymen to the World: The Nursery Gardens of Woking and North-West Surrey and Plants Introduced by Them* (London: The author, 1989). For a discussion of John Cree and John Bartram, see Mark Laird, "This Other Eden: The American Connection in Georgian Pleasure Grounds, from Shrubbery & Menagerie to Aviary & Flower Garden," in Amy R. W. Meyers, ed., *The Culture of Nature: Art & Science in Philadelphia, 1740–1840* (New Haven and London: Yale Univ. Press, forthcoming).

23. I am indebted to Mark Laird for this information.

24. John Coakley Lettsom, *Hortus uptonensis, or, A Catalogue of Stove and Green-house Plants in Dr. Fothergill's Garden at Upton, at the Time of His Decease* (London: The author, 1783).

25. Aiton, *Hortus Kewensis*, 1:30, pl. 1.

26. D. H. Rembert, "William Pitcairn, MD (1712–1791)—a Biographical Sketch," *Archives of Natural History* 12, no. 2 (1985): 219–29.

27. Enid J. Willson, *James Lee and the Vineyard Nursery, Hammersmith* (London: Hammersmith Local History Group, 1961).

28. William Curtis, *The Botanical Magazine, or, Flower-Garden Displayed: In Which the Most Ornamental Foreign Plants, Cultivated in the Open Ground, the Green-House, and the Stove, Are Accurately Represented in Their Natural Colours,...* vol. 6 (London, 1793), pl. 186.

29. Charles Louis L'Héritier de Brutelle, *Sertum Anglicum, seu Plantae rariores quae in hortis juxus Londinum, imprimis in horto region Kewensi, excoluntur, ab anno 1786 ad annum 1787 observatae* ([Paris]: Typis Petri-Francisci Didot, 1788 [appeared 1789]–92).

30. Charles Louis L'Héritier de Brutelle, *Geraniologia, seu Erodii, Pelargonii, Geranii, Monsoniae et Grieli: historia iconibus illustrata* ([Paris]: Typis Petri-Francisci Didot, 1802).

31. Aiton, *Hortus Kewensis*, 1:vi.

32. Lady Llanover, ed., *The Autobiography and Correspondence of Mary Granville, Mrs. Delany*, 6 vols. (London: Richard Bentley, 1861–62), ser. 2, 2:366.

33. Jacob Dillenius, *Hortus Elthamensis, seu, Plantarum rariorum quas in horto suo Elthami in Cantio coluit vir ornatissimus et praestantissimus Jacobus Sherard...*, 2 vols. (London: The author, 1732), 2:321, pl. 241, fig. 312.

34. Carl Peter Thunberg, *Flora Japonica, sistens plantas insularum japonicarum secundum systema sexuale emendatum redactas ad XX classes...* ([Leipzig]: In bibliopolio J. G. Mülleriano, 1784).

35. Martin Hendriksen Vahl, *Eclogae Americanae, seu descriptiones plantarum praesertim Americae meridionalis, nondum cognitarum...*, part 2 ([Copenhagen]: Impensis auctoris, 1798), 24.

36. Druce, *Flora of Buckinghamshire*, xci.

[10]

A PROGRESS IN PLANTS:
Mrs. Delany's Botanical Sources

The inscriptions on the back of the "paper mosaicks" or cut-paper collages produced by Mary Delany between 1773 and 1782 form, through the medium of their locations and names, a unique and intriguing intersection of eighteenth-century preoccupations with botanical acquisition, scientific knowledge, gardening, and social connection. These inscriptions consist generally of botanical terms, and what seem to be the places and dates of "completion" of the depictions. They are thus distinct from the notations on the front of the collages, which generally provide a scientific identification as understood in that period.[1] Nearly three hundred of the verso inscriptions refer to places other than Bulstrode or St. James's Place, the two main centers of Mrs. Delany's later life, and some also mention a donor as the source of these flowers or plants. These verso inscriptions map relationships between Mrs. Delany and her social circle, the great botanical collectors, the scientists and naturalists, and the nurserymen and gardeners of London; they map areas of British colonization and exploration, and the places in Britain where collecting and botanizing came together, crossing social and physical boundaries. This essay charts the "progress" of Mrs. Delany's botanical magnum opus through various estates, gardens, and nurseries, and through the social and scientific circles of late-eighteenth-century Britain.

The nature and process of Mrs. Delany's botanical constructions has been ably described elsewhere in this volume.[2] By the time she settled into the busy social world of her second widowhood, Mrs. Delany, long a lover and student of nature and botany, was accomplished in a wide range of amateur pursuits. Her early years, life in Whitehall, family connections, London life in first widowhood, and visits to relatives at Longleat and beyond, had provided Mary with ready access to royal and noble circles. As Clarissa Campbell Orr has documented in this volume, she received invitations to such court events as George II's coronation to the Prince of Wales's ball at Norfolk House in 1741. To this wide circle of social acquaintance was added the Duchess of Portland's various scientific and artistic friends and protégés. In her second widowhood, Mrs. Delany expanded her circle of acquaintances among those interested in natural history and botany. With her establishment as an intimate of Bulstrode and at the urging of the duchess, she reentered London court circles as a resident in the St. James's Palace area in 1769. At St. James's Place, she lived in close proximity to many people whose names or estates figure in the collage notations: near Spencer House, near the town houses of the dukes of Bridgewater, Marlborough, Norfolk, and Northumberland, and near the residences of the earls of Dartmouth, of Warwick, of Westmoreland, and of her relative Viscount Weymouth and his wife, the Duchess of Portland's daughter. Her comments on the first house she took, in a place called Thatched House Court, indicate her interest in being ensconced in polite society again—"it being so near the park, the chapel, and Whitehall makes it very tempting," and that "people of fashion live in the row."[3] Three years later, she removed to a nearby residence in St. James's Place, which remained her London home until her death, with Bulstrode serving as her country residence in many respects (fig. 206).

These two points of reference—Bulstrode and St. James's—and the steady stream of visitors to both places were largely responsible for the depth of her *hortus siccus* and the exposure it enjoyed. Mrs. Delany's *hortus siccus* is arguably the product of a perfect confluence of factors: a society in which gardening had evolved into a means of displaying wealth, knowledge, and taste through the acquisition of exotic plants; a patroness with abundant wealth and connections as well as scientific and botanical interests; a family that provided additional social and court connections; a residence in the heart of the London social scene that drew numerous visitors of various social strata; a personal interest in natural history and gardening; and artistic talent and accomplishment, all of which were highly fashionable. Additionally, her *hortus siccus* was an unusual craft and may also have attracted attention as a pursuit to which visitors or acquaintances could contribute, if well-connected botanically.

Mrs. Delany's *hortus siccus* began, as did many female accomplishments of that time, at home. Bulstrode provided the impetus, through both its garden collections and its habitués. In October 1768, Mary wrote to her niece, Mary Dewes, about Georg Dionysius Ehret's work in providing images for a great "herbal" (for the Duchess of Portland), saying "he has already painted above *a hundred and fifty English plants*"[4] Natural history, taxonomy, and studies of native plants were thus paramount. She went on to rhapsodize about the benefits of observing nature, calling Bulstrode "a *noble school* for such contemplations!"[5] On 17 December 1771, Mrs. Delany wrote to her brother, Bernard Granville, of a visit to Joseph Banks with the Duchess of Portland, where they were "delighted with paintings of the Otaheitie plants" from Banks's 1768–71 voyage on the *Endeavour*.[6] Visits to Bulstrode by Daniel Solander, Banks, and Ehret brought botanical lectures and discussion, specimens and drawings, and exposure to the painting practices of Ehret (who worked with Philip Miller at Chelsea Physic Garden and Peter Collinson at Mill Hill, as well as for the duchess herself). These could have served as model and academy for Mrs. Delany's practice, particularly once it moved beyond Bulstrode and St. James's Place.[7] The connections Ehret had with Dr. Christoph Jakob Trew, and thereby the Dietzsch family in Nuremberg, are also important, as Mark Laird's essay in this volume makes clear. Her brief comment in October 1772 to Mary Dewes Port—"I have invented a new way of imitating flowers"—certainly betokens an interest in botanical art that led her to develop her own particular style.

For the first few years, Mrs. Delany worked her way through the riches of Bulstrode. In June 1775, she mentioned in a letter to her brother that the Duchess of Portland's botanical garden flourished, and that the duchess's labors in that garden were very beneficial to her person, adding: "How happy would it be for the world if they delighted more in *natural pleasures*, which lye open to everybody, instead of racking their brains and time to invent *irrational* entertainments"[8] Certainly Mary was a practitioner of her own preaching, with a quick eye for the raw materials. While at Bulstrode in May 1775, she wrote to her brother-in-law, John Dewes, "I am just returned with the Dss of P. from the kitchen garden, and have seen Mr. Granville's scarlet geranium in high beauty."[9] This was perhaps the inspiration for 'Geranium fulgidum', probably undertaken at Bulstrode and dated July 1775 (see fig. 196).

When Mrs. Delany wrote to Mary Dewes Port on 29 July 1775 that she wanted tempting "with a pretty flower, and so *that work* at present is idle, and will hardly be renewed till I go to Bulstrode," it is evident she still considered Bulstrode her major resource.[10] It is uncertain how many of Mrs. Delany's collages are of Bulstrode plants, since nearly two-thirds have no provenance or donor inscription. Approximately 550 are inscribed simply "Bulstrode," presumably indicating either the place of "completion" or "composition," the origin of the specimen, or the duchess as the supplier. Evidence from various sources indicates that the duchess was a major collector of the exotics flowing into England from numerous British colonies and beyond. In *The Flowering of the Landscape Garden*, Mark Laird has documented how the bills from various nurseries show the duchess was "amassing a formidable collection" of plants and flowers in the 1750s–60s.[11] These were for ornament and for the expansion of her botanical garden. Bulstrode as a park in its rural environs and the duchess's collecting at Weymouth, Dorset, ensured she had a plentiful supply of natives as well as exotics.

Beginning in the second half of 1776, multiple places and names are entered as donors and as sites associated with collages. Mrs. Delany clearly was applying her handicraft in a new way: looking for, and gathering, plants and producing collages at places she visited in her social round, which added a new dimension and a focus to her socializing. As the collages became a steady and increasingly scientific undertaking, other great estates, nurseries, and botanical gardens enter, by inscriptions, as sources for Mrs. Delany.

In the latter half of the eighteenth century, gardens all over Great Britain and continental

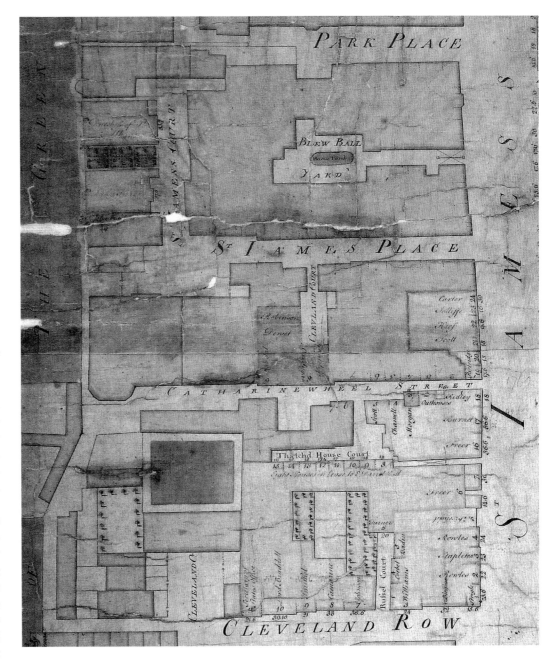

Figure 206. Detail from Zachary Chambers, "A Numerical Register of all His Majesty's Leasehold Houses . . . between St. James's Street & Green Park, etc., 10 April 1769," showing St. James's Place and Thatched House Court near St. James's Palace. National Archives, UK (MR 1/271)

Figure 207: Daniel Paterson, *A General View of the Roads
of England and Wales*, engraving, reproduced in Paterson,
*A New and Accurate Description of All the Direct and Principal
Cross Roads in England and Wales. . .*, 6th ed., corr. (London:
Printed for T. Carnan, 1784). Yale Center for British Art,
Paul Mellon Collection

Europe were springing to life with the products of boxes of seeds and plants sent across the Atlantic by such men as John Bartram and James Alexander, gardener to the Penn family in America. Under the auspices of such organizational patrons as Peter Collinson and John Campbell, fourth Earl of Loudon, men and women eagerly organized networks of those who could help them identify and contact potential suppliers of exotics (nurserymen, clergymen, botanists, and travelers) and those who could move the goods (sea captains and merchants) to the willing buyers.[12]

The availability of myriad new plant species in gardens constructed for beauty and science, as well as Edenic re-creation, formed the perfect moment for Mrs. Delany's botanical art. Although she was not the one doing the purchasing for, or planting of, the famed gardens at Luton Hoo, Kew, Nuneham Courtenay, or Syon House, she was a beneficiary of their owners and suppliers, and of her friends during the latter years of her life. Her good fortune in being a companion of the Duchess of Portland—and of King George and Queen Charlotte—meant that she had access to several of the most plentifully supplied gardens that money and pride could furnish.[13] At the same time, her visits to relatives in Derbyshire, Gloucestershire, Cornwall, and Warwickshire enabled her to pursue her interest in native plants (fig. 207). Mary Delany's first recorded "progress" in collage-making outside the borders of Bulstrode or St. James's—'Myosotis Scorpioides' and 'Rubus fruticosus' (fig. 208)—involved native species. These early collages are dated July 1775. They were apparently composed during a visit to Wellesbourne, the home of her brother-in-law, John Dewes. She perhaps combined her interest in British native plants with an impulse to occupy herself during a family visit, to instruct young relatives in a craft or "accomplishment," or to demonstrate her budding new craft to the inquisitive.

The Wellesbourne collages, and the portable nature of the craft, could have prompted Mrs. Delany to realize a greater scope for this activity. Luton, Kew, and Bill Hill were capable of providing her with interesting flowers, and some materials used in the collages probably originated on the estates to which she traveled: flour-paste glue and wallpaper, for example, could have been found or made quite readily in other homes;[14] paints could have been carried in a dry state and rejuvenated with water; and cutting tools, such as scissors, knives, and bodkins, were small and portable or readily available. In this light, the pocket case given to her by Queen Charlotte in December 1781, which contained a small knife,

Figure 208: Mary Delany 'Rubus fruticosus', 1775, collage of colored papers, with bodycolor and watercolor, 9⅝ × 6¾ in. (24.5 × 17.2 cm). British Museum, Department of Prints and Drawings (1897,0505.752)

Figure 209: Samuel Hieronymus Grimm, *View of Coach Travelling to West Wycombe, Buckinghamshire,* 1773, ink wash on paper. British Library (Add. MS. 15537, fol. 31)

Figure 210: Samuel Hieronymus Grimm, *View of Portland Bill, Dorset,* 1790, ink wash on paper, 11 × 7½ in. (28 × 19 cm). British Library (Add. MS. 15537, fol. 184)

scissors, ruler, compass, and pencil, appears a highly decorative and valuable nod to the tools Mrs. Delany used most often (see fig. 229).[15] A selection from a small cache of various colored papers doubtless traveled with her in a private coach or chaise, a mode of travel with more room for cases and luggage (see fig. 209).[16] In December 1774, Mrs. Delany informed her brother of her use of the duchess's coach when she went out; and letters from 1779 and later confirm that the duchess's coach was at her disposal in London.[17] The Dowager Countess Gower regularly offered Mrs. Delany her post-chaise as a conveyance to Bill Hill. In a letter of 22 July 1776, Mrs. Boscawen offered to have her chaise take Mrs. Delany up to Glan Villa but acknowledged, "I shou'd think it was beyond comparison pleasanter to come in *your own* much better equipage"[18] This suggests that either Mrs. Delany had her own traveling chaise or coach or referred to that of the duchess. When she first viewed the lodgings at Thatched House Court, Mrs. Delany commented that "a coach drives very well to the door"[19] This is surely indicative of her expectations for both travel and visitors.

The summer of 1776 marked a distinct move toward active botanizing and creating on the road. When the duchess left for Weymouth and Portland Bill (fig. 210), Mrs. Delany visited homes of friends and family outside London, including Luton Hoo, as guest of Lord and Lady Bute, and Bill Hill, as the guest of the Dowager Countess Gower. Luton Hoo is a second location associated with early collages 'Crinum africanum' (fig. 211) and 'Hemanthus coccineus', both of which are dated mid-August 1776. The role of Lord Bute in establishing Princess Augusta's gardens at Kew (from 1757 to 1763) precedes his notable contribution to botany, including the *Botanical Tables* of ca. 1785, which he dedicated to Queen Charlotte, writing that he was publishing them "for the Amusement of the Fair Sex" (fig. 212).[20] A 1783 extract from the London *General Evening Post* describes "Luton Hoo, 'the Seat of the Earl of Bute,'" as complete "in every part but in the morass and the aquatic plants," and its conservatory as "perhaps the most perfect in the kingdom." The article refers to the Luton Hoo garden as the most singular next to Kew, and adds that Lord Bute, "with a liberal zeal for science, has given orders that it is to be open to all comers."[21] Certainly Lord Bute seems to have welcomed the idea of the world beating a path to his door, or of all roads leading to Luton Hoo from London. An intricately detailed map book entitled "PLANS of Different Roads from London to Luton Park 1767" shows Luton Park as land thickly dotted

Figure 211: Mary Delany, 'Crinum africanum',
1776, collage of colored papers, with bodycolor
and watercolor, 13½ × 9¼ in. (34.3 × 23.4 cm).
British Museum, Department of Prints and
Drawings (1897,0505.249)

Figure 212: *Rubus fruticosus*, reproduced in vol. 1
of John Stuart Bute, *Botanical Tables, Containing
the Different Familys of British Plants . . .* , 9 vols.
(London, 1785). British Library.

Figure 213: A set of maps of routes from London to Luton Hoo, 1767. British Library (Add. MS. 74215). 1st map showing London, Highgate and Colney Hatch, where Mrs. Boscawen lived.

Figure 214: One of a set of maps of routes from London to Luton Hoo, 1767, showing the section from Harpenden (Herts) to Luton Park (Beds). British Library (Add. MS. 74215)

with trees, as well as detailed routes between points in London and Luton Park in Bedfordshire (figs. 213 and 214).[22] After 1766, Lord Bute never played a significant role in politics again, but he was instrumental in shaping two of the most important botanical collections in England next to those at Bulstrode.[23]

Mrs. Delany's visits to Lord and Lady Bute began under the auspices of the duchess with a sojourn of several days in 1774. From 1776, however, she visited Luton on her own. She wrote to Mary Dewes Port on 31 August 1777: "I am now very busy with my hortus siccus, to w[ch] I added, at Luton, twelve rare plants."[24] Among them was the celebrated 'Passiflora Laurifolia' (see fig. 35). The following summer, while at Luton for two weeks in June,[25] she added a further eight collages. The Dowager Countess Gower congratulated Mrs. Delany in a letter shortly after the 1777 visit: "[B]eing at Luton so many days, among such variety of plants, must have greatly enrich'd y[r] works; in my small improvements I've several pretty ones I never saw before. . . . I hope you'l take a review of 'em next year."[26] Indeed, two of Mrs. Delany's compositions already had marked the route between Luton Hoo and Bill Hill. 'Lathyrus Sativus' was dated 23 August 1776, and, though it appears to have been composed at Bill Hill, the inscription reads "the flower from Luton Park" (fig. 215). The specimen for her 'Fumaria fungosa' was also brought from Luton Park (see fig. 138). Thus she sometimes carried specimens, or half-completed collages, as indicated by the inscription "begun in St James' Place / finished at Bulstrode 12 August 1782" on the verso of 'Budleja capitata'.

Bill Hill was next after Luton to be inscribed as a place associated with seven collages in late August 1776. These included her 'Magnolia grandiflora' (see fig. 160). Since this evergreen *Magnolia* was in abundance at Bill Hill, flowering specimens were easy to come by. In one letter, Mrs. Boscawen told Mrs. Delany that the magnolias at Bill Hill were in bloom and "perfume the air and delight the eye at the green-house."[27] Lady Gower shared her favorite plant with Mrs. Boscawen at Colney Hatch and with the Duchess of Portland. The dowager countess wrote to Mrs. Delany that a magnolia from Bill Hill could not be "so ungratefull as not to bloom at Bulstrode."[28] The road between these botanizing friends was well-traveled both physically and figuratively. Colney Hatch was on the road to Luton, as was Kenwood, the home of Lord Mansfield, a later donor of plants to Mrs. Delany's *hortus siccus* (fig. 213). Mrs. Boscawen was also a guest at Bill Hill, as well as a visitor to Kenwood and Luton Hoo. In October 1776, she wrote of visiting Luton Hoo, dining with Lady Bute, and meeting the gardener and "talking to him of Mrs. Delany"; she mentioned in another letter that Mrs. Delany was welcome to pause at Kenwood during a proposed journey to Glan Villa.[29] Indeed, Mrs. Delany "breakfasted at Kenwood" in September 1775 and planned to do so again in October 1779 while in residence at St. James's Place.[30] The *Ambulator* of 1782, a portable guidebook to notable sites within twenty-five miles of London, praised Kenwood highly, saying "The park is very beautiful spot, commanding the most delightful views; and laid out with consummate taste," and noting the greenhouse "contains a very large collection of curious and exotic plants, trees &c."[31]

Figure 215: Mary Delany, 'Lathyrus Sativus', 1776, collage of colored papers, with bodycolor and watercolor, 9½ × 6¾ in. (24.2 × 17.2 cm). British Museum, Department of Prints and Drawings (1897,0505.497)

Kew—described by Peter Collinson in a 1766 letter to John Bartram as "the Paradise of our world where all plants are found that money or Interest can procure"—became Mrs. Delany's most prolific London source for plants in the summer of 1776, and ultimately provided nearly ninety specimens.[32] The first collage recorded from a Kew plant was 'Eryngium alpinum', dated June 1776, just two months before her first forays at Luton Hoo and Bill Hill (fig. 216). In November and December 1776, Mrs. Delany seems to have worked on eight further collages from Kew flowers. Between these two instances was a mo-

mentous occasion. On 5 August 1776, the king and queen came to Bulstrode. During their visit, Mrs. Delany was summoned to bring her "book of flowers" to show their majesties.[33] The *Eryngium* from their own Kew garden must have impressed the king and queen with its intricacy. Could this conversation have been the impetus behind Mary Delany's botanizing at Luton Hoo and beyond?

Whatever the motivating force, the *hortus siccus* grew apace from August 1776. In 1773–74, Mary Delany had completed only a handful of collages. Her production increased in the following year, with roughly 55 collages dated 1775. Then it reached a peak of approximately 135 in 1776. She exulted to Mary Dewes Port in a letter of 19 September 1777: "This morning I finished my 400th plant!"—nearly half her eventual output.[34] In what is considered to be her most productive single month, October 1777, she completed about 30 collages and thereafter produced roughly 80–100 collages each year until 1781. In 1782 she produced fewer than thirty, and by 1783 she had ceased her labors, owing to the failure of her sight, which she acknowledged in a letter to her niece of September 1782: "My eyes are in much the same state as they have been for some months past, and serve me with some difficulty to attempt a flower *now and then*"[35]

From 1777, the "progress" expanded outside the estates of Kew, Bulstrode, Luton Hoo, and Bill Hill. Donors included a greater mix of peers, the scientifically inclined, and the humbler members of the society who shared botanical interests and had access to exotic or unusual species. At this point, Mrs. Delany's aims went from beyond the duchess's "herbal" to a more ambitious and all-encompassing book of native and exotic floras. She still used the term "herbal" to refer to her collages in a letter of April 1776, in which she also commented: "the *spring flowers* now *supply me with work*, for I have already done since the beginning of March *twenty plants*."[36] In April 1779, she apologized to her niece for not writing more, "but I am so busy now with *rare* specimens from all my botanical friends"[37] By 1781, she had chosen the grander name "Flora Delanica" to denote what she had made from those specimens.[38]

Plotting Mrs. Delany's collection by provenance creates an interesting cultural geography. The first three non-Bulstrode donor sites were among the farthest afield: Wellesbourne, approximately 97 miles from London; Bill Hill, 37 miles; and Luton, 34 miles. In 1776, with the first plants from Kew, Mrs. Delany's sources expanded to London. From that point, most of her donors can be located on a map showing towns and sites within a range of twenty-five miles outside

Figure 216: Mary Delany, 'Eryngium alpinum', 1776, collage of colored papers, with bodycolor and watercolor, 12⅝ × 8⅞ in. (32.1 × 22.4 cm). British Museum, Department of Prints and Drawings (1897,0505.318)

Eryngium alpinum

Figure 217: William Palmer, "Twenty-Five Miles Round London," in *The Ambulator; or, the stranger's companion in a tour round London…* 3rd edition (London, 1787). British Library

London (fig. 217).[39] In 1777 and 1778, the sources in and around London included Syon House, Barnes, Danson Hill, Blackheath, Ealing, and Chelsea Physic Garden. Additionally, Sir George Howard, who provided her with three species of geranium (*Pelargonium*), had an estate at Stoke Poges, just a short drive from Bulstrode. Foraging trips to any of these places would have been a very reasonable exercise for a woman who, with the duchess, made a forty-mile round-trip to Windsor from Bulstrode in one afternoon and evening, or who went off to breakfast at Windsor or Kenwood.

Figure 218: Mary Delany, 'Amaryllis Regis', 1781, collage of colored papers, with bodycolor and watercolor, 12¾ × 9½ in. (32.3 × 24.1 cm). British Museum, Department of Prints and Drawings (1897, 0505.34)

Figure 219: Mary Delany, 'Amaryllis ? attamyasco', 1778, collage of colored papers, with bodycolor and watercolor, 13¼ × 8⅞ in. (33.6 × 22.4 cm). British Museum, Department of Prints and Drawings (1897,0505.27)

Inscriptions of new donors in 1777 represent a cross-section of estates and collectors: "Sion House," estate of the Duke of Northumberland; a partially obscured notation that appears to say "Dr. Pitcairn's garden," presumably the Islington garden of William Pitcairn; "The Rev: Sir John Cullum," whose family properties were Hardwick House on Hampstead Heath and Hawsted, Suffolk; and "Mr. B Grey," a scion of the Stamford family, whose name also appears in connection with the garden of Dr. John Fothergill of Upton, Essex. In 1778, new notations refer to "Sr G Howard," or George Howard, owner of Stoke Place; Lord Dartmouth and his Blackheath estate; Lord Willoughby's "marsh garden," presumably on the grounds of Compton Verney; Sir John Boyd's Danson Hill estate; Mrs. Dashwood; and Mrs. Astley, whose contribution of double flowering peach is inscribed "Barnes." That year also sees the first of the several notations of flowers from the Chelsea Physic Garden. In 1779, Miss Jennings, Mrs. Delany's pupil, is added to the list, as is the name of Richard Bateman, the then-deceased owner of Grove House, Old Windsor;

Dr. John Fothergill; and General Conway of Park Place at Henley on Thames. Contributions from "Weymouth" in Dorset are noted in 1779 and 1780, and two from "Lady Weymouth" (presumably at Longleat) in 1781. Just a few other names appear: Lord Harcourt and Lady Anne Monson in 1780; Mrs. Weddell, Mr. Farwell, and Mrs. Pultney in 1781; and Mr. Lightfoot in 1782.

Many of the names appear once or just a few times, with the exceptions of the Chelsea Physic Garden, and Dr. Pitcairn, whose garden consisted of four or five acres around his house in Upper Street, Islington (where several nurseries and botanical gardens flourished).[40] With these isolated contributions, social nexus coincided with botanical exclusivity. For example, Lord North, Earl of Guilford, when urging Mrs. Delany in September 1778 to visit him at Wroxton, wrote that he had gotten for her not only two beaux in the form of Lord Lewisham and Mr. Legge, but "three sorts of *fine lillies* in full bloom."[41] The earl, whose garden Mrs. Delany had drawn in the 1740s and 1750s, was an old friend whose home was conveniently located on the road to

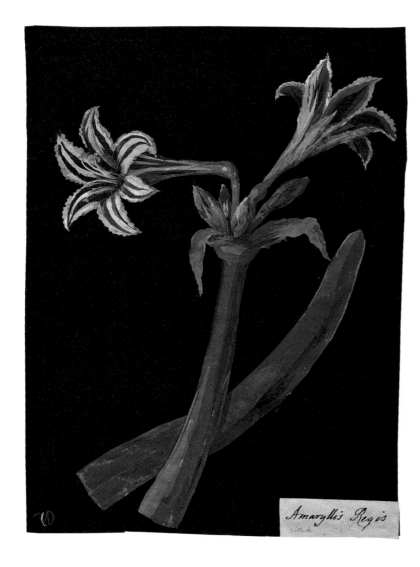

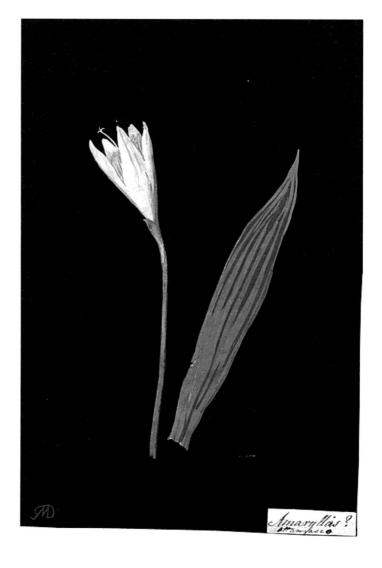

Wellesbourne and who had certainly visited St. James's Place in 1774 and 1775.[42] He came to Bulstrode in July 1778, shortly before his written plea to Mrs. Delany. Perhaps he saw the *hortus siccus* and thought the lilies would be irresistible bait.

That Mary Delany took advantage of her London location to search the nurseries and botanical gardens is indicated by a number of references to concerted forays. In 1779, for example, she wrote to Mary Dewes Port that she had gone to Dr. Fothergill's garden ten miles distant and "crammed my tin box with exoticks, overpowered with such variety I knew not what to chuse!" Two days later, she had "return'd loaded with the spoyls of the Botanical Garden."[43] But not every foray was as successful. In a 1780 letter to Mary Dewes Port, she commented, "we went to Lee's at Hammersmith, in search of flowers, but only met with a *crinum*, a sort of Pancratium."[44] The impetus for adding new collages seems to have shifted from relatively passive to more active; from browsing through gardens to which she had regular access, to hunting new species down or having them provided by interested parties.

The two most generous of her suppliers within London—Kew Gardens and James Lee's Hammersmith nursery—span the spectrum of society from noble consumer to commercial supplier. These were the two interdependent sides of the trade in exotics. Kew and Lee both provided some of Mrs. Delany's rarest specimens. The dramatic 'Amaryllis Regis', lovingly inscribed by Mrs. Delany as "sent me by the Queen," rubs shoulders in the British Museum albums with the equally exotic 'Amaryllis ? attamyasco' and 'Amaryllis aurea', on which the inscription is "Mr. Lee," or sometimes just "Lee" (figs. 218–219). Lee provided at least forty additional specimens. Other botanical collections formed a generous base of contributors: Chelsea Physic Garden provided nineteen; the Islington garden of Dr. William Pitcairn yielded twenty-six; and the Upton garden of Dr. John Fothergill provided another six. In total, ninety-one collages were created of specimens from these four London sites.

Perhaps Lee, a former gardener to the Duke of Northumberland, led her to plants with a "Sion House" provenance, or perhaps they came to Mrs. Delany through close residence to Northumberland House, just down the road from St. James's Place.[45] Syon House was one of several great houses in the eighteenth century whose owners were interested in landscaping and amassing botanical gardens. Hugh Smithson, first Duke of Northumberland from 1750, was an enthusiastic botanizer, and, according to the Victoria County

History, he "planted shrubberies stocked with many foreign trees to the south and north of the house."[46] The "foreign trees" included North American evergreens, which Peter Collinson ordered from John Bartram for "Ld. Northumberland"; the duke himself ordered boxes of American seeds from John Bartram in the 1740s and 1750s.[47] The records of his planting at Syon House feature North American exotics, such as "Carolina poplars" and "Sugar maples."[48]

The letters of Mrs. Delany's close friend Frances Boscawen offer a glimpse of how the collages' fame was spread by friends, which doubtless prompted new donors. Only one collage, 'Cheiranthus cheiri', is inscribed "Glanvilla Mrs. Boscawen," yet Mrs. Boscawen's correspondence is full of stories of botanical exchange and garden exertions.[49] Glanvilla was the name of the modest residence in Enfield she rented in 1772 and lived in until 1773. She then left it for another house, which she dubbed Glan Villa, in Colney Hatch, where she lived until 1787.[50] Mrs. Delany visited the Enfield Glanvilla sometime between 28 June and 14 July 1772, and Mrs. Boscawen wrote of expecting a visit on Mrs. Delany's return from Luton in July 1778.[51] Mrs. Boscawen visited Bulstrode in September 1772, and appears to have visited regularly at St. James's Place.[52] She was as much absorbed in the planting of her garden and the wonders of the natural world as was Mrs. Delany. Their exchange of letters included Mrs. Boscawen's comments that she was feeding her robin almonds on Mrs. Delany's advice.[53] Frances Boscawen also was delighted by the *hortus siccus*, writing to Mrs. Delany on 7 December 1778: "Many plants have been immortaliz'd, I suppose, since I paid my tribute of admiration to them."[54] She also drew them to the attention of others, including Fanny Sayer, her goddaughter. On 8 May 1781, she wrote that Mrs. Delany mentioned having invited Fanny to visit her house, after meeting her at Lady Willoughby's. Mrs. Boscawen encouraged Fanny to go: "Every picture in her room is of her own painting, which will astonish you; and if you can bring out a request to see her Hortus Siccus, the work of her fingers and scissors, you will be astonished and pleased beyond expression."[55] By the early 1780s, the paper collages were attracting visitors. On 3 May 1781, Mrs. Delany wrote to her niece about "4 visitors that come this morning to visit *Flora Delanica*," and, on 8 May, "To-morrow morning curiosity brings Sr Abram and Ly Hume at 1 o'clock to see my book of plants"[56]

Singular offerings of flowers came from wider social and scientific circles. For example, the specimen for her 'Saxifragia stellaris', which grows on

wet mountain rocks, was donated by the Reverend Sir John Cullum, the rector of Hawsted, Suffolk, who almost certainly cultivated it in his garden. He was also the owner of Hardwick House, noted for its plantation of such trees as the cedar of Lebanon and the copper beech. A respected naturalist who published in *Philosophical Transactions of the Royal Society* and *Gentleman's Magazine*, Cullum was a friend of Banks, Solander, and Lightfoot. Mrs. Delany introduced him to the Duchess of Portland in 1779, which suggests that their acquaintance had begun through her St. James's Place visits rather than through the duchess's Bulstrode circle.[57]

On 9 April 1778, Mrs. Delany wrote to Mary Dewes Port that she would dine at Lord Willoughby's on the 11th. Among the collages is 'Amygdalus Nana' (a dwarf almond), inscribed "Marsh gar[den] / Ld Willoughby," which was completed on the 1st of May.[58] Lord and Lady Willoughby (the daughter of the Earl of Guilford) were old friends whose great estate, Compton Verney, was very near Wellesbourne, where the Dewes family lived. In a letter to Mary Dewes of November 1763, Mrs. Delany wrote: "I desire you will never fail to make my compliments in a particular manner to Lord and Lady Willoughby."[59] In April 1778, Mrs. Delany wrote to her that she anticipated a visit from a Mrs. Dashwood. As the four collages on which "Mrs. Dashwood" is noted as donor were dated April–June of that year, perhaps some specimens were brought on that visit. The flow of plants from a varied circle is identified in a letter of 17 April 1779 to Mary Dewes Port, in which Mrs. Delany apologized for not writing more ("I am so busy now with *rare* specimens from all my botanical friends")—not to mention that by this time her eyes were failing and she could write only by candlelight.[60]

In April 1779, she dated collages that are inscribed as of plants from Dr. Fothergill, Booth Grey, the Chelsea Physic Garden, Kew, and Mr. Lee, respectively. Most intriguing is the collage 'Anemone Hortensis', which is annotated "Mr. B Grey, Dr. Fothergill's [garden] Upton, Essex," indicating a possible link between the two. The four collages inscribed with Booth Grey's name were all done at roughly the same time as those of Dr. Fothergill's plants.[61] The Hon. Booth Grey was the brother-in-law of the Duchess of Portland's daughter Henrietta and hence must have visited Bulstrode. He was a member of the Stamford family (as described in Kohleen Reeder's essay, which discusses the Booth Grey collages in the collections of the Yale Center for British Art).

Danson Hill in Kent, the estate of Sir John Boyd, is also represented among the collages.

Edward Hasted described the grounds of Danson Hill as containing "a most magnificent sheet of water It was designed, and with much difficulty formed and secured by the noted Capability Brown."[62] Mrs. Delany's collage 'Calla æthiopica', dated March 1778, is inscribed "Dansen," referring to Danson Hill.[63] Mrs. Delany enjoyed a close, familial friendship with Sir John and his wife, Catherine, due to long-standing relationships: Lady Boyd was the daughter of Mrs. Delany's old friend Sally Chapone, and her sister, Sally Sandford, was Mrs. Delany's goddaughter. In 1768, Mrs. Delany in turn became godmother to one of Lord and Lady Boyd's children; in 1769, she visited Danson Hill for two days.[64] The Boyds were regular visitors to her London home and supported her love of flowers: in February 1775 she wrote that they provided her every week with nosegays.[65]

Mutual friends and the Boyds' near neighbors in the country included another of the St. James's Place visitors who contributed to the *hortus siccus*. On 26 May 1775, Mrs. Delany wrote to the Reverend Dewes: "*Mr.* Boyd of Danson is made a baronet, by ye interest of his friend Lord Dartmouth"[66] Lord Dartmouth was a near neighbor in London, where Mrs. Delany noted a visit to his wife in January 1775.[67] His country estate at Blackheath provided specimens of five plants, three of which were represented in collages dated May 1778. This is close in date to the 'Calla æthiopica', and, given Blackheath's proximity to Danson Hill, she could have visited both estates in a single day. Lord Mansfield and his wife, who was related by marriage to Mrs. Delany's Carteret cousins, hosted Mrs. Delany at Kenwood, and visited St. James's Place and Bulstrode. From Kenwood they supplied Mrs. Delany with the specimen for her 'Cassia Marylandica'.

Another plant donor was George Simon, Lord Harcourt, the owner of Nuneham Courtenay in Oxfordshire. He makes his single appearance in an inscription on the back of the collage 'Hyacinthus orientalis ophir', dated 5 May 1780: "The flower given me by Lord Harcourt." Mrs. Delany called Lord Harcourt "a whimsical man"; he and his wife (then Lord and Lady Nuneham) dined in company with Mary Dewes in 1770 at Wimbledon, and they were acquainted with her Carteret cousins.[68] William Mason, the creator of the famed flower garden at Nuneham Courtenay, was another of her London visitors, often in company with his friend Frederick Montagu, a regular correspondent of hers. Montagu rapturously described Nuneham Courtenay to her in August 1782: "The situation and place are delightful; and such a flower-garden as excells every flower-garden which ever existed either in history or romance!" He goes on to remark that Mason "enquires very much after you." The inscription on the back of 'Canna Indica', dated at Bulstrode 20 June 1776, includes "Mr. Montagu & Mr. Mason there."[69]

The circle of St. James's Place included members of the royal household. One visitor facilitated the delivery of a Kew flower to Mrs. Delany, the beautifully rendered 'Amaryllis Regis' (see fig. 218). The date inscribed on the back of the collage is 16 March, 1781. In a letter of 14 March 1781 to Miss Mary Hamilton, sub-governess to the children of George III, Mrs. Delany wrote: "I hope the regal flower has returned safe into your hands, tho' not so blooming as when I received it," adding, "I fear I have kept it too long, but my vivacity (like the flower) droops with time"[70] On 8 April 1781, Mrs. Delany asked Miss Hamilton to visit, apparently to show her renderings of the 'Amaryllis Regis' and to give her one to take back to the queen.[71] Miss Hamilton was a frequent visitor to Mrs. Delany at her home in London and she also spent time at Bulstrode; there are several notes from Mrs. Delany to Miss Hamilton in 1784–85, offering to send the duchess's coach to collect her for a visit to St. James's Place.[72]

Other names that appear as donors can be mapped more extensively. For example, the road from London to her relatives at Wellesbourne led through Henley, where Mrs. Delany broke her journey on one trip in 1775. Henley on Thames was the site of Park Place, purchased from Princess Augusta in 1752 by Henry Seymour Conway, a cousin and correspondent of Horace Walpole, whose town house was in Warwick Street, Charing Cross, also near St. James's Place. Walpole encouraged his cousin's landscaping during the 1760s.[73] A poem written in 1773 about a visit to Park Place describes "shining laurel spreads," "many a tree from foreign lands," and "a cavern, where a zebra stood," as well as a walled garden with a fishpond where "fragrant flowers promiscuous grew."[74] Park Place developed as a showplace of trees and exotic plants and of such architectural features as a Grecian ruin, a stone arch, and the remains of a tomb or perhaps a Druidic temple. The transplantation of the latter from Jersey, one of the Channel Islands, of which Gen. Conway was governor, was eagerly awaited by Walpole. When he viewed it in 1788, he commented: "Mr. Conway has placed it with so much judgment, that it has a lofty effect . . . it is impossible not to be pleased with so very rare an antiquity so absolutely perfect."[75] In a suitable parallel, Conway's one offering to Mrs. Delany was a handsome picotee carnation, labeled "a variety / Jersey Pink," and inscribed on the back "from Jersey." Walpole also reported on Miss Jennings, described by Mrs. Delany as "a sensible, agreable, and ingenious woman, a pupil of mine in the paper mosaic work (and the *only one* I have *hopes* of)"[76] Three collages have her name inscribed on the back. Walpole, in his description of Strawberry Hill, mentioned that a paper mosaic by Mrs. Delany, and "its companion, by Mrs. Delany's scholar, Miss Jennings of Shiplake," hung on one wall of the breakfast room.[77] Miss Jennings visited Mrs. Delany at St. James's Place and stayed with her and the duchess at Bulstrode.[78]

Miss Jennings and Sir George Howard both offered species of indoor geranium (*Pelargonium*). The geranium that had first inspired the "new way of imitating flowers" is in that group which is also the most represented among the collages, as John Edmondson points out in his essay in this volume. Sir George Howard provided three flowers for collages that bear three separate dates in October 1778: 'Geran: Peltatum', 'Geran: Inquinans' (figs. 220, 221), and 'Geran: Alchemilloides'. These plants came from a greenhouse, presumably at Stoke Place, his estate in Buckinghamshire which had been landscaped by Lancelot "Capability" Brown.[79]

Figure 220: Mary Delany, 'Geran: Inquinans', 1778, collage of colored papers, with bodycolor and watercolor, 13½ × 9⅜ in. (34.2 × 23.7 cm). British Museum, Department of Prints and Drawings (1897,0505.372)

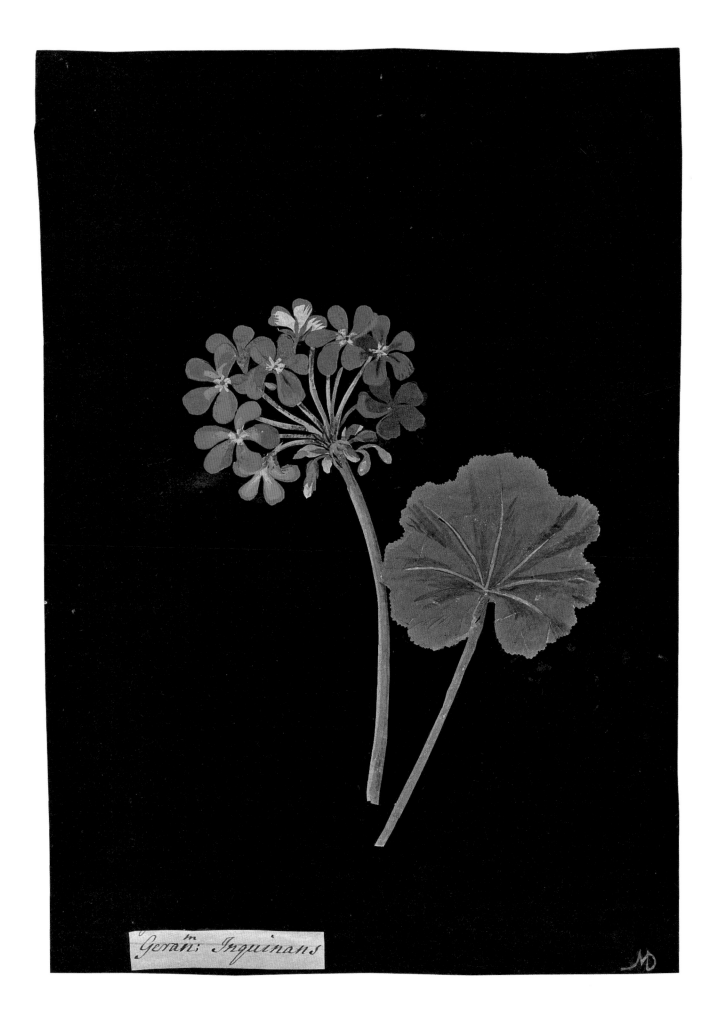

Geran: Inquinans

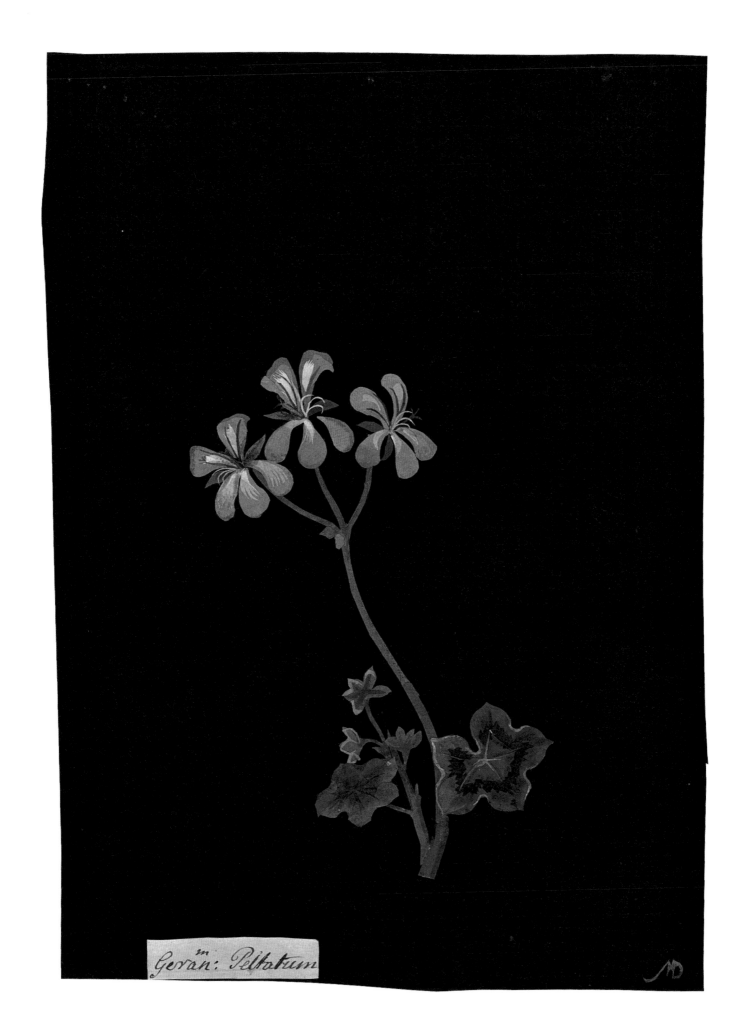

Geran: Peltatum

All three species of geranium (*Pelargonium*) that Mrs. Delany acquired from Sir George Howard were introduced to Britain in the late seventeenth and early eighteenth centuries. *Pelargonium alchemilloides*, called the "Ladies' Mantle-leaved Crane's-bill" in William Aiton's *Hortus Kewensis* (1789), was apparently cultivated in 1693 by Jacob Bobart, presumably at the Oxford Physic Garden where he had been superintendent since 1680.[80] *Pelargonium inquinans*, according to *Hortus Kewensis*, was cultivated in 1714 by Henry Compton, the politically controversial Bishop of London whose interest and skill in botany was manifested through his garden at Fulham.[81] The introduction of *Pelargonium peltatum* into English gardens is credited in *Hortus Kewensis* to Mary Capel Somerset, first Duchess of Beaufort. She was cultivating it by 1701 when, during her widowhood, she focused attention on adding to her already well-stocked garden of exotics at Badminton. She created a *hortus siccus* and consulted with the foremost botanists and collectors, including William Sherard and Sir Hans Sloane.[82] By 1703–5, Everhard Kick had illustrated *Pelargonium peltatum* in the duchess's florilegium at Badminton. These are all from the Cape of Good Hope, the products mainly of Dutch collecting in the period of William and Mary and Queen Anne. All three are also listed in *Hortus Uptonensis* (1783), the catalogue of John Fothergill's Upton garden at the time of his death. By the 1770s, they were no longer rarities, as the nursery trade had combined with private exchange to make them widely available. Why, then, did Sir George Howard act as donor? John Edmondson has observed the closeness of Bulstrode to Stoke Place. The creation of the collages on successive days is suggestive, therefore, of a visit by Howard or his wife to Bulstrode, or Mrs. Delany to Stoke Place as a comfortable and congenial outing.[83]

Pelargonium gibbosum, donated by Miss Jennings, had also been cultivated in England from about 1712. Of the several other *Pelargonium* species represented in Mrs. Delany's collages and with identified donors, five were from Kew, two from James Lee, and one from the Chelsea Physic Garden that is labeled 'Geranium Triste' (but does not match the pure *Pelargonium triste*). The two from Lee's Vineyard Nursery were fairly new introductions: *Pelargonium scabrum* and 'Geranium lanceolatum' (*Pelargonium glaucum*), both from the Cape of Good Hope and (according to Aiton) both introduced by Kennedy and Lee in 1775.[84] The other new species include two from Kew and one from Bulstrode. The two tender geraniums (*Pelargonium*) were brought back from the Cape of Good Hope by Francis Masson on his first trip as the first official collector for Kew (1772–74). It is not clear how the duchess secured the species Mrs. Delany noted as a Bulstrode plant, 'Geranium radula', which is now identified as Masson's 1774 introduction, *Pelargonium radens*. It is not synonymous with *Pelargonium radula* that William Aiton said was introduced to Kew by Masson in 1774.[85] The plant that Mrs. Delany called (following Solander) 'Geran: trigonum' (fig. 222) was also introduced to Kew by Masson in 1774. 'Geranium lævigatum', the second Kew plant, is a true cranesbill and is native to Madeira; Masson sent seeds to Kew in 1778.[86]

Figure 221: Mary Delany, 'Geran: Peltatum', 1778, collage of colored papers, with bodycolor and watercolor 12½ × 8¾ in. (31.8 × 22.3 cm). British Museum, Department of Prints and Drawings (1897,0505.371)

Figure 222: Mary Delany, 'Geran: trigonum', 1778, collage of colored papers, with bodycolor and watercolor, 12¼ × 8½ in. (31.2 × 21.5 cm). British Museum, Department of Prints and Drawings (1897, 0505.382)

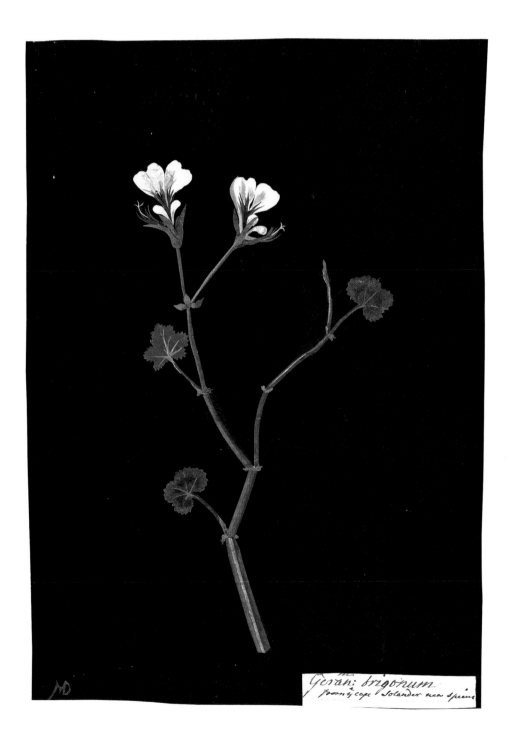

What this indicates is that Mrs. Delany was representing newly introduced exotics within three or four years of the first date of introduction—a remarkable achievement. In this sense, her soundings of the royal collections at Kew was as acute as her sourcing of native plants through Bulstrode, Weymouth, and beyond.

Five of her collages appear to be modeled after drawings ascribed to Lady Anne Monson. Lady Anne, whom Clarissa Campbell Orr has discussed in another context, was a friend to Solander and Banks, who made their agreement to travel together on the South Sea expedition while both were dining at Lady Anne's home in 1768.[87] She was also acquainted with James Lee. It is unclear from the inscriptions whether the drawings were done by Lady Anne or at her commission. Her entry in the *Dictionary of National Biography* relates that Linnaeus's pupil C. P. Thunberg stated that Lady Anne, while visiting the Cape of Good Hope on her way to India in 1774, had "at her own expense, brought with her a draughtsman, in order to assist her in collecting and delineating scarce specimens of natural history."[88] The dates on the collages made from Lady Anne's drawings span a few months in 1780, four years after Lady Anne's death.

Another example of what could be called a memento mori collage is 'Mimosa arborea', depicted after a specimen from the garden of the late Mr. Bateman at Old Windsor. Mrs. Delany had not been impressed with the decor of his house when she visited in 1768, describing it as "fribblish." She roundly criticized his "popish chapel," which she found offensively over-decorated to the point of satire. However, she admired the exterior and the grounds, pronouncing them "most delightful."[89] Horace Walpole described Bateman's estate as "the kingdom of flowers," and took credit for influencing Bateman's turn away from the rage for Chinese taste to the Gothic, which Walpole was avidly pursuing at his own Strawberry Hill.[90] Yet that shift was already under way by 1760, for in 1761 Walpole asked George Montagu to purchase for Strawberry Hill chairs similar to some Bateman had purchased from various places and which he considered ideal for the Great Cloister under construction at his house.[91] While the date on 'Mimosa arborea' is 28 September 1779—long after Bateman's death in 1773—the label on the front of this collage gives the source as "of Old Windser, Mr. Batemans." Mrs. Delany and the duchess had dined with Walpole, Bateman, and Frederick Montagu in June 1770,[92] so Walpole is a possible link with this commemorative plant. He lamented the destruction of the priory, which he described as "despoiled" and "pulled to pieces" by

the auctioning of much of Bateman's collections and furnishings in 1774–75 by his nephew and heir, John, second Viscount Bateman.[93] Walpole snapped up "three cartloads" of chairs, presumably the ones he earlier had coveted for the cloister.[94] Whether Bateman's precious plant also made its way to Strawberry Hill remains conjecture. Walpole had done prodigious amounts of planting by then, of both trees and flowering plants, and he had purchased a nursery adjacent to the estate.[95]

It seemed to please Mrs. Delany to fuse the production of her collages with associations to her social life. In this sense, the *hortus siccus*, though different from the *album amicorum* that Kim Sloan discusses in this volume, shares something in common with all projects of remembering and keeping close one's circle of friends and acquaintances. The long inscription on the back of 'Punica nana' is a pertinent example. It records completion "the day after [their] Majesties, The Prince of Wales, The Bishop of O[snabrück] Three Younge [] Princess Royal, [Princess] Augusta, and Princess Elizabeth had visited." The back of 'Plumeria rubra' also bears the simple inscription "The day after the King and Queen were at Bulstrode." The visit of the royal family in August 1778 prompted an inscription on the back of the 'Cactus grandiflorus?' (see plate 16 in "Theater") commemorating "the Day the King & Queen & the Royal family were at Bulstrode." Two other collages have royal associations: 'Conyza inuloides' is inscribed "When the Queen was at Bulstrode" in October 1781; and 'Necotiana rustica', dated 14 September 1782, is inscribed "begun 13th Sept / went to Queens Lodge / that Evening." Clarissa Campbell Orr has documented in this volume how late in life Mary Delany had a role at Windsor as friend to the king and queen. Her collages had become a source of interest to royalty as well as to close friends, who, like Mrs. Boscawen, paid their "tribute of admiration" to the collages and to Mrs. Delany herself. Yet Mary Delany always remained modest, referring to one notable moment of being seated by the king in a chair he himself had placed for her at a table opposite to the queen "an honr I could not receive without some confusion and hesitation"[96]

When Mrs. Delany finally retired her scissors, knife, and paper, her creations had cut a considerable swathe through notable estates outside London and richly stocked gardens and nurseries within. A scan through her inscriptions acquaints one not only with Mrs. Delany's personal connections, but with connections to the world of botanical collecting, landscaping, and scientific inquiry, to which her collages are a remarkable contribution.

Acknowledgments

This essay owes innumerable debts to Mark Laird, John Edmondson, Clarissa Campbell Orr, and Charles Nelson for their timely and helpful commentary and corrections.

Notes

1. There are a number of notations on the front of the collages that are crossed out and replaced with other plant names, an aspect of the collages that calls for further research. The labels on the front also contain other information regarding the collages, including at least one location and donor identification. Additionally, the term "completion" is used as a general signifier for when she appears to have been working on this particular collage, and cannot be taken as describing the exact date of completion. Mrs. Delany herself used the term "finished" or "begun" in the inscriptions on only four of her collages. My thanks to Charles Nelson for his commentary on this issue.

2. See the essays by Kohleen Reeder and Peter Bower in this volume.

3. Mrs. Delany gave further parameters of her address, commenting that her new house "is behind the Thatched House Tavern in St. James's Street . . . the front faces a cross street now called Little St. James's Street, and the back looks into the Duke of Bridgewater's garden" Mary Delany to Mary Dewes, 14 October 1768, in Lady Llanover, ed., *The Autobiography and Correspondence of Mary Granville, Mrs. Delany*, 6 vols. (London: Richard Bentley, 1861–62), ser. 2, 1:182–83. While she lived in this house her letters were frequently addressed from THC or Thatched House Court.

4. Mary Delany to Mary Dewes, 4 October 1768, in Llanover, ed., *Autobiography and Correspondence*, ser. 2, 1:173. In a letter of September 1768 (ser. 2, 1:163), Mrs. Delany wrote to Miss Dewes: "Mr. Ehret is here, and [the duchess] is very busy in adding to her English herbal" Presumably this comment refers to this same project Mrs. Delany mentions a month later.

5. In Llanover, ed., *Autobiography and Correspondence*, ser. 2, 1:173.

6. In Llanover, ed., *Autobiography and Correspondence*, ser. 2, 1:384.

7. This has been noted in Ruth Hayden, *Mrs. Delany: Her Life and Her Flowers* (London: British Museum Publications, 1980), 132. The gardens and greenhouses of Peter Collinson, a London wool-draper and amateur botanist and gardener, served as an academy of sorts for botanical painters in the mid- to late eighteenth century. In 1744, the naturalist Mark Catesby painted a Meadia plant that had bloomed in Collinson's garden, and, in 1756, Collinson wrote that Ehret was lamenting his arrival at Collinson's house too late to paint a new species of helleborine, which had already bloomed and died. See Janice Neri's essay in this volume, which elaborates on Collinson's role at Bulstrode, and Maria Zytaruk's discussion of Collinson and Ehret.

8. Mary Delany to Bernard Granville, 26 June 1775, in Llanover, ed., *Autobiography and Correspondence*, ser. 2, 2:139.

9. Mary Delany to John Dewes, 8 May 1775, in Llanover, ed., *Autobiography and Correspondence*, ser. 2, 2:124. See Maria Zytaruk's essay in this volume, especially her account of Bernard Granville's "scarlet geranium" as social and scientific currency.

10. Mary Delany to Mary Dewes Port, 29 July 1775, in Llanover, ed., *Autobiography and Correspondence*, ser. 2, 2:149.

11. Mark Laird, *The Flowering of the Landscape Garden: English Pleasure Grounds, 1720–1800* (Philadephia: Univ. of Pennsylvania Press, 1999), 221–24. I am indebted to Mark Laird and John Edmondson for discussion of this point.

12. Sandra Morris comments on the late-seventeenth- to eighteenth-century interest in botanical collecting: "Eminent figures in the world of politics and science were prepared to spend personal fortunes, and to form syndicates, to finance these expeditions," again pointing out the conjunction of those with intellectual training and those with money and influence. See Sandra Morris, "Legacy of a Bishop (Part 2): The Flowers of Fulham Palace Gardens Introduced 1675–1713," *Garden History* 21, no. 1 (Summer 1993): 14. See also Mark Laird, "Exotics and Botanical Illustration," in Christopher Ridgway and Robert Williams, eds., *Sir John Vanbrugh and Landscape Architecture in Baroque England, 1690–1730* (Stroud, Gloucestershire: Sutton in association with The National Trust, 2000), 93–113; Mark Laird, "From Callicarpa to Catalpa: The Impact of Mark Catesby's Plant Introductions on English Gardens of the Eighteenth Century," in Amy R. W. Meyers and Margaret Beck Pritchard, eds., *Empire's Nature: Mark Catesby's New World Vision* (Chapel Hill: Published for the Omohundro Institute of Early American History and Culture by the Univ. of North Carolina Press, 1998), 184–227; Lisa Ford, "A World of Uses: Philadelphia's Contributions to Useful Knowledge in François-André Michaux's North American Sylva," in Amy R. W. Meyers, ed., *The Culture of Nature: Art & Science in Philadelphia, 1740–1840* (New Haven and London: Yale Univ. Press, forthcoming); Joel Fry, "America's 'Ancient Garden': The Bartram Botanic Garden, 1728–1850," in Meyers, ed., *Culture of Nature*; and Mark Laird, "This Other Eden: The American Connection in Georgian Pleasure Grounds, from Shrubbery & Menagerie to Aviary & Flower Garden," in Meyers, ed., *Culture of Nature*.

13. Her good fortune in being the beneficiary of the duchess is expressed also in regard to her collection of minerals, fossils, and shells, of which she says, "Every thing of that kind now bears an *enormous* price, so that were it not for the Duchess of Portland's bounty, I have small chance of *additions* to my collection." Mary Delany to Bernard Granville, 10 October 1774, in Llanover, ed., *Autobiography and Correspondence*, ser. 2, 2:40.

14. For a fuller explanation, see Kohleen Reeder's essay in this volume.

15. From Mrs. Rea (waiting-woman to Mrs. Delany) to Miss Mary Port, December 1779, in Llanover, ed., *Autobiography and Correspondence*, ser. 2,

2:495–96. In the Mary Hamilton archive at Manchester is the draft of a thank-you note to Queen Charlotte in the hand of the Duchess of Portland, written by the duchess on behalf of Mrs. Delany, in gratitude for the gift of a pocket-book in 1781.

16. The notion of traveling with a select group of papers was suggested by Kohleen Reeder in a conversation about Mrs. Delany's collage practice. Mentions of a coach in the Delany correspondence indicate that coaches could generally seat three or four people in comfort. See also Philip Thicknesse, *Useful Hints to Those Who Make the Tour of France, in a Series of Letters Written from That Kingdom . . .*, 2nd ed., corrected (1768; repr., London: Printed for G. Kearsly, 1770), 259, in which Thicknesse writes of his coach being large enough, with four people in it, to include a "small table" on which he could read, write, and set food upon for eating on the road.

17. Llanover, ed., *Autobiography and Correspondence*, ser. 2, 2:87 (Mary Delany to Bernard Granville, 31 December 1774); ser. 2, 2:407, 410 (Mary Delany to Mary Dewes Port, 27 February 1779). Indeed, in correspondence to Miss Mary Hamilton, later Dickenson, during 1783–85, she consistently offers the duchess's coach to collect Miss Hamilton for her visits to and from St. James's Place. Mary Granville Pendarves Delany, Correspondence, 1780–1788, The Lewis Walpole Library, Yale University, MSS Vol. 75.

18. In Llanover, ed., *Autobiography and Correspondence*, ser. 2, 2:240.

19. Mary Delany to Mary Dewes, 14 October 1768, in Llanover, ed., *Autobiography and Correspondence*, ser. 2, 1:183.

20. John Stuart, Earl of Bute, *Botanical Tables, Containing the Different Familys of British Plants, Distinguished by a Few Obvious Parts of Fructification Ranged in a Synoptical Method*, 9 vols. ([London, 1785]), 2:ii. See also Clarissa Campbell Orr, "Queen Charlotte as Patron: Some Intellectual and Social Contexts," *The Court Historian* 6, no. 3 (December 2001): 183–212; and Laird, "This Other Eden."

21. "Luton Hoo, the Seat of the Earl of Bute," [London] *General Evening Post*, 18 November 1783. The author also gives honorable mention to two other gardens: "Dr Pitcairne's at Islington, and the late Dr. Fothergill's at Upton, now destroyed."

22. British Library, Add. MS 74215, viewable at www.bl.uk/learning/artimages/maphist/wealth/lutonextract/utonhoo.html.

23. For more on Bute's botanical pursuits, see David P. Miller, "'My favourite studdys': Lord Bute as Naturalist," in Karl W. Schweizer, ed., *Lord Bute: Essays in Re-interpretation* ([Leicester]: Leicester Univ. Press, 1988), 213–39. For Bute's later years, see Peter D. Brown, "Bute in Retirement," in Schweizer, ed., *Lord Bute*, 241–73.

24. In Llanover, ed., *Autobiography and Correspondence*, ser. 2, 2:318. For the visit with the duchess, see Mary Delany to Bernard Granville, 16

September 1774, in Llanover, ed., *Autobiography and Correspondence*, ser. 2, 2:33. Mrs. Delany stated that Lady Bute had "often press'd me to come," and noted that it was a thirty-mile journey from Bulstrode. Mary Delany to Bernard Granville, 4 September 1774, in Llanover, ed., *Autobiography and Correspondence*, ser. 2, 2:30.

25. Mary Delany to John Dewes, 9 July 1778, in Llanover, ed., *Autobiography and Correspondence*, ser. 2, 2:363.

26. Dowager Countess Gower to Mary Delany, 19 September 1777, in Llanover, ed., *Autobiography and Correspondence*, ser. 2, 2:321.

27. Frances Boscawen to Mary Delany 2 August 1776, in Llanover, ed., *Autobiography and Correspondence*, ser. 2, 2:246.

28. Cecil Aspinall-Oglander, *Admiral's Widow; Being the Life and Letters of the Hon. Mrs. Edward Boscawen from 1761 to 1805* (London: Hogarth Press, 1942), 42–43; Dowager Countess Gower to Mary Delany, 20 July 1777, in Llanover, ed., *Autobiography and Correspondence*, ser. 2, 2:303.

29. Frances Boscawen to Mary Delany, in Llanover, ed., *Autobiography and Correspondence*, ser. 2, 2:266 (17 October 1776), 240 (22 July 1776).

30. Llanover, ed., *Autobiography and Correspondence*, ser. 2, 2:155 (Mary Delany to Mary Dewes Port, 5 September 1780), 475 (Mary Delany to Miss Mary Port, 10 October 1779). On 21 September 1780, she wrote to Miss Mary Port, "I have done some rare flowers" (ser. 2, 2:563).

31. *The Ambulator, or, The Stranger's Companion in a Tour round London; within the Circuit of Twenty-five Miles . . .*, 2nd ed. (London: Printed for J. Bew, 1782), 51.

32. Edmund Berkeley and Dorothy Smith Berkeley, eds., *The Correspondence of John Bartram, 1734–1777* (Gainesville: Univ. Press of Florida, 1992), 674.

33. Mary Delany to Mary Dewes Port, 5 August 1776, in Llanover, ed., *Autobiography and Correspondence*, ser. 2, 2:249.

34. In Llanover, ed., *Autobiography and Correspondence*, ser. 2, 2:320. The 'Hermania Althæifolia' has the date "19.9.77" on it.

35. Mary Delany to Mary Dewes Port, 29 September 1782, in Llanover, ed., *Autobiography and Correspondence*, ser. 2, 3:114.

36. Mary Delany to Mary Dewes Port, 29 April 1776, in Llanover, ed., *Autobiography and Correspondence*, ser. 2, 2:214. In that same volume, Lady Llanover also mentioned that Mary Delany moved from calling it an "Herbal" to a "Flora" (ser. 2, 2:215).

37. Mary Delany to Mary Dewes Port, 17 April 1779, in Llanover, ed., *Autobiography and Correspondence*, ser. 2, 2:421.

38. Mary Delany to Mary Dewes Port, 3 May 1781, in Llanover, ed., *Autobiography and Correspondence*, ser. 2, 3:17.

39. *The Ambulator; or, The Stranger's Companion in a Tour round London, within the Circuit of Twenty-five Miles: Describing Whatever Is Remarkable, Either for Elegance, Grandeur, Use,*

or Curiosity . . ., 3rd ed., improved and enlarged (London: Printed for J. Bew, 1787).

40. J. S. Cockburn, H. P. F. King, and K. G. T. McDonnell, eds., *A History of the County of Middlesex*, vol. 8, T. F. T. Baker, ed., *Islington and Stoke Newington Parishes* (Oxford: Published for the Institute of Historical Research by Oxford Univ. Press, 1985), 72.

41. Earl of Guilford to Mary Delany, 1 September 1778, in Llanover, ed., *Autobiography and Correspondence*, ser. 2, 2:382.

42. For more on Guilford and his family connections, see Clarissa Campbell Orr's essay in this volume.

43. Mary Delany to Mary Dewes Port, 17–20 April 1779, in Llanover, ed., *Autobiography and Correspondence*, ser. 2, 2:422, 424.

44. Mary Delany to Mary Dewes Port, 11 May 1780, in Llanover, ed., *Autobiography and Correspondence*, ser. 2, 2:519.

45. For more on the connections between the Northumberland and Bute families and their shared botanical interests with each other and Queen Charlotte, see Orr, "Queen Charlotte as Patron," 183–212.

46. "Heston and Isleworth: Syon House," in Susan Reynolds, *A History of the County of Middlesex: Volume 3: Shepperton, Staines, Stanwell, Sunbury, Teddington, Heston and Isleworth, Twickenham, Cowley, Cranford, West Drayton, Greenford, Hanwell, Harefield and Harlington* (London: Oxford Univ. Press, 1962), 97–100.

47. Berkeley and Berkeley, eds., *Bartram Correspondence*, 285, 299, 325.

48. Laird, *Flowering of the Landscape Garden*, 142.

49. Frances Boscawen to Mary Delany, 2 December 1775, in Llanover, ed., *Autobiography and Correspondence*, ser. 2, 2:180. Boscawen mentions her wallflowers, saying she had so many to plant at her cottage during the course of one day, along with other tasks, that she did not return to London until much later than she expected.

50. Aspinall-Oglander, *Admiral's Widow*, 42.

51. In Llanover, ed., *Autobiography and Correspondence*, ser. 2, 1:437–41 (Frances Boscawen to Mary Delany, 28 June 1772; Dowager Countess Gower to Mary Delany, 29 June 1772; Mary Delany to Lady Andover, 9 July 1772; Frances Boscawen to Mary Delany, 14 July [1772?]), 2:357 (Frances Boscawen to Mary Delany, 22 June 1778).

52. Mary Delany to Mary Dewes Port, in Llanover, ed., *Autobiography and Correspondence*, ser. 2, 2:98 (24 January 1775), 404 (1779), 516 (28 March 1780), 525 (24 May 1780).

53. Aspinall-Oglander, *Admiral's Widow*, 42–43 ("Letter to Mrs. D, from Glan Villa, 9 Nov 1773").

54. In Llanover, ed., *Autobiography and Correspondence*, ser. 2, 2:399.

55. Aspinall-Oglander, *Admiral's Widow*, 107.

56. In Llanover, ed., *Autobiography and Correspondence*, ser. 2, 3:17, 20.

57. J. M. Blatchly, "Cullum, Sir John, sixth baronet (1733–1785)," in H. C. G. Matthew and Brian Harrison, eds., *Oxford Dictionary of National Biography* (Oxford: Oxford Univ. Press, 2004),

online ed., ed. Lawrence Goldman, January 2008, www.oxforddnb.com/view/article/6878 (accessed 20 October 2008).

58. In Llanover, ed., *Autobiography and Correspondence*, ser. 2, 2:353.

59. Mary Delany to Miss Mary Dewes, 16 November 1763, in Llanover, ed., *Autobiography and Correspondence*, ser. 2, 1:22.

60. In Llanover, ed., *Autobiography and Correspondence*, ser. 2, 2:421.

61. For further discussion of Fothergill and Pitcairn, see John Edmondson's essay in this volume.

62. Edward Hasted, "Parishes: Bexley," *The History and Topographical Survey of the County of Kent: Volume 2* (1797), 162–83, available at www.british-history.ac.uk/report.aspx?compid=62809 (accessed 8 May 2008). Hasted describes him as "Mr. John Boyd, of London, merchant," who in May 1775 "was advanced to the dignity of a baronet." See also Dorothy Stroud, *Capability Brown*, new ed. (London: Faber, 1975); David Jacques, *Georgian Gardens: The Reign of Nature* (London: B. T. Batsford, 1983); David Brown, "Lancelot Brown and His Associates," *in* "Lancelot Brown (1716–83) and the Landscape Park," *Garden History* 29, no. 1 (Summer 2001): 8. After reviewing a draft of this essay, John Harris (personal communication to Mark Laird) made these observations on improvements to Danson: "Between 1745 and 1751 (when Colonel John Selwyn died) the house was enlarged, the rivulet dammed f[a]rther west to create a Bason or Great Pond, at the end of which was a large chinoiserie summer house with lattice work bridges on each side of it. A domed rot[u]nda was reached by a serpentine path built on the north lawn."

63. David Hancock, "Boyd, Sir John, first baronet (1718–1800)," in *Oxford DNB*, online ed., ed. Lawrence Goldman, January 2008, www.oxforddnb.com/view/article/49745 (accessed 29 September 2008).

64. Llanover, ed., *Autobiography and Correspondence*, ser. 2, 1:154 (Mary Delany to Miss Mary Dewes, 25–29 August 1768), 228 (Mary Delany to Lady Andover, 18 July 1769).

65. Mary Delany to Mary Dewes Port, 21 February 1775, in Llanover, ed., *Autobiography and Correspondence*, ser. 2, 2:111.

66. In Llanover, ed., *Autobiography and Correspondence*, ser. 2, 2:129. Peter Marshall, "Legge, William, second earl of Dartmouth (1731–1801)," in *Oxford DNB*, online ed., ed. Lawrence Goldman, January 2008, www.oxforddnb.com/view/article/16360 (accessed 27 February 2009). For more on Dartmouth's relationships, see Clarissa Campbell Orr's essay in this volume.

67. Mary Delany to Mary Dewes Port, in Llanover, ed., *Autobiography and Correspondence*, ser. 2, 2:80 (20 December 1774), 97 (19 January 1775). According to *A New Edition of the Royal Kalendar; or, Complete and Correct Annual Register for England, Scotland, Ireland, and America, for the Year

1775: . . . Corrected to the 20th of January 1775 . . .* (London: Printed for J. Almon et al., 1775), the Earl of Dartmouth's town residence was Charles Street, St. James's Square, just a few streets away from Mrs. Delany.

68. Llanover, ed., *Autobiography and Correspondence*, ser. 2, 2:320 (Mary Delany to Mary Dewes Port, 19 September 1777), 1:266 (Miss Mary Dewes to John Port, 9 June 1770).

69. Their profound friendship with Mrs. Delany is also suggested through the Dowager Countess Gower's comment that the two of them paid only brief visits to her, adding, "perhaps if you had been wth me they might have prolong'd 'em" Dowager Countess Gower to Mary Delany, 23 June 1774, in Llanover, ed., *Autobiography and Correspondence*, ser. 2, 2:6. For more on Mason, see Clarissa Campbell Orr's essay in this volume. For a full discussion of Nuneham Courtenay, see Laird, *Flowering of the Landscape Garden*, 350–60.

70. In Llanover, ed., *Autobiography and Correspondence*, ser. 2, 3:8.

71. Llanover, ed., *Autobiography and Correspondence*, ser. 2, 3:13.

72. Mary Granville Pendarves Delany, Correspondence, 1780–1788, The Lewis Walpole Library, Yale University, MSS Vol. 75. For more on Miss Hamilton, see Clarissa Campbell Orr's essay in this volume.

73. Jacques, *Georgian Gardens*, 92–93.

74. Thomas May, *Poems Descriptive and Moral; Consisting of Imitations, Translations, Pastorals, Narrations, and Various Reflections on the Beauties of Nature, &c.* (Henley: Printed by G. Norton for the author, 1791), 119–23.

75. W. S. Lewis, ed., *The Yale Edition of Horace Walpole's Correspondence*, 48 vols. (New Haven: Yale Univ. Press, 1937–83), 35:396, 459.

76. Mary Delany to Mary Dewes Port, 3 November 1780, in Llanover, ed., *Autobiography and Correspondence*, ser. 2, 2:571–72.

77. Horace Walpole, *The Works of Horatio Walpole, Earl of Orford*, 5 vols. (London, 1798), 2:426. It is intriguing to think that, just as Horace Walpole built his "paper house," Mrs. Delany built her paper *hortus siccus*.

78. Mary Delany to Mary Dewes Port, in Llanover, ed., *Autobiography and Correspondence*, ser. 2, 2:407 (27 February 1779), 571–72 (3 November 1780).

79. Stoke Place is not to be confused with Stoke Park, near Stoke Poges, Buckinghamshire.

80. William Aiton, *Hortus Kewensis, or, A Catalogue of the Plants Cultivated in the Royal Botanic Garden at Kew*, 3 vols. (London: George Nicol, 1789), 2:419.

81. Andrew M. Coleby, "Compton, Henry (1631/2–1713)," in *Oxford DNB*, online ed., ed. Lawrence Goldman, January 2008, www.oxforddnb.com/view/article/6032 (accessed 27 February 2009). As noted above, the bishop died in 1713, so presumably this date of cultivation is inexact. Morris, "Legacy of a Bishop," passim.

82. See Laird, "Exotics and Botanical Illustration."

83. Indeed, in his notes appended to the entries in his *Hortus Kewensis*, Aiton marked for each of these plants "G.H." (greenhouse). I am indebted to Charles Nelson and John Edmondson for these observations and comments on a draft of this essay.

84. Aiton *Hortus Kewensis*, 2: 429, 430. Aiton indicates that *Pelargonium scabrum* was introduced in 1775 by Kennedy and Lee, whereas William Curtis, *The Botanical Magazine; or, Flower-Garden Displayed, in which the Most Ornamental Foreign Plants . . . Are Accurately Represented in Their Natural Colours. To Which Are Added, Their Names . . . Together with the Most Approved Methods of Culture*, 18 vols. [electronic resource] (London: Printed by Stephen Couchman for the author, 1793–1803): 56, claims that Lee first propagated this from specimen seeds brought back from the Cape by Banks.

85. Aiton, *Hortus Kewensis*, 2:423.

86. Curtis, *Botanical Magazine*, 4:136, 6:206.

87. For brief mention of Lady Anne's social status at court, see Clarissa Campbell Orr's essay in this volume. Roy Rauschenberg and Joseph Banks, "A Letter of Sir Joseph Banks Describing the Life of Daniel Solander," *Isis* 55, no. 1 (March 1964): 66.

88. Janet Browne, "Monson, Lady Anne (c. 1727–1776)," in *Oxford DNB*, online ed., www.oxforddnb.com/view/article/57839 (accessed 27 February 2009).

89. Mary Delany to Miss Mary Dewes, 10 October 1768, in Llanover, ed., *Autobiography and Correspondence*, ser. 2, 1:176. See also John Harris, "A Pioneer in Gardening: Dickie Bateman Re-assessed," *Apollo* (October 1993): 227–33.

90. Lewis, ed., *Yale Edition of Horace Walpole's Correspondence*, 31:36.

91. Lewis, ed., *Yale Edition of Horace Walpole's Correspondence*, 9:384–85.

92. Lewis, ed., *Yale Edition of Horace Walpole's Correspondence*, 10:306–7.

93. Lewis, ed., *Yale Edition of Horace Walpole's Correspondence*, 1:325n7, 32:241.

94. Lewis, ed., *Yale Edition of Horace Walpole's Correspondence*, 32:245.

95. Sarah Katz, "Horace Walpole's Landscape at Strawberry Hill," *Studies in the History of Gardens and Designed Landscapes* 28, no. 1 (January–March 2008): 51 and passim.

96. Mary Delany to Mary Dewes Port, August 1778, in Llanover, ed., *Autobiography and Correspondence*, ser. 2, 2:372–73.

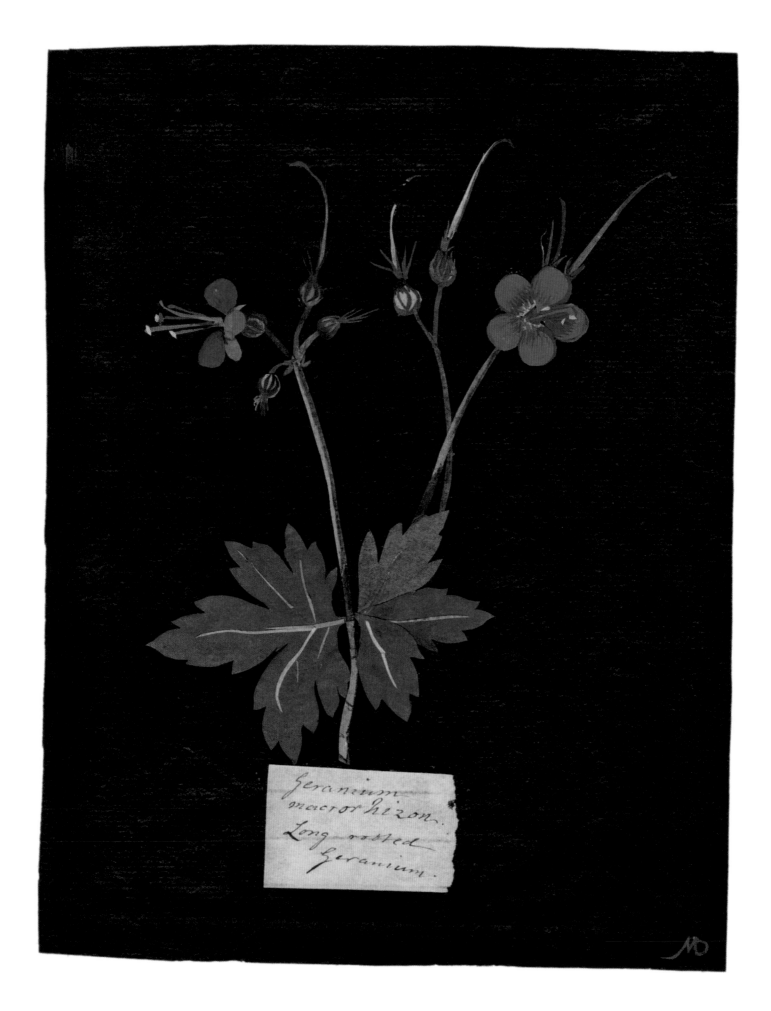

Mrs. Delany & her Circle

[11]

THE "PAPER MOSAICK" PRACTICE
of Mrs. Delany & her Circle

After Mary Delany was widowed for the second time in 1768, she went to live for a large part of each year with her good friend the Duchess of Portland at Bulstrode, Buckinghamshire. As essays in this volume document, Mrs. Delany had been interested in horticulture and gardening since her youth, and she shared a great passion for all branches of natural history with the duchess.[1] It was at Bulstrode that Mrs. Delany began to make her famous cut-paper collages of plants, which she referred to as "paper mosaicks" (fig. 223).[2] In October 1772, when Delany was in her seventy-third year, she wrote to her niece Mary Dewes Port: "I have invented a new way of imitating flowers."[3] Lady Llanover relates that Mrs. Delany first thought of this new art form when, sitting in her bedchamber one day at Bulstrode, she noticed the similarity of color between a geranium and a piece of bright scarlet paper she had on her table.[4] She took her scissors and cut the shapes of the flower out of the red paper; she used a green paper for the leaves and stalk, and created a picture of a geranium (now a *Pelargonium*). When the duchess entered the room she mistook the paper petals for real ones and exclaimed, "What are you doing with the geranium?" The duchess was so enthusiastic and supportive that Mrs. Delany was encouraged to continue with her new art (see fig. 21).[5]

For the next decade Mary Delany created nearly one thousand botanical "paper mosaicks," the major surviving records of this activity being contained in ten volumes now housed at the British Museum.[6] These collages are all made from paper, often cut into hundreds of tiny pieces, assembled to depict a single plant, and attached to black or other colored paper backgrounds; some contain an actual leaf or flower, carefully pressed and dried.[7] Mary Delany referred to her collection of paper mosaics as her "herbal" or "hortus siccus," thereby likening it to a collection of pressed and dried plants.[8] (These names are discussed on p. 34.) Such representations fall short

of a true *hortus siccus* or herbarium, which would contain actual plants, but they do have the advantage of holding color better than pressed and dried flowers, which often fade over time.[9] Moreover, Mrs. Delany's paper mosaics were executed within a social context involving various degrees of collaboration—characteristic of many of the accomplishments and recreations practiced in polite circles in the eighteenth and early nineteenth centuries. Her collage production is thus rather different from the making of a *hortus siccus* under the auspices of one collector, such as the first Duchess of Beaufort, who acted as patron to many donors.

In 2007, the Yale Center for British Art acquired a group of botanical paper collages owned by the Hon. Booth Grey that relate very closely to the collages by Mrs. Delany. An opportunity to study these works from a technical standpoint was undertaken by the author and other Yale Center for British Art and scientific staff. The collages were explored using the tools and methodologies of conservation science and technical art history—including a reconstruction of collages made by both Booth Grey and Delany—in order to shed new light on amateur artistic practice in the eighteenth century and to increase our knowledge and understanding of how these works of art were made. This essay will consider the process, tools, materials, and techniques used to create the paper mosaics by Mrs. Delany and her circle, and how the Delany and Booth Grey collages relate.

The Hon. Booth Grey and His Collages in the Light of Mrs. Delany's Collages
Little is known about Booth Grey that pertains to his collection of botanical paper collages. An inscription on the original pastedown of the album that once held these collages—"98 Plants done by the Honbᵗᵉ Booth Grey"—is the only clue we have as to who made them (fig. 224). Grey was the younger son of the Countess of Stamford, and his

older brother was married to the Duchess of Portland's daughter Henrietta. In all likelihood, then, he would have been a visitor at Bulstrode and it is believed that he was part of Mrs. Delany's circle of acquaintances.[10] He is almost certainly the same "Mr. B Grey" that gave Mrs. Delany plant specimens for at least four of her paper mosaics, all of which were made at her home at St. James's Place between 1777 and 1779.[11]

Booth Grey was a member of parliament, representing Leicester from 1768 to 1784. He was educated at Cambridge, lived at Budworth Magna (near Dunham Massey, the country seat of his elder brother, the Earl of Stamford), and he married Elizabeth Manwaring in 1782. Like other men of his social class, he seems to have been interested in horticulture and the arts.[12] It was not only the gentlewomen of the period, like Mrs. Delany, who studied, collected, classified, and drew plants as amateurs.[13] As Kim Sloan explains:

Figure 223: Mary Delany, 'Geranium macrorhizon', 1773, collage of colored papers, with bodycolor and watercolor on a black ink background 8⅜ × 6⅜ in. (21.4 × 16.3 cm). British Museum, Department of Prints and Drawings (1897,0505.377)

Figure 224: Detail of inscription on Booth Grey album pastedown

Horticulture was as much a field for gentlemen and lady amateurs as limning, and demanded a similar specialist knowledge acquired like other virtuosi pursuits through books and association with experts as well as fellow enthusiasts. In a similar manner to limning and collecting, horticulture was considered a study suitable for kings and connoisseurs.[14]

Alexander Marshal, Richard Waller, and Mark Catesby represent a small group of gentlemen amateur botanical artists; topographical art had many more amateur practitioners.[15] However, Mark Laird, documenting the "amateur gardening culture" of gentlemen and gentlewomen in this volume, points out the special place that genteel women assumed within horticulture, patronage of natural knowledge, and botanical art as imparted to the daughters of aristocracy by Georg Dionysius Ehret. That Booth Grey was drawn to the female accomplishment of the collage appears unique, as no other gentleman is associated with that particular amusement. As Peter Bower explains in his essay, more than one hand is at work in the creation of the collages in this set. Hence, Booth Grey's role could have been

as much patron or coordinator as leading or active participant.

As Mrs. Delany's paper mosaics became famous, her success inspired others to try their hands at this art form.[16] She was always willing to share her work with those around her. In her *Memoirs of the Literary Ladies of England* of 1845, Mrs. Elwood explained: "Mrs. Delany was at all times ready to communicate the secret of her art, which she frequently pursued in company, when she would show her friends how easy it was to execute, and would often lament that so few would attempt it."[17] Mary Delany certainly taught her technique to several ladies, the most accomplished of whom was a Miss Jennings.[18] It is thus possible that she also gave Booth Grey some instruction in her technique.

The Booth Grey corpus currently includes 136 collages, which very closely resemble Mary Delany's paper mosaics.[19] They are made from pieces of cut paper, are attached to paper that was painted black, and are individually labeled with the name of the plant depicted. Identification and dating of watermarks and wallpaper stamps on some of the papers in the collages and original Booth Grey album indicate that the initial set of

Figure 225: Attributed to Booth Grey, 'Geranium Macrorrhisum', ca. 1790, collage on laid paper prepared with watercolor, 9⅞ × 7¾ in. (25.1 × 19.7 cm). Yale Center for British Art, Paul Mellon Fund

Figure 226: Completed reconstruction of 'Geranium Macrorrhisum' by Kohleen Reeder, 2007, collage on laid paper prepared with watercolor

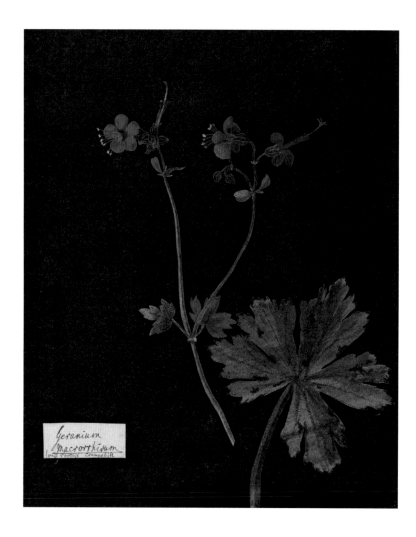

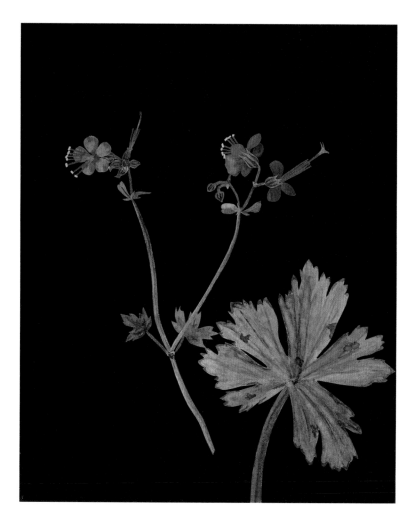

Booth Grey collages was assembled in the 1790s.[20] John Edmondson's essay, which works from the dates of publications that name plants later appearing in the Booth Grey album, confirms this paper evidence. It is known that this collection has been broken up several times; for example, twenty-eight collages were sold during the three years prior to the Yale Center for British Art's acquisition in 2007.[21] Approximately forty-six collages have numbers inscribed on the back, but the numbering system is incomplete and inconsistent. It is apparent through visual examination that several hands were involved in the creation of these collages—the use of different styles and techniques can be observed, and the level of skill with which the collages were executed varies. Clearly, there is still much more to be learned about Booth Grey and his collection of collages, and this area of study could benefit from further research.

Technical analysis was completed on a selection of the Booth Grey collages before reconstructions were made. This analysis was performed by Dr. Henry DePhillips, Jr., Professor of Chemistry at Trinity College in Hartford, Connecticut. The collages were analyzed using Scanning Electron Microscopy (SEM) and Raman Spectrophotometry.[22] Raman Spectrophotometry is a nondestructive method of analysis that does not require taking samples from the artwork. The goal of these analyses was to learn about the specific pigments, binders, and adhesives used to create the artworks.

The Booth Grey collages selected for technical analysis relate visually and/or botanically to Mrs. Delany's collages. Visual analysis under the microscope and with ultraviolet light was carried out on the Booth Grey collages and a group of Delany collages. A close comparison revealed many similarities—in, for example, the use of materials—and some differences, including variation in technique. To understand the collage-making process more fully, reconstructions were made utilizing the same materials, tools, and techniques that were used to create the originals. The first reconstruction was of 'Geranium Macrorrhisum' in the Booth Grey group (figs. 225, 226); Mrs. Delany's 'Geranium macrorhizon' of 1773 (see fig. 223) depicts this same species. The second reconstruction was of Mrs. Delany's 'Narcissus Poeticus' of 1778 (figs. 227, 228).

Figure 227: Mary Delany, 'Narcissus Poeticus', 1778, collage of colored papers, with bodycolor and watercolor, 12½ × 8⅞ in. (31.9 × 22.5 cm). British Museum, Department of Prints and Drawings (1897,0505.595)

Figure 228: Completed reconstruction of 'Narcissus Poeticus' by Kohleen Reeder, 2008, collage on laid paper prepared with watercolor

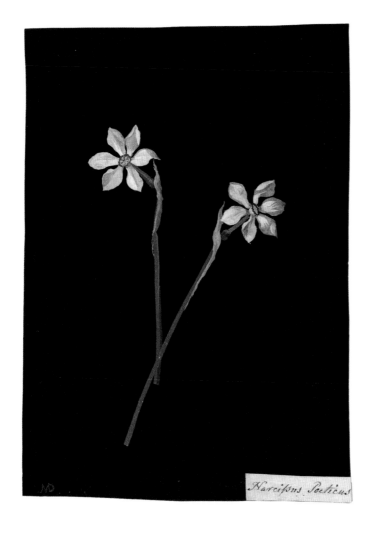

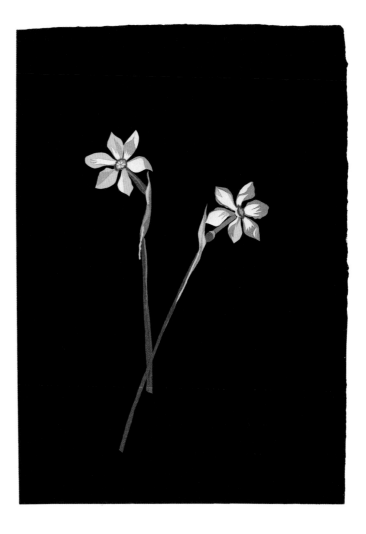

In most instances it is probable that Mrs. Delany worked her mosaics with the living plant in front of her.[23] Lady Llanover describes how Mrs. Delany placed a sheet of folded black paper behind the plant to make the outline of the leaves and flowers more distinct and to increase the contrast between the lights and shadows.[24] Delany then cut small pieces of colored paper to represent different parts of the plant. The shapes of petals and leaves often were cut from a single piece of paper, with smaller pieces placed on top for shading.[25] Additional pieces of paper were cut to represent, for example, the stamens, calyx, stalk, and veins of leaves.[26] The pieces of cut paper were built up in several layers and attached to a black paper background, giving the paper mosaics a very distinctive three-dimensional quality.

Many of the plants Mrs. Delany used as models for her collages came from the garden or hothouses at Bulstrode, or from its surrounding countryside.[27] As her skill became more widely known, plants were sent to her from many different sources, including Chelsea Physic Garden and the gardens at Kew.[28] Once Delany had obtained the plant, it is most probable that she placed the cut flower in a vase or some kind of water

container. It often took her more than a day to work a collage, so it would have been important to keep the flower alive and fresh in order to depict the specimen and its colors correctly. Some plants, especially bulbous species, she could have had as growing specimens in a pot.

Mrs. Delany was very meticulous in portraying the plants as accurately as possible.[29] She took great care to count the correct number of stamens and styles and to use the Linnaean system of classification.[30] However, as Charles Nelson has pointed out, in some plants these parts are far too small to cut and represent, and they are thus omitted.[31] In this sense, her collages are lifelike rather than strictly accurate in a botanical sense; hence, her use of the term "imitating" is correct. It is known that Mrs. Delany dissected actual plant specimens so she could examine them carefully for accurate portrayal. During his visit to Bulstrode in 1776, William Gilpin was shown the Delany "herbal" and described her method thus: "In the process of her work, she pulls the flower in pieces, [and] examines anatomically the structure of its leaves, stems, and buds."[32] It was common practice among botanical artists to dissect plants in order to broaden their knowledge of how the plant was constructed. In fact, Mary Delany described G. D. Ehret's dissection of plants while painting botanical pictures for the Duchess of Portland: "poor Ehret begins to complain of his eyes, he has hurt them with inspecting leaves and flowers in the microscope in order to dissect them."[33] It is possible, then, that Delany had more than just one specimen to work from—at least two, one for portraying and one for dissecting or pressing.

Mrs. Delany occasionally added pieces of the plants to her collages. One example is her 'Lithospermum purpurocæruleum' of 1777, in which she attached a pressed leaf to the underside of a cut-paper leaf. This must have taken careful forethought and planning, in order to have the real leaf ready, pressed and dried, in advance of attaching all of the collage elements. The Delany 'Clethra alnifolia' of 1779 also has a pressed leaf. Her 'Ixia crocata' of 1778 is unusual in having a petal and the central part of the flower attached to the collage after being dissected (see plate 18 in "Theater").[34] This practice is peculiar to the Delany collages and is not found in any of the Booth Grey collages.

By the end of 1775, after creating more than one hundred paper mosaics, Mrs. Delany had perfected her technique.[35] She made them at remarkable speed, using hundreds of delicately cut pieces of colored paper to render a lifelike appearance.[36] Her daily routine was to start her paper

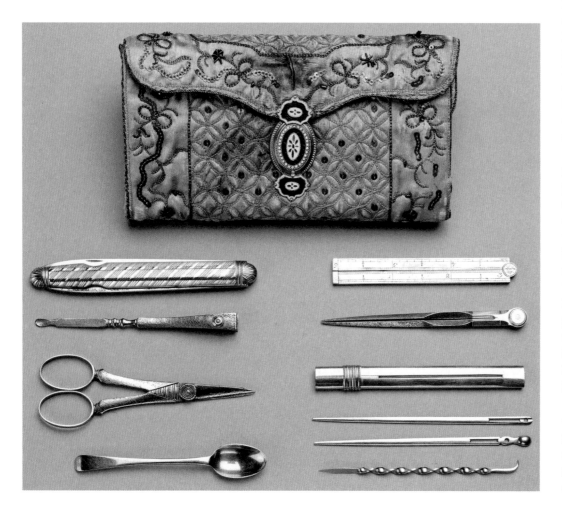

Figure 229: Needlework pocket-book given by Queen Charlotte to Mrs. Delany, 1781, satin, colored silks and enameled gold, 10⅞ × 9⅞ × ⅝ in. (27.7 × 25 × 1.5 cm) (open). The Royal Collection

mosaics after breakfast, although visitors often interrupted her work.[37] In October 1777 Delany created what appears to be a record number of paper mosaics in one month (about thirty). However, in some cases the collage had been substantially composed before its completion and dating that month.[38] Her skill at cutting paper had been developed over a lifetime of practice following the widespread fashion of the eighteenth century;[39] she had been cutting landscape and figural silhouettes since she was a very young person.[40]

Although sources describe Mrs. Delany as always using scissors to cut her paper (see fig. 237), it is very likely that she also used a knife. Early silhouette artists most often used small sharp knives, as suitable scissors were not readily available until the end of the eighteenth century.[41] While making the reconstructions of the Booth Grey 'Geranium Macrorrhisum' (see figs. 226, 234–9) and the Delany 'Narcissus Poeticus' (see fig. 228), it was observed that cutting the very small and delicate parts of the flowers with scissors, particularly the stamens, did not produce a satisfactory result. Using a knife simplified the process of making such precise cuts and gave results that much more closely resembled the original collages.

It should also be noted that both a pair of scissors and a knife are found in a pocket-book set of tools given to Mrs. Delany by Queen Charlotte to assist her in her work (fig. 229).[42] The queen sent Mrs. Delany this small pocket-book, which contained "a knife, sizsars, pencle, rule, compass, [and] bodkin," after a visit to Bulstrode in December 1781.[43] Although Mrs. Delany's eyesight was failing by that time, the set does give us a good idea of what tools she might have been using.[44] The collage reconstructions also made evident that she most likely used other tools as well, such as tweezers and a bone folder (see figs. 238, 239).

The plants in Mrs. Delany's paper mosaics were depicted life-size and with precise perspective. It has been argued that she did this completely by eye, without any preliminary sketching. Lady Llanover, for example, claimed that "Mrs. Delany did not draw the plant; but *by her eye* cut out each flower or rather each petal as they appeared... ."[45] A number of silhouette artists in the eighteenth century were sufficiently accomplished to cut an accurate silhouette freehand after only a brief study of the sitter before them, and Mrs. Delany's silhouetting experience undoubtedly helped her develop these skills.[46] The makers of the Booth Grey collages, as Peter Bower has noted, apparently relied much more on graphite.

There is evidence, however, that Mary Delany occasionally did some drawing before making her cuts. One example is 'Chrysanthemum Lucanthemum' of 1774, on which graphite outlines and shading on the white ray florets are visible, as are graphite guidelines drawn on the black background. Many more of the collages from the Booth Grey set show graphite outlines (as can be seen in the details of 'Geranium Macrorrhisum' illustrated in figures 230 and 231). Most of the collage elements in Mrs. Delany's paper mosaics and in the Booth Grey set are made from cut

Figure 230: Detail of flower from Booth Grey, 'Geranium Macrorrhisum', illustrated in fig. 225

Figure 231: Detail of leaf from Booth Grey, 'Geranium Macrorrhisum', illustrated in fig. 225

pieces of paper that have been painted out with watercolors. It was common practice for watercolorists to use graphite pencils to lay out their design in an underdrawing before washing it with watercolors (see fig. 235).[47] Graphite was being sold in London by 1610, and cedar-encased graphite rods—what we refer to as pencils today—had been available since the second half of the seventeenth century.[48] In Britain during the eighteenth century, slim drawing pencils, usually set into silver or brass mounts, were provided in most pocket instrument cases (fig. 232).[49] It is very possible that Mrs. Delany used such a pencil in her work.

Figure 232: Shagreen-covered pocket case with complete set of instruments including silver-mounted pencil. Probably by Peter Dolland (1730–1820), 6¼ × 2¼ × 1¼ in. (17 × 7 × 3.2 cm). Andrew Alpern Collection, New York

Marks on the collages show us that Mary Delany used other tools to assist her in cutting and assembling her paper mosaics. A bodkin, a sharp slender tool for making holes in cloth or paper, was possibly used when she worked 'Arum esculentum' of 1780. There are claims of evidence of piercing holes of different sizes in yellow and green paper to reveal an off-white paper underneath, but this proves impossible to verify.[50] Pinpricks can be found in many of the black background support papers of Mrs. Delany's collages—in her 'Lavatera Olbia' of 1778, for example, where holes indicate the use of a bodkin or compass to make small guide marks for the placement of the collage elements. Mrs. Delany most likely used tweezers to assist her in assembling the collages, as many of the collage elements would have been too small to handle easily with the fingers (see fig. 238), as well as a small bone folder to rub the collage elements down once they had been attached with an adhesive (see fig. 239).

At times Mrs. Delany made her paper mosaics while she was visiting friends. In a brief visit of three or four days to Lady Bute at Luton Park, she portrayed several plants.[51] The work that she did on these visits suggests that she traveled with her various tools and papers, as Lisa Ford describes in detail in this volume.

The Delany collages and those in the Booth Grey set were made from a variety of papers, but the majority were white laid papers made from linen rags, some with linen and hemp, sized with animal gelatin and rolled between metal plates. They were later prepared with a watercolor or ink wash. The background papers of Mrs. Delany's earliest collages were washed with black iron gall ink and then washed with size to produce a shiny surface.[52] From some point in 1774, many of her background papers—either obtained from paper-stainers who supplied wallpaper or prepared by or for her—were painted with water-based carbon black paints and had a matt surface.[53] A small number are off-white to tan and were not prepared with a black ground. Some of the Booth Grey collages are on white background papers—a few are even on gray backgrounds—but the majority are on black background papers. Results from scientific analysis reveal that most of these papers were prepared with a black watercolor, as the binding agent used is gum arabic, an ingredient of most traditional watercolor recipes.

The colored papers used for the collage elements in Mrs. Delany's works came from various sources. Some were provided by friends and acquaintances or were acquired from paper-stainers, but most would have been painted out with watercolors and/or gouache by Mrs. Delany herself.[54] In some of her collages she used a green paper with mica flakes, which added a slight shimmer. Some of the leaves of her 'Clethra alnifolia' are made from this green micaceous paper. A similar paper can be found in many of the Booth Grey collages. It is likely that this paper was commercially available; Peter Bower acknowledges that it may have come from India.[55] Mrs. Delany must have built up a vast assortment of colored papers over time. Not only was she careful to use papers that matched the colors of the plants she was depicting, but it also has been suggested that she selected papers with textures or finishes that would give an accurate impression of those plants.[56] This is probably the case in many of the Booth Grey materials. In Booth Grey's 'Fumaria Fungosa', it appears that the paper used to make the green stalk was selected for its texture (see fig. 257). The texture comes from shrinkage creases formed by a rope mark created during the papermaking process, when the wet paper was

draped over a rope to dry. Many of the Booth Grey collages, such as 'Geranium Macrorrhisum', use the felt side of the paper to mimic the natural texture of the leaves (see fig. 231). The papers used in the Delany collages and in the Booth Grey set are discussed in much greater detail by Peter Bower in his essay in this volume. Much still remains to be researched, however, including the processes whereby the Delany and Booth Grey collages were labeled.[57]

The Reconstruction of the Booth Grey and Delany Collages

The papers used for the reconstructions of the Booth Grey 'Geranium Macrorrhisum' and Delany's 'Narcissus Poeticus' came from Twinrocker Handmade Paper in Brookston, Indiana. These papers, which are made from 100 percent cotton fiber, were selected for their similar weight and texture to the paper used in the original collages. In order to prepare them for being painted out with watercolors, they were hand-sized using a 3 percent gelatin solution (60g Gelita gelatin granules to 2L deionized water) with 1 percent alum (20g potassium aluminum sulfate). The solution was heated to approximately 50 °C and, when the gelatin was fully dissolved, placed in a shallow tray. The papers were dipped into the warm gelatin, stacked and pressed to squeeze out the excess gelatin, and quickly separated to dry.[58]

The papers, especially those prepared with the black watercolor to create the background, most likely were brushed out with pure water (usually using a rag or a large paintbrush) to relax the paper and to allow for complete wetting by the paint.[59] Evidence of pinholes in some of the corners of the Booth Grey collages leads to the conclusion that once the papers were painted out they were then pinned to a board, to stretch the paper and to prevent it from wrinkling during the drying process. The presence of black paint on some of the back edges of the support papers confirms that the papers were painted out before being stretched on a board (fig. 233).

The pieces of colored paper used in the Delany and Booth Grey collages would have been painted out as much as possible before cutting (see fig. 236). Occasionally, Mrs. Delany touched up her collages with watercolor and/or gouache after the pieces had been attached to the black supports.[60] Her 'Æsculus Hippocastanum' of 1776, 'Arbutus Unedo var' of 1776, and 'Lavatera Olbia' of 1778 all were painted with watercolors after the pieces were attached to their supports. Many of the Booth Grey collages also provide the same evidence. In contrast to the Delany collages, the Booth Grey collages tend to have many fewer individually cut pieces of colored paper and much more painting.

The *Art of Drawing and Painting in Water-Colours*, published in London in 1770, describes using a "painting brush of camel's hair" or a "pencil of camel's hair" for painting watercolors.[61] The term "camel's hair" can be misleading, as the brush hairs did not actually come from camels. A "camel's hair" brush or pencil was common mid-eighteenth century usage for an inexpensive brush of soft hair from various types of mammal, such as weasel or squirrel.[62] By the late eighteenth century, the most sought-after watercolor brushes for fine work were made of the hair of the Russian sable set in a bird's quill.[63]

In the eighteenth century, when pigments were ground by hand with a muller on a stone or glass slab, artists manufactured their own watercolors.[64] The English "colour-man" William Reeves invented dry-cake watercolors in about 1780.[65] They were immediately popular, and, by the beginning of the nineteenth century, most amateur artists were using manufactured watercolors.

Mrs. Delany created her paper mosaics between 1772 and 1782, when commercial watercolor paints were not yet available, so it is presumed that she made her own or had someone make them for her. From her letters we know that she also was given paints and exchanged paint recipes within her circle of friends. On 19 August 1766, for example, she wrote to Lady Andover: "Is it possible to get the receipt of the purple paint y[r] Ladyship gave me a bottle of."[66] In the following month, she wrote to Lady Andover again, saying: "Did I beg the receipt of the purple paint for water colours?"[67]

Skill and experience were required to make successful watercolor paints, and it is certain Mrs. Delany and artists of her period had to experiment with their watercolor recipes.[68] Published watercolor recipes are scarce, and most that have been published are oversimplified.[69] As Ralph Mayer explains, "Those who have made adequately successful [watercolors] usually find that they must do their own formulating by trial and experiment, because each pigment will require its own special proportion of binder."[70]

Watercolor paints are essentially made of finely ground pigments in an aqueous solution of gum arabic.[71] Watercolors historically have been and continue to be made with gum arabic, the natural secretion of an African acacia tree, which is now classified as *Senegalia senegal*.[72] Gum arabic acts as a binder and adhesive, giving watercolor the capacity to stick to paper. It also plays a crucial role in maintaining the dispersion of the pigment particles in water until the film of wash has dried and the colors are gummed in place on the paper.[73] Honey (or some other form of sugar) and ox gall are other ingredients typically found in original watercolor recipes. Honey acts as a plasticizer and contributes smoothness for grinding and painting. Ox gall is a natural wetting agent and traditionally is used in watercolor painting to alter the surface properties of watercolor paints.[74] It breaks the surface tension in watercolor paints,[75] and in grinding helps the water penetrate the pigment particles (forming a "colloidal suspension").[76] Water is used to mix and dilute watercolor paints. Gouache or bodycolor, a paint used on some of the collages in both the Delany and Booth Grey groups, is basically a heavier, more opaque watercolor to which an additional white pigment, such as chalk, has been added. In *Art of Drawing and Painting in Water-Colours*, a "gum-water" recipe, which would have been mixed with various pigments to make the watercolor paints, calls for one ounce of fine white gum arabic and half an ounce of clear, white candied sugar (pure sugar crystals formed from a refined sugar solution; the sugar would have served as the plasticizer)[77] to be dissolved in one quart of "fair," or clean, pure water.[78] It is of interest to note that the *Art of Drawing and Painting in Water-Colours* also mentions the use of "liquor of ox-gall" in watercolor paints.[79]

Figure 233: Detail of bleed over and pin mark on verso of 'Geranium Macrorrhisum', illustrated in fig. 225

Figure 234: Collage-making process: Making watercolors
(mixing pigment with gum arabic solution)

Figure 235: Collage-making process: Drawing collage elements

Figure 236: Collage-making process: Painting collage elements

Art of Drawing and Painting in Water-Colours also describes pigments that were used to make specific colors, explaining, for example, that when painting flowers that "tend towards a reddish colour, you are to use a faint colour of carmine with Gum-water."[80] Red lead, vermilion, and red lake, in addition to carmine, are the pigments recommended to make red watercolor paints. Indigo and ultramarine blue are suggested for blues, gamboge for yellow, sap green and verdigris for greens, and flake white (or lead white) for white. Results from scientific analysis on the Booth Grey materials indicate that pigments such as bone black, ultramarine blue, mars red and mars yellow (iron oxide earth pigments), malachite, verdigris, green earth, and lead white were used. All of these pigments were available in the late eighteenth century.

Watercolors were made by the author for the reconstructions of 'Geranium Macrorrhisum' and 'Narcissus Poeticus', and the pigments used to make these watercolors included bone black, ultramarine blue, mars red, and mars yellow. Based on traditional recipes,[81] the following procedure was used:

1. Pulverize gum arabic using a mortar and pestle.
2. Dissolve 1 part gum arabic in 7 parts hot deionized water (50 g gum arabic in 350 ml water). Strain through sieve.
3. Mix 1 part honey to 3 parts of gum arabic solution (115 ml honey to 345 ml gum arabic solution) and add 4 drops of ox gall.
4. Put heaping teaspoon of pigment on glass plate, make hole in the mounded pigment, and pour some of the solution into the hole.
5. Mix pigment with solution using muller and glass slab. Work muller in a figure-eight motion and sprinkle with gum arabic solution until mixture has the consistency of a smooth, stiff paste.
6. Scrape watercolor with a palette knife from glass slab and place into an empty container.

After the papers had been painted and cut into their shapes, an adhesive was used to attach the collage elements to the support paper. It is uncertain what glue Mrs. Delany used to attach the collage elements; Ruth Hayden has suggested eggwhite.[82] Flour paste is also likely, as laboratory tests completed at the British Museum on three of Mrs. Delany's collages detected a starch-based adhesive.[83] Flour paste was simple to make, and flour would have been readily available in Mary Delany's household. In a letter written to Anne Dewes nearly thirty years before beginning

her paper cuts, Mary discussed using flour paste for pasting paper: "As to pasting paper, I use flour boiled in water as smooth as it can be boiled, and paste both the papers very evenly that are to be pasted together."[84]

The collage elements also could have been attached with an animal glue, such as rabbit skin glue or fish glue. Animal glues were commonly used for bookbinding, furniture making, and various other arts and crafts in the eighteenth century. Isinglass glue—a glue made from the air bladders of some types of fish, especially sturgeon—was also a staple animal glue used during this period. It is prepared by first soaking the dried bladders in water and allowing them to soften, after which the excess water is removed, fresh distilled water is added, and the bladders are slowly dissolved and heated to 60 °C, stirring constantly.[85] If isinglass glue was used, it must have been kept warm in a glue pot, such as was used in a bookbindery, in order to keep the glue fluid and brushable. Mary Delany referred to isinglass glue in one of her letters to her sister, Anne: "As soon as I get my receipt-book I will send you the isinglass cement."[86] Scientific analysis on the Booth Grey 'Geranium Macrorrhisum' has shown that a protein-based adhesive, most likely an animal glue and possibly isinglass glue, was used to attach the collage elements to the support paper. Mrs. Delany could have used several different kinds of adhesives, especially when she worked her collages while visiting friends. What adhesive was used, in her collages as well as in those of the Booth Grey group, was probably determined by what was available at the time.

Mrs. Delany's Legacy

In the decade between 1772 and 1782, Mrs. Delany created a significant collection of nearly one thousand paper mosaics. She shared her paper mosaic work with all those around her and taught others her technique. Miss Jennings, one of the many ladies whom she taught, helped Mrs. Delany finish some of the last collages when her eyesight was fading. Indeed, a small number of the Delany collages worked in the last years are inscribed on the back "begun by Mrs. Delany and finished by Miss Jennings."[87] Her eyesight had begun to fail in 1780 and two years later, in her eighty-third year, she composed a poem bidding farewell to her flowers. This poem was inserted in the front of the first album, along with a record written by Mrs. Delany of their creation, in which she particularly acknowledged the encouragement she had received from the Duchess of Portland.[88]

Figure 237: Collage-making process: Cutting collage elements with scissors

Figure 238: Collage-making process: Attaching collage elements using tweezers

Figure 239: Collage-making process: Rubbing down collage elements using bone folder

Sir Joshua Reynolds, Horace Walpole, and such botanists as Sir Joseph Banks and Dr. Daniel Solander were all admirers of Mrs. Delany's paper mosaic work. Banks said that Mary Delany's representations of plants "were *the only* imitations of nature that he had ever seen, from which he could *venture* to describe botanically any plant without the least fear of committing an error."[89] While this proves under close examination to be a boast (since, as Charles Nelson has determined, the level of strict botanical accuracy is poor in some cases), it points to the influence that her collages had over a generation of artists and scientists. The praise of Mrs. Delany's work by Erasmus Darwin, which is discussed in the Introduction to this volume, increased that influence for the next generation.

In addition to those who made the Booth Grey collages, others followed Mrs. Delany's collage practice. A set of more than two hundred collages were created by Charlotte Hanbury following Mary Delany's paper mosaic technique. Hanbury's collages have many painted elements, and a green micaceous paper was used for some of the leaves, as can be seen in the Delany and Booth Grey sets as well. They are bound into five volumes and are part of the Royal Library collection at Windsor Castle.[90] There is still much more to be learned about this set of collages.

A collection of watercolor copies of a small number of Mrs. Delany's paper mosaics is also found at Windsor Castle.[91] The Hon. Mrs. Herbert of Llanover had some of Mrs. Delany's works copied to present to Queen Victoria at the time of her Diamond Jubilee.[92] These copies were made by the Japanese artist Reikichi Tsayama at the British Museum in 1897. We know via the Booth Grey examples and from these other collections that Mrs. Delany's collages were technically interesting to her contemporaries, and that people were still engaged in this technique even in the nineteenth century. Perhaps more examples influenced by the paper mosaic practice of Mrs. Delany and her circle are yet to be uncovered.

Through the technical study of these works, including the process of reconstructing the Booth Grey and Delany collages, we have achieved a much greater understanding and appreciation of these works of art. In this way, interest in Mary Delany's paper mosaic work will gain momentum and relevant research will continue to flourish. It is believed that this exhibition and publication serves to increase awareness of this woman's remarkable talent and skill.

Acknowledgments
I would like to thank Amy Meyers, Alicia Weisberg-Roberts, and Mark Laird for their encouragement and willingness to have me be a part of this research. Special thanks to Theresa Fairbanks-Harris, all those in the YCBA Conservation department, and other YCBA staff for their support. Many thanks to Henry DePhillips for his brilliant work with the scientific analysis and to Victoria Munroe for her invaluable assistance with the Booth Grey collages. I would also like to thank the British Museum Print Study Room and Conservation staff, particularly Kim Sloan and Helen Sharp, for all of their help with the Delany collages. Thank you to Peter Bower and other authors in this volume for references taken from their essays. I am especially grateful for the kind and loving support of my friends and family, most of all my parents.

Notes
1. Jane Roberts, *George III and Queen Charlotte: Patronage, Collecting and Court Taste* (London: Royal Collection, 2004), 191, 219.
2. In July 1779, Mrs. Delany wrote an introduction to her collection of "paper mosaicks", which was headed: "Plants Copied after Nature in paper Mosaick begun in the year 1774." See Ruth Hayden, *Mrs. Delany: Her Life and Her Flowers*, 2nd ed. (London: British Museum Publications, 2000), 155.
3. Mary Delany to Mary Dewes Port, 4 October 1772, in Lady Llanover, ed., *The Autobiography and Correspondence of Mary Granville, Mrs. Delany*, 6 vols. (London: Richard Bentley, 1861–62), ser. 2, 1:469; Hayden, *Mrs. Delany*, 131.
4. Llanover, ed., *Autobiography and Correspondence*, ser. 2, 2:215; Hayden, *Mrs. Delany*, 131–32.
5. There is no firsthand account by Mrs. Delany of how she came to create her first "paper mosaick" and no collage dated 1772 has been located. Personal communication from Maria Zytaruk, 7 July 2008.
6. Roberts, *George III and Queen Charlotte*, 219.
7. Ibid.
8. See Mary Delany to Mary Dewes Port, in Llanover, ed., *Autobiography and Correspondence*, ser. 2, 2:48 (28 October 1774), which refers to her "hortus siccus," and 2:213 (29 April 1776), which refers to her "herbal." See also Kim Sloan, *'A Noble Art': Amateur Artists and Drawing Masters, c. 1600–1800* (London: British Museum Press, 2000), 64, and Hayden, *Mrs. Delany*, 132.
9. Hayden, *Mrs. Delany*, 131. The *hortus siccus* as herbarium is discussed by Maria Zytaruk in this volume and is also illustrated in Mark Laird's Introduction. It should be pointed out that Mrs. Delany's collages would have faded had they been exposed to light (as is the case with the mounted *Stem of Stock*, which was later presented to the royal household). Keeping them away from light, however, avoided the fading that occurs with pressed and dried plants, even those kept in dark conditions.
10. See Lisa Ford's essay in this volume.
11. "Mr. B Grey" is inscribed as the donor of the plant specimen on the back of four of Mrs. Delany's collages: 'Anemone Hortensis' (from Dr. Fothergill's garden, made at St. James's Place, dated 7 April 1779); 'Ceanothus africanus' (made at St. James's Place, dated 9 April 1779); 'Ixia sceptrum' (made at St. James's Place, dated 26 April 1779); and 'Rododendron Ferrugineum' (made at St. James's Place, dated 29 May 1777).
12. Booth Grey's copy of Sir John Hill's *Eden; or, A Compleat Body of Gardening, Both in Knowledge and Practice…* (London: Printed for the author, 1773), reveals Grey's interest in horticulture and the arts. Currently on the market through Donald A. Heald Rare Books, Prints & Maps (www.donaldheald.com, item no. 15087), the volume is described as having "55 plates with fine partial or full hand-colouring by a later early-19th-century hand, 63 of the plates with some or all of the plant names neatly altered in ink to their Linnaean equivalents in a single early-19th century hand." Booth Grey is most likely the author/artist of these alterations.
13. "Amateur" here denotes a person who loves or practices "the polite arts… without any regard to pecuniary advantage" rather than one who lacks knowledge or skill. See *Oxford English Dictionary Online*, s.v. "amateur," http://0-dictionary.oed.com.library.metmuseum.org/cgi/entry/50006818?single=1&query_type =word&queryword=amateur&first=1&max_to_ show=10 (accessed 23 March 2009).
14. Sloan, *'A Noble Art'*, 45.
15. See Wilfrid Blunt and William T. Stern, *The Art of Botanical Illustration*, rev. ed. (Woodbridge, Suffolk: Antique Collectors' Club, 1994), 136, 139–42, 144, 146; Prudence Leith-Ross, *The Florilegium of Alexander Marshal at Windsor Castle* (London: Royal Collection Enterprises, 2000); Amy R. W. Meyers and Margaret Beck Pritchard, eds., *Empire's Nature: Mark Catesby's New World Vision* (Chapel Hill and London: Univ. of North Carolina Press, 1998); and Sloan, *'A Noble Art'*, passim.
16. Hayden, *Mrs. Delany*, 157.
17. Mrs. Elwood, *Memoirs of the Literary Ladies of England, from the Commencement of the Last Century* (Philadelphia: G. B. Zieber, 1845), 13.
18. Sloan, *'A Noble Art'*, 64; Hayden, *Mrs. Delany*, 157.
19. Other Booth Grey collages are in the British Museum; the Fogg Art Museum, Harvard University, Cambridge, Mass.; The Metropolitan Museum of Art, New York; and several private collections.
20. For the identification and dating of watermarks and wallpaper stamps used on some of the papers in the collages and original Booth Grey album, see Peter Bower's essay in this volume.
21. Personal communication from Elizabeth Reluga, Victoria Munroe Fine Art, 10 July 2008.
22. A DeltaNu Advantage Series 200A Raman spectrophotometer with a NuScope accessory was used for this analysis. "Spectra were obtained directly from the collage… with no prior treatment of the surface. Because the surfaces

studied consisted of complex mixtures of pigment, binder and possibly other materials, the spectra were complex and required careful analysis by derivative and baseline correction methods using Thermo GRAMS Suite software." This information was kindly provided by Dr. Henry DePhillips, 14 February 2008.

23. Elwood, *Memoirs of the Literary Ladies of England*, 13–14. There is evidence of her working from specimens and drawings by others (notably Lady Anne Monson). See also the essays by Mark Laird and Lisa Ford in this volume, which discuss specimens that were transported in a tin box.

24. Llanover, ed., *Autobiography and Correspondence*, ser. 2, 3:97.

25. Sloan, *'A Noble Art'*, 64.

26. Hayden, *Mrs. Delany*, 132–33.

27. See Mark Laird and Lisa Ford's essays for further discussion on Mrs. Delany's plant sources.

28. Hayden, *Mrs. Delany*, 143.

29. Ibid.

30. Sloan, *'A Noble Art'*, 64.

31. Personal communication from Charles Nelson, 12 October 2008.

32. William Gilpin, *Observations, Relative Chiefly to Picturesque Beauty, Made in the Year 1776, on Several Parts of Great Britain; Particularly the High-lands of Scotland*, 2 vols. (London: Printed for R. Blamire, 1789), 2:190.

33. Mary Delany to Mary Dewes, 4 October 1768, in Llanover, ed., *Autobiography and Correspondence*, ser. 2, 1:173.

34. Personal communication from Charles Nelson, 12 October 2008: "This certainly is most unusual and needs to be given prominence because here she is emulating botanical artists such as Ehret. She was llustrating 'Triandria monogynia'."

35. Hayden, *Mrs. Delany*, 133–34.

36. Ibid.

37. Hayden, *Mrs. Delany*, 134.

38. Personal communications from Mark Laird, 1 July 2008, and Charles Nelson, 12 October 2008. For discussion of this process, see Mark Laird's essay in this volume.

39. Sue McKechnie, *British Silhouette Artists and Their Work, 1760–1860* (London: P. Wilson for Sotheby Parke Bernet, 1978), 10.

40. Sloan, *'A Noble Art'*, 46, 64.

41. McKechnie, *British Silhouette Artists*, 9.

42. Roberts, *George III and Queen Charlotte*, 219.

43. Hayden, *Mrs. Delany*, 155.

44. Roberts, *George III and Queen Charlotte*, 219.

45. Llanover, ed., *Autobiography and Correspondence*, ser. 2, 3:97.

46. McKechnie, *British Silhouette Artists*, 9.

47. Marjorie B. Cohn, *Wash and Gouache: A Study of the Development of the Materials of Watercolor*, exh. cat. (Cambridge, Mass.: Fogg Art Museum, 1977), 26.

48. Maya Hambly, *Drawing Instruments, 1580–1980* (London: Sotheby's Publications, 1988), 65.

49. Hambly, *Drawing Instruments*, 66.

50. Hayden, *Mrs. Delany*, 155–56.

51. Hayden, *Mrs. Delany*, 139–40. For further accounts of her composing collages at Luton

and Bill Hill, see the essays by Mark Laird and Lisa Ford in this volume.

52. Sloan, *'A Noble Art'*, 64.

53. For a further discussion on the papers used as grounds and for the collage elements, see the essay by Peter Bower in this volume.

54. Sloan, *'A Noble Art'*, 64; see also Peter Bower's essay in this volume.

55. See Peter Bower's essay in this volume.

56. Roberts, *George III and Queen Charlotte*, 219. Jane Roberts refers to the Delany collage in the Royal Collection. Mary Delany's 'Campanula piramidalis' of 1778 (British Museum, 1897,0505.145, located in vol. II) uses a very thin/transparent paper to represent the thin/transparent flower petals.

57. The Booth Grey collages, unfortunately, have no artist marks or signatures. Although some of them are numbered, there are no other inscriptions on the back. A label indicating the scientific name of the plant depicted is attached to the front of each of the Booth Grey collages, just as in the Delany collages. Most of the inscriptions and labels on both groups of collages are written with iron gall ink, and typically the labels are attached to the background paper somewhere below the plant. The handwriting on the labels varies, which suggests that some of the labels were not made at the time the collages were created.

58. Recipe given to author by Timothy Barrett, The University of Iowa Center for the Book, 7–8 November 2007.

59. Cohn, *Wash and Gouache*, 17.

60. Gilpin, *Observations, Relative Chiefly to Picturesque Beauty*, 2:191.

61. *Art of Drawing and Painting in Water-Colours: Wherein the Principles Are Laid Down… with Instructions for Preparing, Mixing, and Managing All Sorts of Water-Colours Used in Painting* (London: G. Keith, 1770), 64–65.

62. James Ayres, *The Artist's Craft: A History of Tools, Techniques and Materials* (Oxford: Phaidon, 1985), 123.

63. Ayres, *Artist's Craft*, 123; Ursula Weekes, *Techniques of Drawing from the 15th to 19th Centuries* (Oxford: Ashmolean Museum, 1999), 35.

64. Cohn, *Wash and Gouache*, 33.

65. Cohn, *Wash and Gouache*, 36.

66. Mary Delany to Lady Andover, 19 August 1766; OSB collection in the Beineke, 4245.

67. Mary Delany to Lady Andover, 4 September 1766, in Llanover, ed., *Autobiography and Correspondence*, ser. 2, 1:77.

68. Weekes, *Techniques of Drawing*, 35.

69. Ralph Mayer, *The Artists' Handbook of Materials and Techniques*, 3rd ed. (New York: Viking Press, 1970), 299.

70. Mayer, *Artists' Handbook*, 299.

71. Mayer, *Artists' Handbook*, 294; Weekes, *Techniques of Drawing*, 35.

72. Cohn, *Wash and Gouache*, 35.

73. Cohn, *Wash and Gouache*, 35; Weekes, *Techniques of Drawing*, 35.

74. Cohn, *Wash and Gouache*, 33.

75. Mayer, *Artists' Handbook*, 299.

76. Cohn, *Wash and Gouache*, 33.

77. For more on "candy sugar," see www.tis-gdv.de/tis_e/ware/zucker/kandis/kandis.htm (accessed 27 November 2007).

78. *Art of Drawing and Painting in Water-Colours*, 59–96, 93.

79. *Art of Drawing and Painting in Water-Colours*, 64.

80. *Art of Drawing and Painting in Water-Colours*, 59–70.

81. The recipe used was based on a watercolor recipe published in the online catalogue of L. Cornelissen & Son (www.cornelissen.com/pdf/pigments.pdf [accessed 7 November 2007]): "List 1: Pigments gums and resins: Useful information," 16. For another watercolor recipe, see Mayer, *Artists' Handbook*, 294–311.

82. Hayden, *Mrs. Delany*, 133.

83. The three collages tested were: 'Antirrhinum triphyllum' (1776); lizard orchid (vol. 7, no. 30); and 'Phlox Carolina' (1774). The adhesive was tested "by swabbing a loose collage piece [on each of the collages] with a slightly moist swab, and then applying iodine in potassium iodide solution to the swab." All test areas tested positive for starch. Non-conserved collages were deliberately chosen to avoid any confusion of adhesives. The tests were completed on 27 June 2008 by Helen Sharp, Senior Conservator of Western Art on Paper, British Museum.

84. Mary Delany to Anne Dewes, 7 February 1744, in Llanover, ed., *Autobiography and Correspondence*, ser. 1, 2:259.

85. See, for example, www.kremer-pigmente.de/shopint/info/en_international/63110e.htm (accessed 21 March 2009).

86. Mary Delany to Anne Dewes, 26 May 1747, in Llanover, ed., *Autobiography and Correspondence*, ser. 1, 2:461.

87. Hayden, *Mrs. Delany*, 157.

88. Sloan, *'A Noble Art'*, 64.

89. Llanover, ed., *Autobiography and Correspondence*, ser. 2, 3:95.

90. Five volumes containing RCIN 931596-931845: "Green House and Store Plants" I: 31596–31645, II: 31646–31695; and "Hardy Plants" I : 31696–31745, II : 31746–31795, III: 31796–31845.

91. RCIN 32868–32880: "Copies of Mrs. Delany's Plants 1775."

92. George Paston, *Mrs. Delany (Mary Granville): A Memoir, 1700–1788* (London: Grant Richards, 1900), 285.

[12]

AN INTIMATE AND INTRICATE MOSAIC:
Mary Delany & her Use of Paper

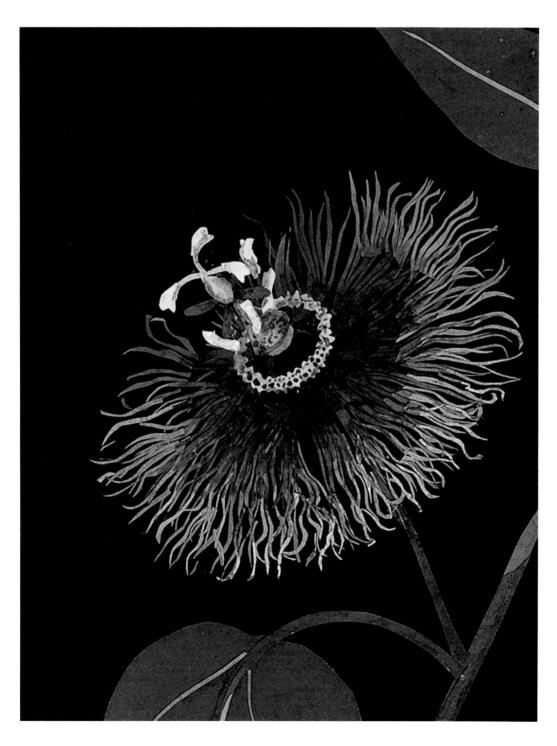

All the various strands of Mary Delany's very rich life—gardening, botany, drawing, and paper cutting—came together in an extraordinary expression of knowledge, skill, and understanding in her *hortus siccus*, the ten albums of detailed and botanically accurate collages of plants that she created with cut and colored papers over a period of ten years. It is one of the most concentrated expressions of artistic endeavor. The activity was both educative and enjoyable, done alone or with a small group of friends of varying levels of skill and slightly different working methods. The works were not intended to be framed and displayed but rather to be held in the hand and closely examined.

The integrity and virtuosity of Mary Delany's work is extraordinary. What sets her apart from the genteel traditions of cut paper patterns and images is her unique accuracy. The bloom of her 'Passiflora Laurifolia' of 1777, for example, is made up of so many individual pieces of paper it is difficult to count them (fig. 240).[1] Her confidence in cutting without benefit of drawn lines, characteristic of the best of the Japanese cut-paper artists, contrasts with many of the botanical collages attributed to William Booth Grey (recently acquired by the Yale Center for British Art), in which greater use of graphite shows that lesser hands had to resort to drawing. Mrs. Delany's intense scrutiny of individual plants and her botanical expertise gave her a sureness rarely seen in this medium.

Figure 240: The accuracy and imaginative intricacy of Mary Delany's talent is admirably illustrated by this detail of the flower of her 'Passiflora Laurifolia', executed at Luton in August 1777, containing well over 100 individual pieces of paper. British Museum, Department of Prints and Drawings (1897, 0505.654)

The variations of skill displayed in the Booth Grey works, particularly in the cutting, layout, amount of pencil used, and the distinctive types of paper chosen, suggest they were done over a considerable period of time and possibly by five or more different individuals. A number of the Booth Grey sheets have for their grounds the same types of paper used by Mary Delany; others, such as some of the wallpaper offcuts, however, bear excise stamps that date from after the 1780s, indicating that her compositional techniques and the methods of constructing such collages were continued by others after her death.

This investigation of the various papers utilized by Mary Delany is not confined to those she used for her botanical works; it also includes an exploration of as many of those that she used for her letters and other documents as it was possible to examine. A range of techniques and equipment was employed in the investigation, such as transmitted light to "read" the wire profile of the sheet, although the black washes of the grounds, for the most part, obscured such examination. Obviously the papers cut for stems, leaves, and petals could not be removed from the sheets. In the lighter-weight sheets that she used as her grounds, the blackness of the washes shows through when the versos of the sheets are examined, allowing us to read the internal structure of the paper and help in identifying their origin.

Papermaking in Eighteenth-Century England
The span of Mary Delany's life coincided with massive changes in the English paper industry: as the century began there was little fine papermaking in England, but by the end of it the best English papermakers rivaled the best in Europe.

The varied tones and surfaces in the nominally white papers she used were the result of the small-scale, local nature of papermaking in the eighteenth century. Most mills operated only one or two vats and produced, depending on a sheet's size and weight, perhaps 500–1,000 sheets per day. Eighteenth-century papers were typically a mix of linen rags, usually of different qualities, that were beaten to a pulp and blended together with hemp fiber derived from either sailcloth or old rope (fig. 241). Each sheet was made individually, by dipping a mould into a vat of dilute pulp made from these beaten rags. Local and regional variations, particularly in the collecting, washing, and preparation of the rags, as well as in the cleanliness and quality of the mill's water, resulted in a wide assortment of subtly different papers (fig. 242).

Figure 241: *A Paper Mill with the Men at Work*, undated [ca. 1747], engraving, 7⅛ × 11 in. (18 × 28 cm), reproduced in *The Universal Magazine* 10 (June 1752), showing papermaking as it was done in England during Mary Delany's life. The waterwheel (F) that provided the mill's power is in the center, the hollander beater (B) pulping rags on the left and a typical crew making paper by hand on the right. The vatman (K) is forming the sheets individually on the mould (M) at the vat (S). The coucher (N) is transferring the newly formed wet sheets onto the *Post* of felts and paper (P) and the layer (Q) is separating out the newly pressed sheets (R), prior to hanging them up to dry. Peter Bower Collection

Figure 242: Photomicrograph, taken in polarised light, of a blend of well-beaten linen rag fibre and hemp fibre, probably derived from sailcloth, typical of the pulps used to make most of the papers used by Mary Delany

They were relatively heavily sized with animal gelatin, then plate-glazed by passing them through heavy rollers interleaved between metal plates.

The industry was somewhat haphazard in its product descriptions, and until well into the nineteenth century it described paper in quite generic terms: that made for writing, printing, or wrapping; thick or thin, large or small, sometimes stout, sometimes coarse. Colors were white, brown, blue, or drab, which covered a limited array of browns, buffs, grays, blue-grays and olive-green papers. Quality was perhaps superfine, fine, retree, or bastard.[2]

Figure 243: Trade card dating from 1761 in which Dorothy Mercier "at the Golden Ball in Windmill Street" advertises for sale "all Sorts of Papers for Drawing &c. . . . Finest Writing Paper Both Gilt & Plain, in all sizes English, Dutch, & French Drawing Paper. . . ." 10 × 5⅞ in. (25.3 × 14.9 cm). British Museum, Department of Prints and Drawings (D,2.3396)

After the early 1700s, the fledgling English paper industry entered a period of rapid expansion. Working from the "excise returns"—the records of the duty paid to the government by the papermakers for the paper they produced for the period 1714–18 — researchers have calculated that England and Wales produced 300,000 of the 418,000 reams consumed.[3] A contemporary report states:

> Before the Revolution there was hardly any other paper made in England than brown; but, the war ensuing, and duties being laid down from time to time on foreign paper, it gave such encouragement to the paper-makers, that most of them began to make white paper fit for writing and printing; and they have brought it by degrees to so great perfection, both for quantity and goodness, that they make now near two-thirds of what is consumed in Great Britain; and several of them make it as white and as well-bearing as any comes from abroad. . . .[4]

This eulogy on both the quality and quantity of white paper being made at this period was perhaps overstated, as much of the recorded increase was in the production of brown and blue paper rather than white. However, by the middle of the century the trade was well enough established to be included in published advice for young men seeking to enter various professions. Joseph Collier, writing in 1761, describes how "several of the principal Stationers of London have mills with which they make their own paper." Echoing the remarks of fifty years earlier, he continued, "This art which has been lately so greatly improved, as almost entirely to exclude the importations of Foreign paper, requires both ingenuity and strength."[5]

Mary Delany and her Papers
The papers Mary Delany chose for her letters, written between 1723 and 1786, offer some support for Collier's enthusiasm. Like most artists, she worked with a range of papers, often several different types within the same period. They not only provide us with a record of the changes in English paper supply during the eighteenth century, they also help us understand what she used for the backgrounds of her collages as well as for leaves, stems, and petals. Papers were easily available, especially in London, from booksellers, print dealers, and stationers, and surviving eighteenth-century trade cards offer clues to the market. For example, in 1761 Dorothy Mercier, "Printseller, and Stationer, at the Golden Ball, in Wind-mill Street" in London, had for sale "all Sorts of Papers for Drawing, &c. . . . Finest Writing Papers, Both

Gilt & plain, in all sizes English, Dutch & French Drawing Paper" (fig. 243).[6]

In the first half of her life, most of the paper Mrs. Delany worked with was imported from Dutch makers, such as Abraham and Isaac van Gerrevinck, the sons of the celebrated Lubertus van Gerrevinck at Phoenix Mill, Alkmaar, North Holland, whose paper she first used in 1728 for correspondence. She continued to choose paper made by the Van Gerrevinck family for letters and backing sheets for her collages until the late 1770s.[7] Paper from other Dutch makers—Dirk and Cornelis Blauw, Piet van Der Ley, Jan Honig and Zonen, H. W. Schoen, and others—was also utilized. The last Dutch paper found in her writings is a document dated 5 July 1779 and is among the loose sheets inserted in the Delany volumes at the British Museum.[8] The Van Gerrevinck family was known in Europe for being fine papermakers and Lubertus's initials, and occasionally his full name, were appropriated by several English papermakers in their watermarks as marks of quality. Examples appear in Mrs. Delany's correspondence between 1768 and 1779, in batches of paper produced by William Jubb at Ewell Mill, Surrey.[9]

The first English-made paper Mrs. Delany used for correspondence, a letter of 1730, was made by Richard Heath at Hurcott Mill, Kidderminster, Worcestershire, and bears the watermark Pro Patria = Crown / GR in circle / HEATH.[10] The continuity of supply, where products from a relatively small number of papermakers are selected, is demonstrated by the various batches of the Van Gerrevinck paper in use for nearly fifty years. Jubb's paper, used for eleven years, is also evidence of Mrs. Delany's increased use of paper made in England, which in turn reflects an increase in the quality and quantity of paper being produced in England as the century wore on. From 1738 to 1768 she utilized paper made by James Durham and his son Richard at Postlip Mill, Winchcombe, Gloucestershire, and, for a few years in the 1770s, those made by Henry French and his son Thomas at Little Ivy Mill in Loose Valley, near Maidstone, Kent.[11] Thomas French was responsible for a very good quality white laid writing paper, watermarked with a simple fleur-de-lys and countermarked with the initials TF. Mary Delany chose it for her correspondence and as backing sheets for many of her collages; it also is found in the Booth Grey group.[12]

The earliest known use of paper made by James Whatman the Elder at Turkey Mill, Boxley, near Maidstone, Kent, is for Delany's "Marianna" manuscript, written in 1759.[13] Her

first letter on paper made by James Whatman the Younger is dated 3 November 1760.[14] She continued to use various Whatman papers throughout her life, though not exclusively so. The other English papermakers so far identified were all in Kent, including Samuel Lay of St. Mary Cray,[15] Clement Taylor of Hollingbourne Old Mill,[16] Robert Williams of Grove Mill, Eyehorne Street,[17] and Lewis Munn of Ford Mill, Little Chart.[18]

Most of the letters Mrs. Delany wrote from Dublin, after her marriage to Dr. Delany, are on Dutch-made paper. A rare example of her using paper made in Ireland is a foolscap writing paper made by Thomas Slater at Swiftbrook Paper Mill, Saggart, near Dublin.[19] An intriguing aspect of her use of Irish-made paper is the appearance of lined wove, made on a woven wire mould but with the addition of parallel lines in the watermark, which were intended to aid writers in keeping their handwriting neat. Mary Delany first used this very distinctive type of paper in 1766; its invention by James Whatman the Younger traditionally has been dated to 1775, yet she was using it regularly nine years earlier.[20] She continued to use it, together with other laid writing papers, for the rest of her life.[21]

The Papers Used as Primary Supports

Ruth Hayden's pioneering study *Mrs. Delany: Her Life and Her Flowers*, first published in 1980, reflects the received understanding of the papers associated with the collages at that date. However, many of the brief mentions of Delany's paper practice in correspondence need to be treated with some caution. On the basis of Mary Delany's correspondence, for example, Hayden wrote: "Initially she used a thin shiny paper for background, but in 1774 she discarded this for a better matt surface, using paper which she obtained from a newly established paper-mill in Hampshire, and which she first washed with Indian Ink."[22] In fact, no trace of india ink can be found in her black background washes; all are water-based, carbon black paints. Also, no new paper mills were established in Hampshire in the early 1770s; however, two of the nineteen mills operating in the county did change hands: William Sharp insured Burn Mill, Romsey, and a mill house and stock "distant in Romsey" in 1770, although none of Sharp's watermarks has been found among Mary Delany's works.[23] A possible candidate is John Gater, who in 1771 took over and expanded Up Mills, West End, South Stoneham. A solitary example of one of the watermarks adopted by Gater early in his career, the letter G, was found in 'Geranium fulgidum', which Mrs.

Delany produced at Bulstrode in 1775 (see fig. 244).[24] Many kinds of papers were used for primary supports for the collages, from Dutch and English foolscap, large post, and demy writing papers to wallpaper offcuts.

Each handmade papermaking mould has a distinctive internal structure, an individual wire profile that can give us much information as to the date and place of the sheet's manufacture. The wire profile can also contain a watermark, which in eighteenth-century laid papers was centered in one half of the sheet with a countermark centered in the other half. As most of Mrs. Delany's collages are on either half or quarter sheets, both watermark and countermark are rarely present in the same work. "Laid lines" are tightly spaced, parallel lines seen in laid paper when it is held up to the light; "chain lines" are parallel lines perpendicular to the laid lines and usually an inch or so apart (fig. 245). The watermark, laid lines, and chain lines are impressions formed in the wet pulp by the wires used in the structure of the mould cover. Paper has two sides: the wire side, which is the side that was next to the forming wire when the sheet was made; and the felt side, which is the side placed onto the felt during "couching," the transferal of the newly formed wet sheets from the papermaking mould to woven woolen blankets, known as felts. The wire profile of the sheet,

Figure 244: G watermark in Mary Delany's 'Geranium fulgidum', 1775. British Museum, Department of Prints and Drawings (1897,0505.391). This paper was made by John Gater at Up Mills, South Stoneham, Hampshire.

Figure 245: Posthorn / 4 / L V GERREVINCK watermark in Mary Delany's 'Amaryllis Beladonna', 1775. British Museum, Department of Prints and Drawings (1897,0505.30). The paper was made by Abraham and Isaac van Gerrevinck, the sons of the renowned Lubertus van Gerrevinck, at the Phoenix Mill, Alkmaar, North Holland.

Figure 246: The watermark and countermark of a paper made by Thomas French at Little Ivy Mill in the Loose Valley, near Maidstone, Kent, whose papers were used by Mary Delany for a few years in the 1770s.

Left: Simple fleur-de-lys watermark in Mary Delany's 'Amaryllis Belladonna Reginæ', 1779. British Museum, Department of Prints and Drawings (1897,0505.26). *Right*: Countermark TF, with damaged letter F, in Mary Delany's 'Antirrhinum Genistifolium', 1779. British Museum, Department of Prints and Drawings (1897,0505.72).

Figure 247: Fleur-de-lys / GR watermark, from an unidentified maker, in Mary Delany's 'Cleome Pentaphylla ?', 1777. British Museum, Department of Prints and Drawings (1897,0505.212). This paper is also found among the Booth Grey works.

the watermarks, and the laid and chain lines are all more visible on the wire side and often can be read in a raking light when transmitted light is not possible because the sheet is laid down or painted thickly. Most, but not all, of the papers used by Mrs. Delany for the backgrounds of works were prepared on the felt side, so that any watermark present in the sheet would not interfere visually with the collage. As a result, the watermarks are visible (figs. 246–247).

Some of Mary Delany's primary supports carry excise stamps on their versos, which relate to the excise duties on "stained paper," otherwise known as wallpaper.[25] Four different types of excise stamps, Charge, Charge Mark, First Account Taken, and Frame Mark, each denoting a different aspect of the taxation process, were used in her lifetime, but only the Charge stamp (fig. 248) is found on the verso of any of her works.

The Charge stamp was stamped on a finished product to show that duty had been paid by the stainer (the maker of the wallpaper). Three versions of this stamp are known, distinguished by color (red, ocher, and scarlet) and the excise officer's identifying number. All bear an image of the royal crown above the word PAPER, under which is the officer's number: on red Charge stamps this is 1, which, though often mistaken for the letter J, is the normal form of the number 1 used by the excise officers in this period; ocher is 11 (JJ); and scarlet 18 (J8).

The Charge Mark (see figs. 249, 250) replaced the Charge stamp in 1786.[26] The First Account Taken stamp was applied to individual sheets of plain, unstained paper that subsequently were pasted together to become a length, or "piece," of wallpaper (fig. 251). Again, the number at the base of this stamp identifies the officer stamping the paper. The Frame Mark was stamped on each end of a roll of wallpaper. It included, from left to right: a coded date over an index or check letter, which changed periodically; the progressive number (which each year began at 1) that identified the piece in the officer's records; the overall length of the piece in yards; and the width of the piece in hundredths of a yard.[27]

The Booth Grey group contains examples of all four tax stamps, including two of the three Charge stamps found on papers used by Mary Delany.[28] The dates in the Frame Marks found in the group are all from 1791, several years after Mary Delany's death.[29]

Figure 248: *Left*: Excise Duty Charge Stamp, pre-1786, on Mary Delany's 'Ludwigia ovata', 1780. British Museum, Department of Prints and Drawings (1897,0505.540). This stamp is also found on papers in the Booth Grey works.

Right: Verso of Mary Delany's 'Lightfootia canescens', 1778. British Museum, Department of Prints and Drawings (1897,0505.512). This stamp was used before 1786 to show that Duty had been charged on the paper stainer who produced the wallpaper.

Figure 249: Incomplete Frame Mark, one of four different Excise Duty Stamps found on wallpapers. Yale Center for British Art, Paul Mellon Collection

Figure 250: Incomplete Frame Mark and Charge Mark, 1791. Yale Center for British Art, Paul Mellon Collection. The Frame Mark carries the date 1791, indicating that this work was executed after Mary Delany's death.

Figure 251: First Account Taken Stamp. Yale Center for British Art, Paul Mellon Collection. These stamps were applied to individual sheets of plain unstained paper before the production of wallpaper.

The Leaves, Petals, and Stems

It has been thought that the paper Mrs. Delany used for the plants was "procured from sailors who were bringing it from China." Even though no specific leaves or petals have been identified as being Chinese paper, among the papers used for the grounds are a few examples that have not been coated with black, and some of those are Chinese papers. In 'Viola Calcarata', of 1778, brush marks are clearly visible in the surface of the paper. These are typical of Chinese papermaking and are made when the newly formed wet sheet has been brushed onto a board or wall to dry (figs. 252, 253).

No traces of paper made in India have been identified with any certainty either, although Mrs. Boscawen apparently sent her some with an offer of more:

> Is this India paper good for anything to you, my dear madam. It is real Indian, I am sure, having found it in a writing-box of ebony, inlaid with ivory, wth was made at Madrass. I have half-a-dozen sheets more if this shou'd be of any use to you.[30]

It has not yet been possible to verify whether her offer was accepted. It is possible that the green paper containing mica used by Mary Delany in 1779 for some of the leaves of her 'Clethra alnifolia', and also found in various Booth Grey works, came from India. It is not European.[31]

The idea that she used papers from "stainers whose colours bled" for the colored leaves and petals might have been true early in her career but there is little evidence in any of the works that she relied on this. Throughout the second half of the eighteenth century a complex web of technical, cultural, and economic influences operating on papermakers, paper merchants, artists' colormen, and artists themselves led to the evolution of papers increasingly designed for very specific uses. Some stationers and bookbinders were producing specially colored papers, painting or dying already made sheets, although one certainly could not buy sheets of paper colored this brightly until the nineteenth century. Mrs. Delany would have had to prepare her own. The chronology of her papers shows that she used papers over varying lengths of time, and must have carried the

Figure 252: Raking-light detail of Mary Delany's 'Viola Calcarata', 1778, collage of colored papers, with bodycolor and watercolor, 7⅞ × 5¾ in. (19.9 × 14.6 cm). British Museum, Department of Prints and Drawings (1897,0505.891). The raking light reveals the brush marks in the surface of this Chinese-made paper.

Figure 253: Anonymous artist, plate 24 of *Art de faire le papier à la Chine: Les explications ont été envoyées en 1775 à m. de la Tour, par le P. Benoist missionaire Jésuite mort à Pékin*, 18th century. Bibliothèque Nationale de France, Paris

makings of her works with her. Judging by the colors, tones, textures, and weights of the papers used for the leaves and petals, she either acquired or prepared sheets to suit her needs. Indeed, where the wire profiles of the laid and chain line impressions can be read in some of the larger leaves, it would seem that many of these papers were actually cut from the writing papers she used for her correspondence. Individual sheets were painted, cut, and adapted. Some of the blues and reds are extraordinarily vivid.

Examination of Mrs. Delany's collages under 10× and 30× magnification reveals the intricacy of her work: minute snips and cuts made with scissors and a knife; the subtlety of toning in the colors; the use of tiny watercolor additions after the collage had been assembled. When examined under similar magnification, the technique, layout, and design of the Booth Grey collages display varying levels of skill, suggesting that several makers were involved. Part of the subtlety in delineating the leaves, stems, and petals comes from using both the wire and the felt sides of papers to advantage by utilizing some of the traces of the papermaking production process that remain in any sheet in order to enhance the "drawing" of a leaf, stem, or petal (figs. 254–258). Many eighteenth-century papers were infinitely better suited to such cutwork than the much weaker modern papers, which do not have the internal or surface strengths of rag-based papers.

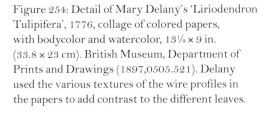

Figure 254: Detail of Mary Delany's 'Liriodendron Tulipifera', 1776, collage of colored papers, with bodycolor and watercolor, 13¼ × 9 in. (33.8 × 23 cm). British Museum, Department of Prints and Drawings (1897,0505.521). Delany used the various textures of the wire profiles in the papers to add contrast to the different leaves.

Figure 255: The same sophisticated use of the wire profiles can be seen in several of the works in the Booth Grey group. For example, the edges of the leaves of this 'Ilex aquifolium' have been detailed with a lightweight white lined wove writing paper. Yale Center for British Art, Paul Mellon Fund

Figure 256: The central leaf of this Booth Grey 'Pelargonium subcœruleum' uses the felt impression in the paper's surface to simulate the leaf. Unlike Mary Delany's work, this image shows considerable over-painting after the collage was assembled.
Yale Center for British Art, Paul Mellon Fund

The presence of wove paper, chosen by Mrs. Delany for leaves and petals, raises questions about its maker. Wove paper, invented in 1756, first appeared when it was used by Birmingham printer and typographer John Baskerville for some sections of his famous edition of *Virgil* (1757). Although Mary Delany used some lined wove papers beginning in the late 1760s, they were not easy to procure and occur infrequently, even in printed books, for several decades. It was not until the 1790s that large amounts of wove paper from many different makers were used for printing, writing, and drawing. It is possible, however, that some of the lightweight sheets used for leaves, petals, and stems are fine wove and laid papers made by Harriet Lea at Hurcott Mill, near Kidderminster, Worcestershire. Lea was probably the largest manufacturer of the newly developed wove paper and during the 1770s made very fine laid and wove writing papers for the London stationery market. She also made a paper that British painter Thomas Gainsborough considered "a fine piece of drawing paper."[32]

The artists John Downman and Gainsborough were the first to utilize wove paper in their work. Very little use had been made of this new type of paper since its invention, and nearly all was in the printing of relatively small editions of various books. Gainsborough was perhaps the first artist to notice the visual potential of wove paper, having encountered it when reading the fifth edition of Christopher Anstey's *New Bath Guide* of 1767. Gainsborough wrote to James Dodsley, the publisher, inquiring whether:

> *You would send me half a doz.ⁿ Quire of the*
> *same sort of Paper as the fifth Edition of the*
> *new Bath Guide is printed on, it being what*
> *I have long been in search of for making wash'd*
> *Drawings upon…. There is so little impression of*
> *wires, and those so very fine, that the surface is like*
> *vellum…. I have some of your fine Writing Paper*
> *but this made for printing is much superior for*
> *the use I want it on account of the substance*
> *& not having so much of the Glaze upon it.*[33]

Figure 257: Some surface details of individual papers that result from part of the production process are used to add to the textural richness of collage. In this Booth Grey work, the wrinkled creases found in the center of many sheets—caused by the shrinkage of the sheet when it is hung over a rope during drying—has been used as an aid to the creation of the stem of the 'Fumaria Fungosa'. Yale Center for British Art, Paul Mellon Fund

Figure 258: The traditional method of drying a newly formed sheet of handmade paper is to hang it over a rope, which results in a crease along the center of the sheet. Peter Bower Collection

Gainsborough was sadly disappointed when Dodsley sent him some fine laid paper but not the wove he craved:

I had set my Heart on getting some of it, as it is so compleatly what I have long been in search of: the mischief of that you were so kind to inclose, is not only the small Wires, but a large Cross Wire at about I I this distance, which the other had none of, not hardly any of the impression of the smallest Wire. I wish Sir, that one of my Landskips, such as I could make you upon that paper, would prove a sufficient inducement for you to make further enquiry.... . I am this moment viewing the difference of that you sent and the Bath Guide holding them Edgeways to the light, and could cry my Eyes out to see those furrows; upon my honor I would give a Guinea a Quire for a Dozn quire of it.[34]

Indeed, so little wove paper was available in the 1770s and early 1780s that it is surprising Gainsborough, Downman, and Mary Delany managed to acquire any of it.[35]

So where would they have found these paper stocks? The wire profiles, the blends of fibers used for the pulp and, to some extent, the surface finishes of all the wove papers found to date, whether in books, letters, and works of art, suggest at least two, possibly three, different origins. Whatman is one, although the combination of very different moulds (as seen in the wire profile) and furnishes, so untypical of Whatman paper, suggests at least one other maker. Many are convinced that few makers in the 1770s were capable of matching Whatman's quality, but an examination of papers shows that several English makers were perfectly capable of producing very fine wove paper. Research unrelated to this particular issue has partly solved the problem of where these papers had been made: John Downman, whose second wife was the daughter of Gainsborough's friend William Jackson, used considerable quantities of lightweight woves, very similar to Mary Delany's, and all were made by Harriet Lea at Hurcott Mill.[36]

Conclusion

Mary Delany's choice and use of papers show that she had an instinctive sympathy for this material and it is likely that her curiosity led her to visit a paper mill. As an aside in a letter to Mrs. Port, she suggests that she was familiar with the conditions inside a working paper mill; commenting on the progress of various refurbishments in the house where she was living in 1771, she writes that "all my books are in pretty good order, and everything else, indeed; but as to comfort or quiet I might for the last three days past as well have lived in a paper-mill...."[37]

She would have had no idea that her life and work would be subjected to such scrutiny more than two hundred years after her death, let alone that her choice and use of paper would be documented and analyzed in such detail. Yet, on some levels, it probably would not have surprised her. She herself had been involved, both practically and intellectually, with a wide range of developments in many related fields, and it is likely that our exploration of her varied endeavors would have appealed to her.

Acknowledgments

I would very much like to thank Amy Meyers for her invitation to share my exploration of Mary Delany's use of paper. A great many people have generously helped with encouragement, advice, practical help, information, criticism, and hospitality. In the United States: Alicia Weisberg-Roberts, Theresa Fairbanks-Harris, Kohleen Reeder, and Scott Wilcox at the Yale Center for British Art; Adrienne Sharpe at the Beinecke Rare Book and Manuscript Library, Yale University; and the staff of The Lewis Walpole Library, Farmington, Connecticut; Dena Williams at the Lilly Library, University of Indiana; and Patricia Cornwell. In England: Antony Griffiths, Kim Sloan, and Angela Roche; the staff at the British Museum Print Room, the British Library, the Nottingham University Manuscripts and Special Collections, and the Newport Reference Library, South Wales; and Niall Hobhouse and William Chubb. My greatest thanks must go to my wife, Sally, for her good humor, patience, and invaluable help.

Notes

1. The number of petals could be as high as 230, which is the figure given in Ruth Hayden, *Mrs. Delany and Her Flower Collages*, new ed. (London: British Museum Press, 1992), 73, 134. However, as Charles Nelson points out, counting the precise number depends on how the "slivers" of paper representing the "corona filaments" were cut, and which are joined ("fringed") and which are separate.

2. "Retree," from the old French *retriés*, refers to sheets of substandard paper in which the faults are not serious enough to prevent them being used. "Bastard" did not always refer to the quality of the paper. Occasionally it was used to describe an odd size or type of paper, a nondescript paper that the excise men would find difficult to categorize in terms of the duty payable.

3. D. C. Coleman, *The British Paper Industry* (Oxford: Clarendon Press, 1958), 54–55.

4. *The British Merchant*, 1713, quoted in Rhys Jenkins, "Paper-making in England, 1495–1788," *Links in the History of Engineering and Technology from Tudor Times: The Collected Papers of Rhys Jenkins… Comprising Articles in the Professional and Technical Press, Mainly Prior to 1920, and a Catalogue of Other Published Work* (Cambridge: Printed for the Newcomen Society at the Univ. Press, 1936. The revolution to which the author refers is the Glorious Revolution of 1688.

5. Joseph Collier, *The Parent's and Guardian's Directory, and the Youth's Guide in the Choice of a Profession or Trade* (London: Printed by R. Griffiths, 1761).

6. The Heal collection at the British Museum also contains cards of several other suppliers: Nathan Drake, James Regnier, Thomas Etteridge, Reeves, Thomas Sharp (the brother of the Hampshire papermaker William Sharp), Francis Stacy, and Thomas Woodhouse, among others.

7. For example, two letters: one, dated 1728, bears the watermark Posthorn/ L V GERREVINK; the other is written from St. James's Place and is dated 5 April 1774. These letters are in volumes 1 and 3, respectively, of the ten bound volumes containing Mrs. Delany's original letters currently in the collection of the Newport Reference Library, South Wales, QM 416.6 / 012 / DEL [hereafter cited as Newport Delany Letters].

8. Loose sheet, very highly glazed surface, written at Bulstrode, watermarked GR = Lion = DG. Inserted in Mary Delany album, vol. 1 (c. 35*). British Museum, Department of Prints and Drawings.

9. The first Jubb paper, which bears a watermark with an Ornamented Posthorn / L V GERREVINK / JUBB (bell), was used for a letter written at Whitehall on 14 October 1768. Newport Delany Letters, vol. 4. The last known Jubb paper used, which bears a watermark with an Ornamented Posthorn / L V GERREVINK / JUBB (bell)= IV, was for a letter written at Bulstrode in June 1779. Ibid., vol. 6.

10. Newport Delany Letters, vol. 1.

11. Letter written on 12 December 1738, paper made by James Durham and watermarked Crown / GR = Pro Patria / DURHAM; and letter written at Bulstrode on 10 October 1768, paper made by Richard Durham and watermarked with a Shield / DURHAM = Pro Patria. Newport Delany Letters, vols. 2, 4. Two letters written at Bulstrode—one on 14 September 1772 and watermarked Posthorn GR = H FRENCH, the other on 16 October 1780, a lined wove writing paper watermarked HF perpendicular to the line—show the spread of dates. Newport Delany Letters, vols. 3, 6. A different Henry French watermark, H FRENCH, appears on a letter dated 13 December 1776, currently in the James Marshall and Marie Louise Osborn Collection, B 4284, Beinecke Rare Book & Manuscript Library, Yale University, New Haven, Connecticut.

12. Mary Delany used the paper for a letter written on 14 December 1776 while she was at St. James's Place. Newport Delany Letters, vol. 5.

13. Watermarked with a Posthorn on Shield = ornate Whatman cipher, made by James Whatman the Elder. Lilly Library, Indiana University, Bloomington, Indiana.

14. Written at Bath, watermarked with the ornate Whatman cipher in a form used by James Whatman the Younger. Newport Delany Letters, vol. 4.

15. Letter of 27 May 1776 watermarked S · L. James Marshall and Marie Louise Osborn Collection, B 4280, Beinecke Rare Book & Manuscript Library, Yale University, New Haven, Connecticut.

16. Letter of 24 May 1780 watermarked C TAYLOR. Newport Delany Letters, vol. 6.

17. British Museum, Volume III, loose inserted Index of 1782, watermarked R WILLIAMS = Britannia in a crowned oval.

18. British Museum, Volumes VIII and X, loose inserted Indexes, watermarked Royal Arms = L M. British Museum, Mary Delany, inserted in Volume III.

19. Letter written at Delville on 15 October 1748, watermarked Hibernia = T SLATOR. Newport Delany Letters, vol. 3.

20. Thomas Balston, *James Whatman, Father and Son* (London: Methuen & Co., 1957), 160.

21. Letter on lined wove paper written at Delville, 3 June 1766, watermarked JW perpendicular to lines. James Marshall and Marie Louise Osborn Collection, B 4243, Beinecke Rare Book & Manuscript Library, Yale University, New Haven, Connecticut. Other forms of this type of paper are found in a letter of 14 September 1781, watermarked with JW & CO between lines, Newport Delany Letters, vol. 6. A lined wove from another maker, Henry French, was used in a letter of 16 October 1780, Newport Delany Letters, vol. 6. For further information on the papers used by Mary Delany for her correspondence, see Peter Bower, "A Life in

Letters: the papers used by Mary Delany (1700–1788) for her Correspondence," *The Quarterly* 68 (October 2008): 1–24.

22. Ruth Hayden, *Mrs Delany: Her Life and Her Flowers* (London: British Museum Publications, 1980), 133.

23. Ibid.

24. A very similar paper, also watermarked with a single G, was used many years later by David Cox for his watercolor *Eton from the Thames* years after it was made (Yale Center for British Art, B1986.29.350).

25. These excise duties were introduced in 1712 by Act of Parliament, 10 Anne c.18, and in 1836 were repealed in England and Ireland by Acts of Parliament, 6 & 7 William IV c.52.

26. Act of Parliament, 26 Geo. III c.78.

27. The most common length number in the Frame Mark is 12, as most wallpaper was made in twelve-yard lengths, but other lengths are found. The measurement found in these Frame Marks, 75 yards, is unusually long.

 The width of the wallpaper was determined by the size of the sheets being used, which could be pasted together along their shorter edge or the longer. In the Frame Marks found in the Booth Grey group, the number 58 indicates 0.58 yards, or 20.8 inches.

28. For further information on these stamps and the relationship between the papers in the Booth Grey works and those by Mary Delany, see Peter Bower, "The Excise Duty Stamps Found on the Versos of a Collection of Collages in the Manner of Mary Delany, 1700–1788," *The Quarterly* 69 (January 2009): 19–25.

29. Much of this information on the taxation of paper has been codified by Harry Dagnall, *The Tax on Wallpaper: An Account of the Excise Duty on Stained Paper, 1712–1836* (London: H. Dagnall, 1990).

30. Letter from the Hon. Mrs. Boscawan to Mary Delany, dated 20 November 1776, reproduced in Lady Llanover, ed., *The Autobiography and Correspondence of Mary Granville, Mrs. Delany*, 6 vols. (London: Richard Bentley, 1862–63), ser. 2, 2:279.

31. Mary Delany, 'Clethra alnifolia'. British Museum, Department of Prints and Drawings (1897, 0505. 214).

32. Gainsborough's comment is in a postscript to an undated letter to William Jackson. He writes: "I have spoilt a fine piece of drawing paper for you because I had no other at hand, and in a hurry to know how you are." Examination of this sheet shows it to be a partial sheet of very fine laid paper with very narrow chain lines and a high laid line frequency using a very narrow wire gauge. One of the characteristics of such a mould, in common with most wove moulds, is that a newly formed wet sheet of paper would drain more slowly, producing a more even sheet. Such papers were capable of a much smoother surface and had less difference between the wire and felt sides. Other examples of this paper are found with AMSTERDAM and VOLTAIRE

watermarks, showing that they were made by Harriet Lea at Hurcott Mill, Worcestershire. MS. Royal Academy of Arts, letter 38, reproduced in John Hayes, ed., *The Letters of Thomas Gainsborough* (New Haven and London: Yale Univ. Press, 2001), 63.

33. John Hayes, *The Drawings of Thomas Gainsborough*, 2 vols. (New Haven: Published for the Paul Mellon Centre for Studies in British Art by Yale Univ. Press, 1971), 1:21.

34. Ibid. The two letters that Gainsborough wrote to James Dodsley from Bath regarding wove paper are both on laid writing papers; the first, dated 10 November 1767, is watermarked with an ornamented Posthorn / 4 LVG; the second, dated 28 November 1767, the other letter is watermarked with a Crown / GR. Both are at Gainsborough House Sudbury, 1968 018 and 019 (letters 25 and 26), reproduced in Hayes, ed., *Letters of Thomas Gainsborough*, 44–46. I am grateful to Hugh Belsey for the information on their watermarks.

35. See Peter Bower, "Thomas Gainsborough's Papers," in *Thomas Gainsborough: Themes and Variations, the Art of Landscape*, exh. cat. (London: Lowell Libson, 2003), 14–28.

36. Peter Bower, "The Papers Used by John Downman: An Identification of Two Probable Sources for the Lightweight Wove Papers Used by John Downman Early in His Career," *The Quarterly* 20 (October 1996): 7–15.

37. Letter from Mrs. Delany to Mrs. Port, dated 7 December 1771, reproduced in Lady Llanover, ed., *Autobiography and Correspondence*, ser. 2, 1:381.

Afterword

Mark Laird

Mrs. Delany lived in London at no. 33 St. James's Place from 1771 until her death in 1788.[1] She moved there from Thatched House Court nearby (see fig. 206), which had been her home since Patrick Delany's death in 1768.[2] Even today, St. James's Place retains much of its original character. There is no plaque there dedicated to Mrs. Delany, but the streetscape brings to life her collage-making world in town. In Windsor, however, there is a Blue Plaque on the Castle wall that runs along St. Alban's Street near the junction with Castle Hill. This is the site of the grace-and-favor house Mrs Delany occupied at the end of her life whenever the Court was at Windsor. The plaque also commemorates Fanny Burney as a frequent visitor while engaged as Keeper of the Robes to Queen Charlotte. The house in Gloucestershire where Mary spent her adolescence, Buckland Manor; the grand mansion of her first wedding, Longleat; and her commemorative tablet in St. James's Piccadilly are further substantial traces in stone of where this remarkable artist-naturalist once dwelt and now rests.

Sadly, nothing substantial remains of the Dublin house and gardens at Delville, while the architecture and landscape setting of Bulstrode have been much altered over the centuries.[3] On Friday, January 6, 1951, *The Irish Times* reported: "Deville, the 18th-century house built by Dr. Delany . . . is being demolished."[4] The house was photographed half way through that process, and other images taken earlier in the century reveal evidence of Mrs. Delany's idyllic environment. From Edward Malins and the Knight of Glin's excellent account we learn that the area of the garden was eleven acres – too small to be a true *ferme ornée*; they also establish the link to Pope, and the resemblance of the neighbourhood of Delville to that of Twickenham.[5] Photographs of the bow window of the east façade from a watercourse in the garden are especially revealing (fig. 259). A Dublin map of 1837 shows that watercourse, which had appeared in two of Mary Delany's sketches (see figs. 12 and fig. 133). The 1745 sketch, depicting a fruit wall within the landscape, offers a glimpse over that wall of the east façade before the bow window was introduced.[6] Such walls, and the straight allées surviving into maturity at Delville (fig. 260), suggest how this hybrid garden was not a pure landscape garden. While Patrick Delany's layout had most in common with the villa gardening of Pope, Mary Delany's "embroidering" brought the applied handicrafts of her cultural and horticultural milieus to work on its topography.

Multifarious changes to house and grounds make Bulstrode unrecognizable today as the place where Mrs. Delany created the most collages of all. Yet the great lime avenue and terrace walk are relic enough to convey a grander version of Mrs. Delany's regular and irregular groves at Deville.[7] Indeed, with the 1784 estate survey in hand, it is still possible to visualize at Bulstrode what the drawings by Mary Delany and Samuel Hieronymous Grimm show. A wealth of un-researched documentation in the duchess's own hand, remains an intriguing further prospect,[8] encouraging ways of looking at Bulstrode as a center of mycological research and habitat gardening, or as a collectivity of flora and fauna akin to the collections at Kew.[9]

Ultimately Mrs. Delany's dwelling in nature ensures (as George Keate wrote in his 1781 encomium to her) "a Kind of Immortality" beyond the remarkable preservation of her petticoat, the drawings, the letters and novella, and the collages themselves.[10] Her perpetual spring is brought to life each January with the unfolding of the Christmas Rose (see fig. 4), and every year-end with the opening of her "Laurestina." Indeed, given her sourcing of plants from across the seven seas, and given the cosmopolitan nature of nature today, reminders of her near-thousand portraits are to be found in almost any location almost anywhere in the world. Though the dating of her collages to a specific day of a specific month should not be mistaken for a scientific record of flowering times (in the manner of Gilbert White or Henry David Thoreau), her information on locality, correctly interpreted, takes on increasing significance as our environment changes today.[11] Mrs. Delany's future has never looked brighter.

Notes

1. See F.H.W. Sheppard ed., *Survey of London: The Parish of St. James Westminster Part One South of Piccadilly* (Athlone Press, University of London, 1960), XXX, 512, and Llanover, ed., *Autobiography and Correspondence*, ser. 2, 1:341, 381.

2. *Survey of London*, XXX, 466. The court ceased to exist when the Conservative Club at 74 St. James's Street was built over its site. I am grateful to Brian Allen for the information in these first two notes.

3. Sizeable yew trees and one tall lime tree along the perimeter wall on the east walk and a declivity in the lawn where the watercourse once ran still evoke something of her garden at Delville today. For Bulstrode, see Audrey M. Baker, "The Portland Family and Bulstrode Park," in *Records of Bucks* vol. 43, 2003, 159–178. I am indebted to John Harris for this reference and to Margaret Riley for sending me a copy of the article. Howard Colvin, *A Biographical Dictionary of English Architects, 1600–1840*, 3rd ed., (New Haven and London: Yale Univ. Press, 1995), 492, 603, 953, 1119, provides key information on the architectural transformations at Bulstrode: beginning with William Talman's work in 1706–7 (with George London's landscaping); moving to Stiff Leadbetter's repairs and alternations for the 2nd Duke, 1744–49, and to James Wyatt's reconstruction of the west wing ca. 1806–09 (with further work aborted on the 3rd Duke's death in 1809); and culminating in the rebuilding of Bulstrode by Benjamin Ferrey in 1862.

4. A photocopy of this account, with a photograph of Delville being demolished, has a note added in 1974 by D.H. Gillman: "I went to see Delville just before this stage – all rooms stripped of fittings – lovely view of Dublin Bay from end bow window."

5. Edward Malins and the Knight of Glin, *Lost Demesnes: Irish Landscape Gardening, 1660–1845* (London: Barrie & Jenkins, 1976), 36–39. This account does not explore so much Mrs. Delany's role in gardening at Delville, which is touched upon in Charles Nelson's history of the National Botanic Gardens, Glasnevin. See E. C. Nelson and E. M. McCracken, *The Brightest Jewel: a History of the National Botanic Gardens, Glasnevin, Dublin* (Kilkenny: Boethius Press, 1987), 42–45. See also Charles Nelson's account of Mrs. Delany's orangery in "The prettiest orangery in the world," *The Irish Garden*, 17/5 June 2008, 60–63.

6. Mary Delany to Anne Dewes, June 11, 1745, in Llanover, ed., *Autobiography and Correspondence*, ser. 1, 2:361.

7. Discrete studies of gardening at Bulstrode include: Sally Festing, "Rare Flowers and Fantastic Breeds: The 2nd Duchess of Portland and Her Circle – I," *Country Life* (June 12, 1986), 1684–86; "Grace Without Triviality: The 2nd Duchess of Portland and Her Circle – II," *Country Life* (June 19, 1986), 1772–74; "The Second Duchess of Portland and her Rose," *Garden History* 14/2 (Autumn 1986), 194–200; "Menageries and the Landscape Garden," *Journal of Garden History*, 8/4 (October-December 1988), 104–17; Mark Laird, *The Flowering of the Landscape Garden: English Pleasure Grounds, 1720–1800* (Philadelphia: Univ. Pennsylvania Press, 1999), 221–24.

8. Papers of Margaret Bentinck, Duchess of Portland in the Portland Welbeck Collection, University of Nottingham, PwE, item 63, for example "Fungi of the different Genera which do not seem to be described either by Ray or Linnaeus."

9. See again Festing, "Menageries," and Mark Laird, "This Other Eden: The American Connection in Georgian Pleasure Grounds, from Shrubbery and Menagerie to Aviary and Flower Garden," in *The Culture of Nature: Art & Science in Philadelphia 1740–1840*, ed. Amy R. W. Meyers (New Haven and London: Yale Univ. Press, forthcoming 2010).

10. George Keate, *The Poetical Works of George Keate, Esq.*, 2 vols. (London: Printed for J. Dodsley, 1781), 2:257–65.

11. See, for example, Abraham J. Miller-Rushing and Richard B. Primack, "The Impact of Climate Change on the Flora of Thoreau's Concord," *Arnoldia*, 66/3, 2009; and see John Edmonson's comments on G. C. Druce's *Flora of Buckinghamshire* (1926) in this volume.

Figure 259: Delville, east façade with bow window. This image is from a glass lantern slide, said to have been taken in the early 1900s. Irish Architectural Archives

Figure 260: Lime walk to garden temple, Delville. Irish Architectural Archives

Marianna

Throughout the 1740s and 50s Mrs. Delany was an avid reader of contemporary novels, particularly those of Samuel Richardson, with whom she corresponded. Her most extended foray into fiction, *Marianna*, exhibits a mixture of eighteenth-century sensibilities and a lingering attachment to older forms. It retains elements of the court romances and *romans à clef* of the seventeenth century, portraying members of Mrs. Delany's circle under exotic names. However, by marrying a "gothick tast" to an Italianate setting, *Marianna* also anticipates Horace Walpole's *Castle of Otranto* (1764). We present here a transcription of the earlier of the two known manuscript copies of *Marianna*, dated 1759 along with its four accompanying illustrations. This copy was probably originally given to Mrs. Delany's sister, Anne Dewes, and is now held in the Lilly Library, Indiana University, Bloomington.[1] The other, prepared circa 1780, belonged to Queen Charlotte.[2]

1. See Llanover, ed., *Autobiography and Correspondence*, ser. 1, 3: 580.
2. Sotheby's London, *English Literature, History, Fine Bindings, Private Press and Children's Books, including the First Folio of Shakespeare* (13 July, 2006), Lot 118.

Figure 261: Mary Delany, *Marianna*, Delany mss (1759). The Lilly Library, Indiana University, Bloomington, Indiana

Leontin, & Honoria, were both descended, from considerable families; and enjoyed, with a splendid fortune, a mutual Happiness, which nothing but the purest principles of virtue, & Religion, could give. They delighted to make all Happy around them, were respected by their superiors, honoured by their equals, Loved, & almost adored, by the poor, for their humanity, affability, & charity. They had one Son, and one Daughter, the Son died at 7 years of age, the Daughter who was a year younger, & a very promising child, was now their Sole care, and after they had recovered their grief for their Son (which was very great) they turned all their thoughts, to the improvement of this darling Child. They considered her, as exposed by her great fortune, to many temptations; & above all, to flattery a weed, which if permitted to take root, will

[2]

taint the fairest flower. She had every advantage from Nature, that fond, and partial Parents, could wish for: and every assistance from Education, which they could procure for her. They saw her improve every day, and she was the delight of their eyes. But their fondness, instead of making them secure in her doing everything that was right kept them in constant allarms, & being doubtfull of their own conduct, they wished to consult some wise Friend on the course of Education she was in. They had lived many years retired and far from Neighbours, such as they cared to live in any intimacy with; except one very extraordinary Lady, who pass'd among the common people, for one endowed with supernatural tallents. She had strong sense, & Judgement, great penetration, was learned, & studious. She had made many, & wise observations, in the course of her Life, and her sagacity founded upon these,

[3]

and the knowledge of the world, and human nature, supplied her with something nearly approaching to foresight, and often interpreted by persons of lower abillities, into a spirit of prediction. She was Generous, Benevolent, & Charitable. Her Fortune (w[ch] was very considerable) was principaly employed in Entertaining, & provideing for the ingenious and distrest. She knew the opinion generally received of her, and she found it a means of fixing the attention, & regard of those who consulted her; which made her humour it so far, as to be a little misterious, in her manner of giving her advise, & to do it, with a kind of Solemn ceremony. She was about 50 years of Age, of a Gracefull figure, with the remains of Beauty. She had been several years a Widdow. Her name was Hermilia, she had one only Son to whom she gave an excellent Education. He inherited his mothers good sense, & Beauty, without the least conceit

of either. At the age of 19, he made it his earnest request to go abroad. Hermilia unwillingly consented, but finding him much set upon it & applied to by the rest of his Guardians, she provided him with an agreable companion, on whose Virtue and religious Principles, she could relye.

Hermilia encouraged no ceremonious visiters, as she seldome left her Castle, but to exercise in her own Park and Forest, (Leontins Seat was about 10 miles distance). Her house, which was a very large Old Gothick building, was always filled with persons of merit, & ingenuity; & she provided them all, with amusements, & entertainments, suited to their years, and tast. She was no enemy to cards in a moderate way; for those whose health would not allow, of their long attention to any employment of more consequence: & she gratified her young aquaintance frequently with Balls: she admitted visits from men of all ages, but

they never were inhabitants of her house, but on those occasions. If any indecorum happen'd whoever [sic] offended was never permitted again to be of that society. There was a fine long Gallery in the Old Castle, adorned most Beautifully in the gothick tast. It had two Chimney's; opposite to each, a large Bow Window; and at each end of the Gallery, a large recess of the same kind. Two of these were fitted up with books. The others furnished w^th. all manner of materials for work, drawing, or Painting. Between the two Bow windows was a niche or rather a Bow in which was placed an organ, and facing it an Harpsicord. Each bow window had a large table, with room sufficient for seats to hold 6 or 8 people. The Gallery thoroughly well furnished, & nothing was wanting either Elegant or commodious. There were several Cabinets, & glass cases, filled with Natural, & Artificial

curiousities; in which Hermilia at her Leisure hours, took great delight, & was well skilled. After Breakfast, the Bell rang, and all the family assembled in the Chapel to prayers. As soon as they were over, everyone chose their own employment, and musick was generally reserved for the evening entertainment; except in hot weather, and then it took place in the morning, to leave the Evenings free for walking or rideing. Those who were desirous of improving themselves, in any particular pursuit, had the liberty of coming into the Gallery by 6 o'clock in the morning if they pleased, the hour of Breakfast not being till ten. Hermilia tho' an early riser, did not leave her own apartment till that hour.

Honoria tho she respected Hermilias Character, had no personal acquaintance with her but hearing every day, some instance of

her wisdom, and goodness: she wished extreamly to consult her, about her Daughter. Leontin was a little superstitious in his nature, & something enclined to favour the common opinion of Hermilia's foresight, which made him wish as well as Honoria, to advise with her. But it required some delicacy, & management to bring about, as they could not possibly address her abruptly, as if she was a fortune-teller. An accident soon relieved them out of this dificulty.

Hermilia was taking the air one Evening with one of her Friends, in a postchaise, & as the road between her Castle, & Leontin's house, was very pleasant, she often took that way, and pass'd through one of the fine woods that joined to his Park pale: just as they came by the great gate of the Park, a Gun was fired, which terrified y^e. Horses to such a degree, that the Postillion

after striving much to keep his seat, was thrown, and his arm broken with the fall: it was with great difficulty, that the two servants who attended them, kept the horses from running away, & disengaged them from the Chaise. The Ladies were much frightened, but their compassion for the poor Postillion, soon made them forget their own fears; they quitted the Chaise & had him placed in as easy a posture, as his Painfull circumstances would admit. Hermilia ordered one of her men to go to Leontin's house, & beg the assistance of a chaise from him. Leontin, &, Honoria, always glad to relieve the distress, immediately took their coach, & went themselves to wait on Hermilia, and offer her, all the Service in their power. When they came which was almost instantly, (as luckily their coach was at the door) they found the two Ladies under the shelter of a spreading Oak; with difficulty

they accepted the offer of coming into their coach being very wet, notwithstanding their fine interwoven canopy, for the rain being very violent began to penetrate thro' the branches. Leontin and Honoria, prest them to go home with them which was but a quarter of a mile from where the accident had happened: and insisted on y^e. Postillions being removed to their house, as it was near: and in their Village or rather small Country Town (not half a mile off) there lived a most famous Bone setter. Hermilia's humanity for the poor man, who was in great pain, made her wave all ceremony, & the generous open manner with which both Leontin and Honoria prest her, made her consent. One Servant led the Chaise, & another went in it, to keep the Postillion steady. By the time they came to the house, it was so late there could be no thoughts of their returning to the Castle

that night, and Hermilia was so struck with the amiable, and engageing Honoria that she was the readier to comply with her earnest solicitation to stay with her. A messenger was sent to the Castle to let the company there know what occasioned their staying, & to assure them the Ladies were well. The bone setter came, & gave them the Satisfaction of knowing, that y^e. fracture not being bad, the man would soon recover.

The evening past most agreeably on all sides. Marianna Leontin's Daughter was introduced to Hermilia, who was much taken with the sweetness of her countenance, & her gentle, modest behaviour. She was then about 11 years of age. The next morning Hermilias equipage attended her & she insisted on Leontin, Honoria, & Marianna's, going home with her, & spending some days at the Castle. Which they complied with, not only as it was very agreable

to them, to enjoy more of her conversation, but it paved the way, for what they had so much wished for, the consulting her on the Education of their Daughter. Marianna was particularly invited, and much transported at the distinction, as she had never been from home, but on formal visits, and that very seldom; being kept very strictly to all her studies, and exercises.

They all arrived at the Castle, about an hour before dinner, and spent that time in viewing the apartments. The rest of the day was spent in variety of amusements, and in all, Hermilia would have Marianna, bear a part. She observed her with so much attention, that Honoria could not but take notice of it, & she thought this the opportunity, she had so much wished for; & as they seperated sometimes, when they were walking, from the rest of the company, Honoria told Hermilia, that as she was so good as

to take particular notice of her little Girl, she wish'd she would give her leave, to ask her advice ab^t. her Education, & to know, if she approved of the method she had hitherto pursued. Hermilia said she was sure by what she had already observed in the proper behaviour & pretty manner of Marianna, that she wanted no assistance, but yet Honoria, should always find her ready on every occasion, most sincerely to give her, her opinion. Honoria entreated her to consider the child well, & when she had done so, to tell her, wherein she thought she was most likely to err. Hermilia promised her she would, if she would compleat the week with her; & would tell her the result of that consideration, the day she left her Castle. The morning Honoria intended going away, as soon as breakfast was over; Hermilia desired her to come into her dressing room alone.

PART SECOND

When Honoria, & Hermilia were retired: Hermilia told her, she had faithfully borne in mind her request, about her Daughter; & had observed her with the utmost attention; and thought, she had every promising good quallity, that could bless herself, and her Parents. That she could object to nothing in Marianna's behaviour, but a little inattention to, & hesitation in, complying with her commands; which tho it did not arise from any corruption of the heart, might in time, prove very pernicious, as she had seen in many instances: & the only thing she feared for her, was *disobedience* where a strong temptation came in the way; & that, if she disobeyed the first positive command, she received from her Father, & mother, it would probably bring her into great distress, & misery

and if she persisted in her disobedience, it would involve her in still greater distress. Honoria turned Pale at this sentence, as if delivered by an Oracle, and said, o! teach me Hermilia how I shall guard her from this error, that threatens her so much? You can do no more she replied, than acquit yourself of *your* Duty, by pursuing the method you have begun give her a Habit of obedience: you have already laid a good foundation, & well taught her *her* Duty: and I hope tho' some interuption may happen, & must in the course of human things, that in the end, she will crown your days with Blessings.

Honoria, and Hermilia after repeated professions of regard, & esteem, for each other; joined the rest of the company, & in the Evening Leontin and Honoria returned home; in their way as no body was in the Coach but Marianna, they talked over what had past at the Castle and

particularly, the conversation between Hermilia, and Honoria; addressing that part to Marianna, & laying a great stress on it: which she took in a very sensible manner, and promised she would ever be very observant of their commands.

Honoria devoted herself very much to the care of her Daughter, & had masters of all kinds, at a great expence to attend her; but as she was very infirm, and unable to walk much abroad, she would not confine Marianna, (when her exercises had been well performed) but allowed her the liberty of walking out, with her Governess; not only in the Gardens, which were very fine, but in an adjacent Lawn, where Marianna used to be much delighted with the little Lambs, & gathering the wild flowers: but she had a positive command never to go over the stile, that was at the end of it.

One day about half a year after her visit at the Castle, she was amusing herself as usual

Figure 262: Mary Delany, *Marianna*, Delany mss (1759). The Lilly Library, Indiana University, Bloomington, Indiana

in this Lawn, when an uncommon & Beautifull
butterflie, fix'd on a flower she was going to gather;
she cryed out in an extacy my Dear Dear
mademoiselle! I must catch this lovely, pretty,
creature; but nimble as she was it flew from flower,
to flower, too quick for her to gain the Prize she
wanted; at last, after some pursuit; mad.^{elle}
admonishing her most vehemently, not to over
heat herself, the butterflie flew over the stile,
at the end of the Lawn, and Marianna almost
with as much swiftness followed: when she had
chased it a few yards, & she thought herself sure
of catching it, it took wing again, & by a succession
of short flights, drew her quite out of sight of
the *fatal Stile* ——she then recollected she had
disobeyed the command laid on her, and turned
back to reapair her fault, as well as she could,
but found she was entangled in so many Briars,
she could not stir a step, & had not only

lost sight of the Stile, but could find no traces of any
footsteps, or path. She called mad.^{selle} as loud as she
could raise her voice—nothing answered, but an
Echo, which by the stilness of the Evening was
very distinct; this as an unusual sound she had not
attended to, & doubled by the flutter her spirits
were in, encreased her fears, & she cryed most
bitterly. However by struggling, she at last
disengaged herself from the Briars, & found a sort
of path, which lead into a by Lane, where she could
perceive no marks of Coach wheels, or track, likely
to convey her to any dwelling. At some distance,
she perceived a woman with a child at her back,
gathering up sticks: this gave her some courage, and
she hastened her steps towards her: when she came
nearer, she saw a great smoke, and Men, Women, &
Children, watching a great Kettle, that was on a fire
of Furz, and sticks. The hideous appearance they

made, terrified her so much, that she started back,
in order to run away, when one of the youngest run
after her, & brought her back again, half dead with
fears. They all flocked about her, & looked like so
many wolves, contending for a tender Lamb. But
finding her so much terrified, & almost in fits the
Eldest of the Women, called them to order, and
told Marianna, they should do her no harm, & that
she would protect her. This gave her some courage,
& she fell down upon her knees, intreating the
Gipsey (for such she was) that she would put
her in a right path to go home, & told her where
she lived. To sooth her the Gipsey spoke kindly
to her, and told her, it was too late that night, but
she should go home with her; & the next morning,
she would take care of her. Poor Marianna was
forced to submit. They led her like a Captive in
triumph, Hollowing, & capering, with a thousand
antick tricks, which at another time would

have diverted her, but appeared now most horrible.
It was almost Pitch dark, when they arrived at
what they called their home, which was the
remains, of an old deserted Barn, in which were
several heaps of straw, that servred them for Beds.
Amongst them was a fiddler, who begun to scrape,
as soon as they had struck a light. Marianna's fears
encreased on seing the whole troop assembled,
which consisted of fifteen men, women and
children. She flung herself down on a heap of
straw, unable to support the terror they gave her,
whilst they danced & roared, till at last tired out,
they all took to their nests. Poor Marianna's
spirits, worn out with grief, and fatigue, at last
yeilded to sleep, till she was awakened, by the
unruly Crew's preparing to go in search of more
prey. The old woman who had the most decent
appearance among them, and seemed to keep
them in some order; and at first spoke kindly

to Marianna, told her, now she must do as they did,
or be starved; and follow their steps wherever they
went; that if she would observe *her* closely, no harm
should come to her, but she must obey *her* exactly,
or she should have neither food, nor raiment; indeed
as to what they called cloaths, it could hardly be so
called, for they took from her, her own, and put her
on most miserable rags. Amongst the train there
was a young woman about 15 years of age, that
wept almost continually, & hardly ever stirred from
the old woman's side: she whispered Marianna,
*don't refuse doing what the old woman bids you, if
you do they will beat you and make you as miserable
as I am; & I will do all I can to make you easy.* This
was but melancholy comfort, but it was some, to
find a friend among such wretches. She submitted

and after they had drest her, in their own way, and
died her face, neck, & hands, with soot water, they
marched in different companies. The young woman
who whispered Marianna, was in the same company
with her that day, & found an opportunity of telling
her, who she was.
„ *Her name was Helena, her father, and mother respec-*
„ *table people, in a country town, what there are*
„ *called mercers; & she had been brought up to*
„ *work, with a view either of going to service, or*
„ *settling in their business. She had many Bro.^s*
„ *and sisters, all very good & dear to her, who*
„ *had been carefully educated, suitable to their*
„ *station, & some well settled.*
The recollection of the friends that she loved so
well affected her so much and the tender hearted
Marianna that she could not for some time proceed
with her story. When a little recovered she said
„ *her eldest sister*
„ *was married to a substantial Farmer, about*

„ *half a mile distant from town, where her father, & mo-*
„ *ther lived. She had been one day to make her sis^r.*
„ *a visit, and on her return home in y^e Evening in*
„ *the dark with an old man (who had promised*
„ *to take care of her,) as they pass'd through a nar-*
„ *row lane, a man started out of the ditch, knocked*
„ *down the poor Old Man, bound up her Eyes (tho*
„ *in the dark) and carried her away. She lost*
„ *her senses immediately, and when she reco-*
„ *vered them, what was her terror, when she*
„ *found herself in a dismal dungeon (as it ap-*
„ *peared to her,) surrounded by the whole troop*
„ *of Gipseys, that looked to her, like so many*
„ *fiends. She in vain supplicated, to be restor-*
„ *to her Parents; but they laugh'd at her, & said*
„ *if she submitted patiently, they would use her*
„ *kindly, w.^{ch} she did, praying constantly to God,*
„ *to deliver her out of their hands. & here I have*

„ *lived most miserably, not daring to complain*
„ *these 3 years; watching for a happy moment*
„ *to fly this wretched, & detested company.*
„ *My heart bled for you, when I saw them drag you*
„ *hither yesterday, & if I can do you any service,*
„ *or give you any comfort, that will make me*
„ *feel my own Sorrows less.*
Upon this the sensible heart of poor Marianna
was so touched that she took her about the neck,
and wept so much she could not speak—but was
forced to break from her, by being called away,
& chid and beaten by some of the crew for not
minding her busyness, which was begging.
However they found times of communicating to
each other, their sentiments, & Marianna told her
every Circumstance, relating to her family, & that
her disobedience had brought her to this great
distress. Helena who was a very Sensible girl

was charmed with Marianna; her good sense,
sweetness of manners, & tender disposition,
appeared to no small advantage in such a situation;
and Marianna was no less delighted with Helena.
This mutual consolation kept up their spirits, and
as they had been religiously brought up, never
fail'd dayly to ask Gods assitance, & protection;
such is the advantage of early habits, that the
wickedness that surrounded them, could not
obliterate the sense they had of their Duty.
They scheemed many ways of escaping, the
hope of succeeding was no small support to them.
One day the company in which Helena, and
Marianna were (for often to their great distress
they were parted) went a new road, that lead
them a great way. The day was excessive hot
& they had no drink left, of which they used to

have store in their Leathern bottles: they were generally shy of going very near any country Seat, but now they proposes going to the next great house to get some drink. To their wishes they soon got to an Avenue, that lead to some out house, belonging to Leontin's seat, where they had never been before; which Marianna no sooner observed, than she fell a trembling between joy, and fear, and had not Helena supported her, would have fallen down. She whispered very softly to her the occasion of her agitation. As they advanced nearer, the hurry of her spirits, grew so violent she fainted away just as they got to the Barn door. Helena screamed out she was dead. Several men flocked about her who were threshing in the Barn, which allarmed the Gipseys so much, that they marched off as fast as they could. But Helena who sate upon the ground, remained with Marianna, crying as she thought dead upon her lap. By this time they had

called the Housekeeper who had lived in the family from her childhood. They had thrown water in Marianna's face, & she began to shew signs of Life. The housekeeper moved with the distress of these two young creatures, ordered them to be carried into the Barn.

PART 3.

The Housekeeper, on wipeing Marianna's face, found the brown hue, which seemed to be natural, came off, & discovered a dazzling complexion, and a countenance, that she was well aquainted with. Upon which in an extacy she cried out, is it possible! Marianna struck by the sound of her well known voice, revived, and clasping her arms about her neck said, o save me! save me! Dear Leonora from Papa & Mama's anger, I have been disobedient but a little. She cryed so violently she could say no more, & Helena who was more composed, & happy to find she was alive, told Leonora how they met, & their whole story. Leonora was so much overjoyed and touched with this discovery (for Helena told her story in such an artless manner, & so

sensibly, that she did not doubt the truth of her account) that she joined her Tears with Marianna's, assuring her dear young Lady, she would do all in her power to obtain forgiveness for her. She immediatly brought them into ye house in as private a manner as she could, she gave them clean cloaths, and took away their miserable rags, imagining that if Leontin, & Honoria should see their darling Child, in such miserable cloathing, it would shock them to a great degree. She had brought them some refreshment of which poor Marianna was not able to tast one bit, so greatly was her mind discomposed, with joy, & fear, of appearing before Parents, she had greived so much by her disobedience. Leonora who was a discreet woman & a very faithfull and affectionate servant; was impatient to

communicate this extraordinary Event to her Master and Lady: which she did with as much caution as possible, by first telling them; she had heard of her young Lady, that she was very well, & in good hands, & would be soon at home; Leontin, & Honoria, hardly able to support the tumult of their joy, said o where is our Child, where can we find her. Order the coach instantly, let no time be lost—Honoria's joy was too much for her, but after she had shed tears plentifully, she grew composed retired into her closet, with orders they should call as soon as the Coach was ready. And when she had returned thanks to God for his goodness in preserving her child; her impatience to know some particulars about her made her ring her Bell, before they brought word the Coach was ready. Leonora as soon as her Lady was retired told her master just

Figure 263: Mary Delany, *Marianna*, Delany mss (1759). The Lilly Library, Indiana University, Bloomington, Indiana

as the case stood, upon which he flew to his Marianna; but stopt before he opened the door for fear of surprising her too much. Leonora gave her notice of his coming, she flung herself all in Tears at her Fathers feet for his Blessing and pardon. You have both my child, his words almost chokeing him, let me carry you to your mother, who will receive you with open arms, and since it hath pleased God to punish you in so extraordinary a manner, for your disobedience, we shall hope the remembrance will be a constant guard to you. By this time Honorias Bell rang; Leonora went to her & by degrees told her Marianna was in the house, and Leontin with her: they were now come to the door of Honoria's dressing room, the moment it was open, the Mother & Daughter were clasped in each others arms their joy too great for utterance. In a few minutes

all were composed & happy. Helena who always treated Marianna with a particular respect, staid behind, and thought the time very long till Leonora returned to let her know, what had passed, and that Honoria desired to see her. Helena who was very Bashfull, was in great confusion at the thought of appearing before her, but obeyed. Her modest, sensible countenance, and humble behaviour, prejudiced Honoria much in her favour; and Marianna's account of the great care, and tenderness, she had shewn her, for the two years they were together, quite engaged Leontin, & Honoria, in her interest. When they went to dinner (for this happened about noon) Helena retired. They would have had her dined with them, but she entreated leave to go to Leonora. A messenger was immediately dispatched with a letter to Helena's mother, who lived but six miles from them, & in the Evening

she came back with the servant, who had orders to enquire after her Character, & satisfied Honoria, that Helena had told her strict truth in the account of herself, & her family. Helena's mother the next day, after making her best acknowledgements to Leontin, and Honoria, for their great goodness to her Daughter, begged leave to go home, and take her with her as her Father was most impatient to see her, & too infirm to Travel; & she feared she had already given too much trouble. Marianna whose gratefull affectionate heart, had been touched by y^e tender care Helena had taken of her, could not command herself when she found she was going to leave her, but burst into tears. Upon which Honoria who was willing to indulge her, & shew her own gratitude to Helena; asked her mother, what way of Life she wished most to settle her Daughter in:

who replyed, the heighth of her ambition, was to place her in service in a good family, for she had brought her up to needle work, and to read, & write very well. Upon which, Honoria told her she was so much pleased with Helena's modest humble behaviour, that she would gladly take her, for her Daughters maid under the direction of her Governess. Which proposal was most readily, and thankfully accepted. Honoria gave the good woman thirty guineas to buy her a new gown, and consented her Daughter should go home for a month, and then return to take possession of her new office; which she did, to the entire satisfaction of Marianna as well as her own.

The Friendship between Hermilia, & Honoria, had by this time, made a considerable progress. Great, & good minds, shine in a particular manner, when under the tryals, either of extraordinary

Prosperity or adversity. Like gold they can bear either the embellishment of the most ingenious artist; or suffer the oppression of the Hammer, or the heat of the Furnace, without losing any part of its intrinsick worth. Honoria's distress endeared her to Hermilia's generous heart: whenever they met, (which was only when Hermilia could come to Honoria) their discourse was about their absent Children, but with a great difference. Hermilia had constant accounts of the progress her Son made, in virtue, & accomplishments; and the unfortunate Honoria had room to conjecture every thing that was distressfull, in regard to her Daughter. Hermilia's tender, and constant attention was no small support to the poor afflicted Parents, under their great Loss. It is needless to say what their grief must have been, and what dilligent tho fruitless

search, was made for the lost Marianna. The day of her arrival home, as soon as the tumult of the surprize, & joy was over, Hermilia was made acquainted with it. Who next morning came to congratulate them all, & satisfied her curiosity about so extraordinary an Event.

Marianna was much grown, & now in her thirteenth year. But the miserable Life she had led, the trouble of her mind, & fatigue of her body, had impaired her health; which with the endearing circumstance of her being restored, when thought to be lost, made Leontin, and Honoria, very attentive to her. She soon recovered, & made a quick progress in all her exercises; & with the happy change of her condition, & amendment of her Health, her Beauty and stature, surprizingly encreased, every year. Nothing could be more amiable, & the charms of her face, and person, tho much distinguished

were, what she was least to be admired for. With the greatest sprightliness, she was attentive, & obliging, to every body. So diffident of herself, & so humble, & modest whenever she was commended, that it engaged every body to Love her. Leontin, & Honoria, as they well might, doated on her. The only draw back they had in their happiness, was their anxiety for the entire recovery of her health, w^ch. their extream tenderness, made them have unnecessary apprehensions about. They were all to go for a week, to a relations house about 20 miles off. The day was fixt, but Marianna having a slight cold the morning they were to set out, made them not care, she should venture, & determined them to stay the less time from home. Most unwillingly they left her, tho in the care of a very discreet sensible Governess, & Helena; who was ever most tenderly attentive to her. Many charges they

gave her, to take great care of herself. They permitted her, to walk in the Garden, & the park, & to take the air in a post chaise, with Made.^selle but laid their absolute command on her, not to walk out after Sun set. The 3^d day after they had left her, she was so well she spent y^e greatest part of the day in the Garden; which was so well planted, as to afford refreshing shade, in the hottest day. At the farther end of it, which joined to the Park, was a rising ground, planted with an infinite variety of flowering shrubs; on the highest part of it, was a grove of tall Trees, & in the midst of them, a Gothick Temple, where Marianna took great delight to sit, to read, or work. Her two faithful attendants followed her steps; The Evening was extreamly hot, & close, she soon grew tired of sitting & said she would go to the wood, on the adjacent hill, which was just without the Park pale. Her Governess who was Old &

infirm, & unable to follow all her lively motions, diswaded her from going, as it might keep her out beyond her limited hour. But she had set her heart on going, & entreated Made.^selle to go home as she was very much out of order, & that she would come back to her immediately; with reluctance she consented to stay in the Temple till she returned. This aluring Hill was in sight of the temple and opposite to one of the walks that led to it. Marianna had the key of y^e. Park gate in her pocket, & with great vivacity sprung forwards, much delighted with the Beauteous rays, & colouring of the declining Sun, which still appeared to greater advantage as she walked along the rising ground. Helena shut the Gate after her, for fear of the cattle's getting into the Garden, & hast'ning after her charge, was stopt & terrified by a roaring Bull that run directly at her.

PART 4^th

Helena had no way of escaping the fury of the Bull, but by climbing up the first Tree in her way, which (being happily low branched) she did, with great agillity, that nothing but the terror she was in, could have given. [Her Enemy, enraged at her escape, after pawing, and roaring, till it was almost dark, left his pursuit; and Helena half dead with fears for herself, and dread of what was become of her young Lady, could just discern him stalking off to his companions. She instantly came down, never ceasing calling after Marianna, but to no purpose: she went to the entrance of the Wood, screaming in vain; she then imagined the sight of the horrid Bull, had made her run back to the Gate, & that she should find her there, with great difficulty, & trembling steps, she found the Gate: but it was locked & the Key in, which made her dispair of Marianna's being gone

home. By this time, it was so dark, she could only find her way to the Gothick Temple, where in an agony of grief, and despair, she threw herself into a seat, unable to support herself. Whilst she rested there, she perceived a number of lights coming from the house. She formed a hope, that Marianna was safe at home, & had sent in pursuit of her. But how were her terrors encreased when on going to meet them, they told her she was not returned; that Made.^{selle} was almost distracted, & had sent out all the ser^{ts}. with lights, & had ordered Horses, and post chaises to the Gate of the Park, & to go everywhere from thence with lanthorns, & flambeaus, in search of her; the night grew more, and more, tempestuous, which augmented their distraction. Marianna evaded (tho unwillingly) their pursuit. As she ran forward, after opening y^e Gate of the Park, she lost sight of Helena whilst she was locking it

and turning back, to see for her, saw the frightfull Bull makeing after her. Terrified to Death, at the sight, instead of running to the wood, struck into a path, and got over a high gate, that led to a very wild Forest. By this time the lovely scene y^t: had enticed her, was changed to a most dark, and Tempestuous night, attended with violent Thunder, and lightning. She knew not where she was but ran on, sometimes stumbling, sometimes climbing over rocks, the Bellowing of the Bull still dreadfull in her ears: and to add to her terror, she found after some time, by the roaring of the Sea, that she must be on the cliffs adjacent to it. And by that situation knew, she was two, or 3, miles from her Fathers house. Weary, & dreading to take another step, in that most dangerous situation, she threw herself down on the Rock where she had stood, and by the flashes of Lightning, discovered some paces below where

she lay, something like a cave; she crawled to it for shelter, from the rain, which fell in great abundance: as she lay, closing her Eyes as hard as she could, to avoid (as much as possible) the horrors of the night; she thought she heard the voices of men at a distance, & as they approached nearer, heard them say, very distinctly, *if our anchors hold this storm, I hope by tomorrow we shall get into Port.* She lay like a poor destined hare, panting with fear, not daring to move; but at last she heard one of the Men say to the other, a Prize! a Prize! and immediately found herself seized, in a very Ruffianly manner, and the first glimpse of daylight, on her opening her Eyes, discovered to her a most horrible Scene. Below the cliff where she had sheltered, she saw the Sea foaming with rage, & a ship in the utmost distress, herself taken Pris'ner and carried most precipitately down the

Rocks, towards a boat near the shoar, so violently tost, y^t it seemed often overwhelmed with the waves; her spirits could endure no more, & when the men got her on board the ship (for they were part of the crew) they thought she was actually dead. This put them into a great consternation, & they debated with themselves, whether they should not, after stripping her, throw her overboard. But a passenger who went a shore with them, & followed them at a little distance to the rock, observed them very attentively, and overheard their inhuman debate; interposed, & called loudly to a young Gentleman whom he attended, to prevent the Saylors barbarous design the young Gentleman immediately came up, & obliged them to quit their prey, and give an account how they came by her; which they did, protesting they meant no harm, and thought as she seemed to belong to no body, they had a good right to her. The young

Gentleman, put her under the care of the surgeon, who assured him, she was not dead. He was a humane, sensible man, & made the Captain acquainted with the extraordinary adventure. Tho he was a rough tarr, & an absolute monarch in his way, he was not totally void of humanity; he ordered a private Cabin for the young Lady; who with proper helps was brought to her senses. By this time, the wind was abated, & blew fair, and they made briskly to Port. But what were Marianna's thoughts & reflections, when she looked round, & saw y^e. strange situation she was in? The motion of the Ship, the noise of the waves, the confusion of the saylors, when they worked the Ship, all added to her astonishment. At last she burst into tears, hid her face in her Pillow, & moved every heart that observed the distracted way she was in. The Surgeon desired no questions might be asked her, till she had had some food

Figure 264: Mary Delany, *Marianna*, Delany mss (1759). The Lilly Library, Indiana University, Bloomington, Indiana

and rest, of which they could not prevail on her to take either in a long time. At last sleep, the great composer of all sorrow, came uninvited to her aid and made her for a few hours forget her misery. When she started out of her sleep, talked of *disobedience*, called for her *Papa* & *Mama* & *Helena*. Then bid them *not come near such a wicked, disobedient wretch*. All this was very strange to the by standers, who were numerous, and flocked to see the wonderfull stranger, whose youth, and Beauty, made them conclude, some happy Lover had enticed her from home and left her desolate, either by some sad accident of perfidy, or Robbers. The surgeon, insisted on her being left quiet, & no body suffered to come into the cabin, beside himself, & the Gentlewoman that attended Marianna; who was his wife. In two days, for so long were they kept at sea by ye shifting, and slackening of ye

wind, she began to recover her reason, and was prevailed on to take proper nourishment, but she let not a word drop, that could satisfye the curiosity of those about her, or make the least discovery who she was. The Captn came several times, to ask her how she did, & tho a rough, unpolished Seaman, was gallant in his way and not proof against the blooming charms of Marianna: he looked upon himself as having saved her Life, & therefore had a right to treat her, as he thought fit. In one of his visits, he carried with him the young Gentleman, who was returning from his Travells, and who realy was the Person that saved her Life. His curiosity had been raised by the account of the Beauty, & affliction of this young creature: he was struck with her appearance, which tho veiled by sickness

and sorrow, had so much dignity, was so lovely, and so modest, that struck with awe, he retired precipitately, thinking he had presumed too much, in approaching her without her leave. She immediately asked who he was, and when the Captain told her his name was Bellario, heir to a vast fortune, his Father Dead, ever since his infancy, & that his Mothers name was Hermilia—struck with this name, she fell into such a fresh agony of Grief, that the surgeon feared she would never be again composed: but at last was roused by a new distress. The Captn. grew impatient to declare his Passion, which he took an opportunity of doing that very day; and with such vehemence, that Marianna forgot all other sorrow, & her resentment gave her strength, and courage to treat him, with the contempt he

deserved: aspurning him, his insolence, & inhumanity, would be humbled by her Friends, as soon as they could be informed of it: he laughed at her anger, called her poor angry child, & that he only talked to her in that manner, to divert himself. Such delicacy, such reserve as Marianna had been brought up with, how must such treatment wound? The Captn. left her to dry her Tears, as he told her, for an hour, & hoped then to find her, in a better humour. & that he would indulge her no longer in her peevish, and complaining ways. The Surgeon's wife, to whom she told her new sorrow, tho but an ordinary weak woman, & who knew the Captns. Gallant disposition, was much moved with poor Marianna's sad distress. She was at a loss how to manage her Turbulent Lover & by ye advice of her husband, communicated the affair to the Old Servant that attended

Bellario who had travelled with him & tho only a servant, was well bred for his station, & much regarded by his master. He immediately entrusted Bellario with the secret, consulting him how to extricate this unfortunate young creature, from the rude Captains persecution. In the midst of this dilemma they arrived in Port, & the hurry that every body was in to Land, & the hopes the Captain had of a better opportunity at land, of engageing Marianna than at sea; made him attend to the busyness of the Ship, little imagining there was a counteplot against him.

Bellario's first thought was of having Marianna carried to the house where he was to lodge; but Anthony took upon him the priviledge of an Old Servant and opposed it, by saying you know not Sr. whom you may take under your protection. Bellario whose superior understanding and modest opinion of himself made him always listen to advice, yielded;

& ditermined to place Marianna under the care of the surgeon and his wife and as his generosity was unbounded on all proper occassions he promised them considerable rewards if they would take care and place her safely & with such privacy that the Captn. should not discover where she was. The task was hard, but they undertook it. As they had been long inhabitants of the Town they had many Friends there & much esteemed for their honesty and good nature. They concluded at last to place their charge with a Friend who lived about half a mile out of the Town. The Captn. who thought himself secure of the Friendship of the Surgeon and his wife (tho his imperious treatment of them no way deserved it) readily agreed to put Marianna into their hands with a charge not to let any body come near her & to let him know when her health was better that he might visit her. His last visit to her, had thrown her into

such a dilirium and fever, that she was convey'd out of the Ship without being sensible of her removal. They amused the Captn. a day or two with saying her Fever grew worse and they despaired of her Life. At last that she was recovering when to their great surprize she had made her escape in the Night. The Captn. stormed but was weary of giving himself any more trouble about her: quarrelled with the surgeon who disclaim'd having any more commerce with him & so they parted. On their going out of the Ship Bellario's servants had orders to convey Marianna as the surgeons wife should direct. He called twice or thrice every day at the place where she lodged, to make his particular enquiries; but never attempted to see her. The Gentleman who had gone abroad with Bellario in a very bad state of health was obliged to leave him when he was on his return & go back to Naples. Anthony grew uneasy at

his Masters delay, & urged him to hasten home to his Friends, who had long expected him. But he begged to stay till ye. stranger was better that a few days would ditermine her Life or Death. Anthony grew allarmed, and thought in justification of his own conduct he must acquaint Hermilia with her sons safe arrival to Port and the reason of his delay. What joy was it to Hermilia to hear of her sons return after having had too much reason to fear he was cast away? But how was her joy checked by the apprehension of some foreign fashionable engagement, that might dishonour the virtuous character he had hither to preserved? She instantly ordered her Coach & set out as soon as she received Anthony's letter in the morning, & sent a servant forward to give Bellario notice of her coming, and arrived at the end of her journey the Evening following. Never had Son a tenderer affection or greater respect for a Parent than Bellario

had for Hermilia; but the transport he should have felt on seeing her was greatly allayed by the consciousness of having seemingly neglected her. But when they met their mutual joy appeared to have no abatement.

PART 5.th

After mutual tender enquiries, Hermilia proposed to Bellario, to return home next day. She said she was impatient to see him where he would be so much respected on his Father's account and she did not doubt as much on his own as soon as he had made himself known to his friends and Neighbours; and to put him in possession of such a fortune, as would enable him to gratifie the utmost wishes of a reasonable mind & generous heart; by Blessing all those around him. He with great respect acknowledged her goodness and partiality to him. But said he hoped the delay of a few days would not be disagreeable to her, as she might be amused with the singularity of the place & some very romantick scenes in the neighbourhood. No consideration she said since he was well cou'd detain her any longer from a most dear and worthy Friend whom she had left in the

deepest affliction, on a very extraordinary occasion. She observed Bellario turn pale & in such confusion as allarmed her excessively, but thought it best to relieve him; and by an open and generous behaviour engage him to yt. confidence, which all wise Parents should endeavour to gain with their Children: I see my Dear Bellario your distress, tell me sincerely what it is, depend on my best advise and indulgence, as far as is consistent with your honour and interest. He threw himself at her feet, declared he never had nor would deceive her, [He] also as well as herself had an attachment that arose purely from compassion & frankly declared to her, that a young creature who had been much distrest at Sea, without any Friend or companion; left on shore in a dying condition & now but just giving hopes of life: had drawn his attention to her so far, as to keep him from flying to the best of Parents immediately as he ought to have done

and only entreated her to stay till the unfortunate strangers Life was safe. Hermilia could not hide the emotions of her heart on this occasion, not knowing how far this engagement might have proceeded; but her fears were calmed by his adding; I have had no opportunity of learning who this Lady is, when her Fever & dilirium abates, she weeps continually, without speaking, nor have I ever seen her but once in her Cabin when on board the Ship my curiosity lead me to make her a visit in company with the Captn. and that but for a few minutes. & I saw her again when my Men were carrying her in their Arms out of the ship expiring as I then thought her. Bellario related every circumstance of this extraordinary adventure that had come to his knowledge, with so much frankness that she could not condemn but rather admire her son for every step he had taken and promised she would go next

morning to see her. When Hermilia retired to her room, she revolved in her mind this uncommon adventure of the Lady found among the rocks, and recollecting what her Son had told her of their distress at Sea & being driven into a Creek. It struck her that it might probably be on the coast in the neighbourhood of Leontins Park; and that Marianna might prove the unfortunate stranger. But whatever her hopes were she resolved to keep her suggestions a secret. And according to her promise went next day to see her, attended by Anthony. She took the Surgeon's wife with her in the coach, & found her account of the adventure corresponded with her Sons, not that she wanted any testimony of the truth of what he had told her as she knew he never would deceive her. When they arrived at the house the Gentlewoman under whose care Marianna was placed

said she had had some hours rest & had taken a little refreshment, was more composed and had asked for Pen Ink and paper; which she was as yet afraid of letting her have the use of. Hermilia desired she might see her, but that they would apprize her of her coming, and call her a relation of the surgeon's wife's, who was come with her. They brought back word, that she was too much obliged to those about her to refuse any request they made, tho it was painfull to her to see a stranger. Upon this Hermilia went up stairs and as she entered the room ye. door opening upon the Bed Marianna screamed & fainted away. Hermilia (with the rest) did all she could to recover her & opening the curtains wider to give her more air, soon knew the lost and much lamented Marianna. She desired to be left alone with her, and with utmost gentleness & tenderness, assured her, all her Friends were well & would receive her

with transports of Joy. To which she could not answer for Tears, only in broken accents said I deserve no such indulgence. Hermilia entreated her to compose herself, that she knew the train of sorrow she had gone thro.' that her recovery would bury all that was past in oblivion; and that she would not leave her, till she was well eno.' to go home with her. That she would leave her for some hours to rest, and bid her depend on her establishing her perfectly in the good opinion of her family.

Hermilia was indeed obliged to retire the scene had been so surprizing & affecting yt. her spirits were hardly able to support it: her affections were warm and tender & she had always loved Marianna like a child of her own, & from the time of her being well acquainted with her wished to give her that Title. She debated with herself before she returned to her Sons lodgeing whether she should

own to him who Marianna was, and at last concluded it most honourable towards Leontin and Honoria not to make the discovery without their knowledge: but instantly dispatch'd a messenger unknown to her Son, with a letter to Leontin to acquaint him with her having discovered where his Daughter was, of her being safe, and that as soon as she could convey her home she would. She thought it cruel to leave them one moment longer in misery when she could relieve them. As soon as she had sent her letter, she enquired if Marianna was awake. They said yes, and had most eagerly entreated to see her again. By this time the Physician that attended her was come, and they went into the room together. He felt Marianna's pulse & examined her looks, and said there was a surprizing alteration for the better, and that now she had little or no fever remaining. Hermilia asked when she might safely be removed he said in

two or three days. But as she was very weak anything that agitated her spirits greatly might occasion a relapse, tho as he believed her illness was chiefly owing to distress of mind, whatever contributed to relieve that would prove her most effectual cure. When the Physician went away Hermilia sate down by Marianna's bed side who was unable to speak, but her Eyes filled with Tears shewed the fulness of her heart & her great concern for having distrest and offended the tenderest, Parents and most valuable Friend in the world. Hermilia's sweetness and goodness, soon cleared away the clouds, by assuring her she was quite forgiven that her sufferings and sorrow made full atonement. And the best amends she could make was returning home in health to bless those Parents who were ready to receive her without reproach. She then told her how far they had been been informed by Helena of her fright from the

Bull, and of the vain search had been made for her. And Marianna acquainted Hermilia with the sequel of wt. had happened to her; of her being seized as she thought by two Robbers and of her finding herself in the ship when she recovered from ye. fits that the terror had thrown her into: Hermilia found her strength began to fail on the recollection and repetition of her distress; entreated her to compose herself to rest; and again promised not to leave her but to convey her home as soon as she was well eno' to travel. Marianna promised she would; but said she she was distrest about the expence she might be to the good people who had under God saved her Life, and taken such care of her. Hermilia desired she would have no cares upon that head, for she would be answerable for all the expence and think of a proper reward for them. This quieted her spirits, for Generosity was one of her most amiable qualities. Hermilia

left Marianna to rest; and when she went down to the parlour, found the Surgeon and his wife and the Gentlewoman of the house who was a widow. She took this opportunity of enquiring what expence they had been at. The Surgeons wife said none; for the young Gentleman who had charged her with the care of the young Lady, had given her a purse with fifty guineas to provide her with everything she could want, and assured her that when y^t. money was gone he would supply her with more; but with a strict injunction not to own to the stranger whence the supply came. They supposed the Gentleman was a relation as he came to the house 2 or 3 times a day to enquire after her but never asked to see her.

Hermilia could not but be delighted with her Sons generosity and great delicacy of behaviour, and was impatient to reward it in some degree, by letting him know she

would take Marianna into her Protection: but was determined not to tell him who she was till she had restored her to Leontin & Honoria: she hastened back to Bellario, who waited with great agitiation of mind for her return. She told him the young Lady was much better and had given so good an account of herself that she was resolved to carry her her home as her Friends lived in that part of the country. She saw joy flash in Bellario's Eyes, he eagerly grasped her hand, and said, how good you are Madam to shew so much compassion to this poor unhappy creature!

Hermilia had observed the house where Marianna was placed to be large and convenient, and she asked the Land Lady if she had a spare room or two. She said she had & could accommodate her and the young Gentleman whom she understood was her son with room eno'. Upon which information she agreed to return with him in the Evening. She asked

Bellario if he had any objection to the agreem^t. she had made, he could hardly contain his joy at the hopes of being under the same roof with a person, who in so short a time, had made so deep an impression on him; they hast'ned back as the Evening was far advanced and had the Satisfaction of hearing that Marianna has slept some hours & was still asleep; orders were given to tell her when she waked, that Hermilia would come to her next day but not to say she was in the house, lest her impatience to see her that night might disturb her rest.

Part 6.^th

The next morning a happy account was brought to Hermilia of Marianna's having waked after a good nights rest quite a new creature; but very earnest to see her, in which she was immediately gratified. She asked Hermilia what brought her the great happyness of seing her in that place and how she came to know where she was. Hermilia told her every circumstance of her sons landing there and of her coming to meet him, of his request to her not to leave the unfortunate stranger (as he called her) destitute, upon which she came to see her. Indeed she told her everything but the state of her son's heart which she plainly saw was most sensibly touched by this lovely fugitive. At the same time she entrusted her with her design of not owning who she was till she got home & desired her to be upon her guard & not betray herself. Marianna was so well as to be able to sit up the greatest

part of that day & the day after went into the next room. The Messenger returned from Leontin's with a letter expressing the greatness of their joy upon the happy occasion & their impatience for her return & left the conduct of bringing home their child entirely to Hermilia, to whom Leontin would instantly have flown had not his tender care for Honoria obliged him to stay. She was ill and low, that he at first could only venture to tell her, there was a rumour of Marianna's being safe and well; & by degrees he told her all that Hermilia's letter informed him of, & shewed her the letter. But she was so possessed by her grief, that cordial hope could hardly revive her.

Hermilia took such good care of Marianna that she was able to travel the day after the Messengers return. The Evening before they set out Bellario was allowed the liberty of drinking Tea with the Ladies. He had secretly most earnestly wished to be admitted to the sight

of Marianna, but did not dare to ask for that liberty least it should give offence to Hermilia. This interview was a most interesting one. Bellario was soon convinced that a stronger motive even than compassion had engaged his attention; & Marianna could not see a Person so amiable to whom she was indebted for her Life and future hopes of happiness, without admiration and tender gratitude. She was silent all the time he was in the room, and he, in too absent a way to enter freely into conversation Hermilia observed their confusion and endeavoured to divert their thoughts: Bellario was not allowed to make a long visit; and Marianna retired early to her own room. At Supper when Hermilia & her son met; she found him extreamly thoughtfull. She asked him what made him so now; he sigh'd and said can't you Madam possibly find out who this young stranger is. Since she has own'd where

her Friends live will she not be prevailed on to tell you who they are since you must know before you can restore her to them. Surely so much sweetness & Elegance as appears in her Person and manner cannot belong to one low born and bred: the people under whose care she is at present are meer savages compared to her. Hermilia told her Son that she was of his opinion, but she had promised to ask no questions till she got to the castle: that as Providence had thrown this amiable Stranger under her Protection as well as his, she had dítimined to carry her home to her Friends who ever they were, & I make it my request to you my Dear Child not to attempt seing her, or enquiring where I shall place her, till I give you my permission. I promise you an opportunity of seing her if she proves worthy your farther notice

Bellario was so much overcome with Hermilia's kind and generous manner of treating him that he could not speak; but the sensibility of his looks, satisfied Hermilia that he was obliged in the tenderest manner by what she proposed. The next morning they set forward on their journey. Anthony was charged not ^+ tell any of y^e particulars relateing to Marianna, at the Castle; her own servant received the same commands. As Marianna was still weak they were obliged to travel slow, which made it late in the Evening they finished their journey; & Hermilia could not venture to carry her home that night. As she had from the time of Marianna's being lost entirely devoted herself to Leontin & Honoria who would see no body else, she had no company in her House. Marianna was directly carried to the Chamber allotted for her, and after proper refreshment

Hermilia finding her a good deal fatigued thought it best to leave her to her repose promising if she rested well and her spirits suficiently recruited in the morning, she would carry her home & so bad her good night. She then went down to her son whose return home had filled her heart with inexpressible joy. She found him much improved in every respect; and was convinced by his attachment and conduct towards Marianna that he was free from any foreign engagement. After supper, she told him he was now Master of himself & of a very considerable fortune w^ch. his Father thought proper not to give him a title to, till he was 24 years of age. That she hoped he would now think of marrying as he was the last of his family, and that a great part of her estate w^ch. was left her by an Uncle would go out of the family if he had no children. But she was unwilling to distress his generous nature by recommending a wife to him that might not be agreable: yet she had a wish—the accomplishment of which

she thought could not fail of making him a happy Man. During this conversation she fixt her Eyes earnestly on him; he changed colour several times and when she paused, said, he hoped he knew too well what was owing to her Judgement & tenderness towards him not to attend to one & to return the other with the most gratefull affection. It would indeed be a misery to him, to have her form a wish which he could not comply with; that her thought he might look a little into his estate and affairs before he settled—but—own'd he had some curiosity to know who the Person was, she wished should be his choice. This was what Hermilia wanted; she then, gave an account of her acquaintance and Friendship with Leontin and Honoria which began whilst he was at the University. She told him the adventure of the gipseys, but said nothing of the last adventure. She mentioned Marianna's Education, her good sense, fine disposition, her ingenuity, diffidence of her self, her great respect

to her Parents & instructors & all her amiable qualities; without once mentioning her Beauty & only entreated him not to encourage any thoughts in prepossession of another, till he had seen this young Lady: who beside all she had mentioned was in point of interest and Fortune the most desireable match for him in the world: that when he had seen her, if he was not of her opinion she would never distress him by mentioning her any more to him. He promised to comply with every thing she desired to the utmost of his power: they parted for that night. Early in the morning after he rode out to take a view of his Park and demesne. Hermilia finding Marianna much refreshed by her nights rest & most impatient, tho fearfull of going home, (acknowledgeing with overflowing gratitude her excess of goodness in the care she had taken of her) gratified her resonable impatience & for expedition carried her in a postchaise. A messenger was sent forward to tell Leontin that Hermilia

was coming with very good news, & to drop as of himself that a young Lady was in the chaise with her. Leontin's fond heart immediately bounded at the news, not doubting but it was his darling Marianna. He went directly to Honorias bed side and told her gently his conjectures: not all his caution could prevent its being too much for Honoria's spirits. But she soon recovered ~~herself~~ and hastened to get ready to receive her most Dear Friend, hardly allowing herself to believe it possible she should at the same time see her Lovely Daughter. But she was hardly up when Hermilia ran into the room embracing her in a transport; of Joy to my Dearest Friend! Marianna's safe & well, and now receiving the Blessing & caresses of her worthy and transported Father;

on w^ch: words Leontin lead her into the room the Mother and Daughter tenderly embraced & were for a considerable time unable to utter

a sillable till Marianna threw herself down on her knees and begged her Forgiveness & Blessing. Hermilia here interposed & said you have both been too ill to enter into any affecting conversation let Marianna lye down to recover the flutter of her spirits & I will inform y^u: of all that has past during her absence. The Faithfull Helena who had welcomed her Dear young Lady with floods of tears, stood waiting at the door to attend her, Leontin conducted her to her own room, & then returned to the two Friends to hear what Hermilia had to communicate; which was every minute particular without disguise of what related to their Daughter & her son: & the scheme she had laid of agreably surprizing him with y^e much admired Marianna. To w^ch. they all agreed & Leontin and Honoria said, no union could make them so Happy if as agreable to their Daughter as it was to them.

Part 7^th & last

When Bellario returned home about breakfast time and found Hermilia was gone & had taken with her the fair Stranger, he was much disappointed and chagrined; having flattered himself with the hopes od seing her once more. Hermilia left word he should not wait breakfast for she would return soon, which she did before 12. and told him she had been as good as her word and placed the Stranger safe in the hands of her Friends. Bellario, mindfull of the promise he had made her, tho most anxious to know who those Friends were asked no questions about them—could only say with a dejected look—I cannot Madam doubt your goodness and humanity. But he grew every hour more and more miserable, he saw plainly that the young Lady was hurried out of his way. Beside the loveliness of her Person

and peculiar sweetness of manners, she had on the journey (tho she talked but little) discovered so good an understanding & such fine sentim^ts: that his admiration for her Person was much less than that of her mind.

Hermilia saw his distress & distraction of thought, and could hardly support the resolution she had taken of not discovering who Marianna was. But to make his uneasyness as short as possible she had promised to bring him with her to dinner to Leontins next day. She proposed it to him he would have put it off for some days, but she told him that could not be without offending those friends for whom she had a particular regard. He consented, most unwillingly. They went next day & got there about 2'o'clock. Leontin received them in the Hall and introduced Bellario to Honoria who came forward to the door to receive them.

Marianna staid in the Drawing Room: Hermilia taking her Son by the hand presented him to her. His surprize! his Joy! Was so great in seing his lovely Stranger in the person of Marianna; that, without knowing what he did, he fell upon his knee and kist her hand in a rapture. He was instantly confounded at his own transport; and got up w^th. precipitation. Leontin and the Ladies seemed not to observe what had past; the conversation grew general, & Leontin Honoria & Hermilia enjoyed a happiness which only tender Parents and sincere Friends can feel. The young peoples minds were not so tranquille. Mariannna too sensible of Bellarios worth & her obligations to him; could not but be under some apprehensions, of his having taken a disadvantagious impression of her, from the manner of her being found on the Cliff. And Bellario whose

mind was not less delicate, should not recollect that circumstance, without some fear of her misconduct: but this shadow of gloom was soon chased away, when he recollected that she was the Person Hermilia so strongly recommended to him; and he was sure, she would not wish him united to one whose character was not in every particular unblemished. He was now thoroughly Satisfied, that she was as fair in mind as in outward form, and most eagerly & impatiently wished for an opportunity of knowing whether she would permit his addresses. And Bellario ditermined in his own mind, to declare his inclination to Marianna and to obtain her leave if possible to make proposals to her Friends that very day. At dinner every body seemed Happy & cheerfull, except Marianna who seemed much dejected tho she endeavoured to put on a

cheerfull air: after dinner was over Honoria asked Hermilia to go with her into her dressing room; Leontin said his daughter must stay & make coffee for him, which he ordered in the Library. The Ladies said they would not have any. Leontin Bellario & Marianna went into the library, which was not only well furnished with books, but with Prints & drawings as Bellario had a tast to things of that kind, they looked over some of the most curious w^ch. naturally led Leontin to ask Bellario severall questions of what he had seen abroad Bellario answered him with good sense, ingenuity and modesty allowing those things excellent which he realy thought so, & not because they were foreign, & he gave himself no conceited airs of knowing all arts and sciences, because he had been at the fountain head from whence they sprung, he knew indeed too much to be conceited. Leontin said he hoped, he was not so much

delighted with the charms of Foreign countrys as to prefer them to his own. His answer was could he ever have given that preference, he was now so much attached to England as to be strongly professed in its favour above all other Countrys. He fixed his Eyes on Marianna when he said this, and their mutual Blushing could not pass unobserved by Leontin. A servant at this time came and told him that Honoria desired Tea might be called for in the Drawing room & desired first to speak with him in her dressing room. The moment was come Bellario so much wished. But found himself in such confusion that it was several minutes before he could utter a word. He then made an apology for the rude liberty he had taken on being presented to her; that his joy on seing she was actually the Lovely Stranger for whom he had so tender a regard and had been so anxious for her safety, that he could not command himself. That he was now very sensible, the Happiness of his

Life depended on her; but he would not presume to obtain the favour of her Friends without her permission. That he would bear any mortification rather than embarass her, or be accepted only because recommended by her Friends. His ambition aimed at possessing her *heart*: and all other advantages that must do honour to whosoever attained, had yet no weight with him—without that.

Marianna received this declaration with dignity, and without the least affectation. She said she was much obliged to him for his favourable opinion of her, & for his consideration of her Happiness. His generosity, & regard claimed her gratitude and best acknowledgements. As for the permission he asked, she thought they should both take time to consider of it. And she could not give him any other answer at present. This would not satisfie the impatient Bellario, he entreated her with all the warmth and eloquence of

a most sincere Lover to tell him if she had any engagement, or any objection to his speaking to Leontin on the subject. She assured him she had no engagement; nor had any proposal been made by her Friends, who always declared they would not engage her contrary to her inclinations. At last she consented he should propose for her to her Father some time hence; and without giving him time to answer rang the Bell to know if Tea was ready, and flew up to her own room to recover herself, as she was much affected by this conversation; & to avoid going into the drawing room with Bellario—He transported at the happy opportunity he had had, &, notwithstanding his natural diffidence, flattering himself that Marianna was not averse from receiving his

addresses, (tho her extream modesty & reserve made her give him but little encouragement) went into the drawing room with so much vivacity and pleasure in his countenance, that Hermilia

saw plainly, and shared the happiness of her Son. In the evening they returned to the castle, and by the way, Hermilia informed her son, of every circumstance relateing to Marianna, which she had till then concealed from him, & her reasons for so doing; and hoped he would forgive ye deceit or rather concealment, as she only meant by it, to heighten his surprize, & joy. Bellario then acquainted his mother, with what had passed between him, and Marianna. How infinitely he was charmed with her, and that since he knew what her *wish* was, he would with her leave disobey in this one article Marianna's commands, and go next day to Leontin to make his proposal.

Hermilia who well knew the delicacy of Marianna's sentiments, & saw she had still some oppression on her spirits, prevailed with him to abate of his impetuosity, & to suffer her to ask permission for him, to make his addresses. With some difficulty he consented; but entreated her to go next morning; which she did. Leontin, & Honoria, most readily accepted

the proposal, and if agreable to Marianna, had no objection to receiving of it whenever Bellario pleased, that it was a Union of all others (as they had already assured her) most desireable to them, but they said, their joy in the return of their Daughter, was much allayed, by a sort of thoughtfull Melancholy, that seemed to hang upon her mind, and clouded that natural vivacity, that used to sparkle, and enliven them; that they wished Hermilia would endeavour to find out, what could be the occasion of it . Hermilia accounted for it from her still feeling the effects of her uncommon fatigues, & illness. But said she wou'd go, and make her a visit in her own room. Upon her coming into Marianna's dressing room, she found her in some confusion, & her eyes betrayed the concern she had been under. Unwilling to add to her distress she took no notice of it, but enquired after her health. Observed the pretty decorations of her room, chiefly ornamented with her own ingenuity. & then told her she was come

as Ambassadress from her Son, to negotiate an affair, that she hoped would be for their mutual happiness; she was sure of his, could he succeed to his wishes. But if she had any sort of objection to him, entreated her to open her heart sincerely, and she should find that her son's happiness could not be dearer to her than Marianna's.

She blushed and ye tears started into her Eyes; & she seemed so opprest that Hermilia was distrest

to the last degree. But giving her time to to recover herself, Marianna told her, that the sudden change from extream misery, to her present happy situation, had almost overpowered her spirits; and she thought she could hardly have supported it, had not the consciousness of her own unworthiness, & the unspeakable grief she had been the occasion of, to the best of Parents and Friends, more than ballanced her joy, and made her look on herself, as most unworthy of ye distinction Hermilia shewed, and ye great indulgence

of her Friends; and she feared she had not yet suffered eno.' to expiate the guilt of her disobedience. Hermilia smiled, and took her by ye hand, saying my Dearest Marianna shall expiate wt is past by vowing to my Son at the Altar, Obedience for Life. Marianna said she could have no objection to Bellario, whose *merit* she could make no doubt of – but – he might of *hers*. She was under such strong obligations to him, not only for saving her Life, but for her being restored to her family, that she must confess, the apprehension she had, of his not being thoroughly satisfied with her conduct, was so painfull to her, that she could hardly support the thoughts of receiving his addresses; till he knew every exact circumstance of what had befallen her, from her leaving the Gothick Temple in the Garden; & she could be convinced he was perfectly satisfied of the innocency of her

conduct. Hermilia assured her that was already done; and that the only amends now expected from her by her Friends, was an attention to her own happiness in which theirs was involved. That Leontin, & Honoria, tho far from disinclined to the proposal she had made were unwilling to press her on the subject, till they were certain of its not being disagreable to her, and had therefore desired her to mention it to her first. Hermilia pleaded her cause so well, that she returned home to her impatient Son, with leave for him to make his proposals which he did the next day, and was received & accepted as he deserved. Some months past before the setlements could be completed, every day, every hour, made them better satisfied with each others merit, & after their happy Union, his Fidelity, tenderness and Generosity to his Lovely Marianna, was rewarded by her Amiable Temper, gratitude

and most tender affectionate attention to him. And their mutual Happiness lasts to this day; as conspicuous as their virtues —which are a bright example to all, who have the advantage of their acquaintance. Their Virtues are built on the Basis of true Religion—a Rock that never fails.

[END]

A
CATALOGUE
OF
PLANTS
COPYED FROM NATURE
IN
PAPER MOSAICK,
finished in the Year 1778,
AND
disposed in alphabetical Order,
according to the
GENERIC
AND
SPECIFIC
NAMES OF
LINNÆUS.

Figure 265: [Mary Delany?], title page, *A Catalogue of Plants Copyed from Nature in Paper Mosaick, Finished in the Year 1778, and Disposed in Alphabetical Order According to the Generic and Specific Names of Linnaeus* ([London], 1778). British Library

Bibliography

Aiton, William. *Hortus Kewensis, or, A Catalogue of the Plants Cultivated in the Royal Botanic Garden at Kew.* 3 vols. London: George Nicol, 1789.

Allen, David Elliston. *The Naturalist in Britain: A Social History.* 2nd ed. Princeton, N.J.: Princeton University Press, 1994. First published 1976.

Arch, Nigel, and Joanna Marschner. *Splendour at Court: Dressing for Royal Occasions since 1700.* London: Unwin Hyman, 1987.

Ballinger, John. "A Great Lady and a Scrap Book." Manuscript of an address given to the Cardiff Fortnightly Club, November 16, 1906, Papers of Sir John Ballinger, The National Library of Wales, Aberystwyth.

Barnard, Toby C. *Making the Grand Figure: Lives and Possessions in Ireland, 1641–1770.* New Haven: Yale University Press, 2004.

Bartrum, Giulia. *Life of Mary Delany (1700–1788).* London, 1992. Delete? Not found

Bennett, Sue. *Five Centuries of Women & Gardens.* London: National Portrait Gallery, 2000.

Bermingham, Ann. "Elegant Females and Gentlemen Connoisseurs: The Commerce in Culture and Self-Image in Eighteenth Century England." In Ann Bermingham and John Brewer, eds., *The Consumption of Culture, 1600–1800: Image, Object, Text,* 509–48. London: Routledge, 1995.

———. *Learning to Draw: Studies in the Cultural History of a Polite and Useful Art.* New Haven: Published for the Paul Mellon Centre for Studies in British Art by Yale University Press, 2000.

Blunt, Wilfrid, and William T. Stearn. *The Art of Botanical Illustration.* Woodbridge, Suffolk: Antique Collectors' Club, 1994.

Bower, Peter. "A Life in Letters: The Papers Used by Mary Delany (1700–1788) for Her Correspondence." *The Quarterly* 68 (October 2008): 1–24.

———. "The Excise Duty Stamps Found on the Versos of a Collection of Collages in the Manner of Mary Delany, 1700–1788." *The Quarterly* 69 (January 2009): 19–25.

Boysen, Jan. "Mrs. Delany's Fabulous Flowers." *International Wildlife* 19, no. 4 (1989): 44–45.

Brewer, John. *The Pleasures of the Imagination: English Culture in the Eighteenth Century.* London: HarperCollins, 1997.

Brown, Irene Q. "Domesticity, Feminism and Friendship: Female Aristocratic Culture and Marriage in England, 1660–1760." *Journal of Family History* 7 (Winter 1982): 406–24.

Browne, Clare Woodthorpe. *Silk Designs of the Eighteenth Century from the Victoria and Albert Museum, London.* New York: Thames and Hudson, 1996.

———. "The Influence of Botanical Sources on Early 18th-Century English Silk Design." In Regula Schorta, ed., *Seidengewebe des 18. Jahrhunderts: Die Industrien in England und in Nordeuropa/18th-Century Silks: The Industries of England and Northern Europe,* 27–38. Riggisberger Berichte 8. Riggisberg: Abegg-Stiftung Riggisberg, 2000.

Buck, Anne. *Dress in Eighteenth-Century England.* New York: Holmes & Meier, 1979.

Cahill, Katherine. *Mrs. Delany's Menus, Medicines, and Manners.* Dublin: New Island, 2005.

Calmann, Gerta. *Ehret, Flower Painter Extraordinary.* Boston: New York Graphic Society, Little, Brown, 1977.

Campbell Orr, Clarissa. "Queen Charlotte as Patron: Some Intellectual and Social Contexts." *The Court Historian* 6, no. 3 (December 2001): 183–212.

———. *Queenship in Britain, 1660–1837: Royal Patronage, Court Culture, and Dynastic Politics.* Manchester: Manchester University Press; distributed exclusively in the USA by Palgrave, 2002.

———. *Queenship in Europe, 1660–1815: The Role of the Consort.* Cambridge: Cambridge University Press, 2004.

———. "Aristocratic Feminism, the Learned Governess, and the Republic of Letters." In Sarah Knott and Barbara Taylor, eds., *Women, Gender, and Enlightenment,* 306–25. New York: Palgrave Macmillan, 2005.

Cornforth, John. *Early Georgian Interiors.* New Haven and London: Published for the Paul Mellon Centre for Studies in British Art by Yale University Press, 2004.

Curran, C. P. *Dublin Decorative Plasterwork of the Seventeenth and Eighteenth Centuries.* Chapters in Art Series. London: Tiranti, 1967.

Dahn, Jo. "Mrs. Delany and Ceramics in the Objectscape." *Interpreting Ceramics* (2001), www.uwic.ac.uk/ICRC/issue001/delany/delany.htm.

Dance, S. Peter. *A History of Shell Collecting.* Rev. ed. Leiden: Brill, 1986.

Darwin, Erasmus. *The Botanic Garden; a Poem in Two Parts. Part I. Containing the Economy of Vegetation. Part II. The Loves of the Plants, with Philosophical Notes.* London: Printed for J. Johnson, 1789–91.

Day, Angélique, ed. *Letters from Georgian Ireland: The Correspondence of Mary Delany, 1731–68.* Belfast: The Friar's Bush Press, 1991.

"Delville, in Two Parts." *All the Year Round: A Weekly Journal Conducted by Charles Dickens* 34 (1875), August 7, 445–49, August 14, 467–72.

Desmond, Ray. *Kew: The History of the Royal Botanic Gardens.* London: The Harvill Press, 1995.

Dewes, Simon. *Mrs. Delany.* London: Rich & Cowan, 1940.

Dobson, Austin. "'Dear Mrs. Delany.'" In *Side-Walk Studies,* 110–29. London: Chatto & Windus, 1902.

Dolan, Brian. *Ladies of the Grand Tour: British Women in Pursuit of Enlightenment and Adventure in Eighteenth-Century Europe.* New York: HarperCollins Publishers, 2001.

Dore, Judith. "The Conservation of Two Eighteenth-Century English Court Mantuas." *Studies in Conservation* 23 (1978): 1–14.

Edmondson, John. *James Bolton of Halifax.* Liverpool: National Museums & Galleries on Merseyside, 1995.

Eger, Elizabeth. "Luxury, Industry and Charity: Bluestocking Culture Displayed." In Maxine Berg and Elizabeth Eger, eds., *Luxury in the Eighteenth Century: Debates, Desires and Delectable Goods*, 199–259. Houndmills, Balsingstoke, Hampshire; New York: Palgrave Macmillan, 2003.

Eger, Elizabeth, and Lucy Peltz. *Brilliant Women: 18th-Century Bluestockings.* Exh. cat. London: National Portrait Gallery, 2008.

Fowler, John, and John Cornforth. *English Decoration in the 18th Century.* Princeton: Pyne Press, 1974.

Frushell, Richard C. "Swift's 6 August 1735 Letter to Mary Pendarves Delany: 'All Other Days I Eat My Chicken Alone Like a King.'" *Philological Quarterly* 74 (Fall 1995): 415–41.

Gearey, Caroline. "Queen Charlotte and Mrs. Delany." In *Royal Friendships; the Story of Two Royal Friendships as Derived from Histories, Diaries, Biographies, Letters, etc.*, 213–362. London: Digby Long & Co, 1898.

Ginsburg, Madeleine. "Ladies' Court Dress: Economy and Magnificence." In *The V&A Album* 5:142–54. London: De Montfort Publishing for the Associates of the V&A, 1986.

Girouard, Mark. *Life in the English Country House.* New Haven and London: Yale University Press, 1978.

Glin, Knight of [Desmond John Villiers Fitz-Gerald], David J. Giffin, and Nicholas K. Robinson. *Vanishing Country Houses of Ireland.* Dublin: Irish Architectural Archive and the Irish Georgian Society, 1988.

Gosse, Ellen. "Of Paper Flowers." *Temple Bar, with Which Is Incorporated Bentley's Miscellany* 112, no. 445 (December 1897): 506–18.

Greig, Hannah. "Leading the Fashion: The Material Culture of London's *Beau Monde.*" In John Styles and Amanda Vickery, eds., *Gender, Taste, and Material Culture in Britain and North America, 1700–1830*, 201–22. Studies in British Art, 17. New Haven and London: Yale University Press in association with the Yale Center for British Art and the Paul Mellon Centre for Studies in British Art, 2006.

Hanly, Jane, and Patricia Deevy. "Imitating Nature, Mrs. Mary Delany or Aspasia (1700–1788)." In *Stars, Shells, and Bluebells: Women Scientists and Pioneers*, 16–27. Dublin: Women in Technology and Science, 1997.

Hart, Avril, and Susan North. *Historical Fashion in Detail: The 17th and 18th Centuries.* London: V&A Publications, 1998.

Haut, Asia. "Reading Flora: Erasmus Darwin's *The Botanic Garden*, Henry Fuseli's Illustrations, and Various Literary Responses." *Word & Image* 20, no. 4 (2004): 240–56.

Hayden, Ruth. *Mrs. Delany: Her Life and Her Flowers.* London: British Museum Publications, 1980.

——. *Mrs. Delany and Her Flower Collages.* New ed. London: British Museum Press, 1992.

——. "'A Wonderfully-Pretty Rurality': Drawings by Mrs. Delany." *Irish Arts Review Yearbook* 16 (2000): 44–50.

Hedley, Olwen. "Mrs. Delany's Windsor Home." *Berkshire Archeological Journal* 59 (1961): 51–55.

Hickman, Peggy. "Plants Copied in Coloured Paper." *Country Life* 1 (1963): 273–74. CK

Hill, Bridget. *Women, Work, and Sexual Politics in Eighteenth-Century England.* Oxford: B. Blackwell, 1989.

Howley, James. *The Follies and Garden Buildings of Ireland.* New Haven: Yale University Press, 1993.

Hudson, William. *Flora anglica: Exhibens plantas per regnum angliae sponte crescentes, distributas secundum systema sexuale… .* [London]: Impensis auctoris, 1762.

Hufstader, Alice. *Sisters of the Quill.* New York: Dodd, Mead, 1978.

Hughes, Bernard, and Therle Hughes. "Mrs. Delany's Paper Flowers." *Country Life* 111 (January 1952): 220–21.

Hunt, John Dixon, and Peter Willis, eds. *The Genius of the Place: The English Landscape Garden, 1620–1820.* Cambridge, Mass.: MIT Press, 1988; 2nd ed., 1990.

Johnson, Reginald Brimley. "The Flora of Mrs. Delany." *Connoisseur* 78 (1927): 220–27.

Jolly, Anna, ed. *A Taste for the Exotic: Foreign Influences on Early Eighteenth-Century Silk Designs.* Riggisberger Berichte; 14. Riggisberg: Abegg-Stiftung, 2007.

Kerhervé, Alain. "Mary Pendarves-Delany's Travels in Ireland as Reflected in Her Irish Letters." Mémoire de maîtrise, Universite de Brest, 1995.

——. "Fabrication du paysage irlandais dans l'oeuvre de Mary Delany." *Kreiz* 11 (1999): 127–53.

——. "La bibliothèque virtuelle d'une grande dame du XVIIIe siècle": Les livres dans la correspondance de Mary Delany. *Bulletin de la Société d'Études Anglo-Américaines des XVIIe et XVIIIe Siècles* 17–18, no. 50 (2000): 137–66. CK

——. "Qui est Mary Delany?" In Jean Balcou, ed., *Actes du forum de l'École Doctorale Victor Segalen*, 46–52. Brest: UBO, 2000.

——. "La correspondance de Mary Pendarves Delany (1700–1788)." Doctorat Nouveau Régime, Université de Brest, 2001.

——. *Une épistolière anglaise du XVIIIe siècle: Mary Delany (1700–1788).* Collection des idées et des femmes. Paris: Harmattan, 2004.

——, ed. *Polite Letters: The Correspondence of Mary Delany (1700–1788) and Francis North (1704–1790).* Newcastle upon Tyne: Cambridge Scholars Publishing, forthcoming 2009.

Kippis, Andrew and Joseph Towers. "Mary Delany." In *Biographia Britannica, Or, the Lives of the most Eminent Persons Who have Flourished in Great Britain and Ireland, from the Earlies Ages, to the Present Times: Collected from the Best Authorities, Printed and Manuscript, and Digested in the Manner of Mr. Bayle's Historical and Critical Dictionary.* 2nd ed., with corrections, enlargements, and the addition of new lives by Andrew Kippis et al., 88–93. London, 1778–93.

Klein, Lawrence E. "Gender and the Public/Private Distinction in the Eighteenth Century: Some Questions about Evidence and Analytic Procedure." *Eighteenth-Century Studies* 29, no. 1 (Autumn 1995): 97–109.

Laird, Mark. "Ornamental Planting and Horticulture in English Pleasure Grounds, 1700–1830." In John Dixon Hunt, ed., *Garden History: Issues, Approaches, Methods*, 243–77. Washington, D.C.: Dumbarton Oaks Research Library and Collection, 1992.

——. *The Flowering of the Landscape Garden: English Pleasure Grounds, 1720–1800.* Penn Studies in Landscape Architecture. Philadelphia: University of Pennsylvania Press, 1999.

——. "The Congenial Climate of Coffeehouse Horticulture: The *Historia plantarum rariorum* and the *Catalogus plantarum.*" In Therese O'Malley and Amy R. W. Meyers, eds., *The Art of Natural History: Illustrated Treatises and Botanical Paintings, 1400–1850*, 226–59 (including appendix, "The Club at the Temple Coffee House," by Margaret Riley). Washington, D.C.: National Gallery of Art, 2008.

——. "The Culture of Horticulture: Class, Consumption, and Gender in the English Landscape Garden." In Michel Conan, ed., *Bourgeois and Aristocratic Cultural Encounters in Garden Art, 1550–1850*, 221–54. Washington, D.C.: Dumbarton Oaks, 2002.

——. *The Environment of English Gardening and Botanical Art, 1650–1800.* Forthcoming.

——. "This Other Eden: The American Connection in Georgian Pleasure Grounds, from Shrubbery & Menagerie to Aviary & Flower Garden." In Amy R. W. Meyers, ed., *The Culture of Nature: Art & Science in Philadelphia, 1740–1840.* New Haven and London: Yale University Press, forthcoming.

Le Harivel, Adrian. *Illustrated Summary Catalogue of Drawings, Watercolours, and Miniatures.* Dublin: National Gallery of Ireland, 1983.

Linnaeus, Carl. *Species plantarum.* Facsimile of the 1st ed. of 1753; introduction by W. T. Stearn. 2 vols. London: Ray Society, 1957–59.

Linney, Verna Lillian. "The *Flora Delanica*: Mary Delany and Women's Art, Science, and Friendship in Eighteenth-Century England." Ph.D., York University, Toronto, 1999.

Lipsedge, Karen. "'Enter into Thy Closet': Women, Closet Culture, and the Eighteenth-Century English Novel." In John Styles and Amanda Vickery, eds., *Gender, Taste, and Material Culture in Britain and North America, 1700–1830,* 107–22. Studies in British Art, 17. New Haven and London: Yale University Press in association with the Yale Center for British Art and the Paul Mellon Centre for Studies in British Art, 2006.

"The Lives of Two Ladies [Mrs. Delany and Mrs. Thrale]." *Blackwood's Edinburgh Magazine* 91, no. 558 (April 1862): 401–21.

Llanover, Lady Augusta Waddington Hall, ed. *The Autobiography and Correspondence of Mary Granville, Mrs. Delany: With Interesting Reminiscences of King George the Third and Queen Charlotte.* 6 vols. in 2 series. London: Richard Bentley, 1861–62.

———. *Mrs. Delany at Court and among the Wits, Being the Record of a Great Lady of Genius in the Art of Living.* Abridged version of 1862 ed., with an introduction by R. Brimley Johnson. London: S. Paul & Co. Ltd, 1925.

Longstaffe-Gowan, Todd. *The London Town Garden, 1700–1840.* New Haven and London: Yale University Press, 2001.

Lummis, Trevor, and Jan Marsh. *The Woman's Domain: Women and the English Country House.* London: Viking, 1990.

MacGregor, Arthur. *Curiosity and Enlightenment: Collectors and Collections from the Sixteenth to the Nineteenth Century.* New Haven and London: Yale University Press, 2007.

Malins, Edward Greenway, and Knight of Glin [Desmond John Villiers Fitz-Gerald]. "Mrs. Delany and Landscaping in Ireland." *Quarterly Bulletin of the Irish Georgian Society* 11, no. 2–3 (1968): 1–16.

———. "Jonathan Swift, Mrs. Delany and Friends." In *Lost Demesnes: Irish Landscape Gardening, 1660–1845,* 31–52. London: Barrie & Jenkins, 1976.

Maxwell, Constantia Elizabeth. "Mrs. Delany." In *The Stranger in Ireland, from the Reign of Elizabeth to the Great Famine,* 136–62. London: Cape, 1954.

Mayer, Gertrude Townshend. "Mrs. Delany: Queen Charlotte's Friend." In *Women of Letters,* 1:163–204. London: Richard Bentley & Son, 1894.

McKenzie, Alan T. *Sent as a Gift: Eight Correspondences from the Eighteenth Century.* Athens, Ga.: University of Georgia Press, 1993.

McKeon, Michael. *The Secret History of Domesticity: Public, Private, and the Division of Knowledge.* Baltimore: Johns Hopkins University Press, 2005.

Moore, Lisa L. "Queer Gardens: Mary Delany's Flowers and Friendships." *Eighteenth-Century Studies* 39, no. 1 (Fall 2005): 49–70.

Mowl, Timothy, and Brian Earnshaw. *An Insular Rococo: Architecture, Politics and Society in Ireland and England, 1710–1770.* London: Reaktion Books, 1999.

"Mrs. Delany." *English Women's Journal* (1869): 31–37.

"Mrs. Delany, or, A Lady of Quality of the Last Century." *Fraser's Magazine for Town and Country* 65, no. 388 (April 1862): 448–57.

Murdoch, Tessa, ed. *Noble Households: Eighteenth-Century Inventories of Great English Houses. A Tribute to John Cornforth.* Cambridge: J. Adamson, 2006.

Myers, Robert Manson. "Mrs. Delany: An Eighteenth-Century Handelian." *The Musical Quarterly* 32, no. 1 (January 1946): 12–36.

Nelson, E. Charles. "James Bolton's Botanical Paintings and Illustrations, and His Associations with Georg Ehret." *The Naturalist* 106 (October–December 1981): 141–47.

Neri, Janice. "Cultivating Interiors: Philadelphia, China, and the Natural World." In Amy R. W. Meyers, ed., *The Culture of Nature: Art & Science in Philadelphia, 1740–1840.* New Haven and London: Yale University Press, forthcoming.

Newton, Stella Mary. "Mrs. Delany and Her Handiwork." *Antiques* 96 (1969): 101–5.

Ogborn, Miles, and Charles W. J. Withers, eds. *Georgian Geographies: Essays on Space, Place, and Landscape in the Eighteenth Century.* Manchester: Manchester University Press, 2004.

O'Malley, Therese, and Amy R. W. Meyers, eds. *The Art of Natural History: Illustrated Treatises and Botanical Paintings, 1400–1850.* Washington, D.C.: National Gallery of Art, 2008.

Papperovitch, Rebecca. "The Social and Literary Life of the 18th Century as Reflected in the Life and Correspondence of Mrs. Delany and of Mrs. Montagu." B.A., Liverpool University, 1924.

Parker, Rozsika. *The Subversive Stitch: Embroidery and the Making of the Feminine.* London: Women's Press, 1984.

Paston, George [pseud.]. *Mrs. Delany (Mary Granville): A Memoir, 1700–1788.* New York: E. P. Dutton; G. Richards, 1900. Abridged version of Llanover, ed., *Autobiography and Correspondence.*

———. *Side-Lights on the Georgian Period.* London: Methuen & Co, 1902.

Pierpont Morgan Library, New York. *Mrs. Delany's Flower Collages from the British Museum.* Essays by Ruth Hayden and Alice Anderson Hufstader. Exh. cat. New York: The Library, 1986.

Pointon, Marcia. *Strategies for Showing: Women, Possession, and Representation in English Visual Culture, 1665–1800.* Oxford: Oxford University Press, 1997.

Prest, John. *The Garden of Eden: The Botanic Garden and the Re-Creation of Paradise.* New Haven and London: Yale University Press, 1981.

Pyle, Hilary. "Artist or Artistic? The Drawings of Mary Delany." *Irish Arts Review* 4, no. 1 (Spring 1987): 27–32.

Robertson, Hannah. *The Young Ladies School of Arts Containing a Great Variety of Practical Receipts, in Gum-Flowers, Filligree, Japanning, Shell-Work, Gilding… &c.: Also, a Great Many Curious Receipts, both Useful and Entertaining, Never before Published.* New ed. 2 vols. Edinburgh: Printed for Robert Jameson, Parliament-Square, 1777.

Rothstein, Natalie. "God Bless This Choye." *Costume* 11 (1977): 56–72.

———. *Silk Designs of the Eighteenth Century in the Collection of the Victoria and Albert Museum, London.* London: Thames and Hudson, 1990.

Sarong, Brenda. "Notes Compiled on Mrs. Delany's Letters." Newport: Newport Reference Library, 1984. CK-include?

Scott, Walter Sidney. "Mary Delany." In his *The Bluestocking Ladies,* 19–44. London: J. Green, 1947.

Scrase, David. *Flower Drawings.* Fitzwilliam Museum Handbooks. Cambridge: Cambridge University Press, 1997.

Sharp, Katherine. "Women's Creativity and Display in the Eighteenth-Century British Domestic Interior." In Susie McKellar and Penny Sparke, eds., *Interior Design and Identity,* 10–26. Manchester: Manchester University Press, 2004.

Shteir, Ann B. *Cultivating Women, Cultivating Science: Flora's Daughters and Botany in England, 1760–1860.* Baltimore: Johns Hopkins University Press, 1996.

Sloan, Kim. *Drawing: A "Polite Recreation" in Eighteenth-Century England.* Studies in Eighteenth-Century Culture, vol. 2. Madison, Wisc.: University of Wisconsin Press, 1982.

———. "Industry from Idleness?: The Rise of the Amateur in the Eighteenth Century." In Michael Rosenthal, Christiana Payne, and Scott Wilcox, eds., *Prospects for the Nation: Recent Essays in British Landscape, 1750–1880,* 285–305. New Haven: Published for the Paul Mellon Centre for Studies in British Art by Yale University Press, 1997.

———. *'A Noble Art': Amateur Artists and Drawing Masters, c. 1600–1800.* London: British Museum Press, 2000.

Sloan, Kim, and Andrew Burnett. *Enlightenment: Discovering the World in the Eighteenth Century.* Washington, D.C.: Smithsonian Books, 2003.

Smith, Charles Saumarez. *Eighteenth-Century Decoration: Design and the Domestic Interior in England.* London: Weidenfeld and Nicolson, 1993.

Smith, Hannah. "The Court in England, 1714–60: A Declining Political Institution." *History* 90 (2005): 23–41.

———. *Georgian Monarchy: Politics and Culture, 1714–1760.* Cambridge: Cambridge University Press, 2006.

Soulsby, Lucy H. M. "Mrs. Delany," parts 1 and 2. *The Overland Monthly,* ser. 2, 3 (March 1884): 283–99; (April 1884): 394–408.

Specimens of Rare and Beautiful Needlework, Designed and Executed by Mrs. Delany and Her Friend the Hon. Mrs. Hamilton; Photographed from the Originals in the Possession of Lady Hall of Llanover. 2 vols. London: Dickinson Bros., ca. 1860.

[Spottiswoode, Anstey, and Roger Spottiswoode, eds.] *Letters from Mrs. Delany (Widow of Doctor Patrick Delany) to Mrs. Frances Hamilton, from the Year 1779 to the Year 1788; Comprising Many Unpublished and Interesting Anecdotes of Their Late Majesties and the Royal Family; Now First Printed from the Original Manuscripts.* London: Longman, Hurst, Rees, Orme and Brown, 1820.

Styles, John, and Amanda Vickery, eds. *Gender, Taste, and Material Culture in Britain and North America, 1700–1830.* Studies in British Art, 17. New Haven and London: Yale University Press in association with the Yale Center for British Art and the Paul Mellon Centre for Studies in British Art, 2006.

Tague, Ingrid H. *Women of Quality: Accepting and Contesting Ideals of Feminity in England, 1690–1760.* Woodbridge, Suffolk: The Boydell Press, 2002.

Thaddeus, Janice Farrar. "Mary Delany, Model to the Age." In Beth Fowkes Tobin, ed., *History, Gender & Eighteenth-Century Literature,* 113–40. Athens, Ga.: University of Georgia Press, 1994.

Tongiorgi Tomasi, Lucia. *An Oak Spring Flora: Flower Illustration from the Fifteenth Century to the Present Time. A Selection of the Rare Books, Manuscripts, and Works of Art in the Collection of Rachel Lambert Mellon.* Upperville, Va.: Oak Spring Garden Library; New Haven and London: Yale University Press, 1997.

Vickery, Amanda. "Women of the Local Elite in Lancashire, 1750–c.1825." Ph.D. diss., University of London, 1991.

———. "Golden Age to Separate Spheres? A Review of the Categories and Chronology of English Women's History." *The Historical Journal* 36, no. 2 (June 1993): 383–414.

———. "Women and the World of Goods: A Lancashire Consumer and Her Possessions, 1751–81." In John Brewer and Roy Porter, eds., *Consumption and the World of Goods,* 274–301. London: Routledge, 1993.

———. *Women's Language and Experience, 1500–1940: Women's Diaries and Related Sources.* Marlborough, Wiltshire: Adam Matthew Publications, 1994.

———. *The Gentleman's Daughter: Women's Lives in Georgian England.* New Haven: Yale University Press, 1998.

Vincent, Susan. *Dressing the Elite: Clothes in Early Modern England.* Oxford: Berg, 2003.

Vulliamy, C. E. *Aspasia: The Life and Letters of Mary Granville, Mrs. Delany (1700–1788).* London: G. Bles, 1935.

Walpole, Horace. "Ladies and Gentlemen Distinguished by Their Artistic Talents." In Frederick Whiley Hilles and Philip B. Daghlian, eds., *Anecdotes of Painting in England with Some Account of the Principal Artists; and Incidental Notes on Other Arts,* 5:228–40. New Haven: Yale University Press, 1937.

Wheeler, Ethel Rolt. "Mary Delany." In *Famous Blue-Stockings,* 78–104. New York: John Lane Co., 1910.

Wilcox, Scott, Gillian Forrester, Morna O'Neill, and Kim Sloan. *The Line of Beauty: British Drawings and Watercolors of the Eighteenth Century.* Exh. cat. New Haven: Yale Center for British Art, 2001.

Wright, Thomas. *Arbours & Grottos: A Facsimile of the Two Parts of* Universal Architecture *(1755 and 1758).* Includes a catalogue of Wright's works by Eileen Harris. London: Scolar Press, 1979.

Concordance

Notes on the concordance of scientific and vernacular plant names
John Edmondson and Charles Nelson

The need for a concordance became apparent during the early stages of editing the chapters of this book. Although Mrs. Delany's collages have been catalogued and posted online by staff of the British Museum, there were difficulties in reading some of the captions to the collages, and inconsistencies were apparent between the text of the collage labels and the names listed by Mrs. Delany in her handwritten catalogue of the collages. In addition, many of the scientific names employed by Mrs. Delany are now obsolete; some, in fact, were not validly published at the time she used them, and others assigned plants to a different genus from the one that is currently recognised.

Because of the difficulties of rendering handwriting in printed form, the following conventions have been adopted when citing scientific names in the volume essays:

Names in single quotation marks and roman lettering are taken directly from the collage labels. By contrast, accepted modern scientific names (the "binomials," genus and species) are italicised. In John Edmondson's essay, which discusses nomenclature, the authors of the scientific names (the "authorities," for example L. abbreviation for Linnaeus) are also included, but they are otherwise omitted throughout the volume. For clarity and brevity, authorities are also omitted from the modern Latin name column of the concordance. Names of plants cited from sources other than the collages are given in double quotation marks to distinguish them from the collage names and from a few cultivar names, which appear in single quotes by international convention. Vernacular (mostly English) names also appear in roman lettering.

In transcribing the handwritten labels, long 's' letters have been modernised but ligatures are quoted as written. Ligatures are not permitted in modern scientific names, hence 'Æsculus' is now written as *Aesculus*.

The full list of Delany collages is available online, and a complete version of the concordance (including plants not mentioned in this book) has been compiled for possible later publication. This will also contain information gleaned from [Mary Delany?], *A Catalogue of Plants Copied from Nature in Paper Mosaick* (1778; fig. 265), which has not been systematically scanned during the present phase of research.

In determining the correct identities of the plants depicted in the collages, we are indebted to: Dr David E. Allen (*Rubus*), Dr David Hunt (*Harrisia*), Myles Irvine (*Passiflora*), Dr Mattias Iwarsson (*Leonotis*), Mark Laird (*Phlox*), Dr J. Manning (*Arctotis*, *Tritonia*), Professor D. M. Porter (*Hymenocallis*) and Dr E. G. H. Oliver (*Erica*).

The following notes apply to the various columns in the concordance table, reading from left to right.

Delany Collage label
This column lists the names written on the labels attached to the recto (front) side of the collage. A colon indicates that part of the name has been omitted, e.g., Geran:m for Geranium. A forward slash indicates a line break. Normally the vernacular name follows the scientific one, but in some cases there is an attribution to a botanist (e.g., Solander), usually where the name was unpublished at the time of writing. Occasionally the garden provenance is given, though this is more often written on the verso (back) of the sheet.

Delany list: Latin name
The names employed in the handwritten catalogue of the Delany collages are listed here. In the full list, a long dash is often employed where there is repetition of a generic name; in these instances, the name is added in square brackets. Attributions of authorship are often latinised, so 'of Solander' in the label column becomes 'Solandri'.

Delany list: vernacular name
Vernacular names taken from the manuscript list or added by the cataloguer are listed in this column, with an expanded version of the names that were abbreviated.

Vol. / Page
The volume number and sequential sheet number of each collage is given here. Some collages previously exhibited at the British Museum are now stored separately in their mounts, but as displays change periodically we have not attempted to give temporary locations (these can be ascertained by consulting the online catalogue).

BM acc. no. suffix
The final numerical element of the British Museum registration (accession) number is listed here. Its prefix 1897,0505. has been omitted to save space.

Source of plant material
This, and the following two columns, list information written on the verso (rear) of the sheets. No attempt has been made to list the Linnaean classes; the online catalogue transcribes them (sometimes inaccurately). This column lists the garden source of the plant illustrated in the collage. Where the garden source can be confidently or tentatively inferred from the name of the donor, this additional information is given in square brackets.

Donor of plant material
The name of the donor of the plant material is listed here, surname first except for Queen Charlotte. Where their forename has been abbreviated or omitted, this is given in square brackets.

Date on verso
Most of the collages are dated on the verso. Some of the earliest collages were dated only to the year.

Modern Latin name
The modern scientific name is given, omitting the authorities. In the case of cultivar names only those that can be given with certainty are provided, for example, *Hyacinthus orientalis* 'Ophir'. For those which have no certain or definitive name, the term "cultivar" follows the Latin name. The names of other subspecific taxa are given in the conventional manner, using abbreviations subsp. (subspecies), var. (varietas) and f. (forma), between the specific epithet and the taxon's Latin epithet. For example, the pink-blossomed forma of the strawberry tree is correctly named *Arbutus unedo* f. *rubra*.

Where an identification is tentative, the abbreviations 'aff.' (affinity) or 'cf.' (compare) are sometimes variously used to express uncertainty.

Delany Collage label	Delany list: Latin name	Delany list: vernacular name
Acanthus spinosus	Acanthus spinosus .	Bears Breech
Æsculus Hippocastanum / Horse Chesnut	Æsculus Hippocastanum .	Horse Chesnut
Allium inodorum L. / Sentless Garlick A.	[Allium] Ursinum ?	Ramsons
Alstromeria Ligtu	Alstromeria Ligta .	—
Amaryllas ? / attamasca	[Amaryllis] Atamasco .	—
Amaryllis aurea / Solander .	[Amaryllis] Aurea Solandri .	—
Amaryllis Beladonna / Lily Daffodil	[Amaryllis] Belladonna .	Lily Daffodil
Amaryllis Belladonna / Reginæ. Solanders	[Amaryllis] Belladonna reginæ Solandri.	—
Amaryllis Regis	[Amaryllis] Regis Solandri .	—
Amygdalus Nana / dwarf almond.	Amygdalus nana .	Dwarf Almond
Amygdalus Persica / double flowering Peach	[Amygdalus] Persica var:	Double-flowering Peach
Anemone Hortensis / garden Anemone	Anemone hortensis .	Garden Anemone
Antirrhinum / Genistifolium	Antirrhinum genistifolium .	Broom Snapdragon
Antirrhinum / triphyllum	[Antirrhinum] Triphyllum .	Ternate Snapdragon
Arbutus Unedo. var. / red flowering arbutus	[Arbutus] Unedo var .	Red-flower'd [Strawberry Tree]
Arctotis calendulacea / Marigold-like Arctotis	[Arctotis] a species not named .	—
Arum esculentum / Eatable Wake-Robin	[Arum] esculentum .	—
Aster cordifolia / starwort	Aster cordifolius .	Heart-leav'd Starwort .
Aster / Dumosus	[Aster] dumosus .	—
Budleja capitata / globosa. Hort: Kewensis	Budleia capitata, Solandri	—
Cactus grandiflorus ? / melon thistle	[Cactus] grandiflorus ?	Large Torch Thistle
Calla æthiopica / arum	Calla Æthiopica .	—
Campanula piramidalis	Campanula pyramidalis .	Pyramidal Bellflower
Canna Indica / Reed / Indian cane	Canna Indica .	Indian Cane
Carthamus cæruleus / Purple saff	[Carthamus] cæruleus .	Blue Saff-flower
Cassia Marylandica	Cassia Marilandica .	—
Catesbæa spinosa / Lily-thorn	Catesbæa spinosa .	Lily-Thorn
Ceanothus / africanus	Ceanothus africanus .	—
[Centaurea] moschata Linn. / Centaurea Centaurium ?	[Centaurea] moschata .	Sweet Sultan
Cheiranthus cheiri / Bloody wall flower	Cheiranthus Cheiri .	Bloody Wall-flower
Chrysanthemum Lucanthemum / common oxeye Daisy	Chrysanthemum Leucanthemum .	Ox-eye Daisy
Citrus Medica / Citron double flow:rs	Citrus medica var :	Double flower'd Citron
Cleome Pentaphylla ?	Cleome pentaphylla ?	—
Clethra Virginia . / alnifolia .	Clethra alnifolia .	Virginian Cat's-Tail
Convallaria majalis / Lilly of the Valley	Convallaria majalis .	Lily of the Valley
Conyza inuloides / Elecampane Fleabane	Conyza Inuloides, Solandri	—
Crinum africanum / Blue african crinum	[Crinum] Africanum .	Blue Crinum
Crinum asiaticum / Asiatic Crinum	[Crinum] Asiaticum .	Asiatic Crinum
Cynoglossum omphalodes / houndstongue	Cynoglossum omphalodes .	Blue Navelwort
Dianthus caryophyllus / 2 varietys	[Dianthus] caryophyllus. Two Varieties .	—
Dianthus caryophyllus / Pink or Carnation var :	[Dianthus] caryophyllus .	A curious Variety of Pink
Dianthus / caryophyllus / a variety / Jersey Pink	[Dianthus] caryophyllus .	Jersey Pink, a Variety
Dracæna terminalis / Purple Dragon-tree .	Dracæna terminalis .	—
Epilobium ramosum / Codlings & Cream	Epilobium ramosum .	Codlings & Cream
Erica coccinea ? / Scarlet-flower'd Heath .	[Erica] not nam'd, with scarlet tubular flowers .	—
Erinus venustus	Erinus venustus Solandri .	—
Eryngium alpinum	Eryngium alpinum .	—
Fumaria vesicaria fungosa new species / Climbing Bladder fumetory	[Fumaria] fungosa, Solandri .	—
Geran:m Alchemilloides	[Geranium] Alchemilloides .	—
Geranium fulgidum / Scarlet	[Geranium] fulgidum .	Scarlet Geranium
Geranium gibbosum / Gouty Geranium	[Geranium] gibbosum .	Gouty Geranium
Geran:m Inquinans	[Geranium] inquinans .	—

Vol./Page	BM acc.no. suffix	Source of plant material	Donor of plant material	Date on verso	Modern Latin name
v1:p1	1			8.8.78	*Acanthus* aff. *mollis*
v1:p7	7			6.6.76	*Aesculus hippocastanum*
v1:p16	16	Kew		28.5.81	*Allium ursinum*
v1:p20	20	Hammersmith	Lee, James	8.1.79	*Alstroemeria caryophyllacea*
v1:p27	27		Lee, James	8.6.78	*Zephyranthes atamasca*
v1:p29	29		Lee, James	21.10.79	*Lycoris aurea*
v1:p30	30			18.9.75	*Amaryllis belladonna*
v1:p26	26		Lee, James	15.10.79	*Amaryllis belladonna*
v1:p34	34		Queen Charlotte	16.3.81	*Hippeastrum vittatum*
v1:p38	38	Marsh Garden	Willoughby, Lord	1.5.78	*Prunus tenella*
v1:p40	40	Barnes	Astley, Mrs	25.4.78	*Prunus persica* cultivar
v1:p49	49	Upton	Grey, B[ooth]	7.4.79	*Anemone pavonina* sterile form
v1:p66	66	Kew		2.10.79	*Linaria genistifolia*
v1:p71	71			3.10.76	*Linaria triphylla*
v1:p81	81			Nov.76	*Arbutus unedo* f. *rubra*
v1:p77	77	Islington	Pitcairn, William	27.5.77	*Arctotis venusta*
v1:p89	89	Madras [from a drawing by Lady Ann Monson]		Mar.80	*Colocasia esculenta*
v1:p99	99			2.10.77	*Aster cordifolius*
v1:p100	100			Oct.77	*Aster dumosus*
v10:p13	912		[Boyd, Sir John?]	12.8.82	*Buddleja globosa*
v2:p32	133	[Bulstrode?]		12.8.78	cf. *Harrisia gracilis*
v2:p40	141	Danson Hill, Kent	Boyd, Sir John	6.3.78	*Zantedeschia aethiopica*
v2:p44	145			3.8.78	*Campanula pyramidalis*
v2:p56	157			20.6.76	*Canna indica*
v2:p64	165			16.10.77	*Stokesia laevis*
v2:p65	166	[Kenwood?]	Mansfield, Lord	23.9.78	*Senna marilandica*
v2:p67	168			4.9.80	*Catesbaea spinosa*
v2:p70	171		Grey, [Booth]	9.4.79	*Noltea africana*
v2:p78	179			Oct.77	*Amberboa moschata*
v2:p82	183	Glanvilla	Boscawen, Mrs	2.5.78	*Erysimum cheiri* cultivar
v2:p91	191			--.1774	*Leucanthemum vulgare*
v3:p5	206	Delville	Keate, [George]	8.7.78	*Citrus medica* cultivar
v3:p11	212	[Luton?]		16.8.77	*Cleome gynandra*
v3:p13	214	[Bill Hill?]	[Gower, Lady?]	1.9.79	*Clethra alnifolia*
v3:p23	224			8.5.76	*Convallaria majalis*
v10:p21	919			20.10.81	*Allagopappus canariensis*
v3:p48	249	[Luton Park]?		20.8.76	*Agapanthus* cf. *africanus*
v3:p49	250	Hammersmith	Lee, James	12.5.80	*Crinum asiaticum*
v3:p59	260			1.4.76	*Omphalodes cappadocicum*
v3:p75	276		Dashwood, Mrs	3.6.78	*Dianthus caryophyllus* cultivars
v3:p76	277		Queen Charlotte	17.8.78	*Dianthus caryophyllus* cultivar
v3:p77	278	Park Place [originally from Jersey]	Conway, General	8.9.79	*Dianthus caryophyllus* cultivar
v3:p96	297	Islington	Pitcairn, William	Apr.80	*Cordyline fruticosa* cultivar
v4:p1	302			10.8.81	*Epilobium hirsutum*
v4:p11	312	Kew		5.11.76	*Erica* cf. *cruenta*
v4:p16	317		Lee, James	19.11.79	cf. *Microdon capitatus*
v4:p17	318	Kew		24.6.76	*Eryngium alpinum*
v4:p37	37	Luton [Park]		23.8.76	*Adlumia fungosa*
v4:p89	389		Howard, Sir George	19.10.78	*Pelargonium alchemilloides*
v4:p91	391			Jul.75	*Pelargonium fulgidum*
v4:p93	393	Shiplake	Jennings, Miss	4.9.79	*Pelargonium gibbosum*
v4:p72	372		Howard, Sir George	21.10.78	*Pelargonium inquinans*

Delany Collage label	Delany list: Latin name	Delany list: vernacular name
Geranium lævigatum	[Geranium] lævigatum, Solandri .	—
[Geranium] lanceolatum / Geranium / non descript	[Geranium] lanceolatum, Solandri .	—
Geranium / macrorhizon / Long-rooted / Geranium .	[Geranium] macrorhizon .	Long-rooted Geranium
Geran:m Peltatum	[Geranium] peltatum .	—
Geranium Radula / of Solander new species	[Geranium] Radula, Solandri .	—
Geranium scabrum / Rough Geranium	[Geranium] scabrum, Solandri .	—
[Geranium] Scarlet Geranium & / Lobelia Cardinalis	[Geranium]	—
Geran:m trigonum / from ye cape Solander new species	[Geranium] trigonum, Solandri .	—
Geranium Triste / Night-smelling Geranium	[Geranium] Triste .	—
Gordonia Lasianthus / Loblolly Bay	Gordonia Lasianthus .	Loblolly-Bay
Helonias Asphodeloides	Helonias asphodeloides .	—
Hemanthus coccineus / scarlet blood flower	[Hæmanthus] coccineus .	Scarlet Blood-flower
Hyacinthus / orientalis. /ophir	[Hyacinthus] orientalis, var:	Yellow Ophir Hyacinth
Ipomœa rubra / Polemonium rubrum	Ipomœa rubra .	—
Ixia crocata	[Ixia] Crocata .	—
Ixia sceptrum / Sceptre Ixia.	[Ixia] Sceptrum, Solandri .	Sceptre Ixia .
Lathyrus pratensis / Yellow Vetchling .	Lathyrus pratensis	Yellow Vetchling
Lathyrus sativus / blue gard:n chick:g Vetch	Lathyrus sativus .	Blue g[arde]n chick[lin]g Vetch
Lavatera Olbia	[Lavatera] Olbia .	—
Lepidium Alpinum	Lepidium alpinum .	—
Lightfootia canescens / new Genus Solander	Lightfootia canescens, Solandri .	—
Liriodendron Tulipifera / Tulip Tree	Liriodendron Tulipifera .	Tulip-Tree
Lithospermum purpurocærul/e/um / purple gromil	Lithospermum purpurocœruleum .	Purple Gromwell
Lobelia / Cardinalis	[Lobelia] Cardinalis .	Scarlet Cardinal Flower
Lobelia pubescens / Downy Cardinal-flower	[Lobelia] pubescens, Solandri .	—
Ludwigia ovata / Oval leav'd Ludwigia	Ludwigia ovata, Solandri .	—
Magnolia grandiflora	[Magnolia] grandiflora .	The grand Magnolia
Melia Azedarch / Bead Tree	Melia Azedarach .	Bead-Tree
Mimosa arborea / at Old Windser Mr. Batemans	[Mimosa] arborea .	—
Mirabilis longiflora / Marvel of Peru	Mirabilis longiflora .	Long-flower'd Marvel of Peru
Mitella diphylla / Bastard A:n Sanicle	Mitella diphylla .	—
Myosotis Scorpioides	Myosotis Scorpioides .	Mouse-ear Scorpion-Grass
Narcissus Poeticus	[Narcissus] Poeticus .	The Poet's Narcissus
Narcissus tazetta / var: / Polyanthos Narcisse	[Narcissus] Tazetta . var: lutea	—
Necotiana rustica / Green Tobacco.	Nicotiana rustica	Green Tobacco
Nymphæa alba / white water Lilly	Nymphæa alba .	White Water Lily
[Ocymum] rugosum . / Ocymum non descript	Ocymum – the Species not named	—
Oenothera / grandiflora / night Primrose	Oenothera – the Species uncertain	—
[Olea] odoratissima Soland. / Olea non descript / Qui fa — from China	[Olea] odoratissima, Solandri .	Chinese Olive
Ophris apifera / Bee orchis	[Ophrys] apifera .	Bee Ophrys
[Orchis - label absent from recto]	[Orchis] militaris. var:	Italian Man Orchis
Pancratium Maritinum / Sea Daffodil	Pancratium maritimum .	Sea Daffodil
Papaver Cambricum / yellow Welch Poppy	Papaver Cambricum .	Yellow Welch Poppy
Parnassia Palustris / Grass of Parnassus	Parnassia palustris	Grass of Parnassus
Passiflora Laurifolia / Bay Leaved .	[Passiflora] Laurifolia .	[Water Lemon – in pencil]
Passiflora rubra	Passiflora rubra .	—
Philadelphus aromaticus / new Zealand Tea Solander	Philadelphus aromaticus, Solandri .	New Zealand Tea
Phlomis Leonurus	Phlomis Leonurus .	Lion's Tail
Phlomis Zeilanica	[Phlomis] Zeilanica .	—
[Phlox] Carolina / Phlox or Lychnidæa	Phlox — the species uncertain	—
[Phlox] Flox divaricata	[Phlox] divaricata .	—

Vol./Page	BM acc.no. suffix	Source of plant material	Donor of plant material	Date on verso	Modern Latin name
v4:p92	392	Kew		6.7.81	*Geranium maderense*
v4:p75	375		Lee, James	12.8.77	*Pelargonium glaucum*
v4:p77	377			[177]3?	*Geranium macrorrhizum*
v4:p71	371		Howard, Sir George	20.10.78	*Pelargonium* aff. *peltatum*
v4:p73	373	Bulstrode		10.6.78	*Pelargonium radens*
v4:p78	378		Lee, James	19.10.79	*Pelargonium scabrum*
v6:p29	529*	Bulstrode		--.1773	*Pelargonium* cf. *fulgidum* cultivar and *Lobelia cardinalis*
v4:p82	382	Kew		30.10.78	*Pelargonium* cf. *tetragonum*
v4:p83	383	Chelsea Physic Garden		13.8.79	*Pelargonium* aff. *triste*
v4:p98	398			6.10.77	*Gordonia lasianthus*
v5:p16	416			3.7.77	*Xerophyllum asphodeloides*
v5:p18	418	Luton [Park?]		19.8.76	*Haemanthus coccineus*
v5:p36	436		Harcourt, Lord	5.5.80	*Hyacinthus orientalis* 'Ophir'
v7:p84	685	Bulstrode		n.d.	*Ipomopsis rubra*
v5:p84	484	Kew		15.5.78	*Tritonia crocata*
v5:p82	482		Grey, B[ooth]	26.4.79	*Watsonia marginata*
v10:p40	938			7.9.82	*Lathyrus* cf. *pratensis*
v5:p97	497	Luton Park		23.8.76	*Lathyrus sativus*
v6:p5	505			4.7.78	*Lavatera olbia*
v6:p10	510	Kew		14.10.77	*Hornungia alpina*
v6:p12	512	Kew		29.10.78	Brassicaceae indet.
v6:p21	521			5.7.76	*Liriodendron tulipifera*
v6:p23	523			6.6.77	*Lithospermum purpurocaeruleum*
v6:p29	529		Pitcairn, William	4.10.80?	*Lobelia cardinalis*
v6:p30	530	Kew		17.5.81	*Lobelia pubescens*
v6:p40	540			10.8.80	*Ludwigia palustris*
v6:p57	557			26.8.76	*Magnolia grandiflora*
v6:p71	571	Blackheath	Dartmouth, Lord	5.7.78	*Melia azedarach*
v6:p86	586	Old Windsor	Bateman, Mr	28.9.79	*Albizzia julibrissin*
v6:p87	587			28.8.76	*Mirabilis longiflora*
v6:p88	588	Islington	Pitcairn, William	8.5.78	*Mitella diphylla*
v6:p92	592			12.7.75	*Myosotis scorpioides*
v6:p95	595			7.3.78	*Narcissus poeticus*
v6:p98	598			22.1.76	*Narcissus tazetta* cultivar
v10:p47	944			14.9.82	*Nicotiana rustica*
v7:p7	607			31.7.76	*Nymphaea alba*
v7:p9	609	Kew		10.10.77?	*Plectranthus japonicus*
v7:p10	610	Chelsea Physic Garden		14.10.80	*Oenothera grandiflora*
v7:p15	615	Islington	Pitcairn, William	26.5.77	*Osmanthus fragrans*
v7:p20	620*			11.6.79	*Ophrys apifera*
v7:p30	630			n.d.	*Himantoglossum hircinum*
v7:p45	645	Bulstrode		7.2.78	*Hymenocallis occidentalis*
v7:p46	646			--.1774	*Meconopsis cambrica*
v7:p50	650			13.9.76	*Parnassia palustris*
v7:p54	654		Bute, Lord	Aug.77	*Passiflora laurifolia*
v7:p51	651			17.10.77	*Passiflora rubra*
v7:p61	661	Chelsea Physic Garden		Jun.78	*Leptospermum scoparium*
v7:p62	662			Oct.77	*Leonotis leonurus*
v7:p63	663	Kew		31.10.77	*Leucas zeylanica*
v7:p64	664			--.1774	*Phlox carolina*
v7:p65	665	Chelsea Physic Garden		24.4.79	*Phlox divaricata*

Delany Collage label	Delany list: Latin name	Delany list: vernacular name
[Phlox] suaveolens / Phlox alba new species / Lychnidea	[Phlox] with a white flower, uncertain / suaveolens	—
Phlox undulata / Greater Lychnidea	[Phlox] undulata, Solandri	—
Physalis cretica / a new species	[Physalis] Cretica, Solandri .	—
Pisum marinum. / Sea Pea	Pisum marinum. .	Sea Pease
Plumeria rubra / Red Plumeria	Plumeria rubra .	—
Portlandia grandiflora	Portlandia grandiflora .	—
Potentilla recta / cinque foil	[Potentilla] recta .	Upright Cinquefoil
Primula / veris / cowslip	[Primula] veris .	Cowslip
Primula Veris elatior / oxslip	[Primula] veris elatior .	Oxlip
Primula Vulgaris . / Primrose	[Primula] acaulis .	The Primrose
Punica nana / Pomegranate	Punica nana .	Dwarf Pomegranate
Pyrus Cydonia / Quince	[Pyrus] Cydonia .	The Quince
Radbeckia laciniata wth. a yellow flower / and 2 varieties of China aster	Rudbeckia laciniata, & two / Varieties of Aster Chinensis in / the Frontispiece	—
Reseda odorata / minionette	Reseda odorata .	Mignonette
Rododendron ferrugineum	[Rhododendron] ferrugineum .	—
[Rosa] Lady Stamford's Rose / Rosa fluvialis ? Flor: / Dan:	[Rosa] fluvialis ? Flor: Dan:	Lady Stamford's Rose
[Rosa] Moss Province / Rose.	[Rosa] Gallica, var.	Moss Provence
Rubus Cæsius / Dewberry	[Rubus] cæsius .	Dewberry
Rubus fruticosus	[Rubus] fruticosus .	Common Bramble
Sanguinaria Canadensis	Sanguinaria Canadensis .	—
Saxifraga stellaris / Hairy Kidneywort	[Saxifraga] stellaris .	Starry Kidneywort
Saxifraga stolonifera [upper label] + 老虎耳 [second label has Chinese characters] # Lo old / # Fo Tygers / # Yee Ear. On verso another inscription – "A Chinese Plant – the name written by Whang at Tong {Huang Ya Dong} The Chinaman as he call'd himself	[Saxifraga] stolonifera .	Chinese Saxifrage
Sigesbeckia occidentalis [?]	Sigesbeckia occidentalis ?	—
[Silene] Sea Campion	[Silene] amœna .	Sea Campion
Solanum Melongena / Egg Plant	[Solanum] Melongena .	Egg Plant
Sparganium ramosum / Branched Bur-reed	Sparganium ramosum .	Branched Bur-reed
Tormentilla reptans / Creeping Tormentil	Tormentilla reptans	Creeping Tormentil
Trifolium pratense / Common Clover	Trifolium pratense	Common Clover
[Tulipa]	[Tulipa]	Double yellow Tulip
Vaccinium / diffusum	[Vaccinium] diffusum, Solandri .	—
Viola Calcarata	[Viola] calcarata .	—

Vol./Page	BM acc.no. suffix	Source of plant material	Donor of plant material	Date on verso	Modern Latin name
v7:p67	667			10.6.76	*Phlox maculata* var. *suaveolens*
v7:p66	666			11.8.81	*Phlox paniculata*
v7:p70	670	Kew	Dower, Lady	13.10.77	*Physalis angulata*
v7:p79	680	Weymouth		13.9.79	*Lathyrus japonicus* subsp. *maritimum*
v7:p81	682	Bulstrode		7.8.76	*Plumeria rubra*
v7:p91	692	Kew		9.8.82	*Portlandia grandiflora*
v7:p93	694			18.10.77	*Potentilla recta*
v8:p3	704			24.8.75?	*Primula veris*
v8:p4	705			29.4.77	*Primula × polyantha*
v8:p2	703			Apr.75	*Primula vulgaris*
v8:p15	716			13.8.78	*Punica granatum* var. *nana*
v8:p19	720			13.5.76	*Cydonia oblonga*
v2:p.–	101			–.1773	*Rudbeckia laciniata* and *Callistephus chinensis*
v8:p27	728			7.2.76	*Reseda odorata*
v8:p32	733		Grey, B[ooth]	29.5.77	*Rhododendron ferrugineum*
v8:p48	749			–.1775	*Rosa cinnamomea*
v8:p39	740			Jun.75	*Rosa × centifolia* 'Muscosa'
v8:p50	751			21.10.77	*Rubus caesius*
v8:p51	752			13.7.75	*Rubus ulmifolius*
v8:65	766	Kew		25.4.77	*Sanguinaria canadensis*
v8:p73	774		Cullum, Sir John	4.7.77	*Saxifraga stellaris*
v8:p77	778			n.d.	*Saxifraga stolonifera*
v9:p4	805			20.10.77	*Verbesina occidentalis*
v9:p6	807			–.1774	*Silene uniflora*
v9:p15	816			8.10.77	*Solanum melongena*
v9:p29	830			14.8.–	*Sparganium erectum*
v10:p72	969			9.10.82	*Potentilla anglica*
v10:p73	970			26.9.82	*Trifolium pratense*
v9:p65	866*			Oct.82	*Tulipa* cultivar
v9:p70	871			Jul.177-[9?]	*Vaccinium arboreum*
v9:p90	891	Hammersmith		13.5.78	cf. *Viola calcarata*

Index

Illustrations are indicated by italic page numbers. The collages and artwork of Mary Delany are listed under her name.

Aberdeen, Scotland, 141
Ackerman, Rudolph, 96
Ackerman's Repository of Art, London, 96
Ackworth School, 191
Adair, Mrs., 86
Adam, Robert, 102
Addison, Joseph, 150, 151, 153
Addlestone nursery, Chertsey, 195
Agnew, Mrs. Rhoda. *See* Astley, Rhoda (later Mrs. Agnew)
Ailsbury, Lady Frances, 102
Aiton, William, 36, 163, 165, 166–67, 191, *191*, 195, 197, 199, 201, 219
A la Ronde, Devon, 104, *104*, 105
Albury Park, Surrey, 125
Alexander, James, 207
Alfred, Prince, 61
Allen, David E., 34
Allen, Ralph, 38
All The Year Round (magazine), 15
The Ambulator (Palmer), 211, 213
Amelia, Princess, *14*, 15, 42, 51, *51*, 56, 156
Anderson, Robert, 195
Andover, Lady. *See* Howard, Mary
Anecdotes of Painting in England (Walpole), 13
Anglo-Irish Ascendency, 6
Anne, Queen of England, 2, 3, 43, 46, 50, 60, 81, 82, 86, 89, 90, 112, 150, 219
Anne, Princess, *51*, 119
Anson, Lady, 87
Anstey, Christopher, 244
Anstey, Mary, 102
"Antirrhinum cymbalaria" (Ehret), 157, *157*
"Aphaca" (Ehret), *136*, 137
Appadurai, Arjun, 132
Aprons, 72, *72*, 85, *85*, 176
Ariosto, 50
Arnold, Janet, *28*, 29
Artamène, ou le Grand Cyrus (de Scudéry), 50
Art and craft kits, 96, *97*, *98*, *99*
Art de faire le papier à la Chine: Les explications ont été envoyées (Anonymous), 242, *242*
The Artist in His Studio (Paye), 38, *38*
Artlove, Mrs., 96
Art of Drawing and Painting in Water-Colours, 231, 232
The Art of Japanning, Varnishing, Pollishing, and Gilding (Artlove), 96
Arundell, Lady, 87
"Aspasia" (nickname for Mary Delany), 50, 120–21, 126, 128
Aspasia (wife of Pericles), 120
"Aspasia's Picture, Drawn by Philomel, in the year 1742" (Donnellan), 121
Astley, Rhoda (later Mrs. Agnew), 12, *119*, 120, 214
"Astrantia foliis quinquelobis lobis trifidis Linn" with "Reseda Aegyptiaca" (Ehret), 160, *160*
Athenian Letters (Yorke), 120
"Athenian" Stuart, 102
Aubriet, Claude, 199
Augusta, Princess (sister of George III), *52*, 53, 56
Augusta (of Saxe-Gotha), Princess of Wales, 29, 36,
42, 51, *52*, 54, 58, 60, 74, 161, 163, 166, 191, 195, 208, 220
Australia, 20, 166
Autobiography and Correspondence of Mary Granville, Mrs. Delany (Llanover, ed.), 15, 62, 67, 112, 166

Bachelard, Gaston, 139
Bacon, Lord, 166
Badminton Park, Gloucestershire, 35, 219
Bahamas, 20
Ballard, George, 10
Baltimore, Lord, 50, 53
Banks, Sir Joseph, 20, 59, 132, 141, 161, 163, 166, 183, 184, 191, 197, 199, 204, 215, 220, 234
Barber, Rupert, *4*
Barberini vase. *See* Portland Vase
Bardwell, Thomas, *43*
Bare-Headed Gorgonia sea shrub (Ellis), 180, *180*
Barnard, Toby, 16
Barnes, Richmond upon Thames, 164, 214
Bartram, John, 165, 180, 207, 212, 215
Bas Bleu (H. More), 60
Baskerville, John, 244
Bateman, John, 2nd Viscount, 153, 220
Bateman, Richard, 33, 150, 164, 214, 220
Bath, 1st Earl of (John Granville), 46
Bath, 2nd Earl of (John Granville Carteret, 2nd Earl Granville), 42, *43*, 49, 53
Bath, 1st Marquis of. *See* Weymouth, 3rd Viscount (Thomas Thynne)
Bathurst, Lady Frances, 81
Bathurst Park, Cirencester, 116
Battle of Lansdowne (1643), 42
Beattie, James, 59, 60
Beauchamp, Lord, 81
Beaufort, 1st Duchess of (Mary Capel Somerset), 35, *35*, 219
Beaufort, 5th Duchess of (Elizabeth Boscawen), 60, *60*
Bedford, 4th Duchess of (Gertrude Leveson-Gower), 43, 70, 76
Bedford, 4th Duke of, Viceroy of Ireland (John Russell), 54
"Bee of Gwent." *See* Llanover, Lady
The Beggar's Opera (Gay), 84
Bentinck, Elizabeth or Lady Betty. *See* Weymouth, 3rd Viscountess
Bentinck, Henrietta, 215, 224
Bentinck, Isabella. *See* Monck, Isabella
Bentinck, Margaret, 56
Bentinck, William. *See* Portland, Earl of
Bermingham, Ann, 2, 94
Bill Hill, Reading, Berkshire, 43, 56, 160, 163, 166, 207, 208, 211, 212
Bill of Rights of 1689, 40–41
Bingley, Charlotte, 95
Biographia Britannica: or, Lives of the Most Eminent Persons … in Great Britain and Ireland (Kippis), 15
"Birmingham boxes," 138
Blackheath Park estate, London, 164, 214, 216
Blaikie, Thomas, 163
Blauw, Cornelis, 238
Blauw, Dirk, 238

Blenheim Palace, 72, 107
Bluestockings, 4, *36*, 60, 102, 141, 143, 161, 166
Bobart, Jacob, 219
Boleyn, Anne, 4
Bolsover Castle, Derbyshire, 51
Bolton, Duchess of, 81
Bolton, James, 157, 182, *182*
Bolton, Thomas, 182
Bonnell, Mr. and Miss, *105*
Booth Grey Collection. *See* Grey, Hon. William
 Booth
Boscawen, Admiral Edward, 60
Boscawen, Elizabeth. *See* Beaufort, 5th Duchess of
Boscawen, Frances, 4, 43, 56, 60, *60*, 164, 215
Boscawen, Hugh (1st Viscount Falmouth), 46
Boscawen, Lucy, 53, 60
Botanical collages, list of. *See* Delany, Mary
 Granville Pendarves – botanical collages
Botanical Magazine (Curtis), 165, 166, 197
Botanical sources, 204–23. *See also* Linnaean botany
*Botanical Tables Containing the Different Familys of
 British Plants* (Bute), 190, 208, *209*
The Botanic Garden (Darwin), 13, 15
Bowes, Mary Eleanor (Countess of Strathmore), 201
Bowles, Thomas, III, *56*
Boyd, Lady Catherine, *née* Chapone, 216
Boyd, Sir John, 214, 215, 216
Bradley Oak, Worcestershire, 123
Brighton, 166
Bristol, Earl of, 89
Brown, James, 98, 105
Brown, Lancelot Capability, 155, 216
Browne, Patrick, 201
Brummitt, Richard, 193
Bucholz, Robert, 82, 85, 90
Buck, Anne, 66
Buckingham House, London, 40, 57
Buckland Manor, Gloucestershire, 112, 150
Budworth Magna, 224
*Buenos Aires the Seat of Benjamin Hyett Esq. near
 Panswyke [Painswick House] Gloucestershire*
 (Robins the Elder), 153, *153*
Bullinbrock, Lord, 89
Bulstrode (Grimm), 178, *179*
Bulstrode, Buckinghamshire, 4, 9, 11, 20, 29, 30, 31,
 33, *33*, 36, 38, 50, 56, 60, 61, 74, 102, *116*, 116–17,
 125, 132, 134, 136, 139, 141–42, 147, 153, 156,
 157, 160, 165, 166, 172, 173, 177, 178–85, *179*,
 188, 199, 202, 204–5, 211, 212, 219, 220, 224,
 228, 239
Bunsen, Madame, 73
Burke, Edmund, 1, 166
Burlington, Countess of, 113
Burney, Charles, 56, 59
Burney, Edward Francis, *135*
Burney, Fanny, 4, 12, 15
Burn Mill, Romsey, 239
Burrell, Peter, 37
Bushe, Letitia, 4, *114*, 114–15, 116, 124, 126
Bute, 3rd Earl of (John Stuart), 20, 36, 58, 160, 161,
 163, 166, 190, 208, *209*, 211
Bute, Lady, 58, 160, 208, 211, 230
Buxton, 181

"A Cabbage-Leaf filled with Field Flowers"
 (Forbes), 159, *159*
Cabinetmakers and cabinets, 98. *See also* Closet
 and cabinet display
A Cabinet of Curiosities (Talman), 130, *130*
Café, John or William, 178, *178*
'Calceolaria Fothergilea' (Grey), 196, *196*
Calceolaria fothergillii (Sowerby), 196, *196*
Calwich Abbey, Staffordshire, 139, 173, *173*
Campbell, Lady Anne, 81
Campbell, John. *See* Loudon, 4th Earl of
Canaletto, 49
Candelabra (Café), 178, *178*
Canning, George, 84
Capel, Elizabeth, 155
Cape of Good Hope, 163, 201, 219, 220
Cardigan, Lady, 81
Card playing, 60
Carey, Mrs., 115
Carlisle, Lady, 91
Carlton House and gardens, London, 29, 36, *36*,
 57, 150, 166
Caroline, Queen, 33, 47, 49, *49*, 50, 53, 73, 156
Caroline, Princess, 51, *51*, 119, 156
Carriera, Rosalba, *116*, 117, 119
Carteret, Bridget, 50, 53
Carteret, George, 42
Carteret, Georgina. *See* Cowper, Lady
Carteret, Grace, 51, 53
Carteret, John. *See* Bath, 2nd Earl of; Granville,
 2nd Earl
Casteels, Pieter, *156*
*A Catalogue of Plants copied from Nature in Paper
 Mosaick, … according to the … names of Linnæus*
 (Delany), 184, *259*
A Catalogue of the Portland Museum (Lightfoot), 38,
 135, *135*, 138, 141, 145, 160
Catesby, Mark, 156, 165, 226
Cavendish, Margaret. *See* Portland, 2nd Duchess of
Chambers, Zachary, 57, *205*
Channel Islands (Jersey), 216
Chaplin, Miss, 86
Chapone, Hester, 102
Chapone, Sally. *See* Sandford, Sally Chapone
 (goddaughter of Mary Delany)
Charles I, King of England, 42
Charles II, King of England, 40, 42
Charlotte, Queen of England, 1, 12, *14*, 15, 40, 42,
 56, 58, 61, *61*, 82, 100, 104, 107, 161, 166, 207,
 228, 229
"Checkered Mitre Mitra Tessellata", *183*
Chelsea Physic Garden, London, 29, 35, 48, 132,
 141, 161, 163, 165, 188, 191, 197, 199, 204, 214,
 215, 219, 228
Chelsea Porcelain Factory, 137, *137*
Chesterfield, Lord, 55
China, 20, 133, 166, 242
Christ's Hospital school, 61
Churchill, John. *See* Marlborough, 1st Duke of;
 Marlborough, 2nd Duke of
Churchill, Sarah. *See* Marlborough, 2nd Duchess of
Church of England, 59
Chute family, 102

Civil and Natural History of Jamaica (Browne), 201
"Clarissa Harlowe," 100
"Claude glass," 138
Clayton, Charlotte, *née* Donnellan, 50, 51, 53, 54,
 55, 114, 172
Clayton, Emilia, 60
Clayton, Lady Louisa, 60
Clayton, Robert (bishop of Killala), 4, 54, 55, *55*,
 114, 139, 172
Clélie (de Scudéry), 50
Clermont, Andien de, 31
Cliveden estate, 51, 91
Closet and cabinet display, *130*, 131–34, 135–36,
 138–43, 174
A Closet at Wimbledon Park, Surrey (Stuart), *130*, 131
Coke, Lady Jane, 89
Colden, Cadwallader, 134
Cole, William, 158
Collages, list of. *See* Delany, Mary Granville
 Pendarves – botanical collages
Colley, Miss, 66
Collier, Joseph, 238
Collinson, Peter, 134, 136–37, 145, 147, 165, 179,
 180, 204, 207, 215
Colney Hatch, London, 211
Compton, Henry (bishop of London), 219
Compton Verney, Warwickshire, 58, 214, 215
Conchology, 4, 60, 134–41, 172–75, 180–84, *180*,
 182–83
Conway, Henry Seymour, 164, 216
Cook, Captain James, 20, 59, 141, 183, 195, 196
Cornbury, Oxfordshire, 33, 152, *152*
Cornforth, John, 31, 33
Cornwall, Duchy of, 46–47, 207
Correspondence of 1804 (Richardson), 15
Coulston, Wiltshire, 1
Court life, 40–65
 dressing for, 84–91
Courtney, John, 101
Covent Garden theater, 47
Coventry, Lady Anne, 175
Cowper, Lady (Georgina, *née* Carteret, later
 Mrs. John Spencer), 42, *43*, 56, 60, 73, 80
Cowper, Lady Sarah, 88
Cozens, Alexander, 124, 125
Cozens, John Robert, 124
Craftwork done by women, 94–108. *See also*
 Embroidery; Shellwork
Cree, John the elder, 195
Cruikshank, George, *86*
Cruikshank, Issac Robert, 86, *86*
Cullum, Rev. Sir John, 214, 215
Cumberland, Duchess of, 60
Curtis, William, 161, 163, 165, 166, 193, 197
Cuzzoni, Mme., 48
Cymbiola aulica aulica, *183*

Danson Hill estate, Kent, 214, 215, 216
D'arcy, Amelia, 88
Dartmouth, 2nd Earl of (William Legge), 58, 164,
 204, 214, 216
Darwin, Erasmus, 13, 15, 234
Dashwood, Mrs., 164, 214, 215

Day, Angélique, 16
Dejima Island, 201
Delany, Mary Granville Pendarves (1700–1788),
 5, 12, 14, 41, 111
*Note: See following headings for lists of collages, other
 artwork, and writings.*
 biographies and collected correspondence of,
 10, 15, 16, 62, 119, 131–47, 166
 botanical studies and sources, 188–220.
 See also botanical collages, *below*
 embroidery. *See* other artwork, *below*
 family trees related to, 44–45
 "Flora Delanica", 9, 10, 12, 15, 20–27,
 35, 61, 181, 212, 215
 life at court and, 40–62, 80–91
 marriage to Delany (1743–1768). *See* Delany,
 Patrick
 marriage to Pendarves (1717–1726).
 See Pendarves, Alexander
 natural history/zoology and, 172–85
 needlework pocket-book from Queen Charlotte
 to, *228*
 paper, use of, 236–47, *237–45*
 "paper mosaick" tools and techniques, 224–35,
 228, 232–33
 shells, study and decorative use of, 4, 8, 60, 110,
 134–41, 172–84
Delany, Mary Granville Pendarves – botanical
 collages
 'Acanthus spinosus', 188
 'Alstromeria Ligtu', *24*
 'Amaryllis ? attamyasco', *214*, 215
 'Amaryllis aurea', 215
 'Amaryllis Beladonna', 239
 'Amaryllis Belladonna Reginæ', 240
 'Amaryllis Regis', *214*, 215, 216
 'Amygdalus Nana', 164, 215
 'Amygdalus Persica', 164, *164*
 'Antirrhinum Genistifolium', 240
 'Arbutus unedo', 231
 'Arctotis calendulacea', *24*, 163
 'Arum esculentum', 230
 'Æsculus Hippocastanum', 231
 'Aster cordifolia', 163
 'Aster Dumosus', 163
 'Budleja capitata', 211
 'Cactus grandiflorus ?', *25*, 220
 'Calla æthiopica', 216
 'Canna Indica', 216
 'Carthamus cæruleus', 163
 'Cassia Marylandica', 164, 216
 'Catesbæa spinosa', 20, *22*
 'Centaurea moschata', 163
 'Cheiranthus cheiri', 164, 215
 'Chrysanthemum Lucanthemum', 160, 229
 'Citrus Medica', 11, *11*
 'Clethra alnifolia', 228, 230, 242
 'Convallaria majalis', 1, *1*
 'Conyza inuloides', 220
 'Crinum africanum', 208, *209*
 'Crinum asiaticum', 164
 'Cynoglossum omphalodes', *24*
 'Dianthus caryophyllus a variety Jersey Pink', 164

'Dracæna terminalis', 143, *146*, 147
'Erica coccinea ?', *25*
'Eryngium alpinum', 163, 212, *212*
'Flox divaricata', 165
'Fumaria fungosa', *22*, 144, *144*, 211
'Geranium fulgidum', *25, 194, 195, 239*
'Geranium lanceolatum', 219
'Geranium macrorhizon', 161, *224*
'Geranium radula', 219
'Geranium triste', 219
'Geranᵐ: alchemilloides', 216
'Geranᵐ: Inquinans', 216, *217*
'Geranᵐ: Peltatum', 216, *218*
'Geranᵐ: trigonum', 219, *219*
'Gordonia Lasianthus', 163
'Helonias Asphodeloides', *23*
'Hemanthus coccineus', 208
'Hyacinthus orientalis Ophir', 166, 216
'Ipomoea rubra', *198*, 199
'Ixia crocata', *24*, 228
"Lady Stamford's Rose", 201
'Lathyrus pratensis', 165
'Lathyrus Sativus', 211, *211*
'Lavatera olbia', 230, 231
'Lepidium Alpinum', 163
'Lightfootia canescens', 241
'Liriodendron Tulipifera', 243, *243*
'Lithospermum purpurocæruleum', 228
'Lobelia Cardinalis', *23*, 28, 161
'Lobelia pubescens', *200*, 201
'Ludwigia ovata', 241
'Magnolia grandiflora', 20, 22, 43, 159, *162*,
 163, 211
'Melia Azedarch', 164
'Mimosa arborea', 164, 220
'Mirabilis longiflora', 20, *22*
'Mitella diphylla', 163
'Moss Province Rose', 21
'Myosotis scorpioides', 207
'Narcissus Poeticus', *36*, 227, 229
'Narcissus tazetta var: Polyanthos Narcisse',
 25, 158
'Nicotiana rustica', 220
'Nymphæa alba', *21*
'Ocymum rugosum', 201, *201*
'Oenothera grandiflora', *23*, 199
'Olea odoratissima', 163, 188, *197*, 197
'Ophris apifera', 161, *192*
'Pancratium Maritimum', *26*, 27
'Papaver Cambricum', *21*, 160, *161*
'Parnassia Palustris', *21*
'Passiflora Laurifolia', *37*, 144, 211, 236, *236*
'Passiflora rubra', 163
'Philadelphus aromaticus', *26*, 195
'Phlomis Leonurus', 163
'Phlomis Zeilanica', 163
'Phlox Carolina', 165
'Phlox suaveolens', 165, *165*, 166
'Phlox undulata', 165
'Physalis cretica', 164
'Plumeria rubra', 220
'Portlandia grandiflora', *26*, 165, 193, 201
'Potentilla recta', 163

'Primula veris', *151*
'Primula Veris elatior', *192*, 193
'Punica nana', 220
'Pyrus Cydonia', 143, *143*, 147
'Radbeckia laciniata… and 2 varieties of China
 Aster', 161
'Reseda odorata', 158
'Rododendron Ferrugineum', 163
'Rubus Cæsius', 163
'Rubus fruticosus', 207, *207*
'Sanguinaria Canadensis', *23*
'Saxifraga stolonifera', *26*, 118
'Saxifragia stellaris', 215
'Scarlet Geranium & Lobelia Cardinalis', *28*, 161
'Sea Campion', 160
'Sigesbeckia occidentalis', 163
'Solanum Melongena', 163
'Tormentilla reptans', 165
'Trifolium pratense', 165
tulip cultivar, *146*, 147
'Viola Calcarata', *242*, 242
Delany, Mary Granville Pendarves – other artwork
 cut-paper work and silhouettes, 58, *58*, 112, 113,
 128, 224–34, *233*
 embroidery designs sewn by or attributed to,
 15, 66–77, 110, 150–71
 apron, 72, *72*
 firescreen, 2, *3*
 seat cushion, 102, *103*
 skirt panel, 6, 7, 67, 69, *71*
 stomacher, 72, *73*
 textile fragment, 30, *30*
 gardening and domestic decorative arts, 94–107,
 150–67
by title
 *The Arbour Oak at Bradley in Worcestershire
 Belonging to Mr. Dewes*, 123, *123*
 Bouquet of Flowers, 154, 155
 The cave at the end of Dovedale in Derbyshire, 32,
 33
 *A Cott in Blank–The Peacefull Residence of your
 faithful MD, 1744*, 8, 9, 115
 Delville fireside 27 Feb^y 1750/51, 111, 115
 A Dog Chasing Wild Fowl, 121
 "Flower Paintings/ ? the work of Mrs Delany,"
 125
 *Fort St. Davids Bull—drawn from the Life by Mrs.
 Delany at Bulstrode 1755*, 184, *185*
 "A green drake Fly," *174, 175*, 176
 Hostess at Leicester, 174, *174*, 175
 The Indian Seat at Wroxton, 152, *152*
 *Java Hare, Drawn from the Life by Mrs. Delany at
 Bulstrode*, 1755, 184, *184*
 Landscape with a Couple by a Stile, 122, *122–23*
 Marianna illustrations, *250, 252, 254, 256*
 A Modern Lady, 174, *174*
 The North-East view of Newark near Glocester,
 112, *112*
 Portrait of Rosalba Carriera (after Carriera), *116*,
 117
 A Seat in Wood Island at Holly-mount, 126, *126*
 The Secretary, 184, *185*

Specimens of Rare and Beautiful Needlework, 15, 67, 72

A Stem of Stock, 12, *12*

Thorp Cloud, Dovedale, Derbyshire, from the Top of Ham Moor, 123, *123*

Three Women and Cow, 125

Two Chained Hunting Dogs, 120

A view of the Bridge & Grotto at Calwich, 1756, 173, *173*

A View of Bulstrode Park, 116, 116–17

A View of Hanbury Pools in Worcestershire, 112, *113*

A view of Matlock with the Cascade, 153, *153*

A view of part of ye little Grove of evergreens at Delville wth. ye Country beyond it & Bay of Dublin, 126, *127*

A View of Part of Dublin Harbour and Deville Garden from the Bow Window in Mrs. Delany's Closet, 138, *139*

A view of ye Beggars Hut in Delville garden, 151

A View of ye improvements in ye Stone quarry at Cornbury the seat of the Earl of Clarendon in Oxfordshire 15 Nov' 1746, 152, *152*

A View of ye Lake at Seaforde Belonging to Mathew Forde Esqr in ye County of Down Ireland, 123, *123*

A View of Ye Swift & Swans Island in Delville Garden 30 Dec 1745, 8, *8*

Delany, Mary Granville Pendarves – writings
 "A British flora after the sexual system of Linnaeus", 10, *10*, 15, *15*, 188
 A Catalogue of Plants copied from Nature in Paper Mosaick, … according to the … names of Linnæus, 184, *259*
 Marianna, 128, 172, 174, 238, 250–61

Delany, Patrick (2nd husband of Mary, d. 1768), 4, *4*, 6, 8, 9, 10, 31, 40, 46, 50, *54*, 54–56, 61, 110, 114, 119, 122, 123, 128, 151, 153

Deliciae Botanicae (Ehret), 190, *190*

Deloraine, Lady, 81

DeLuc, Jean-André, 59

Delville, Dublin, Ireland, 6, 8, *8*, 9, 11, 15, 31, 33, 34, 37–39, 55, 59, 94, 110, 115, 119, 122, 126, *127*, 131, 132, 134, 138, 139, *139*, 145, 147, 151, *151*, 154, 155, 172, 173, 175, 177

Denny, Lady Arbella, 55

DePhillips, Henry, Jr., 227

Derby, Earl of, 156

Derbyshire, 153, 207

Derwentwater, Countess of (Ann), 100, *100*

Derwentwater, 3rd Earl of (James), 100

"A Description of Doctor Delany's Villa" (Sheridan), 8

Description of the Villa of Mr. Horace Walpole… at Strawberry-Hill (Walpole), 13

"Design L" (Wright), 140, *140*

Devonshire, 5th Duchess of (Georgiana, *née* Spencer), 42, 60, 91, 102

Dewes, Anne Granville (sister of Mary Delany), 4, 51, 53, 54, 60, 66, 73, 80, 102, 113, 120, 126, 131, 134, 175, 232

Dewes, Bernard (nephew of Mary Delany), 57

Dewes, Court (nephew of Mary Delany), 57, 60

Dewes, John (brother-in-law of Mary Delany), 51, 58, 123, 207

Dewes, Mary Port (niece of Mary Delany), 42, 60, 66, 204, 216

Dewes, Simon, 15

A Dialogue on Beauty in the Manner of Plato (Stubbes), 120

Diary and Letters, 1842–46 (Burney), 15

Dictionary of National Biography, 220

Dietzsch, Barbara Regina, 2

Dietzsch family, 160, 204

Dillenius, John Jacob, 188, *198*, 199

Dissertatio de generatione et metamorphosibus insectorum Surinamensium (Merian), 177, *177*

Dodsley, James, 244–45

Donnellan, Anne, 4, 54, 55, 89, 114, 117, 120, 121, 137, 172

Donnellan, Charlotte. *See* Clayton, Charlotte

Donnellan, Dr., 115, *115*

Donnellan family, 55

Dormer, Sir Clement Cottrell, 54

Dorset, 3rd Duchess of (Frances Leveson-Gower), 43, 81

Douglas, Lady Jane, 2

Douglas House, Petersham, 48

Down diocese, 54

Downman, John, 244, 245

Downpatrick parish, 8

Dress design, *28–29, 29*–30, *66–77, 66–93, 80–83, 85–88*

Dressing for a Birthday (Rowlandson), 87, *87*

Druce, George C., 188, 193, 202

Drury Lane Theatre, London, 47

Dryander, Jonas Carl, 191

Du Bartas, Guillaume de Salluste, 150

Dublin Castle, Ireland, 6, 66

Dufour, Mr., 177

Dunham Massey, Cheshire, 202

Durham, James and Richard, 238

Dyck, Anthony van, 119

Dysart, Lady Grace (cousin of Mary Delany), 48, 53, 70, 117, 119

Dyve, Dorothy and Penelope, 50

Ealing gardens, London, 214

Early Georgian Interiors (Cornforth), 31

East Indies, 139, 140, 197

"Echinopus major" (Ehret), 160, *160*

The Economy of Vegetation (E. Darwin), 13

Eden: Or, A Compleat Body of Gardening (Hill), 34

Edgeworth, Maria, 102, 105

Educational values, 60

Edward, Duke of Kent, *52*, 53

Edwards, George, 31

Edwards, Sydenham, 161

Eger, Elizabeth, 141

Egerian Grotto, Rome, 139

Egmont, Earl of (John Perceval), 55, 81, 88, 90, 115

Egmont, Lady, 90

Ehret, Georg Dionysius, 2, 9, 31, 33, 36, *136*, 137, 143, 144, 155, 156, 157, *157, 158*, 159, *160*, 166, 175, 177, 181, 188, *189*, 190, *190*, 204, 226, 228

Elizabeth, Princess, 91, 220

Ellis, John, 180, *180*

Ellis, Mrs., 85

Elstob, Elizabeth, 4, 60

Elwood, Mrs., 226

Ely, Lady, 85

Embroidery, 95–96, *95–97*, 100, 100–101, 102, *103*, 106, *106*, 150–71, 176. *See also* Delany, Mary Granville Pendarves (1700–1788) – other artwork; Dress design

Endeavour (ship), 141, 204

Enlightenment, 59

Enumeratio Plantarum in Ericeto Hampstediano (T. Johnson), 161

Epistolary culture, 130–49

Ernest, Prince, 61

Erskine, Lord and Lady, 87

An Essay towards a Natural History of the Corallines (Ellis), 180

Evelyn, John and Mary, 60

Ewell Mill, Surrey, 238

Excise stamps, 240, *241*

Fabrice, Friedrich Ernest von, 50

The Fair Lady Working Tambour (unknown), 98, *99*

Falkland Islands, 196

Falmouth, Earl of (Boscawen), 53

Falmouth, Viscountess, 50

Fan, oriental design, 133, *133*

Farrington, William, 155

Farwell, Mr., 214

Feathers, use of, 102, *104*, 104–5

Fetherstonhaugh, Lady Sarah, 155, *155*

Figures of the Most Beautiful, Useful, and Uncommon Plants (P. Miller), *136*, 137

Filices britannicae; an History of the British Proper Ferns (Bolton), 182

Finch, Lady Charlotte, 58, 60

Fiske, Mrs., *83*

Fitzherbert, Mrs. Maria, 166

Fletcher, Henry, *156*

Flora Anglica (Hudson), 10, 159, 161, 181, 188

Flora Attired by the Elements (Fuseli), 13, *13*

Flora Japonica (Thunberg), 201

Flora Londinensis (Curtis), 161, 166, 193

'Flora Nunehamica' (Walpole), 166

Flora of Buckinghamshire (Druce), 193

Flora Scotica; or, A Systematic Arrangement, in the Linnaean Method of the Native Plants of Scotland and the Hebrides (Lightfoot), 181, *181*

The Flowering of the Landscape Garden (Laird), 33, 205

Flowers in a Vase (Capel), 155

Foley, Grace (later Countess of Clanbrasil), 55

Foley, Thomas (later 1st Lord), 55

Forbes, Mary, *née* Capel, 155, 158, 159, *159*

Ford Mill, Kent, 239

Forster, Georg, 59

Forster, Johann Reinhold, 59, 195

Forsyth, William, 165

Forth, Dorothea, 51

Forth, Francis, 51

Forth Hamilton. *See* Hamilton, Dorothea Forth

Foster, Mrs. Bacon, 98

Fothergill, Dr. John, 20, 141, 191, *191*, 196, 199, 214, 215, 219

Foucault, Michel, 132
Fox, Caroline, 154
Fraser, John, 165
Frederick, Prince of Wales, 29, 30, 51, *52, 53,* 54, 56, 70, 74, 81, 84, 89, 90–91, 156, 166, 220
Freeman, Mr. and Mrs., 107
French, Henry and Thomas, 238
Fréret, Louise, *195*
Frying Sprats, Vide Royal Supper (Gillray), 82, *82*
Fulham garden, 219
'Fumaria fungosa' (Grey), 230, *244*
Furber, Robert, 156, *156*
Fuseli, Henry, 13, *13*

Gainsborough, Thomas, 36, 244–45
The Gardeners Dictionary (P. Miller), 137
"Garden of Adonis" (Spenser), 151
The Garden of Eden (Prest), 34
Garden projects, 134–35
Garthwaite, Anna-Maria, 2, 70–72, *71,* 74, 75–77, *76,* 156
Gater, John, 239, *239*
Gay, John, 84
Gender, Taste, and Material Culture in Britain and North America, 1700–1830 (Styles and Vickery, eds.), 16, 31
A General View of the Roads of England and Wales (Paterson), *206, 207*
Genera plantarum (Linnaeus), 188
Gentleman's Magazine, 215
George I, King of England, 42, 46, 47, 48, 85
George II, King of England, 29, 30, 42, 48, 50, 51, 53, 56, 81, 84, 90, 204
George III, King of England, 1, 12, *14,* 15, 40, 41, *52, 53,* 56, 59, *59,* 61, 82, 84, 87, 91, 191, 207, 216
George IV, King of England, 55, 82
Georgian workboxes, 98
Geraniologia (L'Héritier), 195, 197
'Geranium macrorrhisum' (Grey), 36, *226, 227,* 229, *229, 231, 231, 232, 233*
Germain, Lady Betty, 89
Gerrevinck, Abraham van, 238, 239
Gerrevinck, Isaac van, 238, 239
Gerrevinck, Lubertus van, 238, 239, *239*
Ghini, Luca, 34
Giant's Causeway, Ireland, 6, 20, 126, 140, 141
Giffard, Miss Elizabeth, 98
Gillows of Lancaster, 98
Gillray, James, 82, *82*
Gilpin, Reverend William, 9–10, 11, 110, 124, 145, 147, 188, 228
Girouard, Mark, 31
Gisborne, Thomas, 106
Glan Villa, Colney Hatch, 208, 211, 215
Glanvilla, Enfield, 164, 215
Glegg, Jenny, 74–75
Glin, Knight of, 16
Glorious Revolution of 1688, 40, 42, 47
Gloucester, Duke of, 60
Gloucestershire, 73, 207
Godolphin, Lord, 158
Golden Ball, Windmill St., London, 238
Goldney Grotto, Bristol, 140

Gordon, Duchess of, 91
Gordon, Duke of, 43
Gouldsworthy, Miss, 60
Goupy, Joseph, *117,* 117
Goupy, Louis, 117, 119, 120
Gower, 1st Earl (John Leveson-Gower), 43, 54
Gower, Dowanger Countess, *née* Mary Tufton, 43, 152, 160, 164, 208, 211
Grafton, Duchess of, 89
Grantham, Mary, 86
Granville, 2nd Earl (John Carteret), 43, *43*
Granville, Anne (sister of Mary Delany). *See* Dewes, Anne Granville
Granville, Bernard (brother of Mary Delany), 3, 47, 53, 123, 134, 139, 161, 173, 204
Granville, Bernard (father of Mary Delany), 2, 42
Granville, Sir Bevill (d. 1643), 42
Granville, Elizabeth (maid of honour to Princess Augusta of Wales), 50, 53, 54, 56
Granville, Elizabeth (maid of honour to Queen Anne), 46, 53
Granville, George (uncle of Mary Delany). *See* Lansdowne, Lord
Granville, Grace (later Countess Granville and Viscountess Carteret), 42, 50, 51, 53
Granville, Grace (later Lady Foley), 55
Granville, John. *See* Bath, 1st Earl of
Granville, Mary. *See* Delany, Mary Granville Pendarves (1700–1788)
Granville, Mary Villiers Thynne. *See* Lansdowne, Lady
Granville family tree, 42–43, 132
Gray, Thomas, 158
Great Parterre at Longleat (Thacker), 150, *150,* 156
Greening, Robert, 163
Green Park, London, 42, *205*
Greer, Germaine, 94
Gregory, Dr., 102
Greig, Hannah, 29
Grey, George (5th Earl of Stamford), 201
Grey, Marchioness Jemima, 81, 87, 101
Grey, Lady Mary. *See* Stamford, Dowager Countess of
Grey, Hon. Booth, 36, 163, *165,* 166, 195, 196, *196,* 202, 214, 215, 224–34, *226,* 236, 238, 240, 242, 243
Grignion, Charles, *135*
Grimm, Samuel Hieronymus, 173, *173,* 178–79, *179, 208*
Grosvenor, Lady, 60
Grotto design, 136, 138–41, *139–40,* 172–73, *173*
Grotto in the Park at Bulstrode (Grimm), 173, *173*
Grove House, Old Windsor, *32, 33,* 110, 153, 164, 214, 220
Grove Mill, Eyehorne Street, 239
Grufberg, I.O., 193
The Guardian (newspaper), 102
Guilford, 1st Earl of (Francis North), 33, 58, 159, 214–15

Hall, Augusta, *née* Waddington (great-grandniece of Mary Delany). *See* Llanover, Lady
Haller, Albrecht von, 163

Ham House garden, Surrey, 48
Hamilton, Lord Archibald, 51
Hamilton, Charles, 51, 155
Hamilton, Dorothea Forth, 175, *175,* 176, 177
Hamilton, Duchess of, 86
Hamilton, Duke of, 43
Hamilton, Elizabeth, 51, 53
Hamilton, Mrs. Frances, 15, 60, 138
Hamilton, George (1st Earl of Orkney), 51
Hamilton, Lady Jane Archibald, 51, *52, 53,* 54
Hamilton, Mary, 60, 216
Hamilton, Miss, 74
Hamilton, Sir William, 42, 60, 107
Hammond, Sir J., 89
Hamner, Lady Catherine, 115
Hampton Court, 48
Hanbury, Charlotte, 234
Handel, George Frideric, 1, 3, 47, 50, 56, 62
Handicrafts done by women, 94–108.
 See also Embroidery; Shellwork
Hanoverian dynasty, 42, 46, 55, 82
Hanover Square, London, 102
"Hans Sloane" plates, 137, *137*
Harcourt, Lord (George Simon), 166, 214, 216
Hardinge, Mrs. (in Kent), 105
Hardwick House, Hampstead Heath, 214, 215
Harley, Edward (2nd Earl of Oxford), 59
Harley, Lady Elizabeth, 132
Harley, Lady Harriot, 48, 59
Harley, Margaret Cavendish. *See* Portland, 2nd Duchess of
Harley, Robert (1st Earl of Oxford), 43
Harrington, Lord, 68
Harris, Frances, 89
Harris, John, 163
Hartford, Lady, 80
Hartley, Mary, of Bath, 102, 110
Hartwell House, Buckinghamshire, 166
Hatchlands estate, Surrey, 60
Hauy, Abbé, 144
Haverfield, John, 163
Hawsted, Suffolk, 214, 215
Hayden, Ruth, 15, 29, 232, 239
Haymarket Theatre, 47
Hayter, Charles, *83*
Head of an Old Woman (E. Wesley), 115, *115*
Heath, Richard, 238
Heckle, Augustin, 137
Heidegger, John James, 47
Herbert, Arabella, 51, *52, 53*
Herbert, Hon. Mrs. (of Llanover), 234
Hertford, Countess of, 151
Hervey, Lord, 84
Highmore, Joseph, 38
Hill, Sir John, 34, 163, 188, 193
Historia plantarum rariorum (Martyn), 165
Historia stirpium indigenarum Helvetiae inchoata (Haller), 163
An History of Funguses Growing about Halifax (Bolton), 182
Hoare, William, *43*
Hobbard, Mrs., 85
Hogarth, William, 4, 70, 114

Holland, 86
Hollingbourne Old Mill, Kent, 239
Hollymount, Down, Ireland, 123, *126*, 153
Honig, Jan, 238
Hope-Vere, Lady Anne, *née* Vane, 59
Hortus Cliffortianus (Linnaeus), 190
Hortus Elthamensis (Dillenius), 199
Hortus Kewensis of 1768 (Hill), 34
Hortus Kewensis of 1789 (Aiton), 34, 36, 163, 165,
 166, 167, 191, 195, 196, 197, 199, 201, 219
Hortus siccus (1st Duchess of Beaufort), 34, *35, 142*
Hortus Uptonensis (Fothergill), 219
Houghton Hall, 72
Howard, Lady Caroline, 91
Howard, Sir George, 214, 216, 219
Howard, Henrietta, 50
Howard, Mary (Lady Andover), 4, *5*, 113, 115,
 124–25, *125, 231*
Hudson, Thomas, *124*, 125
Hudson, William, 10, 159, 161, 181, 188
Hume, Sir Abram and Ly, 215
Hunt, John Dixon, 33, 140
Hunter, John, 59
Huntingdon, Lady, 70
Hurcott Mill, Kidderminster, Worcestershire,
 238, 244, 245
Hurd, Bishop Richard, 60, 62
Hurst, Sarah, 96
Hyde, Anne, 43
Hyde, Catherine (Kitty). *See* Queensberry,
 Duchess of
Hyde, Henry. *See* Rochester, 2nd Earl of
Hyde, Jane Leveson-Gower (Lady Rochester), 43
Hyde family tree, 43, 45
Hyett, Benjamin, 33, 153
'Hypericum Androsemum Tutsan' (Ehret), 159

"Icones Fungorum circa Halifax Sponte Nascentis"
 (Bolton), 157, 182, *182*
'Ilex aquifolium' (Grey), 243, *243*
An Illustration of the Termini Botanici of Linnaeus
 (J. Miller), 190
Illustratio systematis sexualis Linnaei (J. Miller), 191
Inconveniences of a Crowded Drawing Room
 (G. Cruikshank), *86*
India, 133, 220, 230, 242
Irish Manufactures, 6, 138
Islington garden, 143, 163, 214
Italianate Landscape (Bushe), *114*

Jackson, William, 245
Jacobites, 40, 47
James II, King of England, 40, 43, 46, 55
James, Duke of York. *See* James II
Japan, 134
Japanned box, 133, *133*
Jefferson, Martha, 102
Jefferson, Thomas, 102
Jekyll, Gertrude, 166
Jenkinson, James, 188
Jennings, Miss, 214, 216, 219, 226, 233
Jenyns, Sarah. *See* Marlborough, Duchess of
Jervas, Charles, *43, 49*

Johnson, R. Brimley, 15
Johnson, Samuel, 1, 59
Johnson, Thomas, 161
Jones, Barbara, 173–74
Jubb, William, 238

Kauffman, Angelica, 102
Keate, George, 10–11, *12*
Kennerley, J., *83*
Kensington Palace, London, 41, 84, 86, 156, *156*,
 166
Kent, Duchess of, 150
Kent, William, *32, 33*, 54, 150, 166
Kenwood, Hampstead Heath, London, 164, 211,
 214, 216
Kerhervé, Alain, 16
Kew (Royal [Botanic] Gardens), London, 20, 29,
 34, 36, 48, 56, 58, 59, 62, 132, 134, 141, 143, 153,
 161, 163–66, 184, 191, 195, 196, 197, 201, 207,
 208, 212, 215, 216, 219, 220, 228
Kick, Everhard, 35
Kielmansegg, Mme., 48
Kilburn, William, 161, 166, 193, *193*
Killala, bishop of. *See* Clayton, Robert
Kippis, Andrew, 15
Kirk, Everhard, 219
Kit-Kat Club (Whig), 90
Klein, Lawrence, 136
Knapton, George, 119

Laboratory; or, School of Arts (Smith), 73
Landscape with a Blasted Tree (Goupy), 117
Landscape with "Le Tombeau de Latitia" (Bushe), 114
Landscape with Ruins (Donnellan), *115*
Lansdowne, Lord (George Granville, uncle of
 Mary Delany), 2, 3, 42, 46, 150
Lansdowne, Lady (Mary Villiers Thynne
 Granville), 42
Lansdowne family, 54
Lansdowne, Battle of (1643), 42
Larpent, Anna, 102, 104
Latham, James, *55*
Lawrence, Thomas, 12, *12*, 13, 122
Lay, Samuel, 239
Lea, Harriet, 244, 245
Lee, Lady Elizabeth, 166
Lee, James, 20, 164, 188, 197, 215, 219, 220
Leeds, Duke of, 88
Lefebvre, Henri, 132
Legge, William. *See* Dartmouth, 2nd Earl of
Leicester House, London, 47, 86
Lely, Peter, 119
Leman, James, 75
Lennox, Lady Caroline, 74
Lens, Bernard, III, 118, *118*, 119, 120
Lens family, 124
Leptospermum, 195
Letters from Georgian Ireland (Day), 16
*Letters from Mrs. Delany ... to Mrs. Frances
 Hamilton*, 15
Lettsom, J.C., 196
Lever, Ashton, 145
Leverian Museum, 143, 145, *145*

Leveson-Gower, Frances.
 See Dorset, 3rd Duchess of
Leveson-Gower, Gertrude. *See* Bedford,
 4th Duchess of
Leveson-Gower, Jane. *See* Hyde, Jane
 Leveson-Gower
Leveson-Gower, John, 1st Earl Gower. *See* Gower,
 1st Earl
Leveson-Gower family tree, 43
Lewisham, Lord, 214
Ley, Piet van Der, 238
L'Héritier de Brutelle, Charles Louis, 195, *195*, 197,
 199
Lightfoot, Rev. John, 2, 9, 33, 36, 38, 59, 134, 135,
 135, 141, 143, 157, 159, 160, 161, 181, 183, 191,
 191, 214, 215
Lilly Library Manuscript Collections, Indiana
 University, 115
Lincoln's Inn Fields, 47
Linnaean botany, 2, 9, 10, 141, 147, *155*, 157, 161,
 181, 184, 188, 190, *190*
Linnaeus, Carl, 36, 141, 188, 190, 193, 201, 220
Linnell, William and John, 33
Lipsedge, Karen, 37
Little Ivy Mill, Loose Valley, Kent, 238
Llanover, Lady (Augusta Hall, *née* Waddington),
 1, 12, 15, 67, 112, 115, 120, 166, 176, 199, 224,
 228, 229
Lock, Matthias, 137
Locke family, 62
London Botanic Garden, Lambeth, 161
London Evening Post, 91
London Foundling Hospital, 96
London General Evening Post, 208
London Tradesman (Campbell), 73
Longleat, Wiltshire, 4, 42, 58, 115, 125, 150, *150*,
 155, 156, 204, 214
Loo, Jean-Baptiste van, *52, 53*
Lost Demesnes (Malins and Knight of Glin), 16
Loudon, 4th Earl of (John Campbell), 73, 207
Loudon, Jane, 166
Louisa, Princess, 48, 81
Louis XIV, King of France, 50, 150
The Loves of the Flowers (Darwin), 13
Lower Brook Street, London, 4
Luton Hoo, Bedfordshire, 20, 36, 56, 160, 163, 166,
 207, 208, *210*, 211, 212, 230
Lutyens, Edwin, 166
Luxborough, Lady, 151, *153, 155*

Madrepora pileus [*Herpetolitha limax*] (Ellis &
 Solander), 180–81, *180*
Maingaud, Martin, *51*
*Making the Grand Figure: Lives and Possessions in
 Ireland, 1641–1770* (Barnard), 16
Malins, Edward, 16
The Mall and St. James's Palace (Anonymous), *41*
Mansfield, Lord Chief Justice, 56, 164, 211, 216
Mantua, 28–29, *29–30*, 66–79, *77*, 81, 87, *87–88*
Manwaring, Elizabeth (Mrs. Booth Grey), 224
Maori of New Zealand, 195
Maria Theresa of Austria, 53
Marlborough, 2nd Duke of (John Churchill),
 42, 43, 89–90

Marlborough, 2nd Duchess of (Sarah Churchill), 42, 43, 50, 60, 81, 89, 107

Marquetry, 98, *98*

Marshal, Alexander, 155, 226

Marsh Gentian with . . . a shell, a butterfly, a moth . . . (Bolton), 182, *182*

Martyn, John, 31, 165, 183, *183*

Mary II, Queen of England, 48, 81, 219

Mary, Princess, 57

Masham, Abigail, 50

Mason, Rev. William (Royal Chaplain), 59, 110, 188, 216

Masson, Francis, 196, 197, 219

Matlock House, Derbyshire, 152, *153*

Mayer, Ralph, 231

Mayfair, London, 55

McCartney, Lady, 86

McKeon, Michael, 131, 136

Meen, Margaret, 36

Meikle, Desmond, 193

Memoirs of Several Ladies of Great Britain Who Have Been Celebrated for Their Writings or Skill in the Learned Languages (Ballard), 10

Memoirs of the Literary Ladies of England (Elwood), 226

Mercier, Dorothy, 238, *238*

Mercier, Philip, 119

Mereworth Castle, 54

Merian, Maria Sibylla, 36, 156, 177, *177*

"Merlin's Cave," 33

Millenium Hall (S. Scott), 104

Miller, John, 190, 191

Miller, Philip, *136*, 136–37, 139, 141, 144, 147, 165, 179, 191, 204

Mill Hill, 180, 204

Milton, John, 35, 139, 141

Miscellaneous Tracts (Stillingfleet), 161

Monck, General, 46

Monck, Henry, 55

Monck, Isabella, *née* Bentinck, 55

Monck family, 46, 48, 55

Monson, Lady Ann, 214, 220

Monson, George, 59

Montagu, Lady Anne, 81

Montagu, Lady Barbara, 104

Montagu, Elizabeth, 4, *5*, 102, 104, 135–37, 141, 143

Montagu, Frederick, 216, 220

Montagu, George, 8, 220

Montagu, Lady Mary Wortley, 58, 86

Montagu House, Portman Square, London, 102, 104

Moore, Lisa, 175

More, Hannah, 4, 60, 106, 107

Mrs. Delany: Her Life and Her Flowers (Hayden), 15, 239

Mrs. Fiske's Fashion and Court Elegance, 83, *83*

Munn, Lewis, 239

Muriel, John St. Clair, 15

National Gallery of Ireland, 122

Natural history, 130–49, 160–66, 172–87

The Natural History of Many Curious and Uncommon Zoophytes (Ellis), 180, *180*

Needlework. *See* Embroidery

Nelson, Charles, 228, 234

Nerquis Hall, Wales, 98

A New and Accurate Description of All the Direct and Principal Cross Roads in England and Wales (Paterson), 206

New Bath Guide (Anstey), 244–45

A New Drawing Book for ye Use of His Royal Highness ye Duke of Cumberland, Their Royal Highness the Princess Mary, and Princess Louisa, (Lens), 117, *118*, 119

Newtonian astronomy, 48

New Zealand, 20, 195

Nivelon, François, *68*

'A Noble Art' (Sloan), 33

Norbury Park, Surrey, 62

Norfolk House, London, 29, 30, 53, 56, *57*, 73, 74, 86, 90–91, 152, 155, 204

North, Francis. *See* Guilford, 1st Earl of

North family, 58

The North-East view of Newark near Glocester (Delany), 112, *112*

Northend, Fulham, 48, 139, 172

Northumberland, 1st Duke of (Hugh Smithson), 31, 214, 215

A North View of the City of Bath (Lens), *118*, 119

Nost, John van the younger, 54

"A Numerical Register of all His Majesty's Leasehold Houses between St. James's Street & Green Park" (Chambers), *57*, *205*

Nuneham, Lord and Lady. *See* Harcourt, Lord (George Simon)

Nuneham Courtenay, Oxfordshire, 166, 207, 216

Observations Relative Chiefly to Picturesque Beauty (Gilpin), 9–10

Ogborn, Miles, 132

"Old Pretender," 46, 47

Old Testament, 107

Osnabrück, bishop of, 220

Opera of the Nobility, Lincoln's Inn Fields, 47

Ophir, Adi, 132

Ophrys apifera (Kilburn), 193

Opie, John, 1, *1*, 4, 13, 40, *41*, 110

Orange, William of, 51, 67, 156

Orkney, 1st Earl of (George Hamilton), 51

Osborne, Francis Godolphin (Marquis of Carmarthen), 88

Ossory, Lady, 158

Outram, Dorinda, 132

Oxford, 2nd Earl of (Edward Harley), 59

The Oxford English Dictionary, 138

Oxford Physic Garden, 134, 219

Pain, Miss Rachel, 95

Painshill gardens, Surrey, 51

Painswick House, Gloucestershire, *153*

Palissy, Bernard, 141

Palmer, William, *213*

Pamela (Highmore), 38

Paper, manufacture and use of, 236–47, *237–45*

A Paper Mill with the Men at Work (engraving), 237, *237*

"Paper mosaick" tools and techniques, 224–35, *228*, *230–33*

Parker, Lady and Lord, 88

Parker, Rozsika, 99

Parkinson, John, 20, 34

Park Place at Henley on Thames, London, 164, 214, 216

Parminter, Misses Jane and Mary, *104*, 105

Paston, George, 15

Paterson, Daniel, *206*

Paterson, William, 201

Paye, Richard Morton, 38, *38*

A Peep at the Plenipo-!!! (I. Cruikshank), *86*

Pelargonium quercifolium (Fréret), 195, *195*

'Pelargonium subcoeruleum' (Grey), 243, *243*

Pelling Place, Old Windsor, 105

Pembroke, Lady, 81

Pendarves, Alexander (1st husband of Mary Delany, d. 1726), 3, 40, 46–47, 50, 110, 113

Pendarves, Mary. *See* Delany, Mary Granville Pendarves

Penn family, 207

Penn, Lady Juliana, 60

Pennant, Thomas, 181

Percival family, 55

"A Perspective View of the Grotto" (Serle), 139, *139*

"A Petition from Mrs. Delany's Citron-Tree, To Her Grace The Duchess Dowager of Portland" (Keate), 10–11

Petre, 8th Baron, 193

Petty, Sophia Carteret. *See* Shelburne, Lady

Petty, William. *See* Shelburne, 2nd Earl of

"Phallus found at Bulstrode Nov. 12 1763" (Ehret), 157, *157*

'Phallus impudicus' (*Phallus impudicus* L.), 157, *157*, 181

Philips, Charles, 68

Philosophical Transactions of the Royal Society, 215

'Phlox suaveolens' (Grey), 165, *165*

Phoenix Mill, Alkmaar, North Holland, 238, 239

Pitcairn, Dr. William, 20, 143, 163, *197*, 214, 215

A Plan of London and Westminster, and Borough of Southwark (Rocque), 46, 47

A Plan of Mr. Pope's Garden (Serle), 139, *139*

"Plans of Different Roads from London to Luton Park 1767," 208, *210*

Plantae et papiliones rariores (Ehret), 175, *176*, 177

Plants and Animals in a Landscape (Fetherstonhaugh), 155, *155*

Plas Newydd, Llangollen, Wales, 105

Pocket instrument case, 230, *230*

Pointon, Marcia, 132

'Polemonium rubrum,' 199

Polymita Picta, 183

Pomeroy, Mrs., 66

Pond, Arthur, 117, 119, *119*, 120

Pope, Alexander, 1, 8, 33, 139, 150, 153, 172

Port, Georgina. *See* Port, Mary Dewes

Port, Mary Dewes (grandniece of Mary Delany), 12, 44, 55, 58–59, 60, 62, 115, 134, 135, 141, 157, 164, 183, 204, 211, 212, 215, 224, 245

Portland, 1st Earl of (William Bentinck), 40, 48
Portland, 2nd Duke of (William Bentinck), 51, 179
Portland, 2nd Duchess of (Margaret Cavendish
 Harley), 2, 4, *5*, 9, 11, 12, 20, 33, 36, 40, 41, 43, 46,
 48, 50–51, 53–54, *55*–56, 58, 61, 102, 110, 112,
 119, 120, 121, 132, 134, 135, 140, 155, 156,
 157–58, 159, 161, 165, 166, 172, 177, 179,
 180–81, 182, 184, 191, 196, 201, 204–5, 211, 215,
 224, 233
Portland Bill, Dorset, 38, 208, *208*
Portland Museum, 38, 134, 135, 136, 144
Portland Vase, 9, 60, 135, *135*
Portman Square, London, 143
Postlip Mill, Winchcombe, Gloucestershire, 238
Powys, Mrs. Lybbe, 106, 107
Poyntz, Georgiana. *See* Spencer, Georgiana Poyntz
Prest, John, 34
"Primitiae florae Novae Zelandiae" (Solander), 195
Puelle, Mlle., 2
Pultney, Mrs., 214

*Quamoclit pennatum, erectum, floribus in thyrsum
 digestis*, 199, *199*
"Queen of the Blues" (Elizabeth Montagu), 102.
 See also Bluestockings
Queensberry, Duchess of (Catherine 'Kitty,' *née*
 Hyde), 29, 31, 42, 43, *43*, 48, 53, 74, 84, 152, 156
Queen's Lodge, Windsor, 220
The Queen's Lodge, Windsor in 1786 (Ward), 15

Rabutin-Chantal, Marie de (marquise de Sévigné), 8
Racine, 139
Raman spectrophotometry, 227
Ramsay, Allan, *59, 60*
Ranelagh gardens, Chelsea, 47
Ray, John, 141, 161
Redouté, Pierre Joseph, 199
Reeves, William, 231
Religion, 59
Remarks on Forest Scenery (Gilpin), 188
Remnans (Windsor, Berkshire), 150
Reni, Guido, 119
Repton, Humphry, 166
The Restoration, 40, 42, 46, 84
Reynolds, Sir Joshua, *197*, 234
Richardson, Joseph, 95
Richardson, Samuel, 15, 100
Richardson, Thomas, 37, *37*
Rizzo, Betty, 104
Roads of England and Wales, *206*, 206–8, *210, 213*
Robertson, Mrs. Hannah, 96, 140, 141
Robertson's Young Ladies School of Arts,
 The Strand, London, 96
Robins, Thomas the Elder, 33, 153, *153*, 155, 166
Rochester, 2nd Earl of (Henry Hyde), 43
Rockingham, Lady, 88, *88*
Rocque, John, 29, *46, 48*
Rosa, Salvator, *117*
Roscrow Castle, Falmouth, Cornwall, 4, 113
Rossier, Miss, 95, *95*
Rousham, Oxfordshire, 54
Rousseau, Jean-Jacques, 59
Rowlandson, Thomas, 87

Royal Academy of Music, London, 47
Royal Academy of Sciences, Paris, 144
Royal Botanic Gardens. *See* Kew
Royal Dublin Society, 55
The Royal Gardens of Richmond and Kew
 (Richardson), 37
Rubens, Peter Paul, 119
Rubus fruticosus 209
The Rudiments of Genteel Behavior (Nivelon), *68, 69*
Russell, John. *See* Bedford, 4th Duke of, Viceroy
 of Ireland
Ryder, Dudley, 85

Sackville-West, Vita, 166
St. Alban's Street house, Windsor, 61, 62
St. Bartholemew's Hospital, London, 197
St. James Chapel, London, 54, 59, 62
St. James Palace, London, 29, 38, 41, *41*, 42, 46,
 53, 57, *57*, 75, *85*, 86, 143, 201, 204, *205*, 211, 215,
 216, 224
St. James Square, London, 56, 57, 58
St. Paul's Churchyard, London, 98
Sandby, Paul, 124
Sandford, Sally Chapone (goddaughter of Mary
 Delany), 56, 60, 119, 138, 154, 216
Saunderland, Samuel, 84
Savile, Miss Gertrude, 102
Sayer, Fanny, 215
Scanning electron microscopy (SEM), 227
Scarbrough, Lady, 89, 152
Schoen, H.W., 238
Scholes, Jenny, 95
Scotland and the Hebrides, 181
Scott, Sarah, 104
Scudéry, Mlle de, 50, *51*
Seamstresses and sewing, 96, 98
"Sensibility: An Epistle to the Honourable
 Mrs. Boscawen" (More), 4
Serle, John, 139, *139*
Sertum Anglicum (L'Héritier), 197, 199
Shackleton, Elizabeth, 132
Shannon, Lord and Lady, 81
Shapin, Steven, 132
Sharp, Robert, 178
Sharp, William, 239
Shelburne, 2nd Earl of, 1st Marquis of Lansdowne
 (William Petty), 55
Shelburne, Lady (Sophia Carteret Petty), 60
Shell Gallery, A la Ronde, Devon, *104*, 105
Shellwork, 4, 8, 102, *104*–5, 110, 134–41, 172–84,
 180, 182–83
Shenstone, William, 151, 153, 155
Sherard, William, 219
Sheraton, Thomas, 105
Sheridan, Thomas, 8
Sidney, Sir Philip, 50
Simpling Day or "General Herbarizing" (botanical
 excursions), 161
Sixteen Discourses (P. Delany), 54, *54*
Slater, Thomas, 236
Sloane, Sir Hans, 35, 137, *137*, 140, 219
Smelt, Leonard, 60, 62
Smith, Daniel, 178

Smith, Hannah, 83
Smith, James Edward, 166
Smithson, Hugh. *See* Northumberland, 1st Duke of
Snuffbox, 174, *174*
Society of Apothecaries, 161
Soho Square, London, 132, 141
Solander, Daniel Carlsson, 2, 9, 20, 59, 141, 180,
 183, 191, *191*, 195, 196, 197, 199, 204, 215,
 220, 234
Somerset, Mary Capel. *See* Beaufort, 1st Duchess of
Somerset House on the Thames, London, 29, 46, 47,
 49, *49*, 57
Sowerby, James, 161, *167, 196*
Species Plantarum (Linnaeus), 36, 188, 193
*Specimens of Rare and Beautiful Needlework, Designed
 and Executed by Mrs. Delany and Her Friend the
 Hon. Mrs. Hamilton*, 15, 67, 72
The Spectator, 106, 150
Spence, Joseph, 139, 153
Spencer, Georgiana Poyntz, 42, 56, 75
Spencer, Hon. John, 42, 43, 56, 75
Spencer, Mrs. John (Georgina Carteret).
 See Cowper, Lady
Spencer, Viscount John (later Viscount Althorp
 and 1st Earl Spencer), 42
Spencer, Lady Lavinia, 85
Spencer, Lady Sarah, 86
Spencer House, Green Park, London, 42, 56
Spenser, Edmund, 50, 150, 166
Spitalfields, 75
Spring Gardens house, London, 48, 56
Squerries Court, Kent, 101
Stafford, Marquis of, 43
Stamford, 5th Earl of (George Grey), 201
Stamford, Dowager Countess of (Mary Grey),
 84, 201, 224
Stamford family, 215
Stanley, Lady Anne, *née* Granville, 3, 46
Stanley, Sir John, 3, 46, 139
Stanley, Sir Thomas, 46
Stanley family, 54
Stationers of London, 238
Stella, 8
Stewart, Susan, 134
Stillingfleet, Benjamin, 161
Stirpes novae aut minus cognitae (L'Héritier), 199
Stoke Place, Buckinghamshire, 216, 219
Stoke Poges, 214
Stomacher, 72, *73*, 88, 175, *175*, 177, 182
Stone, Sarah, *145*
Stowe, 150
Strafford, Countess of (Anne), 81, 86, 89
Strafford, Earl of, 81, 89
Strathmore, Countess of (Mary Eleanor Bowes),
 201
Strathmore, Lord, 201
Strawberry Hill, Richmond upon Thames, London,
 1, 131, 166, 216, 220
"Strelitzia reginae" (Sowerby), 166, *167*
Stuart, James, *130*, 131
Stuart, John (Lord Bute). *See* Bute, 3rd Earl of
Stuart, Lady Louisa, 85
Stuart, Princess Anne, 43

Stuart, Princess Mary, 43
Stuart family, 46, 82
Stuart workboxes, 98
Stubbes, George, 120
Study of English Wildflowers of Field and Wood (Ehret), *158*, 159
Styles, John, 16, 31, 132
Sunderland, 3rd Earl of (Charles), 49
Sunderland, 4th Earl, 42
Sunderland, Lady (Judith Tichborne), 48–49, 87, 114, 133, 134
Surinam, 177
Sutherland, Earl and Countess of, 86–87
Swift, Jonathan, 1, 4, 6, 8, 10, 13, 68, 110, 114, 117, 139
Swiftbrook Paper Mill, Saggart, Dublin, 239
Swiss Alps, 163
Sydney, Lady, 86
Sylvester, Joshuah, 150
Symonds, Emily Morse, 15
Syon House, Northumberland, 31, 204, 207, 214, 215
Systema naturae (Linnaeus), 193, 201

Tabella of Linnaeus's Sexual System (Ehret), 190, *190*
Tahiti, 141
Talbot, Catherine, 120
Talman, John, *130*, 131
Tasso, 50
Taylor, Clement, 239
Tea Party at Lord Harrington's House, St. James's (C. Philips), *68*
Temple of Fancy, Rathbone Place, London, 96, 97
Ten Miles Round London (Rocque), *48*, 49
Textiles, 30–31, *30–31*
Thacker, Robert, *150*
The Thames from the Terrace of Somerset House, Looking toward Westminster (Canaletto), 49, *49*
Thatched House Court, London, 56, 57, 204, *205*, 208
'Thea Thee Tree' (Ehret), 159
Theatrum Botanicum, The Theater of Plantes: An Universall and Compleate Herball (Parkinson), 20, 34
Thorndon Hall, Essex, 193
Thrale, Hester, 87
Thunberg, Carl Peter, 188, 201, 220
Thynne, Louisa Granville (Lady Weymouth), 53, 58, 163
Thynne, Thomas. *See* Weymouth, Viscount
Tichborne, Judith. *See* Sunderland, Lady
Tighe, Mr., 155
Tillotson, Dr., 102
The Times, 88, 91
Toasting Muffins, Vide Royal Breakfast (Gillray), 82, *82*
Tour, Quentin de la, 119
Tower of London, 2, 100
Trevelyan, G.M., 84
Trew, Christoph Jacob, 137, 160, 204
Tribune at Strawberry Hill (Carter), *130*, *131*
Tsayama, Reikichi, 234
Tufton, Mary. *See* Gower, Dowager Countess

Tull, Betty, 102, 104
Turkey Mill, Boxley, Maidstone, Kent, 238
Twelve Months of Flowers: From the Collection of Robt. Furber, Gardiner at Kensington (Furber), 156, *156*
"Twenty-Five Miles Round London" (Palmer), 212, *213*
Twenty-five New Plants (Hill), 34
Twickenham gardens and grotto, London, 8, *32*, 33, 139, 172
Twinrocker Handmade Paper, Brookston, Indiana, 231

Une épistolière anglaise du XVIIIe siècle: Mary Delany, 1700–1788 (Kerhervé), 16
Universal Architecture … Original Designs of Grottos (Wright), 140, *140*
The Universal Conchologist (Martyn), 183, *183*
The Universal Magazine, 237
University of Göttingen, 59
Up Mills, South Stoneham, Hampshire, 239
Upton, Essex, 214, 215
Usher family, 55

Van Gerrevinck family, 238
Vauxhall gardens, London, 47
Veblen, Thorstein, 94
The Vegetable System (Hill), 188
Vernon, Caroline, 60
Vertue, George, 110, 125
Vesey, Mrs., 60, 102, 154
Victoria, Queen of England, 234
Victoria and Albert Museum, London, 30
Villiers, Lady Mary, 91
Viney, Miss H., 115
Vineyard Nursery (Hammersmith), 166, 197, 215, 219
Vulliamy, C.E., 15
Vyne, Hampshire, 102

Waistcoat, man's, 88, *90*, 101, *101*
Waller, Richard, 226
Wallpaper, Chinese, 31, *31*
Walpole, Horace (4th Earl of Oxford), 1, 13, 94, 110, 131, 154–55, 158, 161, 166, 188, 216, 220, 234
Walpole, Lady, 156
Walpole, Robert, 50, 53, 72
Walsingham, Hon. Mrs., 40, 110
Ward, Henrietta, *14*, 15, 115
Warde, Mary, 101
War of the Austrian Succession, 53
Weddell, Mrs., 214
Welbeck, Nottinghamshire, 9, 202
Wellesbourne estate, Warwickshire, 58, 207, 212, 214, 215, 216
Wellesley, Francis, 122
Wentworth, Peter, 81, 89
Wesley, Elizabeth, 115, *115*
Wesley, John, 1
Wesley family, 4, 114
West Indies, 132, 139, 180, 197
Westmoreland, Earl of, 54

Westmoreland, Lady, 54
West Wycombe, Buckinghamshire, 208, *208*
Weymouth, 1st Viscount (Thomas Thynne), 42
Weymouth, 2nd Viscount (Thomas Thynne), 53
Weymouth, 3rd Viscount (Thomas Thynne, later 1st Marquis of Bath), 41, 58, *58*
Weymouth, 3rd Viscountess (Elizabeth Thynne, *née* Bentinck), 49, 58, *58*, 59, 69, 115, 143, 157, 163, 175, 204
Weymouth, Dorset, 20, 38, 159, 160, 166, 205, 208, 214, 220
Weymouth, Lady. *See* Thynne, Louisa Granville
Whatman, James the Elder, 238
Whatman, James the Younger, 239
Whatman paper, 245
White, Gilbert, 163
Whitehall, London, 3, 46, 57, 86, 112, 204
Whitehead, Miss, 84
Wilkes, Wettenhall, 102
William III, King of England, 40, 46, 48, 55, 81, 90, 219
Williams, Robert, 239
Willoughby de Broke, Lady (Louisa North), 58, 164, 215
Willoughby de Broke, Lord, 156
Wimbledon Park, Surrey, *130*, 131, 216
Windsor Castle, *14*, 15, 38, 48, 56, 59, 60, 166, 214, 220, 234
Withers, Charles, 132
Wollstonecraft, Mary, 107
Woman with Basket or Coracle (Lady Andover), 125, *125*
Woollett, William, 36, *36*
Workbag, embroidered, 75, *75*
Workboxes, 97–99, *98*
Worsley, Frances, 49
Wrest Park, Bedfordshire, 81
Wright, Mrs. Phoebe, 74
Wright, Thomas, 33, 140, 150
Wroxton Abbey, Oxfordshire, 33, 58, *152*, 153, 159, 214

Yale Center for British Art, 225
Yarmouth, Countess of, 42
Yealand, Lancashire, 188
Yorke, Lady Elizabeth, 86
Yorke, Philip and Charles, 120
The Young Ladies School of Arts (Robertson), 96
"Yucca aloifolia" (Ehret), 190, *190*

Zincke, Christian Friedrich, 4, *5*, 114
Zoffany, John, *61*, 191
Zonen, 238

Photographic Credits

Abegg-Stiftung, Riggisberg, Switzerland: fig. 62
Ackworth School: fig. 190
The Collection at Althorp: fig. 40
Andrew Alpern Collection: fig. 232
© 1972 J. Arnold: fig. 22

Courtesy of the Duke of Beaufort, Badminton: fig. 32
Beinecke Rare Book and Manuscript Library, Yale University: figs. 60, 130, 134
Bibliothèque Nationale de France, Paris: fig. 253
Peter Bower Collection: figs. 241, 242, 258
Photograph by Peter Bower: figs. 249, 250, 251, 255, 256, 257
Photograph by Sally Bower: figs. 240, 244, 245, 246, 247, 248, 252, 254
By permission of the British Library: figs. 34, 166, 174, 175, 177, 209, 210, 212, 213, 214, 217, 265
© The Trustees of the British Museum: figs. 4, 6, 16, 21, 28, 35, 51, 111, 112, 113, 132, 137, 138, 139, 140, 141, 143, 159, 160, 161, 162, 163, 193, 194, 196, 200, 202, 204, 205, 208, 211, 215, 216, 218, 219, 220, 221, 222, 223, 227, 243; plates 1-24, front cover

Chelsea Physic Garden: fig. 186
Country Life Picture Library: fig. 25

© Dumbarton Oaks Research Library and Collection, Rare Book Collection, Washington DC: figs. 15, 151

© English Heritage Photo Library: figs. 120, 121, 122

Reproduced by permission of the Syndics of the Fitzwilliam Museum, Cambridge: figs. 154, 155, 156, 157

Courtesy of John Harris: fig. 27
Imaging Department © President and Fellows of Harvard College: figs. 171, 172, 180, 197
© Historic Royal Palaces: fig. 86
© Hunterian Museum & Art Gallery, University of Glasgow: figs. 176, 182

Irish Architectural Archives: figs. 14, 259, 260

Judges' Lodgings Museum, Lancaster (Lancashire Museums Service): fig. 92

Courtesy of The Lewis Walpole Library, Yale University: figs. 77, 78, 80, 81, 82, 83, 84, 94, 127
Courtesy, The Lilly Library, Indiana University, Bloomington, Indiana: figs. 13, 102, 105, 106, 107, 108, 261, 262, 263, 264
By permission of the Linnean Society of London: figs. 189, 192, 203
London Metropolitan Archives: fig. 89

Reproduced by permission of the Marquess of Bath, Longleat, Warminster, Wiltshire, Great Britain: figs. 53, 142, 149
© MOTCO Enterprises Limited: fig. 44
Museum of London: figs. 72, 88, 90, 91, 95

Special Collections, National Agricultural Library: fig. 179
National Archives, UK: figs. 52, 206
Courtesy of the National Gallery of Ireland, Photo © National Gallery of Ireland: figs. 8, 12, 29, 50, 103, 104, 115, 116, 117, 118, 119, 123, 124, 133, 144, 145, 146, 147, 165
© The Natural History Museum, London: figs. 31, 136, 153, 164, 181, 187, 199
National Museums Cardiff, Welsh Folk Museum: fig. 22
© National Museums Liverpool: figs. 20, 188
© National Portrait Gallery, London: figs. 5, 39, 41, 46, 114
© NTPL / Geoffrey Frosh : fig. 99
© NTPL / David Garner: fig. 98
© NTPL / John Hammond: fig. 150
© NTPL / Angelo Hornak: fig. 36

Collection of Mrs. Paul Mellon, Oak Spring Garden Library, Upperville, Virginia: figs. 1, 2, 3

The Pierpont Morgan Library: figs. 158, 178
Private collection: figs. 110, 148, 167, 169, 173
Private collection, photo by John Hammond: figs. 7, 10, 11, 24, 58, 61, 63, 66, 67, 109, 170, 183, 184, 185, frontispiece, back cover

RIBA Library Drawings Collection: fig. 125
Rijksmuseum Amsterdam: fig. 65
Reproduced with the kind permission of the Director and the Board of Trustees, Royal Botanic Gardens, Kew: figs. 191, 195
The Royal Collection © 2009 Her Majesty Queen Elizabeth II: figs. 17, 37, 47, 48, 54, 56, 229
© Royal College of Physicians of London: fig. 201
Royal Horticultural Society, Lindley Library: fig. 152

© The Stuart Collection / Courtesy of the National Portrait Gallery, London: fig. 9

Trustees of the Titsey Foundation: fig. 55
Reproduced by kind permission from the Board of Trinity College Dublin: fig. 49

© V&A Images / Victoria and Albert Museum, London: figs. 18, 23, 57, 64, 68, 69, 70, 71, 73, 74, 75, 76, 85, 87, 93, 96, 97, 100, 101, 126, 128, 129, 168
Courtesy of Victoria Munroe Fine Art: fig. 198

Photo + Design, Yale University: fig. 30
Richard Caspole, Yale Center for British Art: figs. 19, 33, 38, 45, 59, 79, 135, 207, 224, 225, 226, 228, 230, 231, 233, 234, 235, 236, 237, 238, 239
Courtesy of Yale University Library: fig. 131